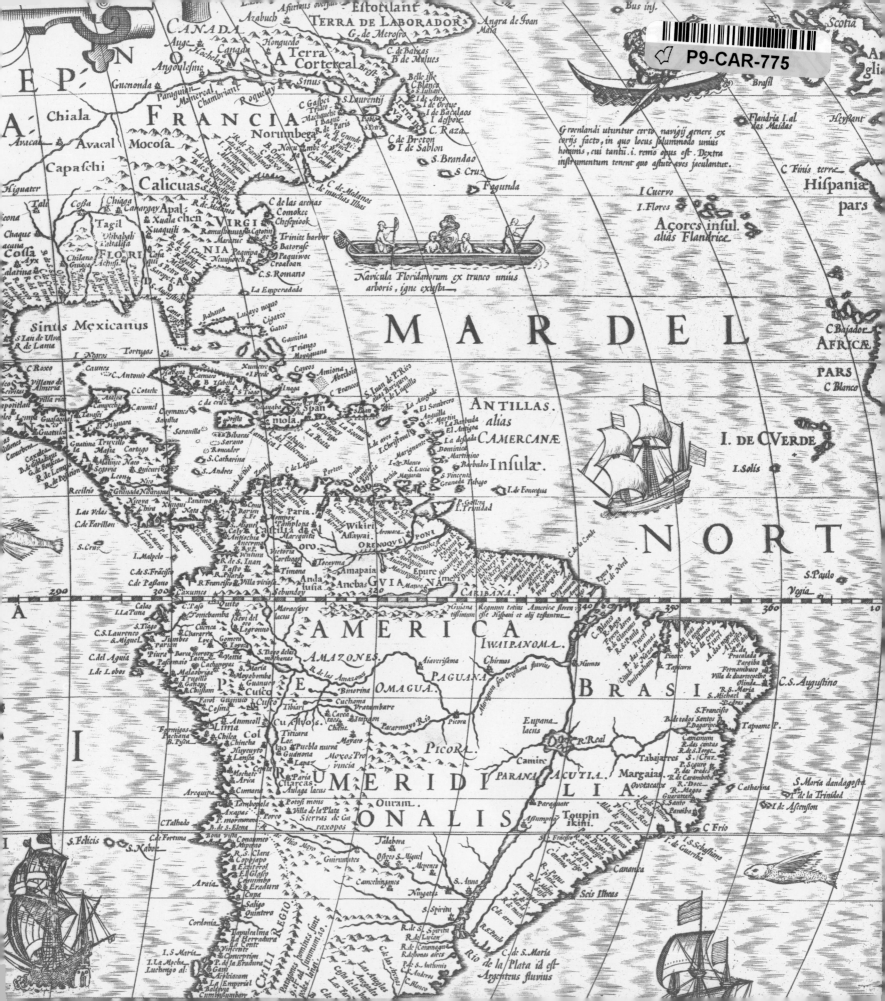

P9-CAR-775

A NEW WORLD IMAGINED

ART OF THE AMERICAS

A NEW WORLD IMAGINED

ART OF THE AMERICAS

Elliot Bostwick Davis, Dennis Carr, Nonie Gadsden, Cody Hartley,

Erica E. Hirshler, Heather Hole, Kelly H. L'Ecuyer, Karen E. Quinn,

Dorie Reents-Budet, and Gerald W. R. Ward

mfa BOSTON PUBLICATIONS *Museum of Fine Arts, Boston*

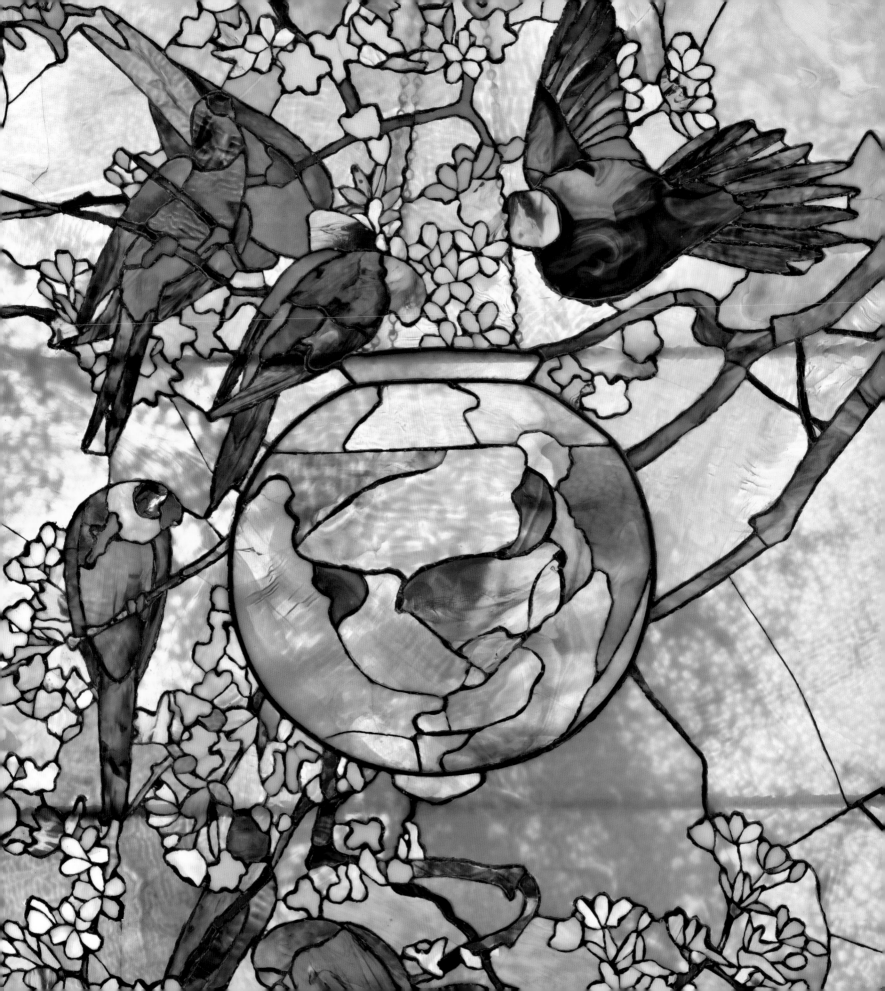

CONTENTS

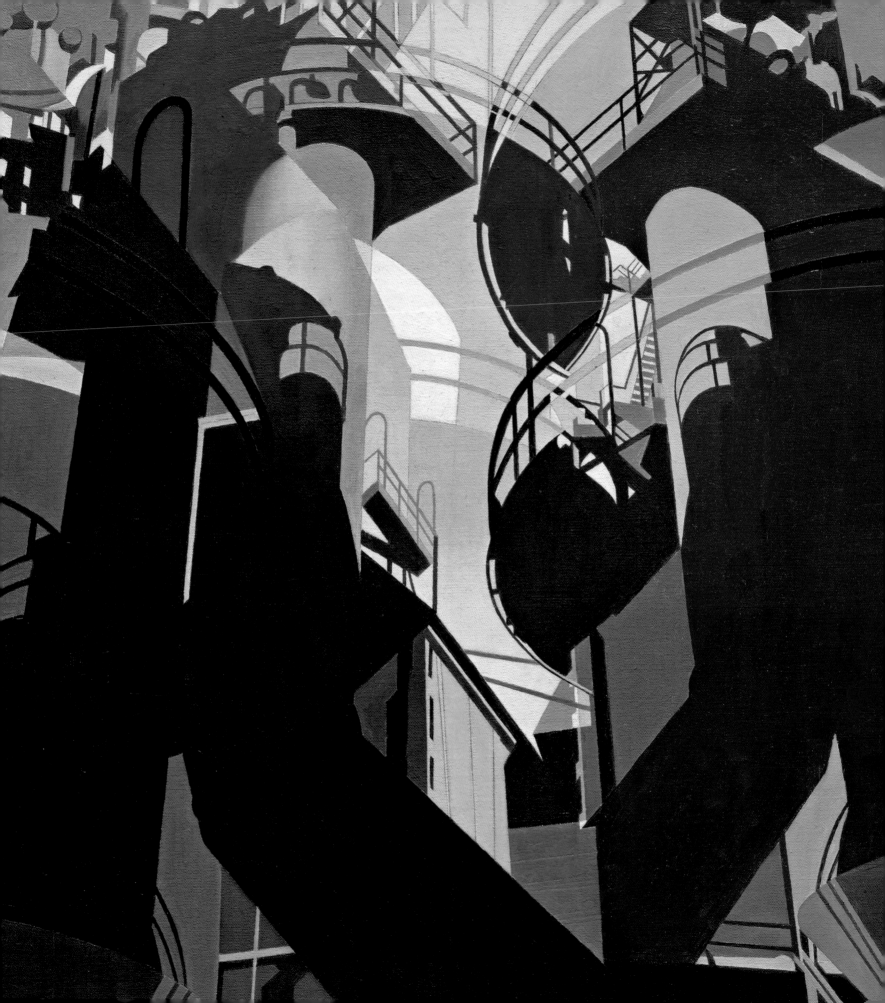

DIRECTOR'S FOREWORD

The Museum of Fine Arts, Boston, opens its new wing dedicated to the Art of the Americas in November 2010. The culmination of over a decade of preparation, the building is a testament to the Museum's commitment to share great art in an inspiring environment. It also represents a new beginning in how we present our American collections, adopting an approach that is geographically expansive, culturally inclusive, and richly contextual.

In the wing, we have thought deeply about how to enrich your encounter with art, how to make the collections speak anew. These galleries feature objects drawn from across the Museum's collections, including paintings, decorative arts, sculpture, fashion and textiles, and musical instruments. With parallel concerns in mind, this publication reaches beyond the physical constraints of the galleries to explore the international context for the Art of the Americas. Just as the wing places the art of the Americas in the midst of our global collections, this book considers the cosmopolitan nature of American art. It traces the migration of people and ideas across the planet through a geographic approach. Each of the following chapters considers the art of the Americas in the context of a different nation or region, renewing our appreciation for the global nature and origins of our collection.

Both this book and the galleries that occasioned it provide compelling visual evidence that the products of civilization, like the world's peoples, are interrelated and intimately connected. The colonial experience of New England, for example, is better understood in the context of the international race to colonize the Americas, recognizing that colonies were complicated enterprises driven by a host of commercial, civic, and spiritual goals. Similarly, we cannot truly appreciate the development of art in the United States without reference to the Native American cultures that preceded it, or to the influx of populations from Europe, Africa, Asia, and elsewhere that infused the American grain with myriad other traditions.

While shaped by contemporary values and current scholarship, the strategies we have adopted are not incongruous with the MFA's past. Our founders and early benefactors looked far beyond New England in their efforts to assemble a collection representing all periods of history and produced by people of all walks of life from around the world, creating a comprehensive encyclopedic art museum. The construction of a wing devoted to the Art of the Americas is a reaffirmation of the founders' aspirations to display the most inspired products of human civilization under one roof.

Many people contributed to the writing and publication of these essays on the Art of the Americas collection. I am especially grateful to Elliot Bostwick Davis, John Moors Cabot Chair, and the curatorial staff under her leadership for their insight and sensitivity in presenting the great depth and richness of the collection, and for making complex topics accessible to our museum-going public.

A book like this can only become a reality through the generosity of many individuals, foundations, and corporations. We are especially grateful to the Vance Wall Foundation for its wonderful support. We also wish to recognize the Andrew W. Mellon Publications Fund for its assistance in funding this publication.

MALCOLM ROGERS
Ann and Graham Gund Director
Museum of Fine Arts, Boston

ACKNOWLEDGMENTS

For more than ten years, the members of the Art of the Americas department have dedicated themselves to refining, interpreting, and building the collections that now appear in the new Art of the Americas Wing. As curators, we benefitted from many perspectives and a wealth of expertise offered not only at the Museum of Fine Arts, Boston, but throughout our profession. Those who offered a helpful hand number into the thousands—more than enough to fill several galleries—and we extend our heartfelt thanks to each and every one.

For their support in creating this publication, we are indebted to Malcolm Rogers, Ann and Graham Gund Director, and Katie Getchell, Deputy Director. Within the Art of the Americas department, the authors of this book worked tirelessly to ensure its completion during an extremely busy time in their professional lives. While developing the broad concepts introduced here, they were also engaged in myriad details, including the composition of more than 6,500 labels for the objects on view in the new wing, the preparation of content for numerous exhibition and educational activities, and, of course, their many ongoing curatorial tasks. For their extraordinary dedication, many accomplishments, and generous collegiality, I am indebted to Erica Hirshler, Croll Senior Curator of American Paintings, and Gerald Ward, Katharine Lane Weems Senior Curator of American Decorative Arts and Sculpture, who began to shape this publication early on, as well as all of the other curators who were engaged in creating the new Art of the Americas galleries: Dennis Carr; Nonie Gadsden, Carolyn and Peter Lynch Curator of American Decorative Arts and Sculpture; Cody Hartley; Heather Hole; Kelly L'Ecuyer, Ellyn McColgan Curator of Decorative Arts and Sculpture, Art of the Americas; Karen Quinn, Kristin and Roger Servison Curator of Paintings, Art of the Americas; and Dorie Reents-Budet. We also greatly appreciate the additional support within the Art of the Americas department of Janet Comey, Katie DeMarsh, Michelle Tolini Finamore, Danielle Kachapis, Toni Pullman, and Victoria Ross, who together handled numerous research and administrative tasks with efficiency and good cheer.

We are grateful to MFA Publications for their help in bringing this volume to fruition. From the outset, publisher Mark Polizzotti and senior editor Emiko Usui were instrumental in formulating critical concepts that shaped this book, and their insightful queries, together with the deft hand and keen mind of editor Fronia Simpson, assisted in numerous ways to refine the essays that follow. We also thank production manager Terry McAweeney, designer Cynthia Randall, production editor Jodi Simpson, and publications assistant Kristen Borg for their expertise in creating a book that is enjoyable to hold and engaging to read.

Many colleagues in other curatorial departments and conservation laboratories generously took time to suggest objects for comparison, share their extensive knowledge, and read drafts of various chapters. We are grateful to Ronni Baer, William and Ann Elfers Senior Curator of Paintings, Art of Europe; Arthur Beale, Chair Emeritus, Conservation and Collections Management; David Becker, Pamela and Peter Voss Curator of Prints and Drawings; Lawrence Berman, Norma Jean Calderwood Senior Curator of Ancient Egyptian, Nubian, and Near Eastern Art; Jonathan L. Fairbanks, Katharine Lane Weems Curator Emeritus, American Decorative Arts and Sculpture; Christraud Geary, Teel Senior Curator of African and Oceanic Art; Karen Haas, The Lane Collection Curator of Photo-graphs; Hiromi Kinoshita; Darcy Kuronen, Pappalardo Curator of Musical Instruments; Alison Luxner; Rhona MacBeth, Eijk and Rose-Marie van Otterloo Conservator of Paintings; Megan Melvin; Elizabeth Mitchell; Anne Nishimura Morse, William and Helen Pounds Senior Curator of Japanese Art; Thomas Michie, Russell B. and Andrée Beauchamp Stearns Senior Curator of Decorative Arts and Sculpture, Art of Europe; Patrick Murphy, Lia and William Poorvu Curatorial Research Fellow, Department of Prints, Drawings, and Photographs and Supervisor, Morse Study Room; Katrina Newbury, Saundra B. Lane Associate Conservator; Pamela Parmal, David and Roberta Logie Curator of Textile and Fashion Arts; Jane Portal, Matsutaro Shoriki Chair, Art of Asia, Oceania, and Africa; Hao Sheng, Wu Tung Curator of Chinese Art; Michael Suing; Ellen Takata; Sarah Thompson; Rebecca Tilles; Laura Weinstein, Ananda Coomaraswamy Curator of South Asian and Islamic Art; and Lauren Whitley. Members of the Libraries and Archives department lent their unfailing assistance with numerous inquiries, and we thank Maureen Melton, Susan Morse Hilles Director of Libraries and Archives and Museum Historian; Deborah Smedstad; Lorien Bianchi; and Liz Prince. It is not easy to work with authors juggling multiple deadlines and demands of a major building project, and we thank all of you for your patience, understanding, and good humor throughout the process.

We are especially grateful to our colleagues who generously assisted us in the work of reinstalling the Art of the Americas collections in the new wing. It was a herculean task, and it could not have been accomplished without the expertise, determination, and dedication of numerous conservators, collections care specialists, facilities staff, registrars, curatorial project managers, guards, and a range of administrators, all of whom were carefully coordinated by capable members of our Exhibitions department, led by Patrick McMahon. For our presentation of the collections in the wing, we thank the members of Foster and Partners who worked with us over the course of eighteen months, and particularly our head designer, Keith Crippen, and assistant designers Jamie Roark and Tomomi Itakura, who brought our ideas to life. We are also indebted to Barbara Martin, Barbara

and Theodore Alfond Curator of Education; Benjamin Weiss; Jenna Fleming; and members of the Education and New Media departments for all of their superb work on the interpretative labels and interactive materials.

To Patricia Jacoby and all of the members of Development department, especially Anne Cowie and William McAvoy, as well as David Blackman and Erin McKenna, we thank you for your sage advice and celebrate all that you have accomplished with the building and gifts of art campaigns. Kim French and all of our colleagues in Marketing and Public Relations, especially Dawn Griffin, Kelly Gifford, Jennifer Gillespie, and Janet O'Donoghue, expertly spread the news about our collections and our Museum. To Mark Kerwin and his Financial team, we thank you for keeping us well accounted for in the face of significant economic challenges, and to Jane O'Reilly and Myriam Negron, we appreciate your generous assistance as we added new members to our department.

We received a tremendous amount of support from the leadership of the Museum: trustees, overseers, and ranks of devoted volunteers who made the dream of the Art of the Americas Wing a reality. We especially thank all the members of our department's Visiting Committee and Karolik Society who kept the home fires for American art burning brightly over the years. Numerous lenders, including many members of the Visiting Committee, graciously shared their precious works of art with the public in celebration of the opening of the Art of the Americas Wing, and we express our sincere thanks to all who have helped to bring out the best in our collections.

Carol and Terry Wall have been extraordinary partners in their generous support of this publication through the Vance Wall Foundation, and have provided inspiration and leadership in so many other ways as well. We value their insight, creativity, intelligence, and treasured friendship throughout many enjoyable encounters over the years spent in the pursuit of excellence in American art. Additional support was provided by the Andrew W. Mellon Publications Fund. We cannot thank them enough.

Inspired by the foresight and drive of Malcolm Rogers, I readily accepted the trust he placed in me ten years ago to assume responsibility for overseeing the development of a vision for a new wing, which is now a reality, owing to a carefully coordinated, collaborative effort with many colleagues and friends. For Malcolm's support and encouragement, I wish to express my deep gratitude. I also wish to thank my husband, who willingly assisted in the relocation of our family to Boston, and my sons, William and James, all of whom have filled this journey with joy.

ELLIOT BOSTWICK DAVIS
John Moors Cabot Chair
Art of the Americas

A NEW WORLD IMAGINED

ARTISTIC INNOVATION AND INSPIRATION IN THE AMERICAS

ELLIOT BOSTWICK DAVIS

Home to more than nine hundred million people living in thirty-five modern-day countries, the continents of North and South America stretch from the Arctic Circle in the north to the tip of Patagonia in the south, over terrain that is as rich and varied as its inhabitants. Vast expanses of ocean on either side of these continents initially separated the cultures and peoples of North, Central, and South America from Europe and Africa to the east and Asia to the west. Before modern history was recorded, indigenous peoples—Native Americans—erected impressive mound structures throughout what is now the southeastern United States and extended farther south into regions of Central America, where ancient American societies as early as 3500 B.C. developed complex and flourishing cultures. Over time, the indigenous peoples, their descendants, and later waves of immigrants to the Americas would encounter other cultures from around the world. How those encounters influenced the works of art they created is the main theme of this book.[1]

During the fifteenth century, the discovery of the Americas by Europeans brought new cultural contacts, and the oceans, physical barriers that once isolated these continents from the rest of the world, now were a means for transporting people, goods, and ideas. Images proliferated of the Americas as the "New World": a fantastic place, unfathomable and different from anything previously known to Western civilization. Europeans marveled at, and fantasized about, the seemingly endless, untouched tracts of land, the wondrous flora and fauna, and the exotic populations. Explorers freely plundered their new conquests and gathered up the spoils, whether fruits, animals, or native peoples (touted as "savages," despite their millennia-old traditions), along with works of art. Many of these were sent back to Europe for public display or as tribute to their royal patrons, sometimes to surprising effect. The fifteenth-century explorer Hernán Cortés, for instance, sent Emperor Charles V of Spain a variety of objects from the Americas. These caught the attention of the German Renaissance master Albrecht Dürer while he was traveling in Brussels and Mechelen in 1520. With an artist's sense of wonder and a European's sense of cultural superiority, Dürer recorded his amazement at encountering these finely wrought works of art from "foreign Lands":

> I saw the things which have been brought to the King from the new golden Land: a sun all of gold a whole fathom broad, and a moon all of silver of the Same size, also two rooms full of the armor of the people there, and all manner of wondrous weapons of theirs. All the days of my life I have seen nothing that Has gladdened my heart so much as these things, for I saw amongst them wonderful works of art, and I marveled at the subtle ingenia of men in foreign Lands.[2]

(page 12)
Attributed to Samuel McIntire
Chest-on-chest (detail, fig. 59)

Tairona
Shaman-bat effigy pectoral
(detail, fig. 9)

Over the following centuries, émigrés from several European countries, lured by the prospect of opportunity, wealth, exotic adventure, or religious freedom, established colonies on the vast new continents, importing many of their artistic traditions with them. As the American Revolution gave way to the founding of the United States in the late eighteenth century, these artistic traditions played a central role in how the newly established nation defined itself. This definition was hardly monolithic, however. Swells of immigration from all parts of the globe diluted the possibility that the United States or the Americas as a whole could be characterized by a single indigenous or national culture. As peoples from different traditions came into contact with each other, artists adopted, adapted, borrowed, and put new or unfamiliar forms to old uses and new ends. The works these artists created incorporated many perspectives, derived from their ancestral homelands, their newly adopted surroundings, and their fertile imaginations, becoming in the process a rich hybrid that we have come to characterize, broadly speaking, as "American." This book is both a window onto this blending of traditions and an attempt to explore some of the perspectives that have contributed to the concept of American art.

It is worth pausing here on the verb "explore," as opposed to "define," as no attempt at definition could do justice to anything as rich and complex as a nation's artistic culture, let alone a culture—or rather, cultures—as mixed and varied as those of the Americas. Moreover, given the challenges for any single volume to offer a truly encyclopedic vision of American art from ancient times to the present day, certain decisions have guided us in conceiving and shaping this discussion. The scope of this book has been mostly determined by the context in which it was written, the collections on which it is based, the historical arc that influenced both of these, and a concern with adopting a structure and viewpoint that are unified without overly simplifying them.

First, it is important to note that the following discussion is based on the Art of the Americas collection of the Museum of Fine Arts, Boston. While this framework guides the paths these essays follow, it also helps illuminate a current that has shaped how we perceive the history of American art. Founded in 1870, the MFA belongs to a small group of art museums established in various metropolitan centers in the United States during that decade. As with several of these museums, the American collections at the MFA were, and still are, dominated by the art of the United States—and, within the United States, by those Anglo-American artists and makers who immigrated to, originated near, or worked in the Northeast.

At the same time, the founders and early benefactors of the MFA looked beyond their immediate surroundings in New England and their own economic, educational, or social circumstances. They attempted to assemble under one roof works of art from all periods of history and created by people from around the globe, in the hope of eventually forming a public institution that could provide a comprehensive presentation of the history of art. As part of its educational mission, the Museum was open to the possibility of including Native American and ancient American art, Spanish colonial art, and folk art in its collections from the moment it first opened its doors on July 4, 1876. Over time, these collections have grown, shaped by successive generations, and they continue to evolve to this day. Therefore, the selection highlighted in this book is broad enough to allow for a rich and varied line of inquiry, and its particular character mirrors the ways in which Americans have viewed and understood their own art over the centuries.

More specifically, this book was written to accompany the opening of the Museum's new Art of the Americas Wing, which has led us to reevaluate many previously held assumptions about how American art has been created, collected, and displayed. These reevaluations are natu-

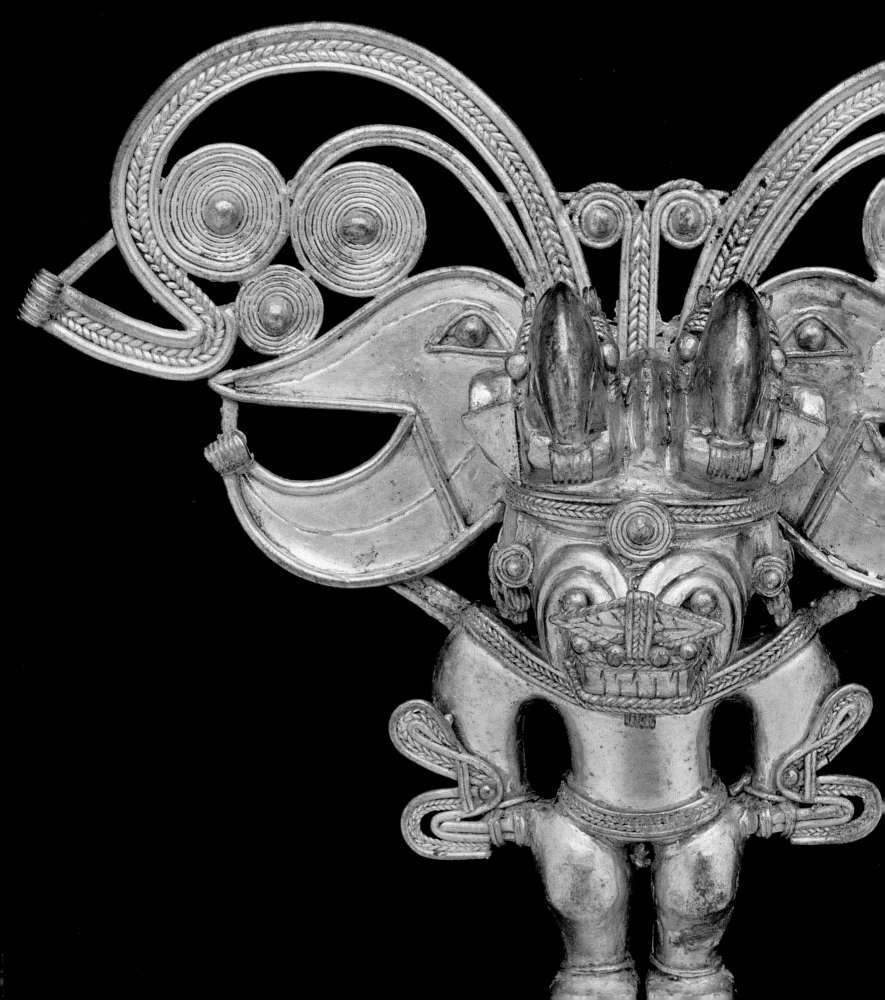

rally reflected in the following pages. To take one example, beginning in the early twentieth century, art created by the indigenous peoples of the Americas disappeared from prominence at the MFA. Many fine examples of Native American art were relegated to storage; others were sent to local ethnographic museums for display in anthropological contexts that focused on the cultures associated with these objects rather than on their aesthetic qualities. Today, however, the works of ancient American and Native American artists form the foundations of the Art of the Americas collections and may be seen alongside artworks created by early settlers in the North, Central, and South American colonies and later immigrants or descendants. In many ways, the creation of a wing that reinstates these works to their rightful prominence is consistent with the original concept of the Museum's founders, who aimed to display together art created by different peoples over long periods of time. Our hope is that the comparisons and contrasts that these artworks generate, both in the Art of the Americas Wing and in this book, will open new and ever more rewarding avenues for exploring and appreciating American art as a whole.

Artists in the Americas brought a variety of traditions to their works, selected them in innovative ways, and decided whether or not to assimilate them in the objects they created. To fulfill their vision, these artists worked in a wide range of media, including painting, sculpture, decorative arts of all kinds, textiles, musical instruments, and works on paper, such as drawings, watercolors, prints, and photography. We have included all of these media in these pages. Certain forms of art, for various reasons, have been omitted from our discussion, though they can be considered part of the broader continuum of art in the Americas. Ephemera, popular and advertising art, conceptual art, and film, for instance, are not part of the Art of the Americas collections (though many of these are well represented in other Museum departments) and have not been included here. Conversely, objects that have been broadly defined by the catchall term "folk art," while a vital part of the Art of the Americas collections, have not figured prominently in this book because their creators were not usually concerned with imitating or incorporating other artistic styles from around the world.[3]

For the purposes of this volume, we interpret the artistic traditions of other cultures by gazing outward from the perspective of the artists working in the Americas, primarily—although, as the case of indigenous peoples demonstrates, not exclusively—through the lens of the culture of the United States. Why these artists turned their attention outward—the traditions and techniques they absorbed, adapted, or even rejected; the effect that these perceptions had on the development of American art— forms the core of the following discussion. In other words, rather than considering the art of the Americas on its own terms (assuming this is possible) as separate and distinct from the rest of the world, we considered it more productive and historically accurate to examine the ways in which American art, broadly defined, has been shaped by its encounters with cultures found around the globe.

Although useful, this approach immediately raises a difficulty: how to discuss the arts of ancient and Native Americans as the foundation for the successive generations of artists who worked in North, Central, and South America. In each case, we have had to adjust our methodology and approach. The ancient American cultures interacted among themselves in ways that had a lasting impact long before the Spanish conquest; Native Americans produced works of art centuries before contact with white settlers and sustain many vibrant cultures to this day. For those chapters, the authors selected works of art that reflect a range of cultural encounters. For ancient Americans, those interactions originally occurred primarily among neighboring peoples; during the nineteenth and twentieth centuries, however, artists working in North and South America drew upon and appropriated ancient American art forms and styles as a vital aesthetic heritage distinctly different from Europe, Africa, and Asia. In the discussion of Native American art, the authors distinguish between those works of art created before and in

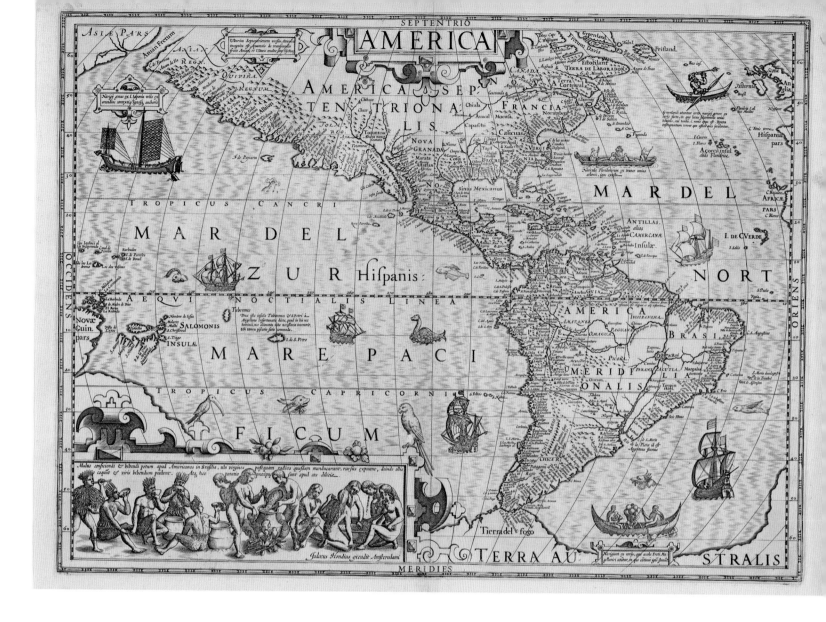

1

Jost (Jodocus) Hondius
Netherlandish, 1563–about 1611
Map of North and South America
Engraving
37.5 x 50.5 cm (14⅞ x 19⅞ in.)

response to contact with European immigrants and their descendants, then explore how several artists working from the late nineteenth century onward sought Native American art as an inspiration for their own creations. To some extent every chapter of this book required the respective authors to think creatively and work collaboratively with our methodology, as no two cultural encounters—and, consequently, no appropriate discussion of them—can be viewed as similar.

Among the many influences on North American culture from the seventeenth to the twentieth century, by far the strongest came from Europe, and, accordingly, we have devoted the largest section of the book to various European countries. Patterns of European colonization and immigration left long and deep traces on the development of the art of the United States. From the European perspective, the New World of North and South America was there for the taking, and Europeans made fast work of carving up available lands. In 1604, before colonies were established in Jamestown, Virginia (1607), or Plymouth, Massachusetts (1620), the Flemish engraver Jost (Jodocus) Hondius began a series of new maps of the world and later published a revealing image of America, with Europe's place firmly inscribed (fig. 1).[4] Along with five imposing flagships from the great European seafaring nations, the

names "Hispanis," "Francis," "Brasilia," "Virginia," and "Nova Albion" appear like so many markers staking their claim to the soil. At the margins, indigenous inhabitants—or the artist's conception of them—are depicted in everyday activities (paddling a canoe or preparing a beverage), yet they appear unprepared to resist the inexorable tide of colonization.

The European notion that the New World offered vast, underutilized resources awaiting cultivation by the hand of Western civilization encouraged artisans and artists to be included among the earliest efforts of colonization. In this regard, the first settlers to Jamestown included German glassmakers, while Dean George Berkeley of England planned to build a college in Bermuda and even recruited the Scottish-born artist John Smibert to teach there, though the necessary funds never materialized.[5] Despite the challenges of establishing firm artistic roots here, not least the hardscrabble nature of colonial life, European artistic influence rose steadily during the seventeenth and early eighteenth centuries. Before the American Revolution, colonial artists in New England, many from British stock, emulated the styles of their ancestors, often replicating objects left behind in the Old World. Artisans brought with them techniques of craftsmanship or tools that had been handed down from master to apprentice for generations, showing little desire to refine or embellish those traditions. As time went on, however, colonists and successive waves of immigrants were forced to confront changing political, social, and economic conditions. Some artists responded to the new context of the American colonies by creating works of art that diverged from the traditions they had left behind, sometimes out of necessity. They introduced different combinations of motifs or new inventions, either variations on or clear departures from the works they had known in their homelands.

After the Revolution, a mix of innovation and reliance on traditions became the order of the day, as residents of the newly minted United States set about creating new systems of government, modes of social behavior, and eventually artistic styles that would express and embody the ideals of a new nation. The founding fathers—George Washington, Thomas Jefferson, John Adams, and Benjamin Franklin, among others—established a government based on traditions they had studied and admired, such as the Enlightenment philosophies of eighteenth-century European thinkers or the precepts of classical antiquity. Artists, artisans, and architects who came of age within this historical context shared a similar approach. Painters such as Gilbert Stuart and Thomas Sully or furniture makers like Anthony Quervelle and Samuel McIntire were well versed in the motifs and forms of the past and, like the authors of the Constitution, selected those artistic traditions they felt best expressed the new nation's ideals for their clientele—however fickle and far between such a clientele might be.

But while cultures from other parts of the globe represented venerable ancestral traditions for some artists, for others they opened unknown worlds. As generation followed generation and growing numbers of Americans were born on these shores, the reality of one's ancestral heritage became ever more remote. To some degree, the life patterns of a mostly agrarian culture were replaced by those of an increasingly industrialized society. At the same time, the difficulties and cost of travel diminished the opportunities for firsthand knowledge of the Old World. An interest in experiencing foreign cultures spurred eager armchair travelers to read popular literature about far-flung destinations and whetted appetites for foreign trade goods imported to the

United States. Interest does not equal knowledge, however; these enthusiasms often bred highly whimsical notions of life abroad, particularly with regard to non-Western cultures. Fantasy, idealization, and racial stereotypes prevailed, fueling artistic imaginations and often producing images that were blatant, even repugnant, reflections of widely held beliefs and prejudices. Trade goods catered to popular taste, often trumpeting aesthetic sensibilities that had nothing to do with the cultures they claimed to represent. Ultimately, however, whether or not these fanciful stories or objects were true to their sources is less important than the fact that artists looking toward these cultures believed they were true, and that inevitably they brought their own attitudes to bear when drawing inspiration from "foreign Lands" (to repeat Dürer's phrase). The chapters in this book on Africa, the Near East, and Asia in particular offer insight into the ways artists reflected their own values by what they did or did not select from foreign traditions and how they assimilated aspects of those traditions in their own works. Although it is true that the culture and art of the United States are the product of assimilation and appropriation, we must not underestimate the role of invention and imagination.

Beginning in the mid-nineteenth century, artists working in the United States had greater access to art produced by other cultures through travel at home and abroad (though this did not guarantee genuine understanding). In major cities, wealthy citizens retracing the Grand Tour abroad of earlier centuries as a means of rounding out their educations often acquired art along the way. Many civic-minded collectors opened their homes for interested parties, especially artists, eventually supporting small public galleries accessible for a fee. Other smaller galleries and public assembly halls departed radically from the tradition of European museum collections, which were largely formed by royal conquests, and catered to popular taste. These establishments proliferated in the United States during the nineteenth century and ran the gamut from entertainment palaces, like Phineas T. Barnum's American Museum (founded in 1841), to galleries run by the American Art-Union, which sought to increase art appreciation and patronage among the public by selling lottery tickets for an original oil painting by a contemporary artist. It was in this context that major U.S. museums such as the Metropolitan Museum of Art in New York; the Corcoran Gallery of Art in Washington, DC; the Philadelphia Museum of Art; the Art Institute of Chicago; and the Museum of Fine Arts, Boston, were established. Prominent Boston families played a key role in these cultural exchanges. They provided funds for sculptors to study in Rome during the 1840s, snapped up modern and contemporary art by the French well before they were appreciated in their own country in the 1880s, or took advantage of new opportunities to travel and work in Japan, paving the way for collectors such as the Spaulding brothers to put together one of the world's greatest collections of Japanese prints at the MFA.[6]

Americans who did not have an opportunity to travel abroad could visit any number of grand public spectacles presented at popular fairs and expositions. Some major fairs, like New York City's Crystal Palace Exhibition of the Industry of All Nations (1853) and the Philadelphia Centennial International Exposition (1876), toured by over nine million visitors, featured international displays or fully realized pavilions, often populated by individuals dressed in native costumes performing what were billed as typical tasks of daily life. While these fairs sought to demonstrate how United States industry and manufactured products were capable of

rivaling goods made around the world, they also expanded public perception of many cultures. The Japanese Pavilion at the Philadelphia Centennial, for instance, was a major factor in promoting popular demand for Japanese goods in the United States, as well as in shaping American notions of Japanese art and culture.

In the twentieth century, new forms of communication and transportation virtually erased distances between different nations, bringing artists in the United States and the Americas closer to foreign cultures than ever before. But global travel also led to global conflict. Millions of troops were mobilized during the two world wars, the Korean War, the Vietnam War, and the Gulf Wars, bearing Americans overseas to experience cultures close at hand— sometimes in the heat of battle, sometimes in its aftermath, as succeeding generations of expatriates stayed behind to learn from cultures they had initially been sent over to oppose, often bringing the lessons of those experiences back home. Other crucial lessons were brought to American shores by the many Europeans who fled fascism in the 1930s and 1940s, settling in Canada, South America, and the United States and finding, in the latter case, refuge in the vibrant, urban artistic communities of New York and Chicago or in small rural settings like Black Mountain College in North Carolina. German painters Josef Albers and Hans Hofmann and architects Walter Gropius and Mies van der Rohe, or the French Surrealist painters and poets, through their teachings or their example, helped foment a revolution in postwar American art and architecture, still very much in evidence today.

There are myriad ways to interpret the creative expressions of artists working in the Americas, and many other works of art that respond to traditions from around the globe— well beyond the scope of the MFA's holdings. The selection and discussion offered here is by no means complete or exhaustive. Rather than see this as a limitation, however, we believe that the MFA's collections, reflecting major historical currents in creating and collecting art, provide a window onto the many strands of American art. Born of creative impulses dating back to the ancient Americas, forged by necessity, and in many cases overlaying imported and appropriated traditions and motifs—whether familiar, misperceived, or fashioned from whole cloth—the art of the Americas showcases the combination of assimilation and invention that characterizes the rich fabric of our culture today.

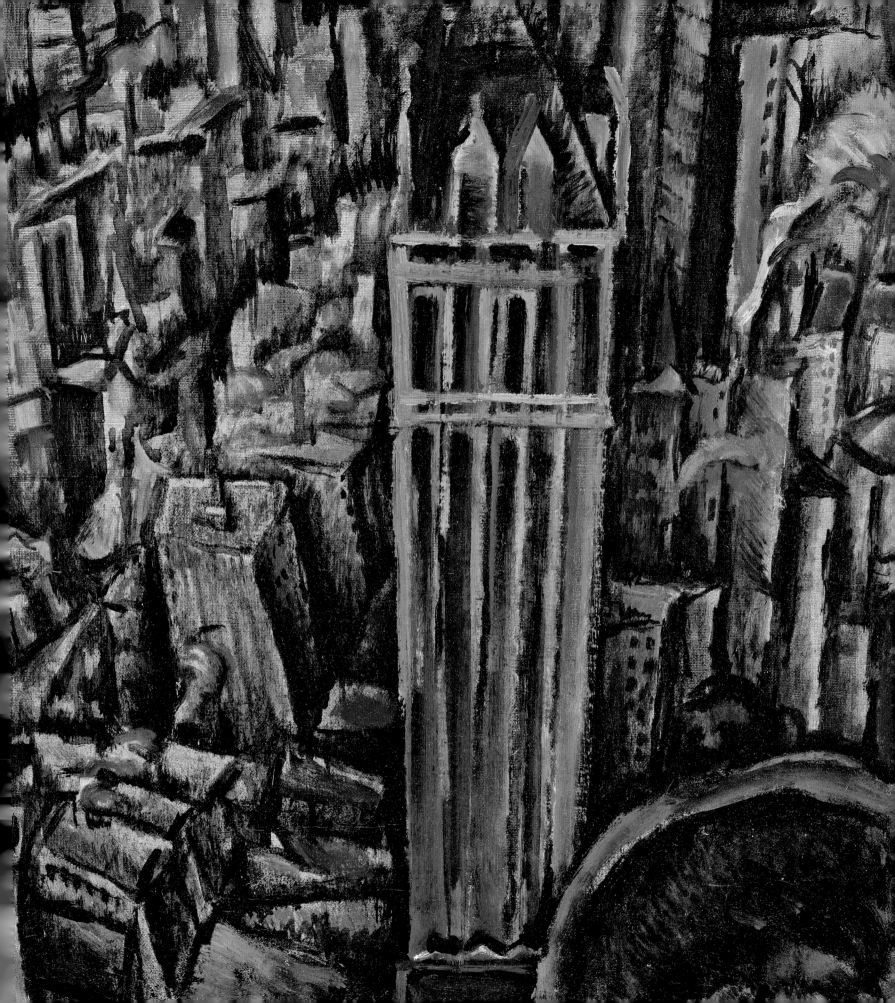

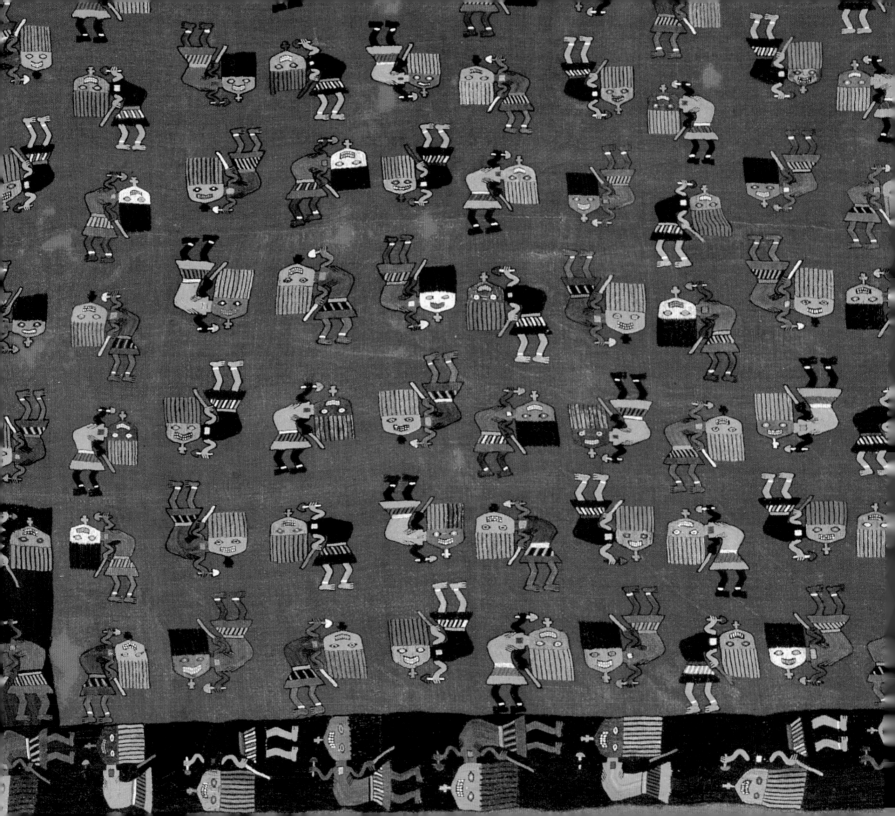

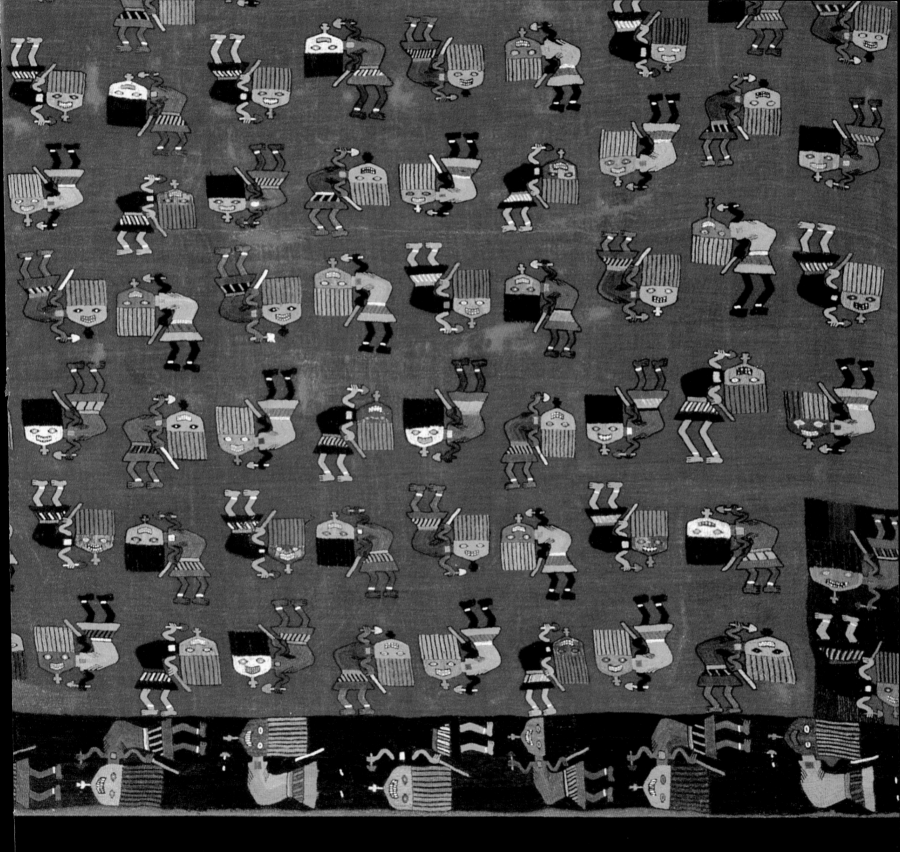

ANCIENT CULTURES, MODERN CONNECTIONS GERALD W. R. WARD

The peoples of ancient North, Central, and South America were far from a monolithic entity, even though European explorers and conquerors often lumped them together as "Americans," a term that was later replaced by the misnomer "Indians." Instead, they consisted of hundreds, if not thousands, of different societies that practiced different religions and customs and spoke various languages over a long period. Some archaeologists and scientists believe that perhaps as early as twenty thousand years ago, immigrants from Asia entered the Americas by crossing the Bering Sea via a land bridge connecting northern Russia and Alaska. By contrast, the creation stories of many Native peoples give a different account. They often note that the first people emerged from mystical locations such as Flower Mountain of Creation, as told among the peoples of Mesoamerica, or from four cavelike underworlds, as recounted by the A:shiwi (Zuni) of New Mexico.

However and whenever they arrived, once established here, many of these peoples, particularly those in contiguous areas, lived in an ever-changing environment of exchange and interaction, characterized at times by peaceful trade and diplomacy but often by conflict, displacement, and outright warfare. Goods, foodstuffs, and ideas were not confined to one area but circulated to some extent between settlements in the large continents of North and South America. These vital links have long been recognized. In an important Museum of Modern Art exhibition catalogue published in 1941—an early acknowledgment of the aesthetic dimensions of indigenous American arts—Eleanor Roosevelt observed that the "hemispheric interchange of ideas is as old as man on this continent. Long before Columbus, tribes now settled in Arizona brought traditions to this country [United States] that were formed in Alaska and Canada; Indian traders from the foot of the Rocky Mountains exchanged goods and ideas with the great civilizations two thousand miles south of the Rio Grande[,] . . . [and] related . . . forms that are truly of America are found from the Andes to the Mississippi Valley."[1] Many people in the American Southwest still cite their connections to a homeland in Mexico known as Aztlán, although such connections are not commonly appreciated.[2]

During the thousands of years before contact with peoples from Europe, Africa, Asia, and possibly Polynesia, indigenous American art developed independently from that of the rest of the world. As a whole, Native art reflects commonalities and shared beliefs among the makers. Many of the objects these diverse peoples left behind were designed to express the power of shamans (spiritual and sometimes healing leaders and personages) through ceremonial use or the wealth and status of their owners, largely in symbolic ways. Carved jadeite masks made by the Olmec, elaborate burial urns and pictorial narrative vases painted by the Maya, exquisite Andean textiles and clothing, finely wrought gold objects

made by the Moche, and many other objects are evidence of extraordinary aesthetic and technical traditions that are hundreds and sometimes thousands of years old. From areas of what is now the United States, painted pottery by the Hohokam, Mogollon, and Anasazi peoples of the Southwest, especially the pictorial works by the Mimbres people; the masks, effigies, and other objects made by the so-called Mound Builders, or the Mississippian Tradition, from much of the eastern half of North America; and the painted and shallow-carved wooden objects from the Pacific Northwest Coast similarly represent significant art traditions and artistic accomplishments.

Although these peoples are known to us primarily through the objects they made, their cities, buildings, tombs, roads, and other transformations of the landscape were also remarkable and are considered notable feats of ancient engineering. Many temples in Mexico and elsewhere and sites such as Pueblo Bonito in Chaco Canyon, Snaketown in Arizona, the Cliff Palace at Mesa Verde in Colorado, and the ubiquitous mounds that dot the landscape of the eastern half of the United States, such as the monumental Monk's Mound at Cahokia in Illinois, rival or surpass the achievements of the ancient Old World.

Europeans' proclaimed discovery of the Western Hemisphere in the late fifteenth century altered everything. In the words of the contemporary curator and critic Paul Chaat Smith (Comanche), "The Indian experience, imagined to be largely in the past and in any case at the margins, is in fact central to world history. Contact five centuries ago that for the first time connected the world was the profoundest event in human history, and it changed life everywhere. It was the first truly modern moment: continents and worlds that had been separated for millions of years became just weeks, then days, and now only hours away."[3] This dramatic turning point in the history of the world took place at different times in different places over several centuries, but its ultimate effects were generally the same. The landing of the Italian sea captain Christopher Columbus in the West Indies on behalf of the Spanish Crown in 1492 provides a baseline date for this cataclysmic event for the New World, but the process went on for hundreds of years. In the sixteenth century, the Spanish, under Francisco Vásquez de Coronado, entered what is now New Mexico and Arizona; Jacques Cartier and the French explored the Saint Lawrence River and Great Lakes region; and the Spaniard Hernando de Soto forayed into the Southeast. Englishmen settled the East Coast of North America in the seventeenth century, and Captain James Cook and others explored what became British Columbia off the Pacific Coast in the late eighteenth century. These contacts continued into the first decade of the nineteenth century with the U.S. government–sponsored Lewis and Clark expedition, which explored the American West and encountered the many tribes of the northern Plains Indians along the way.

These interactions unleashed what some scholars today refer to as the Columbian Exchange, a collision of cultures that had enormous consequences for the history of the world, biologically and environmentally as well as culturally.[4] Although most scholars have studied these phenomena in written documents left by Europeans, some have increasingly relied on evidence from the indigenous peoples, who greeted the foreigners with a multitude of reactions, ranging from attempts at peaceful accommodation to immediate hostility.[5] Tragically, epidemics such as smallpox and influenza acted with deadly force on the Native peoples, who had no immunity to diseases they had never encountered before. Moreover, in many instances, the Europeans, motivated by religious zeal and economic greed, often actively sought to destroy the cultures they found. The Spanish, in particular, melted down gold and silver, shattered stone "idols," and destroyed ancient Mexican and Maya codices; in so doing, they eradicated the culture and history of the indigenous people, whom they sought to convert to Christianity, inculcate with European social values, and subjugate for economic gain.

As time passed, the exchange of plants, foodstuffs, animals, materials, and ideas across cultural boundaries changed the lives of everyone in Europe and the Americas. Corn (maize), potatoes, tomatoes, squashes, peanuts, chilies, vanilla, and chocolate were among the important foods passed from the New World to the Old World. The governing principles of the Haudenosaunee (Iroquois) Confederacy provided a model for the American colonies as they sought to establish a new republic in the late eighteenth century. Perhaps most dramatically, silver flowed from mines in what is now Bolivia and Mexico to Spain (and eventually to China and elsewhere in the world), dramatically fueling the European and world economies for centuries.

Imported materials from Europe also began to affect Native life and the production of Native goods. Often with the assistance of immigrant traders and frequent contact with settlers, Natives quickly incorporated such new items as glass beads and colorful dyes, adapting them to older artistic forms or using them to replace or supplement traditional, natural materials in innovative ways. Diné (Navajo) jewelry makers quickly became adept at silversmithing, a craft taught to them by Mexican artisans in the mid-nineteenth century. As travel to the more remote areas of the continents became easier, the tourist trade grew, generating an important means of subsistence for indigenous artisans, who sought to satisfy the demands of visitors and early collectors hungry for mementoes of their adventures in "Indian country," especially in the Southwest during the late nineteenth and early twentieth centuries.

The massacre at Wounded Knee, South Dakota, in 1890 effectively ended the so-called Indian Wars and marked the closing of the western frontier of the United States. The Native populations were subdued, defeated, fragmented, and herded into large guarded

settlements. Many European and American painters, sculptors, and writers, some of whom visited the reservations, portrayed American Indians in numerous ways, often depicting them romantically as heroic "noble savages"—as idealized by the French Enlightenment philosopher Jean-Jacques Rousseau—about to be brushed aside by the inexorable sweep of Western civilization. Other nineteenth-century artists represented them as cartoonish stereotypes of an inferior race or turned them into mascots, a practice that shamefully continues to the present day.

In the nineteenth century, practitioners of the emerging fields of anthropology and ethnology, assisted by the discoveries of archaeological remains, began to uncover and examine much of the lost world of the indigenous Americans. Displays of "Indian" objects at major world's fairs and exhibitions, such as those held in Philadelphia in 1876 and Chicago in 1893, brought this material to the attention of a wide audience. Several proponents of the Arts and Crafts movement were sympathetic to the handcraftsmanship and natural materials of indigenous art, and by the 1920s, a Maya Revival style found expression in architecture and interior and industrial design.[6]

In the early twentieth century, modernist painters seeking an abstract visual language that represented a departure from traditional European models looked to the arts of the indigenous peoples of the Americas for inspiration. Through their study and appreciation of the art of "primitive" peoples from around the globe, these modernists helped create a climate in which the indigenous arts of the Americas could be understood not only as anthropological specimens but also as works of art, worthy of exhibition in art museums rather than only as natural history displays. Art collectors followed, adding their contribution to this general shift that regarded the indigenous material culture of the Americas from aesthetic as well as historical and ethnographic viewpoints.[7]

Today Native American artists throughout the Western Hemisphere try to balance the expectations raised by their indigenous heritage against the vagaries and demands of the contemporary art world, which tends to value innovation and experimentation. Each individual copes with issues of authenticity and reverence for traditions, which often focus not on the individual but on the collective and spiritual worlds, while simultaneously striving to fulfill personal ambitions and visions.

The experience of Native Americans—throughout the hemisphere—has been what Paul Chaat Smith calls "an ocean of terrifying complexity."[8] A meaningful appreciation of the art of the Americas, however, must begin with an examination of this multifaceted and variegated experience during the full course of its long trajectory, from the ancient Olmec to the modern Maya, from the Anasazi to today's Puebloan peoples.

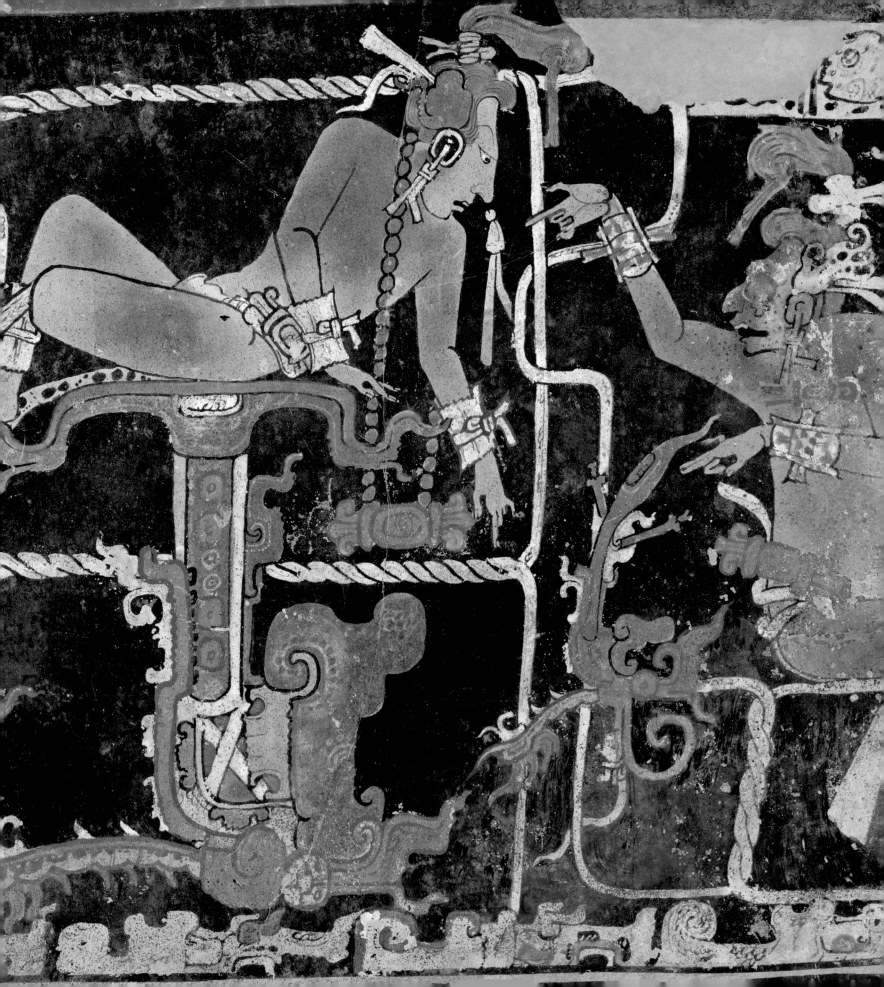

THE AMERICAS' FIRST ART

DORIE REENTS-BUDET AND HEATHER HOLE

In the absence of written texts chronicling ancient American history, archaeologists and art historians turn to surviving art and architecture to reconstruct the past. The arts of the ancient Americas tell the story of the many peoples and societies of the Western Hemisphere, of their religious beliefs, politics, economics, and interrelations with neighboring societies both near and far. Although they have a common origin in Asia more than twenty thousand years ago, the indigenous peoples of the Americas were not a monolithic culture but instead created unique societies. Contact did occur among some of the cultures, especially those in close proximity. Their interactions are reflected in similar forms of governance, social patterns, religious beliefs, and artworks. Over time, artists adopted and adapted new techniques and stylistic forms in response to changes in the social and intellectual landscape and to new demands from patrons. Centuries after Europeans invaded the lands of the ancient Americans, artists continue to respond to their changing circumstances. In the twentieth century, artists turned to ancient American art forms as an alternative to European art, as a model of abstraction, and as a statement of connection to a Native past.

Scholars divide the ancient Americas south of the United States into three areas based on geography and similarities in social structure, religion, intellectual achievements, politics, and art. Mesoamerica encompasses modern Mexico, Guatemala, Belize, El Salvador, and the northern regions of Honduras. Central America includes southern Honduras, Nicaragua, Costa Rica, Panama, and the Darién Peninsula leading into South America. The cultures of the western, or Andean, side of South America are subdivided into those of the northern region (Colombia and Ecuador) and the southern area (Peru and Bolivia).

Perhaps the architectural form most readily associated with this wide swath of the Western Hemisphere is the pyramid. The ubiquitous American pyramid, found among most cultures from the southeastern United States to Bolivia, is actually a truncated platform supporting small buildings or temples. The pyramid punctuated the central districts of towns and expressed the political and religious power of the state. Pyramids and buildings often were decorated with symbols that transformed them into supernatural locales, such as Mesoamerica's Flower Mountain of Creation.[1] It was believed that the first humans emerged from the sacred cave inside Flower Mountain.[2] It was here, too, that the gods preserved maize (corn) for the first peoples. This crop was the prime staple food throughout Mesoamerica.

Incense burners from Mexico's Teotihuacan and Guatemala's Pacific Coast area often portray Flower Mountain, and their similar features are evidence of contact between Teotihuacan and the Maya of southern Guatemala (fig. 2). The burner's base held glowing coals and smoldering incense. The smoke rose up the chimney on the back of the decorated lid and

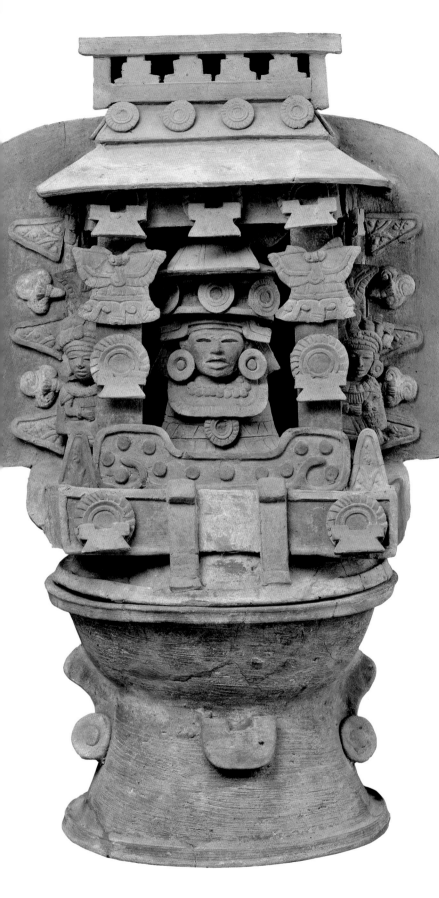

emerged at the top, much like a smoking volcano. Flower Mountain is represented by the two vertical columns of triangular-shaped stone or hill symbols, alternating with flower motifs. The sacred nature of this place is confirmed by the priest or ruler inside the mountain's temple and by the circular divining mirrors. These are framed by feathers, adorning not only the priest but also the base, pillars, and roof of the temple building.

Divining mirrors allowed religious practitioners to contact the gods and travel to the sacred realms. The two butterflies on the temple's pillars refer to both the supernatural world and the souls of warriors. This common pairing of military might and supernatural power was found throughout the ancient Americas.

The form of the incense burner and the concept of the Flower Mountain are examples of shared artistic features and religious beliefs. They often indicate direct interaction among societies and may even reveal the nature of the contact. For example, a significant period of international relations took place during the fifth century A.D., when the city of Teotihuacan was the most powerful social, political, and economic force in Mesoamerica; it also was one of the largest cities in the world (second only to Beijing). Teotihuacan's influence extended from north of modern-day Mexico City to the Gulf and Pacific coasts of Mexico, south through Guatemala, and as far as Costa Rica. Trade probably drove these long-distance contacts; the Teotihuacan people acquired from these foreign lands such valuable commodities as cotton, cacao (chocolate), jadeite, and other semiprecious materials.

Diplomacy and warfare also were important tools of cultural expansion for Teotihuacan, implied by its many buildings painted with murals depicting the ruling nobility and the eagle and jaguar-coyote warrior orders.[3] Teotihuacan's artists perfected the technique of mural painting—that is, applying paint to a stuccoed surface— for the decoration of pottery (fig. 3). The expansion of Teotihuacan's influence among the Maya of Guatemala can be seen in stucco-painted, tripod vessels resembling those of Teotihuacan, the Maya artists mimicking the style of Teotihuacan figures and decorative motifs. Further evidence of this interaction is found in Maya hieroglyphic

texts carved on stone monuments at Tikal, Guatemala. Recording the arrival of foreigners in A.D. 378, the glyphs reveal their Teotihuacan origin by the non-Maya, Teotihuacan-like name of the lead personage, Spearthrower-Owl.[4]

At this time, Tikal's elite artists, too, adopted the Teotihuacan decorative tradition of painted stucco pottery vessels. They also adapted the Mexican concept of pictorial narrative decoration on pottery vessels to their slip-painting (*terra sigillata*) technique. Combining these traditions, one foreign, the other domestic, Maya painters achieved new heights of narrative complexity. The pictorial ceramics of the Maya Late Classic Period (600–850) represent a high point in world ceramic history (fig. 4).

The decoration on some of these vessels features images of warfare, a common tool of political and economic advancement. A member of the eagle warrior order appears on the Teotihuacan vase, identified as such by his feathered eagle helmet and cape. His feathered shield, which is also a divining mirror,

points to the supernatural base of his power. This vase further conveys the sacred charter of Mesoamerican rulers supported by their warriors, which obliged them to sustain the universe through the exchange of sacred liquids. The people of Mesoamerica believed that the gods would bestow rain and fertility on the earth provided they were nourished by the life-giving power of human blood offered in sacrifice. In his headdress the warrior wears two obsidian knives of sacrifice and performs a sacrificial ritual. The resulting balance of the universe is depicted as the visual equilibrium between the horizontal band of red scrolls (blood) encircling the vase and the diagonal bands of green (the Mesoamerican color of water), which sprout flowers and plants.

Shamanism was widespread among the cultures of the ancient Americas,[5] as evidenced by extensive representations on artworks. This shared belief probably stems from a common ancestral religious base in the distant past, when humans first came to the Western Hemisphere from Asia across the Bering

2
Teotihuacan
Incense burner
Mexico, A.D. 350–650
Earthenware with traces of red and yellow post-fire paint
H. 43.5 cm (H. 17⅛ in.)

3
Teotihuacan
Tripod vessel
Highland Mexico, A.D. 250–550
Earthenware with red, white, green, and black post-fire paint on white stucco
H. 11.4 cm (H. 4½ in.)

4
Maya
Drinking vessel
Guatemala, A.D. 700–800
Earthenware with slip paint
H. 16.3 cm (H. 6⁷⁄₁₆ in.)

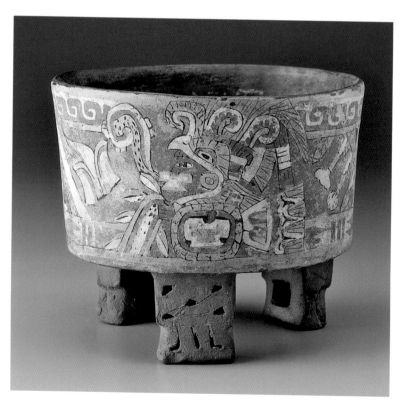

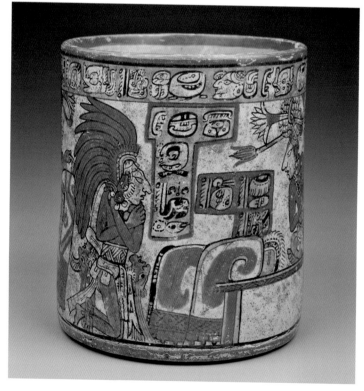

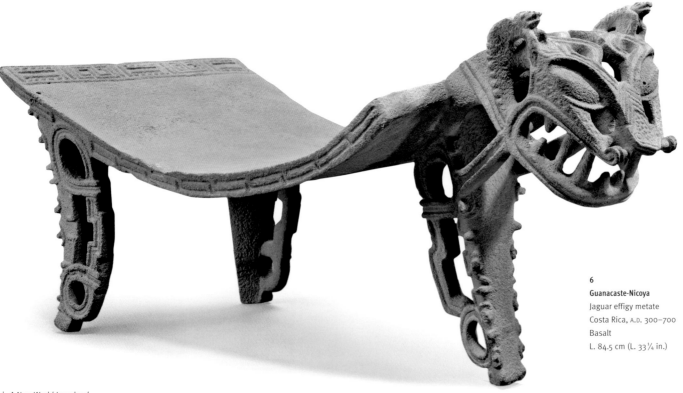

5
Guanacaste-Nicoya
Jaguar effigy vessel,
Costa Rica, A.D. 1000–1350
Earthenware with slip paint
H. 29.2 cm (H. 11½ in.)

Strait. Shamanism is based on the belief that certain individuals can transform themselves into spirit beings and travel to the supernatural realm to acquire sacred knowledge and power. Frequently, the shaman's transformed state is rendered as a powerful animal, such as a falcon or condor, crocodile, or feline, especially the jaguar.[6] The practitioner's animal spirit form can be seen in a shaman-jaguar effigy vase from northwestern Costa Rica, even as the crouching position recalls that of a human seated on a low bench (fig. 5).

Rulers, especially those in ancient Costa Rica, Panama, and Colombia, were believed to be powerful shamans, and sculptors in Costa Rica fashioned regal throne-benches that were ornately carved to render the rulers' jaguar spirit companions (fig. 6). Based on the common food-grinding stones, called metates, the regal benches symbolized the rulers' divine powers in ensuring agricultural fertility and the well-being of the people. Often the benches ended their ancient lives as funerary biers.[7]

Ritual pose also may identify a sculpture as that of a shaman achieving the trance state during which his or her spirit "flies" to the supernatural realm.[8] During the first millennium B.C., Olmec artists in southern Mexico carved

6
Guanacaste-Nicoya
Jaguar effigy metate
Costa Rica, A.D. 300–700
Basalt
L. 84.5 cm (L. 33¼ in.)

7
Olmec
Shaman effigy figure,
Mexico, 1150–550 B.C.
Jadeite
H. 11 cm (H. 3½ in.)

8
Colima
Shaman effigy figure,
Mexico, 300 B.C.–A.D. 200
Earthenware
H. 54.6 cm (H. 21 ½ in.)

shamanic portrayals from precious jadeite, giving the fig-
urines an introspective, otherworldly demeanor (fig. 7).
Seven hundred years later in West Mexico, their counter-
parts rendered shaman figures in more active poses, which
preserve the performance nature of shamanic transforma-
tion (fig. 8).

Shamans in northern Colombia were often depicted as
bats, a form perhaps inspired by the bat's seemingly magical
ability to fly at night and without feathers. The phenomenal-
ly skilled Tairona goldsmiths in the Sierra Nevada highlands
of northern Colombia made a pectoral of the important
man-bat shaman (fig. 9).[9] The wide protuberances flanking
the man-bat's head represent the animal's large, fleshy ears,
and the thin gold bands emanating from his head probably
symbolize shamanic powers.

Among many ancient societies stretching from Peru to Costa
Rica, gold and silver were often used to fashion jewelry featuring
powerful shamanic spirits.[10] These astounding works in alloys of gold,
silver, and copper are direct evidence of face-to-face interaction among
peoples. Metallurgy was first developed in Peru during the second

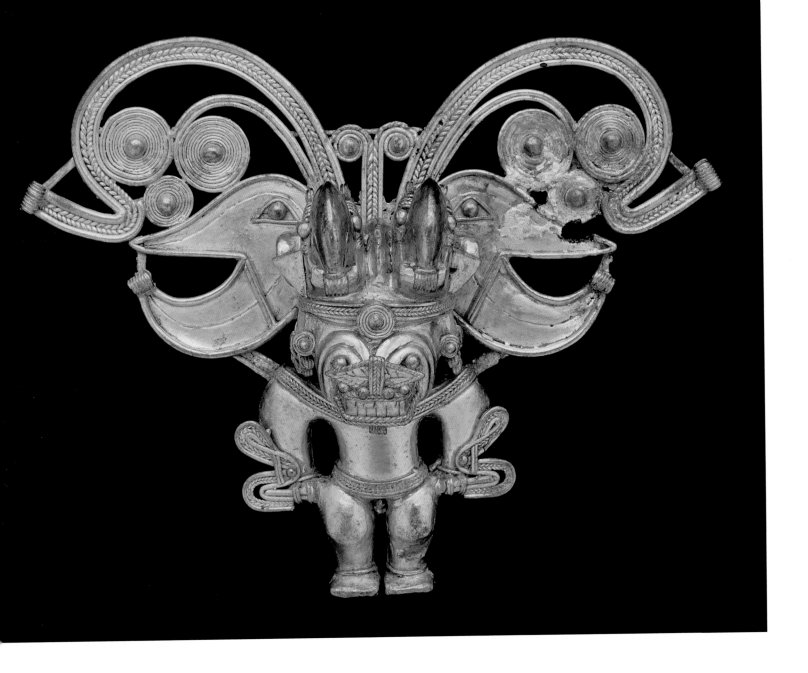

9
Tairona
Shaman-bat effigy pectoral
Northern Colombia, A.D. 900–1600
Gold alloy
H. 16 cm (H. 6 5/16 in.)

millennium B.C.[11] As cultures increasingly interacted over the centuries, knowledge of metallurgy spread northward. By 325 B.C. it had reached the many cultures of Colombia, and by the first century it had moved through the Darién Gap linking Central and South America.[12] Metallurgical technologies found throughout South and Central America emphasized gold-copper alloys (*tumbaga*), depletion gilding, lost-wax casting, soldering, and cold hammering. Precious metals were valued not only for their gleaming visual impact and malleability but also for their symbolic associations. In ancient Peru, gold was associated with the power of the sun, and silver, with that of the moon.[13] Similarly, in Colombia, gold was linked with the solar realm, shamanic powers, and the male principle necessary to fecundate the world.[14] In both regions, precious metals became the premier medium for fashioning personal adornments that signified power and prestige. They were also made into tools such as sewing needles and fishing hooks and used in construction projects to secure wall joints (copper-tin alloys were used, as well as silver and gold con-

struction joints). In a pattern of exchange, as metallurgy and religious ideology moved north from South America into Central America, the peoples of Costa Rica and Panama introduced maize (corn) to the peoples of Colombia, who quickly adopted this new food to supplement, if not replace, their indigenous staple crop of bitter manioc.

The thin strip of land connecting the northern realms of South America to lower Central America was a corridor of interaction from earliest times forward, allowing economic, intellectual, political, ideological, and artistic ideas to range freely. This long-standing reciprocity can be seen by the year A.D. 200 in the golden body adornments in Central America.[15] Not surprisingly, then, the shapes of some Panamanian and Costa Rican body adornments recall those of their southern cousins, and they also share a repertoire of pictorial forms and decorative motifs.[16] The most common body adornment in Central America is a winged pendant portraying a shaman transformed into a bird or crocodile.[17] Over time, the pendant's relatively naturalistic bird form, with outspread wings and long tail, was modified into two broad horizontal bands framing the shaman figure, a shape particularly associated with the gold traditions of southern Costa Rica and adjacent western Panama (fig. 10). Variations on this form and its typical shaman-bird motif are found among the cultures in neighboring Colombia. Artistic interpretations range from the elegantly simple to three-dimensional pendants with many birds.

Because artists working in precious metals continually adopted and adapted forms from throughout lower Central America and northern South America, it is often impossible to ascertain the cultural identity of an artwork and its artist. Similarly, even when a golden adornment is found in an archaeological context, which should identify its place of origin, the extensive economic and political networks of exchange that linked the myriad cultures of lower Central America and neighboring Colombia make such assumptions about attribution unwise.

In Mesoamerica, precious metals were not widely known until after A.D. 600, when gold pendants made in Costa Rica occasionally were acquired by Zapotec

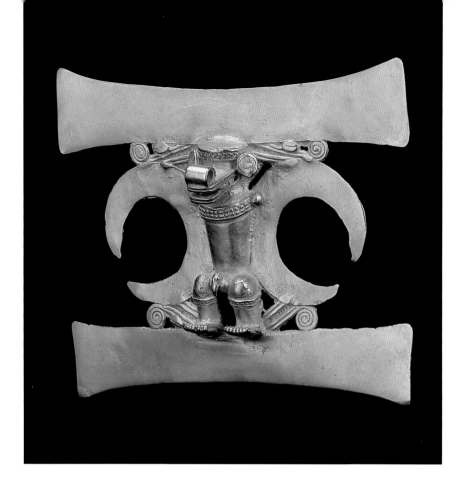

and Maya peoples in Mexico, Belize, and Honduras. Artisans in West Mexico learned about working copper (and, infrequently, gold) directly from their counterparts in Ecuador and Peru about 800.[18] Gold and silver were more commonly worked by Mixtec and Aztec artists after 1100. This technological and artistic development followed dramatic cultural changes associated with the new political and economic landscape that arose after the fall of Teotihuacan (about 650) and the later emergence of a new religion that emphasized a messianic deity in the form of a feathered serpent. The flanged pendant, typical of Costa Rican and Panamanian gold adornments, came to have the general meaning of "gold" in the Mixtec painted manuscripts of southern Mexico.[19]

Gold had significance beyond its association with elite power. For example, Aztec religion stressed the importance of the solar cycle, and for the Mexica (the Aztecs' name for themselves), gold symbolized

10
Diquís or Chiriquí
Shaman-bird-crocodile effigy pendant
Costa Rica or Panama,
A.D. 700–1550
Gold alloy
H. 11.1 cm (H. 4 3/8 in.)

11

Olmec

Portrait mask

Mexico, 1150–550 B.C.

Jadeite with black inclusions

(fire-grayed)

H. 21.6 cm (H. 8½ in.)

the power of the sun, just as it did among their Peruvian contemporaries, the Inkas. Further, the Mexica's religion accorded them the divine responsibility to nourish the sun with human sacrificial blood so that it would have the strength to renew its daily cycle and bring fertility to the earth, a religious concept also found among the Inkas. This ideological convergence, however, does not necessarily indicate direct contact between the Mexica and the Inkas. Instead, it stems from centuries of cultural interaction in Andean South America and Central America and the eventual transference of metallurgy and its ideological meanings northward to Mesoamerica after 800.

If in Central and Andean South America precious metals were the most common artistic medium through which social and symbolic esteem was expressed, in Mesoamerica the preferred material was jadeite.[20] Its color, ranging from green to blue, symbolized the earth's fertility and the Maize god and was associated with the primordial ocean and the gods' creation of the world.[21] The Maya believed that, at creation, the Maize god raised the world tree in the center of the earth and separated the heavens from the underworld. He then gave his blood as a sacrificial offering that infused the universe with life force. The Maize god's twin sons defeated the lords of the underworld and thereby created the path of resurrection after death. This fundamental myth of Mesoamerican religion is based on the natural cycle of maize, its appearance in the fields each spring reenacting the Maize god's miracle of life emerging from death.[22] This ideology has distant origins in Mesoamerican history, reaching back to the rise of the Olmec civilization before 1200 B.C.[23] It is fitting that green jadeite came to symbolize this sacred belief, beginning as early as the first millennium B.C., when jadeite body adornments, often carved to represent deities or shamanic symbols, were worn by people in positions of social, political, and religious power.[24]

Olmec artists carved the very hard and dense jadeite without benefit of metal tools, using abrasion, pressure drilling, patience, and concentration to fash-

ion graceful yet formidable works of art. Olmec technical mastery and artistic expression in jadeite are at their highest level in a life-size mask (fig. 11). The strength of the facial features conveys the power of the individual, which is not diminished by the delicate naturalism that equally conveys the inherent softness of human skin. The gray color of the mask results from its having been subjected to fire, probably during an important ritual pertaining to sacrifice, death, and resurrection.

Throughout Mesoamerica, jadeite and blood, both precious materials denoting fertility and life, were symbolically linked. Therefore, it should come as no surprise to learn that objects used during religious rites were often made of jadeite. For example, the Olmec made ritual objects in a spoonlike shape. It is believed that these curious items, which were also worn as pendants, were used in blood sacrifice and/or shamanic rituals, perhaps to hold hallucinogenic compounds that assisted in the celebrants' transformational and autosacrificial practices.[25] These spoon pendants, carved from the finest and symbolically significant jadeite, are typically of the highest artistic caliber, suggesting they were used by members of the social and religious elite. This is only fitting, since Olmec and later Mesoamerican rulers were responsible for maintaining the fertility of the universe by replicating the Maize god's original blood sacrifice to bring life into the world.[26]

The Maya of the first millennium A.D. bedecked their rulers and members of the social elite in jadeite jewelry, from ear ornaments carved in the form of flowers to necklaces of large beads and arm and leg bands fashioned from strings of tubular beads.[27] Rulers also wore long, thin, celtlike plaques of jadeite attached to their royal belts. (A celt is an ax.) Yet a surprisingly small number of these regal jadeite plaques have been found in the Maya region; instead, many have been found in Costa Rica. These esteemed plaques provide evidence for direct contact between the two regions beginning before A.D. 100 and lasting until at least 550. The migration of the plaques may have resulted from royal dynastic and political disruptions. As the Maya plaques entered the long-distance

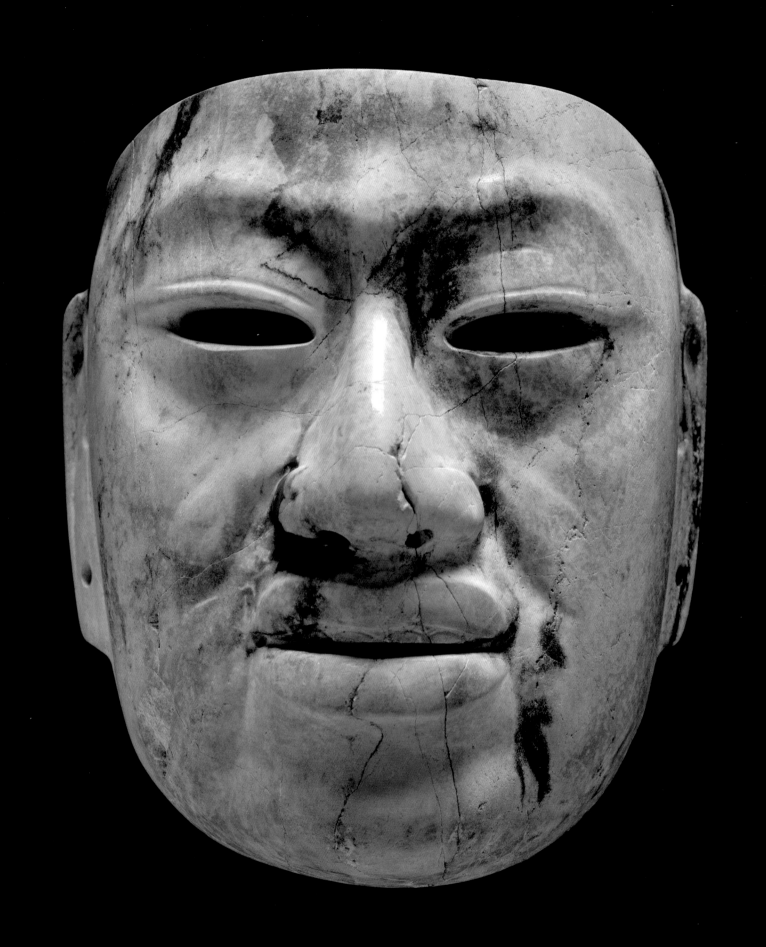

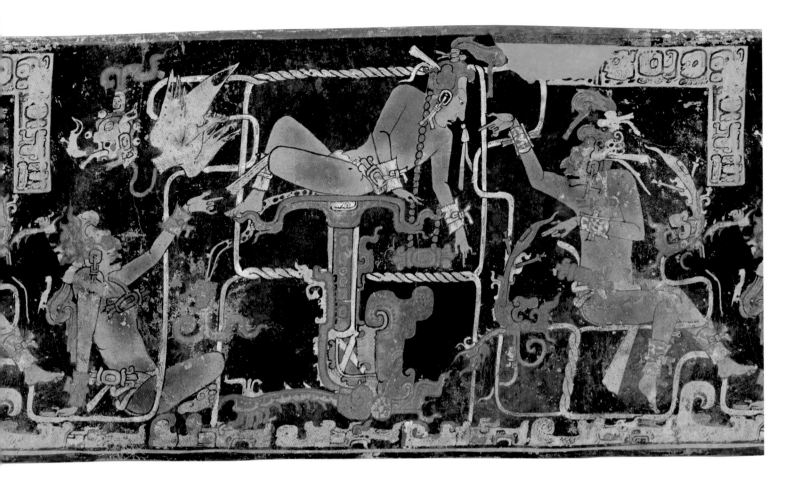

12

Maya

Drinking vessel (detail)
Guatemala, A.D. 740–780
Earthenware with slip paint
H. 22.5 cm (H. 8⅞ in.)

trade system, they dissipated the power of the vanquished ruler who had owned them and augmented the economic advantage of the victor.[28] The ancient Costa Ricans reworked the Maya plaques into forms appropriate to their society and religious beliefs, now carved to represent Costa Rican shamanic spirits.[29]

Jadeite had been the preferred medium to express prestige and power in Costa Rica since 300 B.C., and the presence of Olmec jadeite figurines there implies contacts with Mesoamerica before those with the Maya.[30] It is likely that jadeite grew in popularity in ancient Costa Rica as maize agriculture, perhaps introduced from Mexico and Guatemala, became common (by 100 B.C.). The Costa Rican peoples also may have adopted the Mesoamerican Maize god along with the grain and incorporated the new deity into their religion.[31] This shared belief would explain the Costa Ricans' preference for the celt form of jadeite adornments above all others, the celt referring to the Maize

god and the maize seed, which it had symbolized among the Olmec.

Yet after A.D. 550 a dramatic shift took place in Costa Rica: its peoples turned away from Mesoamerica and embraced new customs from Colombia. Gold replaced jadeite as the preferred artistic material of status, and new pottery styles, architectural forms, and tomb constructions displaced the old traditions. The reasons for this extraordinary cultural and artistic shift are not completely understood. They may include the breakdown of established trade relations with Mesoamerica as political strife disturbed the region, prompting a strengthening of ties with lower Central America and Colombia.

Many ancient American cultures practiced the art of fine painting on the challenging curved surface of earthenware vessels using *terra sigillata* slip paint (see figs. 4 and 5). Applied to an unfired vessel, this unforgiving medium left no latitude for covering mistakes

and required skilled handling of the watercolor-like paint to ensure a successful result. This pottery-painting technique seems to have been developed independently throughout the Americas. However, it is likely that, along with social, political, and economic interactions, novel technical or narrative approaches occasionally were shared among artists from different cultures.

The Classic Period Maya (250–850) are widely recognized as masters of the *terra sigillata* technique, producing polychrome slip-painted, low-fired ceramics that rival even Greek earthenware. Unlike the Greek tradition of pottery decoration, which is a graphic form based on the stylus, the Maya fully developed their tradition based on the brush. Maya pottery painters formulated an extensive palette of slips, using color to create lively images, unlike Greek pottery, which is characterized by a small number of hues. Maya artists also fully exploited the watercolor nature of slip paint, producing delicate washes and often overlaying them to create depth and richness (fig. 12). Further, the Maya appreciated the lasting evidence of the brush in the painted line, unlike most Greek painted wares, and Maya artists were careful to preserve even individual bristle streaks and the flick of the brush's tip at the end of a painted line.

Exquisitely painted wares were created to serve food during aristocratic feasts, which often are depicted on the pottery. Gatherings were not simple events, however, but instead important vehicles that showcased the host's social, political, and economic authority. Feasts also built relationships among the invited guests and secured allegiances. Relations were further strengthened by the obligations of reciprocity borne by the guests, who would be expected to sponsor feasts of their own as well as to participate in economic ventures and provide the host with political and military support.

An important feature of ancient American feasts was the bestowal of gifts on the participants. The gifts' quantity and quality highlighted the host's power and augmented his or her prestige. In Mesoamerica, feasting gifts included maize, meat, and the highly valuable cacao (chocolate beans), as well as finely crafted items such as body adornments made of shell, jadeite, or precious metals, cloth, and beautifully painted ceramic serving vessels, particularly those for rich cacao beverages.

Maya feasting vessels often were decorated with both text and images lauding the patron-host. The imagery also may tell of the host's spiritual preeminence and the sacred basis of political sovereignty. For example, a unique feasting plate depicts a key ideological principle concerning the Maize god, whose power Maya kings were thought to wield (fig. 13). Here the Maize god dances as he sets the three sacred hearthstones, in the center of which the deity planted the world tree at the time of creation.[32] The plate's three tall supports symbolize the cosmic hearthstones, a mythical concept based on the humble, three-stone kitchen hearth found at the center of

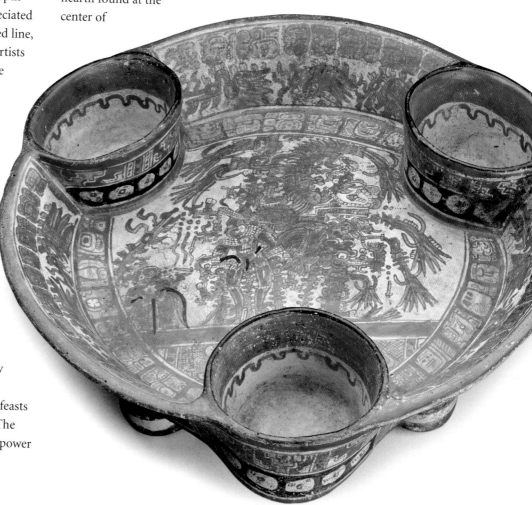

13
Maya
Tripod plate
Guatemala, A.D. 672–830
Earthenware with slip paint
Diam. 33 cm (Diam. 13 in.)

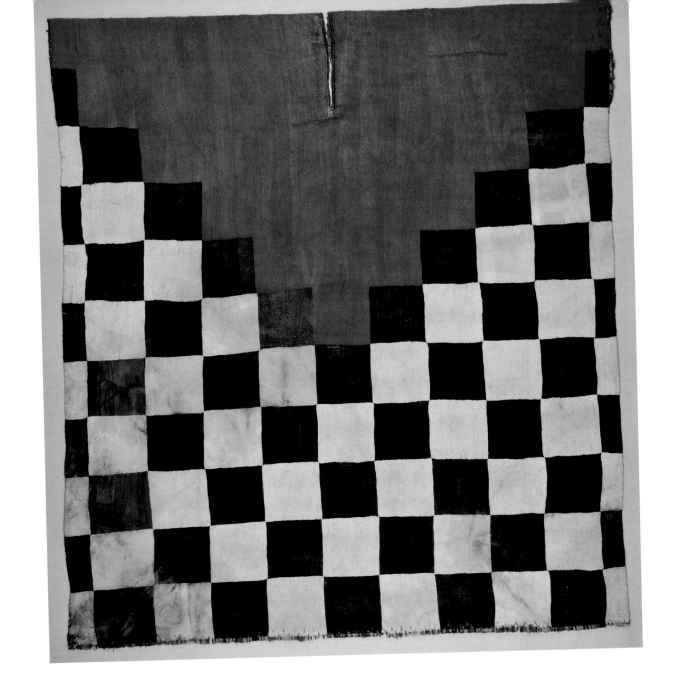

14
Inka
Tunic
Peru, 1476–1534
Camelid fiber
84.5 x 78 cm (33¼ x 30¾ in.)

every traditional Maya house. The hearth fire of cre- ation is represented by a large circle painted red on the plate's underside in the center of the three hearth- stone supports.

Cloth from ancient Mesoamerica—as noted, a crucial gift component of feasting rituals—has not survived, yet its economic, political, and social signifi- cance is underscored by its frequent depiction on Maya painted ceramics of the Classic Period (250–850). In a scene depicting a victorious ruler receiving a lord cap-

tured in battle, we see that the most important result of the victory is tribute in the form of finely made cloth (see fig. 4). Throughout the ancient Americas, cloth signaled wealth and power because it symbol- ized control over land and human labor.[33] Cloth also served as a kind of currency and a principal gift item bestowed by rulers in recognition of loyal service to the state.

The peoples of Andean South America placed especially high value on textiles. The ancient Peruvian

and Bolivian weavers worked with both cotton fibers and wool from llamas, alpacas, vicuñas, and guanacos (the latter two camelids' fine, velvety wool surpasses cashmere in softness and warmth). The sixteenth-century Inkas decorated fine tunics and mantles with specific motifs that indicated a person's social and political position. A bold checkerboard pattern, for instance, recalls motifs worn by Inka warriors at the time of Spanish contact (fig. 14).[34] The unusual stepped-red yoke of this tunic may represent the high status of a military leader who received the tunic as a gift from the Inka ruler.

The dry, cold climates of the Andean region have preserved many textiles dating from as early as 2500 B.C. The embroidered mantles of the Paracas people (fig. 15), who dominated Peru's South Coast at the end of the first millenium B.C., are justly famous as tours de force of technique and design. The Paracas embroiderers, who worked in teams, aptly used the repeated motif of ecstatic shamans—portrayed as flying to the spirit world[35]—for this mantle, which served as a burial shroud. Across the width of the mantle, the shamans' thrown-back heads alternate with their undulating bodies, whose zigzag contours create rippling verticals across the pictorial field. The figural repetition is occasionally broken by figures outside the main patterning, an interruption that contributes to the overall dynamism of the design.

The distinctive visual format, style, and fine decorative techniques of the Paracas textiles did not die out when the Spanish came to South America (after 1532) and can be seen in a rare woman's mantle from the late sixteenth century (fig. 16). Indeed, weavers began to incorporate motifs that up to then were foreign to them. While the motifs in the thin, horizontal bands are fifteenth-century Inka designs (note the stepped squares that recall the Inka tunic [see fig. 14]), images of Europeanized flora and fauna appear in the two broad, black bands. So precious was this mantle, given its exceptionally fine tapestry weave,

15

Paracas

Embroidered mantle (detail)

Peru, 0–A.D. 100

Camelid fiber

142 x 241 cm (56 x 94⅞ in.)

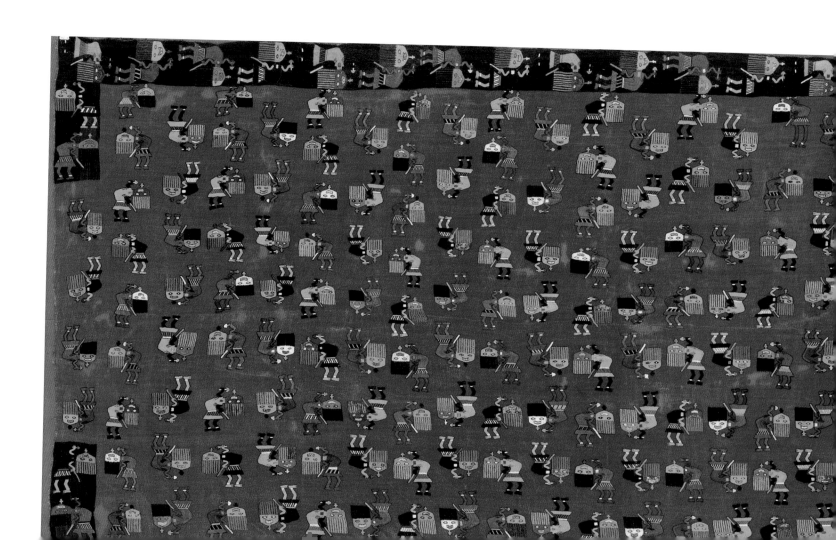

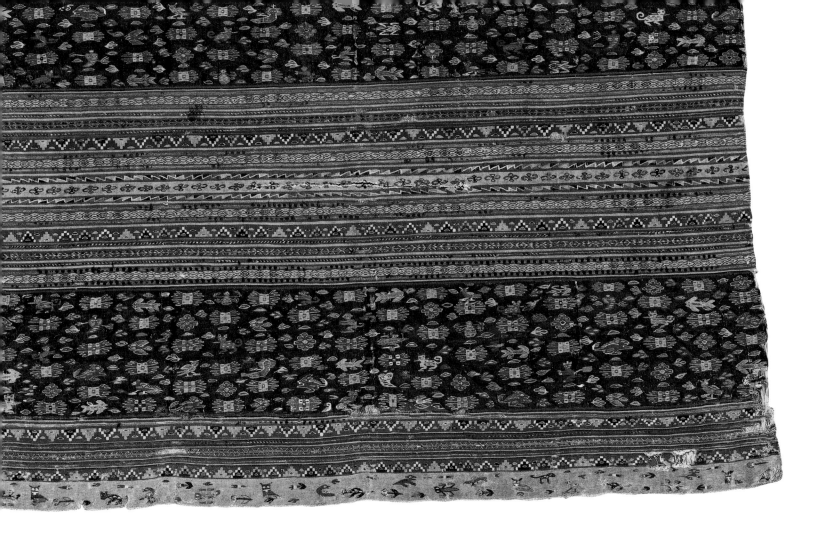

16

Colonial Peru (K'echwa [Quechua])

Woman's mantle (detail)

Peru, late 16th–early 17th century

Cotton, wool, silk, metal-wrapped thread

95.5 x 127.5 cm (37⅝ x 50⅛ in.)

high thread count, and profusion of colors and motifs, that at some point it was converted into a man's poncho with its characteristic slit in the center.

After the Spanish conquest, sacred imagery continued to adorn textiles, but now the decorative images were Christian (fig. 17). Rather than Andean ecstatic shamans, this chair seat or cushion cover is adorned with symbols of the Dominican Order, a major religious and political force in early colonial Peru. The white dogs are Dominican emblems, and the fleur-de-lis motif, rendered in the order's characteristic black and white colors, reproduces the curved tips of the Dominican cross. The stylized border design imitates the scalloped edges of seventeenth-century Spanish bobbin lace. This depiction of one form of textile on another is an additional way in which the indigenous Andean tradition of placing

high social, economic, and ideological value on cloth continued into the colonial era.[36]

Artists of the ancient Americas created marvels of technical expertise, intellectual ingenuity, and aesthetic brilliance. Nonetheless, the imposition of European culture on these cultures by the Spanish, English, French, Dutch, Portuguese, and Germans during the Colonial period (1532–early 1800s) largely relegated these creations to obscurity, if not outright condemnation. Not until the nineteenth century, with its movements for political independence and interest in scientific humanism, did ancient American art begin to be viewed in a more positive light. As Latin American nations achieved independence from Spain, some looked to their ancient heritage to help forge a national identity. For example, in Mexico, the mighty Aztecs provided an ideological and cultural

foundation for the emerging modern nation as well as a national emblem, emblazoned on Mexico's flag and currency: an eagle holding a snake in its mouth and standing on a cactus growing from a stone set in the center of a lake. This emblem stems from the vision bestowed on the Aztecs by their patron god, Huitzilopochtli, to mark their promised land, which was carved on the throne of Motecuhzoma, the last Aztec emperor. This phenomenal sculpture now resides in a place of honor in Mexico's National Museum of Anthropology.[37]

The nineteenth century also witnessed the growth of scientific inquiry, especially in the natural sciences, and the birth of anthropology. Explorers delved deep into the countryside, discovering long-forgotten cities in the jungles and remote highlands, marveling at the imposing buildings and astounding sculptures. They unearthed all manner of fine objects made of precious metals, jadeite, painted earthenware, and cotton and camelid (wool) fibers, to name but the most well known of the myriad media in which America's ancient artists worked. Typically, however, these works were viewed as native curiosities or artifacts for scholarly study, not objects of fine art. The new medium of photography documented many expeditions and their remarkable finds, the images often revealing the photographer-explorer's outstanding technical and aesthetic skills (fig. 18). Today these photographs are crucial sources of data, because many of the artworks and monuments have suffered significant damage, for reasons both environmental and human, or have disappeared altogether.

In the twentieth century, modern artists throughout the Americas drew inspiration from ancient American art and architecture that had recently been uncovered, displayed in museums, and acquired by anthropologists and art collectors. Modernists often misunderstood the original significance of these objects because general knowledge of the ancient American cultures was incomplete, at best. Also, it was frequently based on flawed archaeological studies or influenced by romantic conceptions of vanished civilizations. Nevertheless, ancient American art became an important source for avant-garde artists throughout the Western Hemisphere as they

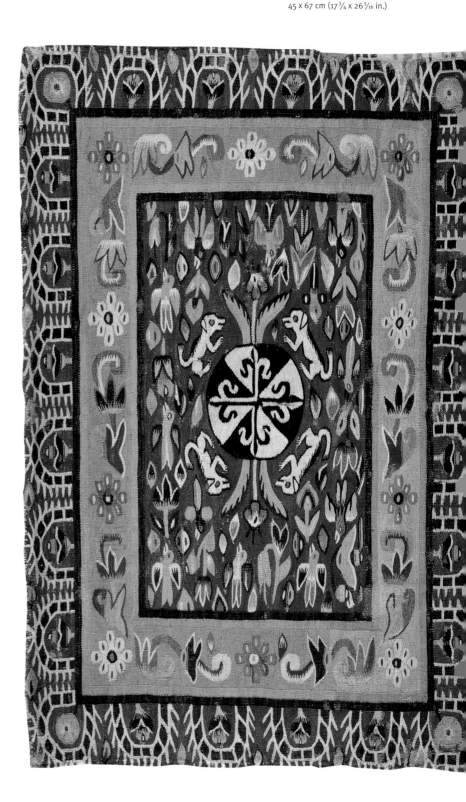

17
Colonial Peru (K'echwa [Quechua])
Chair seat or cushion cover
Peru, 16th–17th century
Cotton, wool
45 x 67 cm (17 ¾ x 26 ⁵⁄₁₆ in.)

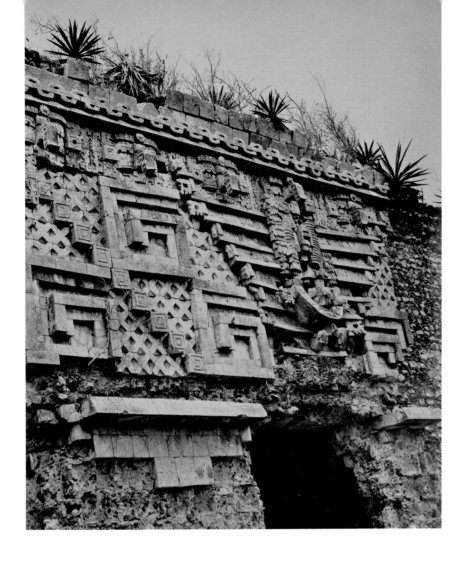

18
Désiré Charnay
French, 1828 –1915
Palace of the Governors, Uxmal,
Mexico, 1860
Albumen print photograph
43.5 x 31.1 cm (17 ⅛ x 13 ¹⁄₁₆ in.)

Americas. They published their findings and amassed vast collections of artifacts housed in anthropological museums such as Harvard University's Peabody Museum of Archaeology and Ethnology (founded in 1866) and the American Museum of Natural History in New York (founded in 1869). This new humanistic science analyzed specific sites and human material remains (artifacts, or art) in order to understand the cultural and historical chronology of the ancient Americas. Both scholars and laypersons also made ambitious and often idealistic attempts to fit ancient American civilizations within a preexisting late-nineteenth-century perception of the pageant of world history from prehistoric times to the present. Many individuals compared the Maya with the ancient Greeks and the Aztecs with the ancient Romans, and others attempted to rank the various ancient American civilizations within a global cultural hierarchy based on their perceived level of complexity. The influential scholar Herbert J. Spinden, for example, exemplified this attitude when he wrote in 1913, "Maya art may be placed in advance of the art of Assyria and Egypt and only below that of Greece in the list of great national achievements."[38]

Modern artists were in large part responsible for the shift in the twentieth century away from this anthropological focus and toward an aesthetic understanding of ancient American art and architecture as one of many global visual traditions. This change is visible when one compares the nineteenth-century documentary photograph of the Palace of the Governors at Uxmal, Mexico, by Desiré Charnay (fig. 18) with the 1923 photograph of the Pyramid of the Sun at Teotihuacan by the modernist art photographer Edward Weston (fig. 19). Whereas Charnay intended to capture the architectural details of the monumental building his photograph depicts, Weston composed his image with an eye to its aesthetic form, rather than concentrating on the subject matter. The great angular masses of the pyramid take on a balanced, rhythmic geometry that is both visually pleasing and highly modern. Weston's photograph, rather than providing information about the structure he shows, is a work of art in its own right, inspired by the beauty of the pyramid it features.

sought to create a new, more abstract visual language. Unlike the African art that inspired many European modernists, this heritage was rooted in the American soil that contemporary North, Central, and South Americans could claim as their own.

This should come as no surprise. Ancient American visual traditions have played an important role in the art of the Americas since colonization. The creative mixing by indigenous and mestizo artists of time-honored forms with those imported by the Europeans is often called hybridity. In the latter half of the nineteenth century, a very different conception of ancient American art emerged as scholars affiliated with the newly established academic discipline of archaeology as anthropology (that is, the study of human society) began systematic excavations and analyses of archaeological remains in the

Modern artists like Weston looked to so-called primitive non-Western art to help them develop daring new visual languages. They hoped these would be entirely independent of long-standing European tradition. Perhaps the best-known artist to explore this strategy fully was Pablo Picasso. In the early years of the twentieth century, Picasso was inspired by African objects he saw in Paris to experiment with revolutionary ideas about the representation of space and even to incorporate masklike forms into his work. Many other avant-garde artists also looked to non-Western art, either as source material for their visual vocabulary or from an appreciation for the formal similarities they perceived between "primitive" and modern art forms. Ancient American art was seen as an important resource in this endeavor. Roger Fry, a key early-twentieth-century critic and theorist, described this search in 1925, writing, "Still more recently we have come to recognize the beauty of Aztec and Maya sculpture, and some of our modern artists have even gone to them for inspiration. This is, of course, one result of the general aesthetic awakening which has followed on the revolt against the tyranny of the Graeco-Roman tradition."[39]

19
Edward Weston
American, 1886–1958
Pirámide del Sol, 1923
Gelatin silver print photograph
18.9 x 23.7 cm (7 7/16 x 9 5/16 in.)

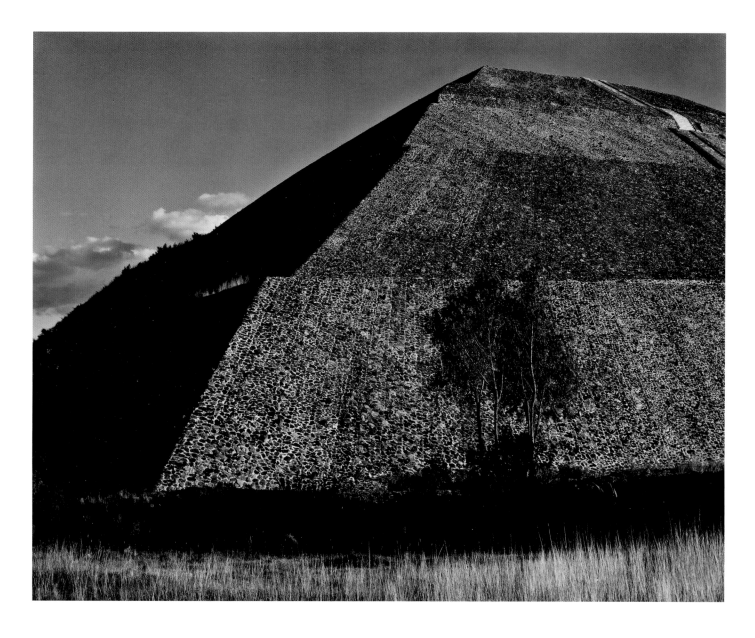

Like the nineteenth-century archaeological view that preceded it, this twentieth-century aesthetic perception of ancient American art was flawed in certain ways. Most ancient American art was created to express specific cultural practices and values; a purely visual approach to these objects, therefore, ignores the important social and ideological context of which they were a vital part. Despite their sincere interest in ancient American culture and its artifacts, many modernists saw the artworks they studied through a distorted lens that rendered the objects mythologized and exoticized. As Fry expressed it, "Nothing in the history of our Western civilisation is more romantic nor for us more tantalising than the story of the wanton destruction of the ancient civilisations of America."[40]

For many modernists born in the Americas, ancient American art held a nationalistic appeal that did not exist for European artists like Picasso. Individuals such as Steve Wheeler looked to indigenous artworks from the Western Hemisphere as part of a broader search for a modernist style formed in the Americas. During his involvement with a movement called Indian Space Painting, from the early 1940s through the 1950s, Wheeler studied the collections on display in New York City at the American Museum of Natural History, the Brooklyn Museum, and the Heye Foundation's Museum of the American Indian (now the National Museum of the American Indian's George Gustav Heye Center, in Washington, DC, and New York), giving particular attention to ancient and Native American symbols. These were the very collections that had been formed by those earlier archaeological expeditions. Wheeler's *Man Menacing Woman* (fig. 20) draws both its composition and its color scheme from ancient Andean textiles (see fig. 15) and is also inspired by the distinctive stylization and patterning found in the art of Northwest Coast Native American peoples such as the Kwakwaka'wakw (Kwakiutl), Tlingit, and Haida. With its pictographic forms of varying sizes, vivid color, and densely patterned composition, the painting adapts indigenous visual conventions from both North and South America to twentieth-century abstract painting. Because Wheeler's style may be drawn from culturally distant sources, his subjects

are often private and difficult to interpret. The small doglike form in the center of the painting, for example, recurs in several of Wheeler's works and is part of a mysterious personal pantheon of mythical forms the artist invented.

For their part, many twentieth-century Latin American artists drew on ancient American visual forms as an expression of their national identity. The Mexican modernists of the early twentieth century, including Diego Rivera, Frida Kahlo, and José Clemente Orozco (see fig. 170), frequently used this strategy in their largely representational paintings and public murals. South American modernist artists also turned to the visual vocabulary of ancient American art, more often in connection with their endeavor to create an authentically American abstract visual language. A number of these artists found in the rigorous geometry of textiles (such as fig. 14 above) and the remarkable rectilinear stonework of the vast architectural structures that ancient American cultures left behind crucial sources in the development of Latin American geometric abstraction, arguably the most important South American art movement of the twentieth century. The Uruguayan artist Joaquín Torres-García originated this movement when in 1934 he returned to Montevideo after spending many years in Europe, where he was a member of the Cercle et Carré group headed by the Neoplasticist Dutch artist Piet Mondrian. Torres-García and many of the twentieth-century South American practitioners of geometric abstraction who came after him understood their work as an advanced, theoretically ambitious expression of modernist abstraction in dialogue with the most avant-garde work being done in Europe or the United States, but one that was also rooted in culturally specific ancient American geometric forms.

The Argentine abstractionist César Paternosto is a leading exponent of the idea that geometric abstraction throughout the Americas has important conceptual roots in ancient American forms. In his book *The Stone and the Thread: Andean Roots of Abstract Art*, Paternosto argues that "there is an underlying *tectonic order* common to both artists [Barnett Newman and Joaquín Torres-García] that, as I have

20
Steve Wheeler
American, 1912–1992
Man Menacing Woman (detail), about 1943
Oil on canvas
76.2 x 63.5 cm (30 x 25 in.)

21
César Paternosto
Argentinian, born in 1931
Staccato, 1965
Oil on canvas
149.9 x 179.7 cm (59 x 70 ¾ in.)

repeatedly pointed out, can ultimately be traced back to the symbolic geometry of the ancient textiles, and that tectonic order is what I now see as the cardinal term defining an abstract art of the Americas" (emphasis in the original).[41] His vibrant 1965 geometric painting *Staccato* (fig. 21) shows both his use of geometric abstraction as an essential component of his work and his early and important, if sometimes less acknowledged, dialogue with European abstraction, particularly the work of the German Bauhaus artist Josef Albers (see fig. 153). Paternosto's paintings, which draw inspiration from ancient Andean textiles as well as European sources, exemplify the continuing adoption by present-day Latin American artists of ancient American motifs removed from those images' original connotations and aesthetic parameters. By so

doing, these artists forge a new visual vocabulary that expresses the varied origins of contemporary American art.

Ancient American textiles are a potent source not only for painters but for textile artists as well, who thereby continue the high value placed on textiles by ancient American cultures. The dazzling *Cesta Lunar 64* (Lunar Basket 64) by the Colombian fiber artist Olga de Amaral is a contemporary reinterpretation of the distinctive gold-covered tunics worn by the most powerful rulers of ancient Colombia and northern Peru's Moche and Chimu cultures (fig. 22). In her work de Amaral purposely invokes the religious and spiritual meaning gold and silver had for ancient American cultures, and she also relates the metal to the golden color of sunlight as it shines on traditional

Colombian stucco walls.[42] Like Paternosto, de Amaral was exposed early on to European aesthetic philosophy, when she spent a year as a student of the Bauhaus-trained Marianne Stengell at the Cranbrook Academy of Art in Michigan. Also like Paternosto, de Amaral views textiles as essential cultural and philosophical objects. As she puts it, "Weaving is a way of constructing your own way of life, your way of thought. It is building a life."[43]

When modernist artists encouraged the aesthetic appreciation of ancient American art and architecture, they recognized the compelling formal correspondences between the so-called primitive and the avant-garde. Their radical rejection of the European representational tradition also allowed the beauty and power of ancient American objects to become more visible to the twentieth-century Western eye. In a slightly different vein, many artists from the Americas purposely sought inspiration from cultures that had flourished in their own hemisphere in order to create visual forms that would then be authentically American. Yet this aesthetic approach to ancient American art, especially as it was expressed in the earlier part of the twentieth century, often ignored the cultural and social context in which the objects were created. Like the late-nineteenth-century archaeological view that preceded it, the modernist view of ancient American art was imperfect in its own way. Indeed, the history of our reception of ancient American art would seem to indicate that any understanding we develop of these extraordinary and fascinating cultures must inevitably be partial and even flawed, especially given that we have an incomplete historical record of the lives of those individuals who lived in them.

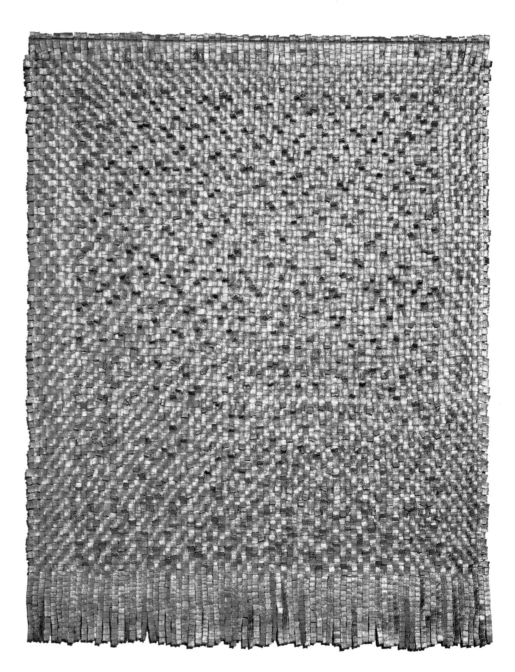

22
Olga de Amaral
Colombian, born in 1932
Cesta Lunar 64, 1998
Fiber, gold leaf, acrylic
185.4 x 152.4 cm (73 x 60 in.)

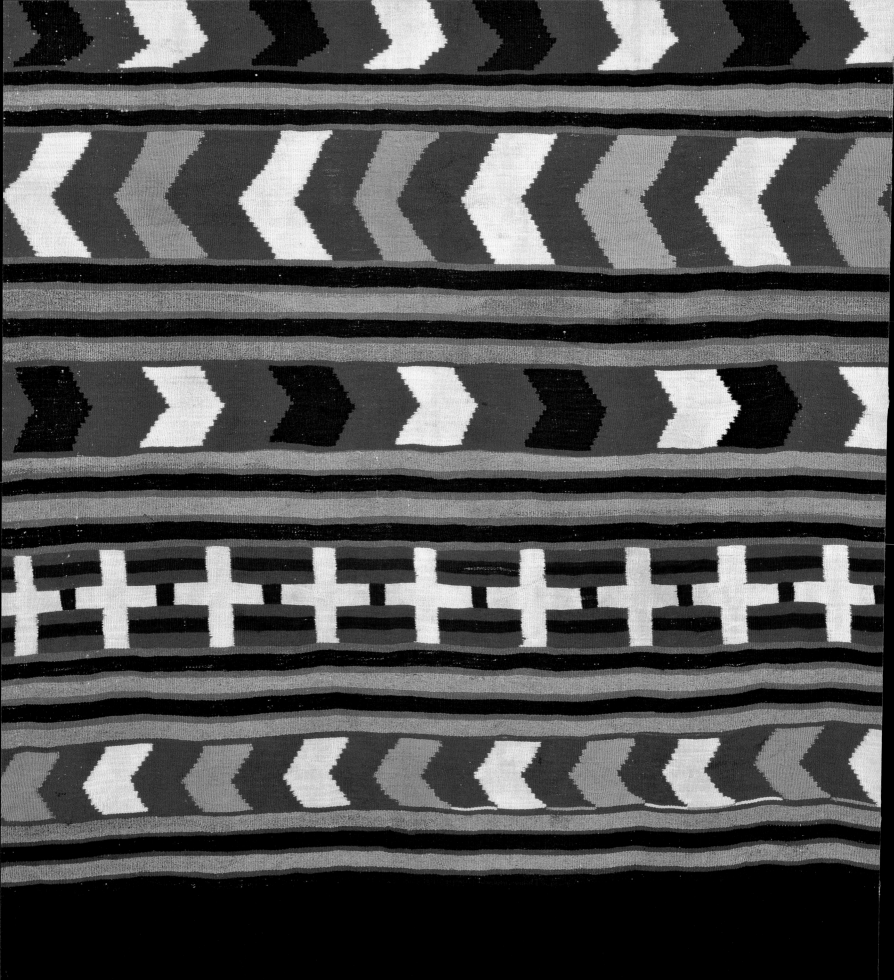

NATIVE NORTH AMERICAN ART

GERALD W. R. WARD AND HEATHER HOLE

For thousands of years, the Native peoples of North America adorned their bodies, furnished their dwellings, and embellished their articles of daily life and religious practice in meaningful cultural ways, creating functional objects that today would be classified as art. Although much of this creative output has been lost through the passage of time, some of it is known selectively via the archaeological record. In some cases it can also be at least partly understood through careful analogy with objects made in historic times. Regardless of the relative scarcity of the surviving evidence, the earliest Native North Americans had a rich, meaningful, and diverse material culture.

Even though many Native American peoples, who lived in disparate areas across the vast North American continent, were somewhat isolated from one another, theirs was not a static world. Migrations, caused by climate change and other factors, and connections established through trade within the continent and with peoples in Mesoamerica created a dynamic and ever-evolving world of material life in what is often referred to as the "precontact" period (as defined from an Anglo-European perspective).[1] This was not a monolithic era, but rather one characterized by many peoples, who fashioned objects mainly from locally available materials, such as clay in the Southwest and cedar in the Northwest. Occasionally they augmented their objects with designs and materials obtained through barter and trade.

A thousand years ago, for example, the Hohokam, Mogollon, and Anasazi peoples engaged in trade not only between their own communities—for the most part located in what is now New Mexico and Arizona—but also with peoples to the south living in present-day Mexico. Birds painted on some ancient Southwest vessels, to cite one instance, may be scarlet macaws imported to New Mexico from their native habitat much farther south.[2] The beautiful images of animals and humans painted on ancient ceramic vessels by the Mimbres people (fig. 23), in addition to the religious and cultural significance they held for their makers, reflect the Mimbres' nomadic mobility or their interaction with traders who visited their land. Some Mimbres pots contain images of sea creatures from the Gulf of California, hundreds of miles from their villages in southern New Mexico.[3]

Many forms of precontact art survived into postcontact years, especially those used in Native rituals and ceremonies kept private from outsiders. A Seneca turtle rattle from the nineteenth century may be one example (fig. 24). The rattle, fashioned mainly from a snapping turtle shell and containing chokecherry pips that sound when the rattle is shaken, references the Iroquois belief that the world is supported on the back of a giant turtle. This type of rattle was used by members of the False Face Society in various healing ceremonies involving dance and singing.[4]

23

Mimbres

Bowl

Mimbres River Valley, New Mexico,

1000–1150

Earthenware with slip paint

Diam. 28.6 cm (Diam. 11¼ in.)

framework for expressing symbolism, often in complicated ways.[6]

Until the twentieth century, the precontact history of Native Americans was not well understood (in fact, many questions remain today). One phenomenon encountered by European explorers and American settlers through the eastern half of the continent were mysterious large mounds and earthworks. These contained human remains and curious objects, and they were sometimes exposed to the elements through weathering or farming or excavated by the inquisitive (fig. 25). (Thomas Jefferson explored one of these mounds in a remarkably sophisticated archaeological way as early as 1782, although his work was not followed up.) Cultural stereotypes of the time prevented an acknowledgment that these ambitious and monumental earthworks were made by Native Americans; as a result, many fanciful theories were proposed about their creators. Some thought they were the work of a mythical lost tribe of white Mound Builders, others of Chinese or African immigrants, and still others of Hindus from India. In 1894 Cyrus Thomas of the Smithsonian Institution, building on the research of John Wesley Powell, Samuel Haven, and other explorers, published the results of his extensive surveys and excavations, demonstrating that the mounds were the amazing accomplishments of Native Americans, the ancestors of living Indians, ending the controversy.[7]

Although Native Americans of many types zealously guarded their traditional ways of life and their forms of material expression, contact with outsiders inevitably altered all aspects of Native American existence—often disastrously, as is well documented. The complex interaction of cultures from the "Old" and "New" worlds began almost immediately upon contact, and it continues today. Imported materials and techniques often replaced or added to Native ones, as an ongoing process of adaptation and selective borrowing took place, underlining the process of change that characterizes Native American (and all) life. The process was often instigated or accelerated by traders, who encouraged Native peoples to create articles that would appeal to their customers. Over time, the

When Captain James Cook and the crew of the *Resolution* entered Nootka Sound off the Northwest Pacific Coast in 1778—the first Englishmen to explore this territory—they encountered Native villages with totem poles, house posts, and potlatch figures, the prototypes of later examples made in this tradition (fig. 26). Potlatch figures, evoking myth, memory, and family, represented the wealth of their owners and were placed outside the home during lavish gift-giving ceremonies. Peoples of the Northwest Coast also developed a distinctive style of painted art that is widely considered one of the most beautiful achievements of any Native American culture.[5] Characterized by the skillful use of colors and the manipulation of an organizing device known as the formline—an allover pattern characterized by symmetry and the splitting of forms—Northwest Coast art provided a

24
Seneca
Rattle
New York, 19th century
Turtle shell, elm wood,
chokecherry pips
L. 43.3 cm (L. 17 1/16 in.)

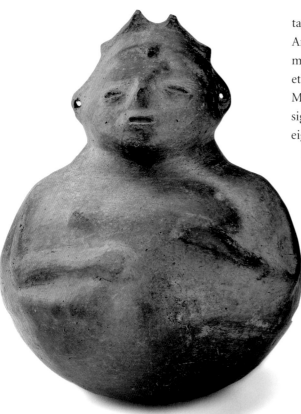

25
Mississippian Tradition
Effigy
Diehlstaat, Missouri, about
900–1400
Earthenware
H. 16.5 cm (H. 6 1/2 in.)

26
Kwakwaka'wakw (Kwakiutl)
Potlatch figure
British Columbia, Canada,
about 1840
Red cedar, paint
H. 172.1 cm (H. 67 3/4 in.)

tastes of collectors also affected the process, as Native Americans began to produce wares designed to appeal mostly to people collecting items for antiquarian and ethnographic, aesthetic, or a myriad of other reasons. Many different objects were created specifically for a significant tourist trade that began as early as the eighteenth century; this trade accelerated when the maturation of the U.S. rail system in the late nineteenth century made most corners of the continent more accessible.[8]

On the northeastern side of the North American continent, contact with European explorers (which started as early as the tenth century, when the Vikings landed in Newfoundland) picked up in pace in the sixteenth century and then increased in intensity as settlement and colonization took place in the seventeenth and eighteenth centuries.[9] Three sashes woven by Eastern Woodlands people demonstrate their quick adoption of new materials introduced by Europeans (fig. 27). Finger-woven (or hand-plaited) sashes had been made by many Native Americans for a variety of uses for centuries, crafted of thin strips of bark, plant fibers, or animal fur and hide, some colored with various natural dyes. The early sash illustrated at left, made in the last half of the eighteenth century, is fashioned of imported wool but retains porcupine quills, a traditional material. In the early-nineteenth-century sash (center), imported white

glass beads were used in place of the porcupine quills. The slightly later wool example (right) was made specifically for trade by Métis weavers employed by the Hudson's Bay Company in L'Assomption, Canada. Over time, the sash became an important symbolic article of clothing for the Métis, who trace their descent to the intermarriage of a number of First Nations peoples with European immigrants.

A pair of Wendat (Huron) moccasins of the late eighteenth or early nineteenth century similarly shows modifications and adaptations of a traditional form for new markets (fig. 28). This pair was probably acquired in 1828 by an Anglo-American tourist named Caira Robbins of Lexington, Massachusetts, on her "grand tour" of the Northeast, which took her across New York State via the Erie Canal (opened in 1825), or even earlier by her father. It retains traditional woven and appliquéd porcupine quills, outlined in imported black wool and silk.

Splint basketry is said to have been brought to the Indians by the Swedes and other Europeans, and many New England Indians eventually made a specialty of crafting fine storage baskets and other containers.[10] Moosehair-embroidered birch-bark goods of various types became staple souvenirs throughout the nineteenth century. Porcupine quillwork was also a skill practiced by many American Indians. In the Northeast, by the mid-nineteenth century, women of the Mi'kmaq (Micmac) of Maine and Nova Scotia

27
Eastern Woodlands
Sashes (details)
Eastern Great Lakes region,
18th–19th century
Plaited (finger-woven) wool
with glass beads (center) and
porcupine quills (left)
L. 208–381 cm (L. 82–150 in.)

28
Probably Wendat (Huron)
Moccasins
Eastern Great Lakes region,
late 18th–early 19th century
Leather, woven and appliquéd
porcupine quills, moose or deer
hair, silk, wool, tinned sheet iron,
bast fiber thread
L. 23.5 cm (L. 9¼ in.)

created porcupine-quillwork panels for standard seating furniture and other objects, fusing two cultures into a single form (fig. 29).[11] Made for American, Canadian, and English markets, these unusual chairs brought Native American craftsmanship into Victorian households.

In the Southwest, Diné (Navajo) weaving provides a capsule history of interchange over many years, as Native American weavers adopted new materials and adapted to new markets, yet consistently created textiles readily identifiable as Diné products. The Diné may have learned weaving from the Hopi people in the mid-seventeenth century, when Spanish persecution of the village-based pueblos forced many residents to live with the nomadic Diné.[12] A panel of a woman's two-piece dress from the 1850s or 1860s still reflects this early phase of Diné weaving, when weavers usually produced articles for their own use in patterns and colors mostly derived from Spanish and Pueblo sources (fig. 30). Later, starting in the 1860s, colorful commercial yarns manufactured in Germantown, Pennsylvania (now a part of Philadelphia), were imported to the Southwest by traders and made available to the Native weavers. They quickly responded to the new, broad palette that these synthetically dyed materials provided. Typical of this emerging new style customarily made for trade are bands of crosses and chevrons (fig. 32). Some of the blue, gray, white, green, pink, and dark red yarns are from Germantown, and others are handspun or raveled from imported cloth, as was traditional. Later, in the 1890s, Diné weavers fashioned large numbers of rugs for the broader market, starting an economy that continues to this day.[13]

Similarly, the Diné learned silversmithing from Mexican craftsmen sometime between about 1850 and about 1870.[14] Using melted-down Mexican and American coins as their raw material, Diné silversmiths developed their own vocabulary of silver jewelry, often inlaid with turquoise, including concha belts, necklaces, bracelets, and other objects, such as a horse's headstall (fig. 31). This silver, made for Native use as well as for trade, quickly became a distinctive branch of Diné art and continues today.

Southwest Indian potters, sometimes encouraged by traders, have always been adept at adjusting to the marketplace. Beginning in the 1880s and 1890s, a new market for decorative tiles—not a form that Native Americans used—was generated by the important trader Thomas Varker Keam, an immigrant Englishman who operated a trading post in Arizona from 1874 to 1902 and sought innovative ways to develop Indian trade. Hopi tiles decorated with an image of a kachina were made as a result of Keam's drive to help Native potters establish a fresh way to sell their handmade goods (figs. 34 and 35). Pierced

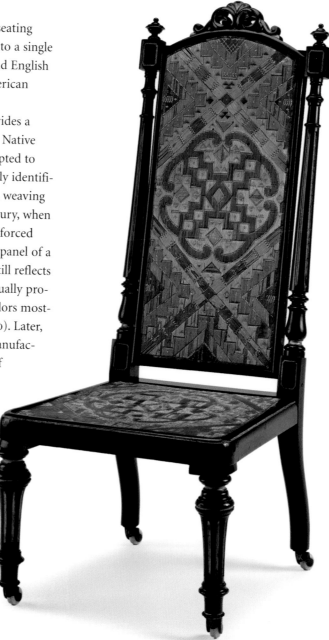

29
Side chair with Mi'kmaq (Micmac) quillwork panels
Nova Scotia, Canada, 1850–80
Ebonized mahogany, porcupine quillwork with vegetable dyes on birchbark with spruce root; porcelain, iron, and brass casters
H. 109.2 cm (H. 42 in.)

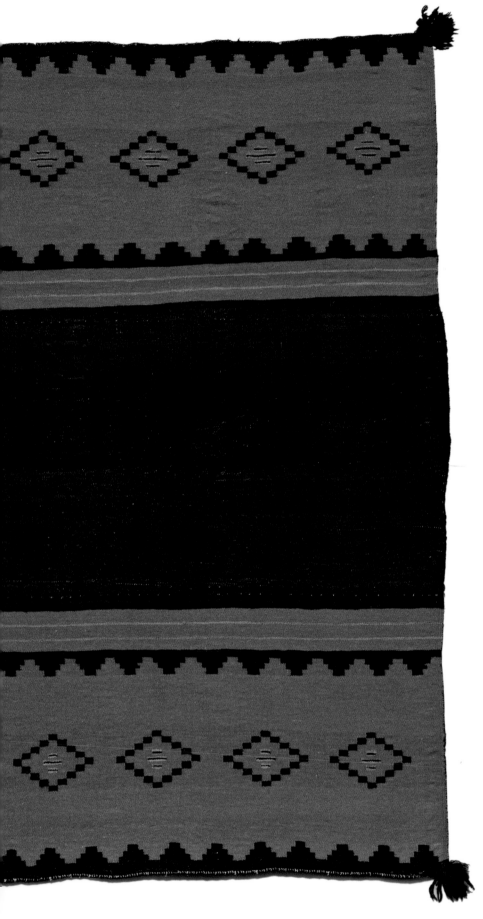

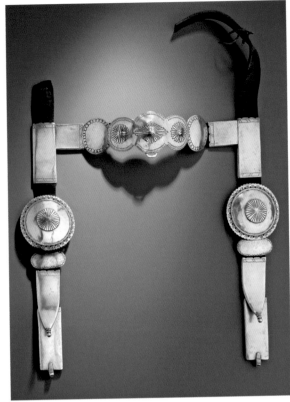

30
Diné (Navajo)
Panel from a woman's dress (detail)
Arizona or New Mexico, about
1850–70
Wool interlocked tapestry
L. 130.8 cm (L. 51½ in.)

31
Diné (Navajo)
Horse's headstall
Arizona, about 1875–1900
Silver, leather
L. 64.8 cm (L. 25½ in.)

32
Diné (Navajo)
Sarape (detail)
Arizona or New Mexico, about 1860–65
Wool interlocked tapestry
141.6 x 184.2 cm (55¾ x 72½ in.)

33
Apsáalooke (Crow)
Martingale
Probably Montana, before 1884
Buckskin, glass beads, wool trade
cloth
85 x 53 cm (33⁷⁄₁₆ x 20⁷⁄₈ in.)

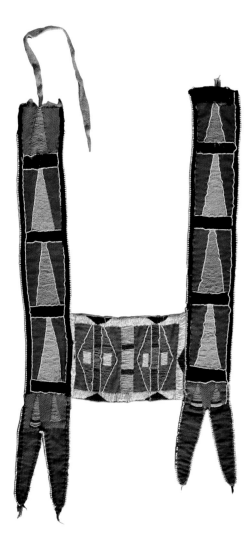

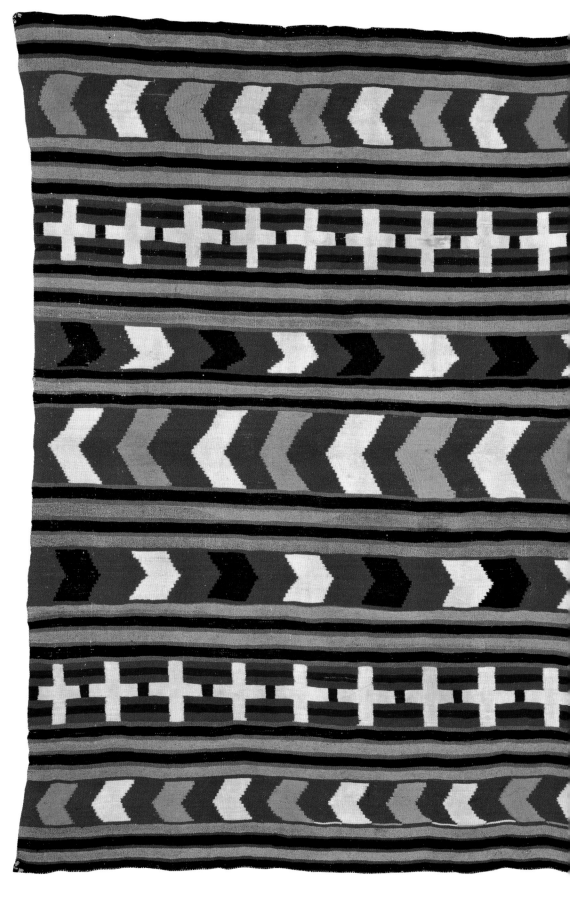

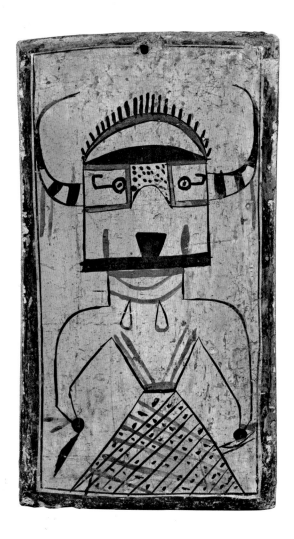

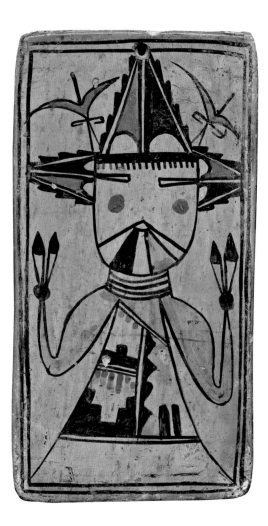

34
Hopi
Tile with a warrior or guard
kachina
Arizona, about 1892–99
Earthenware with slip paint
H. 18.1 cm (H. 7⅛ in.)

35
Hopi
Tile with Palhikwmana kachina
Arizona, about 1892–99
Earthenware with slip paint
H. 18.4 cm (H. 7¼ in.)

36
Haida
Button blanket
British Columbia, Canada, 1865–80
Wool twill embroidered with
dentalium shells and mother-of-
pearl buttons
139.7 x 177.8 cm (55 x 70 in.)

with a hole to facilitate hanging in the home of the purchaser, such slab tiles were attractive souvenirs: small, portable, inexpensive, easily displayed, and with a clear touch of the "exotic" in their decoration.[15]

Similar patterns of adaptation and assimilation can be found repeatedly throughout Native American art. Among Plains Indians, traditional porcupine quillwork was supplanted by beadwork. Small glass beads were imported by traders from Venice and later Czechoslovakia to ornament many articles of clothing and other objects, such as an Apsáalooke (Crow) martingale (decorative horse collar) (fig. 33). (The horse itself had been imported to America from Spain.) In the Northwest Coast, by the mid-nineteenth century, mantles made of cedar bark for chiefs and important personages had been largely replaced by

button blankets fabricated from blankets made and marketed by the Hudson's Bay Company. On a Haida blanket, for example, a beaver clan crest is outlined in traditional dentalium (a mollusk) shells, while its borders are created with imported mother-of-pearl buttons (fig. 36).

Artistic influence has always flowed in both directions, however, and Native American cultures have had a profound impact on the art and society of non-Native peoples of North America. Looking at how Native cultures have been interpreted, stereotyped, and appropriated by others tells us a great deal about the complex ways in which Native Americans have been perceived and mythologized by Western artists working in North America over time. Perhaps even more important, grappling with this difficult

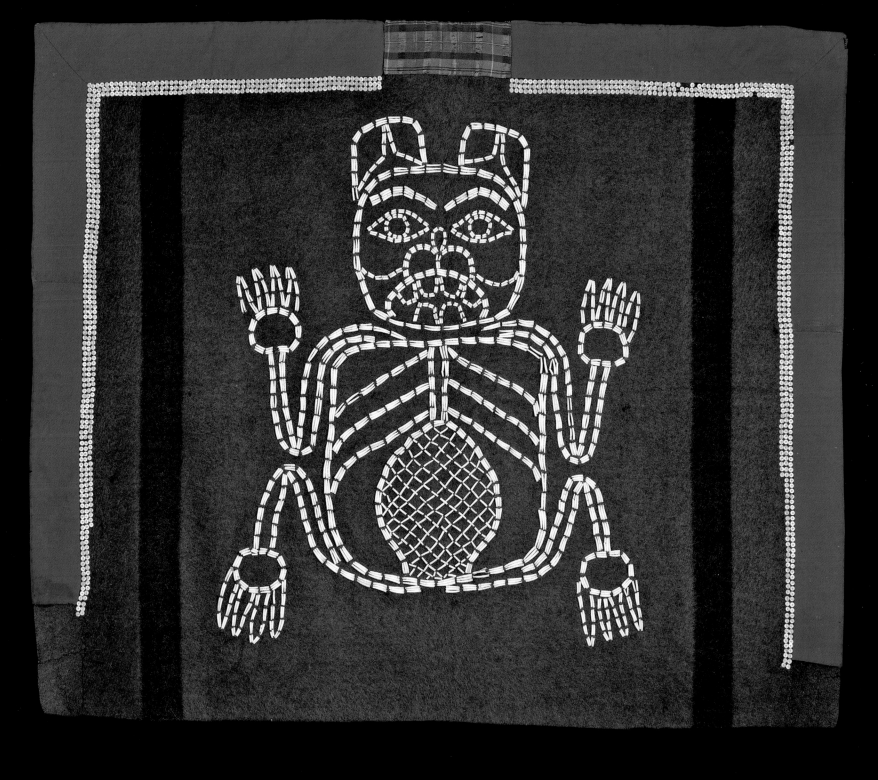

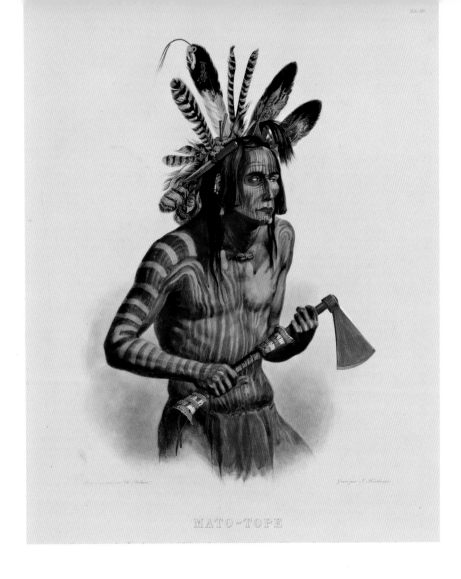

MATO-TOPE

37
Johann Hürlimann
Swiss, 1793–1850,
after Karl Bodmer, Swiss,
active in France, 1809–1893
Mato-Tope (Indian in War Dress),
1834–43
Hand-colored engraving on
paper
59.8 x 44.3 cm (23 9/16 x 17 7/16 in.)

history allows us to fully understand the perspective of those contemporary Native artists who actively refer to and question this thorny legacy in their art.[16]

Images of Native Americans by outsiders usually tell us as much or more about the artist and his or her own time than they do about their subjects, who are often depicted in a threatening, sentimental, romantic, or condescending manner, depending on the prevailing stereotype. An early example is Karl Bodmer's depiction of Mato-Tope, or Four Bears, the chief of the Mandan people of Montana (fig. 37). An artist of Swiss and German descent, Bodmer accompanied the German prince Maximilian of Wied-Neuwied on an extended trip to explore and document North America between 1832 and 1834. In this image, he shows Mato-Tope as exotic and even dan-

gerous, holding a hatchet and painted with red markings that, especially on his face, resemble blood. Created for the European market, as indicated by the German and French inscriptions, this print was intended to reinforce a common early perception of Native Americans as violent savages. Bodmer captured Mato-Tope's likeness only a few years before an 1837 smallpox epidemic brought by Europeans killed an overwhelming portion of the Mandan people, making this one of the last documented images of the Mandan culture before that devastating tragedy.[17] Whatever stereotypes they may embody, Bodmer's images—following in a long tradition of Anglo-European artists' interpretation of Native peoples, begun by the English artist John White and others in the sixteenth century—when analyzed carefully, can provide significant information about costume, objects, architecture, and other aspects of material ways of life that have vanished.[18]

As the nineteenth century progressed, a more romantic and elegiac perception of Native Americans gained currency within American culture in the United States. In this view, Native peoples were vanishing noble savages on the wrong end of history, sorrowfully giving way before the inevitable and righteous westward progress of American culture across the continent. The French Enlightenment philosopher Jean-Jacques Rousseau originated the idea of the noble savage, or the mythical uncorrupted human in a state of nature, in the eighteenth century. This archetype was later explored by nineteenth-century American writers such as James Fenimore Cooper and Washington Irving and by American painters like Thomas Birch, whose work *The Landing of William Penn* shows a fanciful view of peaceful Indians greeting the arriving Englishman.[19]

De Witt Clinton Boutelle's *Indian Surveying a Landscape* of 1855 depicts a stereotypical Indian hunter with a noble profile and mournful expression (fig. 38). He is dressed in a carefully, even ethnographically, observed costume, probably drawn from the widely available popular images of the captured chief Black Hawk of the Sac and Fox Nation.[20] Standing in the foreground on a rocky ledge within the last remnants of a wild and untouched wilderness, he over-

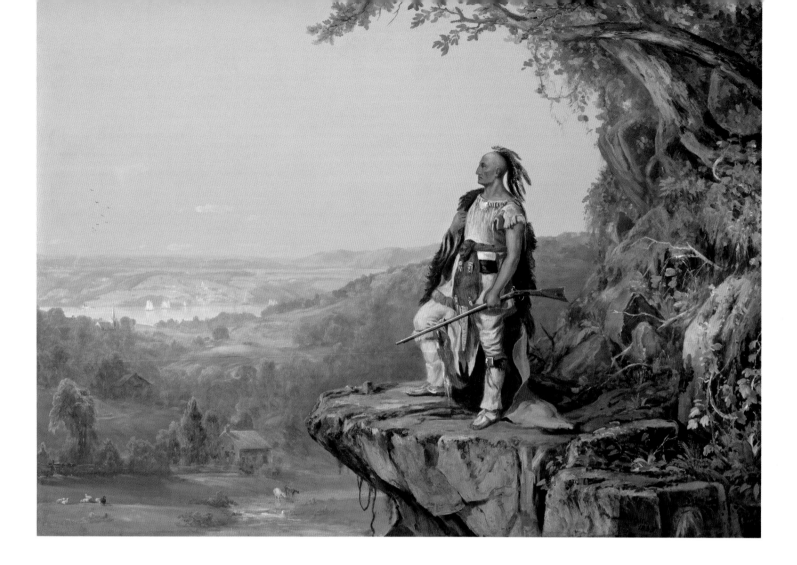

looks a landscape of encroaching settlement, including a fenced-in farm with sheep and cattle, a church steeple, and distant sailboats on the water. This arrangement encapsulates a long history of colonization, contact, and expansion. The Native man in the foreground is clearly intended to stand in for all Native Americans being displaced by what white artists like Boutelle saw as a far more advanced and desirable civilization.

Other examples of this stereotypical approach abound, including images that use Indians as emblems, such as on a lodge symbol or on Indian-head coinage designed by Augustus Saint-Gaudens in the early twentieth century.[21] The Plains Indians, through the influence of movies, television, and literature, were reduced to stereotypes more often than any other

American Indian people. Thus it is not surprising that in the 1920s an American manufacturer should trivialize an image of a Lakota (Sioux) war bonnet—a powerful and important symbol of leadership and power within the Plains community—by using it as the basis for a pattern for a dress fabric (fig. 39). (This sort of attitude has made it possible for a National Football League franchise, located in the nation's capital, to be named the Washington Redskins since 1937.)

Other modern references to Native Americans have been more respectful. As the so-called Indian Wars came to an end toward the close of the nineteenth century, culminating in the massacre at Wounded Knee in 1890, many artists, as well as early ethnographers and ethnologists, became outraged over the

38
De Witt Clinton Boutelle
American, 1820–1884
Indian Surveying a Landscape, 1855
Oil on canvas
101.9 x 137.8 cm (40 ⅛ x 54 ¼ in.)

ence both captivated by their exoticism and concerned about the survival of their creators. In time, American craftsmen and manufacturers responded to this material. For example, the Clifton Art Pottery of Newark, New Jersey, founded in 1905, produced a line entitled Clifton Indian Ware in the early twentieth century. This line consisted mainly of unglazed red clay objects with designs derived from Native vessels (fig. 40). William A. Long and other Clifton designers based their wares on objects excavated in the Southwest by Smithsonian archaeologists or exhibited in museum collections. One example is an ancient form of bottle that was associated in the early twentieth century with the Middle Mississippi Valley (and later attributed to Native Caddo peoples in Arkansas). Other art potteries produced related objects that echoed American Indian pottery in its forms and designs; the Rookwood Pottery of Cincinnati also made a specialty of issuing vases and other objects painted with idealized depictions of Native Americans.[23]

39
Designed by Walter Mitschke
American, born in Germany,
1886–1972
Length of dress fabric (detail):
Sioux War Bonnet from the
American Indian series, 1927
Silk plain weave, printed
99.1 x 121.9 cm (39 x 48 in.)

40
Clifton Art Pottery
Vase
Newark, New Jersey, about
1906–11
Earthenware
H. 30.5 cm (H. 12 in.)

plight of the Indians and concerned about their very survival. Cyrus Dallin's *Appeal to the Great Spirit* is the fourth in a series of equestrian statues fashioned by the sculptor as a sympathetic response to the Indians' tragic tale (fig. 41). *Appeal* depicts a noble Lakota (Sioux) warrior on horseback, arms outstretched in supplication to the Great Spirit, seeking salvation after all earthly attempts at making peace with the white invaders have failed.[22]

The handcrafted nature of Native wares also attracted proponents of the Arts and Crafts movement in the late nineteenth and early twentieth centuries. Indian goods were displayed in quantity at the Philadelphia Centennial International Exposition in 1876, bringing them to the attention of a wide audi-

Twentieth-century modernist painters viewed Native cultures through a different, but no less distorted, lens. These artists were searching for new and more abstract styles that did not depend on the system of one-point perspective that was developed during the Renaissance. Many of these modernists drew their inspiration from the art of cultures they considered "primitive" as they attempted to fashion their own novel abstract visual vocabularies. Some appropriated elements from non-Western art in a haphazard and instinctive way, cherry-picking forms that appealed to them as they explored the collections of nearby museums. Others, like Marsden Hartley, chose more strategically.

While living in Berlin in 1914, Hartley created a group of paintings he called his Amerika series. These symmetrical, brightly colored, and geometric canvases include Native American symbols and draw on Native visual conventions. Many also feature multiple small schematic Native American figures seated in canoes and wearing feather headdresses. In his *Arrangement—Hieroglyphics* (formerly known as *Painting No. 2*), probably created toward the end of this series, Native symbols coexist with others that are emphatically non-Native, like the keyhole at lower left (fig. 42). Highly patterned, the Amerika series was a bid by Hartley, as an artist from the United States, to participate in the revolutionary experimentations with abstraction then taking place throughout Europe. His decision to use Native American art as his "primitive" source material both positioned him as an American and appealed to a long-standing interest in Indian culture within the German market. Native American tipis, canoes, clothing, and totem poles were readily available to Hartley in Berlin's Museum für Völkerkunde, and scholars have identified at least one source for the symbols in the Amerika series from that collection.[24]

Steve Wheeler, Peter Busa, and Robert Barell are other abstract painters who drew on Native American imagery. Critics called these artists the Indian Space Painters for their adoption of Native American and ancient American signs and symbols in such works as Wheeler's *Man Menacing Woman* (see fig. 20). In the late 1930s Wheeler lived in New York and visited the outstanding Native collections at the Heye Foundation, the Brooklyn Museum, and the American Museum of Natural History; he also attended the landmark "Indian Art" exhibition at the Museum of Modern Art in 1940.[25] This show and its catalogue were influential in bringing Native American art to the attention of the New York art community; it was an early step in the gradual transformation of the display and interpretation of Native American art from cultural specimen to work of art.[26]

Busa's *Birth of the Object and the End of the Object* is one of several paintings made in the biomorphic style that the artist pursued in the early to mid-1940s,

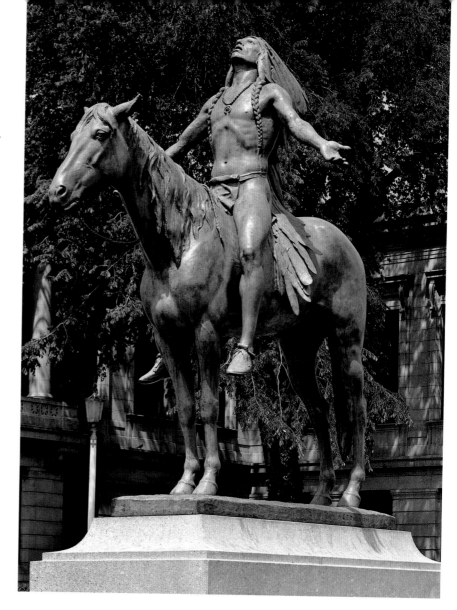

41
Cyrus E. Dallin
American, 1861–1944
Appeal to the Great Spirit, 1909
Bronze, green patina, lost-wax cast
H. 309.9 cm (H. 122 in.)

42
Marsden Hartley
American, 1877–1943
Arrangement—Hieroglyphics
(Painting No. 2), 1914
Oil on canvas
108 x 88.3 cm (42½ x 34¾ in.)

43
Peter Busa
American, 1914–1985
Birth of the Object and the
End of the Object, 1945
Oil on canvas
64.8 x 76.2 cm (25½ x 30 in.)

when he was part of a new and soon-to-be-influential circle of New York School abstractionists that included Jackson Pollock. In these years Busa began to question traditional representation, seeking instead to express inner psychological truths. He used the Surrealist technique of automatic drawing, a process of making marks and images without planning or forethought, as seen in his drawing *Indian Space*. This technique was believed to allow access to the primal unconscious that was the wellspring of both primitive art and advanced modern abstraction.[27] In *Birth of the Object and the End of the Object*, Busa employed this automatic drawing technique to create fluid organic forms with a looping, calligraphic brushstroke (fig. 43). Though a few shapes (such as the area resembling a Northwest coast figure at left) are

suggested, most are entirely abstract. In a compositional structure probably drawn from Native sources, Busa created no illusion of space or depth but instead produced a series of rhythmic squiggles that rest on the painting's surface. His search for an unschooled and instinctive style led Busa to become increasingly involved with the hard-edged, primitivist work of the Indian Space Painters group in the ensuing years.[28]

Many members of the ongoing studio craft movement, especially since the 1960s and 1970s, have found inspiration (still often tinged with idealism) in Native sources and stories, as did their counterparts in the Arts and Crafts movement earlier in the twentieth century. The protest known as the American Indian Movement heightened public awareness of the plight of Native Americans and stimulated a reevalu-

44
JoAnne Russo
American, born in 1956
Porcupine basket, 1999
Black ash, pine needles,
porcupine quills, Createx fiber
reactive dye
26.7 x 15.2 cm (10½ x 6 in.)

45
Evelyn Cheromiah (Sru tsi rai)
Laguna Pueblo, born in 1928
Water jar, 1993
Earthenware with slip paint
23.2 x 24.1 cm (9⅛ x 9½ in.)

from the forest; black ash, pine needles, sweet grass and porcupine quills; incorporating strong visual design elements, like the contrast of black and white or spiky surface decorations, to give each basket a presence—animism."[30] The invocation of animism—the belief that natural objects have souls—is a fairly common sentiment among craft artists and is perhaps a more important link than materials between many studio artists and Native Americans.

In the last century, Native American artists have faced many of the same issues of voice and identity that confront all contemporary artists. But almost inevitably they must deal with their historic identity as well as with whatever individual muse moves them. For many Native Americans, the rediscovery and revival of their ancient, traditional heritage—nearly eradicated in the nineteenth century—has been a primary concern.[31] Nampeyo of Hano, for example, discovered shards of ancient pottery near her home on First Mesa in Hopi Land, Arizona. Her pottery, called Sikyatki Polychrome, is generally thought to be the first "modern" revival of the historic craft of pottery making, which has grown and continues to flourish.[32] Maria Martinez of San Ildefonso Pueblo in New Mexico was encouraged to fashion a modern interpretation of historic black pottery.[33] Martinez's skills, as well as those of her husband, Julian, gained her international fame. Pottery making was revived elsewhere throughout the Southwest as the twentieth century progressed.[34] Evelyn Cheromiah, for example, renewed the craft in her small pueblo of Laguna (fig. 45), and today pottery making flourishes throughout the Southwest.[35]

Similarly, other Native artists have reexamined and reinterpreted the traditional art of their ancestral homelands. Joe David, of Nuu-Chah-Nulth (Nootka) heritage, for example, has been a leader since the 1970s in the exploration of the various styles of Northwest Coast Native art. His *Took-beek* (Sea Lion Hunter), a house post, echoes traditional forms in its symbolic carving, representing a family lineage, and in its polychrome painted scheme (fig. 46).

Other modern American Indian artists have moved in different directions. Preston Singletary's *Raven Steals the Moon*, for example, expresses Tlingit imagery and mythology through the use of the non-

ation of their place in American society during this period. In particular, Native Americans' environmental wisdom, relationship to the land, and status as "outsiders" in mainstream society resonated with many studio craft artists. The studio jeweler Kiff Slemmons, for example, who specializes in using found materials, fashioned her Native American–style breastplate entitled *Protection #4* from pencils, coins, and other modern objects instead of the traditional beads, bones, and other natural materials that Plains Indians would have used. The No. 2 pencils used in the breastplate make ironic reference to government treaties with Native Americans, which officially stated an intention to protect them but which were almost always "erased" and thus had the opposite effect.[29]

Early in her career, JoAnne Russo of Vermont made baskets that drew on several strands of Native American basketry (fig. 44). She noted: "I refined my technique and wove very detailed, intricate baskets that were inspired by Native Americans of the Northeast and the Southwest, I used materials taken

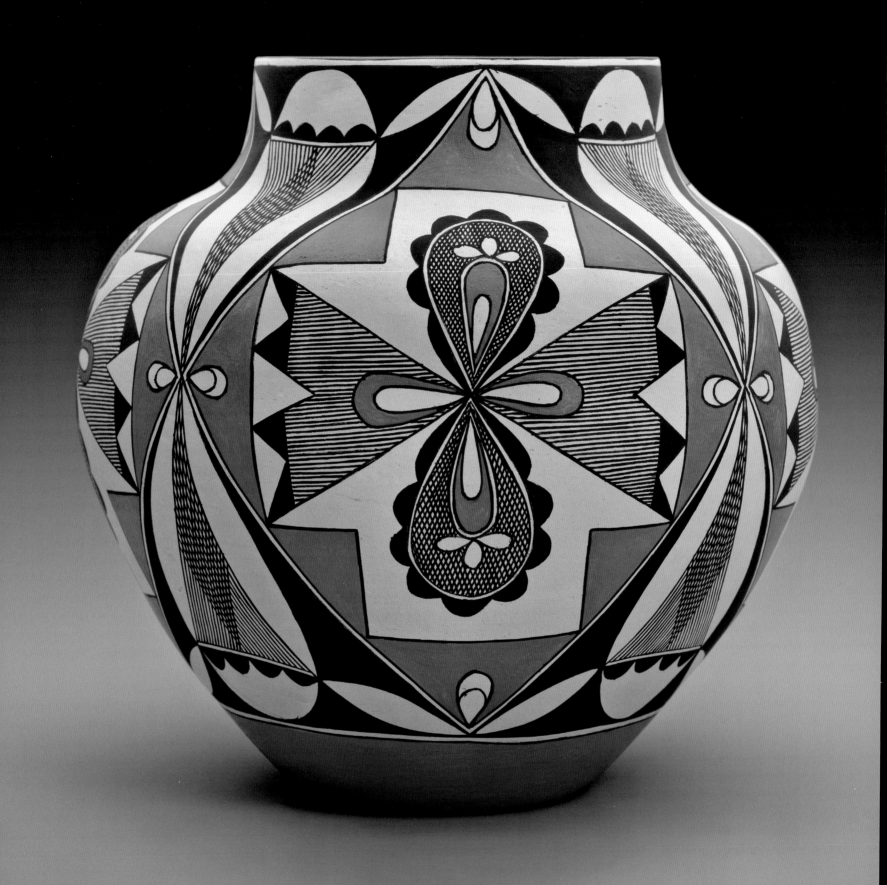

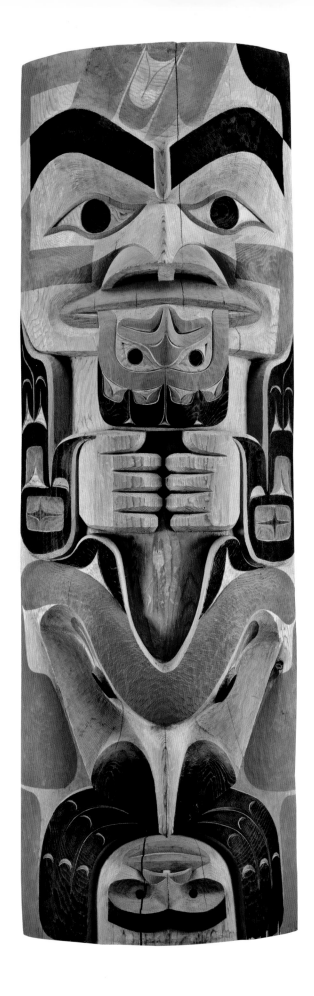

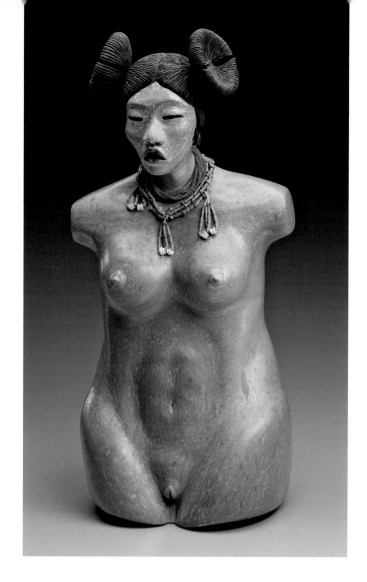

Native material of glass (fig. 48). Nathan Begaye's ceramic vessel *Squash Maiden* takes an even more distinctly nontraditional approach to the image of a Hopi maiden (fig. 47). These works by Singletary and Begaye, along with others by Diego Romero, Susan Folwell, Virgil Ortiz, and others, represent the emergence of Native American artists into the wide realm of studio crafts.[36]

In the twentieth century, American Indian artists also entered the fields of easel painting, printmaking, and sculpture, among other media, often balancing Native content with styles related to widespread artistic movements. Yet this very duality can place them on the margins of both the Native American and the contemporary art worlds.[37] Jaune Quick-to-See Smith, an artist of Salish, Métis, Shoshone, and Cree descent, eloquently describes the difficult position in which many contemporary Native artists find themselves. As she puts it:

46
Joe David
Nuu-Chah-Nulth (Nootka),
born in 1946
Loren White
American, born in 1941
Took-beek, 1982
Painted red cedar
H. 188 cm (H. 74 in.)

47
Nathan Begaye
Hopi/Diné (Navajo),
born in 1969
Squash Maiden, 2002
Earthenware with slip
paint, beads
H. 35.9 cm (H. 14 ⅛ in.)

48
Preston Singletary
Tlingit, born in 1963
Raven Steals the Moon, 2002
Blown red glass; black over-
lay with sandblasted design
H. 49.5 cm (H. 19 ½ in.)

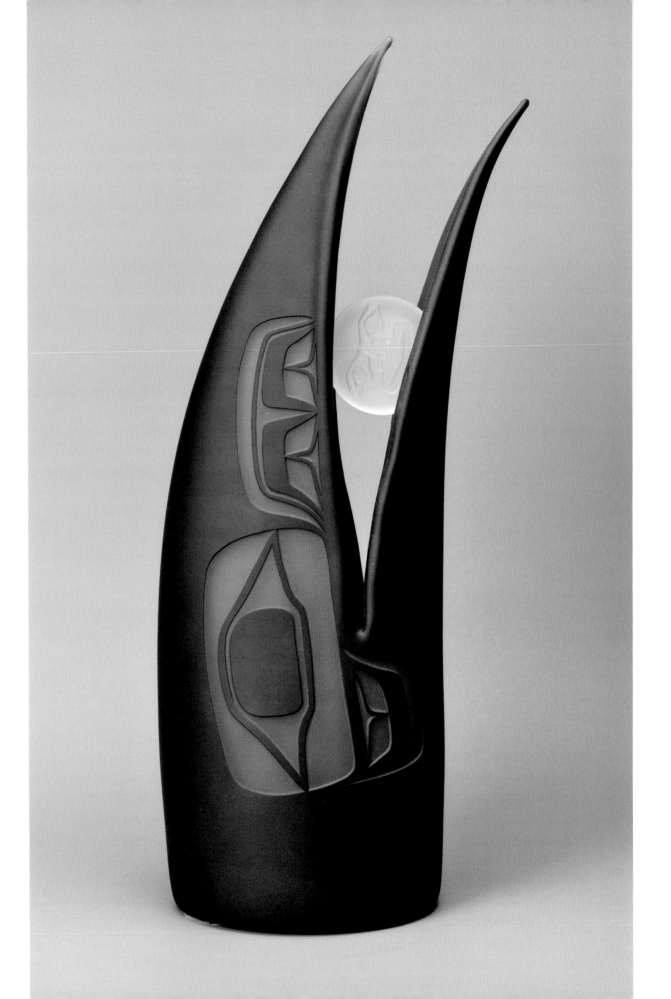

49
Jaune Quick-to-See Smith
Salish (Flathead),
born in 1940
El Morro #34, 1981
Pastel on paper
76.2 x 57.2 cm (30 x 22½ in.)

American Indians who make fine art have found themselves in a real dilemma. Both anthropologists and art historians look for easy references to Indianness—Indian designs, pictographs, or feathers—and dismiss the work for not being Indian enough. On the other hand, fine art critics will look for easy references—Indian designs, pictographs, or feathers—and negate the work for being too Indian. Therefore they claim that they can't write about our art because it's out of their arena. European and American white artists have appropriated or borrowed from all ethnic peoples and that seems to be sanctioned by another standard. . . . The solution, I feel, is to develop writers from within our own ethnic communities. That's not an easy task.[38]

In her *El Morro #34*, Smith includes elements drawn from both Native and European modernist art, placing herself squarely within the critical gulf she describes above (fig. 49). The work is part of a series inspired by the petroglyphs on Inscription Rock at El Morro National Monument in New Mexico, a large sandstone formation near the historic Zuni Trail that for centuries offered a convenient sheltered camping spot to Native, Spanish, and Anglo travelers. These individuals often carved words and pictures into the soft stone, leaving behind a mixture of European inscriptions, including simulated star charts and mapping grids, juxtaposed with American Indian petroglyphs of horses, canoes, people, priests, and conquistadores.[39] Some of these images are recognizable in the El Morro series, as are elements drawn from twentieth-century modernism. With its flat composition, use of dotted lines, and pictographic symbols, *El Morro #34* particularly references the work of Paul Klee, a European artist Smith has often cited as a significant influence. Thus, Smith neatly reappropriates the visual style of a twentieth-century modernist that was developed in part through the appropriation of Native sources.

The painter David Paul Bradley also provocatively combines Native and non-Native visual styles in his work. In *Greasy Grass Premonition #2*, Bradley explores the 1876 Battle of Little Bighorn, called the Battle of Greasy Grass Creek by Native Americans, through a combination of visual styles drawn from Plains ledger books, photography, Pop Art, and mass-market illustrations that deftly emphasizes the clash

of cultures that occurred during the event (fig. 50). The defeat at Little Bighorn of the Seventh Cavalry Regiment of the United States Army by the combined forces of the Lakota and Northern Cheyenne, and the death in battle of General George Armstrong Custer, became a highly publicized cultural touchstone in the late nineteenth century. In his painting, Bradley depicts a row of Custer figures, modeled on a Civil War–era portrait photograph of the general that later became the source for a print by Andy Warhol. A comic book–style thought balloon above is filled with a drawing in the mode of a Plains ledger-book illustration representing Custer's premo-

50
David Paul Bradley
Ojibwa (Chippewa), born in 1954
Greasy Grass Premonition #2, 1995
Mixed media on canvas
76.2 x 61 cm (30 x 24 in.)

nition of the violent conflict in which he would lose his life. Below, in stenciled letters that recall the work of the Pop artist Jasper Johns, are the words "Greasy Grass," and above is a row of American flags.

Other contemporary Native American artists choose to create in a style that gives no overt indication of their cultural affiliation. In *String Game—2 (Kayaker)*, for example, Rick Rivet works in an abstract mode, creating a vibrant and colorful painting (fig. 51) that at first glance appears most influenced by the artwork of mid-twentieth-century artists such as Mark Rothko and Hans Hofmann.[40] Yet non-Western art is an important, if less explicit, source for Rivet, who describes his work as "combining and re-interpreting the iconography of various aboriginal peoples in a contemporary perspective."[41] This is one of several paintings in which Rivet explores the forms created by string games, a nearly universal children's pastime, evoked here by the white lines in the center of the canvas. For Rivet, abstraction is a pathway to depicting common experiences at the root of all cultures, or what he calls "the on-going history of the human spirit."[42]

The life of Fritz Scholder encapsulates many of the issues confronting Native American artists in the twentieth and twenty-first centuries. One-quarter Native American by birth—his paternal grandfather was a member of California's Luiseño tribe—Scholder did not come to grips with his Native ancestry until his college years. The title of a recent exhibition of his work—"Indian/Not Indian"—aptly summarizes the defining issue of his life. In *Cowboy Indian*, Scholder reveals his training in Pop Art through his use of strong color and bold silhouette, while also examining, clearly and without romanticism, the dichotomy faced by a visage from two worlds (fig. 52).[43]

Scholder's struggle to come to grips with his dual identity is just one ongoing manifestation of the multifaceted and complex nature of Indian art. Native American art from all periods—in common with all art—has multiple meanings and is open to interpretation from numerous perspectives.[44] Thousands of years of history, plus more than five hundred years of interaction with European, African,

and Asian peoples, have generated a body of objects that are perhaps more easily recognized than precisely understood. This legacy represents, as Edwin L. Wade eloquently phrased it, "the fragile brilliance of past generations, the great inspirations of a truly new world." Our goal is to examine this art "not as anthropologists compiling trait lists, nor as art historians laboriously charting design elements, but as humanists concerned with aesthetic experience and human expressive potential."[45] That challenge remains for us all.

51
Rick Rivet
Métis, born in 1949
String Game—2 (Kayaker), 2001
Acrylic on canvas
106.7 x 106.7 cm (42 x 42 in.)

52
Fritz Scholder
Luiseño, 1937–2005
Cowboy Indian, 1974
Color lithograph
61 x 43.2 cm (24 x 17 in.)

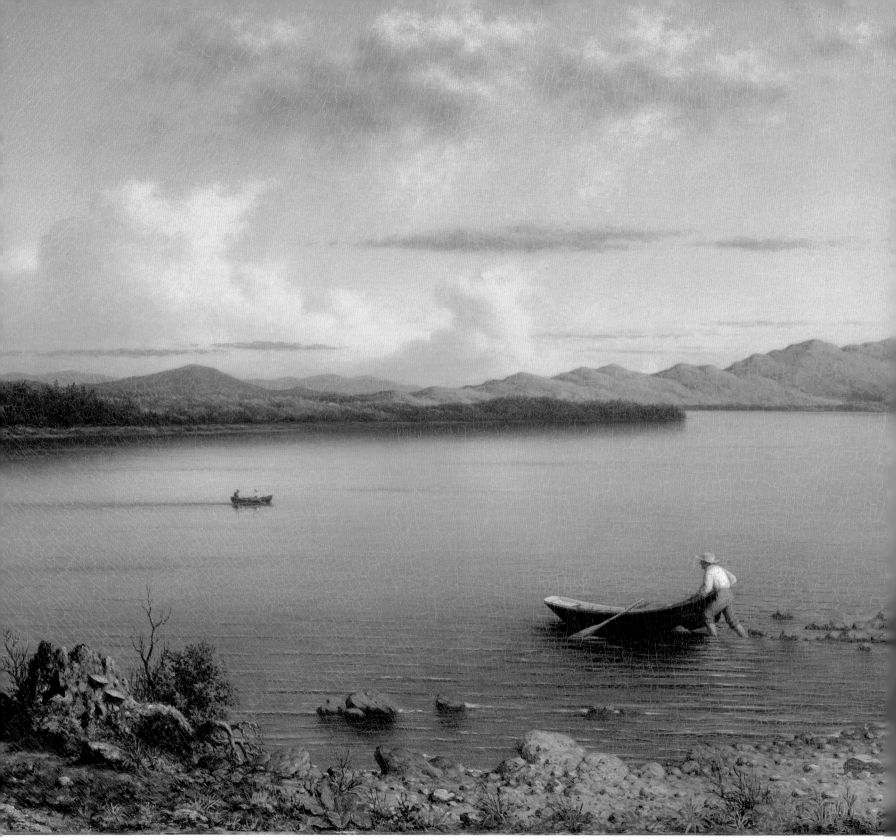

TRANSATLANTIC PASSAGES

ERICA E. HIRSHLER

Being an American, explained the writer Henry James in 1872, was "a complex fate," and "one of the responsibilities it entails is fighting against a superstitious evaluation of Europe."[1] James made the topic his chief theme; an astute observer, he realized that artistic and cultural affairs in the Americas always oscillated between nationalism and cosmopolitanism, swerving from patriotic celebrations of homegrown styles and stories to that ever-present "superstitious evaluation of Europe," wherein the fashions and fables of (predominantly) England, France, Italy, Germany, Spain, and the Netherlands and Scandinavia were promoted as superior, more sophisticated and erudite, than anything the New World had to offer. Regardless of whether the artistic influences of European nations were accepted or rejected in the Americas, they played a vital role in the visual culture of the New World.

The European impact on the Americas did not arise from a single episode or seminal event. There was no "Europe" in the Americas but, rather, multiple factions and competing alliances that, like the separate nations of Europe, were constantly jockeying for position and dominance. There were also radical differences in the way each colonizing power acted within the Americas and what effects it had there over time.[2] The Spanish, Dutch, French, and English settlers who first came to the Americas arrived with a range of goals and expectations, and, in consequence, their influence on American art varies. The Spanish came for conquest, religious conversion, and economic profit, pursuing a bloody takeover in the name of crown and church. They encountered vast interconnected civilizations spread over enormous regions of Central and South America, with cities as large as the capitals of Renaissance Europe. The Dutch arrived in North America with commerce in mind, pursuing a course of relatively peaceful coexistence and trade with native inhabitants. They gave up their largest territory at New Amsterdam to the English in 1664, yet they had a lasting cultural influence in many parts of North America well into the nineteenth century. The French lived in the northern and southern regions of North America and in smaller pockets elsewhere, fishing, trapping, and trading in alliance with native peoples and establishing important commercial centers and religious missions. The English came to stay, founding permanent communities from Virginia to New England, planting fences and fields as they went and radically disrupting the native presence. Waves of new immigrants arrived by ship each year from more and more places—Germany, Sweden, Bohemia, Italy, Ireland. Native American populations dwindled owing to war and disease, whereas European settlements grew rapidly and moved ever inland. The New World was remade on Old World laws and traditions, but the Old World habits were

altered and amended to suit new needs and ideals. Unlike European nations, each with its individual national characteristics derived from a long history, Americans could "deal freely with civilizations not our own," according to James; we "can pick and choose and assimilate and in short (aesthetically, etc.) claim our property wherever we find it." In that sense, James felt, citizens of the Americas were perhaps less parochial than some of their European counterparts.[3]

Whether they came from Spain, England, France, the Netherlands, Scandinavia, or elsewhere, immigrants to the Americas brought art with them, whether in the objects they packed and transported—furnishings, silver, clothing, portraits—or in the form of intellectual and physical skills. These latter intangible possessions were used to craft new homes, churches, and interiors that mimicked familiar settings, albeit sometimes in different materials. Their goods were not always made in the most sophisticated styles of London, Madrid, Munich, or Paris; sometimes they reflected a more vernacular aesthetic, echoing the geographic origins of the immigrants. Styles could lag between capitals and colonies, sometimes by choice, as in the purposely isolated German communities of Pennsylvania. Objects that were reserved for the upper classes in the hierarchical social structure of France were more widely used in America, where society was more fluid. Many colonists were equally determined to keep pace with the fashions of their homeland; the prosperous merchants of New England and the wealthy planters of Virginia and the Carolinas, for example, continued to import stylish British goods, including the latest pattern books and engravings after famous paintings, which served not only their owners but also local craftsmen, who used them as models for original designs. Thomas Chippendale's *Gentleman and Cabinet-Maker's Director* (London, 1754), Charles Percier and Pierre Fontaine's *Recueil de décorations intérieures* (Paris, 1801), and illustrated books and prints from Britain, the Netherlands, and Spain all made their way across the Atlantic to inform art in the Americas. As one British writer declared in 1772 about the transmission of style through printed reproductions and books, "Through the channel of this art . . . the works of the greatest painters are diffused over the world."[4] These sources were not always direct— for example, the Rococo style, generally considered French in origin, came to the North American colonies principally through England and to South and Central America through Spain and Portugal. The Dutch had direct trade routes with the Americas, but the influence of its art also arrived through Britain and Spain.

Certain types of art flourished first—builders, furniture makers, and silversmiths were among the earliest craftsmen to establish themselves. Ceramics, glass,

and textiles, which required more labor and capital investment, came later. Similarly, the colonies offered few opportunities for professional painters in the seventeenth century, but as settlements grew in size, wealth, ambition, and sophistication, portrait commissions from both religious institutions and private families encouraged painters to practice in and around major cities, principally in Montreal, Quebec City, Boston, New York, Philadelphia, Charleston, Mexico City, and Cuzco. Wars between England, France, and Spain, along with revolutions in the Caribbean, caused significant shifts in customary trading patterns and shipping routes, which in turn advanced America's interactions with other places—Asia, Africa, Russia, and the Pacific—but the nations of Europe always functioned as a cultural lodestar.

By the mid-nineteenth century, all of the arts were well established throughout the Western Hemisphere, but the desire to keep abreast of the latest European styles never abated. In a pattern of reverse immigration, American artists flocked to Europe for training, seeking the revered ancient monuments of Greece and Rome, the collections of old master paintings, and the practical education of reputable art academies that were unavailable to them at home. Often they went back to their country of origin—English settlers to London, Spanish colonists to Madrid, and German immigrants to Düsseldorf or Munich— sometimes finding expatriate countrymen to assist them in their quest for experience and education. Benjamin West, for example, was born in Philadelphia but by the 1760s had become one of the leading painters in Britain. Despite his honored reputation and position as president of the Royal Academy of Arts and painter to the king, he kept his door open to aspiring young American artists, allowing his studio to become their training ground. Similarly, Emanuel Leutze, German by birth, had grown up in Philadelphia; in the 1840s, as a leading art instructor in Düsseldorf, he helped a number of American students negotiate the academy there. American painters and sculptors formed significant expatriate communities in the international art centers of Rome, Florence, Venice, and Paris, opening their homes and studios to their visiting countrymen, offering instruction and recommendations, seeking through their efforts abroad to assist in the establishment of a cosmopolitan art culture in the United States, Canada, Mexico, and Central and South America. The European experience served as an imprimatur for many artists and craftsmen, a badge of honor that could translate directly into critical and economic success at home. Some found life in Europe more conducive to their creativity; among them were many women artists and the African Americans who flourished in Paris, experiencing there a freedom to create that had been impossible for them to find at home. "After all, give me France," declared Mary Cassatt. "Women do not have to fight for recognition here."[5]

Simultaneously, the Americas continued to represent freedom and opportunity to new immigrants. Germans came steadily, settling not only in the eastern United States but throughout Pennsylvania, the Midwest, Texas, and areas of Brazil and Argentina. In 1850 Irish refugees from the Great Famine made up more than one-quarter of the population of New York, Boston, and Philadelphia. Over four million Italians came to the United States between 1880 and 1920. Every war and political uprising in Europe, every food shortage, and every instance of religious persecution brought new people to American shores, all of them introducing their own styles and skills as artisans, painters, and craftsmen. They were not always welcomed, as the painter Constantino Brumidi discovered when his elaborate decorations for the United States Capitol were condemned in the 1850s for being un-American, the product of a foreign hand.[6]

The vast shift of populations during the nineteenth century was accompanied by swift technological developments that made the world seem smaller. By 1900 goods and people could cross the Atlantic in a week, and ideas could travel even faster as modern systems of communications were invented and implemented. International trade fairs and expositions had brought the world—and its art—to many cities, among them Philadelphia in 1876, Chicago in 1893, Saint Louis in 1904, San Francisco in 1915, and New York in 1939. Americans still traveled to Europe, but this had become less of a necessity and more a journey of self-discovery. Although civic and cultural leaders in the United States took great pride in their new machines and methods, many of them were conservative in their aesthetic tastes. Thus adventurous artists and patrons sought inspiration in the more modern styles of Paris or Berlin. Among many other New York art lovers, gallery owner Alfred Stieglitz, designer Paul Frankl, critic Walter Pach, collector Abby Rockefeller, and the first director of the Museum of Modern Art, Alfred Barr, worried about the lack of innovation in much of contemporary American art and set about to bring the best examples of European modernism home. Their efforts were aided by two world wars, conflicts that decimated much of Europe and caused some of the most innovative European modernists to settle in the Americas. By the late 1940s New York had (in the words of the French-born American art historian Serge Guilbaut) stolen the idea of modern art.[7]

The interchange between Europe and the Americas continues its pattern of transfer and exchange in an era of internationalism and global concerns. The capacity to create and renew culture through "a vast intellectual fusion and synthesis of the various National tendencies of the world," as Henry James declared, would one day be, he hoped, "the condition of more important achievements than any we have ever seen."[8]

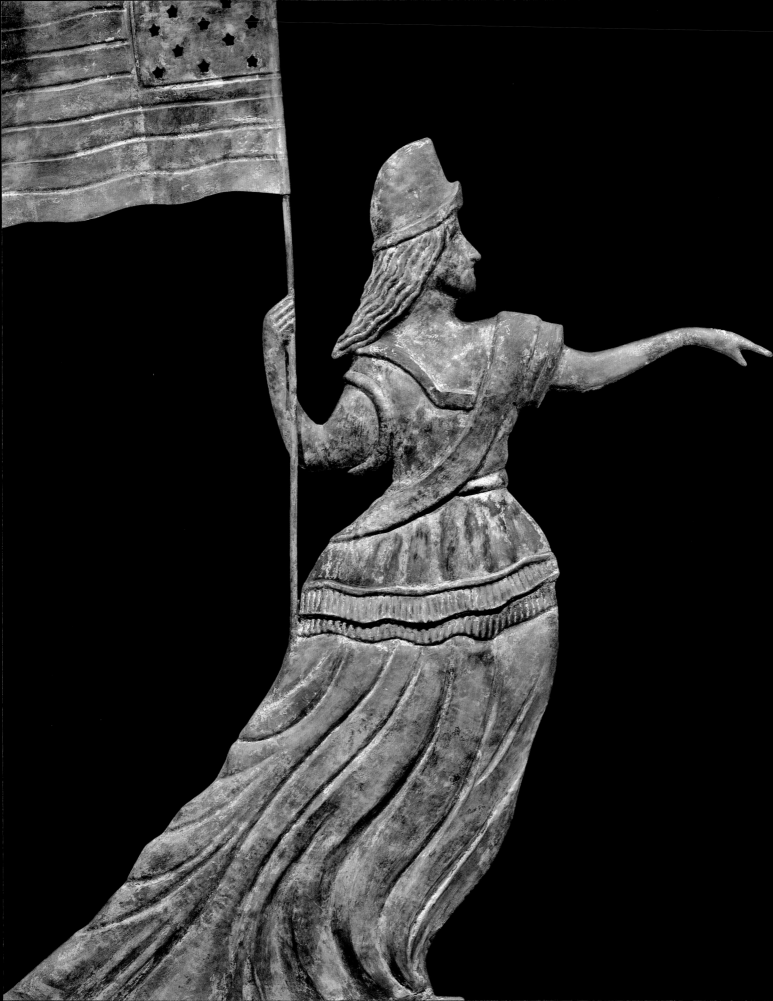

THE CLASSICAL TRADITION

GERALD W. R. WARD AND KAREN E. QUINN

Beginning in the seventeenth century, Neoclassicism (literally "new classicism")—the evocation of the restraint, rationality, and specific forms and motifs of the arts of ancient Greece and Rome (and occasionally of Egypt and Mesopotamia, the predecessors of Greece and Rome)—has been a rich source of inspiration for artists working in this country in all media, from architecture and the decorative arts to sculpture and painting. Different aspects of the classical world permeated almost all areas of American life to such a degree that they are almost unnoticeable. American art and American culture in the United States may not be fully understood without a grounding in the classical world. Systems of proportions, columns, and moldings were the vocabulary for architecture and the decorative arts; myths and personages provided themes for craftsmen, sculptors, and painters; motifs, symbols, and forms (such as eagles, urns, columns, griffins, and the like) were selected by consumers and craftsmen for eating and drinking vessels, furniture, and other objects.[1]

Although its pervasive presence can be traced in most historic periods, classicism was embraced more deeply during specific eras. A significant blossoming came during the years of the new republic, from the late eighteenth through the mid-nineteenth century, when Americans participated in a widespread international wave of Neoclassicism.[2] Classical ideals appealed especially to North Americans, who were establishing the shape of their new democracy in the United States at that time, based in large part on ancient prototypes and concepts.[3] Their respect for Athenian democracy and the virtues of the Roman Republic, reflected in the development of government and legal institutions, was also expressed in most aspects of their environment, from the adoption of ancient clothing styles (the revealing chiton dresses worn by fashionable and daring women), to the naming of new towns (Troy, Utica, Rome, Syracuse, Ithaca, and Palmyra, to mention only a few place-names across upstate New York), to the creation of thousands of Greek Revival homes and civic buildings across the land, including the United States Capitol.[4] Another high point occurred during the so-called American Renaissance of the late nineteenth century. That reaction against the perceived fussy and overly ornamented earlier revival styles of the mid- and late nineteenth century and a desire to assert the United States' position as a world power led to a return to the beaux arts (beautiful arts) of the ancient world, filtered through the lens of the Italian Renaissance.

However, classical details had been part of the artistic repertoire and vocabulary long before this period of full-blown classicism. For example, a chest of drawers made in Boston in the mid-seventeenth century is constructed with a complicated architectural facade that includes applied spindles in the form of Tuscan Doric columns capped with urns, various

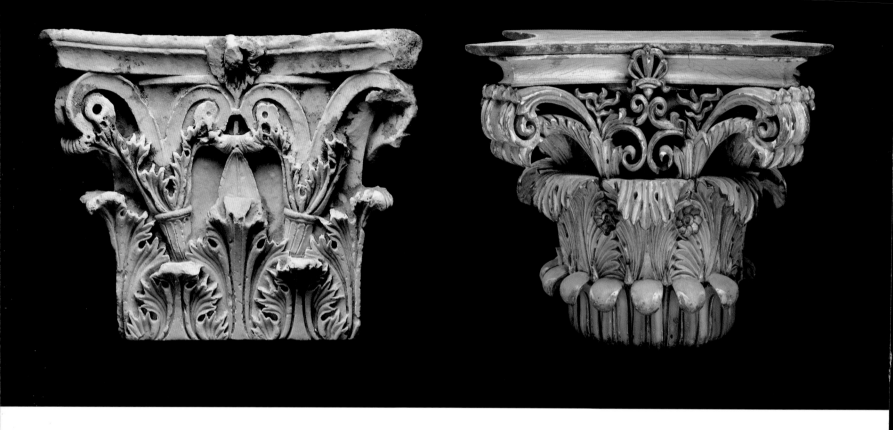

53 (page 80)
Possibly by William G. Henis
American, active 1860–after 1886
Goddess of Liberty weather vane
(detail)
Philadelphia, 1860–80
Copper with traces of gilding
H. 92.7 cm (H. 36½ in.)

54
Roman Corinthian pilaster
capital, 25–1 B.C.
Marble
H. 58.4 cm (H. 23 in.)

55
Corinthian capital
Boston, about 1800
Gilt and painted wood
H. 41.9 cm (H. 16½ in.)

moldings, corbels, bosses, and a row of dentils (see fig. 84). Like many other Anglo-American objects from the seventeenth and eighteenth centuries, the architectural elements on this chest, scaled down for furniture, while ultimately derived from ancient prototypes, did not necessarily come directly from the maker's knowledge of those sources. Instead, transmission was through a long process of borrowing and assimilation that extended back in time from the Renaissance through the Mannerist period, and from Italy through France, the Netherlands, and ultimately England before reaching the shores of the emerging Massachusetts Bay Colony.[5] The Tuscan Doric column itself was an invention of the Renaissance, as authorities at that time hypothesized that there must have been a simpler predecessor of the later, more elaborate orders. At this stage, precise historical accuracy was not important; the evocation of the classical world was the key goal, even if the references were filtered through later sources and slightly misinterpreted.

Classical elements can be seen in furniture and buildings throughout the eighteenth century in the form of pilasters, pediments, finials, moldings, volutes, swags, husks, and other architectural details. Known through books and prints in the seventeenth century, the language of classicism continued to spread later through travel narratives, pattern and design books, and illustrated architectural books that chronicled the results of archaeological excavations like those at Herculaneum (begun in 1738) and Pompeii (starting in 1748). In these ways, the classical orders became the essential foundation of North American architecture from the late seventeenth century on—Ionic capitals were first used in Boston on the Foster-Hutchinson House, for example, built in 1682.[6] A marble Roman Corinthian pilaster capital, carved with its characteristic acanthus leaves (fig. 54), is a generic prototype of a device that was widely imitated by American builders and carvers for many years (fig. 55).

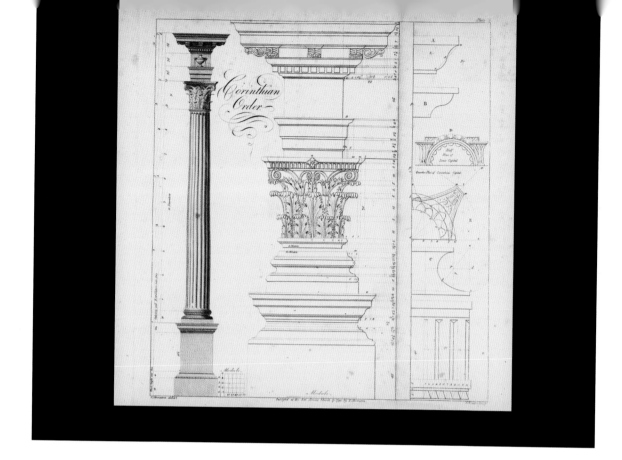

56
Thomas Sheraton
English, 1751–1806
"Corinthian Order," part 1,
plate 12, from *The Cabinet-Maker and Upholsterer's Drawing-Book, in Three Parts [and Appendix]*, 1791–93
Illustrated book with 98 engravings
Image: 23 x 25 cm (9 1/16 x 9 7/8 in.)

Classicism reached its peak in early America in the late eighteenth and early nineteenth centuries, in phases that have come to be called the Federal period (about 1790–about 1820)—or early Neoclassicism—and the Empire style (about 1810–about 1830)—or late Neoclassicism—named for Napoleon's short-lived French Empire. In these decades, classicism extended into almost all aspects of life, including the arts. American architects and artisans continued to learn their orders through apprenticeship and through the study of English pattern books, such as Thomas Sheraton's *Cabinet-Maker and Upholsterer's Drawing-Book* (published in several parts between 1791 and 1802). Sheraton's depiction of the Corinthian order was studied by Thomas Seymour, a leading furniture maker of Boston, who signed his name in the copy of the *Drawing-Book* illustrated here (fig. 56).[7]

In this post-Revolutionary period, American architecture and interiors became even more strongly influenced by the classical past, prompted by the model of Greek democracy and Roman republicanism and the associations these ancient forms of government had for the new American nation. In New England, the architect Charles Bulfinch, inspired by travel to London, returned to Boston at the end of the eighteenth century determined to transform his native town. He wanted to change the city from one filled mostly with narrow streets and provincial structures to a more gracious place modeled on the dignified proportions of the classical styles he had studied abroad. Not only did he expand Faneuil Hall, Boston's famous public marketplace, and design the Massachusetts State House, but he produced plans for all sorts of town houses, possibly including the one depicted in *The Tea Party* by Henry Sargent (fig. 57). The interior of this town house may represent Sargent's own residence in the Tontine Crescent, a handsome suite of Bulfinch row houses that no longer exist, and shows the customs of fashionable upper-class Boston at this time. The architecture of

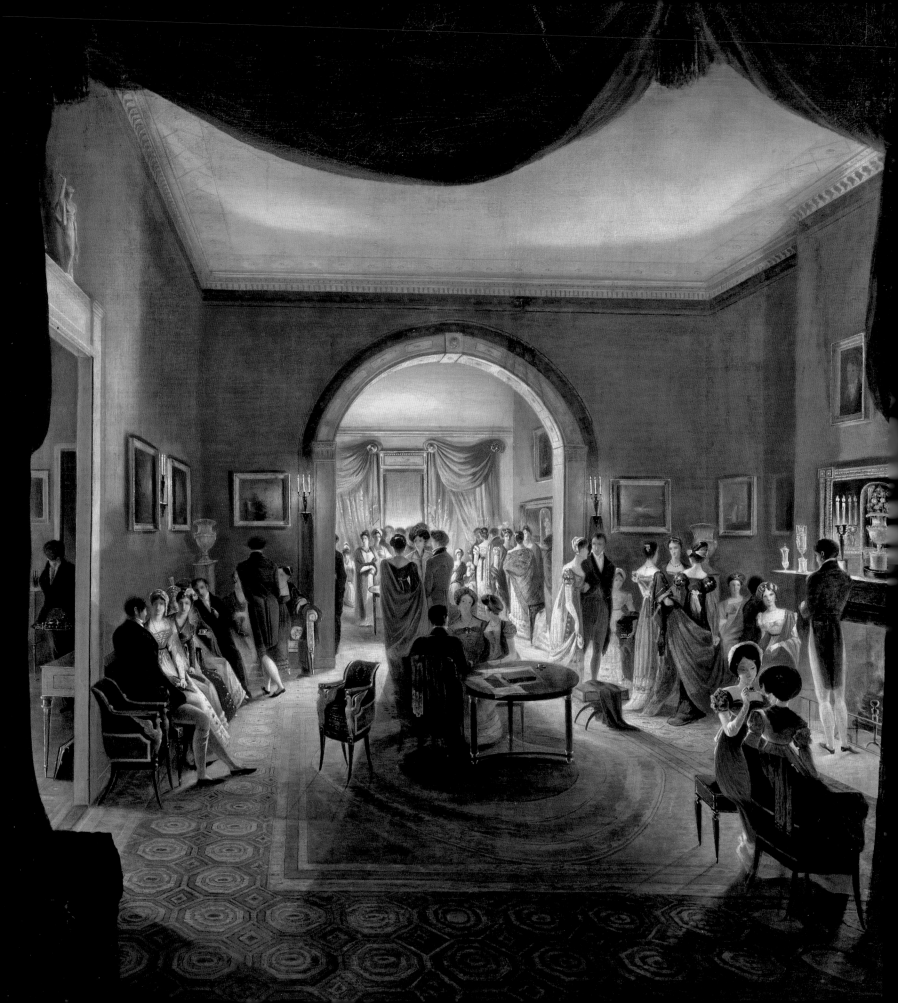

the spacious drawing room is detailed with an arched doorway set on pilasters, a cornice at the ceiling, and other classical features. The elegant Empire-style furnishings include the marble-topped center table and the armchairs at the left adorned with eagles.[8]

People wanted not only to live in surroundings inspired by the classical world but also to wear clothes derived from classical models. The women in *The Tea Party* wear fashionable Empire-style gowns, much like a French-made dress worn by Sarah Bowdoin, wife of James Bowdoin, who served as United States minister to Spain and associate minister to France in the first decade of the nineteenth century (fig. 58). The design of this high-waisted, loose-fitting garment was based on the chiton, a full-length outfit of flowing drapery worn by female figures in classical sculpture. White, difficult to keep pristine, was often reserved for evening wear; the women in Sargent's painting are dressed in colors suitable for an event held earlier in the day.

In addition to architectural orders and proportions, the classical world provided a wealth of motifs and emblems for artists to draw upon. Congress selected the Roman eagle (a multifaceted symbol) for the Great Seal of the United States in 1782, and Americans eagerly adopted the motif in the late eighteenth and early nineteenth centuries.[9] Images of the eagle, large and small, permeated material life in forms ranging from architectural sculptures, like Samuel McIntire's gilt eagle, which was stood atop a Derby family home in Salem (fig. 60), to numerous coins and medals.[10] Other classical forms, such as the urn (a vase-shaped container often used for funerary ashes) and the obelisk (an Egyptian columnar form later adopted by the Romans), were adapted for specific objects, often for purposes far removed from the form's original function. Federal-period silversmiths, such as Paul Revere of Boston, used the urn as sugar containers.[11] Samuel McIntire, an architect and carver of Salem, Massachusetts, used the obelisk form for his perspective machine of about 1800–1810 (fig. 61), capping it with a garlanded urn and embellishing it with a carved portrait profile in low relief, also in the classical taste.[12]

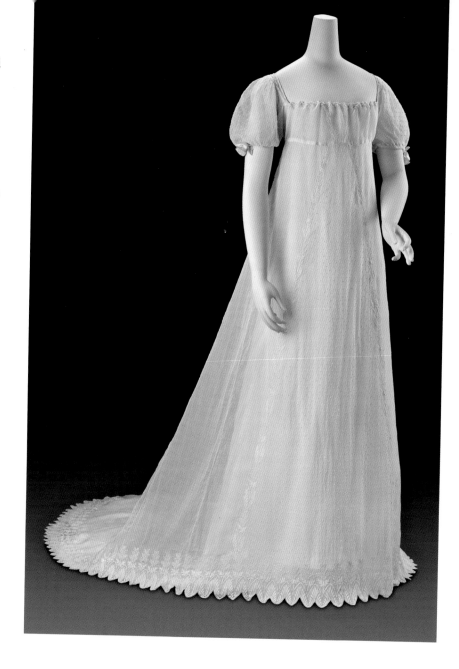

57
Henry Sargent
American, 1770–1845
The Tea Party, about 1824
Oil on canvas
163.5 x 133 cm (64 3/8 x 52 3/8 in.)

58
Woman's formal dress
Possibly France, about 1805
Embroidered cotton plain
weave (mull)
Center front: 121.9 cm (48 in.)

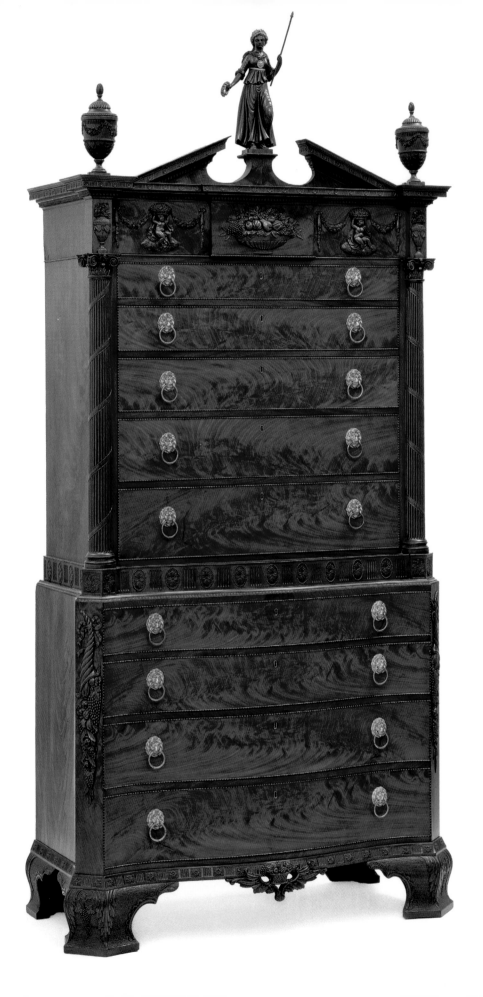

Although they may have been applied idiosyncratically, such motifs and forms were effective communicators of ideas in the Federal period. McIntire's monumental chest-on-chest is a true dictionary of classical ornament (fig. 59). Made for Elizabeth Derby West, the chest is rich in details that expressed not only her wealth (carving was expensive) but her taste as well, as it indicated she was familiar with the latest styles.[13] McIntire carved acanthus leaves—the stylized floral ornament based on a Mediterranean plant and used extensively since the fifth century b.c.—on its feet (see fig. 54). The lower skirt contains a basket of fruit and flowers, evocative of the harvest, at its center, with a band of molding containing sections of five glyphs (shallow channels or grooves) alternating with metopes (square spaces between the glyphs, here ornamented with carved floral ornaments), all referencing the frieze (or decorative band) of a Greek temple. The canted sides of the lower case hold carved cornucopia—the horn of plenty—representing abundance, while the sides of the upper case are flanked with Corinthian columns. The entablature has another basket of fruit and flowers at center, flanked by putti (winged naked boys, used since classical times and popularized as a motif in the Renaissance) and urns with swags. The pediment contains at center a carved allegorical figure—often interpreted as a characterization of America—holding a spear in her left hand and a laurel wreath (a sign of victory) in the other, with a gilt sunburst at her middle. Large urns with swags serve as finials at the side. In all, it is an impressive statement of three-dimensional symbolism that carries many ideas from the mind of its creator to the mind of the viewer; it may have represented the aspirations expressed by the phrase "the rising glory of America."[14] Moreover, the chest-on-chest was used by Elizabeth Derby West in her house called Oak Hill, in which McIntire's architectural and furniture carving was used to dramatic effect to create a unified Neoclassical interior.[15]

As archaeological knowledge of the classical past increased, furniture makers began to make more literal use of ancient prototypes, rather than, as in the case of McIntire's chest-on-chest, applying motifs and details to earlier Anglo-American furniture

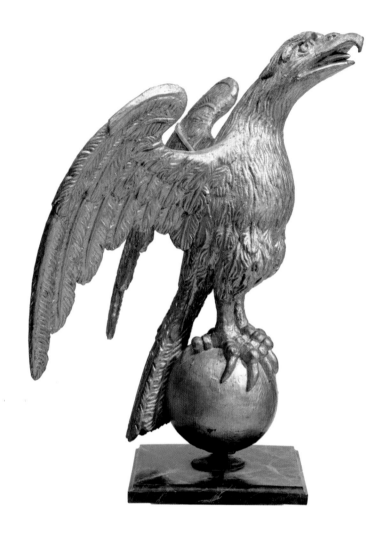

59
**Design and carving attributed to
Samuel McIntire**
American, 1757–1811
Chest-on-chest, 1806–9
Mahogany, mahogany veneer,
ebony and satinwood inlay,
white pine
H. 260.4 cm (H. 102 ½ in.)

60
Samuel McIntire
American, 1757–1811
Eagle, about 1786–99
Gilt white pine
H. 99.1 cm (H. 39 in.)

61
Relief plaque by Samuel McIntire
American, 1757–1811
Perspective machine, 1800–10
Pine, glass lens
Machine: H. 191.8 cm (H. 75 ½ in.)

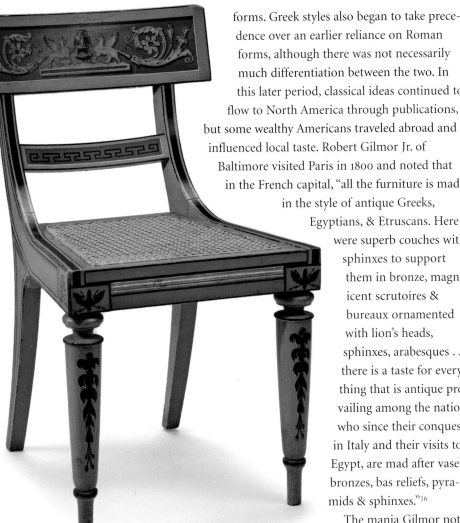

forms. Greek styles also began to take precedence over an earlier reliance on Roman forms, although there was not necessarily much differentiation between the two. In this later period, classical ideas continued to flow to North America through publications, but some wealthy Americans traveled abroad and influenced local taste. Robert Gilmor Jr. of Baltimore visited Paris in 1800 and noted that in the French capital, "all the furniture is made in the style of antique Greeks, Egyptians, & Etruscans. Here were superb couches with sphinxes to support them in bronze, magnificent scrutoires & bureaux ornamented with lion's heads, sphinxes, arabesques . . . there is a taste for everything that is antique prevailing among the nation, who since their conquests in Italy and their visits to Egypt, are mad after vases, bronzes, bas reliefs, pyramids & sphinxes."[16]

The mania Gilmor noted while abroad was eventually transferred to American craftsmen and their clients. A chair from Baltimore (fig. 62) and a New York sofa (fig. 64), for example, illustrate rather literal renditions of the klismos and curule forms, respectively.[17] A Baltimore couch (fig. 63) was known in its own day as a "Grecian" couch. The word *Grecian* may have been the adjective most often applied to furniture to show its proper classical origin beginning about 1815, when objects became sturdier and more substantial in feeling. Classical animal motifs also inspired sculptural furniture featuring three-dimensional eagles, winged caryatids, swans, dolphins, and mythological griffins. New York City cabinetmakers, for example, were among the leading producers of these classical forms in the Empire period, derived from English and French design

books issued by Thomas Hope, George Smith, Charles Percier and Pierre-François-Léonard Fontaine, Pierre de la Mésangère, and others. A shop in New York that has yet to be identified produced a pier table as part of a group of New York griffin furniture (fig. 65). Griffins (called by the Greek playwright Aeschylus "the hounds of Zeus, who never bark, with beaks like birds") combine the head and wings of an eagle with the body of a lion, features seen in classical prototypes (fig. 66).

These forms and ornaments of classical architecture and material culture were adopted in the late eighteenth and early nineteenth centuries not only for their beauty and their utility but for ideological reasons as well. In this period, "The glory that was Greece, the grandeur that was Rome," as Edgar Allan Poe put it, were to be transferred to the new republic of the American nation, as civilization marched westward and Americans took what they believed was their rightful place on the world's stage. Since most of this classicism relied on English and French prototypes and design sources, there is some irony in the American assertion that their adoption and adaptation of the classical mode was somehow unique and

62
Side chair
Baltimore, about 1815
Painted wood, cane
H. 81 cm (H. 31⅞ in.)

63
Attributed to Hugh Finlay
American, 1781–1831
Grecian couch, about 1820
Yellow poplar, cherry, white pine;
rosewood graining and gilded
painting; partial original foundation and new foundation materials, cover, and trim
L. 232.4 cm (L. 91½ in.)

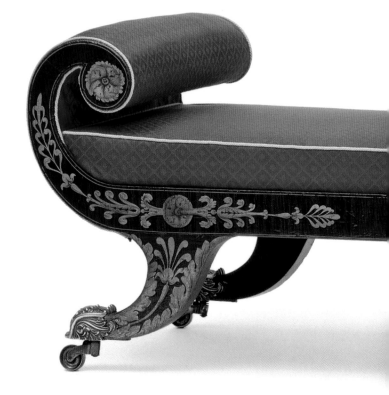

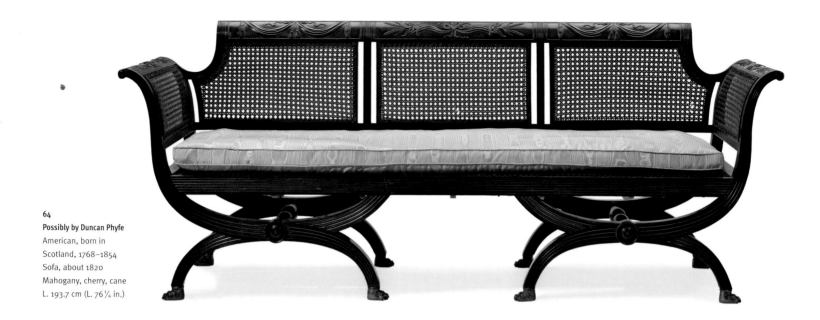

64
Possibly by Duncan Phyfe
American, born in
Scotland, 1768–1854
Sofa, about 1820
Mahogany, cherry, cane
L. 193.7 cm (L. 76¼ in.)

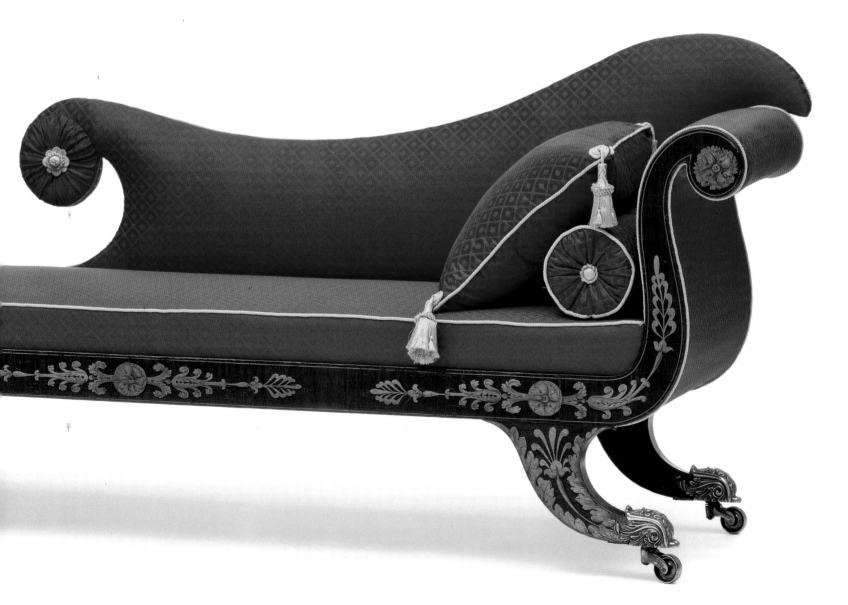

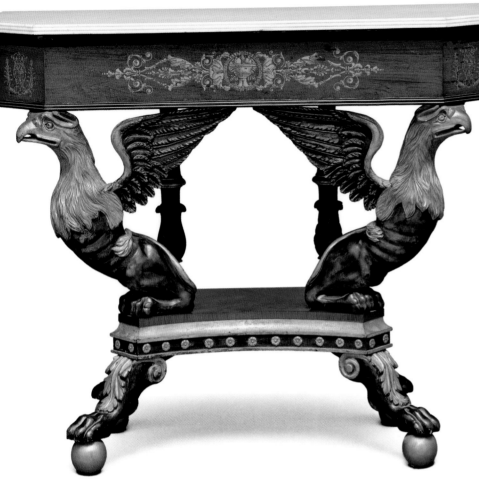

especially appropriate and meaningful for the world's newest nation and its citizens.

As the nineteenth century progressed, classicism began to lose its place as the dominant stylistic mode. Other styles revived different European historical periods or evoked cultures from remote parts of the globe, especially Asia. The use of classical motifs nevertheless persisted, in both high-style and vernacular arts. For example, in Republican Rome, freed slaves often wore a loose, pointed cap that distinguished them as freemen. The cap, named for the ancient Phrygians who lived in what is now Turkey, was adopted in the eighteenth century as a symbol of liberty, and became widespread in France and America. This usage persisted in the Federal period and beyond, when Liberty was often shown holding the cap aloft on a pike. By midcentury the Goddess of Liberty, wearing a Phrygian cap and carrying the American flag (fig. 53), became a common symbol on weather vanes made by a number of firms. Similarly, scenes adapted from the frieze of the Parthenon or other Greek monuments are flat-chased and engraved around the body of a Tiffany "Etruscan" silver coffeepot in the oenochoe form. Designed by Edward C. Moore, it is filled with Greek-inspired detail, including anthemia, fretwork, a helmet, and other details (fig. 67). Based most closely on a French style, the Neo-Grec was an alternative to other historical revival styles of the mid-nineteenth century. Tiffany's knowledge of the ancient past may have been somewhat sketchy—the Etruscans preceded the Greeks by centuries and lived in Italy—but the company's desire to create an homage to the glory that was Greece is unmistakable.[18]

American craftsmen may have imitated ancient forms of architecture, furniture, and decorative arts, but an equally rich source of inspiration could be found in the mythology of the classical world. This was possible mostly because education was grounded in the study of classical literature, providing a common frame of reference for both patrons and artists. In Europe, paintings with subjects taken from classical history and mythology (history painting) had been popular with an elite clientele since the sixteenth cen-

65
Pier table with canted corners
New York, about 1815–20
Rosewood veneer, mahogany
veneer, mahogany, white pine,
yellow poplar, marble
H. 84.5 cm (H. 33 ¼ in.)

66
Roman architectural panel with
a griffin
Italy, about A.D. 175–200
Marble
H. 104 cm (H. 40 ¹⁵⁄₁₆ in.)

67
Designed by Edward C. Moore
American, 1827–1891
Manufactured by Tiffany and
Company
Coffeepot, about 1858–73
Silver
H. 27.2 cm (H. 10 ¹¹⁄₁₆ in.)

68

John Singleton Copley
American, 1738–1815
Galatea, about 1754
Oil on canvas
94 x 132.7 cm (37 x 52¼ in.)

tury. Their patronage of such pictures was a way to advertise their learning and sophistication. Although portraiture dominated colonial American painting and history painting had little appeal for patrons in North America, artists in this country tried their hand at mythological subjects, mostly hoping to fit into the European tradition, but also in an effort to elevate American taste. John Singleton Copley, as a young artist aspiring to this convention, created *Galatea* as early as 1754 (fig. 68). He based it on a print of the same subject after a painting by the Italian Baroque artist Gregorio Lazzarini depicting the triumph of the sea nymph, a grand procession honoring her and a subject made popular in the Renaissance by painters such as Raphael. Triumphal

processions originated in ancient Rome as an honor to a victorious general; in the Renaissance their reach extended to include pagan gods, allegories, and historic heroes. In Copley's painting, Galatea is attended by deities of the sea, including Tritons and Nereids.

One of the most important sources for artists from the Renaissance onward was the *Metamorphoses*, tales of transformation written by the Roman poet Ovid of the first century A.D. In the tenth book appears the story of the poet and musician Orpheus, who, by playing his lyre, lulls to sleep the three-headed hellhound Cerberus so he can rescue his wife, Eurydice. Several American artists were attracted to different aspects of Orpheus's story. The American sculptor Thomas Crawford chose this myth as the

69
George de Forest Brush
American, 1855–1941
Orpheus, 1890
Oil on panel
30.5 x 50.8 cm (12 x 20 in.)

70
Thomas Crawford
American, about 1813–1857
Orpheus and Cerberus, 1843
Marble
H. 171.5 cm (H. 67½ in.)

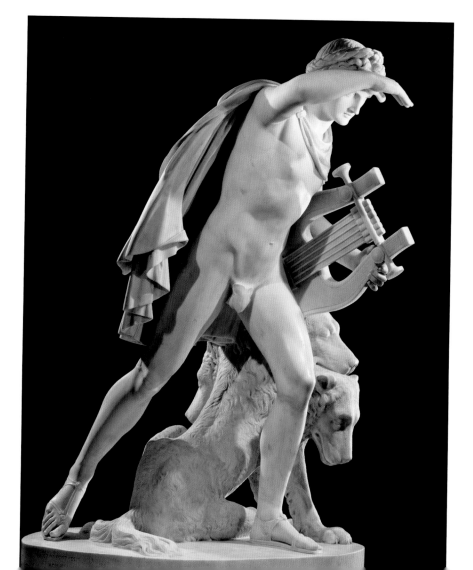

subject matter of his first major marble sculpture, started in Rome in 1839 (fig. 70). For the figure of Orpheus, Crawford was inspired by what was widely believed to be the most important masterpiece of antique sculpture, the Apollo Belvedere in the Vatican, a renowned classical figure of the Greek god Apollo. Crawford's *Orpheus and Cerberus* was brought to Boston in the 1840s and became the introduction to this type of sculpture for many Americans.[19]

George de Forest Brush depicted the poet charming wild hares while playing his lyre (fig. 69). Classical mythology relates that not only did Orpheus's powers extend to all animals, but his music enchanted even trees and rocks. Reclining against a mossy rock, he wears a laurel wreath, the award for victory in ancient Greek contests of poetry and song. The oak leaves at the left may refer to the punishment of the maenads, the wild female attendants of Bacchus, who were turned into oak trees after they murdered Orpheus for his hatred of women after he lost his wife. The classical subject, the idealization of the nude, and the meticulous technique reflect Brush's academic training in the Paris studio of Jean-Léon Gérôme and his connection to the American Renaissance in the late nineteenth century.

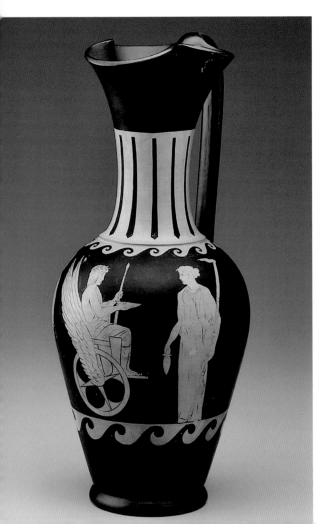

71
Frederic Edwin Church
American, 1826–1900
Erechtheum, 1869–70
Oil on paper mounted on canvas
33 x 27.9 cm (13 x 11 in.)

72
Frederic Edwin Church
American, 1826–1900
Study for *The Parthenon*, 1869–70
Oil on paper mounted on canvas
33 x 50.8 cm (13 x 20 in.)

73
Chelsea Keramic Art Works
Ewer
Chelsea, Massachusetts, 1873–78
Earthenware with slip decoration
H. 39.4 cm (H. 15 ½ in.)

A tall terra-cotta ewer, unsigned but probably made by the Chelsea Keramic Art Works in the 1870s, is painted with mythological images that may have needed more explanation than Orpheus (fig. 73). The scene depicts three people (one is not visible in the photograph) in classical garb, including a central figure seated in a winged chariot with large wheels, representing Triptolemos, about to begin his travels to teach the world agriculture, flanked by Demeter and her daughter Kore (also known as Persephone).[20] The ewer, along with a few other works made at Chelsea Keramic, was probably inspired by the classical wares excavated in the 1870s by Heinrich Schliemann at Troy, or by similar wares displayed at the Metropolitan Museum of Art in New York City and the Peabody Museum at Harvard University in Cambridge, Massachusetts.[21]

If the Tiffany designers were a bit unclear about their historic sources, the painter Frederic Edwin Church was not. Greece, the ultimate source of the classical tradition, had been largely inaccessible to all but the most intrepid of travelers throughout the

first half of the nineteenth century while it fought for independence from the Ottoman Empire in the 1820s. By the middle of the century, artists began to rediscover the birthplace of Western civilization; in 1869 Church arrived in Athens. He wrote, "To be sure in Rome they have famous things—mostly brought from Greece—but on the classic ground itself everything is in its place—The Greeks had noble conceptions—They gave a large God-like air to all that they did."[22] He made numerous pencil drawings and oil sketches at the Acropolis, including Study for *The Parthenon* and *Erechtheum*, which were formerly joined together (figs. 72 and 71). He marveled: "The Parthenon is certainly the culmination of the genius of man in architecture. Every column, every ornament, every moulding asserts the superiority which is claimed for even the shattered remains of the once proud temple over all other buildings erected by man."[23] These oil sketches show a freshness and spontaneity expressed through Church's lively brushstrokes; the painter captured the brilliance of the Aegean light as it bathed the majestic ruins of the buildings.

At this time, prompted by the popularity of the American Renaissance, artists also featured allegorical representations—ideas or concepts in human form. Abbott Handerson Thayer depicted the virtue charity in *Caritas* (fig. 74). *Caritas* ("charity" in Latin), however, refers not to almsgiving but more generally to the concept of love. The image of a woman suckling two children to represent Charity dates from the Italian Renaissance. In Thayer's image, the female figure is dressed in a classical Greek chiton with her arms outstretched to protect the two children at her sides.

Beginning in 1916, John Singer Sargent was commissioned to decorate the grand staircase and rotunda of the Museum of Fine Arts, Boston. With a four-column Ionic portico above the door flanked by Ionic pavilions at the south entrance and the majestic colonnade of twenty-two Ionic columns at the north entrance, the architecture of the building demonstrated its classical roots and connection to the past. Similarly, in his twenty murals and fourteen reliefs, Sargent used only ancient themes or subjects inspired by them. The paintings around the grand staircase depict scenes from mythology, such as Chiron,

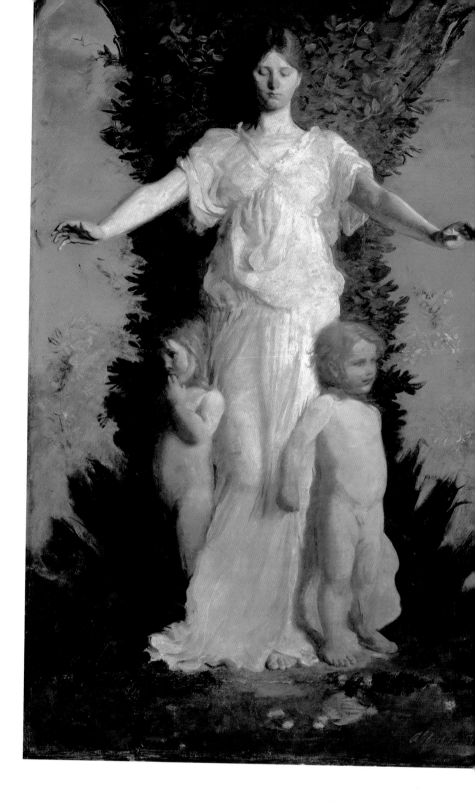

74
Abbott Handerson Thayer
American, 1849–1921
Caritas, 1894–95
Oil on canvas
216.5 x 140.3 cm
(85¼ x 55¼ in.)

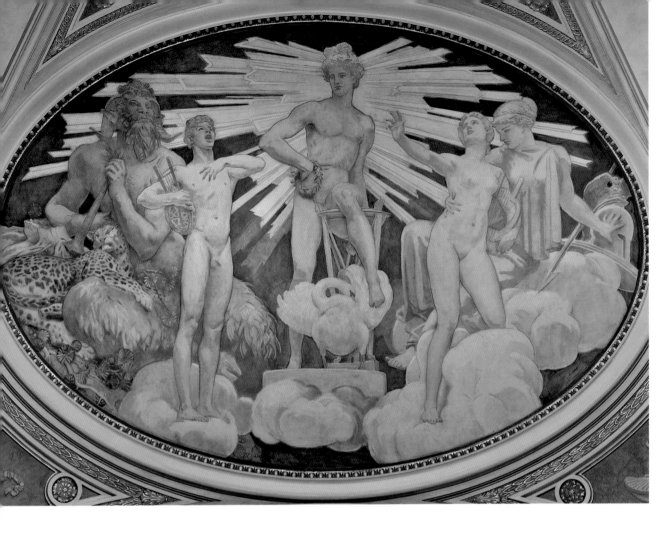

75
John Singer Sargent
American, 1856–1925
Classic and Romantic Art, 1921
Oil on canvas
255 x 424.2 cm (100 ⅜ x 167 in.)

76
John Singer Sargent
American, 1856–1925
Three Graces, 1919–20
Plaster with oil paint
H. 201.9 cm (H. 79 ½ in.)

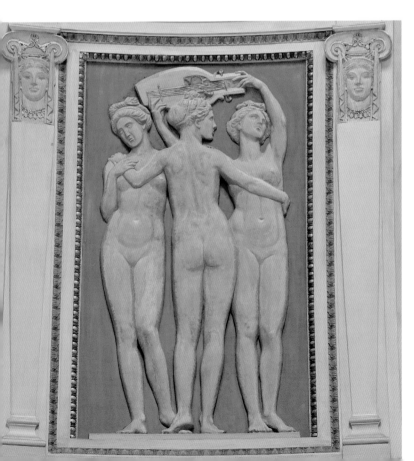

Achilles, and Prometheus.[24] Although featuring mostly Greek and Roman characters, the murals Sargent executed for the rotunda underscore the Museum's role as a guardian of the arts and were the artist's own creation rather than based on specific legends. In *Classic and Romantic Art*, Sargent used allegorical figures to illustrate the popular debate in the arts as a musical contest of the intellectual and restrained against the sensual and emotional (fig. 75). Athena, on the right, goddess of wisdom and prudence, promotes the more reserved classic art. Romantic art, on the left, is under the aegis of Pan, an associate of Bacchus, the god of wine and revelry and often a personification of lust. In the center, Apollo, god of music, presides over the competition. Sargent used a restrained palette of blue, white, and gold throughout the mural cycle to suggest classical sculpture. He accented the paintings

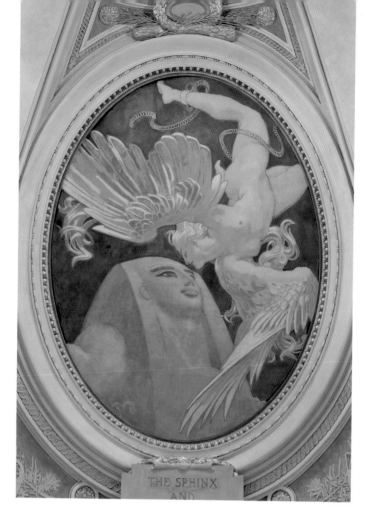

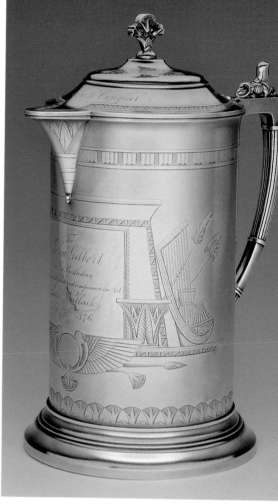

77
John Singer Sargent
American, 1856–1925
The Sphinx and the Chimaera,
1921
Oil on canvas
302.6 x 234.3 cm
(119 ⅛ x 92 ¼ in.)

with low reliefs, also from classical themes, such as the *Three Graces*, typically attendants of the goddess of love, Aphrodite, and the embodiment of beauty and grace (fig. 76). Sargent grouped them as they had been depicted since ancient times—with the two outer figures facing forward and the central one turned away.

Greece and Rome were not the only sources of inspiration for artists at the end of the nineteenth century. As at the beginning of the century, Egypt cast its spell, and Sargent was not immune. In the rotunda he painted *The Sphinx and the Chimaera* (fig. 77). The sphinx, a lion with a human head, originated in ancient Egypt; the Chimera, a monster found in ancient Greek lore, traditionally combined a lioness with a snake's tail and a second head, that of a goat. Sargent's Chimera, however, is a winged human and was intended to represent the imagination. The sphinx

holds the secrets of creation, thus supporting Sargent's theme of the Museum as a guardian of the arts.

A cast sphinx is also featured with a wide array of Egyptian motifs on a large silver pitcher made by the Whiting Manufacturing Company about 1875–76 (fig. 78). Lotus blossoms, papyrus leaves, stringed instruments, a pylon, and a winged uraeus are incorporated into the elaborate decorative scheme.[25] The construction of the Suez Canal in the 1860s and the staging of Giuseppe Verdi's opera *Aida* in 1871 in Cairo accelerated an interest in things Egyptian in the late 1860s and 1870s; this interest was expressed in silver, furniture, and other decorative arts.

Modernism in its various manifestations has steadily eroded the significance of classicism since the early twentieth century, although the term *classic* remains in common use to define anything with some sort of history, from Classic Coke to the Fall Classic

78
Whiting Manufacturing Company
Pitcher (and detail of sphinx)
Probably North Attleboro,
Massachusetts, about 1875–76
Silver
Pitcher: H. 29.9 cm (H. 11 ¹³⁄₁₆ in.)

79
Edward Zucca
American, born in 1946
XVIIIth Dynasty Television, 1989
Mahogany, yellow poplar, ebony,
gold leaf, silver leaf, rush, latex
paint, ebonizing
H. 154.9 cm (H. 61 in.)

(the World Series). Still, postmodern architects and furniture makers of the last half of the twentieth century have used classical motifs along with other historical references in their revolt against the coldness and sterility of much modern functionalist design. A case in point is Edward Zucca's playful *XVIIIth Dynasty Television*, which represents his fascination with Egyptian material, one of many sources that the studio furniture maker has drawn on in his often satirical and humorous work (fig. 79).[26]

Even modernist painters have found inspiration in the classical. Byron Browne, for example, although he devoted himself to an abstract approach in his work, still believed that "there cannot be a new art without a solid basis in understanding of past art. Greek, Roman, Romanesque and Byzantine schools I find the most rewarding."[27] In *Variations on a Greek Urn*, he used the concept of the pure form of an ancient Greek vase, rather than a literal representation of the object, to explore the formal relations of shape and line (fig. 80). The elegant curves of vase forms are echoed in the clean lines traced through changing colors.

The contemporary sculptor Stephen De Staebler derives much of his inspiration from surviving ancient sculptures and monuments. His *Seated Figure with Striped Right Arm*, subtly colored and fragmentary like an ancient sculpture weathered by the elements and eroded by time, links the contemporary with the ancient world (fig. 81). Similarly, the textile artist Marilyn R. Pappas, in her *Nike of Samothrace with Golden Wing* (fig. 83), evokes the Hellenistic masterpiece of about 190 B.C. that was found in 1863 on the island of Samothrace in the Aegean Sea and is now in the collection of the Musée du Louvre.[28] *Nike*—the winged personification of Victory, known for her ability to fly at great speed—is her modern meditation on the power and glory of women. *Nike* is part of her Muses series, which also includes representations of Artemis, Aphrodite, Athena, and others.

The ongoing communication between past and present is encapsulated by the *Death of Hector*, a canteen made by Nathan Begaye and painted by Diego Romero, two Native American artists. Romero depicts the defender of Troy being stabbed in the throat by

80
Byron Browne
American, 1907–1961
Variations on a Greek Urn, 1935–37
Oil on canvas
122.2 x 152.4 cm (48⅛ x 60 in.)

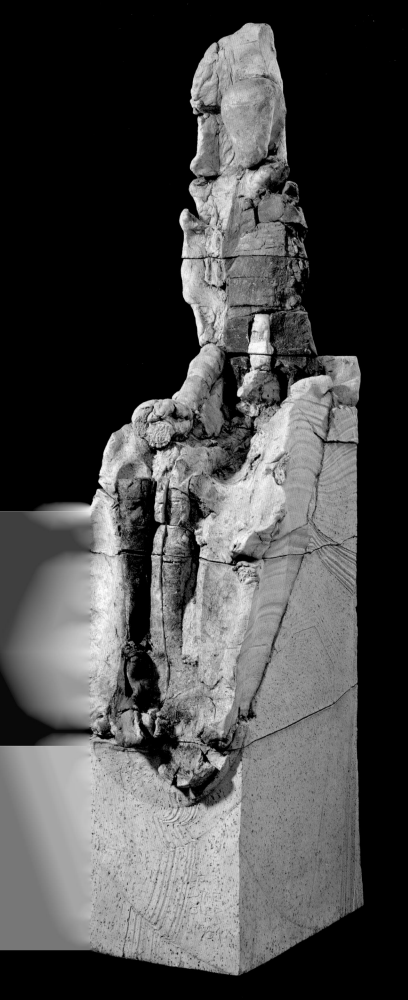

Achilles, the Greek champion in Homer's *Iliad* (fig. 82). Romero's painting of the decisive scene is based on his study of the compositions and pictorial manner of ancient Greek vase painting, while the zigzag decoration at the neck references Anasazi pottery from the ancient Southwest, another important influence on Romero's work. By thus bridging the gap in this vessel of clay between the ancient Trojans, Greeks, and Anazasi, Romero and Begaye remind us of the eternal artistic continuum and of the importance of those who have gone before.

81
Stephen De Staebler
American, born in 1933
Seated Figure with Striped Right Arm, 1984
Fired clay with pigment
H. 182.9 cm (H. 72 in.)

82
Painted by Diego Romero
Cochiti, born in 1964
Made by Nathan Begaye
Hopi/Diné (Navajo), born in 1969
Death of Hector canteen, 2003
Earthenware with slip paint
H. 30.5 cm (H. 12 in.)

83
Marilyn R. Pappas
American, born in 1931
Nike of Samothrace with Golden Wing, 2001
Cotton, 2% gold threads embroidered on linen
396.2 x 148.8 cm (156 x 58⅝ in.)

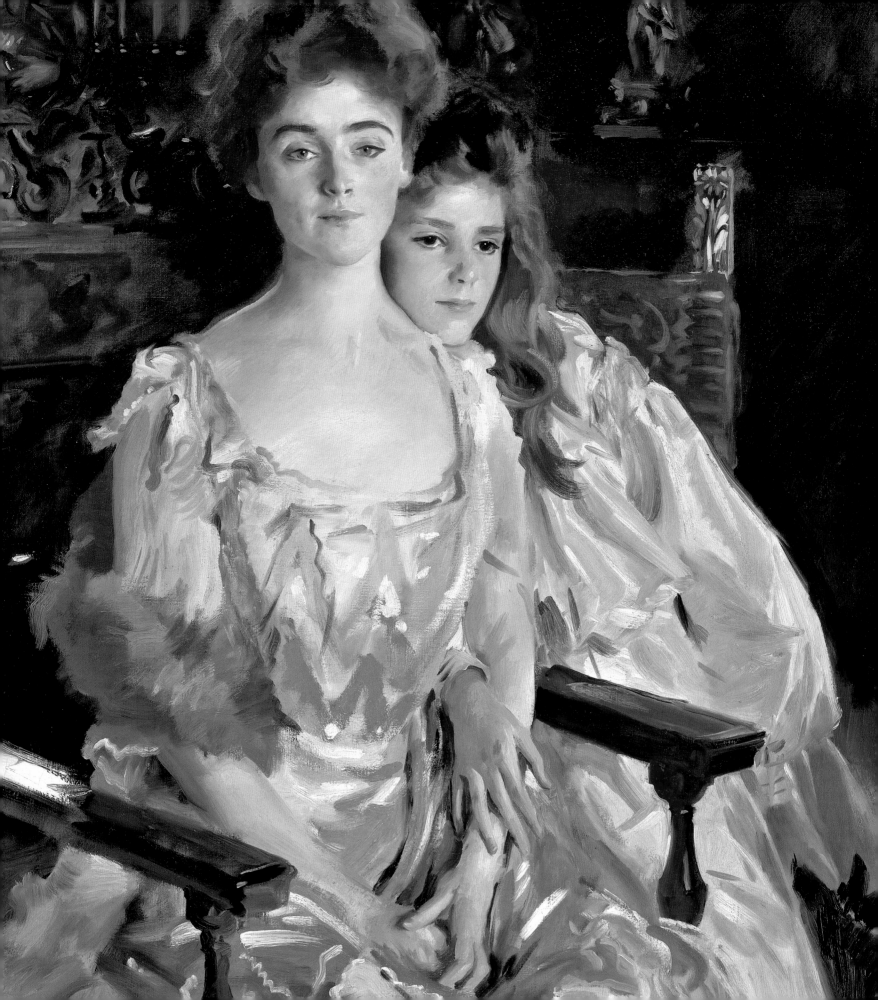

ENGLAND NONIE GADSDEN AND ERICA E. HIRSHLER

When Benjamin Franklin testified before the House of Commons in London in 1766 to bring a complaint from the colonies about the effects of the Stamp Act, he was asked, "What used to be the pride of Americans?" Franklin, knowing the esteemed position that England had held in the minds of his countrymen, responded that Americans had once been proud "to indulge in the fashions and manufactures of Great-Britain."[1] Franklin knew that the Stamp Act, along with many other British regulatory actions, now threatened this long-standing loyalty. Despite fundamental political disagreements that soon led to the War of Independence, Britain still dominated American cultural affairs. No other country had the long-lasting influence on North American art and life that England can claim.[2]

Franklin made his speech at a turning point in history, just before the Revolution. To the majority of settlers in the thirteen colonies before 1776, England was not simply their port of departure, but their own country.[3] For more than 150 years they lived in a colonial outpost of England, an America whose capital was still London. Laws, customs, goods, and artistic styles came from England, their adoption aided by various restrictions limiting trade with other countries, which ensured British dominance. After the establishment of an independent United States, this symbiotic relationship was shattered politically, but it survived culturally. Britain was never absent from the definition of high style in this country. Even in moments of ethnic self-identification, it provided a standard against which to react or rebel. With English the official language, ideas and technologies from Great Britain were easily transferred to American soil. Along the eastern seaboard, where most of the nineteenth-century arts institutions were established in the United States, cultural leaders (many of whom traced their ancestry to early British settlers) encouraged the preservation and study of their own backgrounds, thus defining and promoting the centrality of England in American history and society. In ways both obvious and subtle, British ideas still permeate our cultural heritage. To paraphrase a statement that seems to have originated with the British wit Oscar Wilde, the United States and England were two countries separated by a common language. English influence on the arts of the United States was particularly strong in two historic periods, the colonial era and the second half of the nineteenth century.

Settlers from England—by far the largest group to put down roots in the North American colonies—were not reborn when they entered American waters. They spoke English, swore loyalty to the king, and maintained other patterns of behavior that came from the land they had left behind. Colonial builders continued to make houses the way they had made them in the old country, using joinery and following construction methods particular

84
**Attributed to the Ralph Mason
and Henry Messinger shops;
turnings attributed to the
Thomas Edsall shops**
Chest of drawers
Boston, 1640–70
Oak, cedrela, black walnut,
cedar, ebony
H. 130.2 cm (H. 51¼ in.)

to their region of England. They made only minor variations in lifestyle and craft practices that were necessary to adapt to the American climate and available resources. For example, they used different woods or sheathed the sides of buildings in a different manner (such as the clapboarding used in the northern colonies), adjusting their construction techniques to accom-modate the harsher climate of the New World.[4]

Like builders, furniture makers brought with them the patterns and decoration techniques in which they had been trained, whether the sophisticated fashions of London or the provincial styles of

outlying regions. Two chests from Massachusetts, one made in the city of Boston, the other in rural Ipswich north of Boston, illustrate the migration patterns of immigrants and the development of regional styles in the early colonial period. One chest is attributed to the Boston workshop of Ralph Mason and Henry Messinger, London-trained joiners credited with bringing court-inspired furniture styles to the colonies (fig. 84). The paneled chest has five levels of drawers and is decorated with heavy geometric moldings, bosses (applied ornaments resembling eggs), and turnings made of exotic hardwoods in the Anglo-Dutch Mannerist style popular in mid-seventeenth-century London.[5] The second piece, a lift-top chest with elaborately carved surfaces, is attributed to William Searle and/or Thomas Dennis of Ipswich (fig. 85). Searle emigrated from Devonshire in 1663, and Dennis, also from southwestern England, married Searle's widow after the elder craftsman's death in 1667. The intricate pattern of the shallow relief carving that covers almost every square inch of the chest's facade is closely related to the English Devon style, as is its original brightly painted red and blue decoration, much of which has survived, if muted by time.[6] Both pairs of furniture craftsmen, Mason and Messinger and Searle and Dennis, lived in the New World but worked in the regional styles of the Old.

Craftsmen from England not only introduced most of the styles prevalent in the seventeenth century to the colonies, but also launched many trades in North America, establishing standard colonial shop practices, craft techniques, and types of tools. Robert Sanderson, Sr., for example, deserves much of the credit for founding the first luxury trade in the colonies: silversmithing. Sanderson had served his apprenticeship in London and plied his trade for several years before he immigrated to the Massachusetts Bay Colony in 1638. When he first arrived in New England, his craft skills were not in heavy demand; access to the raw material was limited, and few settlers (most of whom were struggling to obtain basic provisions) needed, wanted, or could afford new silver wares in up-to-date fashions. Silver objects did exist in the colonies, however.

85

Attributed to Thomas Dennis
American, born in England,
1638–1706
or William Searle
American, born in England,
1611–about 1667
Joined chest, 1670–1700
Oak, white pine
H. 77.5 cm (H. 30 ½ in.)

The earliest settlers had brought cups, dishes, and spoons to the New World, not because silver objects were a necessity or even for their sentimental associations, but because of the metal's intrinsic value. In addition to serving as emblems of family tradition and station, silver objects were a convenient way to transport wealth. Since silver was a currency as well as a craft material, early silversmiths often worked as both artisans and bankers. Their skills were needed for verifying the purity and weight of silver used in business transactions, and they repaired wares brought from England.[7]

At some point in the decade after his arrival, Sanderson met young John Hull, who immigrated to New England at the age of eleven and had received some training in silversmithing from his stepbrother. Hull probably completed his apprenticeship under Sanderson. In 1652, thanks to his local connections, Hull was appointed master of the newly formed Boston mint and "chose my friend, Robert Sanderson, to be my partner."[8] With the contacts they gained through this appointment and increased access to raw materials, Hull and Sanderson founded a silversmithing shop in Boston, where they created coinage for the Massachusetts Bay Colony and silver objects in the latest London styles for the growing numbers of Boston's elite. An impressive wine cup made for the First Church of Boston and marked by Hull and Sanderson has a large bowl with a flaring rim supported by a decorative stem. This is composed of a series of rings, an inverted egg-shaped knop (or bulge), and a collar of cast petals, all elements of the

86
John Hull
American, born in England,
1624–1683
Robert Sanderson, Sr.
American, born in England,
1608–1693
Wine cup, 1660–80
Silver
H. 20.3 cm (H. 8 in.)

House builders, furniture makers, and silver-smiths were among the first craftsmen to establish themselves in North America during the early decades of settlement in the seventeenth century. Other crafts, such as ceramics, glass, and textiles, were not developed on a significant scale until much later owing to the lack of resources in the colonies, particularly skilled labor, as well as the British disinterest in investing in manufacturing outside England proper. Similarly, few seventeenth-century colonists sought commissions from professional painters, but as the colonies grew in size, wealth, and sophistication in the early eighteenth century, portraits became desirable acquisitions, and a number of painters began to practice in and around America's major cities, particularly in Boston, New York, Philadelphia, and Charleston. Not many highly trained artists were lured to the New World, where there were still relatively few clients and absolutely no opportunities for public exhibition or advancement. Peter Pelham, for example, the most talented English printmaker to arrive in the colonies, did not immigrate because of the promise of work but may have left London in disgrace, alienated from his father and having abandoned the promising career he had started in London.[10]

The situation changed dramatically in 1729, when John Smibert arrived in New England. His residency was accidental—Smibert had intended to settle in Bermuda to teach at a college to be founded there, but when the British Parliament rejected proposals to fund that institution, he stayed, soon finding a ready clientele for his work in Boston. Smibert was able to offer Bostonians something new: portraits made by someone not only properly trained in the craft of painting in oils but also knowledgeable about current London art and fashion. Americans were well aware of British styles in portraiture; they could see examples all around them. Official images of the king had been sent to each town hall in the colonies, providing models of aristocratic portraiture, and Harvard College (founded in 1636) had been collecting portraits since 1670. Just seven years before Smibert's arrival, for instance, Harvard commissioned Joseph Highmore, a talented London

seventeenth-century Mannerist style, which was popular in England during Sanderson's apprenticeship there in the 1630s (fig. 86). Other works by Hull and Sanderson incorporate later decorative trends, proving that the shop kept abreast of the latest London fashions. Hull and Sanderson trained at least ten apprentices, including Jeremiah Dummer and Timothy Dwight, thus establishing a dynasty that would dominate Boston silversmithing and shape Boston style for generations to come. Documentary evidence strongly suggests that of the two principals, Sanderson played a larger role in shop work, fashioning objects and training apprentices, while Hull handled the business matters. Therefore, one can say that Sanderson was largely responsible for transferring and instilling English form, style, and technique to the colonies.[9]

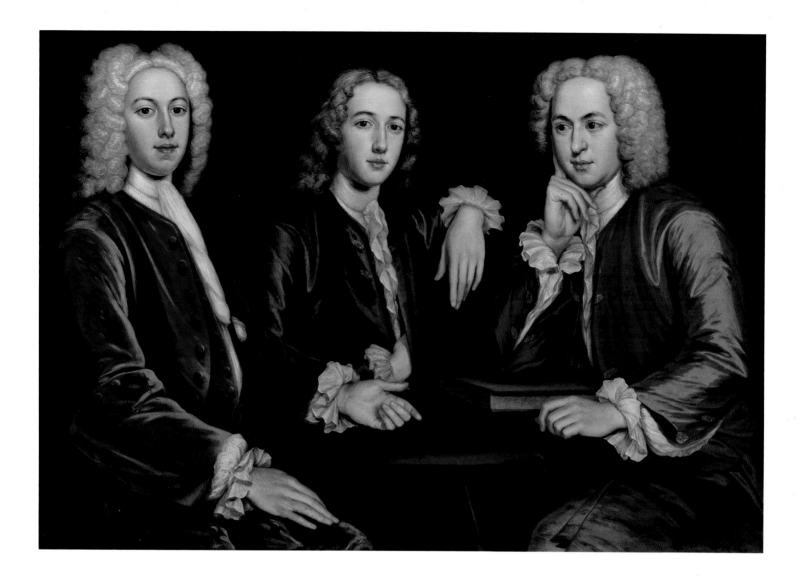

genre painter and portraitist, to make a likeness of Thomas Hollis, an important benefactor of the school. In addition to honoring a generous donor, the painting gave local artisans a model of modern portraiture, and it was later copied in a mezzotint by Boston's resident printmaker Pelham. Smibert did not need to imitate Highmore—he had trained in Edinburgh and London, taken the grand tour to Italy, and enjoyed a successful practice in England making portraits of upper-middle-class professionals.[11] Smibert's patrons in London had come from the same class as the wealthy Bostonians who would commission works from him; they were merchants, lawyers, and other professionals whose desires and

ambitions the painter already understood. Daniel, Peter, and Andrew Oliver, for example, were the sons of a Boston merchant (fig. 87). In his portrait, Smibert posed them around a baize-covered table, linking the figures with the graceful gestures of their hands. The costumes, composition, and idea of painting all three brothers even though one of them, Daniel, had died some years before (his likeness was based on a miniature) are entirely in keeping with British examples of the period.

Immigrant craftsmen like Smibert and Sanderson were one way in which styles were transmitted from the Old World to the New; imported English objects and printed pattern books also contributed. The

87
John Smibert
American, born in Scotland,
1688–1751
Daniel, Peter, and Andrew Oliver,
1732
Oil on canvas
99.7 x 144.5 cm (39¼ x 56⅞ in.)

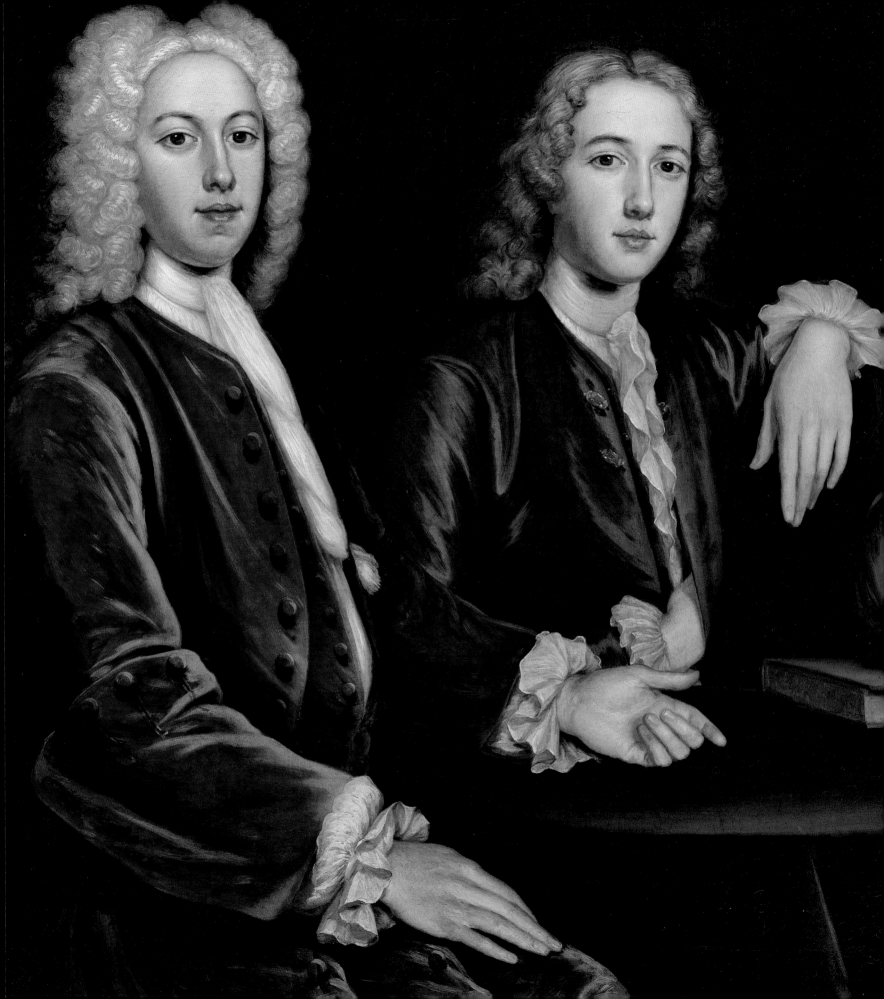

colonial elite regularly ordered their finest furnishings from England, supplementing these goods with locally made products. Charles Apthorp, one of the wealthiest men in the American colonies during the middle of the eighteenth century, was born, raised, educated in England, and a member of a prosperous and prominent family. In 1698 he immigrated to the American colonies to launch his career as a merchant with the help of his family's numerous business and political connections. Not surprisingly, given his occupation and ties to his homeland, Apthorp imported many of the furnishings for his Boston household from England, including an impressive linen press with glass doors.[12] Made about 1740 and apparently shipped to Boston shortly thereafter, Apthorp's linen press may be responsible for introducing the bombé, or swelled, shape to New England furniture.

The bombé is characterized by a low bulge on the front and sides of the form, creating a curvaceous profile. The first dated American example of bombé furniture was made a decade later, in 1753, by Benjamin Frothingham of Charlestown, Massachusetts.[13] In shape, proportion, and execution, the base of Frothingham's desk-and-bookcase is remarkably similar to the imported Apthorp linen press.[14] Shaped facades, including bombé, blocked-front, and serpentine, were enormously popular in New England, despite the fact that they enjoyed limited favor in England and other American colonies. Their widespread use in New England in the second half of the eighteenth century not only demonstrates the influence of imported pieces owned by the fashionable elite like Apthorp but also indicates the growing willingness of colonial furniture makers, and their patrons, to break from English trends and adjust, adapt, and perfect the forms, thus beginning to create a distinct artistic identity.

Unlike Apthorp, the Boston merchant Thomas Hancock was a colonial-born, self-made man who had earned his fortune in trade and the papermaking business. Yet this native New Englander, with few direct family ties to England, still looked across the Atlantic for suitable household furnishings for his refined lifestyle. Hancock and his wife, the former Lydia Henchman, daughter of one of Hancock's business partners, owned an enormous amount of silver, of both English and Boston manufacture.[15] Due to his relationships with numerous colonial silversmiths and his status as one of Boston's fashionable trendsetters, Hancock's imported English silver no doubt played an important role in exposing Boston silversmiths to English fashions, such as George Wickes's two-handled cup with cover (fig. 88).

The Wickes cup, acquired in London, is ornamented with Hancock's and his wife's coats of arms, though evidence of previous engraving under those arms suggests that it was bought secondhand.[16] About 1740–50 a strikingly similar two-handled cup was made by Jacob Hurd, a highly successful and prolific Boston-born silversmith (fig. 89). Hurd's monumental footed cup with a stately, stepped-domed lid and majestic S-scroll handles even copies the midband of the imported cup, completing the overall Baroque architectural composition. It is likely that Hurd based the design of his cup directly on Hancock's imported example, as the two men had maintained a business relationship since the 1730s.[17]

If a colonial craftsman could not examine imported London goods to learn the latest style trends, he could have studied books of fashionable British patterns. Mostly depicting architecture and furniture, engraved pattern books provided colonial patrons and craftsmen with a variety of options regarding the form and decoration of everything from a chair to a chimneypiece.[18] Thomas Chippendale's *The Gentleman and Cabinet-Maker's Director* is one of the best-known furniture pattern books from the eighteenth century. Copies of the *Director* were owned in the colonies by patrons, private intellectual societies, and even some craftsmen, including the Newport, Rhode Island, cabinetmaker John Goddard, whose copy of the 1762 edition is now in the collection of the MFA (fig. 90). Plate 14 in Chippendale's 1762 edition inspired a side chair made by an unknown craftsman in Boston about 1770 (fig. 91). The back splat and crest rail of the chair

88
George Wickes
English, 1698–1761
Two-handled covered cup,
after 1722
Silver
H. 28.5 cm (H. 11¼ in.)

89
Jacob Hurd
American, 1702 or 1703–1758
Two-handled covered cup,
about 1740–50
Silver
H. 34.3 cm (H. 13½ in.)

faithfully follow Chippendale's Gothic-arched design with leaflike sprays and curving ornaments called C-scrolls. The legs of the chair relate closely to those on another Boston chair that has a back splat and crest rail taken from the published designs of Chippendale's competitor, Robert Manwaring. This suggests that multiple printed design sources were available to some Boston craftsmen.[19]

Printed sources also served as inspiration for colonial painters, even such well-known artists as John Singleton Copley. When Smibert died in 1751, his studio was left intact, and it functioned as a sort of school for the ambitious young artist. In Smibert's studio, Copley studied copies after old master paintings, mezzotints based on fashionable British portraits, and Smibert's own work. The experience fed his desire to become a painter, but his sights were set not on a profitable career in Boston but on success in British terms, on a London stage. For his American sitters, he used poses, costumes, and settings that

transported his clients into this fashionable realm. He borrowed gestures, gowns, and gardens from English prints and incorporated them with such attention to detail that one can almost imagine that the splendid classical portico in which Nathaniel Sparhawk presents himself, his pose copied from Allan Ramsay's portrait of King George III, actually existed in Kittery, Maine (fig. 92). This was a strategy that many American portraitists employed, if less successfully, but Copley aimed even higher. He sought to match and even surpass the accomplishments of his British compatriots, wanting to earn a reputation for himself not just in Boston but also in the art-world capital of London.

To that end, in 1765 Copley made an uncommissioned likeness of his half brother Henry Pelham (son of the printmaker, who had married Copley's mother). Well aware that there were no public-art exhibitions in America, Copley painted it for a London audience. He intended to display it at the

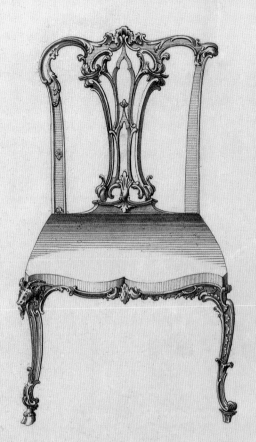

90
Thomas Chippendale
English, 1718–1779
"Chairs," plate XIV from *The Gentleman and Cabinet-Maker's Director*, 1762
Illustrated book with 199 engravings
Image: 22.5 x 35.2 cm (8⅞ x 13⅞ in.)

91
Side chair
Boston, about 1770
Mahogany, maple, pine
H. 93.3 cm (H. 36¾ in.)

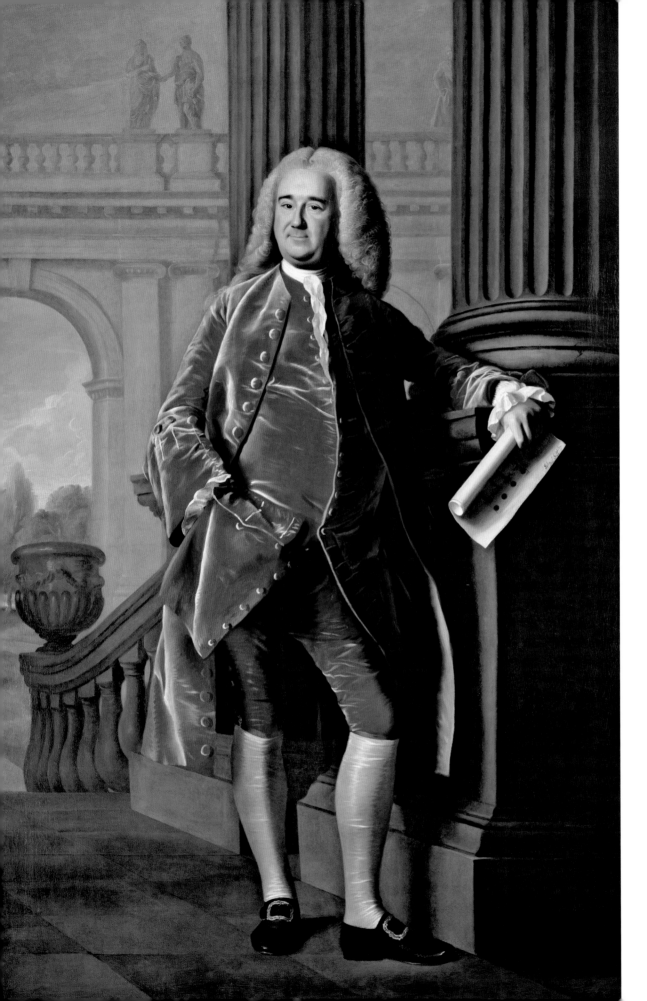

92
John Singleton Copley
American, 1738–1815
Nathaniel Sparhawk, 1764
Oil on canvas
231.1 x 149.9 cm (91 x 59 in.)

93
John Singleton Copley
American, 1738–1815
A Boy with a Flying Squirrel
(Henry Pelham), 1765
Oil on canvas
77.2 x 63.8 cm (30 3/8 x 25 1/8 in.)

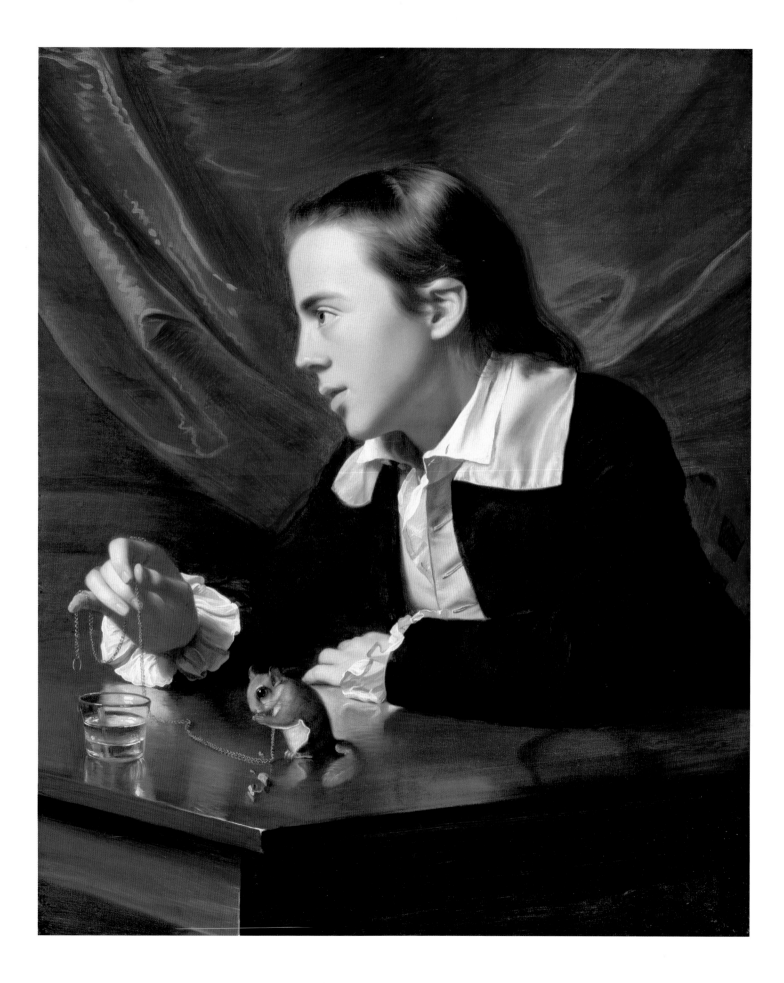

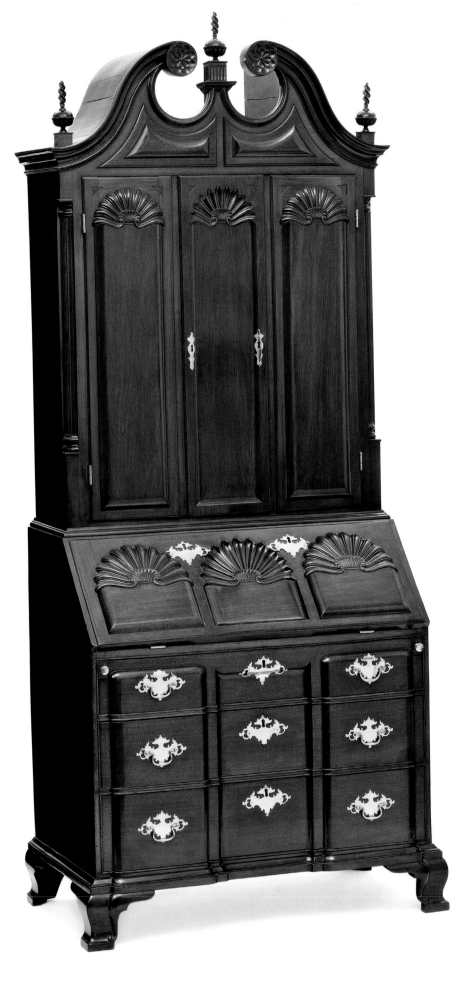

Royal Academy of Arts not as a portrait but as the sort of sentimental, instructive figurative work that had been applauded at the academy and made popular by such British artists as Sir Joshua Reynolds and Joseph Wright of Derby. Copley's *Boy with a Flying Squirrel*, though emblematic of the character traits desired for well-behaved British children, is marked as identifiably American by the squirrel, a species native to North America. It also deliberately advertised Copley's talent at rendering a great variety of materials and textures (fig. 93). The canvas was shown in London in 1766 to favorable acclaim and received encouraging comments from the two contemporary painters Copley most admired, Reynolds and Benjamin West, an American whose successful London career Copley hoped to imitate. Both men offered appraisals to bring Copley's style closer to sophisticated British standards, suggesting that he loosen his technique and concentrate less on meticulous verisimilitude and more on atmosphere and overall effect.

Copley took these lessons to heart, and when his portrait business—so carefully balanced between patriot and loyalist clients—collapsed with the outbreak of the Revolutionary War, he left America for good. After making a study tour to Italy, Copley settled in London and became, in effect, a British painter. In keeping with English preferences, his style grew more fluid, and he devoted himself to making the kind of large historical subject pictures promoted by the Royal Academy but for which he had found no patrons in America. Despite his great efforts in this direction, however, Copley never achieved the success of his countryman West, a painter from Philadelphia who had settled in London in 1763. West won royal commissions and became the president of the Royal Academy and painter to George III, accolades every British painter (including Copley) dreamed of earning. Although he was completely integrated into the highest echelons of the London art world, West never abandoned his American roots. He became a critical contact for aspiring artists from America, and his studio in effect became an American school, where such painters as Charles Willson Peale, Gilbert Stuart,

and Thomas Sully all studied, each of them bringing his lessons home to an American audience. By the 1780s, when Stuart's London portraits began to be praised as equal in achievement to works by Reynolds and Thomas Gainsborough, the American assimilation of British high style was complete.

Despite the dominant desire to imitate the British, a growing number of American craftsmen began to create works that did not match the British definition of high style as established by London craftsmen but represented new, regional styles specific to the colonies. Many of these new looks were hybrid styles that blended the different ethnic traditions of the colonies, and some were novel ideas. For example, the interrelated Newport, Rhode Island, furniture-making families of the Goddards and Townsends developed a uniquely American interpretation of the late Baroque style in the second half of the eighteenth century. Instead of embellishing their chests and secretaries with the lively curves and whimsical floral Rococo carving popular in England (and other colonial cities), the Newport craftsmen accented their stately concave and convex blocked facades with bold, carved shells that followed the contours of the blocking (fig. 94). Expertly crafted, often of solid mahogany throughout, these Newport pieces vary significantly from high-style English examples of the same period. Yet, rather than naive imitations gone wrong, they were a sophisticated new direction for American artisans.[20]

Only over time during the colonial period did America develop a distinct regional identity, its precise character still the topic of much debate among scholars. In early colonial objects, students of American art have long sought to identify characteristic variations from British style that can be used to distinguish art made in the New World. But aside from obvious indicators like woods native to North America or the signature or mark of a known artisan, this quest has proven elusive. While significant variations exist between the paintings produced in London and in Boston, for example, these distinctions become blurred when one starts to compare works made in Boston with examples from

England's regional centers—between Boston and Liverpool, say—or between Copley and Joseph Wright of Derby. One might propose that the art of outlying mercantile cities, whether in Britain or America, shares variations that separate them, in similar ways, from the high-style objects produced in London. In the words of an anonymous seventeenth-century poet who commented on the inherent conservatism of the colonies, "New England is where old England . . . [is] grown new."[21]

Even after the bitter political and military battles of the American Revolution, the art and culture of the fledgling United States relied greatly on that of England. The British quickly ensured that their economic ties with the American colonies remained tight: Parliament waived or limited duty taxes on imported American goods, and British businessmen were much more liberal in extending credit to American merchants than were their French or Dutch counterparts. As a result, in 1790 Great Britain was still receiving nearly one-half of all American exports and supplying more than four-fifths of the country's imports.[22]

During this time, Americans adopted the internationally fashionable Neoclassical style. Classical motifs had been part of the European design vocabulary for centuries, yet archaeological excavations in Herculaneum, Pompeii, and elsewhere in Europe in the mid-eighteenth century reawakened and deepened interest in the distant past. For Americans, the art and culture of ancient Greece and Rome provided not only stylistic inspiration but also guidance in other matters, such as government and education. By surrounding themselves with the symbols and motifs of these revered ancient states, many Americans felt they were forging a modern path. These American patriots, however, intent on creating a new iconography for the new nation, often failed to recognize one of the most direct sources for the Neoclassical style in America: designs by British craftsmen that could be seen in imported British objects and pattern books. The British cultural influence was still dominant in America. Nevertheless, other ideas had already enlivened the young republic through newly established trade relationships with Asia and increasingly

94
Desk-and-bookcase
Newport, Rhode Island,
1760–75
Mahogany, chestnut, pine,
cherry
H. 241.9 cm (H. 95¼ in.)

active trade with various European countries, including France, Russia, and Sweden. These were a result of the disruptions to regular trade patterns brought on by the Napoleonic Wars. The often hostile yet entirely codependent association of the United States with Britain led to another conflict in 1812. By this point, the heavy reliance of the United States on British culture had started to wane.

Americans and Britons had overcome their most severe political differences by the mid-nineteenth century and were no longer at war. Both nations were now driven by innovations in business and technology. England had an early advantage, but the two countries became leaders and soon rivals in the Industrial Revolution. They shared a constant pursuit of new technologies, which revolutionized manufacturing and profoundly transformed their respective societies from agrarian to industrial economies. For the first time, the United States and Britain faced each other as equals.

Technology had both direct and indirect effects on the arts. Each innovation changed the equation. The laying of the transatlantic telegraph cable by the American entrepreneur Cyrus West Field (with the backing of financiers on both sides of the Atlantic and a cable made by English firms) established instant communication.[23] Inventions such as the steam engine, perfected by the Briton James Watt, and subsequent innovations and improvements in travel, such as steamships and railroads by American engineers, brought the world closer and increased the rapid exchange of ideas. New craft technologies that reduced costs and sped up or simplified production crossed the Atlantic quickly, despite patents protecting the rights of the inventors. The 1825 invention of pressed glass by the American inventor John P. Bakewell (in which a plunger pressed molten glass into a mold) revolutionized production and democratized the ownership of utilitarian glassware in America, and England quickly followed suit.[24] In 1840 the Elkington brothers of Birmingham, England, were awarded a patent for electroplating, a process in which a thin layer of metal, often silver or gold, is fused by electric currents onto a substrate (usually

another, less expensive metal such as copper). Electroplating technology had spread to the United States by the mid-1840s, and several companies dedicated to the process had formed by the early 1850s, among them the Meriden Britannia Company in Connecticut, founded in 1852.[25] In both England and the United States, the invention of new technologies accelerated and motivated craft production in the mid-nineteenth century.

In addition to improved methods of manufacture, materials of every description were now more readily available to artists and craftsmen, while new ones were formulated and developed. An artist like Martin Johnson Heade, for example, could employ myriad new and brilliant colors in his paintings—cadmium yellow, chrome green, cobalt blue, magenta, mauve—all synthetic pigments that were developed for artistic purposes following their invention as dyes for the British textile and wallpaper industries. Heade's predecessors could only have dreamed of having such vivid hues in their paint box, and English companies like Winsor and Newton (founded in 1832) supplied American artists with oil and watercolor paints, now easily portable in innovative collapsible screw-cap tubes.

Heade and his contemporaries were connected to England in another way as well, for England was the hub of the printmaking industry. Heade, along with John James Audubon, Frederic Edwin Church, and others, sought to capitalize on the popularity of his paintings by having them made into commercial prints. With this goal in mind, Heade traveled to South America. "It is his intention," explained a writer for the *Boston Transcript*, "to depict the richest and most brilliant of the hummingbird family . . . [and] to prepare in London or Paris a large and elegant Album . . . got up in the highest style of art."[26] Heade produced some of his most original compositions of hummingbirds and tropical landscapes in Brazil (fig. 95) and then traveled directly from South America to London to work on his project for an elaborately illustrated book, a volume to be printed using the finest technologies available in England and sold to collectors both abroad and at home.

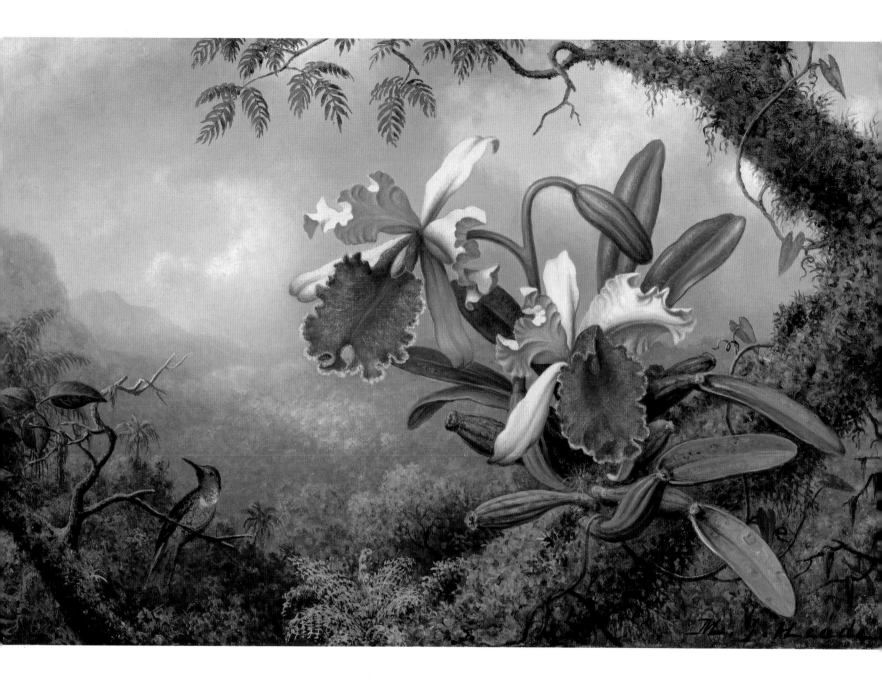

Heade's book was never published, but he did sell a number of his paintings to British patrons, a new class of collectors enriched by industry (some of them mill owners whose wealth was based in American cotton). While Heade, Church, and other American artists now displayed and sold their original paintings in England, many also used British-made reproductions to aid their careers in a variety of ways. Among these was the distribution of their work to wider audiences,

the ability to sell cheaper prints (rather than original oils) to less wealthy patrons, and the means to assist them in establishing a critical reputation in the burgeoning art press. The proliferation of mechanical reproductions flourished with each innovation in the technology of image making, from engravings to colored lithographs to photography.

But technology and mechanization also became an enemy—the foil for the handmade, the unique,

95
Martin Johnson Heade
American, 1819–1904
Orchids and Hummingbird,
1875–83
Oil on canvas
35.9 x 56.2 cm (14 1/8 x 22 1/8 in.)

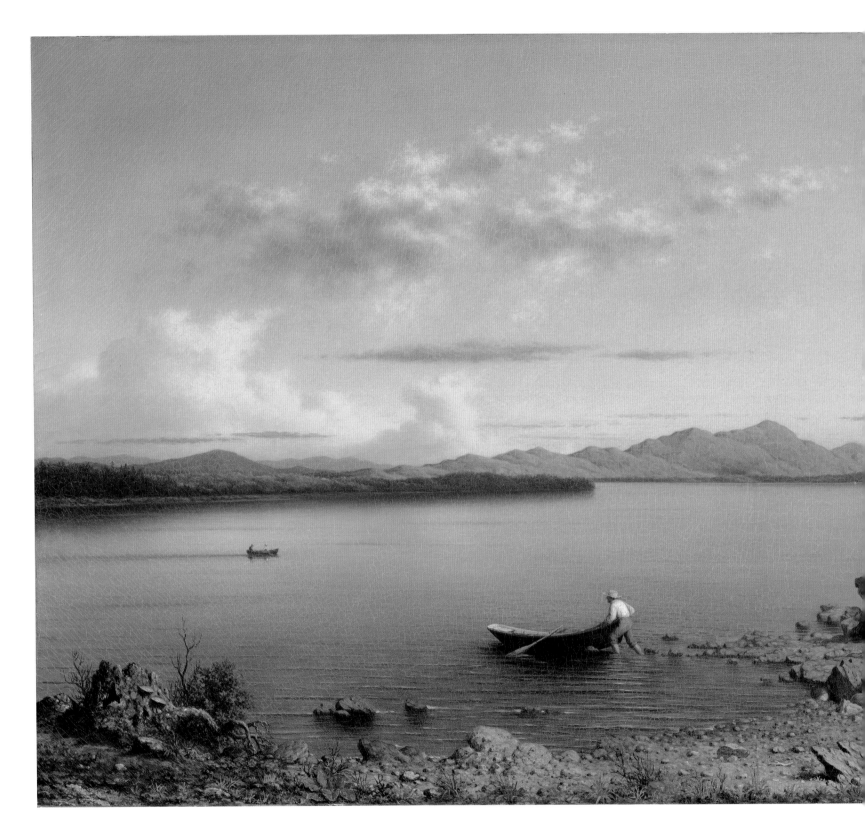

96
Martin Johnson Heade
American, 1819–1904
Lake George, 1862
Oil on canvas
66 x 125.4 cm (26 x 49 ³⁄₈ in.)

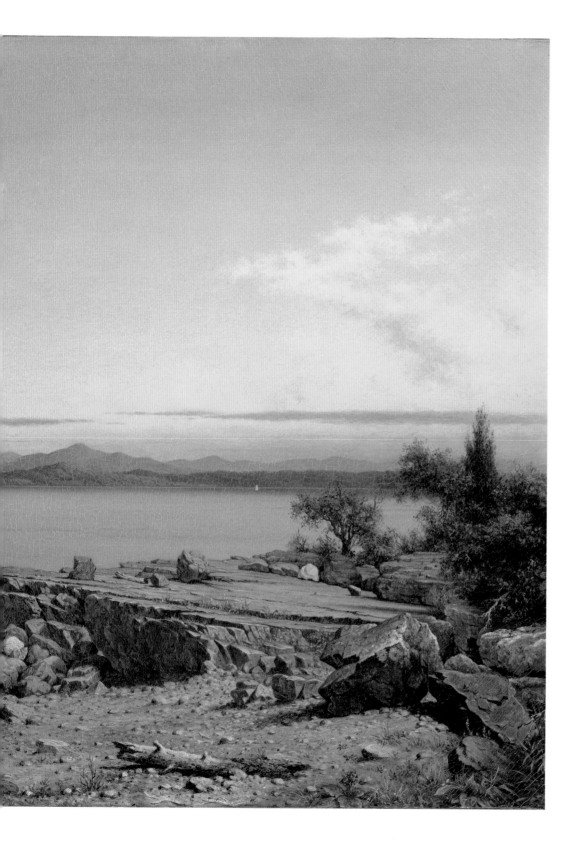

and the personal. An international reaction against industrialization and its dehumanizing effects on society was instigated by several British social critics and philosophers, including John Ruskin and William Morris, whose writings were widely read in the United States. These reformers believed that the moral and social ills perpetrated by industrial manufacturing could be remedied by the revival of handcraftsmanship, the study of nature, and the integration of art into everyday life. They believed in the power of art to uplift and inspire, both morally and spiritually. The Boston scholar Charles Eliot Norton shared many of these ideas and sought out Ruskin in 1855. The two men developed a lifelong friendship based on mutual admiration, respect, and intellectual debate. Norton, who in 1873 was appointed the first professor of art history at Harvard, served as the main conduit of Ruskin's ideas to the United States.[27]

Ruskin's early writings, particularly his advice to artists, were quickly disseminated in the international press. Many heeded his recommendations, and Americans could see the results firsthand in the British paintings that were included in an important exhibition of art that traveled to Philadelphia, New York, and Boston in 1857–58. Ruskin's distaste for the classical tradition and his suggestion that artists follow the guidance of nature were especially welcomed in the United States, which had no monuments from ancient Greece and Rome to provide inspiration but where dramatic vistas were abundant. Landscape had already become the most popular subject in American painting, and spectacular images of untamed nature were given spiritual connotations, representing the natural blessings and great promise provided by God to the continent. Such wonders were easier for Americans to admire in the mid-

the second half of the nineteenth century, they sparked two major international design reform efforts: the Arts and Crafts movement and the associated Aesthetic movement. Both called for aesthetically unified interiors and encouraged artists of all media to work collaboratively and to mine the past for design inspiration—not to imitate past styles, but to learn their underlying design principles. In response, prominent citizens in several American cities established art museums to provide artists, designers, and the general public with examples of good art from past and distant cultures. Art and trade schools were also founded with industry in mind. The first of these, the South Kensington Museum

97
Designed by
Henry Hobson Richardson
American, 1838–1886
Armchair for the Woburn Public
Library, 1878
Oak, leather (replaced)
H. 85.4 cm (H. 33⅝ in.)

98
Brewster armchair
Possibly Gardner, Massachusetts,
about 1876
Oak, maple, cushion (replaced)
H. 114.3 cm (H. 45 in.)

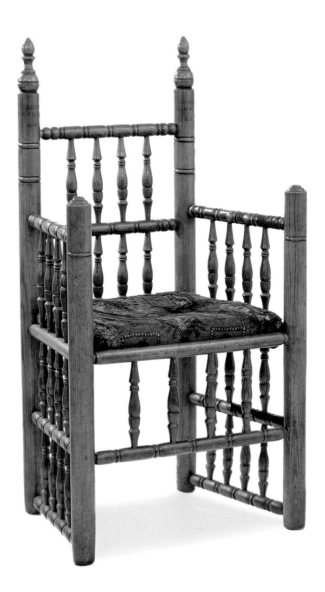

nineteenth century, after the real perils of the wild had been tamed and the attractions of its scenery were increasingly confined to manageable or distant areas safely reached (and left) by railroad. The Adirondacks, in northern New York State, conveniently accessible by train from New York City, still served as wilderness in the popular imagination, and painters flocked there to record it. Unspoiled, scenic Lake George had been praised in both poems and paintings for its pristine beauty. Heade depicted its rocky ledges and shoals in sparkling, minutely described geologic detail, giving equal attention to each part of the scene and thus creating a quintessential example of the mid-nineteenth-century Ruskinian approach to landscape painting (fig. 96).

As the ideas of Ruskin, Morris, and other British social critics spread through Norton and others in

in London (now the Victoria and Albert), organized in 1852, collected fine and decorative arts and offered instruction in the hope of improving the quality of design in both individually crafted and factory-produced goods. The South Kensington model quickly spread across the Atlantic. Among the earliest American institutions to be established according to their principles was the Museum of Fine Arts, Boston, in 1870. The School of the Museum of Fine Arts, Boston, opened for classes in 1877, and its instructors relied heavily on the Museum's collection in their lessons.

The Arts and Crafts movement in the United States, although deeply indebted to its English origins, incorporated a multitude of local ideas and influences to create several distinct regional styles. Thanks to Norton, Boston and the Northeast, the movement's intellectual hub in America, remained closest to the Romantic visions of British proponents, particularly the emphasis on looking to the preindustrial past for aesthetic inspiration. Many British design reformers studied medieval craft traditions, hoping to evoke the spirit of community and workmanship that they associated with the era. Henry Hobson Richardson's Trinity Church, erected in Boston in 1876, was an early expression of the movement in the United States. Richardson's modern interpretation of medieval Romanesque architecture was complemented by a unified, artistic interior executed by a talented team of collaborators, both American and British.[28] For Trinity Church, as for many of his other projects, Richardson designed furnishings to coordinate with his architecture. For the Woburn Public Library, Richardson designed an armchair with sweeping arms that echo the curved lines of the wooden barrel-vaulted ceiling of the library's book room, while its heavy oak frame and exposed joinery evoke the sturdy character of medieval furniture (fig. 97). A later generation of New England designers, including Ralph Adams Cram, Elizabeth Copeland, and Edward Everett Oakes, followed in Richardson's footsteps and continued to experiment with the medieval European styles so popular in Britain.

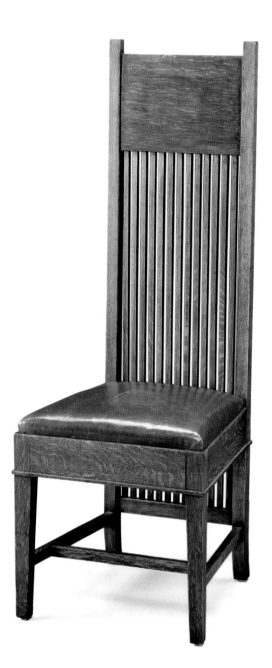

99
Designed by Frank Lloyd Wright
American, 1867–1959
Tall-back side chair, 1900
Oak, leather (replaced)
H. 129.5 cm (H. 51 in.)

Northeastern artists and designers also drew inspiration from their own preindustrial past, colonial America. Much like the nostalgic and romanticized view of the medieval period that attracted design reformers on both sides of the Atlantic, practitioners of the Colonial Revival idealized art and life in early America, prompting the study of genealogy, the collecting of antiques, and the formation of historical societies. The movement gained national attention when a nostalgic re-creation of a colonial kitchen and American relics were prominently featured in the 1876

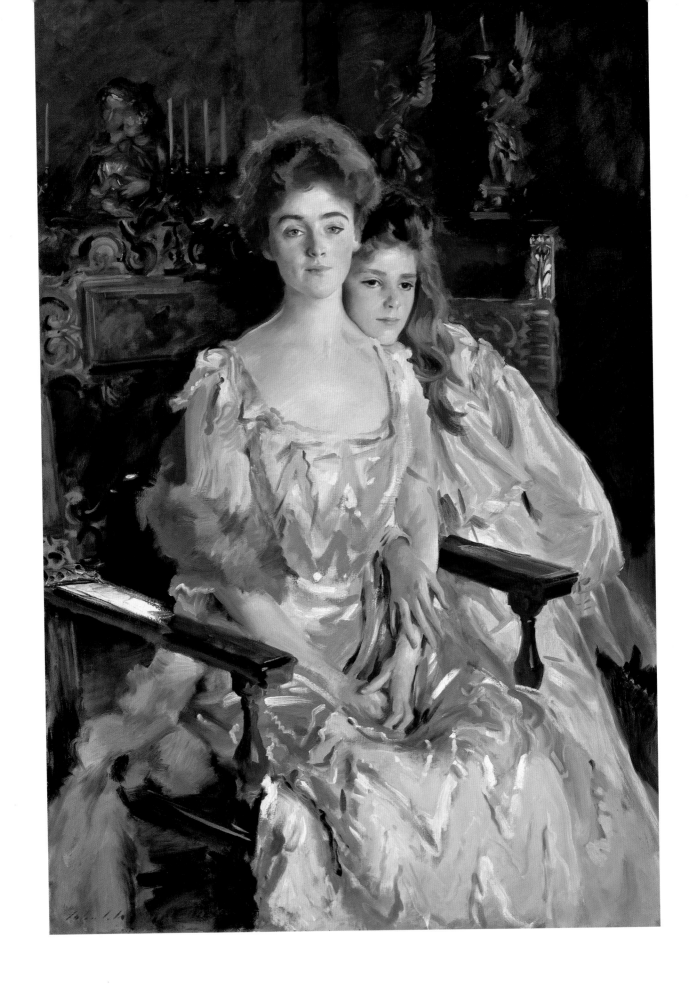

Centennial Exposition in Philadelphia. During a centennial celebration in Boston that same year, Samuel Francis Smith, author of the patriotic ballad "America (My Country 'Tis of Thee)," was presented with a reproduction of a seventeenth-century turned armchair that originally belonged to William Brewster, a founder of the Plymouth colony (fig. 98). The reproduction armchair (whose maker is not identified) not only imitated the English style and construction of the early Brewster chair but also mimicked the signs of its age and years of use. The reproduction was made without its top rail and bottom stretcher, elements lost from the original, suggesting a nostalgia for "old" colonial, English-style objects.

In contrast to the American artists and designers whose Arts and Crafts concepts and styles remained similar to British examples, other design reform leaders, like the architect and designer Frank Lloyd Wright, developed styles that were a new interpretation of British ideas, such as their call to incorporate the local geography in designs. Wright and his contemporaries in the American Midwest created the rectilinear Prairie School style, which captured the horizontal lines of the landscape and emphasized the use of color, texture, and repetitive pattern. Wright claimed that the Prairie style was uniquely American and responded to the needs of modern life. The architecture that he and contemporaries created employed open plans and long, low rooflines. Wright's interior furnishings often complemented those characteristics with strong verticals, thus helping to define space within the open plans. A dining chair Wright designed for the Warren Hickox House of Kankakee, Illinois, in 1900 has an unusually tall back composed of repetitive vertical spindles capped with a solid horizontal crest rail (fig. 99). Placed around a dining table, a set of these high-backed chairs insulated the diners from their surroundings, effectively creating a room within a room. Although a far cry from British medieval-inspired designs, the modern style of Wright's early Prairie-style furnishings echoed the strict geometry of both the English Arts and Crafts designer C. F. A. Voysey and the Scottish architect

Charles Rennie Mackintosh. By 1910, however, a collection of Wright's architectural drawings was published in Germany: British and European architects were learning from the Americans. Wright's innovative use of space and "destruction of the box" served as inspiration for the early modernists of the next generation.[29]

By the time that Wright and other Americans were disseminating Arts and Crafts and modernist ideas in the early twentieth century, the United States had established itself on an international stage. American artists and designers were no longer slavishly copying the styles of Britain or any other country but were interpreting and adapting their ideas to suit their own needs and goals. The nation's cultural leaders sought to define what made their country unique. In an age of increasing and varied immigration, some hoped to bind the nation together with common goals and values. American history was reevaluated and a national mythology created, which depended largely on the Anglocentric cultural history of New England and the events of the Revolution. An American aristocracy emerged, based on descent from the first English settlers, such as those who arrived on the storied *Mayflower* in 1620 or, in the case of a national organization like the Daughters of the American Revolution (founded in 1890), descent from the heroes of the War of Independence. Used both as a means of exclusion and as an invitation to assimilate, this sense of pride in British ancestry also found its way into American art.

John Singer Sargent's *Mrs. Fiske Warren (Gretchen Osgood) and Her Daughter Rachel* echoes the aristocratic pretensions of the eighteenth-century Bostonians whom Copley painted (fig. 100). No longer based on secondhand images of British duchesses depicted by Reynolds and transformed into mezzotints that made their way across the Atlantic, this portrait, as created by Sargent, is instead a direct reinterpretation of the elegance and authority of Reynolds himself, crafted for the modern age by a painter who put forward both himself and his sitter as the rightful heirs to a Grand Manner tradition.

100
John Singer Sargent
American, 1856–1925
Mrs. Fiske Warren (Gretchen Osgood) and Her Daughter Rachel, 1903
Oil on canvas
152.4 x 102.6 cm (60 x 40 3/8 in.)

Gretchen Warren was the wife of an American aristocrat whose New England heritage was old and whose fortune (from paper manufacturing) was new. Sargent, a contemporary painter who already had inherited the mantle of the great portraitists of the past, posed her with her daughter in a Renaissance armchair surrounded by the fifteenth-century sculpture and tapestries amassed by their friend the collector Isabella Stewart Gardner. In this way Sargent created a luxurious setting for his portrait that was equivalent to the stately homes of the British nobility that Reynolds had depicted. The three-quarter-length format, the demure pose, the artistic surroundings, and the great, loose strokes of shimmering white paint also echo the style of Britain's most noble eighteenth-century portraits (which were newly popular among American collectors). "What an heirloom to pass down!" remarked one Boston writer about *Mrs. Fiske Warren.* "There are few portraits of the early English school, even by Sir Joshua Reynolds, which can be compared to this group."[30]

Sargent, an American based in England, was born in Italy, trained in France, and was active in the United States. He was an artist without boundaries, a painter who moved comfortably from country to country in an international sphere. So successful was he at working within the scope of different national artistic tendencies that scholars continue to debate whether he is American or English. That fluidity became a characteristic of the twentieth century, when the American scene was vastly enriched by artists from many countries who came to the United States at the time of the two world wars and as American culture began to influence (and even to dominate) other lands. Although the history of modern art in the twentieth century was not written in Britain, and thus English painters and craftsmen played less of a role in the United States during that century, a special relationship remained between these two countries "separated by a common language." That a contemporary British artist like David Hockney is equally at home in California and in England, and is identified as much with the scintillating blue landscape of swimming pools in Hollywood (fig. 101) as with the hills of his native Yorkshire, is continuing evidence of the freedom of movement between these two nations, and in the easy acquaintance of its citizens.[31]

101
David Hockney
English, born in 1937
*Lithograph of Water Made of Thick
and Thin Lines, a Green Wash, a
Light Blue Wash and a Dark Blue
Wash (Pool I)*, 1978–80
Lithograph in seven colors
66 x 87.6 cm (26 x 34½ in.)

FRANCE ERICA E. HIRSHLER AND KELLY H. L'ECUYER

France, known in Europe for innovative artistic styles, luxurious craftsmanship, and high fashion, extended its influence into the Western Hemisphere beginning in the sixteenth century. Although its impact varied greatly across time and place, and its political power in the New World diminished in the eighteenth century, France gained greater and greater cultural authority, particularly in the United States, and French aesthetics played a major role in art of the Americas. After the American Revolution, French-trained artisans and imported objects helped to disseminate French styles, while American patrons and consumers looked directly to Paris for all things new and fashionable. Their enthusiasms were often mitigated by politics or by the sizable number of Americans, especially New Englanders of Anglo-Protestant descent, who remained suspicious of the luxury and decadence they often associated with all things French. "Will you tell me," asked the uncompromising John Adams of noted Francophile Thomas Jefferson, remembering the effects of easy living on the Roman Empire, "how to prevent luxury from producing effeminacy, intoxication, extravagance, vice and folly?"[1] Despite such dire warnings, many artists and patrons admired and emulated elite French refinement—whether in the elegant furniture of skilled *ébénistes* (cabinetmakers), the hand-stitched details of a couture gown, or the seductive skill that produced the paintings exhibited at the French Salon.

France also represented modernity. As early as the mid-eighteenth century, the ornate Rococo style that originated in the palaces of Louis XV was known as *le style moderne* (modern style) or *le goût nouveau* (new taste).[2] In the nineteenth and early twentieth centuries, the French developed a series of progressive modes of representation and design that came to be known as the new painting, Art Nouveau, and later Art Moderne. For American artists and patrons, France represented innovation and sophistication, continually reinventing the definition of style. Especially after the Civil War, and well into the twentieth century, artists from throughout the Americas joined a worldwide pilgrimage to Paris, which had succeeded Rome as the capital of the Western art world, a center both of academic training and the avant-garde. In 1878 the Massachusetts-born sculptor William Wetmore Story, an Italophile deeply resentful of the leading position France had taken in the arts, grumbled that French fashions had entirely saturated American society. Comparing the preeminence of France in all cultural affairs to a disease, Story declared that "nowhere is its contagion so deeply felt as in the United States."[3] But Story would soon be perceived as old-fashioned, and France came to represent the apogee of aesthetic refinement. Artists from a variety of places and backgrounds found the Parisian art scene liberating and stimulating, and they used it as an incubator to explore new styles and ideas in modern art. In this, they continued a centuries-old association between France and modern taste.

102
Circle of José Maria Rodallega
Mexican, 1741–1812
Chalice (*caliz*), about 1790–1812
Silver with gold wash
H. 24 cm (H. 9⁷⁄₁₆ in.)

In the New World in the seventeenth and eighteenth centuries, major French styles were filtered through regional governments led by Spain, Britain, and other colonial powers, taking on characteristics particular to local cultures and customs. The most telling example of this process is the diffusion of the Rococo style, in many variations, throughout Europe and the Americas. The Rococo, born in France during the reign of Louis XV and developed through the patronage of Madame de Pompadour, the king's mistress, was a sensuous, lighthearted style characterized by sinuous curves, asymmetry, naturalistic flora and foliage, pastel colors, and touches of exoticism and fantasy. It rapidly became an elite international fashion that reached its peak of popularity in urban centers in Europe about 1750 and spread to rural

provinces and European colonies through exported objects, pattern books, and emigrant artisans. Remarkably versatile, Rococo designs appeared in furniture, silver, paintings, prints, costume, and all manner of decorative household goods, such as cast-iron stoves and firebacks, throughout the reaches of European exploration and empire building. In the New World, the appearance of the Rococo revealed not only the global influence of modern French taste but also the ways in which that influence was modified and transformed around the world. In New Spain, for example, the limited use of the Rococo style in the arts and architecture reflected a persistent Spanish preference for heavier Baroque ornament.[4] A chalice made in Mexico City about 1790–1812, long after the Rococo had faded from fashion in Continental Europe, shows the Spanish adaptation of the style in the colonies (fig. 102). The swirling curves of the Rococo are blended in this richly decorated wine cup with the spiraling movement that recalls the twisted columns of Baroque architecture. The bowknots and floral garlands in the cup's raised decoration also reveal the introduction of contemporaneous French Neoclassical motifs that came to Mexico with the establishment in 1785 of a new art school, the Academia de San Carlos, in Mexico City. The chalice reveals a complex blend of French sources with regional tastes.

Similarly, in North America's British colonies in the years before the Revolution, influences from France were distinct, albeit indirect. Centuries of rivalry between England and France—encompassing religious differences, trade disputes, and frequent warfare—made English colonists wary of the French. Furthermore, they were economically tied to Britain, prohibited from trading directly with other countries. Thus, new styles and ideas in the arts, regardless of their country of origin, were almost exclusively received from and filtered through England. British colonists learned of the French Rococo style through English objects or such widely circulated pattern books as Thomas Chippendale's *The Gentleman and Cabinet-Maker's Director* (see fig. 90).[5] In Philadelphia, where the Rococo reached its fullest expression in the British colonies, craftsmen applied richly carved modern

French embellishments to earlier English forms, such as Baroque high chests.[6] Although a number of immigrant artisans of French descent lived throughout the colonies, many became assimilated into English culture, and their influence as bearers of French style was limited. For example, the French-born Apollos Rivoire apprenticed with the Anglo-American silversmith John Coney in Boston, married an English colonist (Deborah Hitchbourn), adopted the name Paul Revere, and made objects strongly English in character and design. His son, Paul Revere Jr., was the well-known Boston silversmith and Revolutionary patriot.[7] Similarly, while portrait painters like John Singleton Copley used the pastel colors, curved ornament, and pastoral conceits of the Rococo style, British portraits provided their immediate inspiration. Copley collected mezzotints, printed reproductions of stylish paintings of famous English aristocrats, and frequently relied on them as prototypes, offering his own sitters examples of the modish Rococo imagery that he could employ (see fig. 210).

In New France, the French colonies in the Americas, the Rococo appeared later and persisted longer than in France. Local settlers adapted it freely to objects made for the unique circumstances of provincial life. The mutation of the style in France's own territories, where one might expect a more direct link to French artistic modes, resulted from the relative isolation of the colonists. The French Crown had been among the earliest of the European powers to stake a claim in the Americas, but it made the least investment to secure and permanently populate its vast lands. Jacques Cartier declared the Gaspé Peninsula (now in Canada) for France's King Francis I in 1534, and for the next hundred years, French explorers mapped and claimed territories spanning the Americas, from Hudson Bay to the Gulf of Mexico, and through the Caribbean as far south as Guiana in South America. However, these French colonies were sparsely settled, unlike the large Spanish colonies in Mexico and Peru or the rapidly expanding British and Dutch mercantile communities on the Atlantic coast of North America, all of which were strongly supported by their European governments. France was Europe's most populous country,

but French immigration to the New World was a small trickle.[8]

Even in their own colonies, French settlers often made up only a small part of the local population and culture, which limited their access to French objects and aesthetic styles. On the French Caribbean islands and in Guiana, for example, the colonial population was predominantly African. The sugarcane plantations there relied on the forced labor of thousands of African slaves, whose high death rate because of the harsh working conditions necessitated the continual replenishment of the slave population with new imports. The owners—who were outnumbered approximately ten to one by slaves in the eighteenth century—were aristocrats who maintained close ties to France and rarely lived full-time on their plantations.[9] In North America, where French settlers traded with Native peoples (including the Wendat [Huron], the Ottawa, and the Algonquin) for beaver pelts destined to enter the lucrative European fur market, a completely different French colonial society emerged. The Roman Catholic Church was a powerful cultural influence, builder, and arts patron; in the three major cities founded beginning in 1608—Quebec, Trois Rivières, and Montreal—religious leaders and wealthy donors adorned churches with sophisticated French furnishings, textiles, silver, and paintings. Outside these urban centers, the church's priests and missionaries were an integral part of the exploration and settlement of the continent. Catholic missionaries, along with traders, developed relationships and trade networks with Native peoples, enabling the French to push deep into the North American interior to establish trading posts along the Saint Lawrence River, the Great Lakes, and the Mississippi River valley all the way to New Orleans. These French outposts consisted of widely dispersed forts and distant rural settlements. The *habitants* (farmers) and especially the fur traders were more rural, mobile, and isolated from outside influences than other groups of European settlers in the New World. As a result, their furniture reveals their conservative preference for styles remembered from their homeland. Most colonists were emigrants from western French provinces like Brittany and Normandy; among them were *menuisiers* (wood-

103
Attributed to Pierre Antoine
Petit dit La Lumière
Died in 1815
Buffet
Vincennes, Indiana, about 1800
Yellow poplar, curly maple,
sycamore
H. 117.5 cm (H. 46¼ in.)

workers), who re-created in the New World the familiar forms of sturdy French provincial furniture.[10]

Despite encroaching Anglo-American immigration in Canada and military and political defeats that were tied to European conflicts—France ceded Louisiana to Spain in 1762 (reclaiming it in 1800 and selling it to the United States in 1803) and Quebec to Britain in 1763—a rich French culture continued to flourish in Quebec, Louisiana, and the upper Mississippi River valley.[11] Regional preferences for remembered French artistic traditions, especially the Rococo style, remained strong well into the nineteenth century. A buffet (used for storing dishes and serving food) from the Wabash Valley Region of Indiana, near Vincennes, could almost be mistaken for a provincial, French-made object (fig. 103). Its particular features of design and construction—the undulating curves of the skirt and door panels; the style and motifs of its carved decorations; the single large dovetails used in the drawer construction—link it closely to rural French furniture in the Louis XV style made in Normandy decades earlier. Its origin is evident from the American woods (yellow poplar and curly maple) used in its construction, its regional history of ownership, and its strong visual relationship to known work by the Vincennes cabinetmaker Pierre Antoine Petit dit La Lumière.[12]

The long survival of the Rococo style in New France is also evident in a commode (low chest of drawers) made in the Montreal area about 1780–90, a piece that also shows how French colonists adapted to their new surroundings and circumstances (fig. 104). In its materials, construction, and form, the commode is a hybrid of American and French characteristics. The commode's materials and workmanship are unmistakably of the New World. The vast old-growth forests of North America gave local joiners no reason to economize in their use of wood, and the Montreal commode was built from solid boards of local white pine and butternut; its curved drawer fronts were deeply sculpted from thick slabs. This heavy construction is markedly different from the elaborate techniques used for such pieces in France, where woodworkers made efficient use of costly materials like oak, walnut, and exotic veneers. The shape of the Montreal commode, however, is purely

French. Its curved front with recessed center takes the *arbelète* (crossbow-shaped) form, a profile common to several Montreal commodes of the period.[13] Like the Vincennes buffet, it is a provincial adaptation of a type that had been current in high-style courtly French furniture forty or fifty years earlier.[14] By the time the robustly curved Montreal commode was made, the rectilinear, smooth-faced surfaces of Neoclassicism had become fashionable in France and in larger, more cosmopolitan cities like New York.

The Montreal commode also reveals important social differences between France and the French colonies. Furniture forms like commodes were reserved for the bourgeoisie and nobility in France, but they were more widely used among common people in the colonies. Several French visitors to Canada observed that, much to their surprise, the *habitants* owned locally made commodes and other furnishings that would have been beyond the reach

104
Commode
Montreal, Quebec, Canada,
1780–90
Butternut, white pine
H. 87 cm (H. 34¼ in.)

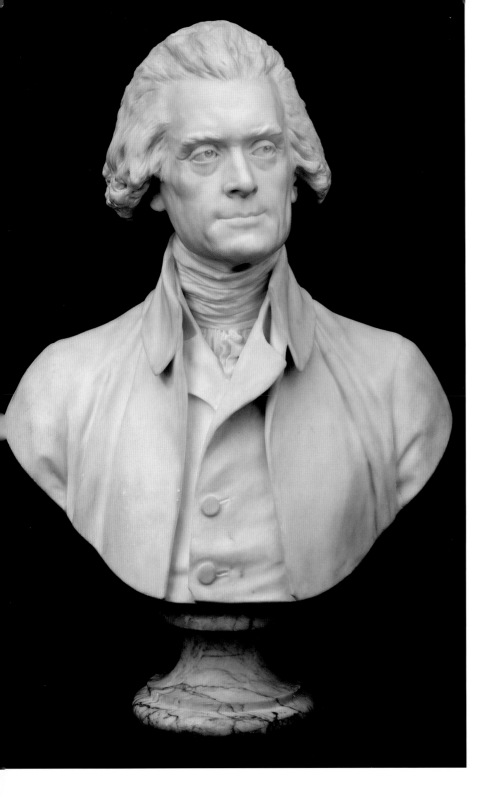

105
Jean-Antoine Houdon
French, 1741–1828
Thomas Jefferson, 1789
Marble
H. 56.5 cm (H. 22¼ in.)

of the comparable peasant classes in France. Louis Franquet, a royal engineer who visited Canada in 1753, wrote of his stay at an inn run by a storekeeper, commenting, "From the furnishings of this house, one must conclude that the country folk here are too well-off."[15] Although some aspects of the French class system were transferred to Canada, social distinctions were notably more relaxed than they were in France. The commode also demonstrates the intermingling of cultures characteristic of the New World: it incorporates bold undercut claw-and-ball feet, a British design feature (inspired by Chinese forms) similar to examples found on English colonial furniture from Newport, Rhode Island. The blending of the French arbelète form with distinctively English feet reflects the exchange of styles and ideas between French and English colonists after the end of the French and Indian War in 1763, the migration of British loyalists to Canada in the wake of the American Revolution, and the flexible nature of immigrant society in the New World.[16]

The American Revolution marked a turning point in the political relationship and cultural exchange between France and the newly formed United States of America. Crucial French support for the American Revolutionary cause made France a key ally and trading partner for the United States, and American patriots were generally sympathetic to the original democratic aims of the French Revolution, if not the chaos and bloodshed of the subsequent Reign of Terror. Despite various diplomatic disputes and disruptions in trade before and after 1800, many in the United States celebrated their connections with the French—their military allies in the Revolutionary War, their fellow seekers of liberty from a corrupt monarchy, their colleagues in modeling an innovative representative government after ancient republican ideals. As a result of these new political and economic ties, Americans had more enthusiasm for—and direct access to—French furnishings, fashion, and art than ever before. One of the first Americans to develop a deep admiration for French culture was Benjamin Franklin, named the first American ambassador to France in 1776 and a darling of French society. His younger compatriot Thomas Jefferson was

the most committed Francophile of his generation, admitting that were he asked where he would prefer to live, he would choose America for "friends, [his] relations, and the earliest & sweetest affections and recollections of my life," but his alternate choice, based on his appreciation of Parisian society, manners, and intellect, would be France.[17]

The mutual admiration, curiosity, and cultural exchange that developed between leading citizens of France and America in the early years of the United States—a relationship so close that even the plan for the new nation's capital city was devised by a Frenchman, Pierre L'Enfant—is neatly represented by two portrait busts: *Thomas Jefferson*, by the French sculptor Jean-Antoine Houdon; and *Marie Joseph Paul Yves Roch Gilbert du Mortier, Marquis de Lafayette*, by the American sculptor Horatio Greenough (figs. 105 and 106). Jefferson succeeded Franklin as the American ambassador to France, serving from 1784 to 1789. During this time, he came to admire and patronize the brilliant portraitist Houdon.[18] He arranged for Houdon to travel to the United States to make an official portrait of George Washington (1785–91, Virginia State Capitol, Richmond), and for his own home at Monticello, he acquired portrait busts of esteemed French and American thinkers and statesmen, including Voltaire and Franklin. In 1789 Jefferson sat for his own portrait with Houdon, who modeled the likeness in terra-cotta. Houdon produced several copies of the portrait in both plaster and marble, and Jefferson returned home with plaster versions to give to friends.[19] The Museum's marble bust once belonged to Comte Antoine-Louis-Claude Destutt de Tracy, an Enlightenment thinker, who, according to a descendant, was "a great friend of Jefferson."[20] Houdon's likeness of Jefferson vividly captures the sitter's intelligence and character and has become the source of numerous other images of Jefferson, including the face on the modern U.S. nickel.

In something of an inversion of the story of Houdon's *Jefferson*, Greenough sought to enhance his own career by sculpting a portrait of the popular Marquis de Lafayette, a hero of the Revolution. Greenough owed his own career to another Frenchman: as a teenager in Boston in 1818, he had met Jean-

Baptiste Binon, a French sculptor briefly in residence, who had inspired him to pursue an artistic career. Greenough became the first American artist to make sculpture his sole professional occupation and the first to study in Rome. He established his studio in Florence and earned the friendship and important patronage of the American novelist James Fenimore Cooper. By the early 1830s, seeking new subjects and new publicity, Greenough developed the idea of modeling a likeness of Lafayette, hoping to capitalize on the Frenchman's celebrity. Lafayette, beloved by Americans for his voluntary service under Washington in the Revolutionary War, had completed

106
Horatio Greenough
American, 1805–1852
Marie Joseph Paul Yves Roch Gilbert du Mortier, Marquis de Lafayette, about 1833
Marble
H. 33 cm (H. 13 in.)

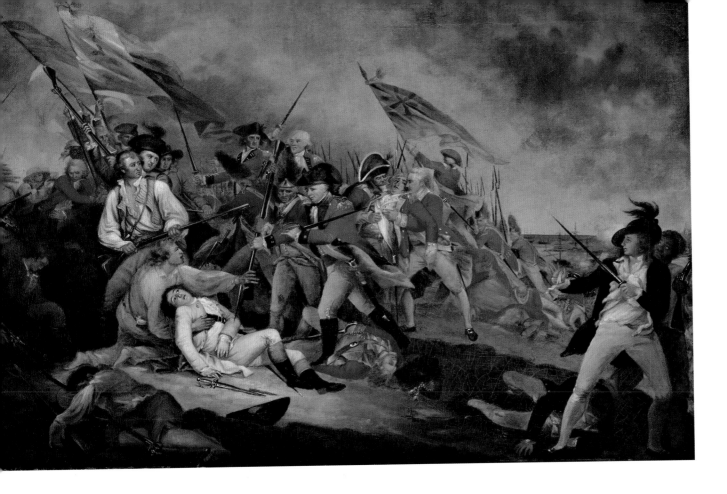

107
John Trumbull
American, 1756–1843
The Death of General Warren at
the Battle of Bunker's Hill, 17 June,
1775, after 1815–before 1831
Oil on canvas
50.2 x 75.6 cm (19 ¾ x 29 ¾ in.)

a triumphal tour of all twenty-four American states in 1824 at the invitation of President James Monroe, to the delight of cheering crowds.[21] Lafayette memorabilia in all forms became wildly popular, and American manufacturers found a ready market for commemorative fans, pins, ribbons, flasks, engravings, salt dishes, and other trinkets in great numbers.[22] Keen to portray the French general, Greenough wrote to his friend Cooper (then living in Paris) to help him obtain permission to model the famous hero, remarking that "his portrait would be fortune to me hereafter."[23] Greenough clothed Lafayette in the stylized drapery of Neoclassical taste but represented the general's distinctly modest features faithfully, intending to inspire admiration for the real individual who for decades had symbolized the cause of liberty in both France and America.[24]

The Revolution also marked a turning point for painters in the United States. After the war, popular taste and the market changed, and for the first time, Americans began to embrace history painting. Historical and religious themes had always been highly regarded by the art establishment in both London and Paris, but there were almost no viable patrons for these subjects in pre-Revolutionary America. The war provided new heroes and patriotic motifs; artists like John Trumbull and Thomas Sully earned recognition and acclaim by creating large-scale images of recent dramatic events. Trumbull, who was fluent in French, made several trips to Paris in the 1780s and 1790s, following an interest in French art that he had developed early in his career when (as a student at Harvard) he had made copies after Charles Le Brun's *Expressions des passions de l'âme* (1698).[25] Trumbull's political affiliations (he served in the Continental Army) and his friendships with Franklin and Jefferson (both of whom were in France at this time) led him naturally in the direction of the

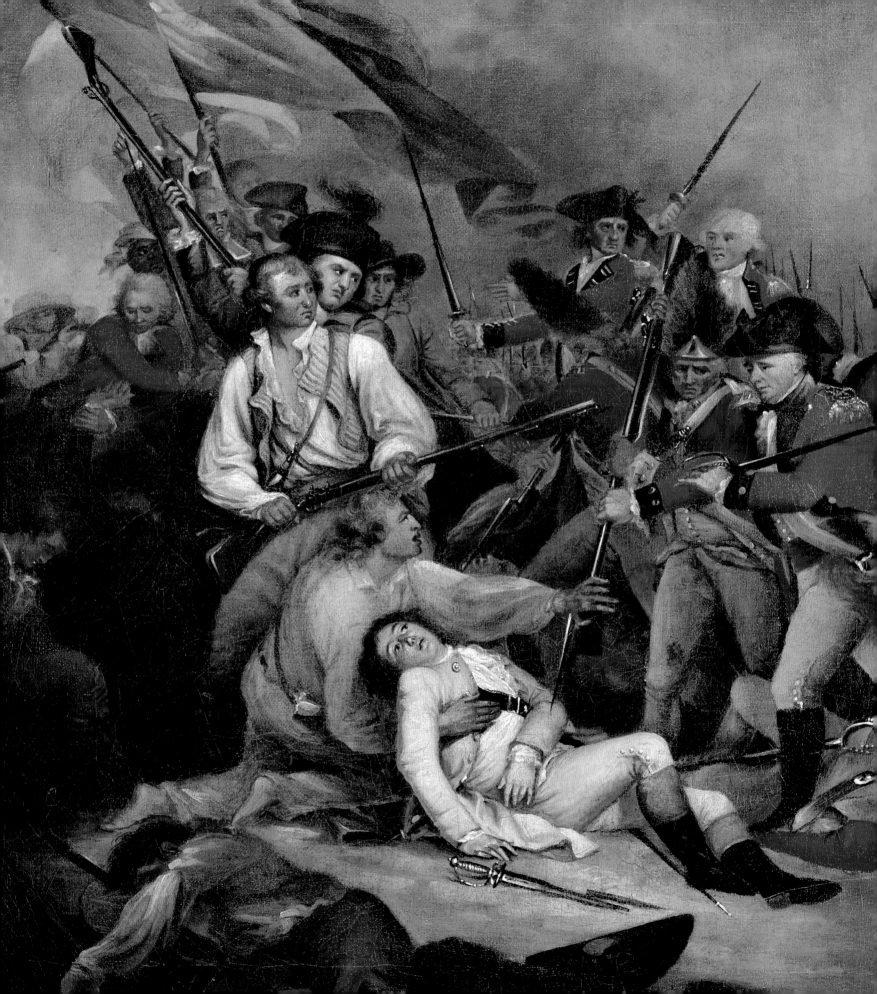

108
Thomas Emmons
American, active 1813–1825
George Archibald
American, active 1813–1834
Fall-front secretary (*secrétaire à abattant*), 1813–25
Mahogany, mahogany veneer
H. 153.7 cm (H. 60½ in.)

Continent, but it was in London, with the advice of the American-born Benjamin West, that Trumbull embarked on his career as a history painter. In 1784 he wrote to his brother that he had in mind to create "a Series of Pictures of our Country, particularly the great Events of the revolution."[26] West had been the innovator in the field of modern history painting; his *Death of General Wolfe* (1770, National Gallery of Canada, Ottawa) borrowed traditional compositional formats from religious and mythological scenes and used them to portray recent events. Trumbull followed West's example, but his heroes were American generals, not the British, and he earned tremendous praise in the United States.

Trumbull's desire to create a new national mythology, a quest that began with a heroic depiction of the battle of Bunker Hill, links his work to the art of France. There, at the end of the eighteenth century, Napoleon had selected the great French classical painter Jacques-Louis David to make monumental images of him and of his triumphs, images that were intended to establish, in a calculated campaign, the legitimacy of his new government. Trumbull also understood the persuasive power of art. His *Death of General Warren at the Battle of Bunker's Hill, 17 June, 1775* describes one of the important early battles of the American Revolution (fig. 107). The motif was the artist's first national history painting; he completed his initial version in 1786 and made a number of subsequent adaptations in oil (including the MFA's, which descended in the Warren family) in the years to come. Trumbull's formula for this painting, with the dying general collapsed into the arms of his compatriot as the battle rages around them, is largely borrowed from the great British historical scenes of West and Copley, but Trumbull had greater aspirations for his compositions. In 1816 he launched a campaign to place monumental versions of several of his history paintings in the heart of the nation, in the U.S. Capitol in Washington. To enhance his petition, Trumbull wrote to his old friend Jefferson, who responded with a letter offering his assistance and support to the man he called "superior to any historical painter of the time except David." Trumbull was given the commis-

sion, and in his letter of thanks to John Adams, another old friend and champion, he wrote that he hoped that in America the arts would be used not, as Adams feared, to further the evils of despots, but instead "in the service of Religion, Morality, and Freedom."[27]

High-style French taste gained a foothold in major East Coast cities as a result of new political, diplomatic, and cultural ties between the United States and France, although British culture remained a major influence. American statesmen and merchants traveling and living in France at the turn of the nineteenth century brought home examples of elegant French furnishings, sometimes acquired at bargain prices at auctions of aristocratic collections following the French Revolution.[28] The Boston entrepreneur James Swan, for example, the American agent for the French Republic's Commission des subsistances, traded American commodities like rice and wheat for French furniture, paintings, and objets d'art confiscated from the ancien régime and shipped to the United States.[29] Fashionable American women like Sarah Bowdoin, the wife of the Honorable James Bowdoin III (who served as associate minister to France under President Thomas Jefferson), shopped in Paris, acquiring elegant French dresses in the Empire style that were then emulated by seamstresses in the United States (see fig. 58). Along with the importation of French objects, the immigration of French artisans—like furniture makers Anthony Quervelle in Philadelphia and Charles Honoré Lannuier in New York—helped to promulgate high-style French taste among American elites. Quervelle, a successful Philadelphia furniture maker who combined English and French stylistic influences in his work, was commissioned by Andrew Jackson to make a series of tables for the redecoration of the White House in 1829. Lannuier marketed his furniture to New York's wealthy merchants and French émigrés residing in the city.[30]

While French-born *ébénistes* like Quervelle and Lannuier could tout their direct knowledge of French taste, American manufacturers worked to produce goods in fashionably up-to-date French styles close to

home. In Philadelphia, the William Ellis Tucker Factory was among the earliest firms to produce high-quality china in the manner of French painted porcelain for the American market.[31] American craftsmen seeking to offer French designs to local clients could draw from books like Charles Percier and Pierre Fontaine's 1801 publication *Recueil de décorations intérieures*, which illustrated and provided sources for re-creating the classically inspired, monumental forms of the French Empire, a style introduced during Napoleon's reign.[32] Wealthy Bostonians could commission such objects from high-end local firms like Thomas Emmons and George Archibald, Isaac Vose and Sons, and others. For example, the *secrétaire à abattant* (fall-front secretary) made by Emmons and Archibald exemplifies the heavy architectural massing of the new Empire style and is directly based on numerous French examples of the type (fig. 108).[33] The matched grain of its mahogany veneers, the handsomely carved hairy-paw feet, and the judicious use of ornamental brass hardware enliven this restrained and sober case, making it a prime example of the luxury and understated sophistication of French taste. Shortly after Emmons died in 1825, an advertisement for the sale of the contents of his shop listed "a large assortment of CABINET TRIMMINGS," including "a variety of elegant French CAPS and BASES, Rings, Knobs, and other Ornaments"; the notice implies that Emmons imported French hardware, perhaps including the caps and bases on the columns of this *secrétaire*.[34] Thus the new ease of exchange between France and America in the early nineteenth century encompassed even such small details as cabinet brasses that were essential elements of the French Empire style.

Paris had always been the source for refined aesthetics and unparalleled artisanry. As the nineteenth century progressed, tastemakers increasingly promoted French art and fashion as the model to which the growing ranks of the American bourgeoisie could aspire, for as the astute French traveler Alexis de Tocqueville noted about Americans, "the one passion that runs deep . . . is the acquisition of wealth," adding that the United States was "a world of merchants."[35]

In 1854 the popular journal *Harper's New Monthly Magazine* expressed a sentiment shared by many in the nineteenth century: "Paris is the central star of fashion. Whatever is seen elsewhere is a ray from her light, diminishing in luster as it recedes from that city."[36] People came from around the world to settle in Paris, but Paris, through the offices of the French state (which controlled many businesses, setting standards for trade and running the luxury industries of fashion, textile, and porcelain manufacture), also marketed itself around the world as the acknowledged capital of shopping, dining, fashion, good taste, and artistic pursuits of all kinds. This stylish and sophisticated metropolis lured artists through its many opportunities for training and display, intellectuals excited by its urbane and often witty exchange of ideas, physicians and scientists seeking the latest experimental developments in their fields, statesmen engaged in diplomacy (at this time always conducted in French), and entrepreneurs eager to provide shoppers at home with the latest luxury goods.

By midcentury, the influence of high-style French taste was no longer reserved for the very wealthy and became the dominant fashion in American decorative arts, particularly in furniture. Major popular journals such as *Godey's Lady's Book* disseminated engravings of French costume, furniture, and interiors as exemplars of refined taste to a broad American public.[37] Manufacturers like John Henry Belter, J. W. Meeks and Sons, and many others took advantage of the craze for all things French by marketing modern adaptations of Rococo furniture.[38] Andrew Jackson Downing, the leading prophet of American middle-class taste, observed in 1850 that "modern French furniture and especially that in the style of Louis Quatorze stands much higher in the general estimation in this country than any other."[39] Magnificent French craftsmanship and design gained wide admiration at international expositions, and French émigrés produced essentially French objects in major American cities. These artisans capitalized on their fashionably French origins in their public notices. Alexander Roux, for example, proudly marked his furniture in the 1850s with a label describing himself

as a "French Cabinet Maker," many years after his immigration to the United States in 1835. Roux ran a large and successful New York shop, employing 120 people in 1855, and Downing specifically recommended that readers could find "the rarest and most elaborate designs . . . at the warehouse of Roux, in Broadway."[40] Roux's designs ran the gamut of French revival styles popular in the 1850s, executed with consummate skill and craftsmanship.

The elaborate cabinet by Nelson Gustafson is the ultimate expression of fashionable French taste in the United States in the second half of the nineteenth century and demonstrates the continued importance of imported French materials and craftsmen (fig. 109). Although Gustafson's name does not sound French, and little is known about his background, the cabinet is unmistakably French in style and workmanship. Cabinets of this type, made as showpieces for elegant drawing rooms, were widely referred to in their day as "French cabinets."[41] By the 1870s the sculptural, heavily carved furniture of the Rococo Revival had begun to fall out of favor, replaced by more architectural and linear designs in a variety of styles. In this cabinet, the tripartite form and the interplay of projecting and recessed elements recall French Renaissance and Mannerist furniture, but the overall emphasis remains on flat surface ornament and linear decoration with classical references. The decorative vocabulary of incised gilt lines, contrasting ebonized (black-painted) wood and gleaming tropical woods, and elaborately patterned marquetry panels reflect the *Néo-Grec* style in fashion during the French Second Empire.[42] Gustafson, like other cabinetmakers, relied on the work of many skilled specialists to produce objects of this quality. Marquetry panels, such as those on the sides of this piece, as well as the painted porcelain plaque at center, may have been imported from France. The gilt-bronze mounts are marked by the shop of Pierre Emmanuel Guerin, a French immigrant whose New York establishment supplied bronze mounts and other hardware to high-end New York manufacturers, thus competing directly with imported French goods.[43]

109
Nelson Gustafson
Active 1873–1875
Cabinet
New York, New York, about 1873–75
Mahogany, rosewood, exotic woods, porcelain and bronze plaques
H. 143.5 cm (H. 56½ in.)

110
Thomas Eakins
American, 1844–1916
Starting Out after Rail, 1874
Oil on canvas mounted on
Masonite
61.6 x 50.5 cm (24¼ x 19⅞ in.)

French paintings were also much admired in the United States, and American artists aspired to achieve their level of craftsmanship and popularity. Paris, with its museums, art schools, and easy acceptance of fine art as a part of daily life, had become the global center for artistic education and academic training. In the French capital, American artists felt at home in an international community of painters and sculptors, finding opportunities for education, exhibition, and critical commentary that helped them to shape successful careers, both when they went home and sometimes as expatriates abroad. As the novelist Henry James remarked in 1887, "It is a very simple truth, that when to-day we look for American art, we find it mainly in Paris. When we find it out of Paris, we at least find a great deal of Paris in it."[44] Paris even shaped some of the painters who seem most quintessentially American. Thomas Eakins, for example, went to Paris in the fall of 1866 to enroll at the Ecole des Beaux-Arts, the state-sponsored academy then considered the finest art school in the world. He studied there with Jean-Léon Gérôme, a leading French master admired for his precise realism and attention to detail, and he continued to seek Gérôme's advice even after returning to Philadelphia. In paintings like *Starting Out after Rail*, Eakins applied Gérôme's exacting method to an American vocabulary (fig. 110). Characteristically, Eakins selected a masculine sporting subject (the two men are hunting rail, small game birds). He carefully plotted the position of the sailboat and the movement of the water, enjoying the technical challenge of the complicated perspective. His painting is tightly crafted and highly finished, following the lessons he had learned from his French teacher. Eakins sent the painting to Gérôme in 1874, seeking approval for his new work, and Gérôme arranged to have the painting displayed in Paris. For Eakins and many of his contemporaries, praise from leading French academic painters and a successful exhibition in Paris were invaluable, for such acknowledgment could translate directly into critical and economic success in the United States.

Paris became the capital of the art world partly on the basis of its modernity. Rome, once the destination of choice, came to seem old-fashioned and merely picturesque. Paris looked toward the future; it was a place for novel display and commerce. Americans sought their fortunes in a city that embraced a variety of approaches to art making. While the polished technique and figurative subjects championed by Gérôme and the French academy represented the ultimate accomplishment to many American painters and patrons in the late nineteenth century, others were drawn to more progressive styles, which also were to be found in Paris. As early as 1850, artists like William Morris Hunt had become attracted to the works of the so-called Barbizon School, particularly to those of Jean-François Millet, the leader of the group (who lived in the village of Barbizon, near Paris). Millet dismissed the mirrorlike finishes and mimetic approach favored by the academic establishment, using instead a direct and broadly conceived painting style to create freely brushed opalescent landscapes and monumental images of rural labor.[45] Hunt, Boston's leading tastemaker in the 1860s and 1870s, encouraged many of the city's collectors to buy such French paintings, and they in turn helped to shape the eye of some of the country's most important artists, among them Winslow Homer.

When Walt Whitman saw the collection of paintings by Millet that Hunt had helped the Boston collector Quincy Adams Shaw to acquire, the poet remarked, "Will America ever have such an artist out of her own gestation, body, soul?" Homer was the answer to his plea. The painter began his career as an illustrator, first in Boston and then in New York, where he recorded images of the Civil War for popular magazines. After the war, Homer turned his attention to oil painting. By late 1882 he had settled along Maine's rocky coast, drawing inspiration from the infinite variations of sky and water he saw before him. His early masterpiece, *The Fog Warning*, depicts a lone fisherman in a dinghy rowing back to his ship, his small craft weighed down by his catch (fig. 111). Through its shimmering atmosphere, broad application of paint, and heroic image of work, Homer has reimagined the French paintings by Millet that he

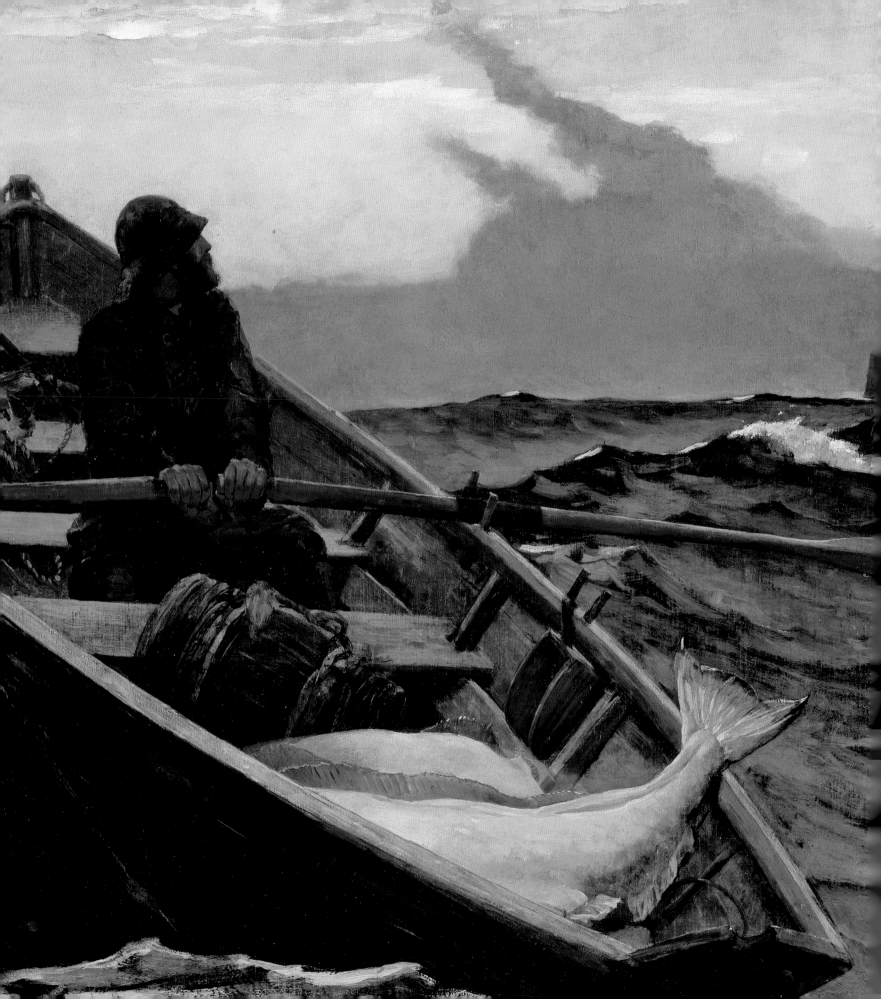

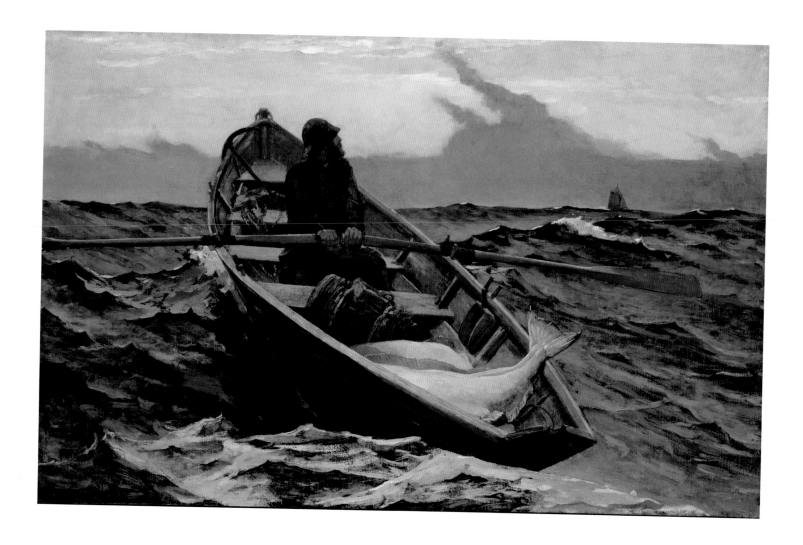

saw during his youth; they are the painterly equivalent of Whitman's epic *Leaves of Grass* (1855), which Whitman had described as "Millet in another form."[46]

The broadly applied paint and interest in light effects that captivated the Barbizon painters and their American counterparts also laid the groundwork for a more radical set of French artists who later became known as the Impressionists. One American, Mary Cassatt, was integral to that movement almost from the start. Cassatt had begun her career with traditional studies in Paris, but by the mid-1870s she had become engaged with more progressive French painters, rejecting the custom of storytelling and preferring to depict isolated incidents drawn from the modern world. The Impressionists worked in a free,

painterly manner, experimenting with conventions of composition and of representation, and declared themselves entirely independent of the academy and the established system of juries that controlled most exhibitions. Instead, they organized their own displays, and Cassatt participated in four of their eight shows.

Cassatt displayed *The Tea* in the Impressionists' fifth group show in 1880, where it met with mixed critical reviews (fig. 112). Her subject was typical for the group, two fashionable women in a modern domestic interior, a topic that had none of the high-minded moral narrative favored by traditionalists or even the dignity of everyday labor depicted by the Barbizon School. More extreme was the way Cassatt depicted her sitters, for when human beings are rep-

111
Winslow Homer
American, 1836–1910
The Fog Warning, 1885
Oil on canvas
76.8 x 123.2 cm (30 ¼ x 48 ½ in.)

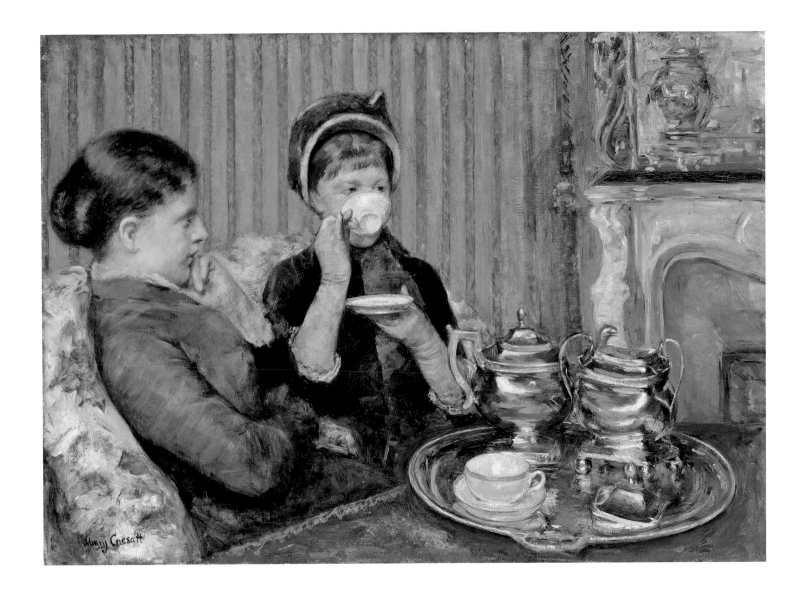

112

Mary Stevenson Cassatt
American, 1844–1926
The Tea, about 1880
Oil on canvas
64.8 x 92.1 cm (25½ x 36¼ in.)

resented in a painting, they are usually given promi-
nence. Instead, these women are almost overshad-
owed by the large tea set in the foreground, and the
face of one figure is almost entirely obscured by her
teacup. As unconventional as Cassatt's work was, she
maintained her close personal connections to many
of America's leading families, and she worked tire-
lessly to promote the new Impressionist style in the
United States.

Many of Cassatt's compatriots experimented with
Impressionism, particularly in landscape painting,
during their residencies in France, some even form-
ing an American colony in Giverny, where Claude

Monet lived. Young artists, among them Childe
Hassam, William Merritt Chase, Edmund Tarbell,
John Twachtman, and Frank Benson, soon adapted it,
using its bright colors, free brushwork, and modern
subjects to depict identifiably American scenes, thus
nationalizing an aesthetic that some American critics
had described as too foreign. In a similar fashion, the
sculptor Augustus Saint-Gaudens (whose father was
French, and who had studied at the Ecole des Beaux-
Arts) created iconic American images using a French
approach to modern bronze sculpture, reveling in
the medium's richly expressive tactile qualities, the
sculptural equivalent of Impressionist painting.

The Puritan, one of Saint-Gaudens's best-known compositions, was commissioned as a monumental sculpture for the city of Springfield, Massachusetts (and widely cast in a tabletop version, as here) (fig. 113). Dramatic and stern, the figure combines the sober appearance of a seventeenth-century New England cleric with all of the animation, movement, and vigor that Saint-Gaudens had perfected through his study of contemporary sculpture in Paris.

By the 1890s, in the most avant-garde artistic circles of Paris, communities of artists and writers were increasingly captivated by dreams and the unconscious; by the symbiotic relation between life, love, and death; and with the role of the arts at the end of a century of social and industrial revolution. Their thoughts took visual form in a style called Art Nouveau (new art), which featured decadent subjects and sinuous curves. One of the few Americans to adopt the method entirely was John White Alexander, who worked in Paris throughout the 1890s and met many French writers and poets through his friend James McNeill Whistler. In *Isabella and the Pot of Basil*, Alexander took his subject from an Italian Renaissance tale (reworked by the British poet John Keats) about love, death, and dreams (fig. 114). He depicted Isabella, the daughter of a merchant, communing in sensual ecstasy with a bowl containing the severed head of her murdered lover. With its stark palette, theatrical lighting, dramatic curves, and charged theme, Alexander's painting incorporates every element of the French style, so much so that the French national museum, the Musée du Luxembourg, tried to acquire it for its own collection.[47]

Theorists of Art Nouveau viewed it as a broad reform movement intended to eradicate the hierarchy between the fine and decorative arts, forging a streamlined, unified design for the modern age. They self-consciously attempted to create a new visual culture that celebrated modernity, introducing the flamboyant style at the Paris Exposition Universelle of 1900. There a worldwide audience saw and quickly adopted its visual vocabulary, including its whiplash curves, curling tendrils, and stylized natural forms, often imbued with an air of mystery, sensuality, and decay.

Americans by and large suspiciously resisted the luxuriously dark and decadent content of Art Nouveau but appreciated its curvaceous lines. Louis Comfort Tiffany, the leading practitioner of the style in the United States, was an imaginative artist who spent decades directing the design and production of extraordinary art objects in glass, metal, textiles, and all kinds of interior furnishings. His experiments with blown glass in the 1890s resulted in what he called Favrile glass (from an obsolete word meaning

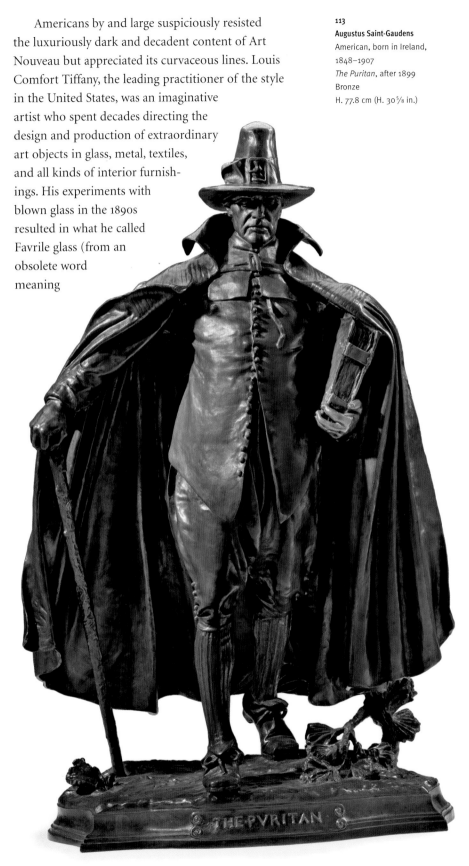

113
Augustus Saint-Gaudens
American, born in Ireland, 1848–1907
The Puritan, after 1899
Bronze
H. 77.8 cm (H. 30 ⅝ in.)

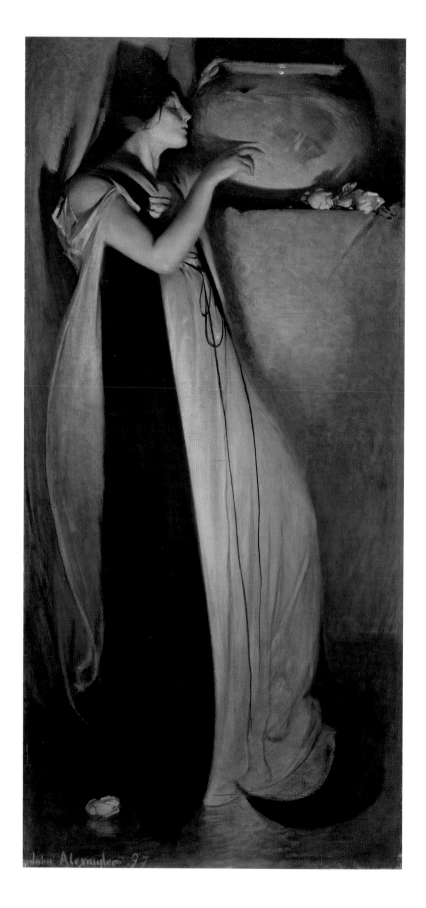

"handcrafted"), and the medium provided a perfect vehicle for his love of natural forms and Art Nouveau influences.[48] Like glass, silver lent itself especially well to such fluid designs, and firms like the Gorham Manufacturing Company of Rhode Island made brief forays into the Art Nouveau at the turn of the twentieth century, adapting the vocabulary of French taste to household objects for the American market with the handmade silver goods of their Martelé line.[49] American Art Nouveau furniture is rare; an imposing gilt armchair by Karpen and Brothers of Chicago is an exceptional example (fig. 115). Karpen and Brothers was a major firm employing the newest manufacturing technologies to mass-produce furniture for the middle to upper range of the market, but this chair represents the firm's small, high-style Art Nouveau line introduced in 1901, which won the Grand Prize in upholstered furniture at the 1904 World's Fair in Saint Louis. The heavy frame of the chair was carved using the latest spindle carving machines, which allowed up to eight duplicate chairs to be roughed out at the same time. Finished by hand carving, the chair was offered to consumers in either mahogany or gilt finish (this example survives with its original machine-tufted red silk upholstery).[50] In overall appearance, with its curvilinear gilt frame, seminude draped female figure on the crest rail, and red silk covering, this chair is perhaps only superficially related to the modern Art Nouveau style of Paris, for it also has much in common with the heavy, florid Rococo Revival of the mid-nineteenth century. Like Gorham's brief production of Art Nouveau silver, Karpen and Brothers manufactured this chair for a span of only about ten years.

Art Nouveau made a limited appearance on the American scene, but it was an important transition to other modern art movements, which also were centered in Paris. The city continued its role as an incubator for new forms of art and design, luring successive generations of Americans. The technological innovations of the late nineteenth century—photography, electricity, film, automobiles—introduced new ways of seeing and perceiving the world, faster forms of movement and communication, and a new set of visual sources and challenges for artists.

Painters grappled with how to represent the modern world around them. They explored different ideas about how to represent three-dimensional objects on a two-dimensional plane, sometimes seeking to show more than one view at the same time. Others attempted to represent concepts that had no visual equivalent—sound, for example, or speed. Americans now traveled to Paris to be energized and inspired by the groundbreaking experiments in structure, color, and form they saw by artists like Paul Cézanne, Henri Matisse, and Pablo Picasso, or by the improbable juxtapositions of dissimilar objects brought together by the Dada group and the Surrealists. Many of them made innovations of their own.

Stuart Davis, who began his career recording the streets of New York, was profoundly influenced by the new French paintings he saw in 1913 in the Armory Show, an important exhibition that first brought modern European art to wide public attention in the United States. Davis worked through a variety of ideas and styles, but his real breakthrough came during the 1920s, when he began to experiment with a series of four still lifes he called the *Egg Beater* series (fig. 116). Davis claimed that he "nailed an electric fan, a rubber glove, and an eggbeater to a table and used them as . . . exclusive subject matter for a year."[51] His disparate and unusual selection of objects recalls the exotic juxtapositions of the Dadaists and the Surrealists, but Davis was less interested in their potential meaning than in their formal qualities. Here traditional perspective and description have all but disappeared. Instead, Davis has created a playful arrangement of interlocking shapes and colors that both recede into space and pop out again at unexpected angles. In 1928, soon after finishing the series, Davis traveled to Paris, taking several of his canvases with him. Among the people who saw them were the French abstract painter Fernand Léger, who found Davis's work akin to his own and told him he thought it interesting that "2 people who did not know each other should arrive at [such] similar ideas."[52] With modernism, Americans like Davis found something novel in Paris—equality. No longer always the students of French masters, American artists now were exploring new ideas alongside their French colleagues.

114
John White Alexander
American, 1856–1915
Isabella and the Pot of Basil,
1897
Oil on canvas
192.1 x 91.8 cm (75 ⅝ x 36 ⅛ in.)

115
S. Karpen and Brothers
Armchair
Chicago, 1901–10
Mahogany, maple, gold leaf;
original upholstery
H. 106.7 cm (H. 42 in.)

116
Stuart Davis
American, 1892–1964
Egg Beater #3, 1927–28
Oil on canvas
63.8 x 99.4 cm (25⅛ x 39⅛ in.)

Alexander Calder, another American of startling talent and originality, also found his artistic footing in Paris in the 1920s. The son and grandson of sculptors, Calder went to Paris because, as he explained, "Paris seemed the place to go, on all accounts of practically everyone who had been there, and I decided I would also like to go."[53] In Paris, he was admired for his wire sculptures, witty caricatures of famous Parisians like the exotic dancer Josephine Baker, and renderings of animals, as in *Vache* (Cow), with its accompanying cow pie (fig. 117) and his miniature animated circus (1926–31, Whitney Museum of American Art). These three-dimensional drawings were more than whimsical toys; they revealed Calder's radical idea that sculpture could be something other than the shaping of solid mass. His wire sculptures describe space with a spare arrangement of line. Calder soon became fully enmeshed in the Parisian art scene, counting among his circle many of the city's leading artists and intellectuals—including Léger, Joan Miró, Piet Mondrian, and others.[54] Paul Nelson, a French modernist architect, incorporated works by Calder in his building designs; he once owned Calder's playful wire cow.

While American artists like Davis and Calder were accepted as equals among the French avant-garde, French artisans were recognized as leaders in decorative arts and design. As they had done in 1900 with Art Nouveau, the French again captured the international "style of the age" at the Paris Exposition internationale des arts décoratifs et industriels modernes of 1925. The type of art and design displayed at this exposition later came to be called Art Deco; during the period, the look was known simply as Art Moderne. The French exhibitors were especially praised for their modern adaptations of late-eighteenth-century Neoclassical French furniture, with its emphasis on straight lines rather than sinuous curves. Jacques-Emile Ruhlmann, the cabinetmaking equivalent of an *haute couturier*, employed traditionally exquisite French handcraftsmanship but used sleeker, streamlined forms and abstract or stylized decorations to give his luxury furniture a modern edge.[55]

American manufacturers soon translated the work of Ruhlmann and other French designers into stylish and compact furniture for a well-to-do urban clientele. The New York furniture retailer W. and J. Sloane created the Company of Master Craftsmen in 1925, a cabinetmaking subsidiary intended to manufacture reproductions of historic furniture designs for a mass market. Working with curators at the Metropolitan Museum of Art, the Company of Master Craftsmen made faithful copies of furniture in the museum's collection. But when the Metropolitan hosted a traveling exhibition in 1926 of masterworks from the 1925 Parisian exposition, the firm quickly developed a line much indebted to Ruhlmann and his contemporaries (fig. 119). An American armoire, part of a matching bedroom set manufactured by the Company of Master Craftsmen, reflects French Art Moderne design, but instead of luxurious woods shaped by traditional artisans, it employs innovative and affordable materials, such as veneered lumber-

117
Alexander Calder
American, 1898–1976
Vache (Cow), about 1929
Brass wire
40.6 x 61 cm (16 x 24 in.)

118
James Richmond Barthé
American, 1901–1989
Feral Benga, modeled in 1935
Bronze
H. 47.6 cm (H. 18 ¾ in.)

core plywood and a newly invented sprayed-on finish of cellulose nitrate lacquer.[56] The cabinet thus represents modern American technological and manufacturing achievements married to the most up-to-date Parisian style.

Paris had earned a reputation as a capital of modernism, representing spiritual and creative freedom for American artists. Among those who felt the most liberated in Paris were aspiring African American artists, who had been hampered in the United States not only by a lack of opportunities but also by institutionalized racism. Henry Ossawa Tanner, for instance, found professional success in Paris that he could only dream of achieving in the United States (see fig. 221). His career was an inspiration to succeeding generations of artists of color, and, by the 1920s, Paris had become established as a second home for many black American writers, musicians, performers, and artists. The entertainer Josephine Baker became an overnight celebrity with her performances of *danses sauvages* (wild dances), and French intellectuals and museums collected, displayed, and celebrated the artifacts of worldwide French colonialism: African masks and carved figures, ancient American metalwork, and Oceanic carvings. These objects in turn inspired modern masters like Picasso and Constantin Brancusi to reinvent conventions of representation. This stimulating and sympathetic atmosphere proved inspirational to a number of African American modernists.

The Louisiana-born African American sculptor James Richmond Barthé had already achieved recognition for his naturalistic male nude sculptures when he visited Paris for the first time in 1934; his *African Dancer* (1933) had recently been acquired by the Whitney Museum of American Art, in New York. Barthé had composed his piece from photographs and other indirect

sources, but in Paris he encountered a live African dancer for the first time at a performance of the celebrated Senegalese cabaret performer François Benga. Benga used the stage name Feral Benga to emphasize the animalistic and wild qualities of his performances; his ecstatic, erotic dancing rivaled that of Baker, with whom he sometimes performed. Baker and Benga were successful in Paris because of the complex racial attitudes of the French in the 1920s and 1930s. Parisians were enthralled with what they viewed as "primitive," "exotic," and "sensual" African culture. From today's perspective, these stereotypes appear demeaning, but as one African American historian has noted, "most black Americans in Paris welcomed and praised the racial attitudes of their French hosts. The French seemed to regard blackness as something of value, an attitude noticeably absent in the United States."[57] Barthé returned to New York in 1935 and created his bronze *Feral Benga* from memory (fig. 118).[58] The resulting sculpture encapsulates a complex, international story: Benga, an African man who played on French racial stereotypes to fashion a career; Barthé, an African American artist of mixed racial heritage, making use of Benga's stereotyped African themes; and Paris itself, as the site of their intersection in the 1930s.

A similar cosmopolitan tale can be related through the work of Wifredo Lam, an Afro-Chinese-Cuban painter who found his voice in Paris. Lam first studied art in Cuba and Spain, but by 1938, having become deeply involved in the losing struggle of the Spanish Republican party against the fascists during the Spanish civil war, he had moved to Paris. There he met Picasso, Matisse, and André Breton, the leader of the Surrealist movement. The experience was decisive, reshaping Lam's artistic vision. In his mature work, Lam combined the visual imagination of Cubism and Surrealism with Afro-Cuban mythology to create fantastical compositions in which bird-, fish-, and batlike forms speak to the unconscious (see fig. 200). Dreams and memories unite in ritualistic visions, a unique repertoire of modern art and ancient Afro-Cuban traditions. Lam spent the last thirty years of his life in Paris, the city that liberated

him to pursue an artistic course that helped to reshape the history of art.

Modern styles had made their way from France to the Americas from the time of the Rococo, but in the twentieth century, with the interruptions and violence of two world wars—fought in large part on the fields and beaches of France—painters and craftsmen began to leave Europe to gather in New York. The progressive world's fairs that had once disseminated French styles internationally also moved to the United States, to Chicago in 1933 and to New York in 1939. The French pavilion in New York featured both picturesque rural displays from the provinces and a tribute to technology; in its brochure, the engineer and politician Raoul Dautry united the two, claiming that the French love of craftsmanship evident in traditional work was now being applied to modern manufacturing. He remarked that "a [French] team of automobile engineers, foremen, and workers . . . makes, in spite of the standardization of production which is now the rule, a product that is both precise and elegant, and has every possible refinement . . . [this demonstrates] the traditional qualities of the race, its love of the beautiful and of the well-made piece of work."[59] In this age of technology, Paris was no longer an inevitable destination, although it retained its magnetism, its appeal and position as a center of art, style, and fashion. "I hardly know what will take place of my weekly visit to the Louvre," wrote the painter John Twachtman in 1885, "perhaps patriotism." Twachtman was one of thousands of Americans who had worked in France in the nineteenth century, but his sentiments remained vital, shared by generations to come. As the avant-garde collector and Pennsylvania native Gertrude Stein put it in 1935, "America is my country but Paris is my home-town."[60]

119
Company of Master Craftsmen
for W. and J. Sloane
Armoire
New York, New York, 1926–42
Mahogany, lumber-core plywood, cherry,
tulipwood, maple, rosewood, brass
H. 134.6 cm (H. 53 in.)

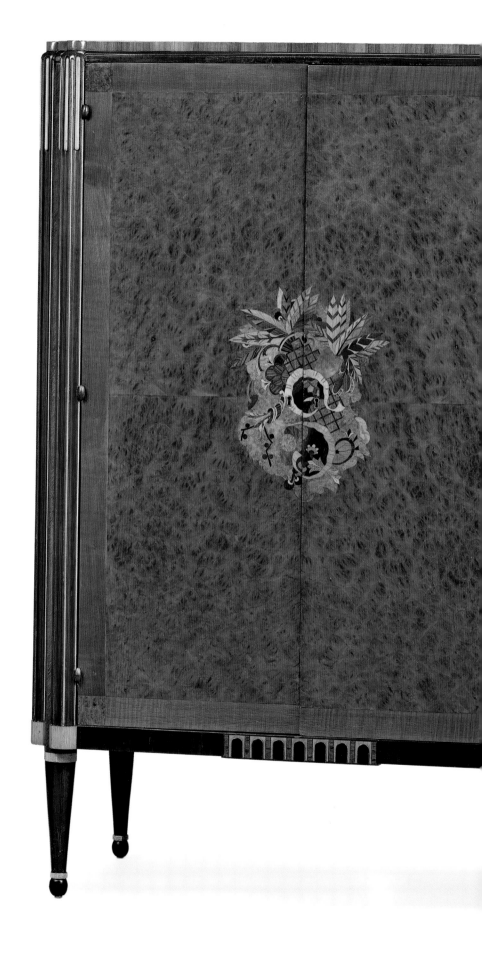

ITALY KAREN E. QUINN AND GERALD W. R. WARD

A site of human habitation for millennia, Italy has been, in succession, the seat of the ancient Roman Empire, center of the Renaissance, and home to the fabled cities of Venice, Florence, and Rome. The art made in Italy over this time has had an enormous and widespread influence on the art of the world for thousands of years. Since the seventeenth century, the relationship between the art of the United States and Italy has been both profound and extensive. Italian works of art and architecture, especially from ancient times and the Renaissance—in the original, as reproductions, and disseminated in printed form—have provided a constant source of inspiration for American artists and craftsmen, who often looked to Italy as their fountainhead. Since the eighteenth century, Italy has served as a mecca for wealthy American patrons seeking enlightenment and for American architects, painters, sculptors, glassmakers, and others who have traveled there in search of training. Since about 1880, a massive influx of Italian immigrants has brought to the Americas their own contributions to the look of American art, and the relationship remains ongoing today.[1]

Although several Italian explorers, including Cristoforo Colombo (Christopher Columbus), Giovanni Caboto (John Cabot), and Giovanni da Verrazzano, had been prominent in the exploration of the North American continent—named for another Italian sea captain, Amerigo Vespucci—the presence of Italian art was felt indirectly in seventeenth- and eighteenth-century America.[2] Colonial perceptions of Italy in most Anglo-American colonies were largely colored by anti–Roman Catholic sentiment; the Massachusetts Puritans, for example, tended to regard the pope as the Antichrist and Rome as the Great Whore of Babylon. Nevertheless, some of the earliest furniture and silver made in colonial New England has Mannerist and Renaissance ornament ultimately derived from Italian sources, filtered through prints and publications from the Low Countries and England.[3] This dichotomy—a perhaps unwitting reliance on the center of the traditional European art world on the one hand, countered by a Protestant-based aversion to elaborate religious art and artifacts (often decried as "idolatry" or "popish trappings") on the other—characterized the ambivalent attitudes toward Italian art in America for centuries. As time passed, some Americans sought recognition for their country by imitating the Old World arts, and others hoped for a more spare, clean, and independent New World art.

Americans, artists and nonartists alike, began to visit Italy in colonial times just before the United States was established as a nation; the first painter to make the trip was Benjamin West, in 1760. American artists were attracted to Italy for the same reasons that Europeans had been journeying there since the Renaissance: to continue their training by copying firsthand the old masters, especially Raphael, but also Michelangelo, Titian, and others, and to study and draw the sculpture and architectural remains of the classical cultures.[4] These venerable collections and ancient ruins of Western civilization were lacking in the New World.[5]

120
John Singleton Copley
American, 1738–1815
The Ascension, 1775
Oil on canvas
81.3 x 73 cm (32 x 28¾ in.)

composition, then considered one of the most important paintings in the Western world and widely known through prints.[6] Copley first learned of the work of Raphael and other masters from engravings and copies he had studied while in Boston. In a letter he wrote to his stepbrother from Italy, he vividly described the transforming experience of seeing the originals in person: "I wish I could convey to you a just Idea of Raphael's Painting."[7] By alluding to the earlier work, Copley would be recognized for paying appropriate homage to the past, but in an original composition.

Copley's yearlong trip to Italy was the artistic equivalent of taking a grand tour—a firsthand grounding in history, art, and culture by extensive travel through the European continent, with Italy as the final destination. Beginning in the sixteenth century and initially associated with young gentlemen of means, Englishmen, Frenchmen, Germans, Scandinavians, and later Americans made the trip. It was considered a proper finish to years of study. All types of travelers eventually joined the pilgrimage. Souvenirs became a significant part of the experience; over time, wealthy travelers brought home jewelry, fans, sculpture, paintings, and other objets d'art to commemorate their trip and serve as reminders of its pleasures.[8] The tourist's most impressive acquisition might be having his or her portrait done. Copley's painting of Mr. and Mrs. Ralph Izard, commissioned by the South Carolina couple while they were on their 1774–75 journey, was executed in Rome and is the only eighteenth-century portrait of Americans on their grand tour done by an American (fig. 121).[9] Beyond a standard likeness of the sitters, the composition is filled with objects related to Italy, which emphasize the Izards' sophistication and connoisseurship. The Greek red-figure vase at the upper left, the sculpture of Orestes and Electra in the center, and the distant view of the Colosseum allude to the classical past. The ornately carved and gilded furniture of eighteenth-century Roman design is probably contemporary to the time of the couple's trip, as is the drawing that Ralph Izard holds of the sculpture behind him.[10] Their clothing, of American (or English) make, distinguishes them as tourists.

These eighteenth-century American travelers to Italy had their counterpart in a small group of Italian

John Singleton Copley, America's foremost portrait painter, left pre-Revolutionary Boston in 1774, spending a brief six weeks in London before heading to Rome in the fall. The first painting he made there, and his first original history painting, was *The Ascension* (fig. 120), based on Raphael's *Transfiguration*, which he would have seen on his visit to the church of San Pietro in Montorio. Copying masterpieces was not only a time-honored artistic tradition that honed the skills of the painter but also a viable way for the traveler to fund his trip, as patrons at home commissioned works for their collections. Copley's *Ascension*, however, was not a direct copy; nonetheless, many viewers at the time would have understood the reference to the Raphael

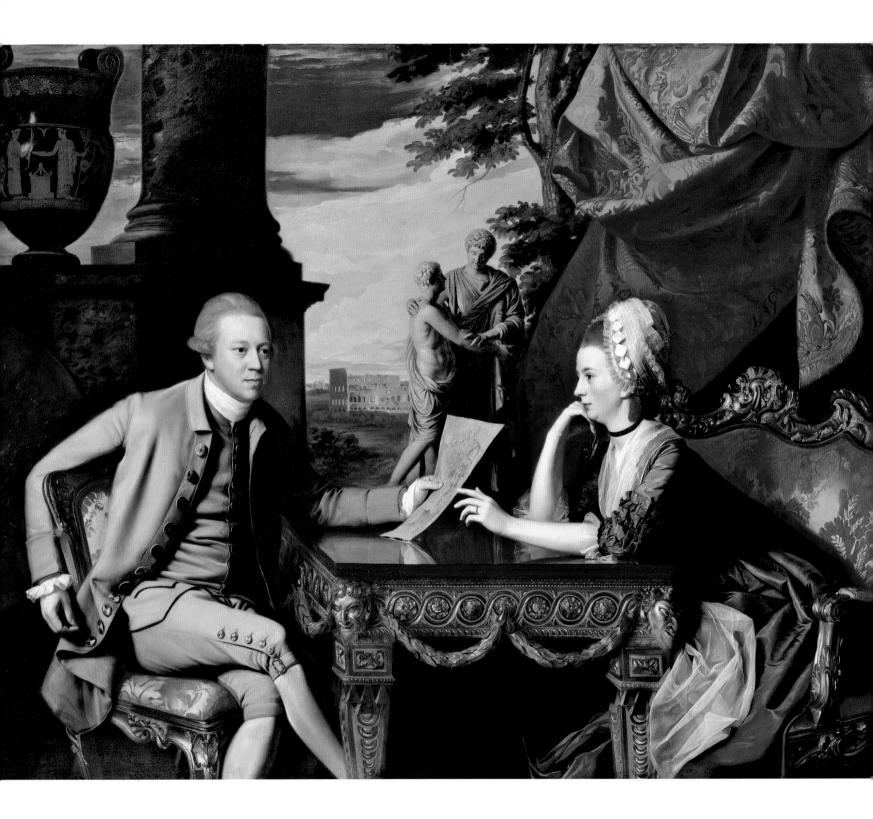

sculptors and painters who came to North America, often at the behest of the new government of the United States. Thomas Jefferson, who incorporated elements from the work of the sixteenth-century Italian architect Andrea Palladio in his designs for Monticello, was particularly enamored of Italy and attempted to promote and foster the study of Italian art, which he appreciated firsthand. Giuseppe Ceracchi (who arrived as early as 1791), Giuseppe Franzoni, and Giovanni Andrei were among the Italian sculptors selected to provide appropriate works for the new nation's Capitol, since it was believed that the United States had no artists to carry out such work. Always careful to avoid "Italian frippery"—a common concern in the story of Italian art and design in America—the architect Benjamin Henry Latrobe directed the sculptors to create architectural details such as the famous corncob and tobacco-leaf capitals, using their skills to design motifs more in keeping with the American experience.[11]

By the second quarter of the nineteenth century, a wave of American artists went to Italy, often establishing studios and spending long periods there. This was particularly true of the first generation of full-time American figurative sculptors, who began to fill the void that had made immigrant artisans a necessity a few years earlier. In a steady stream that persisted for more than a century, American sculptors in Italy studied with European masters, viewed classical, Renaissance, Baroque, and Neoclassical works, and took advantage of the skills of local craftsmen and materials, especially white marble, the material associated with the work of Michelangelo and other masters. The experience of these expatriates eventually translated into an enriched artistic experience for many Americans, as the work they created in Italy was brought back for exhibition.

Horatio Greenough of Boston traveled to Rome in 1825 and became the first American sculptor to pursue training in Italy (see fig. 106). Greenough eventually settled in Florence, where he worked with Lorenzo Bartolini, the renowned professor of sculpture at the Accademia di Belle Arti. Bartolini emphasized the study of anatomy, encouraging his students to observe dissections of human cadavers and to sketch from live models. Hiram Powers and Thomas

Crawford (see fig. 70) were among the other notable first-generation American sculptors to study Greek and Roman sculpture while in Italy.

Randolph Rogers and Harriet Hosmer were prominent members of the next generation of Americans to continue the study of sculpture in Italy. In 1848 Rogers arrived in Florence, where he also studied with Bartolini, Greenough's mentor; he moved to Rome after the Italian sculptor's death and remained there for two decades, becoming fully assimilated into his adoptive country. During his distinguished career, Rogers received honors from the Accademia di San Luca in Rome and was knighted by King Umberto of Italy and decorated with the order of Cavaliere della Corona d'Italia. His *Nydia*, the blind flower girl of Pompeii who searched for her friends after the eruption of Vesuvius in A.D. 79, became one of his most popular subjects with American patrons. A visitor to his shop, on seeing seven Nydias in preparation, commented: "All in a row, all listening, all groping, and seven marble cutters at work, cutting them out."[12] More than fifty replicas were carved for Rogers by these skilled studio assistants, local craftsmen who performed this task for many sculptors of the day. This common practice was a component of craft structure not available in America, and the marble cutters and other local craftsmen were a key element in attracting aspiring American sculptors to Italy.

Hosmer, one of the nineteenth century's most accomplished female artists, began studying sculpture in the United States but moved to Rome in 1852 to advance her education, becoming the first American woman sculptor to do so. There, she served a seven-year apprenticeship with a leading Neoclassical sculptor, the Englishman John Gibson. By the mid-1850s Hosmer's work had become popular, especially her *Sleeping Faun*, depicting a faun sprawled against a tree stump. This work was known for its beautiful, detailed carving (fig. 122). Her mentor John Gibson said, "It is worthy to be Antique"; such a favorable comparison with the classical past was the highest praise Gibson could offer. More important than her choice of subject matter, perhaps, is that Hosmer found the atmosphere in Italy more welcoming to a female artist.[13]

121
John Singleton Copley
American, 1738–1815
*Mr. and Mrs. Ralph Izard
(Alice Delancey)*, 1775
Oil on canvas
174.6 x 223.5 cm (68 ¾ x 88 in.)

122
Harriet Goodhue Hosmer
American, 1830–1908
Sleeping Faun, after 1865
Marble
H. 87.6 cm (H. 34½ in.)

123
Edward R. Thaxter
American, 1857–1881
Meg Merrilies (detail), about 1881
Marble
H. 66.7 cm (H. 26¼ in.)

The classical world and the Renaissance were not the only artistic models at hand in Italy. Edward R. Thaxter, for example, followed in the footsteps of earlier generations of American sculptors frustrated by the lack of opportunities in America. After some training in Boston, he moved to Florence in 1878. He produced several works there, but his *Meg Merrilies* is the only one known to survive (fig. 123). Although derived from several sources, the vigorous carving style and expressive form of *Meg Merrilies* indicate that Thaxter studied the work of Giovanni Lorenzo Bernini, the Italian Baroque sculptor known for his dynamic and energetic works.[14]

Sculptors were not the only American artists to go to Italy in the nineteenth century. When painters went, however, they looked for something else. Although they studied ancient sculpture and the Renaissance masters, it was more important to them to follow in the footsteps of Nicolas Poussin and Claude Lorrain, who in the seventeenth century had helped to establish a classical approach to landscape subjects. In their compositions, these French painters fused the picturesque aspects of Italian scenery with historical references by including ancient architecture and mythological or historic figures, often with a moralizing message alluding to the glories or failures of the past. American painters, aspiring to fit into the tradition of European painting, took up these subjects, whose historic associations were lacking in the New World. They also emulated the compositions of the earlier masters and studied the golden light of the Mediterranean world, which had become a hallmark of Claude's work.

American painters produced canvases based on sketches done on-site, but like Poussin and Claude, they most often created, edited, and sometimes idealized their compositions in the studio. In *Moonlight*, Washington Allston forged an imaginary view that evokes Italy—a composite that includes a stretch of land in the background reminiscent of the Roman Campagna, a dome among the group of buildings that could be the Pantheon, and the river in the foreground that may be the Tiber (fig. 124).[15] Allston sought to capture the mood and spirit of Italy rather than specific sites. For him, Italy was a state of mind steeped in the memories of his 1804–8 trip there, an experience he would draw on for the rest of his career.

Topographical accuracy appealed to other American painters, and they continued the tradition of view making established in the seventeenth and eighteenth centuries by artists painting such images mostly as souvenirs for travelers on the grand tour. In *The Temple of Segesta with the Artist Sketching*, Thomas Cole juxtaposed the ancient structure of the temple with the surrounding vista of its actual setting rather than an imaginary one (fig. 125). The realistic rendering of the site was important, but so, too, was the artist's interpretation of it. What American painters sought from the classical world, which they found in Italy—mainly the sublimity and historic meaning of the landscape as the source of Western civilization—is summed up in Cole's description of the temple: "And surely he [the traveler] never passed through such an Arcadian scene as this. . . . It is a majestic pile. . . . All the columns are standing; the entablatures and pediments are in pretty good preservation, but it is roofless and flowers and weeds are now waving where once trode the white robed priests. The breezes from the fragrant mountains and the distant sea, of which it commands a fine view, sigh through it in harmony with its sad and solitary grandeur."[16] Ironically, the fifth-century-B.C. Greek Doric temple had been left unfinished at the outbreak of war with Carthage in 409 B.C. and never had a roof, underscoring Cole's romanticized vision.

John Gadsby Chapman set his lively genre scene *Harvesting on the Roman Campagna* on the expansive plain just outside Rome, a site replete with ancient connections: the ruins of aqueducts, tombs, towers,

124
Washington Allston
American, 1779–1843
Moonlight, 1819
Oil on canvas
63.8 x 91 cm (25 ⅛ x 35 ¾ in.)

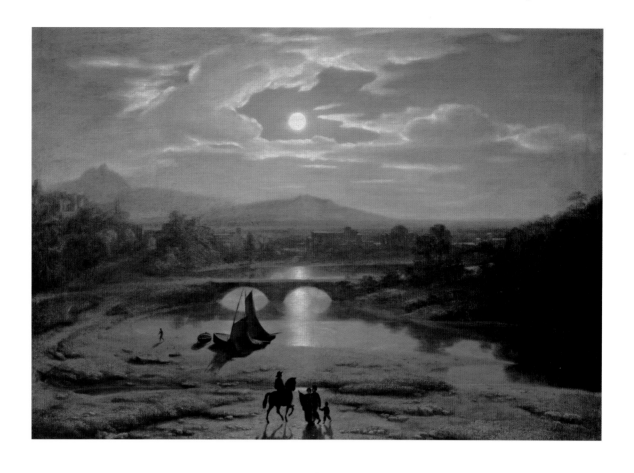

125
Thomas Cole
American, born in England,
1801–1848
*The Temple of Segesta with the
Artist Sketching*, about 1842
Oil on canvas
49.9 x 76.5 cm (19 ⅝ x 30 ⅛ in.)

126

John Gadsby Chapman
American, 1808–1889
Harvesting on the Roman Campagna, 1867
Oil on canvas
73 x 182.2 cm (28¾ x 71¾ in.)

and roads (fig. 126). Although the best-known and possibly most-represented structure on the Campagna was the row of ancient arches of the Claudian Aqueduct, Chapman headed farther out, southeast to the foot of the Alban Hills. The precise location of his composition was important to him, as shown by the etching after it that he sent to Robert O. Fuller, the Cambridge, Massachusetts, iron manufacturer who commissioned the painting. Chapman carefully inscribed the location, identifying Monte Cavo in the right background, Rocca di Papa in front of it, Tusculum to the left, and so forth. Of equal importance, however, was the activity he depicted, what he called "the process and details of getting out the grain," and which he documented in a lengthy letter to Fuller.[17] In the painting, Chapman featured the duties related to the harvest. In the center, for example, a worker is driving a group of six horses to trample the already scythed wheat, separating the grain from the straw. The appeal of Chapman's work was summed up by a contemporary writer, "His compositions illustrate the picturesque aspects of Italian peasant life,

associated with the ruins of the Campagna and with the landscape charms of the mountains near Rome, and they constitute some of the most prized souvenirs of an American traveller's sojourn in Italy."[18]

The historical associations with the Italian past were superseded later in the nineteenth century by the exploration of color and light as subjects in themselves. Venice, which painters visited to study the techniques and colors of Titian, Tintoretto, and Veronese, did not become a subject for Americans until the third quarter of the century. John Singer Sargent had spent time in Venice as early as 1880 and intermittently thereafter, but he visited almost yearly between 1900 and 1914. On these trips he increasingly turned to watercolor, a medium especially suited for capturing the ephemeral effects of the ever-changing light on buildings and water and their reflections on each other, features unique to Venice. In *Venice: Under the Rialto Bridge*, Sargent chose to depict the less familiar underside of the famous bridge (fig. 127). The fluid brushstrokes evoke the shimmering sunlight and shadow on the restless water of the canal.

Even though the paintings by Chapman and Sargent pictured modern-day Italy, the Italian Renaissance, four hundred years in the past, continued to exert its influence on art produced in the United States. As part of the successive and overlapping series of revival styles characteristic of the nineteenth century, some American furniture pieces and other objects in the post–Civil War era were created in a Renaissance-Revival mode that ultimately was deeply informed by Italian sources.[19] A more profound evocation of the Italian Renaissance in all the high-style arts occurred later in the century. From about 1876 to the beginnings of World War I, many Americans, sensing their rising power on the world's stage, believed that the spirit of the Renaissance in Italy (about 1420 to about 1580) rightfully should be reincarnated in America. Artists of all varieties looked to the Italian past to generate an art that would be truly American. John La Farge observed in 1900 that the new practice "was not one [of] imitation; it is rather the revelations of one's real intel-lectual desires, the initiation into one's real home and family."[20]

Augustus Saint-Gaudens was the leading American sculptor of this period, best known for his work in bronze. His bronze reliefs, for example *Mildred Howells* (fig. 128), are indebted to his study of works by Italian Renaissance masters like Pisanello and Donatello, as well as to sculptures by his French contemporaries, such as Henri Chapu. Donatello's masterpiece *Madonna of the Clouds*, of about 1425–35, represents the type of subtle textures and painterly techniques that Saint-Gaudens sought in his own reliefs.[21] Reflecting the notion that the work of artists should be collaborative—a Renaissance ideal—*Mildred Howells* is surrounded by a frame designed by the architect Stanford White.

Much of Renaissance art was funereal, and Frank Duveneck's memorial for his wife, *Tomb Effigy of Elizabeth Boott Duveneck*, was done in this spirit (fig. 129).[22] Duveneck and his wife enjoyed a brief time together in Florence, and after her untimely death, he

127
John Singer Sargent
American, 1856–1925
Venice: Under the Rialto Bridge,
about 1909
Transparent and opaque
watercolor over graphite
pencil on paper
27.6 x 48.3 cm (10⅞ x 19 in.)

128
Augustus Saint-Gaudens
American, born in Ireland,
1848–1907
Frame attributed to Stanford White
American, 1853–1906
Mildred Howells, 1898
Bronze, brown patina,
lost-wax cast
Frame: 78.7 x 73.7 cm (31 x 29 in.)
Diam. of bronze: 53.3 cm (21 in.)

129
Frank Duveneck
American, 1848–1919
Clement John Barnhorn
American, 1857–1935
Tomb Effigy of Elizabeth Boott
Duveneck, 1894
Marble
H. 71.1 cm (H. 28 in.)

130
John La Farge
American, 1835–1910
The Infant Bacchus window, 1885
Leaded stained, enameled, and
opalescent glass
226.2 x 112.7 cm (89 1/16 x 44 3/8 in.)

had the memorial, cast in bronze, placed on Elizabeth's grave in the American cemetery in Florence in 1892. The marble version was made in 1894 and put on display at the MFA for the benefit of family and friends in this country. In the tradition established earlier in the century, it was carved in Florence by several Italian stonecutters, with some of the finish work done by Duveneck himself. The recumbent form is based on medieval and early Renaissance examples.[23]

The World's Columbian Exposition of 1893 in Chicago, celebrating the four hundredth anniversary in 1892 of the "discovery" of America as declared by Columbus, epitomizes the splendor of the American Renaissance. There, at the Great White City, American manufacturers of all types revealed their awareness of European modes, as they attempted to demonstrate their knowledge of current trends and to establish a prominent place as a world leader in design, fashion, technology, and other areas.[24]

Wealthy Americans also sought to assert their taste and prominence in world affairs by hiring entire studios of artists and craftsmen to decorate the interiors of their homes, creating mansions worthy of the Medici family of Florence. Mural paintings, stained glass, textiles, and wallpapers as well as furniture pieces and small objects were harmonized to establish a unified decorative scheme. Stained glass had not been explored much in America, and both John La Farge and Louis Comfort Tiffany used it to great effect as part of the interior decoration of both public and private buildings. La Farge's *Infant Bacchus*, made for a home in Beverly, Massachusetts, reflects the American Renaissance use of classical imagery in combination with La Farge's mastery of color and his material (fig. 130).

Although Italy had been the ultimate source of inspiration for Western art for centuries, toward the end of the nineteenth century a new aspect of the Italian American story began. Several Italian immigrants, as noted, had made an impact on American plastic arts, such as the sculptors of the Capitol in the late eighteenth and early nineteenth centuries. Later in the century, Constantino Brumidi, best known for his work at the Capitol in the third quarter of the nineteenth century (when he was regarded as "the Michelangelo of the United States Capitol"), contin-

131
**Carved by Salvatore Cernigliaro
("Cherni")**
American, born in Sicily, 1879–1974
Carousel figure of a pig, about 1905
Painted wood, glass
L. 127 cm (L. 50 in.)

ued in that vein, although his work was much criticized by American politicians and artists, who objected to giving lucrative commissions to a foreigner and to the "heathen mythology" his frescoes expressed.[25] But immigrant Italian artists had been the exception rather than the rule.[26] That changed dramatically starting in about 1880. Fleeing poor economic conditions, especially in southern Italy, some 4.1 million Italians entered America between that year and 1920, arriving mostly through New York City. Although a substantial percentage returned to Italy (the *ritornati*), many stayed, usually living in urban settings.[27]

Many of these Italian immigrants were farmworkers, but some brought with them Old World bench skills in specialized crafts and trades, such as woodworking, jewelry, silversmithing, and, again, sculpture—both high style and vernacular. Members of the Piccirilli family of sculptors and marble cutters, for example, came to this country in the 1880s and established a workshop in New York City. American sculptors, including Saint-Gaudens and Daniel Chester French, drew on their technical expertise; French used them, for instance, to enlarge his model of Abraham Lincoln into the over-life-size marble figure in the Lincoln Memorial. Attilio Piccirilli became the most famous member of the family, receiving many commissions in his own right, including one for the memorial to the battleship *Maine*, located in New York's Columbus Circle.[28]

In the popular and vernacular arts, the carving of carousel figures at the turn of the century was dominated by European immigrants.[29] A carousel pig, attributed to Salvatore Cernigliaro, is a good example (fig. 131). Cherni, as this Sicilian native was known, is often credited with introducing menagerie figures, including the lion, zebra, and sea horse, as well as the pig, to the line of carousel figures produced by the Gustav A. Dentzel Carousel Company of Philadelphia.[30] Dynamic in form and charming in personality despite his sharp teeth, the pig has rippled layers of muscle and fat under his chin and on his plump hindquarters, perky ears, and a flying posture that energizes his appearance.

Icilio Consalvi came to America about 1890 and in time became perhaps the most talented artisan active in Boston's musical instrument industry. His main employer was the banjo maker W. A. Cole, but Consalvi also apparently worked as a journeyman specialist for other instrument firms in Boston, providing mother-of-pearl inlays with incised decoration, hardware with delicate engraving, and beautifully carved ornaments for their products.[31] Consalvi's banjo masterpiece, according to his own account, contains thousands of pieces of engraved and inlaid pearl and ivory (fig. 132). The hooks and hardware that encircle the head are of finely chased silver and gold, and a resonator ring, patented by Consalvi in 1896, is mounted atop the rim, its silver surface engraved with a handsome laurel wreath (an ancient sign of victory). The heel of the neck is carved and gilded to represent the head of Christopher Columbus, whose face is also rendered in mother-of-pearl at the upper end of the fingerboard. Consalvi was probably inspired to include these motifs by the 1892 celebrations of the four hundredth anniversary of Columbus's voyages to America.[32]

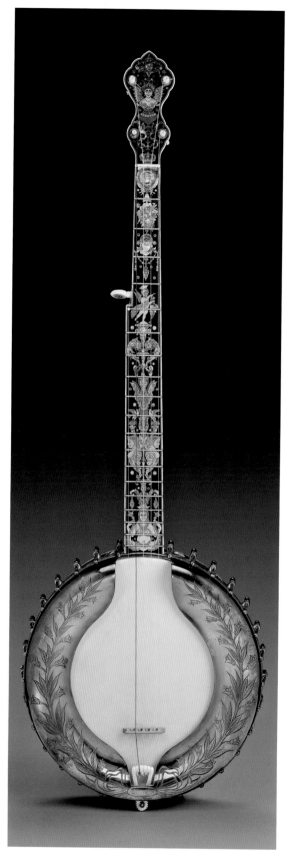

132
Icilio Consalvi
American, born in Italy, 1865–1951
Banjo, 1895
Maple, ebony, mother-of-pearl, abalone, ivory, silver, semi-precious stones
L. 88.9 cm (L. 35 in.)

133
William James Glackens
American, 1870–1938
*Italo-American Celebration,
Washington Square*, about 1912
Oil on canvas
65.4 x 81.3 cm (25 ¾ x 32 in.)

The immigrant experience was one aspect of modern urban life that appealed to a group of early-twentieth-century painters who came to be known as the Ashcan School for the unsentimental realism of their subjects. In *Italo-American Celebration, Washington Square*, William Glackens depicts a parade commemorating Christopher Columbus's discovery of America (fig. 133). Columbus Day was first marked with a celebration by Italian Americans in New York in 1866, although it was not made a federal holiday until 1937. Here the Old World intersects the New, seen in details like the Italian and American flags displayed at the right, the crowd of the well-heeled and the more modestly attired, and the setting, a neighborhood that had become a mix of the town houses of wealthy, old New York families and the tenements of the new arrivals. Even Stanford White's

Washington Square Arch ultimately traces its form back to the triumphal arches of ancient Rome.

Joseph Stella, himself an immigrant, also merged the Old World and the New in his paintings of the Brooklyn Bridge, an engineering marvel that made reference to the past (albeit not necessarily Italian) in the Gothic arches of its towers. Traveling back to Italy to study, Stella became familiar with Futurism, the Italian modernist style that attempted to capture motion and speed, a more abstract approach than almost any method used by artists in the United States when he returned to New York in 1912 (the painting by Glackens, almost impressionistic, is dated that year, for example). In the fractured composition and jewel-like color of *Old Brooklyn Bridge*, Stella used this method to evoke the intangible qualities of movement (fig. 134).

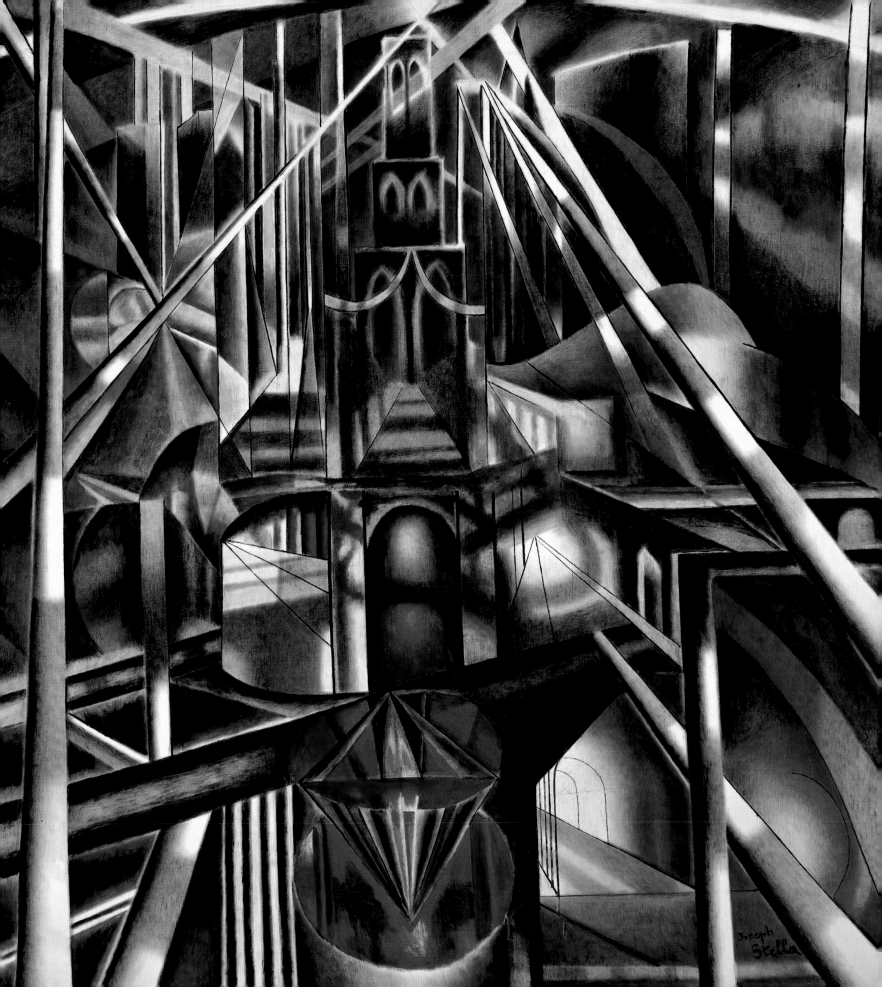

134
Joseph Stella
American, 1877–1946
Old Brooklyn Bridge, about 1941
Oil on canvas
193.7 x 173.4 cm (76 ¼ x 68 ¼ in.)

135
Paul H. Manship
American, 1885–1966
Lyric Muse, 1912
Bronze, dark green patina;
lost-wax cast; copper wire
H. 32.4 cm (H. 12 ¾ in.)

136
Dale Chihuly
American, born in 1941
Rembrandt Blue and Oxblood
Persian, 1990
Blown glass
88.9 x 67.3 x 69.9 cm
(35 x 26½ x 27½ in.)

137
Lino Tagliapietra
Italian, active in United States,
born in 1934
Vessel from the *Mandara* series,
2006
Blown glass
H. 59.7 cm (H. 23½ in.)

Paul H. Manship—one of America's most popular sculptors in the 1920s and 1930s—was another exception. Awarded the American Prix de Rome in 1909 as a young man, Manship was the recipient of a three-year fellowship at the American Academy in Rome, which he put to good use by traveling widely throughout Italy and Greece, studying a broad range of works of art, including Hellenistic and Renaissance bronzes. His *Lyric Muse* of 1912, created near the end of his stay at the American Academy, reflects his ability to synthesize modernism with archaic elements derived from his European studies (fig. 135).[33] The prominent architects, painters, and sculptors who established the academy in the 1890s as an outgrowth of the Chicago World's Fair would have been pleased with Manship's demonstration of the "advanced position of this country [the United States] in the arts of

civilization" and his willingness to improve his art through study in what they believed was still "the art centre of the world."[34]

Just as American sculptors went to Italy in the nineteenth century to learn their craft, American glassmakers in the twentieth century traveled to Italy, specifically to Venice and the small nearby island of Murano, to learn theirs. These places have long been centers of artistic glassmaking, and the influence of highly skilled Italian glassblowers has been felt throughout the world since at least the thirteenth century. Even the Virginia Company sent Italian glassmakers to Jamestown as early as 1620.[35] The contemporary studio craft movement in America is generally understood to have been pioneered by Harvey Littleton and Dominick Labino in the 1960s at the University of Wisconsin.[36] Dale Chihuly is often cred-

ited with being the first American studio glassmaker to study the ancient craft in Italy. He was granted permission to work at the Venini glass factory on Murano. His experiences there have informed his work ever since. His *Rembrandt Blue and Oxblood Persian* vessel of 1990, for example, is indebted in its undulating form to much earlier glasswork by Paolo Venini, who started working as early as the 1920s (fig. 136).

Chihuly was not alone. Richard Marquis worked at Salviati and then moved to the Venini shop. During his stay, he learned many techniques and enhanced his understanding of others, such as the use of *murrine* (mosaic) cane glass. This technique, known to the ancient Egyptians, was perfected in sixteenth-century Venice and revived for the Venini factory in the 1940s by the Italian glass artist Carlo Scarpa. Marquis's *Marquiscarpa* makes use of the *murrine* technique and is an homage to Scarpa.[37]

The career of Lino Tagliapietra (universally known as Lino) exemplifies the interconnectedness of Italy and America in modern studio glass. Lino plied his craft in Italy for several decades. Since 1979 he has traveled frequently to the United States, where he has inspired nearly every American glass artist through lectures and demonstrations. His large vessel from his *Mandara* series is an example of the glass he produced during one of his recent stays in the United States (fig. 137).

Thus, from Mannerism to modern glass, the arts of Italy and the United States have intersected in myriad ways since the seventeenth century. As with most things, the relationship has been tinged with contradictions. Italy's centrality as the mother of all the arts has held great appeal for many American artists, craftsmen, and wealthy patrons, although other Americans have been troubled by the elaborate, even gaudy, nature of much Italian art—especially those images and objects redolent of luxury, excess, and self-indulgence. All of that seemed out of place in a new republican land, and, for some, cosmopolitan yearnings for Continental sophistication were often seen as a threat to rock-ribbed patriotism.[38] Today, however, such ideological concerns seem largely an artifact of the past as Italian culture has seeped into American life at many levels.

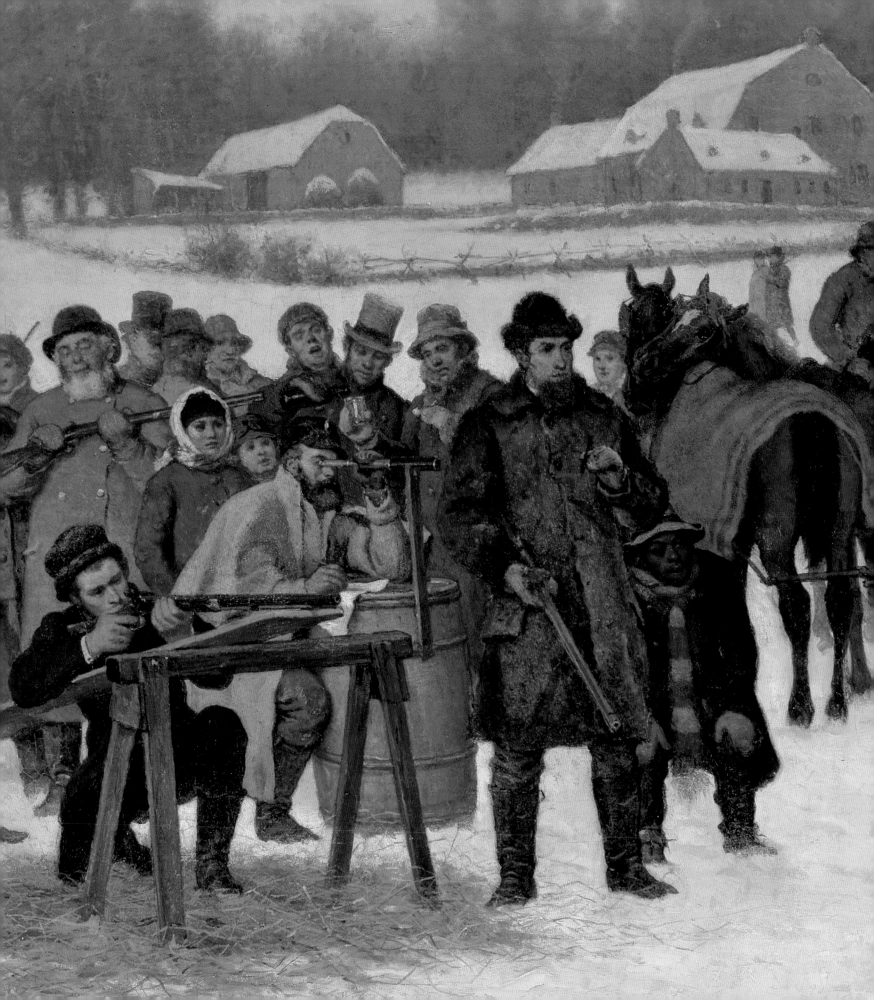

GERMANY ELLIOT BOSTWICK DAVIS AND DENNIS CARR

As was the case with many groups, the majority of Germans who settled in North America before the American Revolution left their homeland to escape the effects of poor crops, overpopulation, and lack of work. Many of these people were either skilled artisans able to make a living by their various trades or propertied peasants who would make their mark in the New World.[1] Although they came from a wide area of Europe made up of modern-day Germany, Switzerland, Austria, Poland, and Lithuania, most spoke German and shared a sense of communality based primarily on religious beliefs or allegiances to one of the many principalities in the region. Works of art produced in their communities tended to stay there and, because of this insularity, remained as much German as American. In the nineteenth century, by contrast, American society became more heterogeneous, and objects circulated more broadly. The impact of German art in the Americas in the twentieth century was more far-reaching. Artists who came to this country often taught or even founded schools, thereby disseminating German pedagogy and ideals, as well as sharing and exhibiting their works of art.

The early German North American colonial settlements—from Ontario, Canada, in the north through southeastern Pennsylvania, Virginia, and into North Carolina in the south—remained culturally German and often German-speaking. These communities coexisted but in many cases did not seek to integrate fully with their English-speaking neighbors, bearing witness to the settlers' strong roots and their interest in maintaining circumspect and sometimes closed societies. They conducted business, wrote legal contracts, certified marriages, and recorded births with documents written entirely in German or in various dialects, often embellishing them with illustrations harkening back to earlier forms of medieval manuscript illumination. They decorated their homes with plates inscribed with German and Swiss sayings and dower chests painted with Old World emblems, and they lived in buildings derived from architectural models from central Europe.[2]

Perhaps the most easily recognized of these Germanic objects made in the North American colonies are fraktur drawings, produced in Pennsylvania during the late eighteenth and early nineteenth centuries. Pennsylvania may have been especially attractive to early German settlers because of William Penn's offer of land suitable for farming.[3] The term *fraktur* denotes a type of illumination that often combined black-letter script, which was characterized by the angled calligraphic line made by the scribe's lifting of the quill or pen to break the stroke and thus form individual letters, and an array of decorative motifs such as hearts, tulips, birds, and figures. Fraktur drawings were first made to commemorate important religious rites of baptism, confirmation, and marriage, and essentially documented an individual's

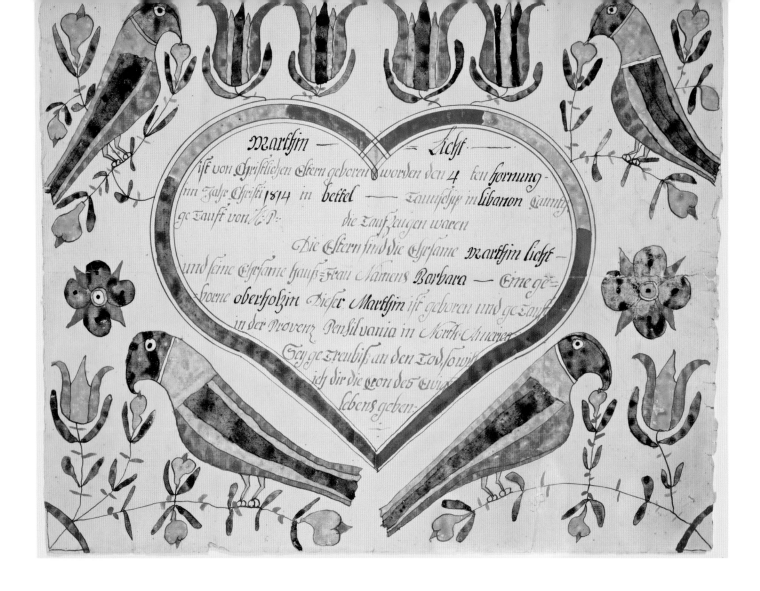

138
Martin Licht, 1814, 1814
Watercolor and pen in red
and black ink on paper
33.7 x 40.6 cm (13¼ x 16 in.)

relation to society. In Germany, records of important religious rites of passage were largely the purview of the local Catholic or Protestant churches and were eventually overseen by the state, but in the early German communities in the New World, in the absence of centrally controlled institutions for recording vital statistics, fraktur drawings filled that void. Over time, fraktur drawing also flourished in Pennsylvania German parochial schools, where the master presented fraktur decorations as models to copy, awards of merit, or tokens of affection to pupils at the end of the school year. Whether created for religious or secular reasons, Pennsylvania German fraktur usually incorporated a passage from the Bible.

A baptismal certificate for Martin Licht in 1814 exhibits many of the finest qualities of fraktur drawings (fig. 138). In this instance, the calligrapher carefully paired birds on either side of a central heart shape: the two at the top face inward, whereas the two birds at the bottom face outward. Tulips bloom along the upper edge of the sheet and bracket the birds below. Such lavish depictions of birds, hearts, and flowers could either symbolize the nurturing growth of the human spirit or be purely decorative elements. In the composition commemorating Licht's baptism, the artist exhibited a mastery of symmetrical design. As was typical for fraktur drawings in the New World, the calligrapher used iron gall inks (the kind medieval monks used to write their manuscripts)

and a limited palette of colors—reds, yellows, and blues with accents of green—choosing them from the latest imported pigments.[4]

Text and imagery are similarly incorporated in other decorative arts objects made by Germans in Pennsylvania, such as redware plates. Around the edge of this plate appear the German words "Ich bin gemacht von hefner sin wan ich verbrecht so bin ich hin im iahr 1834" (I am made of potter's thoughts. When I break, I will be gone. In the year 1834) (fig. 139). This expression of loss and the fragility of life (memento mori) was a common theme in European art, and the predominantly Protestant settlers brought it to their new communities in America. The decoration of tulips and vines, common Pennsylvania German motifs, is incised into the slip-decorated ceramic with a technique known as sgraffito (Italian for "scratched"). Like many fraktur drawings, the plate is signed by the maker, in this case with a simple *Neis*, the last name of the potter John Neis (Johannes Neesz), who lived in Upper Salford Township in Montgomery County, Pennsylvania.[5]

Trained German craftsmen were highly sought after in specialized trades and manufacturing industries seeking to gain a foothold in the New World. English investors invited German glassmakers to Jamestown, Virginia, the earliest permanent settlement in North America, to establish a glasshouse in 1608, the year after the founding of the colony.[6] Later, in 1752, German craftsmen established a productive glass manufactory in an area known as Germantown (now Braintree), Massachusetts.[7] Glassblowing required large quantities of fuel (wood was the cheapest), and chronic timber shortages in England and parts of Europe made it an increasingly difficult industry to sustain, despite the presence of many trained craftsmen. Although the earliest attempts in Virginia and Massachusetts failed to produce a viable industry to compete with English imports, they paved the way for successful German-run glasshouses during the eighteenth century. The most notable of these included the manufactories headed by Caspar Wistar in New Jersey, Henry William Stiegel in Pennsylvania, and John Frederick Amelung in Maryland, all using skilled workmen brought from Germany.[8] Only Amelung's New

139
Attributed to John Neis
1775–1867
Plate (detail)
Montgomery County, Pennsylvania, 1834
Earthenware with incised and slip decoration
Diam. 27.3 cm (Diam. 10¾ in.)

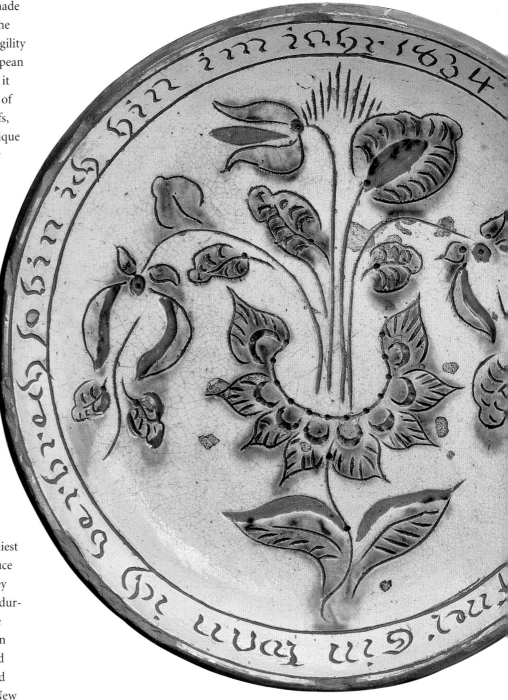

140
Attributed to the New Bremen Glass
Manufactory of John Frederick
Amelung
American, born in Germany,
1741–1798
Covered goblet (*pokal*), 1784–95
Nonlead glass, free blown
H. 31.4 cm (H. 12 ⅜ in.)

141
Engraved by Louis Vaupel
American, born in Germany,
1824–1903
Goblet, about 1860–75
Blown, cobalt blue cased glass,
cut and engraved
H. 15.9 cm (H. 6 ¼ in.)

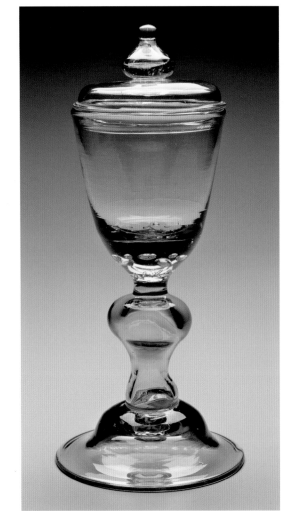

Bremen Glass Manufactory in Frederick County labeled certain of its products, and consequently we know of a relatively large body of work that was made in the short time the factory was in business (1784–95), including a rare covered goblet, or *pokal* (fig. 140). Notable for the grayish green cast of the glass typical of New Bremen products, the pokal has stylistic similarities to eighteenth-century vessels from the glassmaking region of the Weser River valley in Germany, where Amelung had trained, including the characteristic cluster of bubbles in the base of the bowl, found in products of the Lauenstein factory in Hannover.[9] The goblet lacks engraving, befitting its use as a Communion vessel, and its history indicates that it may have been commissioned for a nearby German Lutheran and Evangelical Reformed church, established in 1781 in Biglerville, Pennsylvania, about forty miles north of the factory in New Bremen.

By the mid-nineteenth century, certain forms of German craftsmanship found a ready market outside Germanic communities. One such form was Bohemian-style colored and engraved glass, which was created with labor-intensive and complex techniques that had originated in Bohemia (now the Czech Republic) in the sixteenth century. The demand for this kind of glass was so great that skilled glassworkers adept in the technique found ready work in the United States. Among these glassworkers was Heinrich Friedrich Louis Vaupel, the son of a glassmaker and engraver from Schildhorst, Prussia. He arrived at the New England Glass Company in East Cambridge, Massachusetts, in April 1851, as a humble technician and quickly rose to the position of first engraver, responsible for overseeing the engraving of glass vessels and presentation pieces for the next three decades.[10] A goblet with engraving attributed to Vaupel from the late 1860s or 1870s displays his skillful handling of figures and balancing of form and movement characteristic of the best German glass of the period (fig. 141). Here, wolves attack a galloping horse in a traditional hunt scene accentuated by the careful delineation of rippling muscles and detailed foliage framing the action. The striking cobalt blue casing of the bowl of the goblet

surrounds a layer of clear lead glass and provides a background of color for the cameolike figures, which were skillfully cut using a grinding wheel. Until the late 1870s, this central European style of *Glaskunst* was among the most popular in the American market, made more widely known through expositions such as the Fifth Exhibition of the Massachusetts Charitable Mechanic Association in Boston in 1847 and the Crystal Palace Exhibition in New York in 1853.[11]

German immigration to North America was not confined to the East Coast and Canada, and by the nineteenth century it had spread to areas as far south as Texas and westward to the Comanche territory. A good deal of furniture survives from the Texas Hill Country, including a large wardrobe, or *Kleidershrank*, made by Heinrich Kuenemann II of Fredericksburg, Texas (fig. 142). Kuenemann, who came from a village near Hannover, immigrated to Galveston in 1845 as a young child. He later moved to Fredericksburg, a community settled mostly by German Americans beginning in the mid-1840s. By 1853 the population of Gillespie County, including Fredericksburg, was 85 percent German.[12] The wardrobe is made in the Biedermeier style, a German and Austrian interpretation of the Neoclassical mode, with the heavy framed construction typical of German folk furniture of the eighteenth century. The wardrobe features highly figured southern yellow pine, a local wood used to great visual effect, particularly in the paneled doors and drawer fronts. Kuenemann, like his father-in-law, Johann Peter Tatsch, a Prussian-born furniture maker, produced many of these traditional wardrobe forms to cater to their predominantly German American audience. To do so, they utilized local woods and sometimes mass-produced decorative elements, such as the drawer pulls and spiral colonnettes, to adapt to new conditions and tastes on the western frontier.

In more urban areas, especially on the East Coast and in the upper Midwest, factory production of furniture benefited from the infusion of German-trained craftsmen in the nineteenth and early twentieth centuries. Among the waves of immigrants were important furniture makers such as John Henry

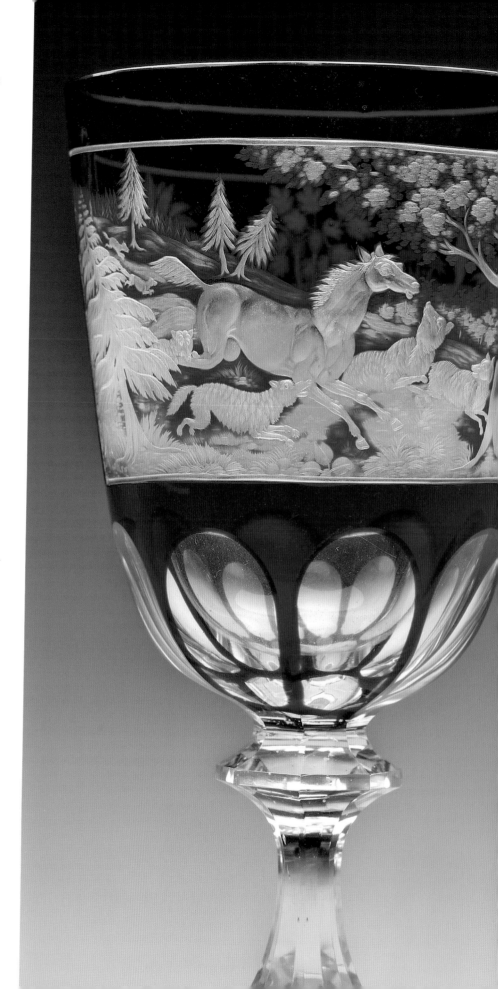

Belter and Gustave and Christian Herter (see fig. 245), who, along with the French and others, became a major, if not dominant, influence in the furniture trades. Belter settled in New York in 1833 after emigrating from his native Württemberg, Germany, where he trained as a cabinetmaker's apprentice. The furniture style he introduced to the antebellum North was notable both for its highly ornamental carving in the Black Forest tradition and its method of manufacture: bending laminated rosewood into shape with steam heating, a process Belter patented (fig. 143). Because his factory in New York employed numerous apprentices and craftsmen, many of them immigrants, the Belter style lived on, even after his death in 1863 and the factory's closing four years later. Gustave Herter, who had trained with his adoptive father, Christian, a skilled woodworker in Stuttgart, Germany, immigrated to New York in 1848 and later established a furniture factory. When his half brother Christian joined him, the Herter Brothers firm became highly successful in marketing a wide range of furniture styles and providing full-service interior design to wealthy clients in the post–Civil War period.

During the nineteenth century, many American artists looked to Europe for training and inspiration. Those who chose to go to Germany, rather than England or France, were often of Germanic heritage or had been born in Germany but grew up in the United States and returned to Germany for training. Both Emanuel Leutze and Albert Bierstadt fall into this category.[13] Düsseldorf initially attracted American artists, since the academy there offered a program rich in history and landscape painting and a highly collegial atmosphere. One American painter, George Henry Hall, characterized the traditional course of study in this way: "The Düsseldorf School was excellent in all the preliminary art studies, drawing from the nude, anatomy, perspective and composition; but in color it was very deficient; not one of the many artists living there was a colorist."[14] Composition on a grand scale, not color, was emphasized by the director of the academy, Wilhelm von Schadow, who was known for his history painting. Landscape painting also flourished in

Düsseldorf, following Karl Friedrich Lessing's formation in 1827 of the Association for Landscape Composition with Wilhelm Schirmer, who, with Andreas Achenbach, was one of the leading landscape painters in residence.[15] The appeal of the academy was its very liberal curriculum and willingness to draw on many different styles of painting, among them the English, French, Belgian, Norwegian, and Russian.[16] Leutze fulfilled the role of mentor and advocate, often interceding on behalf of the American artists, helping them circumvent admissions requirements, or allowing them to share his studio space.

Among those whom Leutze befriended were John Whetten Ehninger, Eastman Johnson, Worthington Whittredge, and Bierstadt. While at the academy in Düsseldorf, Ehninger focused on acquiring basic drawing skills, which he considered one of the primary distinctions between study there and elsewhere in Europe or the United States. Ehninger's later *Turkey Shoot*, with its many carefully delineated figures focused on a single action, is closely related in composition to history paintings by other Düsseldorf artists (fig. 144). The composition epitomizes Hall's characterization of the lack of color in Düsseldorf painting; it is a somber scene in which browns and grays play across a monochromatic winter landscape. In addition to his highly accomplished anatomical and portrait drawings, Johnson took home with him from Düsseldorf an ability to create accomplished genre scenes incorporating multiple figures. Johnson shared an atelier with Leutze and other artists while Leutze was working on his monumental *Washington Crossing the Delaware* (1851, Metropolitan Museum of Art). After returning home, Johnson produced masterly large-scale genre scenes such as *Life in the South* (1859, New-York Historical Society), *The Corn Husking Bee* (1876, Art Institute of Chicago), and *Family Group (The Hatch Family)* (1871, Metropolitan Museum of Art). These, like Ehninger's *Turkey Shoot*, recall the ambitious scenes with multiple figures arrayed across a shallow foreground that he would have been familiar with during his stay in Düsseldorf, such as Leutze's *Washington Crossing the Delaware*.

Leutze and Achenbach established the Malkasten, a gathering place where the American artists could mingle with the leaders of the Düsseldorf Academy.[17] Whittredge and Bierstadt eagerly took advantage of this opportunity. For Whittredge and Bierstadt, the association with the academy inspired forays into painting outdoors, which would become a mainstay of their later work. Whittredge related how Bierstadt's experience in Düsseldorf inspired him to take to the woods.

[He] fitted up a paint box, stool and umbrella which he put with a few pieces of clothing into a large knapsack, and shouldering it one cold April morning, he started off to try his luck among the Westphalian peasants where he expected to work. He remained without a word to us until late autumn when he returned loaded down with innumerable studies of all sorts, oaks, roadsides, meadows, glimpses of water, exteriors of Westphalian cottages, and one very remarkable study of sunlight on the steps of an old church. . . . [It] was a remarkable summer's work for anyone to do, and for one who had had little or no instruction, it was simply marvelous.[18]

142
Heinrich Kuenemann II
American, born in Germany,
1843–1914
Wardrobe (detail), about 1870
Southern yellow pine
H. 221.7 cm (H. 87¼ in.)

143
Attributed to John Henry Belter
and Company
Slipper chair
New York, New York, 1844–67
Carved and laminated rosewood
H. 114.3 cm (H. 45 in.)

144
John Whetten Ehninger
American, 1827–1889
Turkey Shoot, 1879
Oil on canvas
63.5 x 110.2 cm (25 x 43 3/8 in.)

In the United States, Bierstadt continued to use the same panoramic views, controlled manner of applying paint, and golden light reminiscent of such German landscape painters as Caspar David Friedrich in his own scenes of the West and the spectacular views of the Rocky Mountains. A good example of his approach can be seen in *Valley of the Yosemite* (fig. 145). Traveling with the New York writer Fitz Hugh Ludlow and the artists Virgil Williams and Enoch Wood Perry, Bierstadt spent seven weeks in the Yosemite Valley, which he called "the Garden of Eden. The most magnificent place I was ever in, I employ every moment painting from nature."[19] Bierstadt's small-scale painting and numerous sketches from the trip became the foundation for his many large-scale panoramic scenes of the Rocky Mountains, one of which captured the highest price paid for a painting by an American artist in 1863.[20]

During the nineteenth century, German art was greatly admired in the United States among connoisseurs seeking to encourage local artists and patrons. John Godfrey Boker (the Anglicized Johann Gottfried Bocker) left Germany in the wake of the 1848 revolutions and established the Düsseldorf Gallery in New York, hoping to cater to the popular taste for German painting. Boker exhibited a core group of paintings by Leutze, Lessing, Christian Köhler, and others, while frequently adding new acquisitions.[21] Selections from the Düsseldorf Gallery also made the rounds of other cities, including Boston, where the Athenæum hosted rotating selections in 1852, further disseminating the styles of German history and landscape painting.[22]

Following the Civil War, Munich eclipsed Düsseldorf as a fashionable destination in Germany for American art students. The Bavarian Royal

Academy of Art was established in 1847, and, beginning in 1869, Munich hosted its first international exhibition at the Alte Pinakothek, home to Bavaria's royal collections of old master paintings, which were comparable to those of the Musée du Louvre in Paris.[23] Art academies in England and France emphasized the progressive mastery of drawing and restricted attendance in painting classes to only the most advanced students,[24] whereas in Munich even beginning students were allowed to enroll in classes on painting techniques. Encouraged by their ability to advance, the number of American artists matriculating at the Bavarian Academy increased steadily from twenty-six in 1872 to forty-two in 1878.[25] Wilhelm von Diez, a professor at the academy in 1870, stressed the

study of the old masters, especially the Dutch and Flemish.[26] Diez was also a major supporter of realism of the sort produced by the French painters Gustave Courbet and Edouard Manet, as was his student Wilhelm Leibl. Leibl applied paint in a liquid, fluid manner, and he and his students (the so-called Leiblkreis, or Leibl Circle) went so far as to immerse their canvases in water or place them in a specially constructed damp cellar so they could continue to work "wet on wet." This technique subsequently caused many of the fine works by this group of artists to lose paint that had not adhered properly to the surface.[27]

Frank Duveneck, one of the foremost Americans who adopted Leibl's technique, was upheld by fellow

145
Albert Bierstadt
American, born in Germany,
1830–1902
Valley of the Yosemite, 1864
Oil on paperboard
30.2 x 48.9 cm (11⅞ x 19¼ in.)

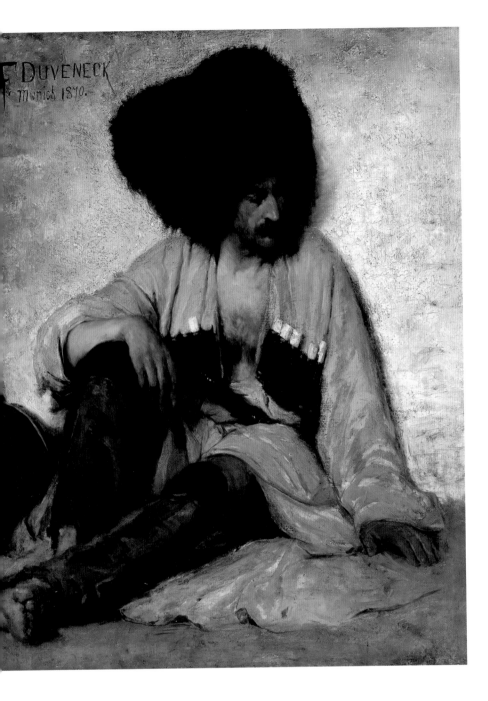

146
Frank Duveneck
American, 1848–1919
A Circassian, 1870
Oil on canvas
128.3 x 105.4 cm (50½ x 41½ in.)

Munich teachers and students for his virtuoso mastery of the Munich style and by John Singer Sargent as the "greatest talent of the brush in his generation."[28] While in Diez's class from 1870 to 1873, he executed the masterly costume study entitled *A Circassian* (fig. 146).[29] The soldier sports the distinctive fur hat and costume of the Circassians, an ethnic group that was driven from the North Caucasus region near the Black Sea into the Ottoman Empire by the Russians in 1859.[30] Duveneck's choice of a Circassian soldier as the subject for his costume study may reflect either the soldiers' popularity in Germany among revolutionaries such as Karl Marx, who admired them as freedom fighters courageously battling Russian imperialism, or simply the exoticism of the soldier's costume.[31] Duveneck's composition demonstrates his facility with drawing the figure in a foreshortened pose, as well as his ability to render light effects over a full range of values, from bright lights to deep darks.[32] Clearly pleased with his effort, Duveneck, in the upper left corner of the canvas, prominently signed, dated, and inscribed the study as being done in Munich.

With the end of the Franco-Prussian War in May 1871, Germany moved toward the concept of a German Reich when the Prussian king Wilhelm I accepted the crown and thereby united, if briefly, most of the German-speaking inhabitants of Europe until his death in 1888.[33] Wilhelm II, Germany's third emperor, who witnessed the fall of Chancellor Bismark and the beginning of World War I, sought to defend "religion, morality, and sound order" in the face of the increasingly influential German Social Democratic Party's efforts to promote Marxism.[34] As a result of these developments, Germany and the United States found themselves on opposite sides of a war, a tension that had repercussions in the art world.

Between roughly 1905 and 1923, artistic forms in Germany, including the visual arts, literature, theater, and film, investigated individual responses to the outside world, the seen and the unseen, the world of the conscious and the unconscious mind. These various explorations, collectively described as

Expressionism, represented a spectrum of abstract spiritual ideals, musical forms, atavistic or primitive impulses, and dreams and recollections from early childhood or the imagination. Music was considered particularly potent, especially the example of Richard Wagner's *Gesamtkunstwerk* (total work of art), which integrated musical form, the human voice, and theatrical production into a single sensory experience. August Endell, a designer in Munich, articulated the desire for a new artistic style at the beginning of the twentieth century: "We stand at the threshold of a totally new art, an art with forms that mean nothing, represent nothing, and recall nothing, yet which can move our souls as deeply, as strongly, as only music has previously been able to do with tones."[35]

Young German artists working in the early years of the twentieth century sought to break the bonds of earlier academic traditions to forge new means of expressing their personal vision. Four students at the Dresden Architectural Institute, unified in their rejection of standard rules of exhibition, formed Die Brücke (The Bridge) in 1905 so they could mount their own display in a local gallery, which they hoped would link the art of the past and the present. They admired such German old masters as Albrecht Dürer, Matthias Grünewald, and Lucas Cranach the Elder, yet their technique resembled Vincent van Gogh's emotional use of color, which they had seen when his works were shown in Germany. Similarly, though a bit later, Der Blaue Reiter (The Blue Rider) was founded by Wassily Kandinsky, Franz Marc, Lyonel Feininger, and others. Their goal was to promote ideas Kandinsky expressed in *On the Spiritual in Art* (1911), especially the relation between visual art and music, the spiritual and symbolic associations of color, and an intuitive approach to painting that relied on imagination, naïveté, and the subconscious.

When Marsden Hartley arrived in Berlin for his first visit in January 1913, he soon became aware of these developments and embraced them. He wrote to Alfred Stieglitz, his dealer and sponsor, saying that he had "found my place in the art circles in Europe."[36] Kandinsky and Marc were instrumental in including Hartley's paintings in exhibitions alongside major European modernists. Hartley was drawn to the spiritualism and mysticism articulated by Die Brücke and Der Blaue Reiter and forged a distinctive combination of Synthetic Cubism, German Expressionism, Synchromism (practiced by the Americans Stanton Macdonald-Wright and Morgan Russell, who were working in Paris), and his own vision. In tandem with Kandinsky and other German artists who looked to eastern European folk painting, Hartley found inspiration in Native American culture in the ethnographic collections of that material he saw in Berlin (see fig. 42).[37] Many American expatriate artists working in Europe or elsewhere around the world rediscovered a sense of their American identity and the traditions of their homeland more forcefully when they encountered other cultures abroad.

The rise of Nazism in the early 1930s led to an influx of German émigrés to the United States, including many followers of the proponents of Die Brücke and Der Blaue Reiter, who fostered the tenets of German Expressionism in the postwar era.[38] Jacob Kainen, a painter and writer, summarized the new outlook. Artists confronted with the reality of war and destabilization attempted "to reduce the interpretation of nature or life in general to the rawest emotional elements." They were "complete[ly] and utter[ly] dependen[t] on pigment as an expressive agency rather than an imitative or descriptive one." Finally, the Expressionists promulgated "an intensity of vision which tries to catch the throb of life, necessarily doing violence to external facts to lay bare internal facts."[39] Peter Busa, an artist in Kainen's circle in New York City, conceived the life-giving force as Expressionist swirls of paint and womblike, biomorphic forms in *Birth of the Object and the End of the Object* (see fig. 43). As Hartley did, Busa drew on Native American imagery, deriving the masklike face at the left from potlatch figures of the Northwest Coast (see fig. 26).

The German-born Karl Zerbe was in the United States by 1933 and first taught at the Fine Arts Guild of Cambridge and then, in 1937, was named head of the Department of Drawing and Painting at the School of the Museum of Fine Arts, Boston, where he

taught until 1955. An admirer and friend of Oskar Kokoschka and Max Beckmann, Zerbe shared with them the desire to represent the emotional and spiritual experience of individuals by using a rich palette, broad brushwork, and darkened outlines around forms. This technique is evident in the work of many European modernists as well, including Pablo Picasso, Georges Rouault, and Chaim Soutine, and can be seen in *Job*, Zerbe's self-portrait in the guise of the Old Testament figure (fig. 147). During his first year at the Museum School, Zerbe painstakingly resurrected the ancient Egyptian technique of painting with oil and wax known as encaustic, superimposing translucent layers of wax and pigment over black underpainting.[40] Distinguished as one of the leaders of the Boston Expressionist School, Zerbe, along with Jackson Pollock, was singled out for his innovative approach to technique.[41] By the time he painted *Job*, with the figure shown stripped of his clothing and kneeling down with palms open, imploring the viewer, Zerbe had developed a serious allergy to encaustic. This composition was his last use of the medium that had made his reputation in the foremost publications of the day. The compression of the figure within the composition evokes a pathos and suffering that may have been inspired by Zerbe's familiarity with Otto Dix's *Job*, which alludes to the wartime experiences and the suffering of the Holocaust victims.[42]

Zerbe was but one of many Germans who came to this country and taught, either in established schools or in schools they founded. Another German artist who had a great influence in America because of his teaching was Hans Hofmann, who immigrated to the United States in 1932 and became a citizen in 1941. Hofmann inspired generations of young painters with his lectures and books, including *Creation in Form and Color: A Textbook for Instruction in Art* (1932) and *Search for the Real* (1948), as well as his classes in Berkeley, California, at the Art Students League of New York, and later at his own schools of painting in New York City and Provincetown, Massachusetts. Nearly half of the original members of American Abstract Artists, who first exhibited as a

group in 1937, were Hofmann's students, and many of the second generation of Abstract Expressionists had studied with him.[43] In *Twilight*, made near the end of his life, Hofmann applied paint in thick layered patches that assert themselves against the plywood support (fig. 148). One of Hofmann's central concepts concerned the duality of flatness and depth and how pure colors, when juxtaposed, had the plastic effect he described as "push-pull." As he described in *Search for the Real*, depth "is not created by the arrangement of objects one after another towards a vanishing point, in the sense of the Renaissance perspective, but on the contrary (and in absolute denial of this doctrine) by the creation of forces in the sense of *push* and *pull*."[44] As Hofmann recounted sometime in the late 1950s after a sunset ride in Truro, Massachusetts, he professed that he wanted to paint in the landscape again with what he now knew about painting.[45] Here, the combination of complementary colors red and green creates the effect of an afterglow in the analogous orange and blue that relate Hofmann's experience of the landscape he admired. Although he achieved his ends by very different means, Hofmann ultimately shared with his fellow German colorist Josef Albers a sense that color should be unbroken by modulation, much like a jewel found in nature.[46] For Hofmann the nature of painting was ultimately spiritual, which he defined as an "emotional and intellectual synthesis of relationships perceived in nature rationally or intuitively."[47]

Just as the German Expressionists sought new ways to represent pure feeling and authenticity of experience and emotion, other European artists who had been trained either in high or applied art found that traditional means of studying drawing and painting at the well-established art academies were outmoded. In Vienna a group of artists known as the Vienna Sezession, led by the Austrian painter Gustav Klimt, broke free from the established art community in the capital city in 1897. They formed their own society of artists and supported the dissemination of the progressive ideas of modern art through exhibitions and publications, such as their journal, *Ver Sacrum*. The ideals of the Sezession gave rise to the

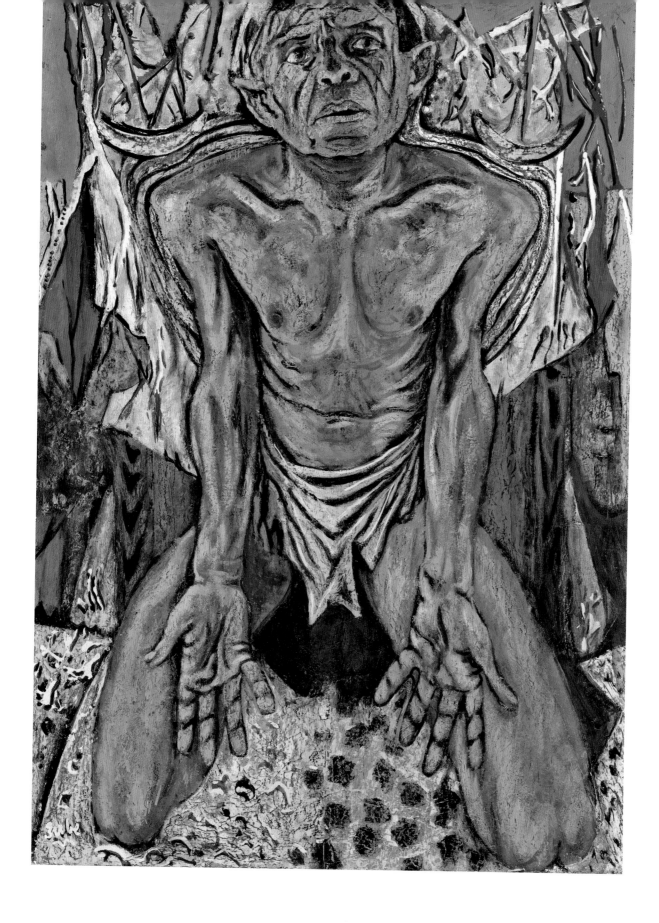

147
Karl L. Zerbe
American, 1903–1972
Job, 1949
Pigmented wax on Masonite
94.3 x 65.1 cm (37 ⅛ x 25 ⅝ in.)

Wiener Werkstätte, or Vienna Workshops, founded in 1903 by three leading members of the group, the architects and designers Otto Wagner, Josef Hoffmann, and Koloman Moser. The Wiener Werkstätte was Vienna's version of the model Arts and Crafts community, based in part on C. R. Ashbee's Guild of Handicraft in England, which promoted the revival of handcraftsmanship in the applied arts. Reacting against the prevailing revival styles of the late nineteenth century, the designs of Hoffmann and those of the other Sezession artists emphasized simple patterns and geometric shapes, such as squares and circles, expressed in the unifying ideal of the *Gesamtkunstwerk*.[48] Their products were widely influential, especially in like-minded artistic communities in Europe and the United States. The designer Dard Hunter, working at the Roycroft Community in East Aurora, New York, was inspired by the German-language magazines *Dekorative Kunst* and *Deutsche Kunst und Dekoration* he read at Roycroft, which included the work of the Vienna Sezession. As he stated: "These magazines were a monthly inspiration, and many of the commercial designs I made during my early years at the shop show this influence."[49] A series of lamps designed by Hunter are indebted to the designs of the Vienna Sezession in their simple but bold geometric design of squares reminiscent of Hoffmann's work of the period (fig. 149). They were made in collaboration with the Viennese craftsman Karl Kipp, who was the head of Roycroft's copper studio. Hunter's interest in Viennese design was such that he left Roycroft in 1908 to travel and work in Vienna and then again in 1910; there he produced some of his most innovative and intriguing designs.[50]

Following the lead of the Vienna Sezession, artists, architects, art historians, and industrialists working in Germany joined forces in the early twentieth century to place the artist at the center of modern, industrialized society and to produce objects that possessed qualities of "good form," which they defined in terms of quality and functionalism.[51] In 1907 the German Werkbund (Art and Craft League) was formed, and four years later, Walter Gropius, an architect, designer, and teacher, joined their efforts. In 1919 Gropius founded the Staatliches Bauhaus in Weimar by combining two schools of art, one that taught fine art and another that taught applied art. The experimental atmosphere of the Bauhaus under Gropius attracted artists who were essentially hopeful, youthful, and utopian in their desire to replace the dominance of old orders with new creative energies.[52] Gropius brought his ideals and pedagogy to the United States, having escaped Nazi Germany in the early 1930s. He taught at the Harvard Graduate School of Design from 1937 to 1951, educating generations of architects, and, along with his colleagues at the German Bauhaus, promulgated the importance of the foundation for all the arts in the pedagogical methods they innovated in Germany and continued to refine during their years in the United States.

148
Hans Hofmann
American, born in Germany, 1880–1966
Twilight, 1957
Oil on plywood
121.9 x 91.4 cm (48 x 36 in.)

149
Roycroft Community
Active 1895–1938
Designed by Dard Hunter
American, 1883–1966
Made by Karl Kipp
American, 1882–1954
Hanging lantern (one of a pair), about 1906–8
Copper, nickel silver, stained glass, leather
H. 76.2 cm (H. 30 in.)

150
Lyonel Feininger
American, active in Germany,
1871–1956
Regler Church, Erfurt, 1930
Oil on canvas
126.7 x 102.2 cm (49⅞ x 40¼ in.)

In 1919 the prospectus for the Bauhaus was illustrated with a woodcut by Lyonel Feininger of a cathedral crowned by stars. The German Expressionists revered the religious painting of the northern Renaissance School for its expressiveness and pathos. For those at the Bauhaus, the Gothic cathedral took on new meaning as a building erected by artisans according to a designer's ideal and resonated as a symbol representing the return to craft work. Feininger's *Regler Church, Erfurt* thus takes on special meaning in the context of the Bauhaus (fig. 150). An American of German extraction who lived in Germany from 1887 to 1937, Feininger was active in the Bauhaus for more than a decade before he became increasingly uncomfortable with the emphasis on technology.[53]

The Hungarian-born Lázsló Moholy-Nagy represented the trend at the Bauhaus with which Feininger disagreed. Because Moholy-Nagy had experimented with constructions, collages, typography, design, and especially photography, Gropius found in him a willing collaborator in his efforts to promote the "unity of art and technology."[54] Moholy-Nagy considered the machine central to modern life and the ultimate tool of the masses. In his article "Constructivism and the Proletariat" (May 1922), he wrote, "The reality of our century is technology: the invention, construction and maintenance of machines. To use machinery is to act in the spirit of this century. It has replaced the transcendental spiritualism of past eras. . . . It is the art of Constructivism. In it the pure form of nature finds expression—unbroken color, the rhythm of space, the balance of form. It is independent of picture frame and pedestal. It extends to industry and architecture, objects and relationships."[55] Although Moholy-Nagy contributed significantly to a wide range of arts, to the extent that a Bauhaus colleague described him as "Leonardian," he was particularly drawn to photography.[56] Foremost among his many publications was *The New Vision*, in which he promoted his concept that photography could establish a whole new way of seeing and his belief that those who knew nothing of the photographic medium were visual illiterates unable to read the world.[57]

Moholy-Nagy, like Feininger and Gropius, spent his last years in the United States. Here, at the recommendation of Gropius, he headed the New Bauhaus and School of Design in Chicago, which was established in 1937, where he promoted the Bauhaus interest in fusing science, technology, and the arts. Moholy-Nagy's influence is evident in the work of the American jeweler Margaret De Patta, who was one of his students at the Chicago School of Design in 1940–41. De Patta absorbed the experimental concepts of the New Bauhaus, as well as Constructivist ideas of transparency and movement in space. Her *Ring* exemplifies her pioneering use of overlapping geometric forms and continued exploration of the properties of rutilated quartz, with its inherent crisscrossing, linear patterns of crystalline inclusions (fig. 151).[58] De Patta likened her jewelry to sculptures, in which the intersecting planes and prismatic effects changed depending on the perspective of the viewer.

Moholy-Nagy's theories of photography and his exploration of light and form in his photograms had a far-reaching influence, even among artists who were not his students. Theodore Roszak was born in Poland and first encountered Moholy-Nagy's theories of photography and *The New Vision* when he was traveling in Europe on a fellowship in 1929–30.[59] By the time Roszak joined the faculty at the Laboratory School of Industrial Design in Chicago in 1938, he was probably aware of the work being done by Moholy-Nagy at the New Bauhaus. In an untitled photograph and photogram from 1930–40, Roszak experimented with geometric forms and the play of light and dark to suggest varying levels of depth across the rectangular photographic plate (fig. 152). It recalls similar works by Moholy-Nagy and earlier experiments in abstract form by Kandinsky.[60]

Perhaps the most famous of the émigré artist-teachers from Germany was Josef Albers, who served longer than any other teacher at the Bauhaus, from 1920 until its closing in 1933, and continued his remarkable artistic trajectory in the United States. Dissatisfied with the training he received at the royal art schools in Berlin and Munich, he was trans-

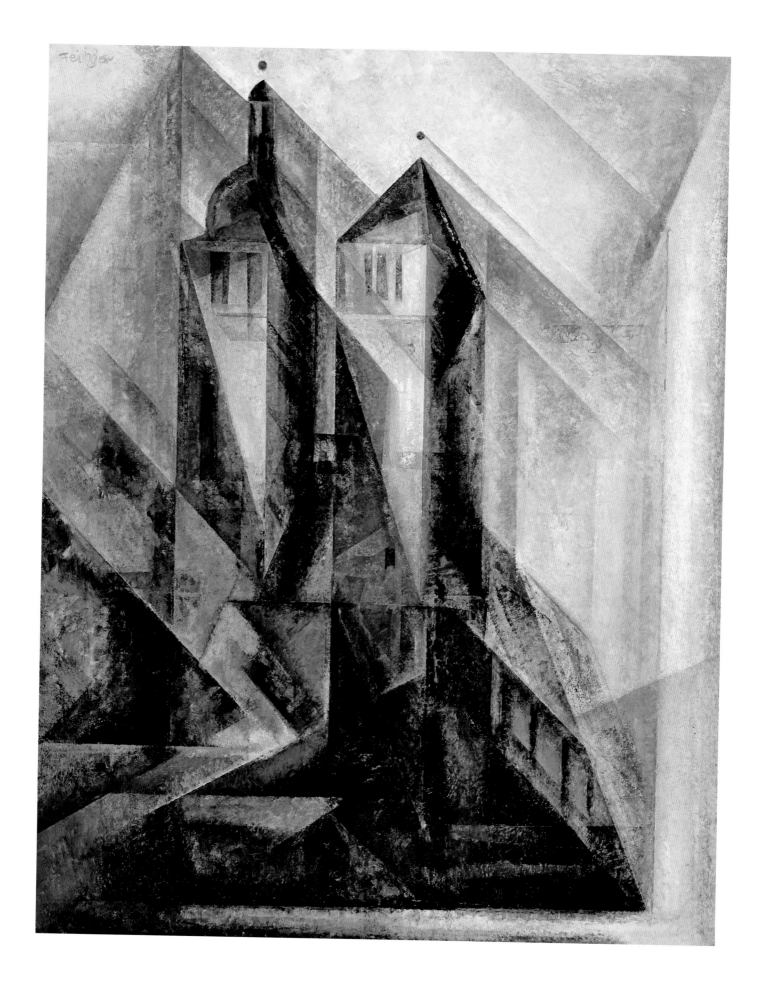

151
Margaret De Patta
American, 1903–1964
Ring, 1947–48
18-karat white gold, tourmalinated
quartz
H. 2.4 cm (H. ¹⁵⁄₁₆ in.)

152
Theodore Roszak
American, born in Poland,
1907–1981
Untitled, 1930–40
Photogram, gelatin silver print
photograph
25.3 x 20.3 cm (9 ¹⁵⁄₁₆ x 8 in.)

formed at the Bauhaus: "I threw all the old junk overboard and went right back to the beginning again. It was the best thing I ever did in my life."[61] His glass assemblages and grid paintings in glass could be manufactured according to Albers's designs by other artisans or by purely mechanical means, neatly epitomizing the fusion of art and craft that lay at the heart of Bauhaus teaching.[62]

Albers's first teaching position in the United States was at the newly established progressive school of Black Mountain College in North Carolina near Asheville, from 1933 to 1949. There, Albers called the design course *Werklehre*, or learning through doing,

encouraged "independence, critical ability, and discipline,"[63] and counted among his students Kenneth Noland and Robert Rauschenberg. After leaving Black Mountain, Josef and his wife, his former Bauhaus colleague Anni, settled in Connecticut, where Josef eventually served as chairman of the Department of Design at the School of Art at Yale University, a post he held until his retirement in 1958. In 1950, expanding the rigorous studies of color and form that he began during his Bauhaus years, Albers embarked on his famous series *Homage to the Square*, which came to include more than one thousand pictures. *Gay Desert*, painted between 1947 and

1954, represents a work inspired by those exercises (fig. 153). Squares of pink and mesa green resonate against an orange and ocher background as an exploration of how colors react in relation to their proportions, juxtapositions, and shapes. The title may refer to Albers's sabbatical year of painting in the desert of New Mexico in 1941, although the artist took pains to specify that the names for some of his compositions were chosen after the composition was finished.[64] Two vertical rectangles stand side by side, suggesting doorways of buildings rising above the flat expanse of desert. Double images had preoccupied Albers in the late 1930s and early 1940s, when he explored forms that move outward and inward at once.[65] As with his Homage to the Square paintings, the proportions of the two rectangles and surrounding bands of color in *Gay Desert* are modified slightly so that they are

unequal. Albers emphasizes the handmade quality of the skin of the paint surface by leaving visible brushwork in the bands of color; the brightest orange exhibits the greatest range of textured strokes, suggestive of the effect of brilliant desert flowers blending together across a panoramic expanse of landscape.

While at Yale, Albers cultivated a serious following and exerted considerable influence on generations of students. Albers did not believe that art could be taught, and he stressed "visual intelligence, intellectual rigor, emotional restraint, formal invention, material articulation, direct physicality, structural clarity, an emphasis on shared experience rather than subjective expression, lived experience over abstract theory."[66] As one student remarked, reflecting a view echoed by many, "Albers taught me to see."[67] Among those who studied with Albers were

153
Josef Albers
American, born in Germany, 1888–1976
Gay Desert, about 1947–54
Oil on Masonite
52.4 x 91.8 cm (20 ⅝ x 36 ⅛ in.)

154
Anni Albers
American, born in Germany,
1899–1994
Brooch, 1941–46
Aluminum strainer, paper clips,
safety pin
H. 10.8 cm (H. 4¼ in.)

many of the leading artists of the postwar era, including Chuck Close, Eva Hesse, Nancy Graves, Robert Mangold, Brice Marden, and Richard Serra.[68] As students in the advanced painting courses noted, Albers supported the need for artists to work "independently and undisturbed" if he felt their work was progressing satisfactorily.[69] Ever grounded in the reality of what was on paper or canvas, one student remarked that Albers "was always bringing people back, often in very emphatic ways, to the visual reality."[70]

The impact of Albers's work ranged far and wide. On leave from Yale in 1953–54, Albers lectured in the Department of Architecture, Universidad Católica, Santiago, and at the Escuela Nacional de Ingenieros del Perú, Lima.[71] The Argentinian painter César Paternosto initially experienced Albers's color exercises when a series of Homage to the Square compositions was exhibited at the Di Tella Institute in Buenos Aires in 1964, although he was well familiar with Albers and his work in the United States and Europe.[72] In 1965 Paternosto remarked that the experience "encouraged me to apply color directly from the tube with the palette knife."[73] He subsequently started painting bands of color, describing his efforts to explore the "atonality of color: strange chords, such as a brown next to a pink, and the like. Soon the bands became waving and concentrically arranged."[74] The result was a series of large-scale compositions inspired by the relationships between color and sound to which *Staccato* belongs (see fig. 21). Against a brilliant background of opaque orange and red, Paternosto created an undulating sweep of colored bands that form a pulsating bulge. The stripes are cut by the right edge of the canvas, evoking the forceful eruption of a staccato beat that brings structure to a musical phrase. Albers followed clear directives for the laying on of pure colors straight from the tube and the proportions of colors within the square formats so as to achieve harmonious and subtle arrangements, which to some viewers appeared spiritual; Paternosto plays off the curving waves of color that effectively envelop the viewer with a lively cacophony of color and shapes.[75]

The Bauhaus was noted for the collegial atmosphere that Gropius nurtured among students and teachers. In keeping with the greater freedoms that the Weimar Republic gave women to study and to vote, the Bauhaus Manifesto of 1919 declared, "Any person of good character whose previous education is deemed adequate by the council of masters will be accepted without regard to age or sex."[76] Reality, however, proved to be quite different from theory, and women within the Bauhaus were often marginalized. Even Gropius did not encourage women to work in "heavy craft areas such as cabinetmaking," and he was "fundamentally opposed to the training of women as architects."[77] Women were welcomed in the textile, bookbinding, and pottery workshops,[78] as well as Moholy-Nagy's metalwork shop, where they were trained to use everyday materials and found objects in new designs.

Albers's wife, Anni, trained at the Bauhaus beginning in 1922 and later taught textile making and design both at the Bauhaus and at Black Mountain College. Her work epitomized the Bauhaus interest in pattern and color and the use of industrial materials, all the while pushing the boundaries of modern design. A series of hand-assembled jewelry, including *Brooch*, was a collaboration with her student Alexander Reed in 1941 (fig. 154). The brooch interprets the round shapes and hanging elements of a pierced sink drain threaded with a pin and paper clips. The design was exhibited at the Museum of Modern Art in New York in the groundbreaking jewelry exhibition of 1946, "Modern Handmade Jewelry," which included the work of other Bauhaus artists, including Margaret De Patta.[79] Of her work, Albers commented: "We have useful things and beautiful things—equipment for works of art. . . . The useful thing could be made beautiful in the hands of the artisan, who was also the manufacturer."[80] Her design sensibility sought to combine these disparate worlds, as she saw them, by appropriating everyday materials and reusing them in unexpected ways, a goal of both the Bauhaus and Surrealist art of the period.

While Josef Albers's teaching and work have been described as an incendiary catalyst for creativity,[81] the integration of German artists and artisans into the United States and Latin America during the last three centuries produced many opportunities for similar creative catalysts. The heritage of the German Expressionists and the Bauhaus School continues to the present day, as discoveries are made about the interrelationships between artists and critics during the Abstract Expressionist era, and the lessons of Gropius and the Bauhaus continue to inspire new, experimental uses of color, shape, form, and design in innovative and functional ways.

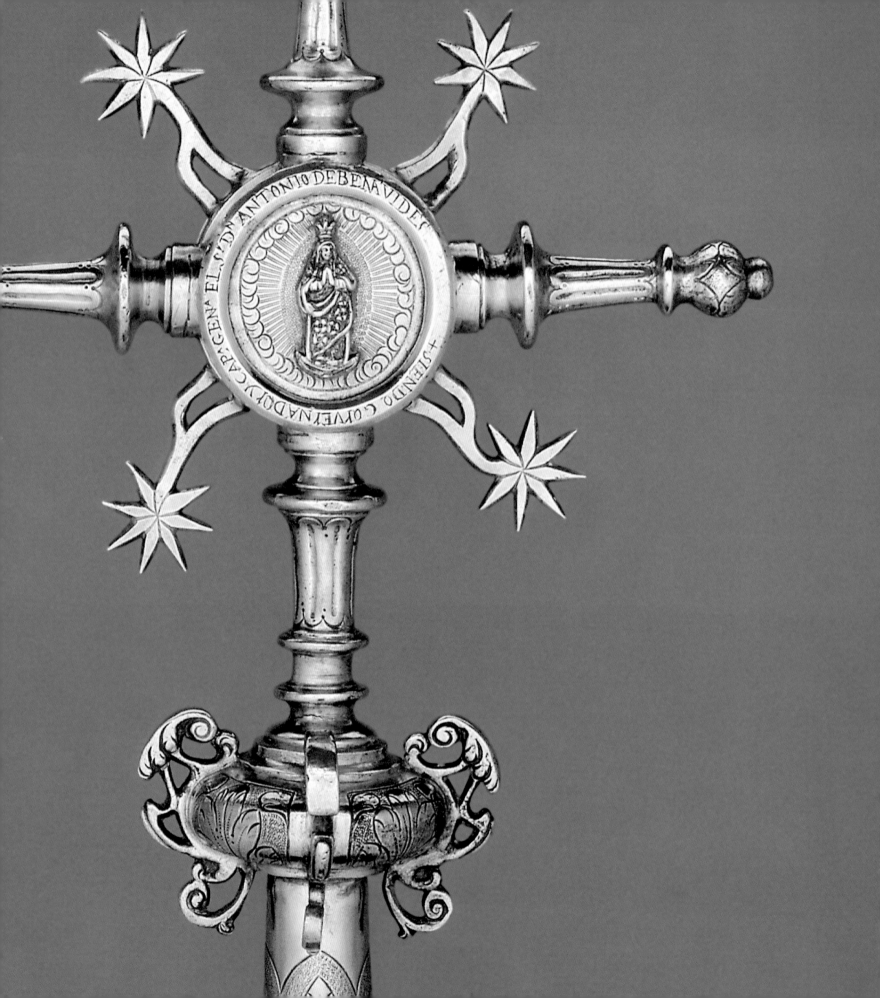

SPAIN HEATHER HOLE AND DENNIS CARR

More overtly than any other European power, Spain came to the Americas for material treasure and spiritual glory. Beginning in the sixteenth century, the Spanish colonial government extracted enormous amounts of gold and silver, other raw materials, and trade goods from North, Central, and South America for export across the ocean. The legendary Spanish silver mines in Mexico and Peru alone, particularly the mine at Potosí (in modern-day Bolivia), yielded huge quantities of silver ore, which, once converted to bullion and coinage, flooded the European markets. Its effect on the early global economy made Spain the wealthiest and most powerful country on the planet.

In addition to exporting raw materials, the Spanish pushed to convert the indigenous peoples of the Americas to Catholicism, both for the greater glory of the Catholic Church and, on a more practical level, to establish a large pool of labor. This desire to incorporate native peoples into Spanish culture, on the one hand, and to exploit them, on the other, led to an extraordinary mixing of visual styles and techniques in art, craft, and architecture. Today the works created by native and mestizo (mixed-blood or multiracial) artists are often called hybrid forms, since they blend the styles of indigenous cultures with those of Europe and Asia, areas linked through Spain's interconnected global colonies.[1] The distinctive hybrid style created in colonial Latin America was both greatly influenced by foreign art and defined by indigenous characteristics, materials, and workmanship. Such artworks provide a fascinating glimpse of the complexity and nuance of colonial society.

The portions of the Americas claimed by the Spanish retain an indelible physical mark. Many of the sixteenth- and early-seventeenth-century colonial towns—from Mexico City to Antigua, Guatemala to Cuzco, Peru to Santa Fe—still bear the unmistakable grid pattern of streets surrounding a central square, which was the standard of urban town planning. The Spanish ordered the construction of hundreds of churches and monasteries, schools, universities, and missions spread across the countryside, inculcating the Gospel and rooting the Catholic Church and the various offices of the Spanish government at the local level.

The Spanish colonies in the Americas covered a vast territory, stretching from the modern-day states of New Mexico, Arizona, Texas, and Florida to the rugged highlands at the southern tip of South America. Following the arrival of Christopher Columbus in 1492, colonists from Spain began a process of conquest and domination over the large and diverse indigenous populations they encountered in the New World. By the mid-1500s Spain's colonial empire in the Americas was divided into two massive realms: the Viceroyalty of New Spain, covering much of southern North America, Central America, the Caribbean islands, and the Philippines, and the Viceroyalty of Peru, which encompassed the northern and western

155
Miguel Cabrera
Mexican, 1695–1768
Don Manuel José Rubio y Salinas,
Archbishop of Mexico, 1754
Oil on canvas
181.9 x 124.9 cm (71⅝ x 49³⁄₁₆ in.)

regions of South America (by the eighteenth century, these enormous entities were subdivided into four smaller viceroyalties).

The Spanish were not the only Europeans to colonize South America. The Portuguese established the major colony of Brazil, which included important Atlantic trading ports at Salvador and Rio de Janeiro, and both the French and the Dutch held smaller colonies in the northeastern portion of the continent. Yet, by many measures, the Spanish were the dominant colonial power in the region. It is astonishing to consider how relatively few Spaniards were needed to effect such dramatic changes on a continental scale, and how their cultural and artistic influence grew over time, seeping into nearly every facet of life in Hispanoamérica.

The cities established by Spain in the Americas were exceptionally advanced, large, and ambitious when compared with those founded by other European powers. The plan for Mexico City, for example, was laid out over the former Aztec capital of Tenochtitlán in 1523–24, long before the English, French, and Dutch had even ventured to establish their first, rudimentary colonies in the New World. Just a few years after Mexico City was established, Franciscan missionaries founded the earliest institutions of higher learning in the Americas; the seminary college of Santa Cruz in Tlatelolco, designed to train ruling-class Aztec boys for the priesthood, was established in 1526, and the school of San José de Belén de los Naturales opened to teach elite native youths about European religion, art, craft, and music in about 1527. Printing presses were set up in Mexico City by the 1530s and produced religious tracts and pamphlets, some with illustrated engravings. By contrast, the first small, failed English colony of Roanoke was founded and then abandoned in present-day Virginia in 1586–87, roughly sixty years later.

Painting became an important part of the vibrant cultural and religious life of Mexico City in its early history. A number of Spanish painters, beginning with Simon Pereyns in 1566 and Andrés de Concha in about 1570, came to Mexico to supply religious paintings that would adorn the interiors of Spanish mission churches, especially the elaborate *retablos*, or

altarpieces, which contained paintings and silverwork. These early arrivals laid the groundwork for a flourishing and distinctive Spanish colonial visual culture.

Miguel Cabrera, a mestizo painter born in the late seventeenth century in present-day Oaxaca, was among the most important native-born artists to emerge from the complex Spanish colonial society in Mexico City. Life for indigenous and multiracial people under the Spanish was both shaped and limited by laws that enforced a strictly codified racial and social hierarchy. Though little is known of his early life, it is certain that Cabrera would have faced enormous challenges in rising to the highest levels of his chosen profession. Nevertheless, he became the most influential painter of his generation in colonial New Spain, serving as the official painter to the archbishop of Mexico, Don Manuel José Rubio y Salinas, and establishing a thriving commercial painting workshop.

Cabrera's commanding portrait of Archbishop Rubio y Salinas demonstrates the artist's ambition to create artworks equal to any produced in Spain (fig. 155). This painting uses long-established European artistic conventions for communicating power and authority, such as the archbishop's stern gaze, elaborate religious garments and accoutrements, and seated position in an impressive, thronelike chair. For a mestizo artist in New Spain to paint in this manner was to stake a claim to the highest European artistic traditions.

This painting of Archbishop Rubio y Salinas also documents one of the countless individuals who played a role in the sprawling bureaucracy that the Spanish monarchy used to control its colonies. At the center of the Crown's power in the Americas were the various political and administrative posts appointed by the royal government and the Catholic Church. This is the earliest of several official portraits Cabrera made of the archbishop, many of which were sent to various religious institutions within the rapidly expanding network of Spanish missions in Mexico during the mid-eighteenth century.[2] Official portraits such as this, like the portraits of heads of state on the walls of government offices today, served as vivid reminders of the watchful presence of the Spanish

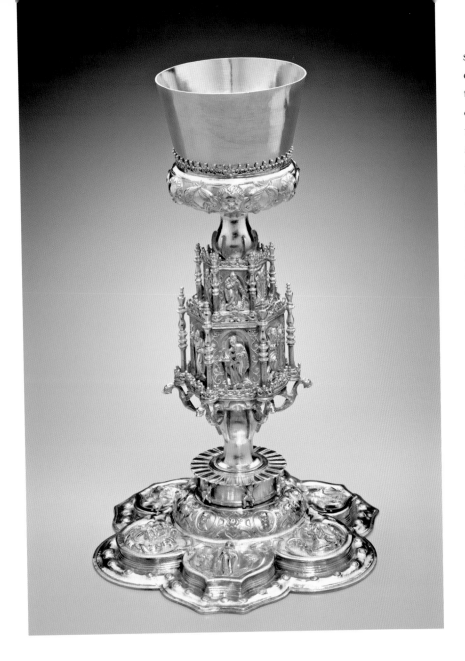

silversmith Pedro Hernández Atenciano in the city of La Antigua in Guatemala is a prime example of the high caliber of European workmanship in the colonies (fig. 156). A masterpiece, it incorporates figures of the twelve apostles placed in niches in the stem, along with repoussé (hand-hammered) cherubs that encircle the base of the cup and expressive figures at the foot. Hernández was among the early waves of Spaniards to settle in the former Maya region. Bearing the mark of the city of Santiago de los Caballeros (now La Antigua), this chalice was probably commissioned by the Dominican Order. The order was expanding its network of churches in New Spain during the sixteenth century, which included the powerful monastery of Santo Domingo, founded in La Antigua in 1543.[3]

During the same period, highly trained native craftspeople reimagined their traditional art forms with extraordinary creativity and ingenuity to respond to new markets. For example, Inka weavers in the Viceroyalty of Peru adapted their skills to cater to the Spanish taste for domestic textiles such as table covers, hangings, carpets, and cushions. Artists associated with an indigenous workshop wove a tapestry in the late sixteenth or early seventeenth century with designs that look largely European (fig. 157). Its interlaced ornaments relate to European silk textiles and sixteenth-century Spanish carpets. The border surrounding the central field is drawn from Renaissance ornamental designs and includes urns, heraldic lions, and various birds intermixed with complex, foliate Baroque strapwork. This kind of imagery, foreign to Inka weavers until the sixteenth century, was gradually incorporated in colonial Peruvian textiles to form a unique synthesis of European influences and local traditions.

By the sixteenth century, indigenous cultures that for millennia had developed in relative isolation from the rest of the world were now linked to the sprawling trade network that connected Spain's far-flung empire. Objects like this tapestry, produced by indigenous craftsmen for the Catholic Church, viceregal governments, and lavish domestic residences, show how native peoples adapted and responded to this new and complex global context.

156
Pedro Hernández Atenciano
Spanish, worked in Guatemala and Peru, 1510–1584
Chalice, about 1560
Silver-gilt
H. 28.3 cm (H. 11⅛ in.)

157
Tapestry cover
Peru, late 16th–17th century or later
Cotton and wool interlocked and dovetailed tapestry
238.5 x 216 cm (93⅞ x 85⁵⁄₁₆ in.)

authorities in the religious and political affairs of the viceroyalty.

The abundance of raw materials in the New World lured many craftsmen to the Americas. Silversmiths in particular saw enormous opportunity in the wealth of readily available precious metals. These individuals often established workshops and created objects of great beauty in an elaborate style already well known in Spain and its western European territories, which in this period included parts of Italy, Germany, Belgium, and the Netherlands. A remarkable sixteenth-century silver-gilt chalice made by the Spanish

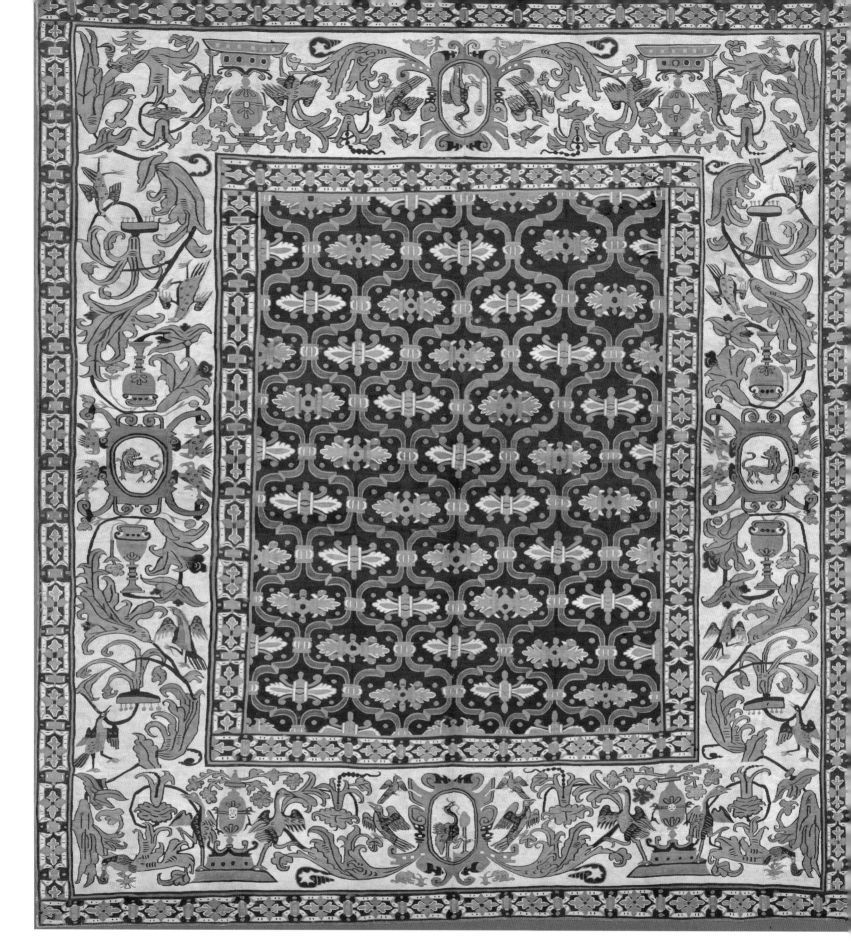

century when the English attempted to drive the Spanish out of the region, was unearthed in the late nineteenth century.[4] Among them are a small group of silver Communion vessels and a striking processional cross (fig. 158). Made in 1721, most likely in Mexico, and sent to the Spanish garrison in Saint Augustine, this cross bears a dedication to Don Antonio de Benavides, a military leader and the twenty-eighth governor of La Florida. This dedication surrounds the image of the Virgin Mary, in the center of the cross, thereby linking religious and secular authority. Crosses such as this, mounted on long staffs, were carried in the processions of church and political leaders as well as guilds and other secular groups that were often affiliated with the church.

Santa Fe was another important early outpost of the Spanish Empire. Claimed by the Spanish after their arrival in present-day Mexico in 1519, New Mexico was first explored by Francisco Vásquez de Coronado in 1540. Yet because the Spanish failed to discover gold, silver, or other desirable natural resources in New Mexico and because travel north from Mexico along the Rio Grande corridor was arduous and time-consuming, colonization was slow. The Pueblo Indian peoples were even able to expel the Spanish from New Mexico for twelve years following their armed revolt in 1680, a feat accomplished nowhere else in the Americas.

The New Mexican Hispanic settlers, or Españoles, lived in relative isolation from the flourishing metropolitan centers of New Spain. They followed a largely agrarian way of life similar in many ways to that of a traditional sixteenth-century Spanish village, yet linked to Mexico City via the *camino real* (royal road), over which caravans of trade goods were periodically brought from the south. They created Catholic religious art, including *santos*, or painted wooden holy figures, in a quasi-medieval style that had long been outmoded in Spain. These traditions are alive and well today, as the *santos* of Raymond López, for example, make clear (fig. 159). They also built houses and mission churches of dried bricks, or adobes, combining Spanish methods with techniques they learned from the nearby Pueblo Indians to construct a distinctive hybrid architectural form.

158
Cross (*cruz guión*)
Probably Mexico, 1721
Silver
H. 33.2 cm (H. 12 ⅛ in.)

159
Raymond López
American, born in 1961
*Our Lady of Sorrows
(Nuestra Señora de los
Dolores)*, about 2000
Painted and carved wood
H. 52.7 cm (H. 20 ¾ in.)

In the colonial era, from the sixteenth until the early nineteenth centuries, Spanish-controlled territories extended far into what is now the American South and Southwest, including the present-day states of California, New Mexico, Arizona, Texas, and Florida. Two important early Spanish colonial outposts, Saint Augustine (founded in 1565 in present-day Florida) and Santa Fe (founded in 1608–10 in present-day New Mexico), are important reminders of the magnitude of Spanish colonial influence on the art and culture of the United States.

In Saint Augustine, a remarkable cache of silver religious objects, possibly buried in the eighteenth

A number of twentieth-century modernist artists born in the Unites States traveled to New Mexico precisely because of this rich Spanish colonial legacy. They included Ansel Adams, Marsden Hartley, Robert Henri, Rebecca Salsbury (Strand) James, John Marin, Georgia O'Keeffe, and Paul Strand, who visited or relocated to the area, helping to establish artists' colonies in Taos and Santa Fe that still thrive today. Many of them explicitly described their search for an alternative national history that had its origins not in New England but in the West. The region, with its vibrant Hispanic and Pueblo Indian communities, seemed to offer cultural difference within an American framework. These individuals often drew inspiration for their own artwork from hybrid and vernacular forms that evoked an archaic, much transformed Spanish cultural heritage.

Many modernists were drawn to the stark, earth-colored adobe buildings they saw, which appealed to them in part because the dwellings were fashioned from the land itself. Plain, functional, yet extraordinarily beautiful, these simple structures appeared both primitive and modern to the eyes of the twentieth-century artists who saw them. They also functioned as romanticized, ghostly reminders of an imagined past filled with the vanished conquistadores and Native American laborers who created them.

Foremost among the American artists to draw inspiration from the vestiges of New Mexico's Spanish colonial tradition was Georgia O'Keeffe, who painted historic adobe buildings as part of her broader interaction with the physical and cultural landscape of the American Southwest. O'Keeffe first saw New Mexico in 1917, when, as a young art teacher in Texas, she briefly visited Santa Fe while traveling through the state by train. She later said that after that first glimpse, she kept trying to return, though she did not succeed until 1929. The Southwestern experience was so powerful for O'Keeffe that for many years thereafter she divided her time between New Mexico and New York. In 1949 she relocated permanently to New Mexico, where she lived until the end of her life in 1986.

Over more than five decades, O'Keeffe painted New Mexico with an almost spiritual devotion. She

160
Georgia O'Keeffe
American, 1887–1986
Deer's Skull with Pedernal, 1936
Oil on canvas
91.4 x 76.5 cm (36 x 30⅛ in.)

161
Georgia O'Keeffe
American, 1887–1986
Patio with Black Door, 1955
Oil on canvas
101.6 x 76.2 cm (40 x 30 in.)

162
Gilbert Stuart
American, 1755–1828
Matilda Stoughton de Jaudenes,
1794
Oil on canvas
128.6 x 100.3 cm (50⅝ x 39½ in.)
The Metropolitan Museum of Art,
New York

depicted many southwestern subjects, including the landscape and, perhaps most famously, the animal bones she saw in the desert (fig. 160). Her most daring and abstract southwestern paintings, though, were her depictions of the simple shapes and subtle earth tones of Spanish colonial adobe buildings, including her own carefully restored home in Abiquiu.

When O'Keeffe purchased the five-thousand-square-foot eighteenth-century compound from the archdiocese of Santa Fe in 1945, it was in complete disrepair. She later described her first visit to the building:

> When I first saw the Abiquiu house it was a ruin with an adobe wall around the garden broken in a couple places by falling trees. As I climbed and walked about in the ruin I found a patio with a very pretty well house and bucket to draw up water. It was a good-sized patio with a long wall with a door on one side. The wall with a door in it was something I had to have. It took me ten years to get it—three more years to fix up the house so I could live in it—and after that the wall with a door was painted many times.[5]

One of the most striking depictions of this subject is *Patio with Black Door* (fig. 161), which shows the interior adobe wall of the enclosed patio viewed at a sharp angle. The series of square paving stones running along the bottom of the wall, picked out in a lighter pinkish brown, is difficult to understand unless one is familiar with the patio. This work is, above all, a quiet meditation on the infinite variety of shades of adobe, earth, and sky.

Spain directly influenced the culture of the United States in other ways as well. Perhaps the most significant is a movement called Hispanism, in which visual artists, writers, and composers drew their inspiration from Spanish culture. At Hispanism's peak, in the second half of the nineteenth century, Spanish art was seen as an important precedent for avant-garde painters interested in depicting modern life in a realistic way. In a somewhat modified form, it continued to influence artists committed to realism well into the twentieth century.

Artists and writers in the United States had been inspired by Spanish culture long before Hispanism

reached its zenith. In 1794 the painter Gilbert Stuart completed his portraits of the Spanish diplomat Josef de Jaudenes y Nebot and his wife. The paintings drew on the rich visual conventions of Spanish portraiture, including those of Stuart's contemporary Francisco Goya y Lucientes, and depicted the elaborate Hispanic dress of the sitters (fig. 162). In 1832 the author Washington Irving published his influential book *Tales of the Alhambra*, which described his experiences at the exquisite Alhambra Palace built by Muslim rulers in fourteenth-century Granada. In 1835 the poet Henry Wadsworth Longfellow published a prose reminiscence of his travel overseas, *Outre-Mer*, which included extensive descriptions of the nation. Both writers on some level perceived Spain as a country with an extraordinary cultural history that was now relatively impoverished and lagged behind the other European powers in modernization and industrialization.

Later in the nineteenth century, many artists from the United States, especially those who had studied and traveled in Europe, were attracted to things Spanish because they were eager to present themselves as the equals of members of the French avant-garde, who also held Spanish styles in high regard. Mary Cassatt, Thomas Eakins, William Merritt Chase, and John Singer Sargent are just a few of the American painters who traveled to the Iberian Peninsula to experience firsthand the masterworks of Spanish art, while others, including James McNeill Whistler, studied the growing number of Spanish paintings collected in European capitals. Most, though not all, experimented with or even adopted the dark palette, rich brushwork, and commitment to realism they saw in the Spanish images they viewed.

To avant-garde mid-nineteenth-century French artists such as Gustave Courbet and Edouard Manet, seventeenth-century Spanish painting offered an important prototype for the unflinching realism, dramatic use of light and shadow, and daring organization of space they sought in their own work. These artists looked to the Spanish masters Diego Rodríguez de Silva y Velázquez, Francisco Goya y Lucientes, and Francisco de Zurbarán, among oth-

ers, as an alternative to the more restrained French academic Neoclassicism developed earlier in the century by Jacques-Louis David and Jean-Auguste-Dominique Ingres.

One of the leading American artists to draw on the rich tradition of Spanish painting was Sargent. The child of American expatriates, Sargent was born in Florence and spent his childhood traveling through Europe. In 1874 he entered the Paris studio of the successful portraitist Charles-Emile-Auguste Carolus-Duran to continue his formal training as a painter. Velázquez was a major influence on many teachers of the day and was often held up as the most daring, accomplished, and truthful Spanish painter. Carolus-Duran was one of the artist's chief proponents, telling his students, "Velázquez, Velázquez, Velázquez, ceaselessly study Velázquez."[6] By the 1870s Spanish styles had become an established part of the vocabulary of serious artists. Ambitious young painters active in Europe were expected to make a pilgrimage to the Museo Nacional del Prado in Spain, the greatest repository of Spanish painting in the world. In the fall of 1879 Sargent did just that, registering as a copyist and painting copies of the masterworks on view. This process was commonly regarded as the best way for a student to learn a master's technique.

One of the Prado's greatest treasures is Velázquez's enigmatic masterpiece *Las Meninas*, a work that has been copied by countless artists, Sargent among them (fig. 163). Painted in 1656, *Las Meninas* (literally, The Maids of Honor) depicts the court of Philip IV of Spain. In the center is the Infanta Margarita, surrounded by attendants and court members, including Velázquez himself, who stands before the large canvas at the left with paintbrushes and palette in hand. Much of what Velázquez represents is based on fact; each of the individuals in the composition is a documented member of the court, and even the paintings that decorate the room (by Peter Paul Rubens) correspond with a contemporary inventory. However, Velázquez creates a complex meditation on the nature of image making from these familiar elements, a meditation that has become a touchstone for generations of artists and scholars intrigued by

163
Diego Rodríguez de Silva y Velázquez
Spanish, 1599–1660
Las Meninas, or The Family of Philip IV, 1656
Oil on canvas
318 x 276 cm (125 3/16 x 108 11/16 in.)
Museo Nacional del Prado, Madrid

164
John Singer Sargent
American, 1856–1925
The Daughters of Edward Darley Boit, 1882
Oil on canvas
221.9 x 222.6 cm (87 3/8 x 87 5/8 in.)

dence. As in *Las Meninas*, the figures in Sargent's painting are scattered around the room as though captured in the course of their daily activities, rather than arranged before the painter or viewer in a central grouping as tradition would dictate. The empty spaces between the children and the deepening shadow enveloping the two older girls give the painting a sense of psychological depth and quiet unease that echoes the mood of *Las Meninas*. The painting also shares specific formal elements with Velázquez's. Both works are structured around a deep, surprisingly empty square interior, with a distant mirror reflecting an image from outside the painting: in *Las Meninas* the mirror may reflect the king and queen, and in *The Daughters of Edward Darley Boit* the mirror reflects light from a hidden window. Both paintings also share a rich, silver-and-black palette and an attention to subtle gradations of light and shadow.

Sargent's references to *Las Meninas* in *The Daughters of Edward Darley Boit* could not possibly have gone unnoticed, given the older painting's great renown among European and American artists at that time. In fact, they spurred one American critic, William C. Brownell, to call Sargent "Velázquez come to life again."[7] These connections served an important purpose, both demonstrating Sargent's understanding of this esteemed masterwork and laying his claim to Velázquez's mantle of greatness. The references to *Las Meninas* in *The Daughters of Edward Darley Boit* also helped to legitimize the most daring and radical elements of Sargent's painting, for example the strikingly empty composition, which one critic described as "four corners and a void."[8]

As his career progressed, Sargent became a highly successful and sought-after portraitist, painting virtuoso likenesses of many of the wealthiest and most powerful people of his day. He also came to be recognized as an expert on Spanish art, even facilitating the MFA's 1904 acquisition of a major work by the sixteenth-century painter El Greco (Doménikos Theotokópoulos) (fig. 165). Though Sargent's paintings were less clearly influenced by Velázquez after he relocated to England in the mid-1880s, occasional traces of the Spanish artist's long-standing importance to Sargent remained. His *General Charles J. Paine*

his representation of representation. With its dark, composition of figures enveloped by voids, exploration of reflections, immediacy, and bravura brushwork, *Las Meninas* had a strong influence on many nineteenth-century artists, including Sargent.

Sargent drew on and transformed several elements of *Las Meninas* in his extraordinary early masterwork *The Daughters of Edward Darley Boit* (fig. 164). Like *Las Meninas*, *The Daughters of Edward Darley Boit* departs radically from the conventions of group portraiture, depicting a complex, momentary, and ambiguous scene. Sargent's painting shows the four daughters of Edward Boit, a Boston-born painter and a friend of the artist, in their Paris resi-

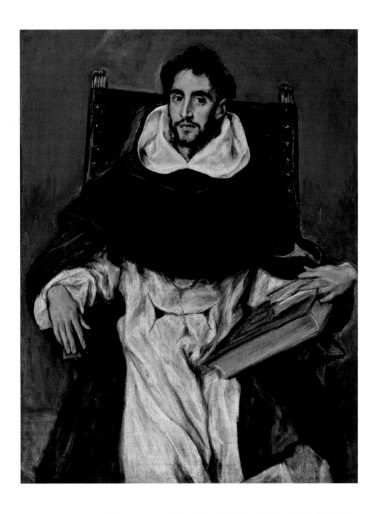

(fig. 167), for example, appears inspired in part by Velázquez's stark and intimate portraits, such as *Luis de Góngora y Argote* (fig. 166). Charles Paine, the commander of an African American division during the Civil War and a prosperous railroad industrialist, was known for his modesty and lack of pretension. These attributes of his personality may have prompted Sargent to paint him in the manner of Velázquez's straightforward and unadorned portrait.

A somewhat modified form of Hispanism continued into the early twentieth century, as a new group of artists took their own inspiration from Spanish painting and as important collections of Spanish art were brought to the United States. The influence of Spanish realism is especially visible in the work of artists like John Sloan, George Luks, and Robert Henri, who often painted working-class people in an unflinchingly realist manner. Henri, an influential art teacher, made multiple trips to Spain between 1900 and 1912. On his first visit, he spent six weeks in Madrid studying the masterworks at the Prado, just as Sargent had done more than twenty years earlier. Over the next several years, he produced a series of paintings of women and girls in Spanish dress, including *Spanish Girl of Segovia* (fig. 168). In 1908 perhaps the most important collection of Spanish paintings in the United States, the Hispanic Society of America, opened its doors. Located on Audubon Terrace in Upper Manhattan, the institution was founded by the wealthy collector Archer M. Huntington to showcase his painstakingly assembled comprehensive holdings of Spanish fine and decorative arts.[9] Containing major works by Velázquez, Goya, El Greco, Bartolomé Esteban Murillo, and many others, the Hispanic Society has given generations of American artists the opportunity to study a large number of original Spanish masterworks in New York City.

Spain lost many of its American colonies over the course of the nineteenth century until, with the Spanish-American War of 1898, its political presence in the Western Hemisphere was entirely extinguished. In the twentieth century, many Mexican, Central American, and South American artists from newly independent countries that had once been Spanish

165

El Greco (Doménikos Theotokópoulos)
Greek, active in Spain, 1541–1614
Fray Hortensio Félix Paravicino,
1609
Oil on canvas
112.1 x 86.1 cm (44⅛ x 33⅞ in.)

166

Diego Rodríguez de Silva y Velázquez
Spanish, 1599–1660
Luis de Góngora y Argote, 1622
Oil on canvas
50.2 x 40.6 cm (19¾ x 16 in.)

167

John Singer Sargent
American, 1856–1925
General Charles J. Paine, 1904
Oil on canvas
86.7 x 72.7 cm (34⅛ x 28⅝ in.)

possessions depicted the colonial period of their cultural history with profound ambivalence and even anger. A striking example of this is José Clemente Orozco's *The Franciscan* (fig. 169) of about 1929, one of the artist's best-known critiques of Mexico's Spanish colonial past. Along with Diego Rivera and David Alfaro Siqueiros, Orozco was one of the so-called *tres grandes*, or three great ones, of the Mexican muralist movement. This movement flourished after that nation's bloody revolution of 1910–20 and sought to define a national modern style suited to a new government that had promised to be more responsive to the needs of its citizens. Based on a detail from one of Orozco's early murals, this lithograph shows a Franciscan missionary wearing his distinctive robe and pressing his lips to the mouth of a limp, naked, and emaciated native figure. The disturbing embrace appears to be the kiss of death, in which the large and dominant Spanish figure draws the life out of the withered and passive indigenous man. This simple, powerful image expresses the artist's deep resentment of the death and destruction of native peoples perpetrated by the Spanish colonists.

Other artists from nations once colonized by Spain emphatically turned their backs on the masterworks of Spanish painting that had been so important to previous generations, looking for inspiration instead to their indigenous heritage. One such artist was Carlos Mérida, who developed an innovative abstract style in part through his exploration of indigenous Maya sources, at the same time rejecting the influence of Spanish art. As he put it, "As time went by I began to realize that I had my own past, and that my ancestors the Mayas had painted extraordinary murals. I feel much closer to the frescoes of Bonampak [an ancient Maya archaeological site in the Mexican state of Chiapas] than to Velázquez's *Las Meninas*."[10] This feeling of distance from Spanish art is in its own way a powerful legacy of colonial rule, representing a deep identification with the indigenous peoples who were subjugated during that period.

Born in Guatemala of mixed Mayan and Spanish heritage, Mérida spent much of his career in Mexico, where, like Orozco, he played an important part in

the muralist movement. In 1929 he first encountered the *Popol Vuh*, the ancient Mesoamerican text that records the central mythical religious narrative of the Maya, which quickly became an important source for Mérida's abstract work. He later stated:

> I felt it intensely, as it is the sacred book of the Mayas, very similar to all sacred texts which explain the origins of the world. Ours is very poetic and very difficult to understand. We understand it, but for a non-Maya it is difficult. . . . It has been very important to me as an aid for entering a world which is mine. It was not difficult for me to enter into a phase of work which is at the same time religious, poetic, lyrical and which transformed my painting completely. It began by being folklore, then it became more poetic, and finally more abstract.[11]

168
Robert Henri
American, 1865–1925
Spanish Girl of Segovia, 1912
Oil on canvas
103.5 x 84.1 cm (40 ¾ x 33 ⅛ in.)
New Britain Museum of American Art, Connecticut

169
José Clemente Orozco
Mexican, 1883–1949
The Franciscan, about 1929
Lithograph
30.5 x 25.4 cm (12 x 10 in.)

Mérida drew many themes for paintings and drawings from the stories of the *Popol Vuh*, and in 1943 he produced a series of lithographs illustrating the text, the *Estampas del Popol-Vuh*, or *Impressions of the Popol-Vuh* (fig. 170). These abstractions eventually led him to create more angular compositions, such as his *Architectures* (*Arquitecturas*, fig. 171).

Spain's impact on the Americas over the last six centuries has been complex, multifaceted, and profound. Because of its extensive history as a colonizing power, Spain was a dominant force in the Western Hemisphere through the eighteenth century; however, in recent centuries, its influence has been more fragmented, contingent, and sometimes even repressed. Yet throughout, Spanish painting styles, decorative arts techniques, and even architectural modes have played a key role in the art of the Americas.

170

Carlos Mérida

Guatemalan, 1891–1984

"Thus the creation and the formation of man took place. . .," from the portfolio *Impressions of the Popol-Vuh* (*Estampas del Popol-Vuh*), 1943
Color lithograph
42.9 x 32.7 cm (16 ⁷/₈ x 12 ⁷/₈ in.)

171

Carlos Mérida

Guatemalan, 1891–1984

Architectures (*Arquitecturas*),
1955–66
Oil on canvas
76.2 x 62.2 cm (30 x 24 ¹/₂ in.)

THE NETHERLANDS AND SCANDINAVIA DENNIS CARR AND CODY HARTLEY

From the Norse explorers who journeyed across the Atlantic centuries before Columbus to the Dutch and Swedish colonists who vied for possession of eastern seaboard colonies in the sixteenth and seventeenth centuries, the people of the Netherlands and Scandinavia established an early presence in North America. Subsequent generations of Dutch and Scandinavian emigrants transported their traditions directly to American shores. Dutch culture also entered the Americas as trade goods, books, maps, prints, and old master paintings, while the romantic appeal of legendary ancestors, be they Vikings or Knickerbockers, inspired authors, artists, and historians. The American legacy of interaction with the Netherlands and Scandinavia is indelible.

As the Rhine, Scheld, and Meuse rivers flow out of northern Europe to meet the North Sea, the land flattens, and the waterways fan out into wide deltas. Much of the region is at or even below sea level; *neder land*—the Netherlands—literally means "low land." Historically, this was an area of smaller provinces or counties, sharply divided at times by church or state. Catholic Spain ruled much of the Low Countries from the sixteenth to the eighteenth centuries. Protestant counties in the north, with Holland being the most populous and influential, forged the Dutch Republic in revolt against the Spanish. In 1581 the Republic of the Seven United Netherlands declared independence from Spain, setting a precedent for North American colonists to follow almost two hundred years later.

By the seventeenth century, the United Netherlands was a global economic power controlling an empire of colonies throughout Asia, Africa, and the Americas. Wealthy traders supported a flourishing of art and culture—the Dutch Golden Age—by patronizing artists such as Rembrandt van Rijn, Jacob van Ruisdael, Johannes Vermeer, Frans Hals, and Jan Steen. Amsterdam and other cities in urbanized Holland became havens for Protestants fleeing areas controlled by Spain, notably Flanders. Relatively tolerant of religious diversity, the Netherlands attracted merchants, artists, and intellectuals from all over Europe, including the *Mayflower* Pilgrims, who spent over a decade in Leiden before eventually settling the Plymouth Colony in Massachusetts in 1620.

An instance of the Dutch imprint on American art and one of the earliest examples of the fine art produced in colonial New England is a portrait of a young girl named Margaret Gibbs (fig. 172). Between 1670 and 1674 Margaret, her younger siblings, and a handful of children from other prosperous Boston families sat for an unknown artist now called the Freake-Gibbs painter, after the surnames of the sitters in the artist's most prominent portraits. These young children from the Massachusetts Bay Colony have come to shoulder a large burden in the history of American art. Since at least the 1860s, American historians have turned to them as proof that the seed of artistic culture found early nourishment in American

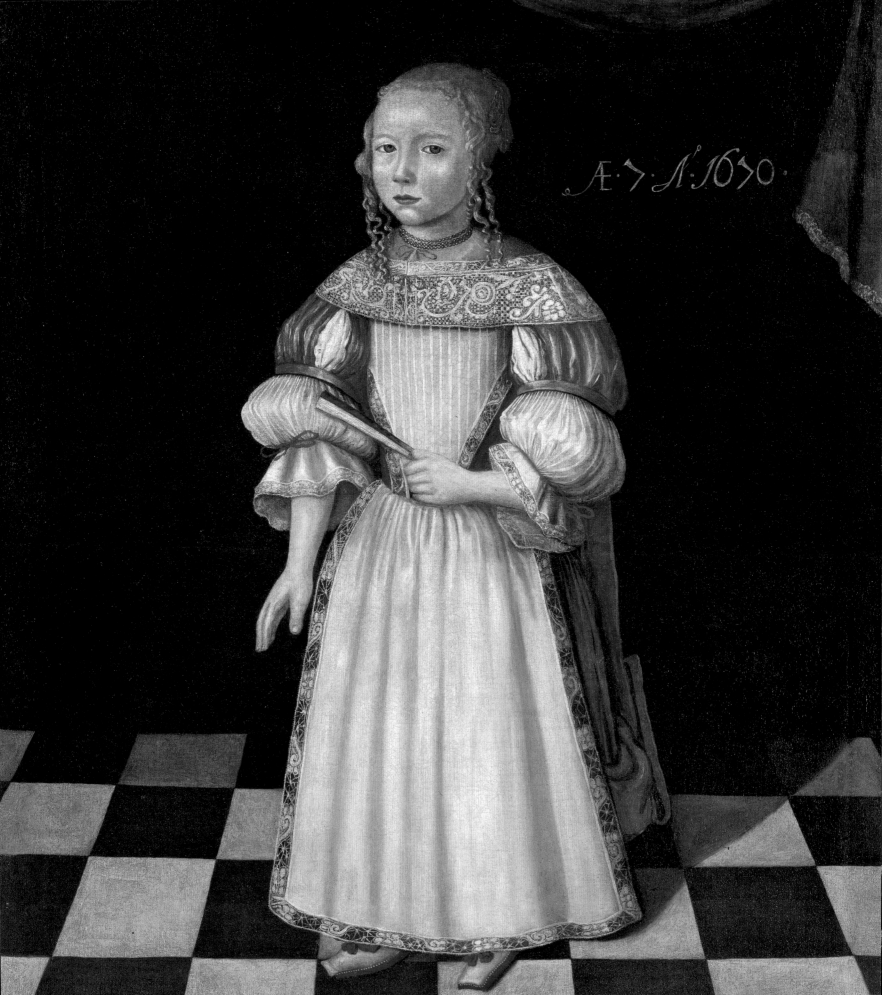

soil.[1] In the twentieth century, this group of portraits was described as late examples of the Elizabethan court style—they were painted nearly seventy years after the end of the reign of Elizabeth I—and cited as proof of the English nature of the earliest artistic practice in the colonies.[2] Complicating this portrayal, however, is the fact that the so-called English style of Margaret's portrait is not entirely English but in fact reflects the artistic traditions of the Low Countries. Henry VIII, who ruled England from 1509 to 1547, owned many Flemish paintings, and his daughter Elizabeth I employed Dutch artists in her court, infusing the Elizabethan style with Netherlandish influences.[3] The Freake-Gibbs painter used conventions for portraiture that were honed in the lowlands and imported into England. The arrangement of the figure in a shallow space against a dark background, the inscription of the year and age of the sitter in the upper right section, and even the checkered floor provide evidence that the Freake-Gibbs painter was at least aware of Netherlandish precedents. With its careful attention to the detail of costume and intense Protestant solemnity, the Gibbs portrait is indebted to earlier Dutch and Flemish painting. Margaret stares out from her somber portrait to remind us that North America's artistic heritage, like the broad continent and the people who lived here, is richly diverse.

Aside from the early explorations of the Vikings, the tangible presence of Dutch and Scandinavian settlers in North America began with the colonies of New Netherland and New Sweden.[4] Well after Henry Hudson's 1609 exploration of his namesake river, conducted on behalf of the Dutch East India Company, the legacy of the Dutch colony of Nieuw Nederland continued to shape New York. From 1609 to 1664 the Dutch held dominion over a colony occupying much of the mid-Atlantic region, from Delaware to New York, including New Jersey and portions of Connecticut. During this era, the Swedish Empire grew to control vast portions of Scandinavia and established colonies in Africa and the Americas. New Sweden, centered along the Delaware River at Fort Christina, near modern Wilmington, was more or less under Swedish rule from 1638 until 1655, when the Dutch took control of the colony. Under the rule of Governor Peter Stuyvesant, Dutch sovereignty lasted until 1664, when the English overtook both New Netherland and New Sweden.

These colonies were remarkable for their diversity. New Amsterdam has been described as "America's first melting pot," and, indeed, one could find eighteen languages being spoken there in the mid-seventeenth century.[5] Religious tolerance made New Netherland a haven for those escaping persecution in Europe and even those who found Puritan New England too restrictive. One-fifth of New Netherland's colonists were dissenting Puritans, who, like Anne Hutchinson, sought a degree of religious freedom that Massachusetts's leaders would not allow. The Dutch offered greater religious tolerance as well as a legal system that afforded women greater rights than English common law offered. Furthermore, as a practical commercial matter, tolerance was good for business. When Governor Stuyvesant tried to dissuade Jews from settling in New Netherland, his Dutch superiors invoked the ideal of religious tolerance but also curtly reminded him that Jews had invested substantial capital in the Dutch West India Company.[6] Many of the skilled craftsmen living in the colony, for reasons of business, moved easily within this pluralistic society, regardless of their origins. After the English took over administration of the colony in the 1660s, the ability to cater to the needs of the culturally mixed Dutch and English patrons in New York became even more valuable.

Jacob Boelen was just a toddler when he arrived in the New Netherland colony with his parents in 1659. His Dutch family left Holland bound for New Amsterdam just a year after Margaret Gibbs's father, Robert, immigrated to Massachusetts from England. By the time of Boelen's death, he had become a successful silversmith and, despite his Dutch heritage, was a leading citizen of what by then was the British city of New York, serving as alderman of the North Ward four times.[7] Boelen was also an elder of the Dutch Reformed Church, a prominent role that undoubtedly secured business for his shop and forged his relationships with other silversmiths and

172
Freake-Gibbs painter
Active late 17th century
Margaret Gibbs (detail), 1670
Oil on canvas
102.9 x 84.1 cm (40½ x 33⅛ in.)

affluent Dutch patrons who were members of the church. Judging from the silver that survives from his shop, Boelen, like his son Henricus, also a silversmith, specialized in forms that had a specifically Dutch cultural valence, including ceremonial silver cups, known as brandywine bowls (*brandewijnskom*) (fig. 173). These two-handled cups held brandied raisins or other sweets and were passed among groups at christenings, weddings, funerals, feast days, and other social gatherings. Numerous American examples, many with six panels and two vertical handles, survive from the seventeenth and eighteenth centuries. This small example by the elder Boelen has stylized flower motifs of the type often seen in Dutch botanical engravings and silver.

Similarly, Swedish-born Henry Hurst, or Hindrich Husst, as he often spelled his name, readily received commissions from Boston at the turn of the eighteenth century. Although documents indicate that Hurst worked as a journeyman in London and later moved to Boston as an indentured craftsman for the English émigré silversmith Richard Conyers, the affinity of Hurst's Boston work with Swedish silver of the 1680s suggests that he trained as an apprentice in his native country, perhaps in the capital city of Stockholm.[8] For example, the distinctive hand-hammered and raised fruit and foliate decoration on the handle of his masterly tankard (one of only three surviving pieces that bear his personal HH mark) is highly unusual for handle decoration made in an English fashion from this period, which more typically would have been cast separately and then applied (fig. 174). The tankard has a history of being given as a wedding gift to celebrate the union of Abigail Lindall and Benjamin Pickman II, a prominent Boston merchant. Hurst may also have had a hand in creating a group of celebrated silver sugar boxes between 1700 and 1702, when he may have worked for the Boston silversmith Edward Winslow, whose maker's mark appears on the surviving examples produced by his shop. The elaborately chased lids of the sugar boxes bear the same kind of raised work seen on the tankard handle and are unlike other silver marked by Winslow.[9] Swedish stylistic influences in American art, although less prominent

than the Dutch, were still present and, like immigration into the colonies, often took the same route through England during the seventeenth and eighteenth centuries.

Along the Hudson River, throughout the eighteenth century, a small number of wealthy Dutch families retained control of large tracts of land—a legacy of the patroon system enacted by the Dutch West India Company to lure settlers to its colony. The most famous and long-lived of these patroonships was Rensselaerswyck, which encompassed the modern New York counties of Albany and Rensselaer. Under the control of the Van Rensselaer family, this was the only patroonship to survive intact after the English took possession. Even after the Dutch ceded control, the English sustained a manorial system based on the patroon system. These wealthy and powerful landholders stood at the center of a society that retained a strong allegiance to its Dutch cultural heritage. They held fast to the architecture, domestic goods, and arts favored by their forebears a century earlier. They also preserved their language and their church, the Protestant Dutch Reformed Church— both important forces in sustaining an exclusive Dutch community.

Like their peers and predecessors in the Netherlands, the Dutch of the New Netherlands appreciated art. In the 1640s, as the colony achieved a degree of security and comfort, the settlers began importing prints and paintings. In addition to portraiture, home inventories describe marine views, landscapes, still lifes, and genre scenes.[10] Within a few generations, native painters emerged to satisfy local demand. *Isaac Blessing Jacob* is a rare extant example of a devotional painting made locally for a New Netherland home (fig. 175). Five similar paintings are known to exist, made by at least three different hands, all dating to the 1740s and all found in or near Albany.

The Dutch Reformed Church, as a Protestant church founded largely on the teachings of John Calvin, banned graven images but deemed illustrations of scripture acceptable in private homes. A strong tradition for such images existed in the Netherlands up through the end of the seventeenth century. In fact, this kind of religious work has its

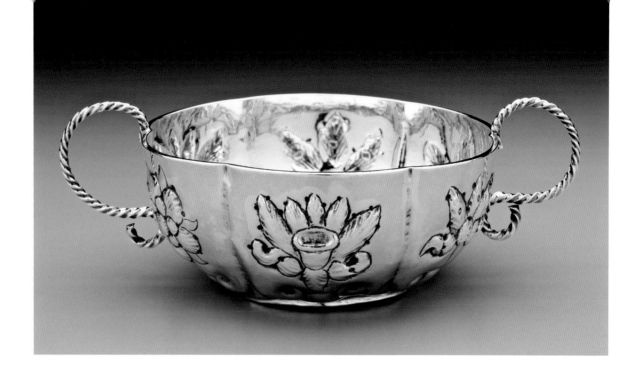

173
Jacob Boelen I
American, born in Holland,
about 1657–1729 or 1730
Two-handled bowl, 1690–1710
Silver
H. 4.6 cm (H. 1 ¹³⁄₁₆ in.)

174
Henry Hurst
American, born in Sweden,
about 1666–1717 or 1718
Tankard, about 1700
Silver
H. 17.8 cm (H. 7 in.)

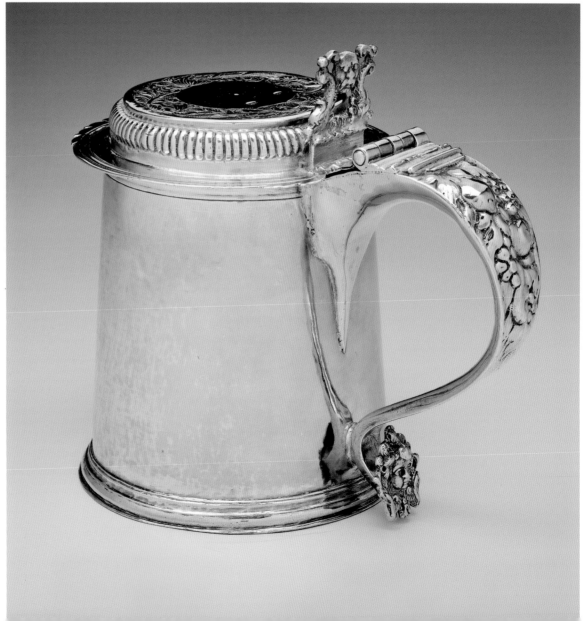

175

Isaac Blessing Jacob, about 1740
Oil on canvas mounted on
Masonite
78.1 x 102.6 cm (30¾ x 40⅜ in.)

origins in seventeenth-century paintings of Isaac and Jacob by the Flemish painter Willem van Herp. Around the 1660s van Herp painted multiple versions of Isaac blessing his son. It is unlikely that any of van Herp's paintings made it to the North American colonies, but copies of his paintings or prints based on one or more of his pictures might have circulated in New Netherland. Conforming to standard European iconography for this biblical story, van Herp's paintings show the aged Isaac in his bed, with Jacob kneeling to receive his father's blessing. In collusion with his mother, Rebecca, Jacob disguised himself as Esau by covering himself with furs, thus deceiving his father and cheating his brother of his

rightful inheritance. Esau appears in the background, having just returned from the hunt. Illustrated Bibles enjoyed great popularity precisely at this moment, providing another possible source for the imagery.

Remnants of Dutch colonial culture persisted well into the early nineteenth century as descendants of the original Dutch settlers continued living in the Upper Hudson River Valley, northern New Jersey, and Long Island. A patrimonial system of land tenure allowed multiple generations of children to own land in the same area; at the same time the Dutch pressed outward from the island of Manhattan as populations grew and vast tracts of farmland became increasingly scarce. The intermixing of Dutch and English settle-

ments was common, and the survival of hundreds of Dutch-style *kasten*, or cupboards, from this region reveals the lingering influence of the Dutch tradition on American decorative arts (fig. 176). Made in large numbers from the middle of the seventeenth to the early nineteenth centuries, the form of the American *kast* evolved little over time. Except for certain variations following regional preferences and shop traditions, American kasten generally follow a convention derived from Dutch prototypes: a massive architectonic form, with a broad, overhanging cornice, paneled doors, tripartite front, and applied decorative moldings. According to Dutch (and Continental) preferences, clothing could be folded and stored on open shelves inside the kast instead of being placed in multiple drawers, as was the English custom. The example pictured here is attributed to the craftsman Roelef D. Demarest, who was born in Schraalenburgh in Bergen County, northern New Jersey.

The existence of paintings like *Isaac Blessing Jacob* and the enduring popularity of the kast in New York suggest that Dutch descendants living along the Hudson experienced a good degree of cultural independence, strengthened no doubt by linguistic, religious, and geographic isolation. Much more so than their kin in urban New York, the upriver Dutch maintained a culture that was distinct from that of their English neighbors, unique enough to become the material of legend. By the time of the American Revolution, the Dutch patroon system of landownership had been dismantled, but the Dutch language and culture survived. As late as 1788, it was necessary to translate the Constitution into Dutch so that voters in Albany could consider ratification. Even into the 1840s, Dutch continued to be spoken among some descendants of the old colony.[11]

Over time, as the Dutch progeny of the New Netherland colony assimilated into the broader, English-speaking society of the young United States, and as the traces of a living Dutch America grew fainter and seemed in danger of disappearing, the Dutch—both the Hudson River and the North Sea varieties—became sources and models for American culture, identity, and mythmak-

ing. Generations of American artists, art collectors, writers, and historians would prove to be deeply interested in the art and culture of the Dutch.

Throughout the nineteenth century, Dutch art provided a model for artists and patrons throughout the United States. Eager to establish an independent cultural identity, to forge an art appropriate to the values of the young nation, Americans looked to many sources, especially the Athenian democracy and Roman Republic of the classical world. The United Netherlands, as a Protestant republic that championed

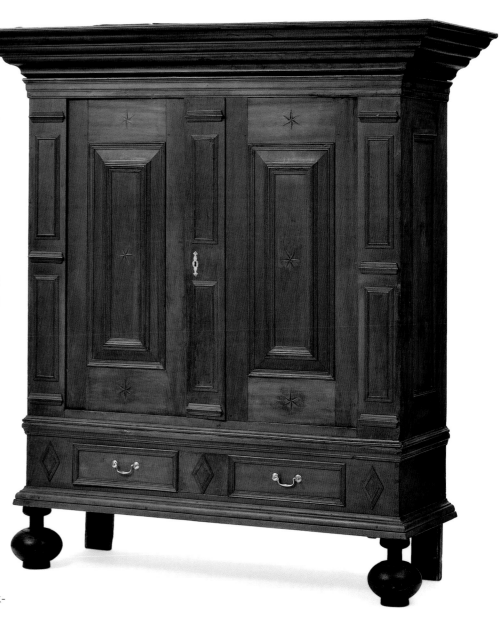

176
Attributed to Roelef D. Demarest
American, 1769–1845
Kast, 1790–1810
Red gum, yellow poplar, pine
H. 198.1 cm (H. 78 in.)

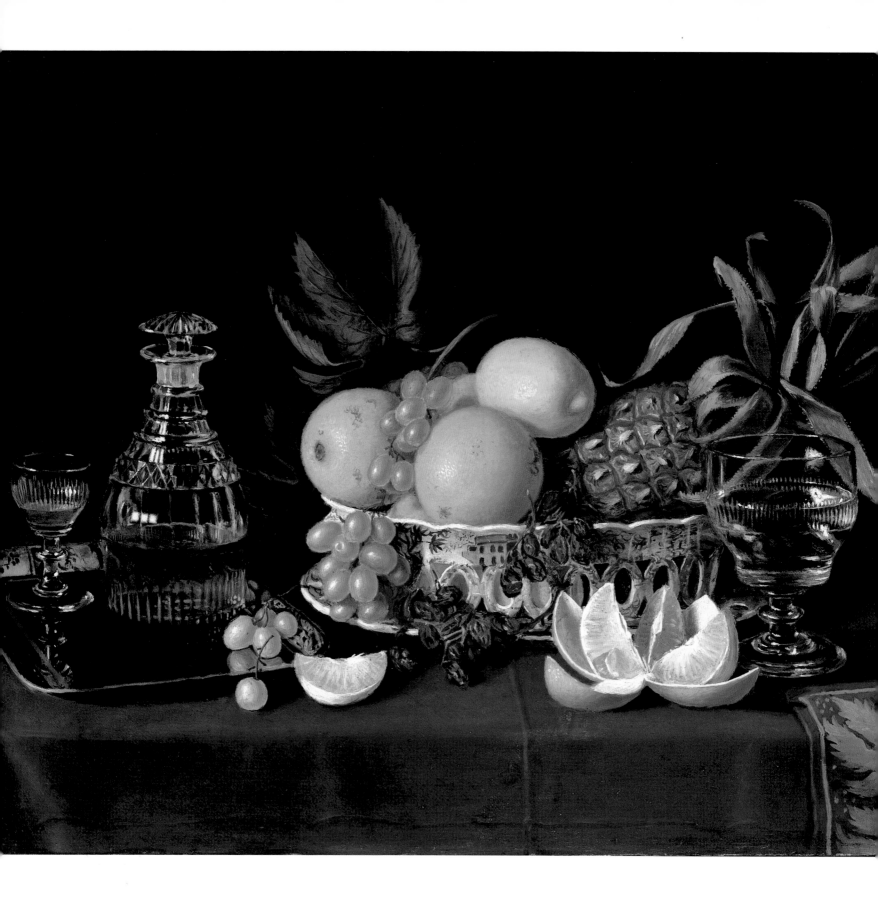

individual liberty and handsomely rewarded the enterprising ambitions of a vibrant mercantile class, offered a model with striking similarities to the United States. John Adams, sent to Holland to seek political recognition and financial support for the Revolutionary War, observed, "The originals of the two republics are so much alike, that the history of one seems but a transcript from that of the other."[12]

In Dutch art, particularly in the still-life and genre paintings that celebrated the humble objects and daily lives of ordinary people, some Americans found a mode of painting that seemed suitable for capturing the character and ideals of their nation.[13] Ralph Waldo Emerson's imploring call for a new, distinctly American culture conveys this appreciation for the simple value of everyday life: "I ask not for the great, the remote, the romantic. . . . I embrace the common, I explore and sit at the feet of the familiar, the low."[14]

Wherever American artists studied, whether in America or in Europe, Dutch art was inescapable. Even during the colonial era, prints and copies after Dutch paintings circulated in cities like Boston, New York, and Philadelphia, much as the Spanish imported Flemish pictures and prints into Mexico City and other urban centers of Latin America. By the 1820s examples of Dutch art appeared prominently in American private collections and public exhibitions. This familiarity encouraged Americans to emulate the types of paintings that the Dutch excelled at: portraits, land- and seascapes, still lifes, and genre scenes.

Charles Bird King discovered Netherlandish examples by studying prints in America and then from direct study of the Dutch and Flemish paintings widely available in English collections during a six-year stay in London, from 1806 to 1812. *Still Life on a Green Table Cloth*, painted about 1815, shortly after his return to the United States, follows in the tradition of Dutch *pronk* still lifes (fig. 177). *Pronk* paintings often feature crystalline glassware, glowing Chinese porcelain, carefully wrought metalware, and rich displays of fruit and foodstuffs. The variety of material surfaces allowed artists to demonstrate their masterly ability to handle color, light, and texture while also conveying the wealth and worldliness of their patrons.

In rendering the various fruits and objects with convincing naturalism, King emulates the exacting trompe-l'oeil techniques perfected by lowland painters in the seventeenth century. King's tableau suggests a wealthy host's hospitable welcome. Sherry has been poured, the orange cut and peeled, ready to be offered to the guest. A pineapple—meaningful as both a New World fruit and a traditional gesture of welcome—rests prominently in a blue-and-white porcelain bowl. Invoking earlier models, King's painting is a declaration of his artistic sophistication and a visible demonstration of the growing wealth and cultured refinement of his nation.

Nineteenth-century American artists also drew inspiration from Dutch and Flemish genre paintings, those scenes of everyday life. They looked back to artists like Jan Steen and Adriaen Brouwer, who painted entertaining, moralistic images of unkempt houses and raucous taverns.[15] Brouwer's *Peasants Carousing in a Tavern*, for example, depicts a drunken circle of ne'er-do-wells (fig. 178). A similar ambience of slovenly leisure and rowdy inebriation appears two centuries later in the paintings of John Quidor, a friend of Washington Irving's, who made something of a specialty illustrating scenes from the author's fictional (and mostly derogatory) accounts of America's Dutch past. Irving's "Rip Van Winkle" and "The Legend of Sleepy Hollow" appeared serially in 1819 and 1820 and proved to be enormously popular with American readers. Replete with stereotypically Dutch details, including long-stemmed pipes and stepped gable-end buildings in the distance, Quidor's painting *Rip Van Winkle and His Companions at the Inn Door of Nicholas Vedder* shows Rip retreating to the company of the tavern to escape his nagging wife (fig. 179). The spirit of earlier Dutch examples animates Quidor's depiction. Like Brouwer's boisterous scene of carousing peasants, Quidor's composition includes several groups, suggesting multiple, overlapping conversations. Activity is spread across the immediate foreground, compelling the viewer to travel back and forth between Rip's sluggardly form on the right—he seems to rely on the tree's support just to keep himself upright—and the pair on the left, where a plump smoker in red listens with lazy

177
Charles Bird King
American, 1785–1862
Still Life on a Green Table Cloth,
about 1815
Oil on panel
47.6 x 55.9 cm (18¾ x 22 in.)

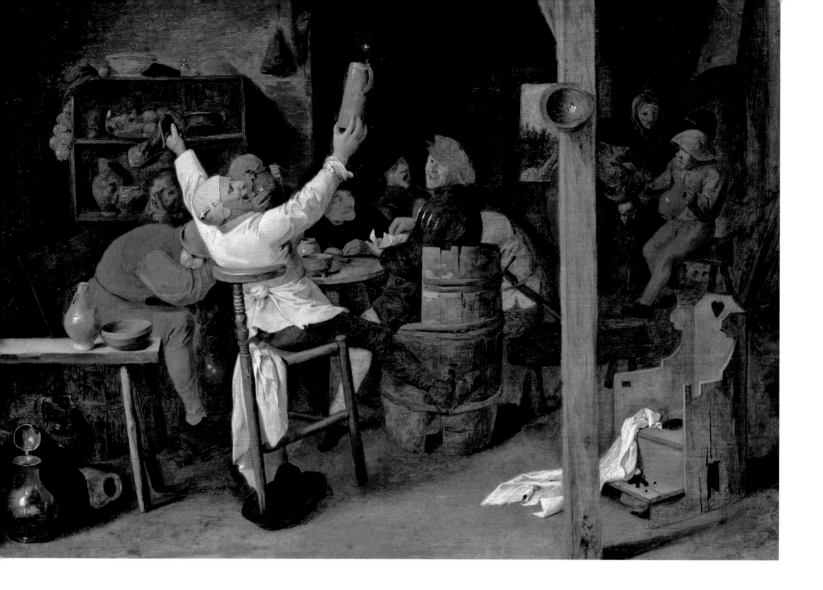

178
Adriaen Brouwer
Dutch, about 1606–1638
Peasants Carousing in a Tavern
Oil on panel
33.3 x 49.2 cm (13 ⅛ x 19 ⅜ in.)

skepticism to the insistent pontifications of his companion in blue, whose sneer suggests an unseemly topic. Quidor, in all likelihood, was more familiar with prints by the British satirical artist William Hogarth than with Dutch sources directly, but Hogarth in turn based his work on Dutch models.

One of Quidor's most dynamic and entertaining paintings purports to illustrate a historic event, the battle between the Dutch and the Swedish for control of New Sweden (fig. 180). The source for this "history" is none other than Washington Irving's first book, *A History of New-York from the Beginning of the World to the End of the Dutch Dynasty*, a mockery of the Dutch experience in New York published in 1809 under the

pseudonym Diedrich Knickerbocker. New Netherland's attack on New Sweden, led by Governor Peter Stuyvesant, warranted a chapter in Knickerbocker's *History*. Quidor's illustration of the scene closely follows Irving's description. The Swedish Fort Christina is visible on the hillside in the upper right. The respective flags of the Dutch and Swedish can be seen in the center, surrounded by hordes of inept citizen-soldiers fighting with a range of implements, from rifles to broken swords and farmer's spades. An unfortunate goose falls from the sky, the victim of Swedish cowardice. Irving's narrator reported that the Swedes observed "their usual custom of shutting their eyes, and turning away their heads at the moment of discharge."[16]

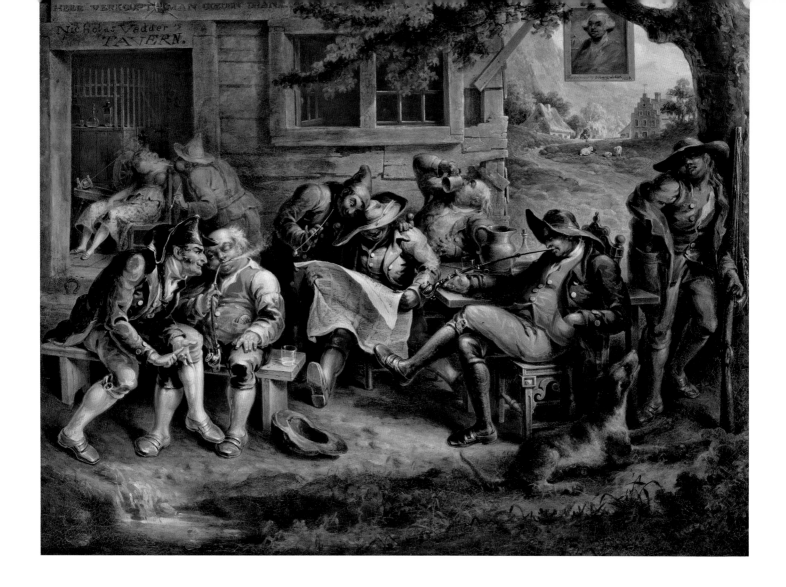

Quidor depicted a moment of high drama, just after the Swedish governor Johan Rising has landed a blow on the head of Governor Peter Stuyvesant that "would have cracked the crown of any one not endowed with supernatural hardness of head; but the brittle weapon shivered in pieces on the skull of Hardkoppig Piet [Hardheaded Peter]," as Irving told it. Reeling from the knock on his noggin, the one-legged Stuyvesant has fallen and defends himself by lobbing a jug toward Rising. In a few moments, Stuyvesant would give Rising "a thwack over the sconce with his wooden leg, which set a chime of bells ringing triple bob majors in his cerebellum." Next in Irving's story, as the Swedish general stag-

gered, Stuyvesant seized "a pocket-pistol which lay hard by, discharged it full at the head of the reeling Risingh," and the battle was over. Irving's text and Quidor's image are rollicking caricatures. Where Irving transformed the language of history into satire, Quidor deployed the motifs of grand battle scenes as mockery.

Although Quidor and Irving portrayed the Dutch past as a series of humorous follies, their exaggerations refer to actual historic events. Despite the slanderous derision of Dutch proclivities found in Irving's stories and Quidor's paintings, the focus on New Netherland nonetheless raised interest in the disappearing Dutch culture in the United States, just as his-

179
John Quidor
American, 1801–1881
Rip Van Winkle and His Companions at the Inn Door of Nicholas Vedder, 1839
Oil on canvas
68.9 x 86.7 cm (27 1/8 x 34 1/8 in.)

torians and others were most concerned with identifying the origins of the young republic.

In the mid-nineteenth century, an era preoccupied with racial purity, when eugenics was considered sound science and good legal policy, historians like Henry Adams, a Boston-born descendant of Presidents John Adams and John Quincy Adams, presented a version of United States history that emphasized the Anglo-Saxon roots of American democracy, tying an idealized medieval past to an idealized American past.[17] The Brahmin elite of New England could secure their sense of racial and cultural superiority by imagining themselves the descendants of the heroized Saxon (Germanic) warriors who ruled England before the Norman Conquest. While the Englishness of Anglo-Saxon identity was always predominant, the bold exploits of the Vikings and Dutch were also thought of as expressions of Anglo-Saxon blood and proof of the noble racial character of all who shared such blood, including Americans.

Vikings offered a seductive alternative to Christopher Columbus, especially for those with anti-Catholic sentiments. A Danish scholar first suggested the idea. Carl Christian Rafn's *American Antiquities* of 1837 suggested that the legendary Vinland described in Norse sagas was a real place in North America, starting a long public fascination with the Vikings. Sites for the Norse colony were proposed from Narragansett Bay in Rhode Island to Newfoundland. Several locations in Massachusetts were also put forward, including sites on Martha's Vineyard, on Cape Cod, and even in Cambridge. Henry Wadsworth Longfellow's 1841 poem "The Skeleton in Armor" took inspiration from the supposed discovery of a Viking burial in Fall River, Massachusetts. In the 1840s the amateur historian Asahel Davis found popular acclaim with his *Lecture on the Discovery of America by the Northmen Five Hundred Years before Columbus*, which went through nineteen editions by 1847. For some, the search for the Viking settlement became an obsession. The chemist Eben Norton Horsford, who had made a fortune selling his Rumford Baking Powder, was intent on proving the Vikings had landed in Massachusetts. Through his research, including excavations near his home along the Charles River, where Longfellow

was a neighbor, Horsford became convinced that the Vinland settlement was on the Charles. According to Horsford, Leif Ericson had built a home in the year 1000 on a site near present-day Mount Auburn Hospital; the location is still marked with a marble plaque placed there by Horsford.

However dubious Horsford's scholarship—there is no evidence to support his theories—his enthusiasm and wealth ensured a lasting Viking legacy in Boston. During an 1870 visit by the famed Norwegian violinist Ole Bull, a small group of Bostonians, including Longfellow, proposed erecting a statue of Leif Ericson. Despite the fact that more than fifty prominent citizens, including Horsford, enlisted to support the cause, the project stalled. A few years later Horsford made another push for an Ericson sculpture, commissioning the Boston sculptor Anne Whitney to create the monument that now stands in the Commonwealth Avenue mall. Whitney's *Leif Ericson* was calculated to appeal to American tastes and provide a worthy Viking ancestor, not a violent warrior

180

John Quidor
American, 1801–1881
A Battle Scene from Knickerbocker's History of New York, 1838
Oil on canvas
68.6 x 87.9 cm (27 x 34⅝ in.)

181

Arthur Stone

American, born in England,
1847–1938
Porringer, 1925
Silver
5.4 x 21.6 cm (2⅛ x 8½ in.)

in full sail (fig. 181). The handle bears the initials JHR for John Herbert Ross, a gift to him from loving grandparents in celebration of his birth in 1925.

However large the Vikings' presence was in the American imagination, their physical presence was tenuous and remote. Not until the 1960s did archaeological evidence confirm the existence of a Norse settlement in Newfoundland, but no evidence has yet surfaced to posit a Viking visit to Massachusetts. The situation with the Dutch, with their very real presence in New Netherland, is different. In the wake of Irving's pseudohistory, a handful of historians produced more sincere considerations of America's Dutch heritage. Histories emphasizing the role of the Dutch as founders of American society became more numerous in the 1880s and 1890s, as appreciation of Dutch culture grew.[19] Among the earliest was Asahel Davis's 1854 publication *History of New Amsterdam; or, New York as it was, in the days of the Dutch.* A few years later, John Lothrop Motley, born in Dorchester and educated at Boston Latin School and Harvard College, achieved acclaim with two histories of the Netherlands that emphasized the Dutch resistance to Spanish oppression and the formation of the Dutch nation as a united federation of states. *Rise of the Dutch Republic* was published in 1856, and *The United Netherlands* appeared in 1860. Motley explicitly linked Dutch history, United States history (specifically of Massachusetts), and a grand racial narrative of Anglo-Saxon accomplishment, writing, "The history of the great agony through which the Republic of Holland was ushered into life must have peculiar interest, for it is a portion of the records of the Anglo-Saxon race—essentially the same, whether in Friesland, England, or Massachusetts."[20] Motley saw the Netherlands as a direct precursor to the United States. The two peoples shared "much of that ancient and kindred blood," that Anglo-Saxon blood, and traced "their political existence to the same parent spring of temperate human liberty." The importance of such a study could not be overestimated, according to Motley: "The lessons of history and the fate of the free states can never be sufficiently pondered by those upon whom so large and heavy a responsibility for the maintenance of rational human freedom rests."[21]

so much as a noble explorer. One critic interpreted Ericson as "a Norseman Apollo . . . a handsome vigorous fellow, whose well-modeled limbs, spirited characteristic pose, figure-displaying armor are all calculated to win women's hearts and men's admiration." Another noted that "the knit brow and noble bearing of Leif tell not only of the firm resolve and daring of the explorer, but also that he was a worthy forerunner of the Pilgrims," and credited Whitney "for having chosen as the type of the Northmen ancestors, not the Berserk warrior, but the Iceland merchant, explorer and Christian, as Leif Eriksson truly was."[18] In Boston, interest in Norse mythology continued through the Arts and Crafts period, firing the imaginations of young and old alike. The firm of leading Boston silversmith Arthur Stone produced fine silver objects in the Viking Revival style, including a porringer that has an elaborate handle with a Viking ship

Motley's histories emerged just before the Civil War, a time when questions about the preservation of the U.S. republic were becoming dangerously real, and many Americans were wondering how human freedom could be maintained. In the decades after the Civil War, interest in identifying sources for the country's national character continued, reaching a fevered pitch by the turn of the century. For many of the ruling white elite, it seemed that the Protestant, Anglo-Saxon values that they believed essential to the preservation of the United States were under threat. Some portrayed New England's Puritan ancestry as the cultural and spiritual foundation of the nation. Others inflected this narrative by incorporating the Dutch or Scandinavian past.

These efforts to assert the Viking and Dutch presence within the historical imagination paralleled growing public interest in all things Dutch between the 1870s and 1890s, peaking around 1900. "Holland Mania," as one historian has aptly called it, saw wealthy industrialists building collections of Dutch old master paintings, while Americans from all classes redecorated their homes to imitate seventeenth-century homes in Holland.[22] Throughout the United States, private collectors and museums alike enthusiastically acquired Dutch art in the 1880s and 1890s. New York banker Henry Marquand's Dutch paintings enriched the Metropolitan Museum of Art. John G. Johnson's collection, rich in Dutch and Flemish works, went to the Philadelphia Museum of Art. In Boston, the merchant Stanton Blake acquired ten Dutch and Flemish paintings from the collection of Prince Demidoff of San Donato in 1880. The Blake collection came to the MFA in 1889 and was soon after followed by a gift of two Rembrandt portraits and other examples of Dutch and Flemish seventeenth-century painting. By 1909, when New York celebrated the three hundredth anniversary of Henry Hudson's journey and Richard Fulton's navigation under steam, it was possible for the Metropolitan Museum of Art to organize an exhibition featuring over 140 seventeenth-century Dutch paintings drawn from American collections juxtaposed with a large section of early American decorative arts, many in the Dutch style.[23]

Rediscovered in the mid-nineteenth century, Vermeer was especially prized by American collectors. Marquand bought *Woman with a Water Jug* in 1887, giving it to the Metropolitan Museum of Art in 1889. Johnson purchased *Lady with a Guitar* in 1896, which went to Philadelphia as part of his gift, where it was eventually deemed a copy. Isabella Stewart Gardner purchased her Vermeer, *The Concert*, in 1892 (it was infamously stolen a century later and remains lost). By 1919, nearly one-third of Vermeer's few known works were in the United States. The Delft master became a model, in particular, for Boston School painters like Edmund Charles Tarbell. His *Girl Reading* emulates Vermeer's atmospheric lighting but remains a modern painting (fig. 182). The serene woman absorbed in thought, a type familiar from Vermeer, has been updated with contemporary dress and setting. Boston painters, advocates for beauty in art, in contrast to the gritty realism and nascent abstraction emerging in New York, perceived a kindred spirit in Vermeer. Here was a figurative, representational painter whose work also seemed to grapple with the questions of modern painting. In a 1913 biography of the Dutch painter, the author, critic, and Museum School instructor Philip Hale described Vermeer's work as "singularly modern," identifying "his point of view, his design, his colour values, his edges, his way of using the square touch, his occasionally *pointillé* touch," as "peculiarly modern qualities."[24]

Collectors and artists in the United States also responded to more recent Dutch art, eagerly purchasing works by a group of painters known as the Hague School. Dutch painters like Jozef Israëls, trying to return to the greatness of the Golden Age, turned to the regional landscape and people, particularly the humble lower classes, to produce virtuous idealizations of Dutch life that many Americans found appealing in the late nineteenth and early twentieth centuries.[25] Israëls traveled throughout the Netherlands seeking source material for such scenes, living in rural villages like Laren, which rose to prominence as an art colony in the 1880s. In the 1890s Marcia Oakes Woodbury spent three summers in Laren with her husband and fellow painter Charles Woodbury. The Woodburys, like many American painters who

MOEDER · EN · DOCHTER · HET·
GEHEELE · LEVEN ·

worked in Holland, produced pictorial scenes of Dutch life that conveyed an idealized preindustrial past, often conceived as an antidote to the jarring disruptions of modern urban life. A humble peasant mother and daughter appear in the grand triptych painted by Marcia, *Mother and Daughter: The Whole of Life* (fig. 183). Its form harks back to northern Renaissance altarpieces. In the center panel they spin wool, both a reference to the Fates spinning the thread of human life and a representation of a practical skill passed from generation to generation, from mother to daughter. Its title, inscribed on the frame in Dutch, *Moeder en Dochter, Het Geheele Leven,* emphasizes the continuity of preindustrial life and family. In the wings of the triptych, the mother and daughter are portrayed separately, one with a book in hand—most certainly the Bible—and the other with a rosary. They appear to be not so much distinct individuals as the same individual at different stages

of life, the whole life. Like works by Israëls, this, too, is a study of the virtuous peasant family, pious and hardworking.

While Hague School artists and their American followers looked back to traditional Dutch subjects and styles, others in the Netherlands embraced modernism by turning their attention to contemporary subjects, exploring abstract styles, and participating in the international artistic dialogue. These works marked a radical break with the artistic styles of the past and the historicism that characterized the late nineteenth century. Piet Mondrian was one of the earliest Dutch painters to pursue abstraction. Seeking what he termed *nieuwe beelding* (new imagery), he reduced his work further and further, eventually restricting himself to nothing more than intersecting straight lines and blocks of primary colors. Mondrian articulated his artistic theories in Dutch, French, and German publications from the 1920s and had his

182
Edmund Charles Tarbell
American, 1862–1938
Girl Reading, 1909
Oil on canvas
81.9 x 72.4 cm (32 ¼ x 28 ½ in.)

183
Marcia Oakes Woodbury
American, 1865–1913
Mother and Daughter: The Whole of Life (Moeder en Dochter, Het Geheele Leven), 1894
Watercolor on paper
H. of sheets: 67.3 cm (26 ½ in.)

paintings exhibited throughout Europe and the United States. For many, Mondrian was the epitome of modern art. His work was shown in North America as early as 1926 and was available for study at A. E. Gallatin's Museum of Living Art in New York, which opened in 1927 as America's first museum exclusively for modern art, and in a 1936 show at the Museum of Modern Art.[26]

Mondrian made his greatest impact on the New York art world after moving to the city in 1940, in flight from the Nazi occupation of the Netherlands. For some American artists, Mondrian's abstractions were shocking, and that could be liberating. Ilya Bolotowsky, a Russian-born painter and founding member of the American Abstract Artists (AAA), an organization of like-minded artists united as advocates for the aesthetic validity of abstraction, remembered his first encounter with Mondrian paintings vividly: "I thought it was totally fake and I couldn't forget it. In other words, I felt it was too extreme. Finally I was influenced by it; I couldn't reject it. It just hit me. It really impressed me. It made me very uncomfortable and yet I fell for it strongly."[27] Bolotowsky, whose previous abstractions had featured organic, biomorphic forms in the style of Joan Miró, began producing rigidly geometric, completely abstract paintings, like *Spiral Movement (Small Configurations within a Diamond)*, featuring blocks of color in the style of Mondrian (fig. 184). Bolotowsky came to identify himself as a Neoplasticist, a term derived directly from Mondrian's writings and reserved for the handful of artists most influenced by his theories.

Another member of the AAA proved indispensable in preserving and disseminating Mondrian's legacy. Trained as a journalist, Charmion von Wiegand took up painting in the 1920s. Like Bolotowsky, she saw Mondrian's work in the Gallatin collection, and she, too, initially found it cold and felt Mondrian had pushed abstraction into "a bleak mathematical world."[28] Von Wiegand met Mondrian six months after he arrived in New York, and they became close confidants until his death in 1944. She acted as an editor, assisting Mondrian in translating his memoirs and various essays into English, thereby making his theories widely available for American painters and

184
Ilya Bolotowsky
American, born in Russia, 1907–1981
Spiral Movement (Small Configurations within a Diamond), 1951
Oil on canvas
71.8 x 71.8 cm (28 ¼ x 28 ¼ in.)

185
Charmion von Wiegand
American, 1899–1983
City Rhythm, 1948
Oil on canvas
43.2 x 30.5 cm (17 x 12 in.)

186

Designed by Sven Markelius
Swedish, 1889–1972
Length of furnishing fabric:
Pythagoras, 1952
Screen-printed cotton
171 x 130 cm (67 5/16 x 51 3/16 in.)

ensuring Mondrian's place in the history of modernism. In the process of studying his writing and watching him work, she came to realize that Mondrian's geometric purity was not cold and bleak but infused with feeling and a deeply felt spiritualism. Her own art was transformed by the experience. In the years after Mondrian's death, she committed herself fully to Neoplasticism, producing paintings such as *City Rhythm* (fig. 185), which are indebted to the Dutchman for the sense of structure and the syncopated composition that fill the canvas. At the same time, von Wiegand developed her own innovative style, using a lighter palette with loose, open forms that are more organic than strictly linear. The resulting creations placed her among the leading abstract painters of the era.

Mondrian's more exacting geometry and interest in mathematical purity were influential in other ways, particularly to a generation of designers by the mid-twentieth century who sought to bring abstraction and modernism's focus on rational design into the home (that is, to spheres of life other than easel painting). To these artists and designers, the concepts of modern design could be applied to a wide range of materials, and, at the same time, the visual austerity of the paintings could be replaced with a greater variety of geometric designs, more complex patterns, and a broader palette, increasing their appeal to a larger audience. Yet the optical effects of Mondrian's mature style and the crisp, hard-edged nature of his work continued to be fashionable in a wide array of designs in the 1940s and beyond.

Epitomizing the geometric complexity of this midcentury style were the textile designs of the Swedish architect Sven Markelius, who created screen-printed cottons through the textile studio Nordiska Kompaniet in his native Stockholm. His *Pythagoras* line, which began production in 1952, was marketed widely in the United States by the Knoll Design firm (fig. 186). With its intricate latticework of overlapping triangles and rigorous massing of forms, *Pythagoras* pays homage to the ancient Greek mathematician and philosopher and reflects Markelius's training as an architect. *Pythagoras* was featured in a *Life* magazine photo essay in 1954,

titled "Mathematics by the Yard: Science's Symbols Decorate Fabrics," where it appeared alongside other geometrically patterned textiles by the American designers Angelo Testa, Ben Rose, and Elenhank of Chicago. These textiles illustrated the celebratory age of science in the 1950s, when the imagery of science was both elevated to high art and used increasingly in the home.[29] Markelius's designs were also brought to wider attention through his high-profile architectural commissions, such as the interior of the Economic and Social Council chamber (1952) at the United Nations Building in New York, where *Pythagoras* served as a key decorative element. Although Markelius spent most of his career as a practicing architect in Sweden, as well as teaching in Stockholm, he gained wide influence in the United States through his furnishing fabrics and a teaching stint at Yale.[30]

By the 1950s, due to the pioneering work of architect and designer Alvar Aalto and others, design trends in Denmark, Norway, Sweden, and Finland had moved away from the strictly angular and "machine" look of functional modernist design in favor of more organic and biomorphic forms. Many designers emphasized natural hardwood surfaces and the look of handcraftsmanship that had evolved from the Arts and Crafts movements in these countries since the 1930s. Known broadly as Scandinavian Design, these products had a wide and long-lasting influence on American designers and consumers and became ubiquitous in modern American homes in the postwar period. In furniture, the well-oiled look of natural wood with softly molded edges and organic features, such as those by the Danish designers Hans Wegner and Finn Juhl, drew inspiration from natural forms and from a host of traditional, Asian, and other styles. The look of natural wood was thought to bring warmth into the home, replacing the chrome and tubular steel of earlier high-modern furniture, and the functionality and simplicity made it especially popular with a new class of modern homeowners.[31]

An early advocate of the style was the New York furniture and silver designer John Van Koert, who worked for the venerable firm of Towle Silversmiths in Massachusetts in the early 1950s. The company's *Contour* line, including a three-piece beverage service

"PYTHAGORAS" SVEN MARKELIUS DESIGN: KNOLL TEXTILES, INC. MADE IN SWEDEN

187

Designed by Robert J. King

American, born in 1917

John Van Koert

Canadian, 1912–1998

Contour beverage service,

1953–about 1960

Silver, melamine

H. of pitcher: 26.2 cm (10 ⁵⁄₁₆ in.)

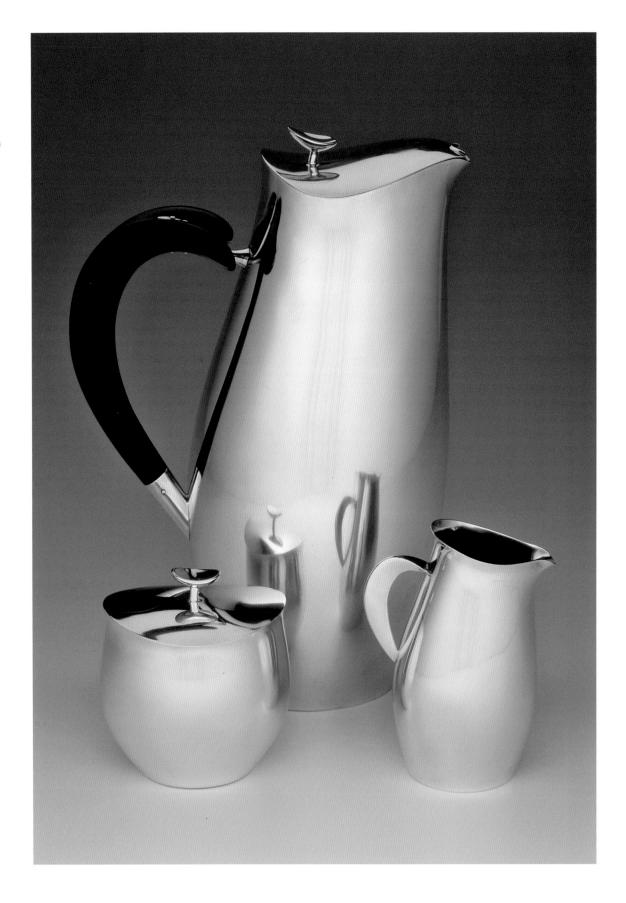

designed by Robert J. King under Van Koert's supervision, was the company's first significant foray into a style of organic modernism that had been popularized by such Scandinavian modern designers as Henning Koppel, who worked for the famed silversmith Georg Jensen in Denmark, and the Swede Baron Erik Fleming (fig. 187).[32] Van Koert did much to promote the Scandinavian style in the United States, and in 1954 he served as director of the exhibition "Design in Scandinavia," which toured the country for three years. The tenets of simplicity, functionality, and affordability in Scandinavian Design made it popular with American consumers and were widely copied by American designers, who were apt to use the recognizable brand name as their own.

Lacking opportunities to study traditional craft techniques in the United States, some American craftsmen traveled to Scandinavia to learn hand skills and traditional methods that were still widely taught there in schools and training centers. One such craftsman was the American silversmith and jeweler Robert Ebendorf, who first went to Oslo as a Fulbright Fellow to study at the State School for Applied Arts and Crafts.[33] Another was the American silversmith John Prip, who became a leading designer of domestic wares for the Massachusetts-based firm Reed and Barton. Born in New York to a Danish father and an American mother, Prip spent his teenage years apprenticing and later working in his family's silversmithing factory in Denmark. When he returned to North America in 1948, Prip taught at the School for American Craftsmen in Alfred, New York (later the Rochester Institute of Technology), at the School of the Museum of Fine Arts, Boston, and for many years at the Rhode Island School of Design. Combining the fine handcraftsmanship he had learned as a student in Denmark with an innovative design sensibility, Prip produced a range of forms—particularly as an artist-craftsman in residence with Reed and Barton—that were indebted to Danish Modern silver.[34] One example is his *Onion* teapot from 1954 (fig. 188), which served as the prototype for Reed and Barton's popular *Dimensions* line.[35] In 1958 the company introduced Prip's *Denmark* pattern, first marketed in pewter and

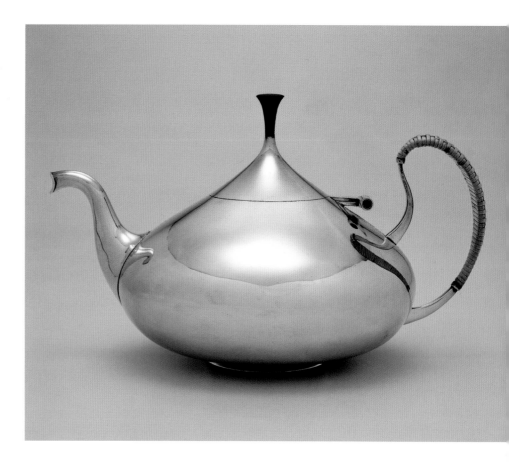

later in silver plate, which was based in some measure on Koppel's work.[36] Embodying the sense of experimentation of the period and furthering the traditions of Scandinavian craftsmanship in the United States, Prip taught generations of American students and became one of the most significant and influential American silversmiths in the second half of the twentieth century.

In traveling to Scandinavia to study craft skills, Ebendorf and Prip returned to the deep wells of tradition, much as the Woodburys and other American painters working in the style of the Hague School sought inspiration and renewal in the picturesque villages of Holland. Such journeys traced in reverse the migration of styles and ideas from the Old World to the New and reinscribed ties of ancestry, trade, and philosophy. Today, centuries after the first Dutch and Swedish settlers arrived in North America, their presence continues to resonate.

188
John Prip
American, 1922–2009
Onion teapot, 1954
Silver, ebony, rattan
H. 15.8 cm (H. 6 3/16 in.)

ARTISTIC INFLUENCES OF THE NON-WESTERN WORLD NONIE GADSDEN

The art of the Americas is the product of a rich and diverse blend of cultures from around the globe. Though much attention has been focused on the native and European roots of American art, the cultures of Africa, the Middle East, and Asia, among others, have also had a profound effect on the styles, techniques, and philosophies informing it. The nature of these non-Western influences—including the many ways in which they were introduced, how they were perceived, what they symbolized, and how they were manifested in art—not only varied over time and place, but also differed significantly from their European counterparts. Whether basket-weaving techniques from West Africa, arabesque design motifs from the Islamic world, or principles of composition from Japan, these customs consistently offered artists working in both Europe and the Americas a stimulating alternative to Western traditions.

The essays that follow explore the impact of three broad regions—sub-Saharan Africa, the Islamic world of the Middle East, and Asia, particularly China and Japan— on the art and design of the Americas. The character of this impact naturally differs with each region, but all involve the presence of economic and racial politics in the transfer and appropriation of artistic styles and techniques. While the artistic influences of the Islamic world and Asia followed many of the same patterns, albeit at different times, those of Africa had their own trajectory, complicated by the issue of slavery. The similarities and differences in each culture's imprint on American art reveal much about the changing world of art and culture in the Americas during the past five centuries. Non-Western cultures have played an active and vital role in the visual arts of the Americas, from the time of the first European settlements in the late fifteenth century to the present day.

Unlike European artistic traditions, which were primarily transferred to the Americas via immigration or travel, the arts of the Middle East and Asia were usually introduced to the New World by way of objects rather than people. Imported luxury goods, such as sophisticated Turkish carpets with intricate, swirling designs or blue-and-white decorated Chinese porcelains, often provided American artists and consumers their first encounter with non-Western art. These imported objects exposed artists not only to non-Western design motifs and conventions but also to innovative techniques, such as inlaid Islamic metalwork, and previously unknown materials, such as Chinese or Japanese silks or lacquerwares.

Non-Western artistic motifs and traditions, however, were regularly filtered through Europe, removing American interpretations even further from their original source. Compare, for instance, the work of seventeenth- and eighteenth-century Mexican potters in Puebla with that of their eighteenth-century counterparts working in the North American colonies: while the Puebla potters could examine the shapes, decorations, and materials of the thousands of blue-and-white Chinese porcelains scattered throughout their region (or

perhaps even learn from Asian craftsmen living in Mexico), Anglo-American potters often had to rely on English interpretations of the Chinese style (a European fashion called chinoiserie).[1] This direct exposure allowed the Puebla potters to more closely replicate Chinese forms and decoration than the North Americans.

Another source of information about non-Western styles was travel literature. The detailed accounts of Islamic life provided by Lady Mary Wortley Montagu, the wife of a British diplomat stationed in Istanbul, sparked a fashion trend for *turquerie* (a style inspired by Turkish costume) in England and North America in the late eighteenth century that was made manifest in stylish portraits by John Singleton Copley.[2] Similarly, the zoologist Edward S. Morse's carefully documented sketches and observations about Japanese dwellings, published in 1885, exposed artists in the United States to Japan's very different approach to architecture and interior design.[3] Although only a small number of Asian or Middle Eastern people ever traveled to, let alone settled in, the Americas before the mid-nineteenth century, their arts, as introduced through imported objects and Western writings, had a significant impact on visual culture in North, Central, and South America.

In marked contrast, thousands of Africans, most forcibly enslaved and transplanted by European colonists, had lived in the Americas since the earliest settlements, but the impact of their artistic heritage was suppressed by the conditions of slavery. Although slaves maintained some traditions from their homelands, particularly those related to foodways, folk stories, and music, surviving visual evidence of African styles or techniques is often difficult to detect, especially in objects made by slaves for white users. In North America, where importation of African-born slaves declined throughout the eighteenth century while American-born slaves significantly increased in number, objects made by slaves and free blacks often reflected adaptation to economic and material conditions in the New World, rather than direct transfer of styles from Africa. One important exception is the coiled-grass baskets introduced to the South Carolina Lowcountry by West African slaves for harvesting and processing rice.[4] Yet, when compared with the influences of Islamic and Asian art, even when those styles and techniques were filtered through Europe, African arts had a less overt effect on art and design in the Americas until the late nineteenth and twentieth centuries.

The impact of non-Western art and design relied heavily on how those cultures were perceived by the American people. Although many eighteenth- and nineteenth-century European Americans may have perceived Asian and Islamic goods as luxurious and exotic, they viewed the culture of enslaved Africans as barbaric and "savage." Local attitudes toward the population in question, the desirability and salability of their crafts, and the ebb and flow of ethnic and race relations greatly affected how artists in the Americas approached and assimilated non-Western motifs, techniques, and ideas. What does become apparent is

that the use and appropriation of non-Western art in the Americas reflects more about American prejudices, attitudes, and ambitions than about the specific cultures.

Most Americans initially inherited their views of non-Western cultures from their European homelands. These views were generally broad stereotypes, a mixture of limited knowledge and complete fantasy that rarely differentiated between distinct nations or ethnicities (all of Asia, for example—nearly half the globe—was usually lumped under the term "the Orient"). In general, non-Western cultures were identified not by their similarities to European cultures but by their differences. These perceptions of "otherness" could evoke reactions ranging from curiosity and admiration to fear and outright dislike, and these constantly shifting reactions often affected how and whether artists drew upon those foreign cultures for inspiration.[5]

American artists often appropriated non-Western styles and motifs as superficial symbols of the exotic. Ever since Marco Polo recorded his tantalizing accounts of Central Asia and China in the early 1300s, Europeans dreamed of Islamic and Asian lands, imagining them as magical paradises full of unfamiliar treasures. The lack of direct interaction between the East and West, and the exorbitant cost of imported goods, only perpetuated this vision and heightened the mystery and allure. Even after communication and interaction increased, ownership of Asian and Islamic goods, or imitations of Asian or Islamic styles and motifs in American art, evoked that fantasy and, consequently, were meant to reflect the wealth, power, and worldly sophistication of the owner. Asian or Islamic motifs were often applied conspicuously to objects made in the Americas, such as japanned decoration that mimicked imported Asian lacquerwares or turkey-work upholstery that mimicked Oriental carpets, to ensure that the intended signals were clearly communicated.

Other elements of Asian or Islamic art and design were so deeply absorbed into European culture that they probably lost their alien associations by the time they reached American shores. This was the case with Islamic arabesque decoration and geometric, interlaced strapwork, already common motifs in European designs when the American colonies were founded, as well as the Chinese-inspired forms of early-eighteenth-century European furniture. Occasionally such assimilation of non-Western designs took place in the New World. The banjo is a notable example of an African object that was appropriated by white musicians, and it was so thoroughly incorporated into white American culture by the late nineteenth century that many believed it had been invented in the United States.[6]

By that time, moreover, attitudes in the United States toward many non-Western cultures started to change. Improved transportation and communication systems, as well as the start of voluntary non-Western immigration to the United States, shattered long-held fantasies about far-off lands. The influx of Chinese immigrants on the West Coast, and a flood of inexpensive and lower-quality Chinese goods, soured American perceptions of China. This change in attitude resulted in a significant drop in the use of overtly Chinese styles and designs in American art and prompted negative or satirical depictions of Chinese people or ways. Conversely, the Civil War, emancipation, and the struggles that followed during the Reconstruction period heightened interest in depicting African Americans and

African American life in genre paintings, but this interest was more of a curiosity in the subject matter than interest in African art and design. And the increased associations of Islamic culture with sexual license in the late nineteenth and early twentieth centuries, buttressed by depictions of the Middle East in popular movies such as the Rudolph Valentino vehicle *The Sheik* (1921), further limited the use of explicitly Islamic styles and motifs to broad stereotypes.

In contrast, after the forced reopening of Japan's ports in the mid-nineteenth century, American perceptions of Japanese art and design not only came from tastemakers in Europe but were carefully crafted by the Japanese government. In concert with the country's ardent efforts to Westernize their military, education, and manufacturing, the government, paradoxically, mounted a publicity campaign that promoted Japan's traditional art and culture in an effort to appeal to American consumers. Prominent Americans, invited by the Japanese government, touted the living ancient culture as an antidote to the ills of modern, industrialized society.[7] As a result, during the second half of the nineteenth century, the work of American artists and designers who studied Japanese art and culture steadily evolved from superficially appropriating motifs (similar to earlier treatments of Chinese art and design) to gaining a deeper understanding and appreciation of Japanese design theory. Japanese arts and philosophies—particularly the careful composition of space, attention to light, atmosphere, and the natural world, and the connection between mind and body—continued to inspire a wide range of artists well into the twentieth century, from John La Farge, James McNeill Whistler, and Mary Cassatt, to Arthur Wesley Dow, Georgia O'Keeffe, Peter Voulkos, and Jackson Pollock.

Similarly, American artists of the early twentieth century, following the lead of the European modernists, found new modes of nonrepresentational artistic expression in the forms of African tribal art. Although they perceived these objects as relics of a primitive culture, they believed that the abstracted and emotional qualities of African masks and sculpture could reinvigorate Western art. At the same time, many African American artists, such as those associated with the Harlem Renaissance, adopted African motifs and design concepts in an effort to reclaim their heritage. Other African American artists have been more ambivalent about the role of African traditions in their work, or, like the contemporary artist Willie Cole, have directly confronted the complicated history of racial stereotypes in the Americas.

In the global, interconnected world of today, American artists continue to explore non-Western cultures for inspiration. Some, such as the Japanese American potter Toshiko Takeazu and the African American furniture maker Frank Cummings, look to their heritage, hoping to learn more about themselves while studying the art of their ancestors. Others draw upon the art of other countries to emphasize a political or social statement. Some still use non-Western motifs as symbols of the exotic, while others immerse themselves in the conceptual aspects of a culture's visual language. No matter what their approach, artists throughout the Americas will continue to imitate, discover, and experiment with elements of non-Western art and design for generations to come.

AFRICA CODY HARTLEY AND KELLY H. L'ECUYER

Despite the thousands of miles of ocean separating Africa and the Americas, these two vast landmasses have been inextricably linked since the first Africans were forcibly brought to Portuguese and Spanish colonies in South America in 1502. Slaves were integral to the establishment of European colonies throughout the Western Hemisphere, especially in the plantation economies of the Caribbean islands and southeastern North America. In 1619, just twelve years after the founding of Jamestown in Virginia, tobacco-growing English settlers purchased twenty Africans, the first slaves to live in what would become the United States. They were Bantu-speaking people, abducted from the Ndongo and Kongo kingdoms (in present-day Angola and the Democratic Republic of the Congo). Between the 1520s and the 1860s, eleven to twelve million Africans were shipped to the Americas. Millions died en route. Those who survived provided the backbreaking labor that enabled European colonies and the United States to flourish. Dispersed across the globe in one of the largest diasporas in human history, Africa's peoples carried with them throughout the New World the rich, diverse cultures of their homelands.[1]

The majority of slaves came from the areas south of the Sahara, particularly West and Central Africa. They represented hundreds of distinct ethnic groups and spoke many languages. Their ability to retain their culture varied, depending on whether they could remain together as families and communities. On large plantations, slaveholders assigned different groups of slaves to different kinds of work, according to perceptions then widely held among whites about the relative industriousness and submissiveness of specific ethnicities. Africans selected for domestic duties, who lived and worked in close proximity to their masters, were acculturated more rapidly to Euro-American society. Out of such interactions emerged elements of American southern folk life shared by whites and blacks, like the Uncle Remus stories of Brer Rabbit, Brer Wolf, and other characters who originated in Wolof folk tales brought by Hausa, Fulani, and Mandinka peoples. Slave owners set other ethnic groups, notably Bantu-speaking peoples from Central Africa, to agricultural work. These enslaved Africans were better able to retain their culture in the relative isolation of the fields and slave quarters. From the traditions of people who spoke Bantu languages emerged a more distinctly African American culture, from soul food and the blues to religious and artistic practices.[2]

The imprint of African cultures is found throughout the entire Black Atlantic—a term that has been used in recent decades to describe the geographic scope of slavery, the intricate connections binding Europe, Africa, and the Americas as a result of their participation in the slave trade, and the rich cultural heritage that transcends national or racial boundaries. In the Americas, many areas of speech, literature, and music have specifically iden-

189
Pair of andirons
Rhode Island, about 1700
Wrought iron
H. 41.6 cm (H. 16 3/8 in.)

tifiable African traits. Yet some aspects of African American life seem entirely products of the American experience, without African sources.[3] In the twentieth century, black and white artists alike claimed Africa as a creative wellspring. Tracing expressions of African cultures in art objects, whether made by African Americans or white artists with no African ancestry, raises complicated questions of methodology, authenticity, appropriation, and attribution. While assumptions about the role of African inspirations in American art are rightly subject to frequent challenge and reconsideration, the impact of Africa in America is undeniable.

The earliest examples of objects made by Africans in the Americas are those that slave artisans created. Many of these objects, however, are difficult to identify as African-influenced because they were embedded in the everyday material culture of white society. African slaves in North America brought with them craft traditions from their homelands, particularly metalsmithing, woodworking, and textile production. Shipping manifests on slave ships identified particular individuals as artisans, who therefore carried a higher market price. Slaves were also trained in spe-

cific trades by white owners or by their parents, or they were bound out as apprentices to master craftsmen. Documents such as runaway advertisements (placed by slave owners in newspapers to find missing slaves) or sale notices often described slaves' valuable craft skills. Throughout the colonial period and into the nineteenth century, thousands of skilled African and African American slaves worked as craftsmen in a variety of trades. They built houses in cities and on rural plantations and made boats, furniture, architectural ornaments, tools, pottery, wheels, textiles, shoes, and all manner of utilitarian goods that their masters used or sold to white customers. By the mid-eighteenth century, black craftsmen began to outnumber skilled white workers in some areas. The legislature of South Carolina, for example, passed a law banning independent craft shops run by slaves. It also required that white masters "constantly employ one white apprentice or journeyman, for every two Negroes that they shall so teach and thenceforth employ," to ensure that whites were not crowded out of some trades entirely.[4]

Many of the objects that slave craftsmen made for white users may not exhibit specific African visual characteristics, but their attribution to an African American slave can be based on the objects' history of ownership, oral tradition, and even circumstantial evidence. A pair of wrought-iron andirons dating from the early eighteenth century was passed down in the family of Rowland Robinson, an early settler on the western shore of Rhode Island's Narragansett Bay (fig. 189). According to Robinson family lore, these andirons were made by a slave blacksmith. In the Narragansett region, climate, geography, and social conditions combined to create an area dominated by large-scale plantation slavery, unusual in New England but similar in many ways to slave agriculture in Virginia and other southern colonies.[5] Three generations of Robinson plantation owners held slaves. At the time of his death in 1713, Rowland Robinson's probate inventory included nine black slaves, his son William's estate in 1751 included nineteen, and his grandson Rowland was said to have imported twenty-eight Africans from the coast of

Guinea in the mid-eighteenth century.[6] The andirons are unmarked, as is typical of such utilitarian goods, but the evidence of slave authorship is the oral tradition and continuous ownership in the Robinson family. Today, in the context of an art museum display, these andirons are appreciated for their sculptural qualities, and they serve a broader, symbolic role. The survival of rare objects attributed to slave artisans attests to the numerous, essential, and often invisible contributions of African artisans to the material life of the Americas.[7]

Even when the maker of an object can be known with certainty—as in the case of Dave the Potter, a South Carolina slave who signed his work—historians disagree about the degree to which African influence can be located in works by slave artisans, particularly those made as commercial products sold primarily to whites.[8] In the Edgefield District of South Carolina, where Dave worked, and at most American ceramics manufactories, the pottery industry used European technology and materials: treadle-operated wheels for turning pots, wood-fired kilns, and decorative glazes. In contrast, throughout most of Africa, pottery was hand-built (rather than wheel-turned) and fired at low temperatures over open fires; it was also typically a craft practiced by women.[9] Therefore, the black male slaves employed by the Edgefield potteries in the first half of the nineteenth century—many of them second- and third-generation slaves by this period— did not necessarily draw on African experience or traditions in making these commercial, utilitarian wares.

Dave's monumental jars show we cannot assume that works by African American artists are distinctively African in nature. Rather, they may tell stories about the individuals who made them and the time and place in which they lived. Dave distinguished himself not only as an extraordinarily skilled potter who made large, technically accomplished stoneware vessels, but especially because he was literate and his owners allowed him to sign and inscribe his works (fig. 190). This example bears the rhymed couplet "I made this Jar for Cash – / though its called

lucre trash," an example of Dave's typically witty verbal play. The couplet probably refers to a biblical passage advising deacons of the church not to be "greedy for filthy lucre."[10] Not only did Dave sign and date the work, but he added the initials of his owner, "Lm," for Lewis Miles. Inscriptions on other jars contain references to biblical texts invoking God's final judgment and may be coded references to the innate equality of all people before God and to divine justice for oppressive slave owners. In an era when teaching slaves to read and write was illegal, Dave's marking his words in clay can be understood as a protest against slave society and a heroic act of individual self-expression.[11] His work, and the attention it has

190
Dave Drake (Dave the Potter)
American, about 1800–about 1870
Storage jar, 1857
Stoneware with alkaline glaze
H. 48.3 cm (H. 19 in.)

received by scholars, reveal the complexities of distinguishing between the continuance of African traditions and the lived experience of African American individuals.

While the unknown Robinson slave in Rhode Island and Dave the Potter in South Carolina made objects for whites' use, other slaves made objects for their own community. These directly echoed African traditions and practices, including baskets, wood carvings, graveyard decorations, and musical instruments. In the late seventeenth through the late eighteenth centuries, many Euro-American colonists described African slaves throughout the Caribbean and the southern American colonies playing a type of West African stringed instrument with a gourd body, over which was stretched a tanned skin as a resonating membrane. Calling it a *banza*, *banshaw*, or *banjer*, these writers consistently identified it as an instrument the slaves brought from Africa.[12]

Over the course of the nineteenth century, white musicians and instrument makers appropriated this African instrument and transformed it into the modern banjo. In the 1840s white musicians in the United States made the banjo the centerpiece of a new form of popular entertainment, the minstrel show. Performed by white men in blackface for white urban audiences, minstrel shows purported to depict "Negro" life on the plantation with songs and music. While the earliest minstrels played gourd instruments similar to those used by slaves, as the popularity of minstrel shows grew, professional performers demanded a sturdier and more sophisticated instrument. This prompted entrepreneurs, such as William Boucher, Jr., of Baltimore, to specialize in producing banjos as modern instruments (fig. 191). Boucher and his competitors replaced the gourd with a round wooden rim, to create a more durable sound chamber. Instead of tacks to secure the animal skin over the rim, they used metal brackets and clips to make it easier to adjust the tension of the skin.[13] In the second half of the nineteenth century, the modern banjo became a broadly popular instrument, played not only in minstrel shows but also in middle-class parlors and classical performances in concert halls. By the early twentieth century, some writers believed it was an entirely American invention, and not until

the 1960s and 1970s did scholars of folk studies and African American studies begin to fully document the African origins of the banjo.[14]

African forms of expression, blended with American material culture, resonate in the work of African American quilters. A pictorial quilt (one of only two known) by the former slave Harriet Powers is one of the most-studied quilts in existence because of its arresting visual power and its contested meanings as a symbol of African influence in African American art.[15] Powers was born a slave in 1837 and after emancipation lived in Athens, Georgia. In 1895, after seeing one of Powers's narrative quilts at a cotton fair exhibition, a group of women whose husbands were Atlanta University faculty commissioned Powers to make this quilt as a gift for a retiring trustee (fig. 192). The quilt is composed of fifteen boldly appliquéd squares, each with an independent narrative scene. The appliqué technique used in the quilt is visually similar to the appliquéd cotton cloths of the Fon people of West Africa, in the former kingdom of Dahomey (now the Republic of Benin). How such African precedents could have been known to Powers remains unclear. The Fon cloths were made by guilds of male craftsmen in the royal city of Abomey; Powers was born in Georgia, where quilt making was a craft widely practiced by women, white and black alike, and where many slaves in the early nineteenth century were imported from the Congo-Angola region in southern Africa. It is possible, however, that although Powers and her generation of African American slaves were distant in time and place from Africa, they acquired artistic conventions from older slaves.[16] The quilt's formal qualities incorporate distinctively African visual properties: improvisation, bold designs and colors, and complex, asymmetrical designs. Each square is a different composition, seemingly arranged in an improvisational manner, with the figures and objects set at haphazard angles. The figures are boldly abstracted and depicted in poses conveying action and movement, and the overall effect of the quilt is lively and complex. The quilt's narrative sequence, moreover, is ordered by the arrangement of its squares in vertical columns, a structure possibly derived from African strip-woven textiles.[17]

While the quilt is testimony to an African aesthetic inheritance, it also reveals its origin in the complicated culture of the American South in the late nineteenth century. Recent scholarship has documented more than nine thousand quilts from Georgia, including thirteen hundred made before 1900. Several examples made by white quilters show similar appliqué techniques and whimsical motifs.[18] What makes the Powers quilt unique is its personal, spiritual, and perhaps political message. Like the inscriptions on Dave the Potter's pots, the quilt's narrative themes express the worldview—and veiled resistance to racial oppression—of its maker. The stories depicted in each quilt square center on spiritual themes of God's judgment, deliverance, and humankind's ultimate salvation. A handwritten transcription of Powers's description of the quilt's squares is preserved at the MFA. Ten of the scenes are drawn from familiar Bible stories demonstrating God's power and mercy, including Jonah and the whale, Noah with pairs of animals, and the Crucifixion. The rest are illustrations of oral folk tales about real events—such as a remarkable meteor shower and an extremely cold night (in which a man was found frozen to his jug of liquor)—cataclysmic happenings that for Powers signified revelations and warnings from an all-powerful God. When she described the central square depicting the eight-hour meteor shower that occurred in November 1833, Powers explained, "The people were frightened and thought the end of time had come. God's hand stayed the stars." One square in particular appears to express resistance to slavery. In this scene, the middle one in the bottom row, which Powers described as "rich people who go to punishment and the independent hog named Betts," the two rich people, condemned to eternal suffering, may represent slave owners. The largest figure in this square and on the entire quilt, however, is the runaway female hog, who, according to legend, ran five hundred miles north from Georgia to Virginia, probably a thinly veiled reference to the northward journey of runaway slaves. The scene draws together Powers's experience of slavery and emancipation with her belief in God's divine justice and deliverance from oppression, encoded in narrative appliqué quilting.[19]

191
William Esperance Boucher, Jr.
American, 1822–1899
Banjo, about 1845–55
Oak, maple, calfskin
L. 94.7 cm (L. 37 5/16 in.)

192
Harriet Powers
American, 1837–1910
Pictorial quilt, 1895–98
Cotton plain weave, pieced,
appliquéd, embroidered,
and quilted
175 x 266.7 cm (68⅞ x 105 in.)

Although many African resonances in American art point to the blending of African and New World cultures, the coiled grass baskets made in the South Carolina Lowcountry for more than three centuries are a uniquely well-preserved African craft tradition. Baga peoples of West Africa (who lived in such modern-day nations as Senegal, Guinea, Sierra Leone, and Mali) had used coiled grass baskets since prehistoric times for different tasks related to growing and processing rice. Similar baskets were used for all kinds of agriculture in the Benguela Highlands of Angola, where 70 percent of the African slaves in South Carolina originated.[20] In the New World, slaves retained coiled baskets because in their homelands

they were a part of everyday life, and they could be easily transferred to the climate and plantation economy of the Carolinas. In South Carolina early planters discovered that rice was an immensely profitable crop, well suited to the low-lying tidal marshes near the coast. First planted in South Carolina in the late seventeenth century, rice became the region's major export, shipped first to England and then throughout Europe. English planters, with little experience in growing rice, relied especially on their West African slaves, who were experts in rice cultivation. Along with helping to improve field construction and irrigation, African slaves introduced the special flat baskets called fanners, which cleaned the rice by sepa-

rating the grain from the chaff. The earliest baskets were sturdy, utilitarian objects made of rushes bound with thin strips of palmetto butt or white oak, then coiled and stitched together; they were nearly identical to the African coiled baskets used in rice agriculture.[21]

The American coiled basket evolved over time in response to changing cultural and economic conditions and remains a vibrant craft today. After the Civil War, the rice economy in the South Carolina and Georgia Lowcountry never recovered, but freed blacks continued to farm in the region and made coiled baskets for all types of agricultural and household use. For example, black farmers used a version of the flat fanner baskets to carry their surplus vegetables to market in the cities of Savannah and Charleston. In the first half of the twentieth century, as tourism replaced agriculture as the main economic engine of the Lowcountry, coiled baskets for the consumer market became a cash product for the descendants of black slaves living in close-knit communities on the coastal islands near Charleston. Women increasingly became basket makers as a way to supplement their income or even as an alternative to work outside the home in the region's hotels, hospitals, and other businesses. As the baskets became more decorative than functional, the materials changed; instead of the stiffer, sturdier rush strips, basket makers used pliant sweet grass and longleaf pine needles, bundled with strips of palmetto fronds.[22] Today many makers produce baskets as a commercial enterprise and a vehicle for personal expression. Mary Jackson, who learned the craft from her parents at the age of four, makes baskets characterized by their grand scale, dramatically curved handles, and geometric patterning created by the strategic placement of contrasting grasses and pine needles (fig. 193). Her work, which has been acquired by major art museums and for which she was awarded a MacArthur Fellowship, epitomizes the evolution of an African craft tradition into a contemporary art form.

In the early years of the twentieth century, many artists sought ways to reinvigorate art with fresh energy and new ideas. At the end of the nineteenth century, artists like Paul Cézanne and Vincent van Gogh distorted their subjects and introduced expressive, nonrepresentational color to produce emotional, highly personal paintings. They moved away from the obsessive imitation of the natural world that had underwritten Western art practice since the Renaissance. As the twentieth century progressed, artists pushed abstraction further, using the visual language of art—line, color, form, and pattern—to suggest sensations beyond representation. Often rejecting traditional ideals of beauty, they struggled to redefine art as powerful, meditative, and universal. In this search, many turned to what they called primitive art, now considered a derogatory term. In early-twentieth-century usage, it was an inexact term used to refer to the traditional indigenous arts of Africa, Oceania, and North America.

193
Mary A. Jackson
American, born in 1945
Basket with lid, 1992
Sweet grass, pine needles, bulrush, palmetto fiber
H. 43.2 cm (H. 17 in.)

194
Max Weber
American, born in Russia,
1881–1961
*New York (The Liberty Tower
from the Singer Building)*, 1912
Oil on canvas
46.4 x 33.3 cm (18 ¼ x 13 ⅛ in.)

About 1905, avant-garde artists in Paris began to collect and appreciate African sculptures and masks, objects that Europeans imported as curiosities, colonial trophies, and ethnographic research material. "It was Picasso," according to the painter Maurice de Vlaminck, "who first understood the lessons one could learn from the sculptural conceptions of African and Oceanic art and progressively incorporated these into his painting. He stretched the forms, lengthened, flattened and recomposed them on his canvas. He colored assemblages with red, ochre, black or yellow ochre, just as the Negroes did for their idols and fetishes."[23] It was the birth of Cubism. The resulting paintings, famously *Demoiselles d'Avignon* (Museum of Modern Art, New York) of 1907, announced a decisive break with Western art's mimetic compulsion. From that point forward, the stylized forms of African sculpture became a model for modernist abstraction.

African art changed the look of Western art. It also changed how artists and audiences thought about the function of art. "Negro art has re-awakened in us the feeling for abstract form, it has brought into our art the means to express our purely sensorial feelings . . . to find new form in our ideas," wrote the Mexican artist Marius de Zayas.[24] This reawakening was formal and emotional, generating a new awareness of art's affective power—an understanding that de Zayas and others attributed to the "pure expression" produced by "savages." The exotic novelty of Africa, its otherness, fascinated many, inspiring fantastic beliefs and claims about "primitives," almost all founded on misunderstanding and inflected by deep-seated racism. Even as European and American artists praised and emulated the masks and sculptures of Africa, they demeaned their creators as inferior people. For some, African art was an "authentic" expression of a universal humanity, supposedly "untainted" by exposure to "civilization," an art capable of revealing truths that Western education and training had obliterated. Others saw the masks and carvings as primeval fetishes and talismans of dark magical powers and witchcraft. Remembering his first visit to the Musée d'Ethnographie du Trocadéro in Paris, Picasso

described being transfixed, unable to leave owing to the power of African masks. "They were magical things," he wrote, "they were weapons."[25]

The American artist Max Weber also encountered African art in Paris while studying there from 1905 to 1908. He also discovered Cézanne, studied with Henri Matisse, and became familiar with Picasso, Georges Braque, and other leading artists. He then brought knowledge of European modernist art practice to the United States. Weber—one of the first American artists to collect African sculpture—recommended that Alfred Stieglitz visit the Musée d'Ethnographie du Trocadéro to experience firsthand the masks and sculpture that inspired Picasso. And it was Weber who is believed to have brought the first Picasso painting, a Cubist still life, to this country.

In the 1910s, grappling with the ideas that Picasso and Braque put into their art, Weber painted figurative Cubist works featuring attenuated bodies topped by masklike faces that directly echo the sculpture he saw at the Musée du Trocadéro. The powerful response that carved African figures generated led him to questions of scale and presence. He observed that a "Congo statuette often gives the impression of a colossal statue" because it conveyed a "boundless sense of space or grandeur."[26] He concluded that "two objects may be of like measurements, yet not appear to be of the same size," because one has a greater sense of what Weber called a fourth dimension, "the dimension of infinity." This could be described as the aura around real objects that reaches beyond their physical boundary to stimulate perception and imagination.[27]

Such play in scale and presence is visible in Weber's 1912 painting *New York (The Liberty Tower from the Singer Building)* (fig. 194). It is a sharply angled view looking down at the Liberty Tower, a slender thirty-three-story skyscraper completed in 1910, as seen from the even taller Singer Building one block away. Weber simplified the form of the building and eliminated its Gothic decoration and the peaked copper roofs that give Liberty Tower its distinct appearance. What remains in Weber's image is an attenuated column with an irregular, broken facade—not Gothic, not geometric, but rough, like

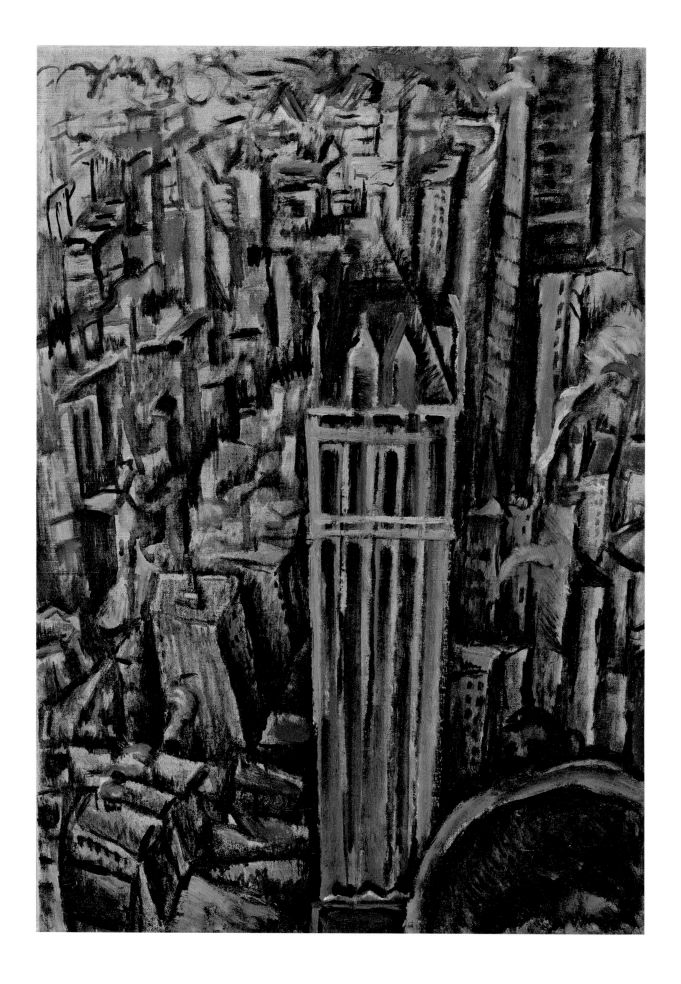

195
Max Weber
American, born in Russia,
1881–1961
Three Literary Gentlemen, 1945
Oil on canvas
73.7 x 92.7 cm (29 x 36½ in.)

some hand-carved African sculptures. Using a small canvas—just over eighteen inches in height—Weber portrayed Liberty Tower as a totemic presence set against the confusion of the city. Here Manhattan becomes an energized space surrounding the tower, a fitting illustration of Weber's concept of the fourth dimension. In a 1910 article in *Camera Work*—a pioneering modernist art journal published by Stieglitz—Weber defined the fourth dimension in art as a "consciousness of a great and overwhelming sense of space-magnitude in all directions at one time." "It is," he wrote, "the space that envelops a tree, a tower. . . . It arouses imagination and stirs emotion. It is the immensity of all things."

For Weber, the influence of African art was as much conceptual as it was directly imitative of African forms. Weber was photographed in the 1920s contemplating a Yaka sculpture, part of his personal collection.[28] Two decades later, the form of that small sculpture, with a rounded hat and stubby bent knees, reappeared in *Three Literary Gentlemen* of 1945 (fig. 195). In contrast to *New York (The Liberty Tower from the Singer Building)*, these figures directly resemble African sculptures and masks—the hat on the leftmost figure closely imitates the sculpture, yet Weber retains the conceptual interest in conveying the effect of African art. By outlining the hat on the rightmost figure, Weber draws attention to the mutability of form,

resisting the simple recognition of the shape as "hat" in favor of something more imaginative, open-ended, and universal; it is an intentional ambiguity that opens up space and meaning to multiple interpretations.

Weber is generally thought to have passed through a Cubist phase in the teens—a period when the influence of African sculpture is most evident—before achieving a mature style. This style was typified by figural scenes drawn from his experience of contemporary life, particularly Jewish life with portraits of rabbis and scenes of men talking, praying, or reading, as in *Three Literary Gentlemen*. Yet this painting demonstrates Weber's sustained interest in the expressive possibilities of African sculpture. The faces are strongly masklike and colored with the "red, ochre, black or yellow ochre" that Vlaminck observed in Picasso's works. As a complicated arrangement of figures in an unstable Cubist space, it is as though we see thoughts, dialogue, faces, and personalities revealed in multiple perspectives. It could be Weber's response to *Demoiselles d'Avignon* or, perhaps even more directly, Picasso's *Three Musicians*, a painting that came to the United States in 1921 and, despite the increasingly reductive nature of Synthetic Cubism, retains a debt to the forms of Africa.

In the years after Weber returned to the United States, African art became increasingly visible and closely associated with the emerging and still highly controversial new modern art. In 1914 de Zayas organized the first American exhibition to present African sculpture as modern art objects, rather than ethnographic artifacts. "Statuary in Wood by African Savages: The Root of Modern Art" appeared at Stieglitz's 291 gallery, a singularly influential exhibition space for the introduction of modernism in the United States. A contemporary magazine account of the exhibition opened with the headline "African Savages the First Futurists," eliding the "primitive" past and avant-garde painting and emphasizing the degree to which modernist abstraction and the formal properties of African art combined in the minds of artists and the public.

After the 291 show, de Zayas continued his writing about African and modern art. This culminated in the 1918 publication *African Negro Wood Sculpture*,

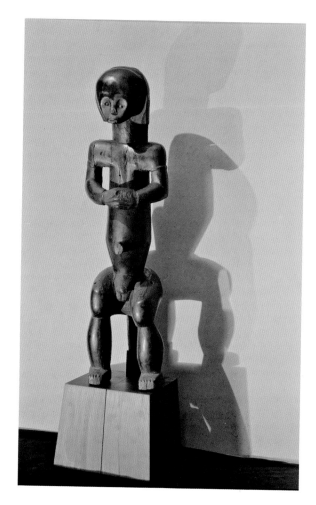

196
Charles Sheeler
American, 1883–1965
Fang Figure, 1916–17
Gelatin silver print photograph
22.8 x 16 cm (9 x 6⁵⁄₁₆ in.)

for which de Zayas invited Charles Sheeler to prepare photographic plates. In *Fang Figure* Sheeler placed a sculpture against a light background, set the camera to the side rather than directly in front of the figure, and used strong lighting from several directions to create so many overlapping shadows that more than half of the photo is shadows (fig. 196). The cast reflections embody Weber's concept of a fourth dimension that "exists outside and in the presence of objects." Light from below emphasizes the sculpture's volume and outline. Light from above and the side casts a less recognizable translucent form that overlaps and interferes with the larger shadow, creating multiple views as in a Cubist painting. The Fang piece provided Sheeler with an opportunity to explore a modern way of making pictures, balancing form with abstraction, alternately defining and dissolving structure. He

197
Charles Sheeler
American, 1883–1965
Ore into Iron, 1953
Oil on canvas
61.3 x 46 cm (24⅛ x 18⅛ in.)

ping forms of Marcel Duchamp's *Nude Descending a Staircase* of 1912 (Philadelphia Museum of Art), the most infamous painting of the Armory Show of 1913, inspired Sheeler. Following the photography of African sculpture closely, where he explored the use of multiple and overlapping shadows to achieve, in a single shot, something equivalent to multiple exposures, Sheeler's photographs for *African Negro Wood Sculpture* deserve equal consideration as a formative artistic experience. In much later paintings, like the 1953 *Ore into Iron*, Sheeler created an industrial parallel to his photograph of the Fang figure by using multiple-exposure photographs of the U.S. Steel Company plant in Pittsburgh (fig. 197). Rendered as overlapping translucent forms with contrasting tones reminiscent of the shadows cast around the Fang sculpture, the factory towers take on the presence and spirit of a figurine.

worked with multiple and overlapping visual echoes of the Fang figure to invest the finished work with an aesthetic impact that goes well beyond a straightforward picture of an object.

When Sheeler turned to painting about 1930, he continued to use the camera in preparatory studies. One technique that the camera allowed him to explore in anticipation of completed paintings was multiple-exposure photography, which he first tried about 1918–19. It has been suggested that the overlap-

"While modern art got its first impetus through discovering the forms of primitive art," wrote the Abstract Expressionist Adolph Gottlieb in 1943, "its true significance lies not merely in formal arrangements, but in the spiritual meaning underlying all archaic works."[29] Believing that "a whole ripe new area" for painting awaited "in the inner world," Gottlieb wrote that he focused "on what I experienced within my mind, within my feelings."[30] To explore this inner world, Gottlieb turned in the 1940s to African sculpture, which he had been studying since the early 1920s and collecting since 1935.

In the three hundred or so pictograph paintings he made between 1941 and 1953, Gottlieb drew on many sources—literature, his own work and that of fellow artists, objects from numerous cultures—for the suggestive symbols and imagery that fill the compartmentalized canvases, but African masks were particularly important. To the extent that any one source can be isolated, plank masks provide an organizing logic for Gottlieb's 1945 painting *Alkahest of Paracelsus* (fig. 198). With its strong vertical banding, bold surface patterns, exaggerated facial features, and a limited palette of black, brown, ocher, and off-white, *Alkahest* resembles the plank masks of the Bwa, Nafana, and other peoples of Burkina Faso and Ivory Coast. Gottlieb is not imitating specific masks

but trying to use their visual language—a language that Gottlieb and others believed was universal and relevant to all humankind—to say something appropriate to the times. The title further points to Gottlieb's sense that a primal, global visual vocabulary could reveal truths that are otherwise undiscoverable. Paracelsus was a sixteenth-century German alchemist and physician who, in addition to being one of the first Western scientists to study the unconscious, coined the word *alkahest* to describe the universal solvent that alchemists believed was capable of dissolving all other substances to reveal the irreducible form of nature and the fundamental truth of existence. Gottlieb's painting sought a kind of pictorial alkahest capable of exposing the brutal truth of a civilization that tottered at the edge self-destruction. In the face of World War II, Gottlieb felt that "primitive" artifacts revealed a "constant awareness of powerful forces, the immediate presence of terror and fear, a recognition and acceptance of the brutality of the natural world."[31]

When Max Weber, Charles Sheeler, and Adolph Gottlieb turned to African sculpture, they looked at Africa as complete outsiders. For many black artists, by contrast, Africa offered a way to reclaim a heritage and construct a new, more powerful African American identity. As the poet Countee Cullen expressed it in his 1924 poem "Heritage," African Americans who were "three centuries removed" from their African ancestors sought to understand what Africa could mean in a modern American context.

> What is Africa to me:
> Copper sun or scarlet sea,
> Jungle star or jungle track,
> Strong bronzed men, or regal black
> Women from whose loins I sprang
> When the birds of Eden sang?
> *One three centuries removed*
> *From the scenes his fathers loved,*
> *Spicy grove, cinnamon tree,*
> *What is Africa to me?*
> —Countee Cullen, excerpt from "Heritage," 1924

During the remarkable flowering of black culture in the 1920s and 1930s, when the sounds of jazz drifted from packed clubs, singing out new possibilities for life and art, when it seemed that everybody, black or white, wanted to be in Harlem, leading intellectuals sought a basis for the artistic identity and consciousness of African Americans in the legacy of Africa. The luminary black author, teacher, and philosopher Alain LeRoy Locke, in essays entitled "The Legacy of Ancestral Art" (1931) and "The American Negro as Artist" (1933), articulated an identity for black artists founded on an ancestral African heritage. The poet Langston Hughes encouraged black artists to take pride in their unique experience as black Americans, to "paint and model the beauty of dark faces and to create with new technique the expressions of their own soul-world."[32] If European modernists like Picasso could look to African sculpture for formal inspiration, certainly black artists could take pride in the aesthetic sophistication of their ancestors and lay claim as heirs to one of the world's great artistic wellsprings—the arts of the African continent.

"The African art object," recognized Locke in 1924, "has now become the corner-stone of a new and more universal aesthetic that has all but revolutionized the theory of art and considerably modified its practice." Given the vitalizing influence of African art on white artists, Locke speculated that by "the sense of being ethnically related, some of us will feel its influence," and this recognition would embolden the work of black artists. "Nothing is more galvanizing than the sense of a cultural past," Locke wrote, and that is what African art offered to the descendants of Africa.[33] In cities across the United States where vibrant black communities formed, artists such as Archibald Motley, Sargent Johnson, Augusta Savage, Aaron Douglas, Lois Mailou Jones, and James Richmond Barthé (fig. 118) produced works that incorporated formal elements of African sculpture, as did their white counterparts. Yet many black artists went further, developing a strong sense of an African heritage and seeking expressions of America's African roots.

Black writers and artists explored, for example, how the African past infused black spirituals and the sermons of the black church.[34] The author James Weldon Johnson, arguing that faith provided African slaves "their first sense of unity and solidarity," preserved black sermons in a 1927 book, *God's*

Trombones: Seven Negro Sermons in Verse. Aaron Douglas's illustrations for the book were inspired by black spirituals, themselves a confluence of African and European music traditions. His characteristically bold graphic compositions, with elongated and angular silhouetted figures, first appeared in black-and-white drawings of the early 1920s. His style reached maturity in the illustrations prepared for *God's Trombones.* In one, Douglas portrays an angel—note the wings and trumpet—announcing Judgment Day (fig. 199). Douglas's desire to create a visual equivalent of the rhythm and harmony of the spirituals—and his familiarity with the language of modernism—is evident in the pulsating concentric circles, stylized sculptural figures, and translucent zones of light that charge *Judgment Day* with dramatic emotion.

In the 1940s the Cuban artist Wifredo Lam explored aspects of African spiritualism that survived and flourished in the Caribbean. When Lam returned to Cuba in 1942 after several decades of studying in Spain and France, where he became a friend of Picasso, he was already regarded as a leading Surrealist painter. In the Afro-Cuban culture and spiritualism of Cuba, he found new imagery. *Untitled,* painted in Havana in 1943, incorporates whirling surreal creatures that have sources in Santeria, the religious tradition that is closely related to the spiritual practices of the Yoruba peoples of Nigeria and Benin in West Africa (fig. 200). For example, the double-headed creature in the upper left is a representation of Changó (or Shango), a popular *orisha* (deity) associated with thunder and lightning in the Yoruba pantheon. In traditional Yoruba sculpture, Changó takes the form of a double-headed ax.[35] Ogún, another orisha associated with iron and fire, is linked to the horseshoe that appears behind Changó. The tail-like groups of lines could reference horses, a favored subject of Picasso and other modernists, but horses are also important symbols of spiritual possession in Afro-Cuban ceremonies. These "tails" also resemble Yoruba ceremonial fly whisks, objects with ritual use and meaning. The eyes and bold outlined forms in *Untitled* are similar to the written *anaforuana* characters of the Abakuá society, a secret

men's fraternity that originated in the Cross River area of southeastern Nigeria and southwestern Cameroon and was carried by slaves to Cuba in the nineteenth century.[36] Lam's first-person experience of African-derived spiritual practices in Cuba resulted in some of his most original works and allowed him to "paint the drama of my country . . . the beauty of the plastic art of the blacks" in a way that he believed conveyed the dignity of the people and the power of their living faith.[37]

For Eldzier Cortor, an interest in his African heritage, and "an especial interest in painting Negroes whose cultural tradition had been only slightly influenced by whites," led him to spend several years among the Gullah people.[38] Living in relative isolation on the Sea Islands off the coasts of Georgia and South

198
Adolph Gottlieb
American, 1903–1974
Alkahest of Paracelsus, 1945
Oil and egg tempera on canvas
152.4 x 111.8 cm (60 x 44 in.)

199
Aaron Douglas
American, 1899–1979
Judgment Day, illustration from
God's Trombones: Seven Negro Sermons in Verse, 1927
Illustrated book with eight collotypes
Image: 15 x 11.4 cm (5⅞ x 4½ in.)

200
Wifredo Lam
Cuban, 1902–1982
Untitled, 1943
Oil on burlap
61 x 78.7 cm (24 x 31 in.)

201
Eldzier Cortor
American, born in 1916
Room No. V, 1948
Oil on Masonite
78.7 x 68.6 cm (31 x 27 in.)

Carolina, the Gullah have maintained much of their African heritage. Cortor's experience with the Gullah connected him with a sense of African traditions. "In some ways I might as well have been in Africa," he wrote. It also forged an abiding sensitivity to the cultural richness and physical beauty of African Americans.[39] While he was a young black artist living in Chicago, African sculpture awakened Cortor to the beauty of his own people. In *Room No. V*, the pensive woman reflected in the dresser mirror, with her elongated limbs, torso, and neck, is rendered with the "cylindrical and lyrical quality" that Cortor appreciated in African sculpture (fig. 201).[40] Tightly confined within the space of this airless room, even further restricted within the narrow space of the mirror, the woman retains a distanced silence, impervious to the decay of the room around her.

The frayed condition of the room, with its peeling and cracked walls, tattered carpet, and tired nineteenth-century furniture—and the artist's original distressed frame—suggest a commentary on the poverty experienced by many blacks in the United States. In addition to the nude figure, the composition and technique show Cortor's interest in African culture. The mirror and dresser are presented in a manner reminiscent of shrines found in Africa and the Americas, where the accumulation of offerings creates a rich visual display testifying to the fervor of faith. Such accumulation appears in power objects in many African cultures. In *nkisi nkondi* power figures created by the Kongo peoples, each nail represents a petition arousing the powers of the sculpture (fig. 202). In rituals seeking to restore the well-being of the petitioner, the figure acted as an intermediary

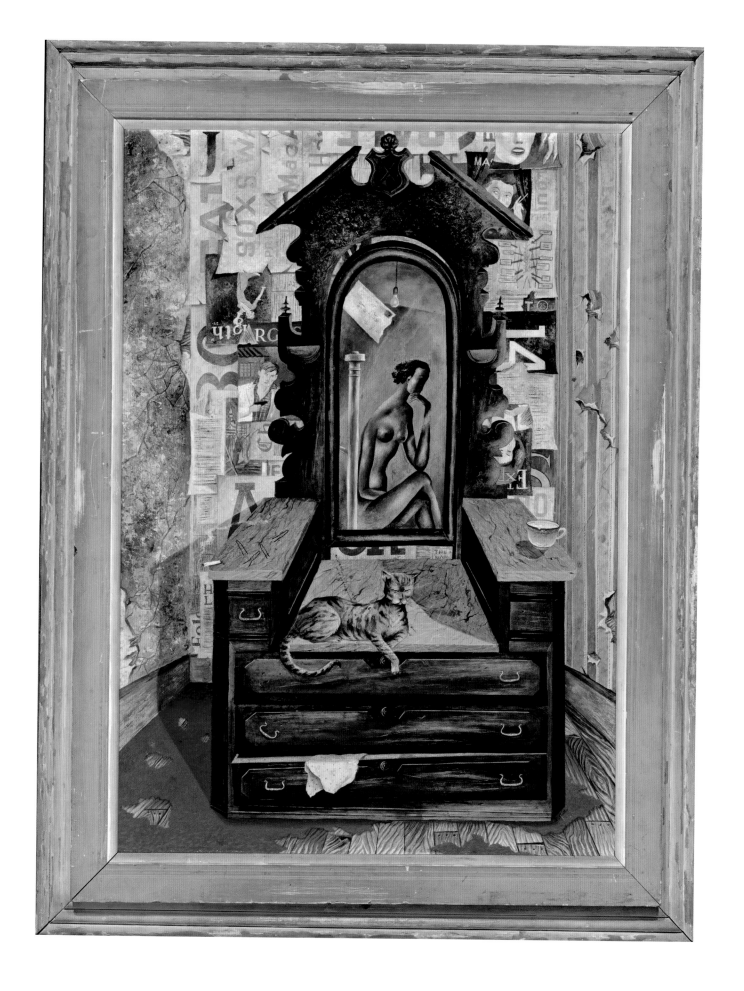

202
Kongo power figure (*nkisi nkondi*)
Democratic Republic of the Congo,
19th–20th century
Wood, glass, iron nails, pigment,
sacred material
H. 61 cm (H. 24 in.)

between the living and the dead. Both the Cortor painting and the Kongo sculpture are centered on a mirror, traditionally thought to help see evil and discover witches. In African American cultures, this acknowledgment of the power of accumulation can be found in everything from burial practices to bottle trees and lawn decorations. The magazine and newspaper clippings covering the wall in Cortor's painting open up many readings—the figure of a white man pointing a gun at the woman's reflected image is particularly charged. In total, the clippings replicate the papered walls of sharecropper shacks—images made familiar by Farm Security Administration photography of the 1930s.[41] The images conjure a sense of personal memories and private meanings. As an ensemble, they embody the aesthetic of accumulation.

Cortor pushes this sense of accumulation and accrued meaning even further with his handling of paint. He builds up layers of paint to represent the cracking plaster wall on the left. At the top of the dresser, Cortor applied accretions of paint to create a craggy sculptural surface that suggests carved wood. To create this texture, Cortor appears to have used scrapings from his palette. Like *nkisi* nails representing many acts of faith, the accumulated paint stands for many acts of painting.

The painted assemblage of clippings across the back wall of *Room No. V* prefigures the collage work of Romare Bearden. In *Mysteries*, from 1964, Bearden includes small clippings of photographs of African sculpture in the fragmented, composite faces—the mouth and nose of the leftmost woman's face, for

example (fig. 203). His collage technique emphasizes and stylizes faces, structuring them like a mask. Collage is an important technique of twentieth-century modernist movements, including Cubism, Dada, and Surrealism, but it can also be related to the African American tradition of patchwork quilts and earlier African traditions like West African appliquéd textiles (fig. 192). Through these references to African traditions, Bearden connects himself with the modernists who found inspiration in "primitivism" while also reclaiming for himself an African artistic heritage to illustrate African American life.

Like Cortor, Bearden exhibits an interest in women and their roles. Women from several generations, from a young child to the grandmotherly elder who holds her, sit around a kitchen table. They stare directly out, refuting their traditional invisibility as women, as minorities, and as poor laborers, confronting the viewer, who might doubt their humanity or reduce them to stereotypes. They are not "mysteries," some unknowable other. They are women, mothers and daughters, visible and human. Created during the time of the civil rights movement, Bearden's work is directly confrontational, sharing with that movement an impulse to reclaim and celebrate the African heritage of African Americans. Where the modernists saw "primitive," frightful, supernatural visages, Bearden found strength, resiliency, and humanity.

Art Smith, an African American studio jeweler, had a complicated relationship to African sources for his work. Although some contemporary writers described his large-scale jewelry as primitive, in the 1940s and 1950s Smith denied that he tried to "achieve a primitive or African feeling" and preferred to present his work as "good design." He had his jewelry photographed on stylish white models and marketed his designs to the mainstream fashion press as modern and bold but entirely wearable.[42] Smith declined to cite direct African influences in his work, and late in his career he discussed this topic with some ambivalence:

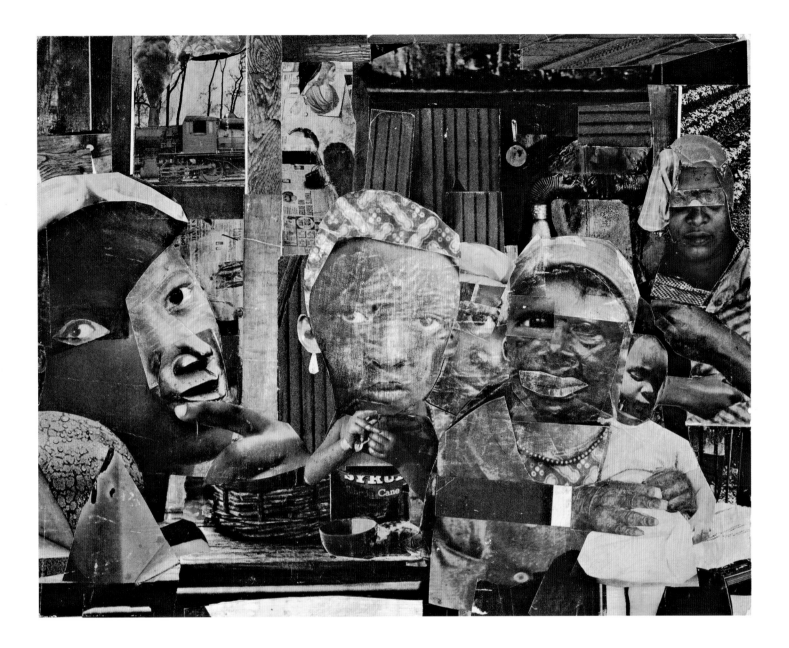

I would say that really any artist, any craftsman should see what they have to offer personally outside of labels, nationalistic labels, religious labels, or racial labels. There is a very good chance that as a member of a certain group you may have characteristics that may come through in the course of your work if you allow yourself to remain free and just work, rather than saying to yourself, I am black so I'll do black art or African art, or I'm gonna be black and shocking and bold and primitive. . . . There's nothing that says you can't be conscious of a heritage, and call on it, but don't let it be a restriction.[43]

However, in his personal and artistic life, Smith was influenced by black nationalism and the revival of African heritage among the black intelligentsia of New York. His parents were Jamaicans who immigrated to the United States via Cuba. His father was an officer in Marcus Garvey's black separatist organization, the Universal Negro Improvement Association and African Communities League in New York.[44] One of six black students to attend Cooper Union in the 1940s, Smith studied architecture, graphic design, and sculpture. When he took a part-time job as an assis-

203
Romare Bearden
American, 1911–1988
Mysteries, 1964
Collage with hand-applied color
28.6 x 36.2 cm (11¼ x 14¼ in.)

tant to the African American jewelry maker Winifred Mason, he not only found his vocation in studio jewelry but also was introduced to the vibrant black arts community in New York. He counted among his friends black artists, writers, and performers like Charles Sebree, Ralph Ellison, Gordon Parks, and Ruth and Bill Attaway. A lifelong jazz lover, Smith became a founding member of the Duke Ellington Society and designed jewelry worn by Ellington and his sister, Ruth. Most important, Smith maintained close associations with several African American dance troupes and choreographers, including Talley Beatty, Pearl Primus, and Claude Marchant, who revived African and Afro-Caribbean dance motifs in their work. Smith designed stage jewelry for these black dance groups, and his jewelry's large scale, rhythmic qualities, and sensitivity to the human body resulted from this experience.[45]

Like other studio jewelers of his generation, Smith was largely self-taught in jewelry making, and his designs combined many strands of modern art of the postwar era: the influence of Surrealism in free-form, biomorphic shapes; Constructivist ideas of structuring positive and negative space; and kinetic elements of balance and motion derived from Calder's mobiles. Formal qualities of some of his work, however, suggest African inspiration. Smith's design notebooks from his early career contain clippings from *National Geographic* and other magazines depicting African body adornments, and the size and sculptural presence of these objects are apparent in his work.[46]

One of Smith's most famous designs was what he called *Modern Cuff*, a large bracelet that covers most of the wearer's arm (fig. 204). This and his other outsize bracelet designs suggest the ornaments some African peoples wore on their forearms. The protruding brass wire prongs on his *Modern Cuff* bracelet also resemble the metal keys on the *mbira*, an African musical instrument that is sometimes called a thumb piano or *sanza*.[47] African influences in Smith's art can be inferred from the physical qualities of the work, as well as the artistic milieu in which the artist operated, although he preferred to see these elements as part of an overall modern approach to design.

In the 1960s and 1970s, as the civil rights movement progressed and a reinvigorated black nationalist movement developed, black American artists increasingly turned to Africa and African art as a source for developing black pride and black power. Many African Americans in this period took African names (the poet LeRoi Jones became Amiri Baraka, and the boxer Cassius Clay became Muhammad Ali) and began to wear African hairstyles and textiles. Black artists traveled to new postcolonial African nations like Ghana and Nigeria and found that connections with contemporary Africans bolstered their cultural identity. New organizations sponsored exhibitions linking African art with African American artists, and many artists explored the African roots of the African diaspora throughout the Caribbean and Latin America.[48] In the same decades, artists engaged with postmodern thought increasingly abandoned the formalist principles of modernist design and abstract art in favor of renewed interest in figurative representation, historical sources, personal narrative, and political content. These broad trends encouraged African American artists to confront issues of race, heritage, and African sources more directly.

Among the artists who traveled to postcolonial Ghana in the 1970s was Frank E. Cummings III, a virtuosic wood-carver and turner who was making sculptural wood objects in the 1960s and early 1970s. A 1972 review of his work displayed at a New York gallery prompted Cummings to travel to Africa to understand why his work was so often assumed to be African, and whether he might find personal connec-

204
Art Smith
American, born in Cuba, 1917–1982
Modern Cuff, 1948
Copper, brass
L. 10.8 cm (L. 4¼ in.)

205
Frank E. Cummings III
American, born in 1938
Clock, 1979–80
Ebony, ivory, African blackwood, 14-karat gold, black star sapphires, glass
H. 172.7 cm (H. 68 in.)

tions to African craft traditions. Cummings recalled that "the reviewer said I had been influenced by the American Indian and African cultures, which was not true, and that I was making true fetishes [objects thought to embody spirits or magic powers]; and I thought, 'how neat, what's a fetish?' . . . Suddenly I had to learn why my work expressed these attitudes. I was getting sick and tired of hearing my work called primitive."[49] In a 2007 interview, Cummings recalled that in 1972 he had "no connection with Africa except for the L.A. County Zoo and Tarzan," but the review prompted him to question whether there was in fact an unconsciously expressed African sensibility in his art. To "find out if there was a connection," in 1973 he traveled to Ghana, where he lived in several villages and studied with John Yaw Barimah, an Asante carver in Kumisi.

For Cummings, living in Ghana was a moving experience that gave him a greater awareness of the spiritual qualities of handmade objects. In one especially important encounter, Barimah discussed with Cummings the difference between *akuaba* fertility figures he made for sale to tourists and those he made for local ritual use. The "real ones," as Cummings understood it, were imbued with spiritual meaning in the hands of the craftsman and also in their use as part of the shared community belief system. After returning to the United States, Cummings did not try to make self-consciously African furniture. Rather, his renewed sense of direction took shape in powerful objects that would inspire connections between people. His work of this period culminated in an extraordinary clock of 1979–80, which he considers his masterpiece—a full statement of his technical abilities and artistic vision (fig. 205).[50] Making this intricate, functional timepiece required virtuosic design and execution, consuming an entire year's work, and Cummings delighted in the excitement and fascination the clock generated among viewers whenever it was displayed. He used African materials, combining ivory with African blackwood, but the clock was not a literal reference to African art forms. Rather, it was a conceptual statement of the sense of purpose, intensive craftsmanship, and spiritual meaning he gained from his contact with African

artisans. In Cummings's words, after he lived with the Asante people and observed their use of ritual objects, his work became "spiritual in that I'm trying to establish and/or strengthen the connection between that person over there and me, and it's done through the object."[51]

Cummings visited Ghana in an attempt to better understand his personal experience and biography within a broader cultural context. The artist Willie Cole has pursued a similar journey of self-understanding, but without leaving the United States. Cole explored the complex and often painful history of Africans in America through a series of autobiographical works that feature digitally manipulated images of his own body imprinted with scorch marks made with a household iron. Irons have become a signature motif in Cole's art, his "brand," as he describes it. Cole first considered the artistic possibility of irons after recognizing that an abandoned iron on the street looked like masks made by the Dan people of Liberia and Ivory Coast. Irons are replete with layered meanings. Most obviously, they refer to the domestic work of ironing clothes, often carried out by African American women, a connection that is also biographical, since three generations of Cole's female relatives worked as domestic servants. There is also a reference to the historic branding of slaves to mark their status as property. Branding also calls to mind the practice of scarification in Africa. In other works, Cole, adding yet another layer of meaning, compares the pattern of the iron to diagrams of slave cargo ships, with their human cargo kept in brutal, inhumane conditions.

In *Silex Male, Ritual*, Cole transforms himself into an African warrior (fig. 206). He digitally superimposes iron scorch marks over his body to create decorative patterns and make the mask and headdress. The title is a sly critique of consumerism and another form of "branding"—that of the corporation.

The Proctor Silex is one of Cole's favorite models. In related works, he has developed a complicated metaphor in which various multinational brands—Silex, GE, Sunbeam, Black and Decker—stand in for various tribes sold into slavery. Thus, Cole represents himself as the ideal specimen of the "Silex" tribe.[52]

Cole draws influence and ideas from many twentieth-century sources and art movements, including Pop Art and Minimalism and the assemblage and found-art practices popularized by many artists, notably Duchamp and Robert Rauschenberg. African culture takes a prominent place in Cole's work. His appropriation of African art is deeply felt and sincere and perhaps less troubling than that of early modernists who snatched at forms and phantasms. Cole, like other artists of his generation, demonstrates a conceptual and intellectual agility combined with a social conscience and political savvy that are conceivable only in the wake of the civil rights movement. As a child of the civil rights era, Cole was fascinated with black history and African history and art. In college, a collector and dealer of African art befriended him, providing him with an opportunity to study African art directly. Cole's experience as an African American, and his self-conscious perspective as a descendant of slaves, has shaped how he uses Africa in his art. Cole's willingness to tackle politics and personal issues allows him to navigate the fraught territory of race to transform stereotypes into statements.

Tellingly, Cole knows Africa by the fruits of its seeds in the New World. Five hundred years after the first Africans arrived in the Americas, Cole's art bears witness to the lasting impact of the African diaspora, positive and negative, making it evident that the influence of Africa's descendants has permanently enriched America. Put another way, America is African. As Cole has said, "I have been close to Africa just by being in Brooklyn, Harlem, and Newark."[53]

206
Willie Cole
American, born in 1955
Silex Male, Ritual, 2004
Digital ink-jet print on heavy
white wove paper
154.9 x 111.8 cm (61 x 44 in.)

(1) (2)

Fig. 1 & 2. Silex Male, Ritual.

THE NEAR EAST NONIE GADSDEN AND HEATHER HOLE

For centuries, American artists have been fascinated, confused, agitated, and inspired by the art and culture of the region of the globe that has variously been called the Near East, the Orient, the Levant, the Middle East, and the Islamic world. These many terms represent the historical Western constructs that attempted to define the broad area between North Africa and Central Asia, and sometimes incorporated peoples and lands from farther afield. These labels seldom referred to any specific reality, but each evoked a mythical world of exotic "others," often arising from cultural and racial stereotypes. More important, these all-embracing labels were not, and are not, used by the people they were intended to describe but were fabricated for Western convenience. Because of this, they often projected changing Western prejudices and aspirations.[1]

Few American artists traveled to the Near East, and those who did often experienced it without a deep and thorough understanding of the cultures and peoples they encountered. These artists were more likely to be inspired by literature, fashion, and trade objects, often filtered through Europe, than by true knowledge of the region. From these diverse and incomplete sources, they constructed a rich, fantastical imaginary world. The incorporation of recognizably Near Eastern styles in American painting, sculpture, or decorative arts often produced a seductive alternative to Euro-centric American culture. This shadowy inverse of the rapidly modernizing United States was seen as a place of sexual license and adventure, ancient civilization and primitive cruelty. Paradoxically, it was also the Holy Land—the land of the Bible—and some Americans sought a greater understanding of Christianity through their study of the region.

Not surprisingly, colonists in the Americas inherited their vision of the Near East from their European homelands, which had, since the Middle Ages, actively traded goods with the Islamic world. Although ongoing religious wars between Christian Europe and the predominantly Muslim Near East had divided the two worlds for centuries, producing Western stereotypes of ferocious Turks or untrustworthy Arabs, a mutually beneficial trade-based relationship remained in place. Thus, expertly knotted carpets and woven silks, intricately inlaid metalwares, and brightly painted ceramics were the main vehicles for information about and images of the mysterious other world. The few contemporary European accounts of life in the Near East to offer tantalizing tidbits about the people and their habits were enormously popular and influential. These descriptions not only fueled Western curiosity and imagination but even sparked aristocratic fashion trends in eighteenth-century Britain and its colonies. To the European aristocracy that could afford to acquire Near Eastern objects or dress in Near Eastern fashions, the distant Islamic world symbolized luxury, wealth, power,

207
Indo-Persian carpet (detail)
Probably Isfahan, Persia,
17th century
Cotton warp, cotton weft, wool pile,
asymmetrical knot
202 x 141 cm (79½ x 55½ in.)

and worldliness. These associations were well established in European cultures by the era of colonial expansion into the Americas.

Carpets variously called Oriental or Turkey were probably the most widely known, distributed, and admired Near Eastern trade commodity in the West. First introduced to Europe during the Crusades (1095–1291) and regularly imported by the fifteenth century, these carpets (not all of which came from modern-day Turkey but were made throughout the region) dazzled Europeans with their richly colorful designs and soft textures (fig. 207). These coveted luxuries became status symbols, as proven by their presence in European paintings of royalty, aristocracy, and religious figures from the Renaissance onward. Most Europeans considered carpets too delicate and costly to place on the floor and instead spread the textiles over tables, hung them on walls, or used them in some other ornamental fashion. Whether deployed as decorative luxuries or floor coverings (a practice that became more common in the eighteenth century), Oriental carpets remain symbols of elegance and wealth to this day.[2]

To meet the growing demand for Oriental carpets, in the sixteenth century European weavers began to imitate Near Eastern wares, copying not only the method of hand-knotted pile but also the designs. When introduced to England in the late sixteenth century by Flemish weavers, the technique was called turkey work. English turkey work consisted of colored worsted wool yarns that were knotted onto a hemp base during weaving (as opposed to the plied wool warp of the Near Eastern wares); the yarns were then cut to produce an even pile. Turkey-work chair covers with designs vaguely related to Oriental carpets were fashionable in wealthy households in Britain and her American colonies from the late sixteenth century into the early eighteenth century.[3]

Indeed, these turkey-work chair covers were so precious and expensive that wooden chair frames were often made to accommodate the cover, not the other way around. Rolled-up turkey-work covers were far easier and less expensive to ship to the colonies than heavy, bulky finished chairs.[4] Several surviving American-made chair frames dating from the late 1600s retain the original English turkey-work

A mid-eighteenth-century Spanish colonial leather trunk, made in New Spain (present-day Mexico) and used to store expensive cacao beans, is extravagantly embroidered with motifs that stem from Near Eastern sources, such as the four vertical bands of flowing arabesque decoration on the lid (fig. 209). Westerners borrowed the French term *arabesque*, which simply means "Arabian," to describe the non-representational, symmetrical, and intertwined designs.[7] By the time of the Renaissance in the sixteenth century, Europeans had appropriated such designs from Islamic textiles, objects, and architectural ornamentation. For Muslims, these patterns, which were infused with symbolism and often extended over a broad surface, and were seen as emblems of infinity. The Western versions, however, like the one seen on the top of the Spanish colonial trunk, were usually confined within strict borders, as was customarily seen on imported carpets.[8]

On the sides of the trunk, the embroidery depicts scenes of conquest and battle, including an explorer with a telescope, and figures with revolvers, shields, and swords intermixed with exotic animals. Surrounding these figures is a meandering interlaced

208
Turkey-work chair
England or America, about 1675
Maple, beech, turkey-work
upholstery (black background
is replaced)
H. 94 cm (H. 37 in.)

209
Embroidered trunk
Mexico, about 1750–75
Leather, embroidered with linen,
silk, and metallic thread; iron,
canvas lining, wood
H. 44 cm (H. 17 5/16 in.)

covers for which they were constructed.[5] A chair frame of maple and beech, in the common, low-backed style of the seventeenth century, often called a back stool or Cromwellian chair, could have been made in England or the colonies, since it is of a type that was commonly used on both sides of the Atlantic (fig. 208). The turkey-work cover, with its dense design of naturalistic flowers, including stylized tulips, roses, and carnations, on a black background, framed with a red, white, and black striped border, is a diluted Western imitation of the carpets imported from the Near East.[6]

The intricate designs and ornamental motifs of imported Near Eastern carpets were so widely imitated in Europe and its colonies that many elements became absorbed into the Western design vocabulary.

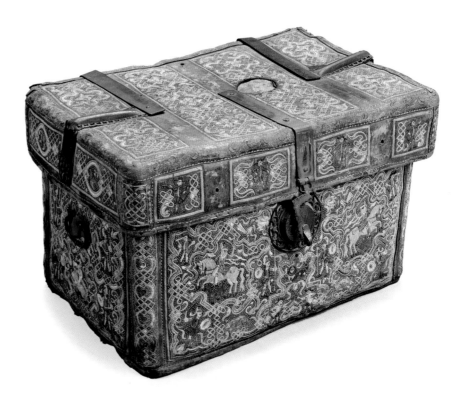

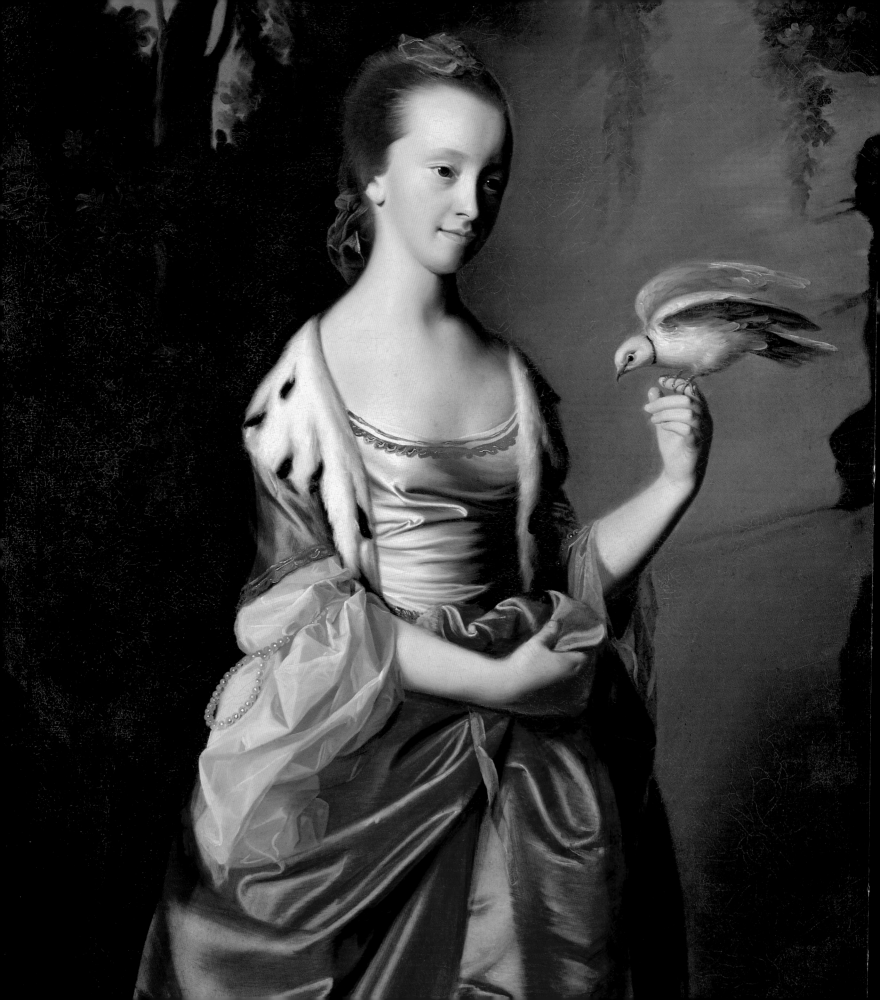

geometric strapwork, a common filler or border motif on Near Eastern carpets and other textiles. The strapwork and arabesque designs, as well as images of flowers native to the Near East such as tulips and carnations, were commonly embroidered on Western textiles and carved into Western furniture.

Another export from the Near East that had a large effect on Western culture was coffee. Introduced to Europe in the early 1600s via Venetian trade with the Near East, coffee is known to have been consumed in the American colonies by the middle of the century. Until the eighteenth century, the difficulty and expense of importing coffee from the Near East limited its consumption to the very wealthy. The cultivation of coffee bushes by the Dutch colonies in Indonesia and the New World in the 1720s brought coffee drinking to a broader populace, and, like other imported luxuries of the seventeenth and early eighteenth centuries such as sugar, tea, and chocolate, coffee inspired the creation of new, specialized tablewares. The earliest known American silver coffeepots date from the 1730s, and to this day Americans continue to be the world's largest consumers of coffee.[9]

From time to time in colonial America, specific elements of Near Eastern culture attracted attention, such as clothing styles. *Turquerie*, a Western interpretation of Near Eastern dress, became a fad among the eighteenth-century English aristocracy in large part because of Lady Mary Wortley Montagu. Montagu wrote letters from Istanbul—where she had accompanied her husband on a diplomatic posting—that described the culture, customs, and fashions she encountered there. Because so few Westerners had firsthand experience of the region, her vivid, nuanced, and often sympathetic descriptions of Turkish life were a revelation. As the letters circulated among her circle of acquaintants in England, upper-class British women began dressing for masquerade balls in the style Montagu described, and the vogue for turquerie was born. After Montagu's death, her letters were published and became a sensation in both Europe and America.

Upper-class Americans developed a modified form of English turquerie. This colonial interpretation of the style most often included ermine-trimmed robes, caftans, jeweled belts, turbans, and tasseled head-

dresses. Such clothes were loose and comfortable, requiring no corset for women. In any setting, turquerie had luxurious, exotic, and even seductive connotations. John Singleton Copley, the preeminent painter of colonial Boston, created a number of portraits of wealthy individuals who chose to be painted wearing the new fashion.[10] Sitters thought long and hard about how they would be immortalized in paint and often chose to be depicted in ways that demonstrated their wealth, position, and power. Those who decided to be represented wearing turquerie were sending an important message about their awareness and understanding of aristocratic British fashion and, by extension, of distant cultures.[11]

Copley painted Elizabeth Ross wearing turqueriestyle ermine-trimmed robes (fig. 210). The loose bodice indicates she is not wearing a corset, creating an impression of delicate sensuality, and the bird she holds reinforces the sense of lavishness and mystery. Copley and his sitters, like fellow colonial Americans who owned turkey-work upholstered chairs, appropriated Near Eastern style not to associate themselves with the people of the Near East but to align themselves with Westerners who could afford these sumptuous imports.

In the nineteenth century, American contact with the Near East steadily increased through a variety of means: military skirmishes, religious movements, biblical archaeology, and, in the last third of the century, tourist travel. These contacts led to a proliferation of Near Eastern subjects and styles in American art that ranged from superficial imitations and adaptive interpretations to sympathetic depictions, imperialist imaginings, academic studies, escapist fantasies, and the commercialization of stereotypes. While many Americans continued to link Near Eastern art and imagery with wealth and worldliness, the motifs often became more politicized. Some artists and collectors, particularly those who traveled to the region, began to take a more nuanced approach that often revealed more about American anxieties and attitudes toward the other culture than about the Near East itself.

Shortly after the formation of the United States government, the new nation was challenged by Algerian corsairs who in July 1785 captured the U.S. schooner *Maria* and took her crew hostage, demand-

210

John Singleton Copley
American, 1738–1815
Elizabeth Ross (Mrs. William Tyng) (detail), about 1766
Oil on canvas
127 x 101.6 cm (50 x 40 in.)

211

William Jay Dana
American, 1839–1913
Under the Natural Bridge,
Lebanon, 1880
Wood engraving
30.3 x 24.1 cm (11¹⁵⁄₁₆ x 9½ in.)

ing the right to tax American ships in Mediterranean waters. In response to this flagrant attack and others that followed, the United States fought and won a series of battles with the so-called Barbary States of North Africa, composed of the Kingdom of Morocco and the Republics of Algiers, Tunis, and Tripoli, in what are now the nations of Morocco, Algeria, Tunisia, and Libya. This early victory gave the young republic a higher profile on the world stage and heightened Americans' awareness of the Islamic world. The popular literature spun fantastical tales about barbarous pirates, depicted as dangerous infi-

dels accustomed to wanton self-indulgence, attacking the noble, ethical, and democracy-loving American citizens. One example was Royall Tyler's fictitious memoir *The Algerian Captive,* published in 1797. For most Americans, the Near East remained a distant, exotic land of luxury, but that perception was increasingly colored by negative stereotypes of the broad category of Near Eastern people.

With the rise of the evangelical movement in the 1820s, the American public became fascinated by what was called the Holy Land, the place they believed had witnessed divine revelation as described in the Bible. Many Americans, especially those of Protestant faiths, began to see the United States as a new promised land not unlike that described in the Old Testament.[12] For some, including the artist Thomas Cole, America was a new Eden, an untouched and pristine country given to the American people by God. Cole expressed this belief in his influential 1835 "Essay on American Scenery," in which he wrote, "We are still in Eden."

Influenced by this view of America, many nineteenth-century Americans wanted to learn about the original Holy Land. To satisfy this desire, missionary letters, travelogues, and archaeological reports (which often read like informal travelogues) were widely published. These publications, such as John Lloyd Stephens's enormously popular *Incidents of Travels in Egypt, Arabia Petraea, and the Holy Land* (1837), linked modern-day ruins with biblical places and events, while often pointedly describing the current deplorable and degenerate state of the once-glorious Holy Land.[13] By the last quarter of the nineteenth century, much of this descriptive travel literature was richly illustrated with maps and engravings of unearthed ruins and other locales. One such book was *Picturesque Palestine, Sinai and Egypt,* published in 1881 in two impressive leather-bound volumes by the New York firm D. Appleton and Company. The book brought together texts and images by many individuals, including the illustrator William Jay Dana, who contributed engravings such as *Under the Natural Bridge, Lebanon* (fig. 211). Like many similar images, this illustration idealizes the scene and does not depict the reality of contemporary life. The people

212
Elihu Vedder
American, 1836–1923
The Questioner of the Sphinx,
1863
Oil on canvas
92.1 x 107.3 cm (36 ¼ x 42 ¼ in.)

here are timeless, stereotypical representatives of the inhabitants of the region.

Later in the nineteenth century, American artists began to picture the Near East as a fantasy land. Many artists working in this vein, such as Elihu Vedder and William Rimmer, painted the Near East without any firsthand experience. (Vedder journeyed to Egypt near the end of his life, long after he created his iconic images of the place, and Rimmer never traveled to the region.) These artists most often represented the Near East as a site of ancient mystery and legend that contrasted sharply with the increasingly industrialized United States. Perhaps the best-known and influential image of this type is Vedder's 1863 *The Questioner of the Sphinx* (fig. 212). Painted while the artist was living in

New York, this work is an invention of Vedder's imagination, constructed from readily available published photographs and engravings of the Sphinx. Vedder may also have used for inspiration the collection of Egyptian antiquities at the New York Historical Society, which was acquired to much public fanfare in 1861.

The Questioner of the Sphinx shows a group of Egyptian ruins almost entirely subsumed by the golden desert sand. In the foreground, a dark-skinned figure, presumably intended to be native to the region, leans his ear to the lips of a great stone sphinx as if to hear a whispered secret. Nearby, a skull rests among the sands, emphasizing the transience of human life and the many generations of men who have knelt where this man now kneels.

213
Elihu Vedder
American, 1836–1923
Fisherman and the Genie,
about 1863
Oil on panel
19.4 x 35.2 cm (7⅝ x 13⅞ in.)

Vedder presents us with an image that both mourns and glorifies a lost civilization. This sense of a world that can never be recaptured, a mystery that can never be solved, gives the painting its nostalgic force. After he visited Egypt, Vedder stated that he hoped the ruins he saw would never be cleared of sand, because to do so would destroy their evocative power. He wrote, "It is their unwritten meaning, their poetic meaning, far more eloquent than words can express; and it sometimes seemed to me that this impression would only be dulled or lessened by a greater unveiling of their mysteries, and that to me Isis unveiled would be Isis dead."[14] *The Questioner of the Sphinx* became widely known in both Europe and the United States when it was reproduced in the popular British travel narrative *A Thousand Miles up the Nile* in 1877.[15]

Vedder also had a hand in popularizing literature from the Near East, which contributed to an American view of the region as a land of storybook fables. He

created the original artwork for the first American illustrated edition of the *Rubáiyát of Omar Khayyám* in 1884, and his painting *Fisherman and the Genie* represents a story of the same name from *The Arabian Nights*, a collection of Persian, Arabic, Egyptian, and Indian folktales (fig. 213). First translated into French in the early eighteenth century, *The Arabian Nights* became enormously popular among Europeans and Americans. Vedder's painting shows the moment in the story (supposedly told by Scheherazade to her husband, the sultan, in an effort to postpone her execution) in which a poor fisherman opens a mysterious vessel caught in his net only to discover a wrathful genie determined to kill his rescuer. With its illustrative quality and imaginative rendering of beings such as the genie and the enormous black spiderlike creature in the foreground, this painting seeks to make visible the fantastical vision many Americans projected onto the Near East.

Like Vedder, Rimmer was interested in literary and mystical themes. His best-known and most enigmatic painting, *Flight and Pursuit*, is set in the passageways of an imaginary temple or palace (fig. 214). In this faraway space, a mysterious scene unfolds. One man races toward a flight of stairs, perhaps pursued by another, suggested by the irregular shadow behind him. In a parallel hallway in the background, a ghostly man holding a sword and swathed in white also runs, mirroring the posture of the runner in the foreground with eerie precision. Any possible explanation for this extraordinary scene is left to the viewer's imagination. The tableau seems to unfold in a deeply symbolic, dreamlike space, and the imputation of a Near Eastern setting further distances

what we see from the everyday American world. In this instance, however, the fantasy land has turned nightmarish.

This vision of the Near East as a place of the imagination also made its way into interior decoration; many wealthy Americans started using "Turkish" styles in their homes, primarily in textiles such as draperies and upholstery. Turkish-style upholstery, characterized by large, overstuffed forms with an abundance of fabric, trim, cords, and fringe, was an invention of French upholsterers and not related to any furnishings found in the Near East. The forms of Turkish-style furniture generally encouraged relaxation, comfort, and informal repose, all of which Westerners equated with an opulent, and often sinful, Near Eastern culture.[16]

214
William Rimmer
American, born in England, 1816–1879
Flight and Pursuit, 1872
Oil on canvas
46 x 66.7 cm (18⅛ x 26¼ in.)

In wealthy American homes in the 1860s and 1870s, Turkish-style decoration, sometimes called Moorish after the Islamic Moors who had lived in Spain, was most often used to furnish men's smoking rooms, a male retreat in a household that was increasingly dominated by women.[17] Americans had long associated smoking with Turkey and the Near East and accentuated this connection by filling the smoking room with Oriental carpets, Turkish-style upholstered forms, foreign objects, and Near Eastern architectural elements and decorative motifs. A good example of such a haven was in John D. Rockefeller's New York mansion (fig. 215).[18] As one critic of the period noted, "Where attempts are made to decorate the smoking room there is, by common consent, a turning towards the Orient."[19] The decor not only provided an air of romance and the picturesque but also conjured images of harems and a world of male dominance. Some men took the fantasy even further by donning Near Eastern–style clothing when relaxing in their smoking room. Smoking hats resembled Near Eastern headdresses (or at least American interpretations of them). Unconstructed, with a wide

215
Moorish Smoking Room, the John D. Rockefeller House, built about 1864–65, remodeled about 1881
5.3 x 4.7 m (17 ½ x 15 ½ ft.)
Brooklyn Museum

216
Man's smoking cap
United States, 19th century
Wool embroidered with wool, silk tassel
21.6 x 16.5 x 19 cm
(8 ½ x 6 ½ x 7 ½ in.)

band of floral embroidery at the rim and a fringed tassel hanging from the top (fig. 216), the smoking hat was often worn with a loose silk robe, which emphasized the sensuous, sensual aura of the room.

Those with the interest, desire, and money did not rely on secondhand accounts in travelogues, engravings, or paintings but voyaged to the Holy Land themselves. Thanks to advances in transportation, particularly the American invention of the steamship early in the century and substantial improvements in ocean-faring steamships in the 1870s, travel had become faster, more comfortable, and more economically viable than ever before. Scores of wealthy and adventurous Americans set out to explore the far reaches of the world, some on their own pilgrimages in search of biblical ruins and perhaps divine inspiration, others with the mission to collect art and artistic ideas, and still others to investigate and examine the living cultures of the Near East.

Some American artists who had direct experience of the Near East painted in an American Orientalist style, related to but distinct from the well-established and highly refined Orientalist style that flourished among French academic painters of the period. Driven in many ways by the ideology of French imperialism, French Orientalist painting often reduced the region to a place of exotic corruption and indolent temptation, frequently presented through the nude or partly nude bodies of young women. Perhaps the leading practitioner of French Orientalism was Jean-Léon Gérôme, a well-respected French painter and teacher who had many American students. In his *Moorish Bath* of 1870, for example, Gérôme offers us a view of the naked back of a beautiful light-skinned woman, attended by a darker-skinned female servant with exposed breasts (fig. 217). In its original context, this kind of image would have immediately evoked a complex European mythology about female sexual submission in harems and palaces in the Near East.

American Orientalism was different from European Orientalism in many ways, but perhaps most significantly, American artists were far less likely to create such blatantly erotic images. American Orientalist paintings were often more restrained and more touristic, as can be seen in the work of one of Gérôme's American pupils, Frederick Arthur Bridgman.

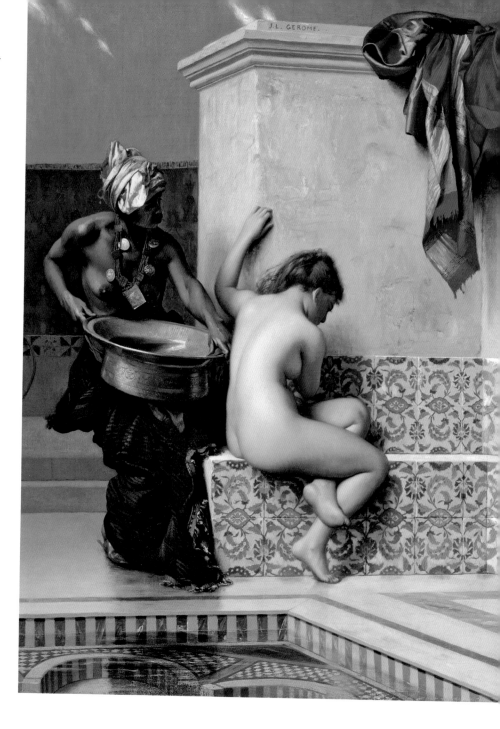

Bridgman traveled to North Africa several times and even published an illustrated book about his experiences in 1889 called *Winters in Algeria*. In his 1881 painting *A Circassian*, Bridgman presented a far more staid and reticent vision of female beauty than that of his teacher (fig. 218). Circassian women, who belonged to a distinct ethnic group displaced from the Northern Caucasus into Turkey, were reputed to be exceptionally beautiful and desirable and were a

217
Jean-Léon Gérôme
French, 1824–1904
Moorish Bath (detail), 1870
Oil on canvas
50.8 x 40.6 cm (20 x 16 in.)

218
Frederick Arthur Bridgman
American, 1847–1928
A Circassian, 1881
Oil on canvas
22.9 x 18.1 cm (9 x 7⅛ in.)

219
John Singer Sargent
American, 1856–1925
Head of an Arab, about 1891
Oil on canvas
80 x 58.7 cm (31½ x 23⅛ in.)

220
John Singer Sargent
American, 1856–1925
Frieze of the Prophets, about 1892
Oil on canvas
56.2 x 71.1 cm (22 ⅛ x 28 in.)

frequent subject of Orientalist painting and litera-
ture. In this work, the translucent veil calls to mind
the tantalizing sense of mystery that intrigued nine-
teenth-century Western men when confronted with
the Near Eastern practice of covering women's faces.

A different group of American artists who trav-
eled to the Near East painted the places and people
they saw there, but they approached this subject mat-
ter in a way that furthered their long-standing artistic
interests. Two important such figures were John
Singer Sargent and Henry Ossawa Tanner. Beginning
in December 1891, Sargent spent several months trav-
eling in Egypt, Turkey, and Greece in preparation for
his work on his Boston Public Library mural series,
The Triumph of Religion. While there, he depicted the
people he saw with an eye to capturing their distinc-
tive physiognomies, as in his painting *Head of an
Arab*. In this unfinished work, Sargent sensitively rep-
resents his subject's face, chest, and turban with

broad yet dazzlingly effective brushstrokes (fig. 219).
Sargent later drew on his experience painting Near
Eastern individuals while completing the Boston
Public Library commission. For example, in this 1892
preparatory study, *Frieze of the Prophets*, he incorpo-
rated the robed and bearded figures he saw on his
travels (fig. 220).

Tanner, the African American son of a bishop
in the African Methodist Episcopal church, spent
much of his career depicting Christian spiritual and
religious scenes. Tanner's painting *The Resurrection
of Lazarus* so impressed the wealthy Rodman
Wanamaker that he underwrote the artist's trip to
the Near East. There, Tanner saw firsthand the set-
tings in which biblical events were said to have taken
place. In early 1897 Tanner visited Jerusalem, Cairo,
Port Said, Jaffa, Jericho, the Dead Sea, and Alexandria.
While there, he sought out Muslim and Jewish reli-
gious sites in addition to Christian ones, as can be

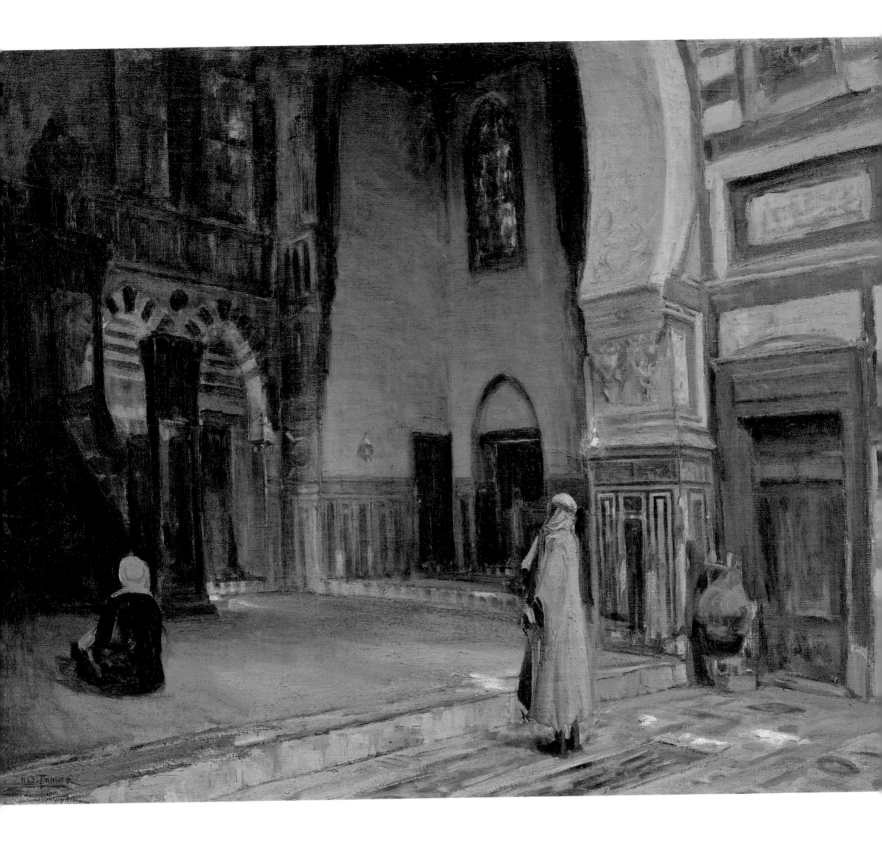

seen in his depiction of the interior of a fifteenth-century Mamluk mosque (probably Qait Bey) in Cairo (fig. 221). In this painting, Tanner shows two turbaned Egyptian Muslims in peaceful religious contemplation. Although this work does not depict the miraculous manifestations of God one often finds in Tanner's Christian or biblical paintings, the tone of the image is solemn and respectful of the people and practice it depicts.

For American artists and art consumers unable to travel to the Near East, the 1876 Centennial International Exposition in Philadelphia brought the region to them. Nearly nine million visitors attended the fair and had the opportunity to experience the various displays, stores, model interiors, and entertainment venues. The Turkish Bazaar, specifically the Turkish café, which served steaming Turkish coffee and provided visitors reclining on comfortable divans with long-stemmed Turkish pipes, attracted much curiosity and comment in the popular literature of the day.[20]

Increased interest in and exposure to the art and culture of the Near East in the 1870s coincided and intersected with the American Aesthetic movement, which sought to reinvigorate American art and craft and define the elements of beauty. Artists were encouraged to draw inspiration from the art of past and exotic cultures without regard to their original function, source, or meaning. Yet many associations, such as exoticism, continued to retain their entrenched allusions. By melding the best designs of past and present cultures (and their associations), Aesthetic movement proponents hoped to create a new superior artistic vocabulary.

A sideboard made in the 1870s by the New York firm Kimbel and Cabus is a prime example of the Aesthetic movement's disengaged appropriation of different cultural motifs, highlighting those from the Near East (fig. 222). Composed of an eclectic mix of classical, Jacobean, modern Gothic, and stylized Japanesque design elements, the ebonized frame is further embellished with three decorative tiles in an "Islamic style." Each tile features arabesques densely arranged on an electric blue ground (a color associated with excavated Syrian and Egyptian ceramics) around a central medallion. This medallion is formed by interlaced strapwork (similar to that seen on the Spanish colonial leather trunk) made up of pseudo-Kufic, or imitation Arabic, script. (Kufic is an Arabic script that emphasizes straight and angular strokes.) The meaningless script lends the piece an air of mystery, exoticism, and authority.

The Aesthetic movement's emphasis on drawing inspiration from the art of past and distant cultures motivated some Americans to form large collections of art and artifacts. Some of these collections were made available to the public through newly founded art museums, and others served to enlighten private collectors or even companies. Edward C. Moore, head

221

Henry Ossawa Tanner
American, 1859–1937
Interior of a Mosque, Cairo, 1897
Oil on canvas
52.1 x 66 cm (20 ½ x 26 in.)

222

Kimbel and Cabus
Sideboard
New York, New York, about
1870–75
Ebonized cherry, porcelain
H. 156.2 cm (H. 61 ½ in.)

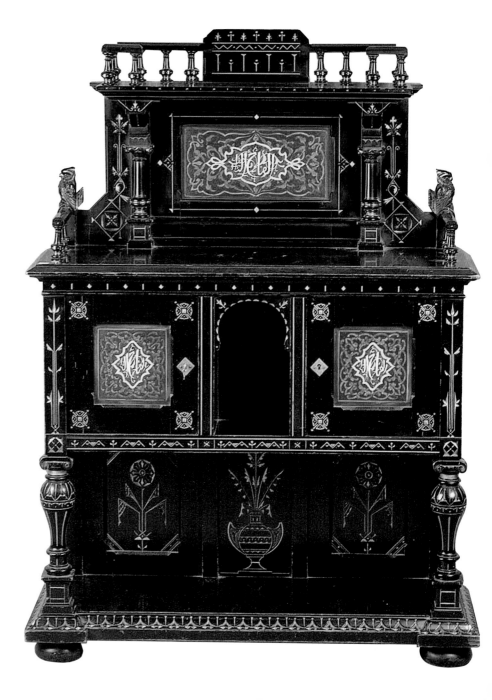

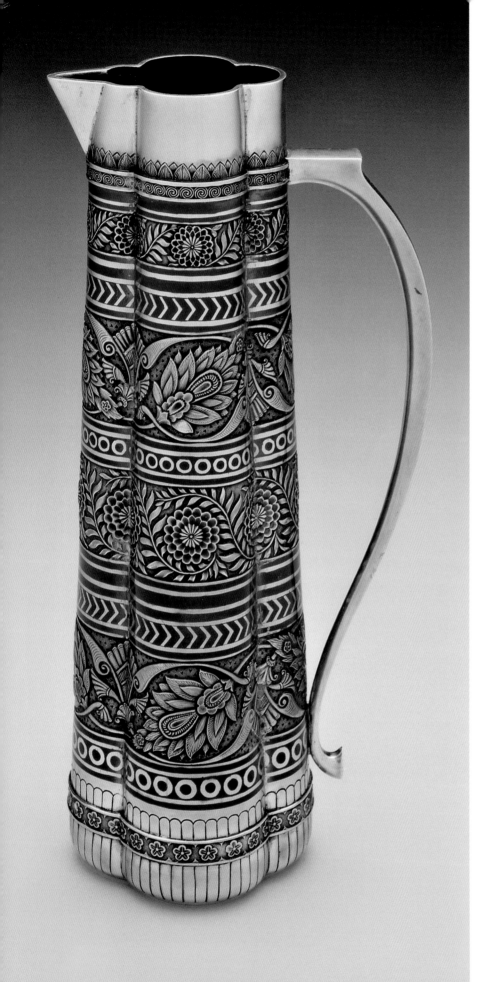

silver designer at Tiffany and Company, acquired an impressive collection of Islamic glass, ceramics, and metalwork as inspiration for himself and his employees. Several Tiffany designs from the 1870s and 1880s can be directly linked to objects in Moore's collection, and others reveal strong artistic similarities.[21] One similar object, a small silver and copper pitcher, was purchased for the Museum of Fine Arts, Boston, at the Philadelphia Centennial Exposition in 1876 (fig. 223). The pitcher, in a quatrefoil shape, is decorated with thin bands of geometric patterns and wider bands of stylized flowers and palmettes similar to those seen on imported Oriental carpets. The Tiffany designers not only imitated some of the motifs on the Islamic wares but attempted to replicate the inlaid metal technique as well.

American art potters were also intrigued by the Islamic wares that they saw in museums and in published images. They sought to revive ancient craft techniques, such as the *cuerda seca*, or dry line, glaze technique, which originated in Persia and migrated west to Spain with the Moors around the eleventh century. Several American art potteries, such as the Paul Revere Pottery of the Saturday Evening Girls in Boston (1908–42), used the *cuerda seca* technique to create the playful Arts and Crafts–style designs on their wares. A Paul Revere Pottery tea caddy illustrates the technique in which the artist/decorator painted a design on the ceramic body using diluted wax or oil mixed with manganese (fig. 224). Different-colored glazes, such as the blues, whites, and greens seen here, were then applied to the surface, and the wax/oil lines kept the glazes from running together. When the wax/oil burned off in the kiln, the manganese was left as black lines on the clay body surrounding raised pools of colored glaze.

In the twentieth century, the luxury, sensuality, and license associated with the Near East became increasingly visible in popular culture, especially in the rapidly growing area of product advertisements. Advertisers referred to the Orientalist fantasy to sell everything from cigarettes to light bulbs, in effect institutionalizing and broadcasting the visual stereotype to a large and diverse American audience. This was set in motion in part by the displays and events at the 1893 World's Columbian Exposition in Chicago.

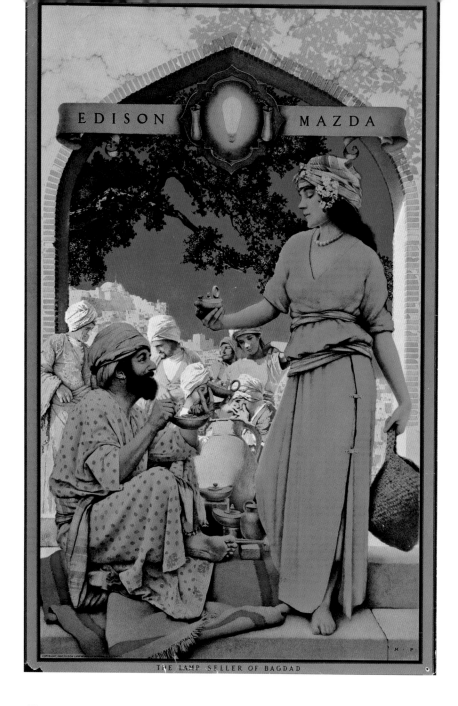

The fair's Midway Plaisance section was made up of pseudo-ethnographic cultural microcosms that purportedly gave visitors the opportunity to experience other cultures, much as the 1876 Centennial Exposition had tried to do. The Near Eastern entertainments, such as the Turkish Bazaar and especially the belly-dancing performances, were among the most scandalous—and therefore most popular—attractions. In this exposition, among other venues, the public appetite for titillating Near Eastern adventure became increasingly apparent to corporations, which used stereotypes of the Islamic world in merchandise and advertising.[22]

For instance, to advertise Edison Mazda lamps, the artist and commercial illustrator Maxfield Parrish evoked Near Eastern allure more subtly. Parrish's poster for an early brand of electric light bulbs marketed under the name Mazda (after the ancient Zoroastrian god Ahura Mazda, then thought by Westerners to be the god of light) shows a man and a woman in a beautiful, light-filled landscape wearing

223
Tiffany and Company
Pitcher
New York, New York, 1875
Silver, copper
H. 21 cm (H. 8 ¼ in.)

224
Decorated by Sara Galner for the Paul Revere Pottery
American, born in Austria-Hungary, 1894–1982
Tea caddy, 1914
Glazed earthenware
H. 11.1 cm (H. 4 ³/₈ in.)

225
Maxfield Parrish
American, 1870–1966
Edison Mazda / The Lamp Seller of Bagdad, 1922
Poster
65 x 41 cm (25 ⁹/₁₆ x 16 ⅛ in.)

stereotypical Near Eastern dress (fig. 225). Here, the mysterious and elegiac fantasyland of Vedder's nineteenth-century painting *The Questioner of the Sphinx* has become an imaginary twentieth-century paradise, promising timeless and unthreatening beauty. Parrish contrasts the romantic beauty of the Near East with America's technological sophistication, represented by the advertised light bulbs.[23]

Advertisements for cigarettes often incorporated images of the Near East as well. The association between smoking and the Near East continued long after the nineteenth-century fad for smoking rooms faded away. The tobacco that filled American cigarettes was typically imported from Turkey, whereas tobacco for chewing or pipe smoking was domestically grown. As a result, cigarette smoking was more expensive and less common than other forms of tobacco use. With the development of new strains of American-grown tobacco and the invention of the mechanical cigarette-rolling machine, cigarettes became a more widespread indulgence by the end of the nineteenth century. Three major types of cigarettes were available on the American market: Turkish blends, American blends, and blends of Virginian and Turkish leaves. To distinguish the source of a brand's tobacco, companies adopted Oriental names for their Turkish-leaf varietals and placed Near Eastern imagery on their packaging and advertising. Mogul, Omar, and Fatima all purveyed stereotypical images of turbaned men and veiled women, as well as disseminating the related notions of opulence, romance, self-indulgence, and innuendo in their marketing. Many Orientalist brands disappeared because of an interruption in the Turkish tobacco industry during World War I, but a few, such as Camel, survive to this day.[24]

Similar erotic imagery was employed by sculptors at the Northwestern Terra Cotta Company in Chicago for an ornamental standing lamp. Frank Lloyd Wright may have chosen this object to illuminate Midway Gardens, a spectacular entertainment venue and beer hall in downtown Chicago (fig. 226). The molded terra-cotta lamp is composed of a pedestal surmounted by a nearly naked Middle Eastern maiden holding aloft two exposed light bulbs. The allure of both Parrish's poster and the lamp is the underlying sensuality of the female figures.

As the twentieth century progressed, the flow of people, objects, and information among different parts of the world continued to increase. Artists inhabited an ever more transnational world, often moving between several cultures and creating unique hybrid styles. One such individual is Claudio Bravo, a Chilean painter who moved to Morocco in 1972, after having lived for more than a decade in Madrid and having spent a significant amount of time in New York City. Bravo describes his work as a "cultural cocktail," containing aspects from many places.[25]

In his painting *Interior with Landscape Painter*, Bravo depicts the interior of his home in Morocco, decorated with Middle Eastern–style tiles, furniture, and carpets (fig. 227). Whereas for residents of the American colonies Oriental or Turkey carpets were exotic luxuries from distant and mysterious lands, by the late twentieth century they had become familiar items reproduced by manufacturers all over the globe. Here they appear as accents in an almost placeless interior.

Today, with the historical and political events of the late twentieth and early twenty-first centuries, the region we now call the Middle East poses urgent and profound challenges to America's view of the world. The region has taken on a different and often more difficult meaning and resonance for many American artists. The Middle East is no longer the mythical Near Eastern playground of aristocrats, artists, and world travelers but is of great consequence to all of American society. The ways in which this will play out in American art are as yet unclear, but whatever the future holds, it will no doubt be inflected with the legacy of the past.

226
Pedestal designed by Fernand Cesar
Auguste Bernard James Moreau
American, born in France,
1853–1920
Lamp designed by Fritz Wilhelm Albert
American, born in Alsace-Lorraine,
1865–1940
Pedestal and lamp (detail), about
1911
Glazed terra-cotta
H. 162.6 cm (H. 64 in.)

227
Claudio Bravo
Chilean, born in 1936
Interior with Landscape Painter,
1989
Oil on canvas
199.4 x 152.4 cm (78½ x 60 in.)

ASIA NONIE GADSDEN AND ELLIOT BOSTWICK DAVIS

The arts and philosophies of East Asia—including China, Japan, and, Korea—have been a consistent force in shaping visual culture in the Americas for more than four centuries. Europeans long viewed East Asia, like the Near East, as an exotic and mysterious land of strange, "other" people. For centuries, many Westerners did not distinguish, or care to distinguish, between the two, let alone the various countries and cultures in those regions. Instead, they lumped the entire Eastern world under the umbrella term the "Orient" or "Oriental." With increased interaction and trade with the Islamic world in the fifteenth and sixteenth centuries, Europeans slowly began to differentiate between the Near and Far East (Western labels of convenience for the Middle East and East Asia, respectively), but only at superficial levels. Most Westerners, however, remained charmed by the Asian world, a mindset reinforced by their primary modes of contact: rare trade commodities, expensive luxury objects, infrequently published travel accounts, fictitious escapist literature, and fanciful European interpretations of Asian style. Distance and incomplete knowledge colored European views of Asia from the fifteenth through the nineteenth centuries and therefore affected how and in what ways artists in the Americas appropriated Eastern artistic techniques, materials, styles, and subject matter. The influence of Asian art on that of the Americas matured from ill-informed adaptations of decorative techniques and imagery to the disciplined study of conceptual artistic philosophies to create fresh interpretations and new styles. China and Japan have had the greatest influence on the Americas, not only in the degree of contact and exchange but also in American imaginings of the fanciful Orient.

Western interaction with Asia started long before the colonization of the Americas. Goods that were unknown in Europe and were therefore prized commodities, such as spices, tea, and silk (the most valuable of the commodities being traded), passed from hand to hand, from agent to agent, slowly making their way from east to west along the Silk Road, an ever-changing and often disrupted overland network of trade routes connecting Europe, Persia (now Turkey), India, Central Asia, and China. Few travelers attempted to make the grueling and often dangerous journey. Consequently, for several millennia, Western knowledge of the East was limited to the precious objects that survived the trek and the remarkably advanced inventions that migrated via the Islamic world, including gunpowder, movable type, and paper made from plant fibers (as opposed to old rags).[1] The European discovery of a sea route around Africa's Cape of Good Hope at the end of the fifteenth century allowed direct trade and communication with China, India, Japan, and the cultures of Southeast Asia (collectively known in Europe as the East Indies). Although economics and trade, particularly the acquisition of spices, were the driving forces behind Western initiatives in East Asia, the mystery, allure, and strange sophistication of the "Orient" had captured European imaginations.[2]

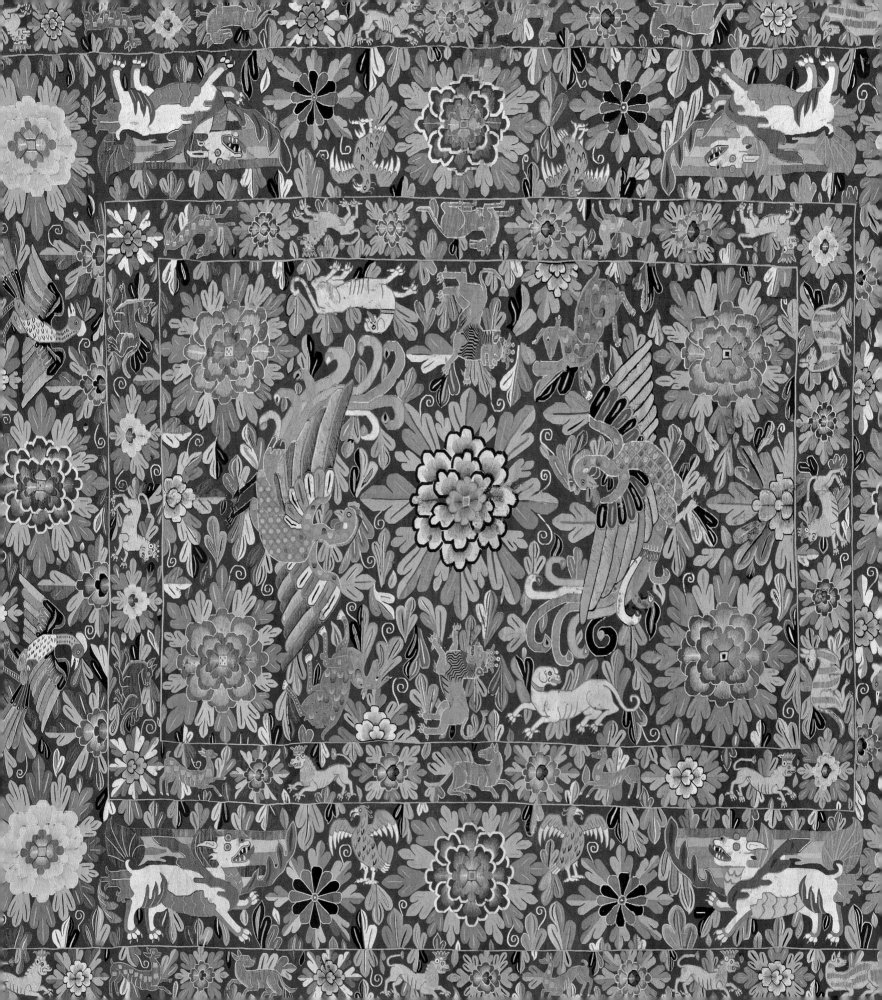

The mounting competition for Asian goods in the sixteenth century not only coincided with but precipitated the founding and development of European colonies in North, Central, and South America. Christopher Columbus, after all, was on a mission to find a western route to China when he declared he discovered America in 1492. Spain and Portugal, the two countries that dominated European exploration and maritime trade in the sixteenth century, soon founded colonies in Central and South America not only to exploit the natural resources of the New World, such as silver ore, but to establish friendly ports for ships traveling to the East. They used the silver that they mined in the New World to purchase raw materials and finished products from merchants in China.[3] As early as 1549 Portuguese East Indiamen regularly stopped in Brazil on their way from Asia to Lisbon, and, starting in 1573, the Spanish Manila galleons transported Asian cargo from the Philippines to Acapulco in New Spain (present-day Mexico). In exchange for silver and other domestic products such as cochineal, a red dye for textiles derived from beetles, the Latin American colonies received enormous amounts of Chinese silks and porcelains, Japanese folding screens and lacquerwares, Filipino ivory statues, and Southeast Asian spices and pearls, among other goods. These cargoes were transported overland to awaiting Spanish vessels in the Atlantic port of Veracruz, but many of them never made it to the ships. Instead they were dispersed throughout the region, including eastward to Mexico City and southward into the northern Andes and Peru. Asian people also came to Latin America, primarily those of Chinese, Filipino, and Japanese origin. While some were transported to the Latin American colonies as slaves, others immigrated voluntarily, bringing with them objects as well as design ideas and craft traditions.[4]

Some of the earliest and most magnificent manifestations of this artistic exchange occurred in the textile-making region of the Peruvian Andes. Native highland artisans combined their sophisticated traditional weaving techniques with the styles and materials they saw on Chinese imports. The stunning results were expertly woven tapestries made of wool, cotton, linen, and imported silk that mixed Chinese designs and motifs with images of flora and fauna indigenous to the Andean coast (fig. 228). Some, like this extraordinary tapestry, closely imitate the style and composition of Chinese embroidered textiles of the late Ming era. This work features a pair of Chinese phoenixes surrounded by a lively pattern of Chinese peonies and various animals on a brilliant cochineal red background. The animals include mythical Chinese beasts, European crowned lions, and *vizcachas*, long-eared, silky-haired rodents indigenous to South America.[5]

Similarly, potters in Puebla, Mexico, were influenced by the shapes and decoration of the blue-and-white Chinese porcelains flooding the region. By 1653 a guild regulation instructed Pueblan potters, "In making the fine wares the coloring should be in imitation of the Chinese ware, very blue, finished in the same style with relief work in blue."[6]

228
Cover (detail)
Peru, late 17th–18th century
Wool, silk, cotton, and linen
tapestry weave
238.3 x 207.3 cm (93 ¹³⁄₁₆ x 81 ⅝ in.)

229
Jar (*tibor*)
Puebla, Mexico, about 1700–1725
Tin-glazed earthenware
H. 26 cm (H. 10 ¼ in.)

These Chinese-style wares (now known as *talvera poblana*) were made not of porcelain but of tin-glazed earthenware, a dark clay body covered with a thick glaze containing tin oxide, which becomes white, opaque, and shiny when fired (fig. 229). This shouldered, straight-necked jar (*tibor*) adopts a classic form from the late Ming era. The blue-and-white decoration depicts a typical Chinese scene of a bird flying among clouds over a simplified landscape of rocks. The jar also shows regional adaptations to the Chinese style. The darker cobalt decoration is contoured with thinner, lighter blue accents, a characteristic of Puebla wares, and the bird depicted is an upside-down flying quetzal, a majestic creature native to Central America, unlike the mythical phoenix of Chinese decoration. Surrounding the base of the jar is a common Puebla border composed of a pattern of stylized Islamic structures, which evolved from the calligraphic motifs of Hispano-Moresque ceramics.[7]

If colonists in Central and South America enjoyed direct exposure to Asian arts, the situation in North America was different. England and the Netherlands established colonies in North America in the first quarter of the seventeenth century, more than a century after the Spanish did so in Latin America. During this time, the English and, to a much greater extent, the Dutch began to surpass the Spanish and Portuguese in maritime power and influence in all regions of the globe, particularly Asia. By 1609 the Dutch East India Company (founded 1602) established active trading posts in both Java and Japan and was angling for new avenues into Chinese markets. In fact, Dutch interest in establishing new routes to China led to their discovery of the rich wilderness of North America and the founding of the New Netherland colony (now New York) in 1624. England, finding it difficult to compete in the East Indies trade, also sought to tap into the natural riches of the New World and founded the Virginia colony in 1607 and the Plymouth colony (now Massachusetts) in 1620. But unlike the Latin American colonies, which served as way stations for treasure-laden China trade cargoes en route to Europe, the North American colonies received Asian goods only after they had passed through Europe, by way of immigrants or irregular

trade.[8] Furthermore, while small communities of Japanese and Chinese immigrants lived and worked in New Spain and Brazil, no analogous communities existed in colonial North America.

Then, as the seventeenth century continued, contact with the East was sharply curtailed for all of the West, but especially the North American colonies. The Japanese government abruptly closed its ports to all foreigners except the Chinese and the Dutch, and China's Ming dynasty fell, which dramatically disrupted craft production, especially export wares.[9] During the same period, England captured the New Netherland colony from the Dutch and enacted highly restrictive mercantile laws, which meant that, after 1664, most North American colonists' exposure to Asian goods, styles, and motifs was filtered primarily through England. As a result, most seventeenth- and eighteenth-century colonists living in North America formed their impressions of East Asia and East Asian goods from fanciful European imitations, called chinoiserie.

Chinoiserie offered an attractive alternative to traditional European styles, which were based on the classical art of Greece and Rome. Meant to evoke the exoticism of the "Orient," chinoiserie began as an imaginary, playful style composed of randomly assembled motifs from a range of Asian cultures. These were taken from imported objects and showed little understanding of authentic Asian designs. Defined more broadly, chinoiserie also encompassed the European use of Asian form, composition, and space, as well as attempted to imitate unfamiliar Asian craft techniques and materials, such as lacquer and porcelain. Craftsmen in each European country created their own regional versions of chinoiserie, which often reflected that country's attitudes toward Asia. Colonial North America generally followed the English chinoiserie style, a particularly fanciful interpretation that conveyed a peaceful, pastoral view of the "Orient."[10]

A striking early manifestation of chinoiserie in the North American colonies is the decorative technique that the English erroneously called japanning,[11] despite the fact that the technique was invented in ancient times by the Chinese and only later adopted by the Japanese. Japanning was an English method of decorating furniture that imitated the look of Asian lacquer. Genuine Asian lacquer, composed of multiple layers of tinted and clear sap from an indigenous Asian sumac tree, was a time-consuming process that produced a durable, protective surface for such materials as wood, bamboo, textiles, and leather; it was usually embellished with raised gold figures and motifs. By the end of the seventeenth century, imported Asian lacquerwares had become status symbols in aristocratic English homes.

Recognizing a business opportunity, English craftsmen began to emulate lacquer using their own materials and methods so they could offer the look of Asian imports at lower prices. In 1688 the Englishmen John Stalker and George Parker published an influential treatise on japanning, which outlined both the technique and the decoration. The English used whiting and glue as a base layer to smooth the surface of the wood, followed by several layers of dark varnish, each individually polished to create a lustrous dark background. Raised figures and other motifs in random arrangements were built up using gum arabic, whiting, gesso, or sawdust, finished with pigmented varnishes or gold leaf. Stalker and Parker also supplied engravings to be used as templates for decoration by other craftsmen. They had removed the motifs from their original context and even admitted, "Perhaps we have helpt them a little in their proportions, where they were lame or defective, and made them more pleasant yet altogether as Antick." This embellishment of Asian motifs is a classic example of the often condescending attitude that informed chinoiserie. This attractive and fanciful surface decoration was usually applied to traditional Western furniture forms, thus tempering the overall effect.[12]

By the 1690s English japanned wares were owned in the North American colonies, and by 1712, if not before, colonial craftsmen were adapting the technique (fig. 230). Japanning in North America was concentrated in Boston, the wealthiest and most powerful city in the British colonies at the time. The tight-grained woods available in New England did not require the base layer of whiting or glue used by English japanners, and Boston craftsmen used oil paints mixed with lampblack instead of pigmented varnishes. Yet they employed the same incongruous

230
High chest of drawers (detail)
Boston, about 1730–40
Japanned butternut, maple, white pine
H. 182.2 cm (H. 71¾ in.)

designs seen in Stalker and Parker's treatise, randomly placing motifs to convey the so-called Chinese taste. In addition to fanciful animals, long-legged birds, and pagoda-like buildings, this high chest features a simulated tortoiseshell background composed of vermilion covered with streaks of black paint, a technique popular in Boston in the 1730s and 1740s. Like lacquer, imported tortoiseshell from the Pacific Islands was a rare luxury item; therefore, imitating its mottled red and black surface enhanced the exotic appearance of the final product.[13]

In a more subtle manifestation of chinoiserie, colonial craftsmen, following the lead of their European contemporaries, also adopted several formal elements from Chinese objects.

Furniture of the late Baroque style, developed in the 1710s and 1720s, was composed of elegantly restrained designs made of hardwoods, similar to Chinese furniture of the Ming era. The curved cabriole legs that became standard on European and American furniture of the eighteenth century appear to be derived from Chinese *kang* tables, while solid chair splats, yoke-shaped crest rails, and shaped backs that conformed to the human figure are all refined features originating from Chinese high-backed scholars' chairs (fig. 231).[14]

At the same time that these Chinese forms were being absorbed into the Western design vocabulary, some Chinese habits were being adopted as well, particularly tea drinking. During the early eighteenth century in England and its colonies, tea drinking became so popular that demand for tea leaves skyrocketed, and the acquisition of tea dominated the China trade. Tea drinking revolutionized habits of social interaction from royal courts to colonial homes. Afternoon and evening tea parties were the latest type of social gathering that brought men and women together in an informal setting. Despite the air of informality, tea parties developed strict rules of tea-table decorum. The elite increasingly emphasized these unwritten codes of polite etiquette (appropriate postures, ways of holding a teacup, proper conversation) to distinguish themselves from the growing masses who could also afford tea. The increasing popularity of tea-related customs inspired the proliferation of myriad tea-drinking accessories. Teakettles, teapots, teaspoons, teacups, tea caddies, and tea tables soon became necessities for every society hostess. Inspired by the Eastern origin of the beverage, European and American craftsmen frequently drew on imported Asian wares for the design of these new tea accessories. For example, the shape of a squat, bulbous teapot with an S-curved spout and C-shaped handle made by the Boston silversmith Jacob Hurd about 1730–35 is derived from Chinese export porcelain examples (fig. 232).[15]

Millions of pieces of Chinese hard-paste (true) porcelain were imported to Europe and its colonies

231
Side chair
Massachusetts, 1740–60
Walnut, maple
H. 100.3 cm (H. 39½ in.)

232
Jacob Hurd
American, 1702 or 1703–1758
Teapot, about 1730–35
Silver
H. 13.3 cm (H. 5¼ in.)

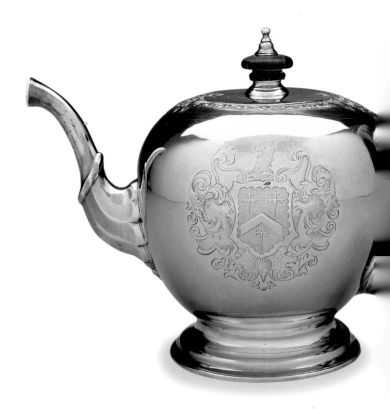

by the middle of the seventeenth century, but despite these high numbers, the supply never met the demand, and the Chinese wares were prohibitively expensive for most members of society. Consequently, European craftsmen and entrepreneurs feverishly attempted to replicate the prized characteristics of the imported wares (durability, thinness, smoothness, translucency, and a pure white base color), but the secrets of making true porcelain remained elusive for years.[16] By the mid-seventeenth century, however, a range of porcelain imitations was produced and eagerly acquired by those striving to set a fashionable table, such as the remarkably thin tin-glazed earthenware made in Delft, Holland (delftware), and the English bone china, or soft-paste porcelain, a medium developed from experiments to replicate Chinese hard-paste porcelain without knowledge of the proper ingredients.[17]

A few determined British colonists in North America tried creating porcelain as well. John Bartlam (working in South Carolina in the late 1760s) and Gousse Bonnin and George Anthony Morris (at the short-lived American China Manufactory in Philadelphia in the early 1770s) successfully produced small quantities of soft-paste porcelain, but neither endeavor could compete with less-expensive English imports. A delicate fruit basket by Bonnin and Morris, with pierced fretwork sidewalls and applied molded flowers on the exterior, closely follows the shape and decoration of British-made soft-paste porcelain from the Chelsea and Bow factories (fig. 233). Both this fruit basket and the British work it resembles allude to the Eastern origin of the medium by limiting the color palette to the ubiquitous Chinese standard of blue and white.[18]

In the middle of the eighteenth century, the Rococo, a lavishly ornamented design style from France, encouraged the more decorative and superficial aspects of chinoiserie. Whereas French Rococo design, whimsical and unfettered, mixed stereotypical Chinese-inspired motifs with French *rocaille* (embellishments), Gothic, and other ornaments, the English adopted a more staid version, which was further

233
American China Manufactory of Gousse Bonnin and George Anthony Morris
Fruit basket
Philadelphia, 1771–72
Soft-paste porcelain, underglaze blue decoration
Diam. 17.5 cm (Diam. 6⅞ in.)

diluted as it spread to the rapidly growing North American colonies via immigrant craftsmen, imported objects, and printed design books. A Rococo dressing table made about 1760–70 by an unidentified craftsman working in Philadelphia incorporates several Chinese-inspired elements, including curved cabriole legs, fretwork in the cornice molding, and chinoiserie columns flanking the central figure of a swan (fig. 234). The carved chinoiserie ornaments were undoubtedly drawn from printed design books, such as Thomas Chippendale's *The Gentleman and Cabinet-Maker's Director* and Thomas Johnson's *150 New Designs*.[19] The dressing table also features carved claw-and-ball feet, a motif that appeared on Rococo furniture throughout Europe and its colonies in North, Central, and South America. The birdlike claw with talons grasping a round ball may have been inspired by images of Chinese guardian lions. Often seen as sculptures flanking the entry to a tem-

Dressing table
Philadelphia, about 1760–70
San Domingo mahogany,
mahogany veneer, yellow poplar,
cedar
H. 81 cm (H. 31⅞ in.)

235
John Singleton Copley
American, 1738–1815
Nicholas Boylston (detail),
about 1769
Oil on canvas
127.3 x 101.6 cm (50⅛ x 40 in.)

ple or palace, Chinese guardian lions were usually depicted in pairs, the female with her paw resting on a cub and the male clutching a ball.[20]

As the wealth and power of North American colonists increased in the second half of the eighteenth century, more people were able to acquire Chinese silks, porcelains, wallpapers, and other wares. The Boston merchant Nicholas Boylston, an importer of textiles, paper, tea, and glass, showed off his wealth through his material possessions both in his richly appointed mansion and in his personal adornment. For his portrait by John Singleton Copley, Boylston chose to be portrayed bedecked from head to toe with luxurious fabrics that he had acquired through the China trade (fig. 235). Recognizing the symbolic power of these materials, Copley took great pains to render convincingly the sumptuous surfaces of the various weaves of Boylston's imported brown silk

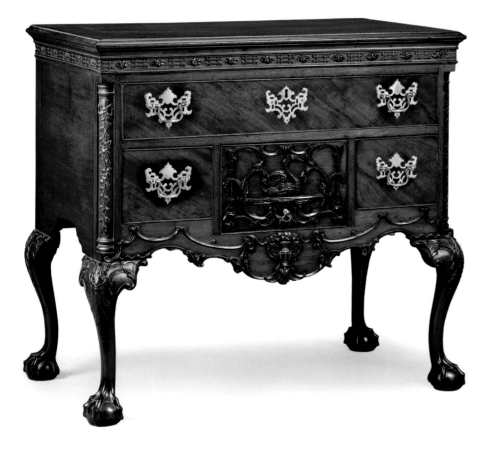

brocade, purple satin vest, and jaunty red silk turban. His dressing gown, called a banyan, was a style developed in Europe in the late seventeenth century from a mixture of Chinese, Indian, Persian, and Japanese sources. In England and America, banyans came to connote scholarly gentility, and many ambitious colonial men, such as Benjamin Franklin, David Rittenhouse, and Boylston, chose to wear one in their formal portraits.[21]

High British taxes on imported goods, including China trade luxuries such as silk, tea, porcelain, and wallpaper, eventually drove colonists to agitate for independence from Great Britain. Sealing their pact to oppose these restrictive tariffs, the Sons of Liberty drank from a vessel made by Paul Revere, now known as the Liberty Bowl (1768), made of precious and durable silver in a form derived from Chinese punch bowls. One of the best-known and symbolic events leading to the American Revolution was the December 1773 Boston Tea Party, during which enraged colonists protested British taxes by dumping cargoes of imported Chinese tea into Boston Harbor. After the colonists officially won their independence in 1783, they wasted no time in establishing their own direct trade with China. In February 1784 the *Empress of China*, backed by the forerunners of modern-day venture capitalists, departed from New York Harbor bound for the Chinese port of Canton. In exchange for Spanish American silver dollars and American ginseng (a native North American plant that the Chinese believed to possess health benefits), the crew of the *Empress* acquired tea, porcelains, and silks.[22] After the *Empress of China* made her triumphant and very lucrative return to the United States in 1785, trade with China grew exponentially, allowing Americans ready access to Chinese goods, which they proudly displayed in their homes.

The Boston merchant Thomas H. Perkins was one of the first New Englanders to enter the China trade, making his inaugural trip in 1789. In partnership with his brother James, Thomas actively traded with China for more than forty years. Guests to his home in Brookline, Massachusetts, stepped into another world; they were surrounded by bamboo

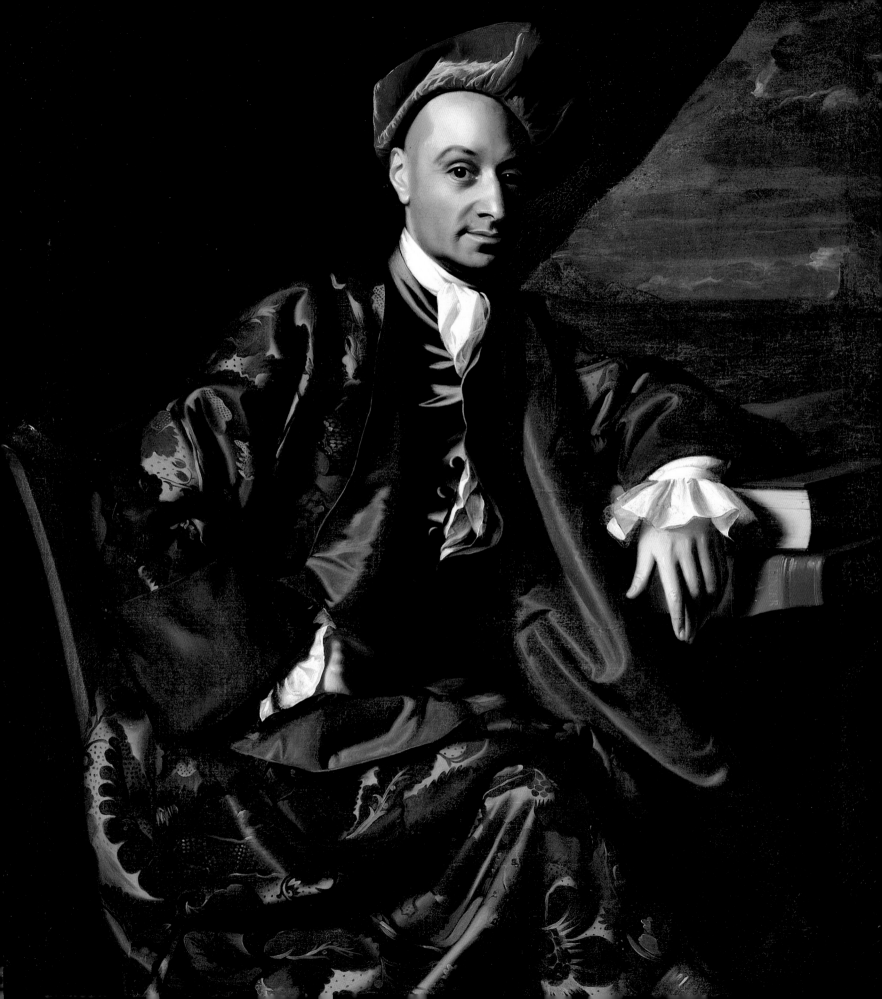

trees, unusual birds, and colorful butterflies on a robin's egg blue background, all on hand-painted imported Chinese wallpaper (fig. 236). To complement his wallpaper, Perkins served his guests refreshments on blue-and-white Chinese porcelain, including plates emblazoned with the quintessential chinoiserie image: an eight-level pagoda with flaring rooflines.[23] Although direct trade routes allowed for greater access to Chinese goods, they did not necessarily provide the citizens of the United States with better knowledge of the Chinese people, their culture, or their art. The early U.S. merchants and adventurers who traveled to China got only a tiny glimpse of Chinese life owing to the highly restrictive policies of the Chinese government.[24] Therefore, for Americans and other Westerners, China retained its shroud of mystery well into the nineteenth century.

By the mid-nineteenth century, American attitudes toward China started to change for the worse. The loosening of Chinese trading restrictions in the 1820s and 1830s allowed not just more goods but cheap and shoddy goods to be exported to the United States, thus tarnishing the reputation of Chinese wares in general.[25] Merchants imported fewer luxuries like fine porcelains and more affordable or frivolous non-necessities, such as handkerchiefs, fans, fireworks, and snuffboxes, which they then marketed to the emerging middle class with promotional stunts and newspaper advertisements. For many, the allure of China faded in the face of crass commercialism. In addition, China's Opium Wars of the 1840s and the increasing migration of Chinese laborers to the United States after the 1849 California gold rush provoked negative, racist attitudes, which found their way into American art and design. A bar pitcher by the Union Porcelain Works of Brooklyn, New York, graphically illustrates a scene from "The Heathen Chinee," a popular 1870 poem by Bret Harte (fig. 237). The pitcher shows the poem's hero, Bill Nye, a California miner, physically confronting Ah Sin, a Chinese immigrant, who he claims is cheating at cards.[26] The growing prejudice against Chinese immigrants further besmirched China's reputation in the United States, eventually culminating in the Chinese Exclusion Act of 1882—the first federal law to prohibit the immigration

of individuals of a specific nationality. Although interest in China and chinoiserie never vanished, the American romance with China lost its luster. But a new suitor soon filled China's previous role in American imaginations: Japan.[27]

Japan entered the American public consciousness in July 1853, when a U.S. naval squadron under the command of Commodore Matthew C. Perry brazenly entered Japan's Edo Bay (now Tokyo) with the objective of opening Japanese ports for trade with the United States. Except for the Dutch and the occasional rogue merchant ship, no Western trading ships had visited Japan since the island nation had decreed its self-imposed semi-isolation more than two hundred years earlier. After several years of negotiations, Japanese ports began to welcome merchant ships from the United States and elsewhere in the summer of 1859.[28] Although Perry's diplomatic achievements were much publicized, they happened in a distant and unknown place, and most Americans still knew very little about (and generally paid little attention to) Japan or the Japanese people. During the ensuing decade, most Americans focused on the horrors of the Civil War and the struggles of postwar recovery, not international discovery and trade relations. However, several European countries, particularly France, took advantage of Japan's newly opened ports (courtesy of the United States) and began to discover the country's artistic talents. Japanese woodblock prints called ukiyo-e, meaning "floating world," a reference to the fantasy and allure of Japanese pleasure districts, especially intrigued and excited Western artists.[29] Although the Japanese considered many of these prints produced during the Edo period (1615–1868) ephemeral and unimportant, Western artists admired their originality of composition, color harmonies, subject matter, and use of the woodblock technique to create flat areas of color and decorative patterns delineated by crisp outlines.

The rising enthusiasm in Europe for Japanese art and commodities in the 1860s sparked the development of japonisme. Like the related chinoiserie style, which had entranced Westerners for the previous two centuries, much of japonisme had little connection to actual Japanese styles, instead reflecting

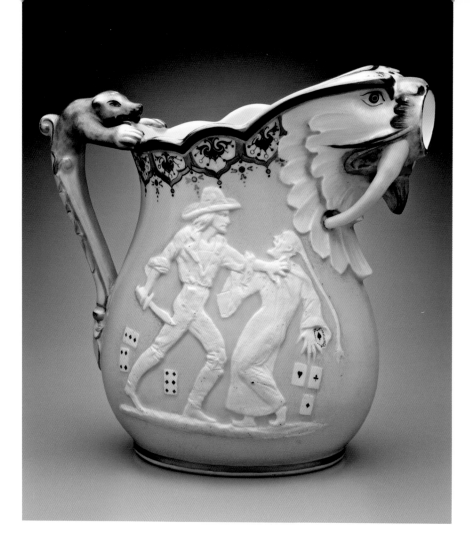

Western interpretations and appropriations of Japanese motifs and design elements, often combined with other influences. After the Civil War, Americans started to create their own interpretations of japonisme, much of which similarly involved the superficial appropriation of Japanese motifs. But in the hands, hearts, and minds of American artists, japonisme as a style evolved over the ensuing decades from a focus on Japan as a symbol of the exotic to a deeper and richer understanding and interpretation of the concepts behind Japanese aesthetics.[30]

Among the early artists intrigued by Japanese arts and crafts was the American expatriate James McNeill Whistler, a Massachusetts native who established his career in Paris and London beginning in

236
Wallpaper
Probably Guangdong Province, China, about 1805
Opaque watercolor on paper
335.3 x 121.9 cm (132 x 48 in.)

237
Designed by Karl L. H. Müller
American, born in Austria, 1820–1887
Pitcher, about 1876
Porcelain
H. 24.1 cm (H. 9½ in.)

238
James Abbott McNeill Whistler
American, active in England,
1834–1903
Harmony in Flesh Colour and Red,
about 1869
Oil and wax crayon on canvas
39.7 x 35.6 cm (15 5/8 x 14 in.)

1855. Whistler was probably introduced to Japanese art through his close friend and French colleague Félix Bracquemond, who is frequently credited with being one of the first European artists to incorporate the natural motifs, sense of perspective, and palette of Japanese ukiyo-e prints into his designs for porcelain. Whistler in turn touted the virtues of Japanese prints in England and the United States.[31]

In his paintings, Whistler emulated the compositional arrangement, subjects, and colors of Japanese woodblock prints. The decorative array of women within a flattened picture plane and a masterly range of a pale coral palette in such compositions as

Harmony in Flesh Color and Red resemble prints by Kitagawa Utamaro (fig. 238; compare to fig. 239). Whistler posed his subjects in the manner of Japanese actors or courtesans, whose graceful postures were enhanced by the curves of the kimonos trailing behind them. The three women are artfully disposed within an interior that opens onto a background decorated with Asian fans, motifs that often appear in Utamaro's scenes of daily life.

Whistler's contemporary John La Farge first encountered Japanese prints in the mid-1850s, probably while browsing in a curio shop in Paris, and was immediately captivated by their novelty and beauty.[32] Settled in Newport, Rhode Island, by the early 1860s, La Farge had begun to experiment with Japanese materials and artistic effects based on his intense study of the Japanese works he was able to acquire, including eighteenth- and nineteenth-century prints, lacquers, porcelains, and other items. Well before he traveled to Japan in 1886, La Farge infused his compositions with a reverence for Japanese artistry. Several early painted still lifes, *Vase of Flowers* (fig. 240), *Hollyhocks and Corn (Decorative Panel)*, and *Water Lily* feature Japanese motifs, spatial effects, and decorative surfaces.[33] In *Vase of Flowers*, a cylindrical vessel, placed just off center, creates a dynamic sense of asymmetry. Behind the floral arrangement, delicate branching shapes resembling pine needles appear on a gold-leafed screen, enlivening the empty space of the background.[34]

Unlike many of his contemporaries, who were initially inspired by the superficial appearance of Japanese art, La Farge, beginning in the 1860s, assimilated Japanese techniques, often trying to blend the traditions of East and West. La Farge's early and sustained interest in the Japanese ideals of form, color, beauty, and craftsmanship played an important role in bringing the genius of Japanese art and design to the fore among American artists and art enthusiasts.

The Centennial International Exposition of 1876, held in Philadelphia, marked a watershed in both American and Japanese cultures: the Americans sought to confirm the strength and solidity of their union and to assert the country's leadership in technological achievements, while the Japanese sought to

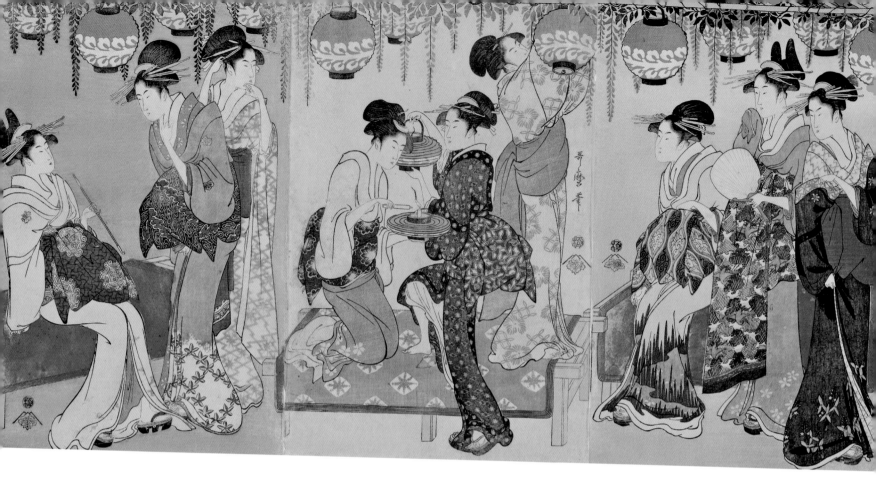

establish themselves as equals to the West. After years of isolation, followed by bitter internal political debate, the Japanese imperial government, now restored, decided to promote its art and culture to the Western world and to modernize (in effect, Westernize) the Japanese military, economy, educational systems, and more.[35] Many Americans, and Westerners in general, saw Japan in a very different light. They envisioned a peaceful and natural paradise with a living feudal culture where life and art were completely integrated and where craftsmanship and individual artistic expression were prized above all. Instead of trying to rectify these inaccurate perceptions, the commercial-savvy Japanese administrators capitalized on them.

In carefully planned exhibits in Philadelphia, the Japanese government showcased Japan's handwork and traditional artistry in antique as well as newly created ceramics, lacquer, textiles, and metalwork, specifically designed to suit Western tastes (fig. 242). These displays attracted more popular and media attention than almost any other exhibit at the fair. The Japanese authorities erected a traditional Japanese dwelling house, a teahouse surrounded by a Japanese garden, and a Japanese bazaar, all built and manned by Japanese natives. Although visitors were not permitted to enter the dwelling house, they could be served tea in the garden teahouse or shop in the bazaar, which sold moderately priced Japanese-style souvenirs so everyone could take home a little piece of Japan. For many, the exhibits at the fair made the American fantasies about Japan appear real, if only for a brief moment.[36] Unlike the Chinese, who severely restricted interaction with the West and thus did not participate in these public spectacles, the Japanese played an active role in creating the American vision of their art and culture, both accurate and not.

239
Kitagawa Utamaro
Japanese, died in 1806
Courtesans beneath a Wisteria Arbor, about 1795
Woodblock print triptych; ink and color on paper
Three sheets, each approx. 39 x 26 cm (15 5/16 x 10 1/4 in.)

240
John La Farge
American, 1835–1910
Vase of Flowers, 1864
Oil on gilded panel
47 x 35.6 cm (18½ x 14 in.)

By the mid-1880s, the romance of Japan had instilled a commercial fervor for Japanese and Japanese-style objects within a broad swath of American society that cut across lines of class, gender, and even ethnicity.[37] Newly established shops sold a range of Japanese wares—from mass-produced modern replicas and goods made specifically for the export market to the work of contemporary master craftsmen and even authentic Japanese antiques.[38] The popularity of

imported Japanese wares spurred American craftsmen, artists, architects, and designers to create works in the Japanese style. Taste for the Japanese style was particularly evident in a range of designs created by the leading silver manufacturing firms in the United States, Tiffany and Company of New York and Gorham Manufacturing Company of Rhode Island.

Several firms tried to replicate the imported Japanese wares, including some of the sophisticated and challenging Japanese metalworking techniques, such as artificial patination and novel combinations of iron, steel, bronze, copper, gold, silver, and other alloys. For example, the craftsmen at Gorham created a small copper tea caddy that features a patinated and hammered surface accented by asymmetrically applied natural motifs in silver, gold, and alloys (fig. 241). The contrasting color effects heighten the realism of the three-dimensional naturalistic ornaments in the Japanese style, such as the tiny mouse on the lid, which looks as if it might scurry away at any moment. In the understated manner of traditional Japanese aesthetics, the quiet, subtle elegance of the design and its modest subject matter belie the high degree of technical sophistication needed to produce it.[39]

Most American japonisme of the 1870s and 1880s, however, did not attempt to faithfully replicate Japanese styles or designs but instead developed a hybrid style associated with the Aesthetic movement. This international design reform movement purported that art and beauty had the power to improve human character and to enhance society. Proponents encouraged people of all class levels to surround themselves with an abundance of beautiful things in order to make their lives happier and more fulfilled. Witnessing and assimilating the mixing of cultures at the international expositions and new public museums, artists drew inspiration from past and distant cultures and combined those elements in novel ways. The romanticized Western vision of Japan meshed perfectly with Aesthetic movement ideals. Both valued traditional, time-honored craftsmanship, the intense study of nature, and the dedication to finding beauty in all aspects of life.[40]

Under the influence of the Aesthetic movement, most American decorative arts in the Japanese style

remained superficial interpretations of the originals, a veneer applied to the dominant Western forms and concepts of beauty. For instance, like the tea caddy described above, the decoration of an elaborate silver punch bowl, also by Gorham, is clearly inspired by Japanese naturalistic imagery drawn from newly formed American collections of Japanese art or the newly available source books of Japanese design (fig. 243).[41] But unlike the tea caddy, every inch of the punch bowl and its matching ladle is crawling with extraordinarily detailed renderings of sea life—from the leviathan at the ocean bottom to the seaside of sand, crabs, shells, and seaweed at the upper lip. The excessive, almost compulsive, ornamentation of the punch bowl's surface typifies the prevailing Western aesthetic—sometimes derisively known as horror vacui (fear of empty spaces)—that

241
Gorham Manufacturing Company
Tea caddy
Providence, Rhode Island, 1881
Copper, silver
H. 10.5 cm (H. 4⅛ in.)

242
The Japanese Exhibition at the Philadelphia Centennial International Exposition, 1876
Photograph
Courtesy of the Free Library of Philadelphia Archives

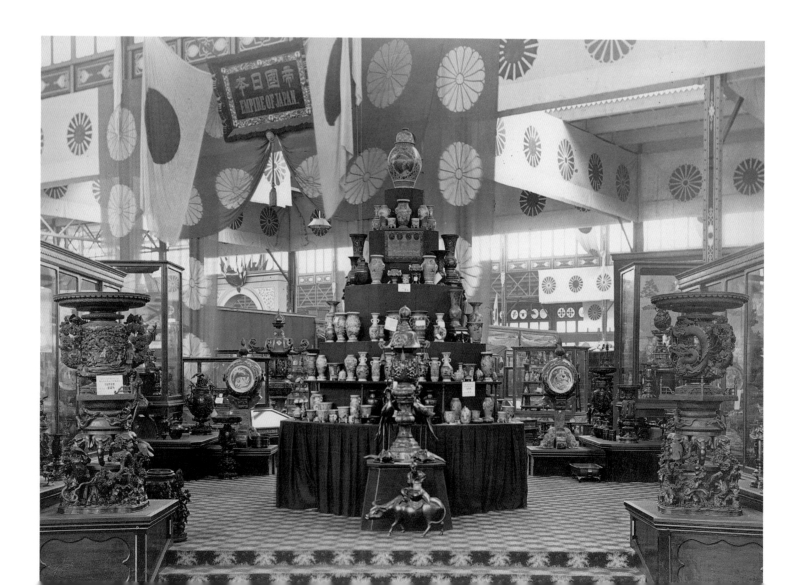

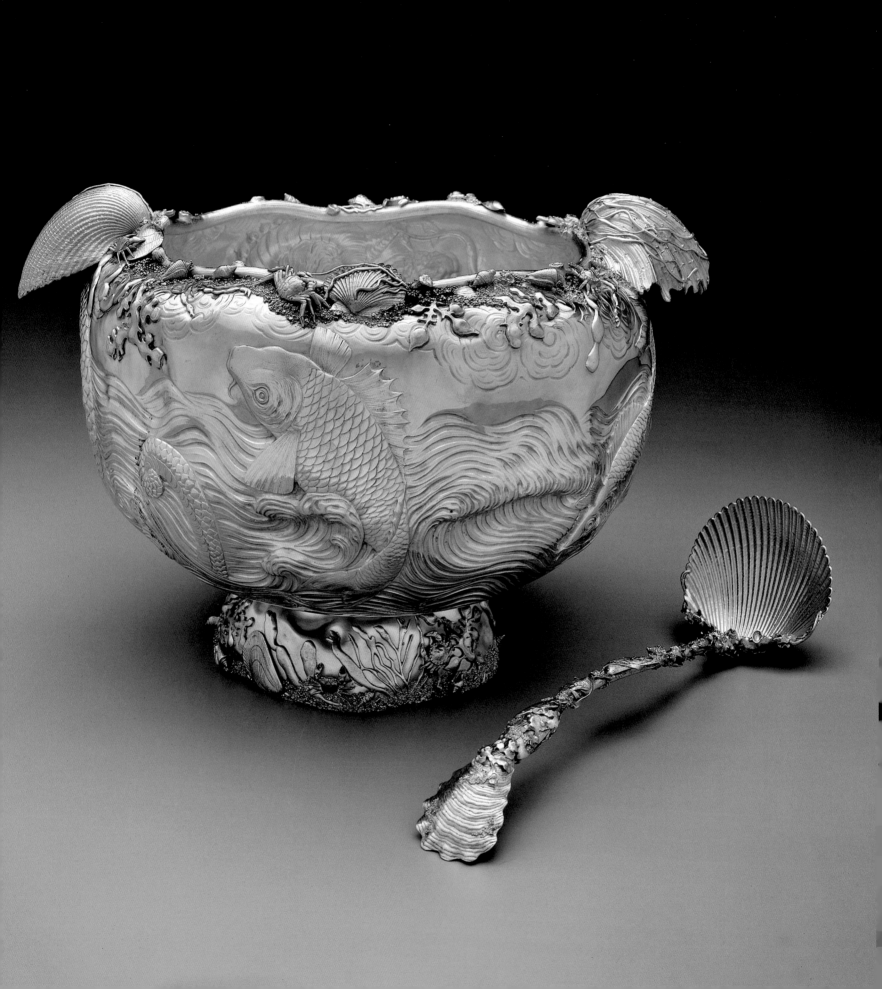

was common in Aesthetic movement designs. This contrasts with traditional Japanese design, which balances ornamented and unornamented areas to create a sense of calm within the composition.

Busy, Aesthetic-style japonisme was also popular for decorating pottery. The elegant forms and exquisite craftsmanship of the highly ornamented Japanese export wares, custom-made for the Western market, immediately attracted the Japan-crazed American public. The unusual motifs—birds, insects, flowers, grasses, bamboo, geometric patterns, and fans—in asymmetrical, often gilt compositions, were soon imitated by large-scale pottery and porcelain manufacturers, such as the Greenwood Pottery Company and Ott and Brewer, both of Trenton, New Jersey.[42] Yet the subtle and refined beauty of the traditional Japanese pottery, which tended to be more simple and rougher in execution, also drew the attention of some of the more progressive and creative American potters, such as Maria Longworth Nichols. Nichols, an amateur potter and Cincinnati socialite, became enamored with the artistry of the Japanese ceramics at the Centennial Exposition and announced that she wanted to create her own artistic pottery and hire only Japanese artisans. In 1880 she established the Rookwood Pottery in Cincinnati, but her father, who funded the project, discouraged her at first from trying to attract Japanese workers. Instead, Nichols experimented with Japanese styles and designs on her own and encouraged her professionally trained American employees to do the same (fig. 244). The resulting works ran the spectrum between Aesthetic movement japonisme and imitations of traditional Japanese wares. In this example, made in 1882, the soft mottled background in tones of yellow and brown provides a warm atmospheric quality, while a flowering vine meanders across the surface. In 1887 Nichols successfully lured the Japanese potter Kataro Shirayamadani to join the Rookwood staff. Shirayamadani's presence only amplified the Japanese influence on Rookwood's products. Nichols and Rookwood Pottery were at the forefront of the art pottery movement, which sought to raise the status of pottery from utilitarian craft to fine art.[43]

The German immigrants Gustave and Christian Herter, who established Herter Brothers, a leading cabinetmaking and interior design firm in New York at the end of the nineteenth century, drew inspiration from Japanese art for some of their best-known and most successful interiors.[44] In the spirit of the Aesthetic movement, the Herters did not try to imitate Japanese objects or spaces accurately but to create Western interiors infused with the aura of Japan. Their furniture designs for such rooms consisted of traditional, Neoclassical forms ornamented with motifs that evoked the image of Japan as a culture that revered nature and handwork. A magnificent Herter Brothers cabinet expresses the vocabulary of the Japanese taste in an Aesthetic style, using a rich variety of materials (fig. 245). The exquisite marquetry decoration, featuring extraordinarily detailed insect and plant life, including tiny beetles munching holes in the leaves on the top panel, playfully celebrates Japanese naturalistic ornament while alluding to fine Japanese craftsmanship. The gilt, embossed, and sten-

243
Gorham Manufacturing Company
Punch bowl and ladle
Providence, Rhode Island, 1885
Silver, gilding
H. of bowl: 25.7 cm (H. 10⅛ in.)

244
Rookwood Pottery Company
Perfume jar
Cincinnati, Ohio, 1889
Earthenware with underglaze decoration
H. 12.7 cm (H. 5 in.)

245
Herter Brothers
Cabinet
New York, New York, about 1880
Maple, bird's-eye maple, oak or
chestnut, stamped and gilt paper,
with gilding, inlay, and carved
decoration; original brass pulls
and key
H. 133.4 cm (H. 52½ in.)

ciled paper lining the niches and splashboard of the
cabinet (a fragile, rare survival) adds even more
Asian-style flair.[45]

Similarly, Charles Caryl Coleman's *Still Life with
Azaleas and Apple Blossoms* was probably intended
for an Aesthetic-movement interior in the Japanese
style (fig. 246). The narrow, vertical format of the
canvas recalls a panel from a Japanese screen or a
scroll painting, and Coleman further enhances the
resemblance by creating a shallow space behind the
blossoms with an embroidered kimono fabric ren-

dered in threads of coral, blue, and pale yellow.[46]
The blossoms that fan upward are drawn in such
thin paint that they suggest lyrical strokes of Asian
calligraphy. Coleman applied metallic pigment to
the canvas in the Japanese manner to suggest the
luminous appearance of the bronze vessel in the
foreground. On the reverse of the canvas, an inscrip-
tion indicates that the painting was intended for a
particular location of the dining room, probably
part of a set of panels meant to lend an Asian air
to the interior.[47]

John La Farge continued to draw on the lessons he gleaned from Japanese prints, ceramics, lacquer, and metalwork for his experiments with large-scale mural painting, interior decoration, and stained-glass windows. In glass, as with watercolor, La Farge was able to realize his desire to imitate the Japanese use of color and light to create subtle atmospheric effects and a suggestive, impressionistic naturalism by pioneering the use of opalescent glass in windows. Milky and opaque, opalescent glass varies in translucency and tone depending on the density of tiny suspended color particles that refract and scatter light. The streaked, mottled, and sometimes murky opalescent glass, such as that used to simulate flowing water in *The Fish*, could also be plated, or layered (as seen in the surface water in the upper half of the window), to create great effects in color, shading, and depth (fig. 247). Essentially, La Farge "painted" the asymmetrical, Japanese-inspired composition with glass and light.[48]

Japanese prints and objects also influenced La Farge's main competitor, Louis Comfort Tiffany.[49] While Japanese motifs often appeared in Tiffany's designs, Japanese aesthetics and philosophies, including a focus on the natural world and the persistent pursuit of the beautiful in all things, played a strong role in nearly all of the designer's work. In his stained glass, such as his 1893 masterpiece *Parakeets and Gold Fish Bowl*, Tiffany's debt to Japanese prints can be seen in the bold outlines (here, composed of lead came) and close-up, cropped, and asymmetrical composition (fig. 248). Although the subject matter of the *Parakeets* window is not overtly Japanese, the composition, as well as the treatment of colors and materials, derive from the designer's study of Japanese art.[50]

By the late 1880s and early 1890s, as Japanese art became increasingly available at public exhibitions here and abroad, painters and printmakers like Mary Cassatt grew more sophisticated in utilizing the tenets of Japanese prints in their compositions. After settling in France by 1865, Cassatt, who never traveled to Japan, was captivated by her visit to an exhibition of Japanese prints in Paris in 1889.[51] Like many American and European artists, including La

246
Charles Caryl Coleman
American, 1840–1928
Still Life with Azaleas and Apple Blossoms, 1878
Oil on canvas
180.3 x 62.9 cm (71 x 24¾ in.)

247
John La Farge
American, 1835–1910
The Fish (or *The Fish and
Flowering Branch*), about 1890
Glass, lead
66.7 x 67.3 cm (26 ¼ x 26 ½ in.)

248
Designed by Louis Comfort Tiffany
American, 1848–1933
Manufactured by Tiffany Glass
and Decorating Company
Parakeets and Gold Fish Bowl,
about 1893
Glass, lead, bronze chain
195.6 x 97.8 cm (77 x 38 ½ in.)

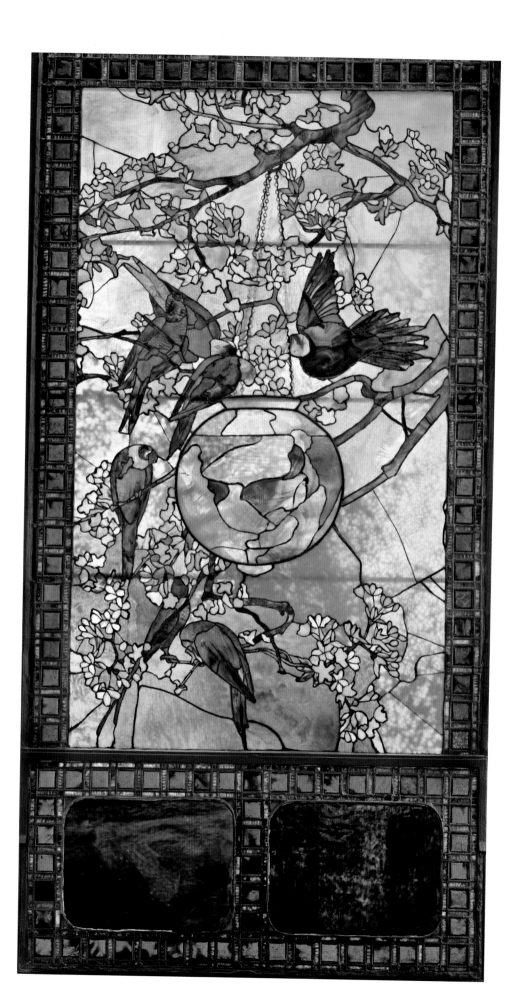

249
Designed by Greene and Greene
Bench for the Robert R. Blacker
House
Pasadena, California, 1907
Mahogany, ebony
H. 52.1 cm (H. 20½ in.)

Farge, Whistler, Wright, and Tiffany, she collected Japanese prints as a source for her own compositions. One of her colored aquatints, *The Coiffure* (fig. 250), closely resembles a print by Utamaro that Cassatt owned. As was true for many of the Japanese prints, those that Cassatt knew and acquired in the early 1890s had faded over time. Patterns that otherwise would have been visible appeared on images that were exposed to light for too long as pale, flat areas of color, which Cassatt and other artists emulated. In *The Coiffure*, Cassatt depicts a woman bending over to adjust her hair after bathing. The pose exposes the nape, which was considered highly sensual in the Japanese culture that consumed ukiyo-e prints. The woman's bare torso, visible in the reflection of the rectangular mirror, recalls Utamaro's pose of a robed woman with her nape featured near the center of the composition (fig. 251). Cassatt translates the hand mirror the woman holds to inspect her tightly wrapped hairstyle as a large rectangular mirror. The striped pattern of the blinds in Utamaro's print may have inspired Cassatt's familiar use of striped fabric on the upholstered chair, and the overall floral pattern of the woman's kimono—although pale in the impression that Cassatt owned—may have prompted her liberal use of a foliate pattern on the rug and wall-

paper that surround the model. Cassatt remained abroad until her death in 1926, yet her prints, and especially her series of color aquatints of 1890–91, continued to inspire American artists well into the twentieth century.[52]

While American artists were rapidly assimilating the tenets of Japanese woodblock prints and other crafts in a variety of media, American proponents of the Arts and Crafts movement found a wealth of inspiration in Japanese aesthetics and traditional Japanese life. The nostalgic Western image of preindustrial Japan, created both by wistful Westerners and the Japanese themselves, epitomized Arts and Crafts ideals: the complete integration of art and life by a culture that valued skilled craftsmanship, integrity, and virtue. Japanese art figured prominently in the wide range of styles inspired by Arts and Crafts philosophies, including the work of Charles and Henry Greene in California and Frank Lloyd Wright in the Midwest. The Greene brothers had been exposed to Japanese art and architecture, as well as the fledging Arts and Crafts movement, during their five years of studying and working in Boston from 1888 to 1893. Wright credited Japanese woodblock prints, which he actively collected for himself and others, for teaching him the virtues of geometric structure, drama through simplicity, and a unified whole—in essence, the seeds of modernism.[53] The influence of Japanese art and architecture can be seen in aspects of Wright's buildings—long, low rooflines; deep, overhanging eaves; open floor plans; and unified interiors in a muted color palette inspired by the surrounding landscape. In like manner, the furniture designed by the American architects drew on Japanese motifs and ideas to project a refined, yet informal elegance and sophistication. Greene and Greene's piano bench for the Robert R. Blacker House incorporates soft edges, superb craftsmanship, and rounded knee brackets that imitate post-and-column construction seen in Japanese temple architecture (fig. 249). Wright, following the Japanese credo of simplicity, stripped his forms down to their basic elements, creating a strikingly modern look (see fig. 99).

250
Mary Stevenson Cassatt
American, 1844–1926
The Coiffure, about 1891
Drypoint and color aquatint
on paper
36.5 x 26.2 cm (14 3/8 x 10 5/16 in.)

251
Kitagawa Utamaro
Japanese, died 1806
Takashima Ohisa, about 1795
Woodblock print; ink and color
on paper
36.3 x 25 cm (14 5/16 x 9 13/16 in.)

252
Arthur Wesley Dow
American, 1857–1922
Bend of a River, about 1898
Color woodcut on paper
23 x 6.1 cm (9 ¹/₁₆ x 2 ³/₈ in.)

253
Utagawa Hiroshige
Japanese, 1797–1858
Nihon Embankment, Yoshiwara, 1857,
from the series *One Hundred Famous
Views of Edo*
Woodblock print; ink and color on paper
33.5 x 21.8 cm (13 ³/₁₆ x 8 ⁹/₁₆ in.)

Arthur Wesley Dow, another artist enamored with Japanese art, also profoundly influenced the direction of American art and the Arts and Crafts movement during the late nineteenth and early twentieth centuries. Under the tutelage of Ernest Fenollosa, a curator at the Museum of Fine Arts, Boston, Dow began to study the Japanese print collection at the Museum in 1891.[54] In their conversations, the two men developed a new approach for teaching art, which combined ideologies from the East and the West. They called this new process synthesism.[55] Synthesism used the underlying principles of Japanese art—the basic elements of line, color, tone, and interplay of light and dark—to build a cohesive and unified composition. Dow began to apply these ideas to his paintings and soon experimented with woodblock prints. In his sliver of a composition, *Bend of a River* (fig. 252), he delicately balances a slender flowering tree against the dark and light shapes formed by earth and water. Dow later acknowledged that his landscapes were indebted to his early exposure to Hokusai's *Manga* (a term variously translated into English as "random sketches," "cartoons," "sketches from life," and "drawing things just as they come"). The spirit of his composition closely resembles the curving elements of land and river in Utagawa Hiroshige's brilliant woodblock print *Nihon Embankment, Yoshiwara* (fig. 253),[56] a print that Dow may well have known when he embarked on creating similar scenes inspired by the scenery of his native Ipswich in Massachusetts.

Dow's ideas on art education, which were derived largely from his studies of Japanese art, applied not only to paintings and prints but also to a wide range of the arts, including photography, woodworking, metalworking, and ceramics. He was not concerned with the distinctions between fine art, decorative arts, and photography, but, rather, according to his student Georgia O'Keeffe, he "had one dominating idea: to fill a space in a beautiful way—and that interested him."[57] Dow disseminated these ideas in lectures and courses at the Pratt Institute (1895–1903), the Art Students League (1898–1903), Columbia's Teachers College (1904–22), and his own Ipswich Summer School of Art (1891–1907), as well as in his publications

Composition: A Series of Exercises in Art Structure for the Use of Students and Teachers (1899) and *The Theory and Practice of Teaching Art* (1912). Through these many venues, Dow's Japanese-infused teachings influenced generations of American artists, designers, and craftspeople.[58]

Some of Dow's students would later leave their distinct mark on early modernist art in the United States, including the painter O'Keeffe and the photographer Alvin Langdon Coburn. Coburn studied with Dow at the Ipswich Summer School and credited his teacher with his appreciation of Asian qualities, observing: "I learnt many things at this school, not the least an appreciation of what the Orient has to offer in terms of simplicity and directness in com-

254
Alvin Langdon Coburn
American, 1882–1966
The Dome of Saint Paul's,
photogravure from *The Novels and Tales of Henry James V: The Princess Casamassima I*, 1922
Book illustrated with one photogravure by Coburn
Image: 10.1 x 8.8 cm (4 x 3⁷⁄₁₆ in.)

255
Jackson Pollock
American, 1912–1956
Number 10, 1949
Oil, enamel, and aluminum paint
on canvas mounted on panel
46 x 272.4 cm (18⅛ x 107¼ in.)

position."[59] Coburn cropped his image of a London bridge with the dome of Saint Paul's Cathedral in the distance to allow the arched form of the dark bridge to appear high against the horizon, bracketing toned areas of water and shoreline that created curves like those seen in Dow's and Hiroshige's landscapes (fig. 254).

By the mid-twentieth century, new generations of American and European artists seeking to move beyond representation into various modes of abstraction were again drawn to both the formal and the spiritual qualities of Asian art as viable alternatives to Western traditions. During the 1950s, this global interest in Asian art and culture inspired artistic communities ranging from New York to Paris, Munich, and the Netherlands to explore a range of Asian philosophies, particularly Zen Buddhism.[60] One of the most influential scholars of Asian philosophy in the United States during the first half of the twentieth century was Daisetz T. Suzuki, who, starting in 1921, published an English-language magazine, *The Eastern Buddhist*, and lectured widely. In attempting to define Asian philosophy for a Western audience, Suzuki inevitably resorted to classifying binary opposites and their rela-

tive characteristics, which offer insight into the various ways American artists understood Asian culture. For Suzuki, characteristic qualities of the East were "deductive, synthetic, nondiscriminatory, and intuitive"; by comparison, he wrote, the West could be more typically described as "analytic, differential, inductive, individualistic, and scientific."[61] Suzuki's explanations pointed to new methods of art making that emphasized the process rather than the final product, incorporating the aesthetics of spontaneity, responsiveness, and bodily gesture and the unconscious dialogue between body and mind.[62]

An emphasis on being one with the here and now, contact with the physical world and nature, and the practice of Zen calligraphy were particularly important for American Abstract Expressionist artists, whether or not they chose to acknowledge their debt to Zen or Asian art. Mark Tobey succinctly summarized the relation between Eastern and Western art as a fundamental dichotomy: "Eastern artists have been more concerned with line and in the West with mass."[63] The gestural nature of Asian calligraphy was seen to embody an artist's personal creative energy and yet to connect with a universal sense of beauty.

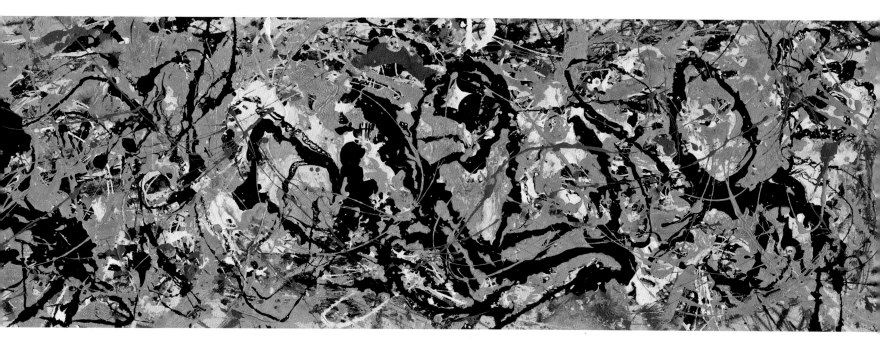

It is in this context that artists like Franz Kline traced boldly gestural black brushstrokes on white canvas, suggesting Asian calligraphy writ large, even though Kline vociferously denied any connection between his work and Asian antecedents.[64]

Jackson Pollock, however, readily acknowledged the Asian origins of his process of painting, or pouring, on canvas that was placed horizontally, noting, "I paint on the floor and this isn't unusual—the Orientals did that."[65] In *Number 10*, Pollock's loops of black paint create lyrical swirls that stretch across the long, narrow canvas (fig. 255). On top of the black paint, Pollock added curls of gray and dabs of white to create multiple skeins that both retain their own planes, distinct from the canvas support, and merge into a monochromatic field. Pollock's line is ultimately freed from delineating form and evokes the spontaneity and happenstance of execution, as in the Chinese *p'o mo* (splash ink) technique of painting.[66]

Zen Buddhism influenced pottery as well as painting during the mid-twentieth century. The Zen pottery aesthetic, rooted in the traditional Japanese tea ceremony, values imperfections, idiosyncrasies, and happy accidents that reveal the hand of the maker.

Peter Voulkos was inspired to explore Japanese Buddhist aesthetics by Bernard Leach, a Hong Kong–born British potter who studied in Japan for eleven years. In 1952 Leach, Hamada Shoji, and Yanagi Soetsu (both well-regarded Japanese potters) toured the United States, hoping to reawaken interest in craft pottery. Voulkos met the trio in Montana and in the fall of 1955, after several years of study and exposure to Zen Buddhist philosophy and aesthetics, began to create his own interpretations. Voulkos's large-scale works, such as *Camelback Mountain*, required great strength, agility, and bodily involvement, a spontaneous dance involving both the clay and the potter (fig. 256). He stacked, slashed, pounded, and molded the clay, emphasizing spontaneity and imperfection.[67]

Building on the interest in Zen throughout the middle decades of the century, Brice Marden sought a new direction in his work during the 1980s, when he was facing what he would later describe as a midlife crisis. Marden's visit to Asia in December 1984 inspired a radical shift in his artistic vision. He was moved by the landscape, the appreciation for nature, and the manner in which artists sought to

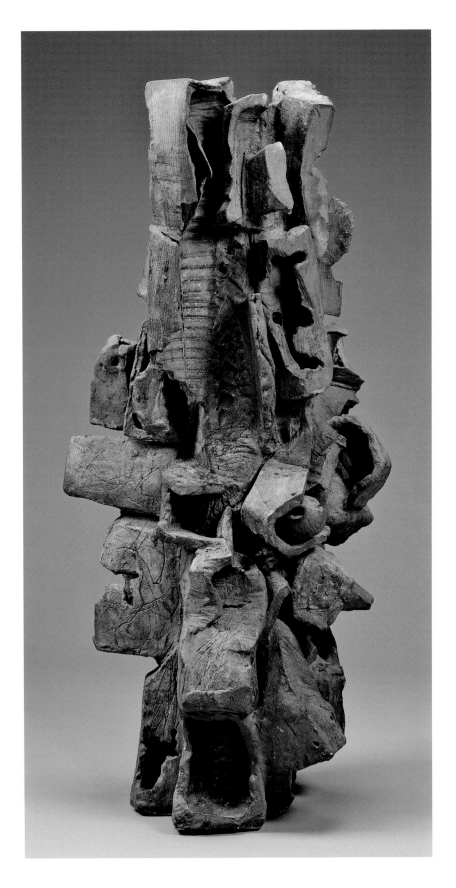

represent forms and scenery found in the natural world according to various ideals that had been refined over many centuries. Marden was especially drawn to the work of one of the greatest Chinese poets, Du Fu (about 712–770), known to him through translations by the American Ezra Pound, as well as later translations by the American poet Kenneth Rexroth.[68] Marden's appreciation of Asian calligraphy, his understanding of Zen Buddhism, his knowledge of Asian poetry in translation, and his travels in Asia all contributed to his perspective on Asian art, which appeared in his work beginning in the mid-1980s.

Ignited by his 1984 Asian sojourn, which followed directly upon his experience of seeing an exhibition of Japanese calligraphy in New York, Marden began a series of drawings based on seashells spotted at a museum in Thailand.[69] Layering strokes of the stylus and brush, he developed these sketches into a portfolio of prints he called *Etchings to Rexroth*, illustrations inspired by *Thirty-six Poems by Tu Fu*, translated by Kenneth Rexroth (fig. 257). Whether creating a drawing, applying a stylus or brush to an etching plate, or using a longer stick to render calligraphic paintings that are closely related to the *Etchings to Rexroth* portfolio, Marden believed he was able to tap into the creative force that he felt was present in Chinese or Japanese scroll paintings. For Marden, the meditative state of mind was essential, comparable to the higher consciousness that followers of Buddhism achieved through meditation. As a self-professed amateur with a deep passion for Chinese

256
Peter Voulkos
American, 1924–2002
Camelback Mountain, 1959
Stoneware
H. 115.6 cm (H. 45½ in.)

calligraphy, Marden drew on the long tradition of Asian art in a way that allowed him to express his distinctive strain of abstraction, which further extended the earlier work of Pollock in new and meaningful ways.

For artists in the Americas, the materials and artistry of Asia, particularly those associated with China and Japan, have had a lasting influence. During the age of exploration in the seventeenth and eighteenth centuries, the North and South American colonies responded to Asian styles in different ways. In South America, where immigrants from Asia settled, artistic styles were woven into the fabric of existing traditions. In the North American colonies, Asia was largely a source of luxury goods highly coveted by the newly arrived immigrants in an effort to assert their status. This trend continued in the United States well into the later nineteenth century with the rage for all things Japanese, whether authentic or crafted for American consumption. Following the atomic devastation of Hiroshima and Nagasaki in World War II, artists working in the United States were encouraged by creative insights that East Asian culture and philosophy, particularly Zen Buddhism, offered, a vivid and rich counterpoint to Western traditions of representation and craftsmanship. The force of the Asian markets continues to affect our world economy today and, with it, offers the power to shape the aesthetic destiny of the Americas.

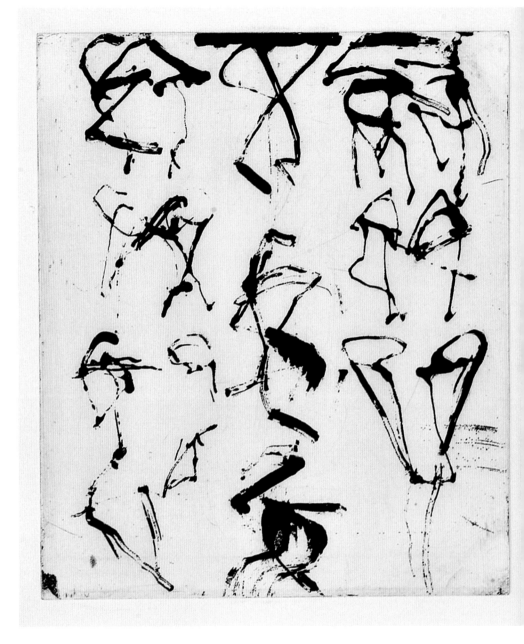

257
Brice Marden
American, born in 1938
Plate 5 from *Etchings to Rexroth*
(25 illustrations inspired by
Thirty-six Poems by Tu Fu, translated
by Kenneth Rexroth), 1986
Etchings with sugar-lift aquatint on paper
20.3 x 17.5 cm (8 x 6⅞ in.)

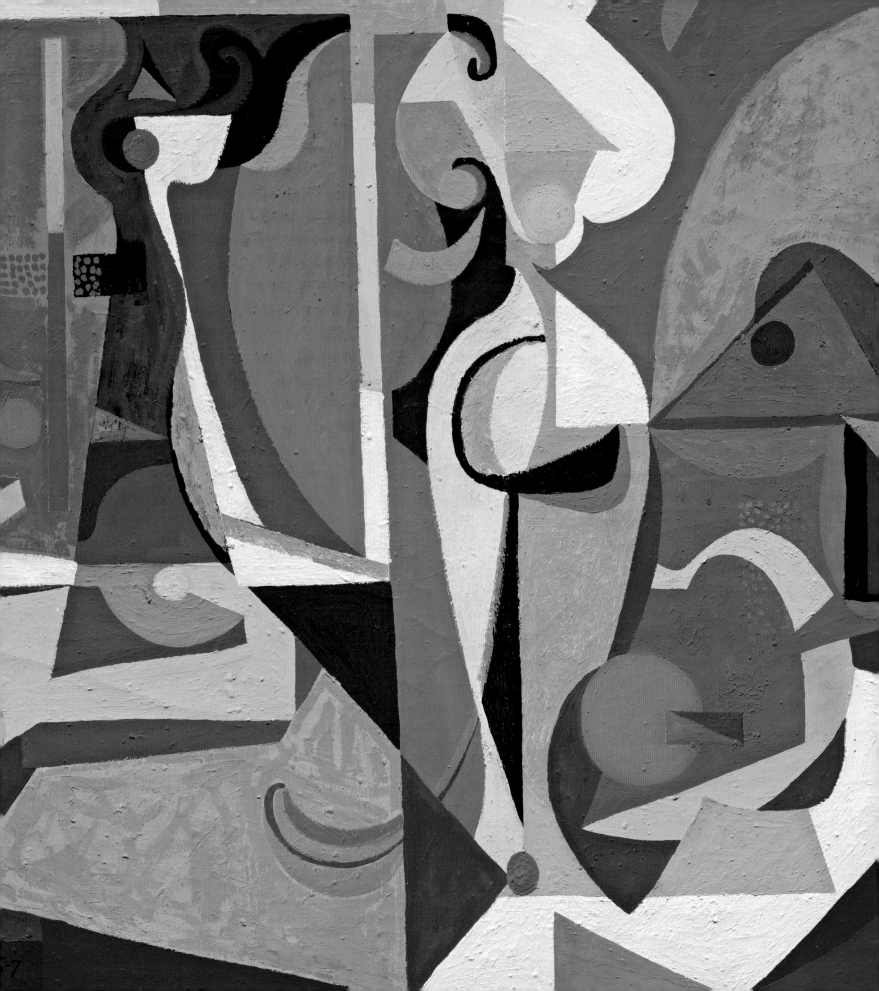

NOTES

NOTE TO THE READER

Images of objects in the collections of the Museum of Fine Arts, Boston, may be found on the "Collections" page of the MFA Web site at http://www.mfa.org/collections by entering the accession number in the "Advanced Search."

A New World Imagined: Artistic Innovation and Inspiration in the Americas

1. The notion of cultural encounter has been treated at length in Angela L. Miller et al., *American Encounters: Art, History, and Cultural Identity* (Upper Saddle River, N.J.: Prentice-Hall, 2007).

2. Quoted in Stephen Greenblatt, "Resonance and Wonder," in *Exhibiting Cultures: The Poetics and Politics of Museum Display*, ed. Ivan Karp and Steven D. Levine (Washington, D.C.: Smithsonian Institution Press, 1991), 52. On Dürer's travels in Belgium, see Jane Campbell Huchison, *Albrecht Dürer: A Biography* (Princeton: Princeton University Press, 1990), 141.

3. On folk art at the MFA, see Gerald W. R. Ward et al., *American Folk: Folk Art from the Collection of the Museum of Fine Arts, Boston*, exh. cat. (Boston: MFA Publications, 2001).

4. I am grateful to Dennis Carr and Heather Hole, assistant curators, Art of the Americas, for bringing this map to our attention in the context of this publication.

5. Richard H. Saunders, "The Portrait in America, 1700–1750," in *American Colonial Portraits, 1700–1776*, exh. cat. (Washington, D.C.: National Portrait Gallery, 1987), 9.

6. See, among others, Kathryn Greenthal, Paula M. Kozol, and Jan Seidler Ramirez, with an introductory essay by Jonathan L. Fairbanks, *American Figurative Sculpture in the Museum of Fine Arts* (Boston: Museum of Fine Arts, 1986); Carol Troyen and Pamela S. Tabbaa, *The Great Boston Collectors: Paintings from the Museum of Fine Arts*, exh. cat. (Boston: Museum of Fine Arts, 1984); Erica E. Hirshler, *Impressionism Abroad: Boston and French Painting*, exh. cat. (London: Royal Academy Books, 2005); Frederic A. Sharf, *Art of Collecting: The Spaulding Brothers and Their Legacy* (Boston: MFA Publications, 2007); and Anne Nishimura Morse, *The William S. and John T. Spaulding Collection at the Museum of Fine Arts, Boston*, exh. cat. (Tokyo: Shogakukan, 2009).

NATIVE PEOPLES OF THE AMERICAS
Ancient Cultures, Modern Connections

1. These comments are from the foreword—signed by Eleanor Roosevelt—to Frederic H. Douglas and Rene d'Harnoncourt, *Indian Art of the United States*, exh. cat.

(New York: Museum of Modern Art, 1941), 8. Such remarks reflected a Pan-Americanism characteristic of the Roosevelt-era politics of the 1930s and 1940s; see Barbara Braun, *Pre-Columbian Art and the Post-Columbian World: Ancient American Sources of Modern Art* (New York: Harry N. Abrams, 1993), 42.

2. Virginia M. Fields and Victor Zamudio-Taylor, *The Road to Aztlan: Art from a Mythic Homeland*, exh. cat. (Los Angeles: Los Angeles County Museum of Art, 2001).

3. Paul Chaat Smith, *Everything You Know about Indians Is Wrong* (Minneapolis: University of Minnesota Press, 2009), 10.

4. Alfred W. Crosby, Jr., *The Columbian Exchange: Biological and Cultural Consequences of 1492* (Westport, Conn.: Greenwood Press, 1972); and Herman J. Viola and Carolyn Margolis, eds., *Seeds of Change: Five Hundred Years since Columbus*, exh. cat. (Washington, D.C.: Smithsonian Institution Press, 1991). For an update on one of the most significant foodstuffs, see Louis Evan Grivetti and Howard-Yana Shapiro, eds., *Chocolate: History, Culture, Heritage* (Hoboken, N.J.: John Wiley and Sons, 2009).

5. Daniel K. Richter, *Facing East from Indian Country: A Native History of Early America* (Cambridge, Mass.: Harvard University Press, 2001).

6. Braun, *Pre-Columbian Art*, esp. 39–43.

7. For the contours of this transition, see Shepard Krech III and Barbara A. Hail, eds., *Collecting Native America, 1870–1960* (Washington, D.C.: Smithsonian Institution Press, 1999).

8. Smith, *Everything You Know*, 10.

The Americas' First Art

1. Karl Taube, "The Teotihuacan Cave of Origin," *RES* 12 (1986): 51–82.

2. Doris Heyden, "Caves, Gods, and Myths: World-View and Planning in Teotihuacan," in *Mesoamerican Sites and World-Views*, ed. Elizabeth Benson (Washington, D.C.: Dumbarton Oaks Research Library and Collections, 1981), 1–35.

3. Annabeth Headrick, *The Teotihuacan Trinity: The Sociopolitical Structure of an Ancient Mesoamerican City* (Austin: University of Texas Press, 2007), 90–102.

4. David Stuart, "The Arrival of Strangers: Teotihuacan and Tollan in Classic Maya History," in *Mesoamerica's Classic Heritage: From Teotihuacan to the Aztecs* (Boulder: University of Colorado Press, 2000), 465–513.

5. Elizabeth P. Benson, ed., *The Cult of the Feline: A Conference in Pre-Columbian Iconography* (Washington, D.C.: Dumbarton Oaks, Trustees for Harvard University, 1968).

6. Peter Furst, "The Olmec Were-Jaguar Motif in the Light of Ethnographic Reality," *Dumbarton Oaks Conference on the Olmec* (Washington, D.C.: Dumbarton Oaks, Trustees for Harvard University, 1968), 143–74.

7. Rebecca Stone-Miller, *Seeing with New Eyes: Highlights of the Michael C. Carlos Museum Collection of Art of the Ancient Americas*, exh. cat. (Atlanta: Michael C. Carlos Museum, Emory University, 2002), 133–40. Michael J. Snarskis, "The Imagery and Symbolism of Precolumbian Jade in Costa Rica," in *Jade in Ancient Costa Rica*, ed. Julie Jones, exh. cat. (New York: Metropolitan Museum of Art, 1998), 61–62.

8. Peter Furst, "Shamanism, Transformation, and Olmec Art," in *The Olmec World: Ritual and Rulership*, by Michael D. Coe et al., exh. cat. (Princeton: Art Museum, Princeton University, 1995), 69–81. Also see Kent Reilly and Carolyn Tate, "The Shamanic Landscape and Journey," ibid., 163–95, 303.

9. Santiago Londoñoz Vélez, "Tairona," in *The Art of Gold: The Legacy of Pre-Hispanic Colombia*, by Clara Isabel Botero, Roberto Lleras Pérez, Santiago Londoñoz Vélez, and Efraín Sánchez Cabra, exh. cat. (Bogotá: Fondo de Cultura Económica, Banco de la República, 2007), 184–203.

10. Botero, Lleras Pérez, Londoñoz Vélez, and Sánchez Cabra, *Art of Gold*. Richard G. Cooke and Warwick Bray, "The Goldwork of Panama: An Iconographic and Chronological Perspective," in *The Art of Precolumbian Gold: The Jan Mitchell Collection* (Boston: Little, Brown, 1985), 35–45. Michael J. Snarskis, "Symbolism of Gold in Costa Rica and Its Archaeological Perspective," ibid., 23–33.

11. Joel W. Grossman, "An Ancient Gold Worker's Tool Kit," *Archaeology* 25, no. 4 (1972): 270–75.

12. Warwick Bray, "Across the Darien Gap: A Colombian View of Isthmian Archaeology," in *The Archaeology of Lower Central America*, ed. Frederick W. Lange and Doris Z. Stone (Albuquerque: University of New Mexico Press, for School of American Research, 1984), 323–26. Also see Ana María Falchetti, "The Gold of Greater Zenú: Prehispanic Metallurgy in the Caribbean Lowlands of Colombia," in *Precolumbian Gold: Technology, Style and Iconography*, ed. Colin McEwan (Chicago: Fitzroy Dearborn Publishers; London: Trustees of the British Museum, 2000), 133.

13. André Emmerich, *Sweat of the Sun, Tears of the Moon* (Seattle: University of Washington Press, 1965).

14. Santiago Londoñoz Vélez, "Symbolism and Aesthetics in the Ancient Metalwork of Colombia," in *Art of Gold*, by Botero, Lleras Pérez, Londoñoz Vélez, and Sánchez Cabra, 26–27. Also see "Muisca," ibid., 205.

15. Richard Cooke, Luís Alberto Sánchez Herrera, and Koichi Udagawa, "Contextualized Goldwork from 'Gran

Coclé,' Panama," in *Precolumbian Gold*, ed. McEwan, 156.

16. Warwick Bray, "Sitio Conté Metalwork in Its Pan-American Context," in *River of Gold: Precolumbian Treasures from Sitio Conte*, ed. Pamela Hearne and Robert J. Sharer (Philadelphia: University of Pennsylvania Museum of Archaeology and Anthropology, 1992), 34–35.

17. See MFA 22.284.

18. Dorothy Hosler, Heather Lechtman, and Olaf Holm, *Axe-Monies and Their Relatives* (Washington, D.C.: Dumbarton Oaks Research Library and Collection, 1990), 2.

19. See MFA 22.284 and Alfonso Caso, "Lapidary Work, Goldwork, and Copperwork from Oaxaca," in *Handbook of Middle American Indians*, vol. 3, pt. 2 (Austin: University of Texas Press, 1973), 915–16.

20. Jadeite, a relatively rare pyroxene mineral found in Mexico and Guatemala, is related to albite, serpentinite, and chloromelanite. Jade, on the other hand, is a calcium-magnesium amphibole mineral and is found primarily in Asia. See Cornelius Klein and Cornelius S. Hurlbut, Jr., *Manual of Mineralogy*, 20th ed. (New York: John Wiley and Sons, 1985), 404, 415–16, 516.

21. Carolyn Tate, "Art in Olmec Culture," in Coe et al., *Olmec World*, 49–50.

22. Linda Schele and David Freidel, *A Forest of Kings: The Untold Story of the Ancient Maya* (New York: William Morrow, 1990), 87–95. Also see David Freidel, Linda Schele, and Joy Parker, *Maya Cosmos: Three Thousand Years on the Shaman's Path* (New York: William Morrow, 1993).

23. F. Kent Reilly, "Art, Ritual, and Rulership in the Olmec World," in Coe et al., *Olmec World*, 27, 38–40. Also see Virginia M. Fields and Dorie Reents-Budet, *Lords of Creation: The Origins of Sacred Maya Kingship*, exh. cat. (Los Angeles: Los Angeles County Museum of Art; London: Scala Publishers, 2005).

24. See MFA 1982.763.

25. F. Kent Reilly, "The Olmec Dragon," in Coe et al., *Olmec World*, 209.

26. Virginia M. Fields and Dorie Reents-Budet, "The Origins of Divine Kings and the First Ajawo'ob," in *Lords of Creation*, 99.

27. See MFA 1988.1249.

28. Dorie Reents-Budet and Virginia Fields, "Historical Implications of the Jade Trade between the Maya Lowlands and Costa Rica during the Early Classic Period," in *The World of Jade* (Bombay, India: Marg Publications, 1992), 81–82.

29. See MFA 1972.945.

30. Mark Miller Graham, "Mesoamerican Jade and Costa Rica," in Jones, *Jade in Ancient Costa Rica*, 42–50.

31. Michael Snarskis, "The Lower Caribbean," in Lange and Stone, *Archaeology of Lower Central America*, 216–17.

32. Matthew G. Looper, Dorie Reents-Budet, and Ronald L. Bishop, "Dance on Classic Maya Ceramics," in *To Be Like Gods: Dance in Ancient Maya Civilization* (Austin: University of Texas Press, 2009), 116.

33. Susan Niles, "Artist and Empire in Inca and Colonial Textiles," in *To Weave for the Sun: Andean Textiles in the Museum of Fine Arts, Boston*, by Rebecca Stone-Miller, exh. cat. (Boston: Museum of Fine Arts, 1992), 51–53. Dorie

Reents-Budet, "Power Material in Ancient Mesoamerica: The Roles of Cloth among the Classic Maya," in *Wrapping Traditions in Ancient Mesoamerica: Ritual Acts of Wrapping and Binding in Mesoamerica* (Washington, D.C.: Center for Ancient American Studies, 2007), 105–26. Rebecca Stone-Miller, "To Weave for the Sun: An Introduction to the Fiber Arts of the Ancient Andes," in *To Weave for the Sun*, 11.

34. Guaman Poma, *El primer nueva crónica y buen gobierno*, ca. 1615, ed. John V. Murra y Rolena Adorno, 3 vols. (Mexico City: Siglo XXI Editores, 1980), 1:226. Stone-Miller, *To Weave for the Sun*, 172.

35. Anne Paul and Solveig A. Turpin, "The Ecstatic Shaman Theme of Paracas Textiles," *Archaeology* 39 (1986): 20–27.

36. Stone-Miller, *To Weave for the Sun*, 186.

37. Esther Pasztory, "The Major Monuments of Tenochtitlán," in *Aztec Art* (New York: Harry N. Abrams, 1983), 167. Also see Emily G. Umberger, *Aztec Sculptures, Hieroglyphs and History* (Ann Arbor, Mich.: University Microfilms, 1981), 172–92.

38. Herbert J. Spinden, *A Study of Maya Art: Its Subject Matter and Historical Development; Memoirs of the Peabody Museum of American Archaeology and Ethnology, Harvard University*, vol. 6 (Cambridge, Mass.: Peabody Museum, 1913; repr., New York: Dover Publications, 1975), 15.

39. Roger Fry, *Vision and Design* (London: Chatto and Windus, 1925), 107.

40. Ibid., 104.

41. César Paternosto, *The Stone and the Thread: Andean Roots of Abstract Art*, trans. Esther Allen (Austin: University of Texas Press, 1996), 235.

42. Marjorie Agosin, *A Woman's Gaze: Latin American Women Artists* (Fredonia, N.Y.: White Pine Press, 1998), 61.

43. Quoted ibid., 57.

Native North American Art

1. Brian M. Fagan, in *Ancient North America: The Archaeology of a Continent*, 3rd ed. (New York: Thames and Hudson, 2000), provides a survey of the subject. Many of the points made in this essay are addressed in Edwin L. Wade, ed., *The Arts of the North American Indian: Native Traditions in Evolution* (New York: Hudson Hills Press, in association with Philbrook Art Center, Tulsa, 1986), and in Mary Louise Krumrine and Susan Clare Scott, eds., *Art and the Native American: Perception, Reality, and Influences* (University Park: Department of Art History, Pennsylvania State University, 2001).

2. See MFA 1993.666.

3. J. J. Brody, Catherine J. Scott, and Steven A. LeBlanc, *Mimbres Pottery: Ancient Art of the American Southwest*, exh. cat. (New York: Hudson Hills Press, in association with the American Federation of Arts, 1993).

4. For a synthesis of the Iroquois origin myth, see Dean R. Snow, *The Iroquois* (Cambridge, Mass.: Blackwell, 1994). We are grateful to Michael Suing for providing this reference.

5. See MFA 1997.9.

6. For a detailed formal analysis of form-line decoration, see Bill Holm, *Northwest Coast Indian Art: An Analysis of Form* (Seattle: University of Washington Press, 1965).

7. Fagan, *Ancient North America*, 31–35. For more detailed overviews, see Robert Silverberg, *Mound Builders of Ancient America: The Archaeology of a Myth* (Greenwich, Conn.: New York Graphic Society, 1968); and Roger G. Kennedy, *Hidden Cities: The Discovery and Loss of Ancient North American Civilization* (New York: Free Press, 1994). For a discussion of an ambitious city created by these ancient peoples, see Timothy R. Pauketat, *Cahokia: Ancient America's Great City on the Mississippi* (New York: Viking, 2009).

8. Jonathan Batkin, in *The Native American Curio Trade in New Mexico* (Santa Fe: Wheelwright Museum of the American Indian, 2008), thoroughly documents this trade in one region. See also Ruth B. Phillips, *Trading Identities: The Souvenir in Native North American Art from the Northeast, 1700–1900* (Seattle: University of Washington Press; Montreal: McGill-Queen's University Press, 1998).

9. Phillips, *Trading Identities*.

10. Sarah Peabody Turnbaugh and William A. Turnbaugh, *Indian Baskets* (West Chester, Pa.: Schiffer Publishing, in collaboration with the Peabody Museum of Archaeology and Ethnology, Harvard University, 1986), 114. For the basket, see MFA 1989.80.

11. See Ruth Holmes Whitehead, *Micmac Quillwork: Micmac Indian Techniques of Porcupine Quill Decoration, 1600–1950* (Halifax: Nova Scotia Museum, 1982), for a thorough discussion of the genre and illustrations of related examples.

12. Kate Peck Kent, in *Navajo Weaving: Three Centuries of Change* (Santa Fe: School of American Research Press, 1985), presents a lucid history of the long-term developments in this field. For a Diné textile reflecting this Hopi influence in its design, see MFA 12.1084.

13. Kent, in *Navajo Weaving*, 107, notes that "weaving may almost be regarded as a model of the dynamics of the Navajos' acculturation."

14. John Adair, *The Navajo and Pueblo Silversmiths* (Norman: University of Oklahoma Press, 1944), remains an excellent overview of the craft. The wide range of Diné jewelry appears in many publications; for an overview based on a significant collection, see Louise Lincoln, ed., *Southwest Indian Silver from the Doneghy Collection*, exh. cat. (Minneapolis: Minneapolis Institute of Arts; Austin: University of Texas Press, 1982).

15. For the story of this specific symbiotic relationship between traders and potters, see Kim Messier and Pat Messier, *Hopi and Pueblo Tiles: An Illustrated History* (Tucson: Rio Nuevo Press, 2007). See also Laura Graves, *Thomas Varker Keam, Indian Trader* (Norman: University of Oklahoma Press, 1998).

16. See Sarah E. Boehme et al., *Powerful Images: Portrayals of Native America*, exh. cat. (Seattle: Museums West, in association with University of Washington Press, 1998). See also Elizabeth Cromley, "Masculine/Indian," *Winterthur Portfolio* 31, no. 4 (Spring 1996): 265–80, in which the author categorizes early images of Indians into three main groups: warlike, timeless, and natural.

17. David C. Hunt, et al, *Karl Bodmer's America*, exh. cat. (Omaha: Joslyn Art Museum and University of Nebraska Press, 1984), 308–9.

18. Hugh Honour, *The New Golden Land: European Images of America from the Discoveries to the Present Time* (New York: Pantheon Books, 1975). For John White, see Kim

Sloan et al., *A New World: England's First View of America* (Chapel Hill: University of North Carolina Press, 2007).

19. See Jean-Jacques Rousseau, *Discourse on the Origin of Inequality* (1754), trans. Donald A. Cress (Indianapolis: Hackett Publishing Company, 1992); James Fenimore Cooper, *The Last of the Mohicans: A Narrative of 1757* (1826; repr., Albany: State University of New York Press, 1983); Washington Irving, "Traits of Indian Character" (1820), in *The Works of Washington Irving* (New York: P. F. Collier, 1885), 72–75. For Birch's painting, see MFA 47.1179.

20. Patricia Anderson, *The Course of Empire: The Erie Canal and the New York Landscape, 1825–1875*, exh. cat. (Rochester, N.Y.: Memorial Art Gallery of the University of Rochester, 1984), 48.

21. For the lodge symbol, see MFA 69.1362; for the coins, see MFA 2004.1089.

22. Rell G. Francis, in *Cyrus E. Dallin: Let Justice Be Done* (Springville, Utah: Springville Museum of Art, in cooperation with the Utah American Revolution Bicentennial Commission, 1976), provides a rounded look at the sculptor's work; chapter 3 examines Dallin's "Epic of the Indian," and the *Appeal* is discussed specifically on 44–50. See also Kathryn Greenthal, Paula M. Kozol, and Jan Seidler Ramirez, with an introductory essay by Jonathan L. Fairbanks, *American Figurative Sculpture in the Museum of Fine Arts, Boston* (Boston: Museum of Fine Arts, 1986), cat. no. 90; and Jonathan L. Fairbanks, *Becoming a Nation: Americana from the Diplomatic Reception Rooms, U.S. Department of State*, exh. cat. (New York: Rizzoli, 2003), cat. no. 134 (entry by Wayne Craven).

23. Examples from Rookwood and Clifton are compared in Wendy Kaplan et al., *"The Art That Is Life": The Arts and Crafts Movement in America, 1875–1920*, exh. cat. (Boston: Museum of Fine Arts, 1987), cat. nos. 55, 56. For Clifton, see Paul Evans, *Art Pottery of the United States* (New York: Feingold and Lewis, 1987), 60–62. See also Anita J. Ellis, *Rookwood Pottery: The Glorious Gamble*, exh. cat. (New York: Rizzoli and Cincinnati Art Museum, 1992), 19–20, 80–83; and Anita J. Ellis and Susan Labry Meyn, *Rookwood and the American Indian: Masterpieces of American Art Pottery from the James J. Gardner Collection*, exh. cat. (Athens: University of Ohio Press, 2007).

24. Wanda Corn, "Marsden Hartley's Native Amerika," in *Marsden Hartley*, ed. Elizabeth Mankin Kornhauser, exh. cat. (New Haven: Yale University Press, in association with Wadsworth Atheneum Museum of Art, 2002), 77.

25. See Sandra Kraskin and Barbara Hollister, *The Indian Space Painters: Native American Sources for American Abstract Art*, exh. cat. (New York: Baruch College Gallery, 1991). See also Joseph Jacobs, "Indian Space Painters," *Art and Antiques* (February 2007): 59–60.

26. Frederic H. Douglas and René d'Harnoncourt, *Indian Art of the United States*, exh. cat. (New York: Museum of Modern Art, 1941).

27. See MFA 2001.890.

28. See Oral History Interview with Peter Busa, September 5, 1965, Archives of American Art, Smithsonian Institution, available online at http://www.aaa.si.edu/collections/oralhistories/transcripts/busa65.htm (accessed March 8, 2010). See also Ned Jalbert, *Peter Busa: Indian Space*, exh. cat. (Boston: Acme Fine Art and Design, 2004).

29. In commenting on a related Slemmons piece, Mija Riedel observed, "The shaved pencils raise the question, 'Who scalped whom?' . . . The Plains Indians wore bones across their chest as a symbolic form of armor; Kiff's breast plate of pencils suggests the power of the written word, of writing as a form of protection. . . . In the context of the U.S. government and the Plains Indians, one might think of broken treaties, and the efforts to erase native Americans and their culture from North America." See Riedel, "Uncommon Means of Measure: The Jewelry of Kiff Slemmons," *Metalsmith* (Summer 1993): 27.

30. Artist's statement in Museum of Fine Arts, Boston, Department of Art of the Americas, American Decorative Arts, object file, 1999.19.

31. Judith Ostrowitz, in *Privileging the Past: Reconstructing History in Northwest Coast Art* (Seattle: University of Washington Press; Vancouver: UBC Press, 1999), examines the difficulties that Native American artists often encounter when they value historicism more than avant-garde modes.

32. Barbara Kramer, *Nampeyo and Her Pottery* (Albuquerque: University of New Mexico Press, 1996). For the Museum's piece (1995.101), see Linda Foss Nichols, *Voice of Mother Earth: The Art of the Puebloan Peoples of the American Southwest*, exh. cat. (Nagoya, Japan: Nagoya Museum of Fine Arts, 2001), cat. no. 72; see also cat. nos. 73, 74.

33. See MFA 1996.241.

34. Susan Peterson, *The Living Tradition of Maria Martinez* (Tokyo: Kodansha International, 1977). See also Foss Nichols, *Voice of Mother Earth*, cat. no. 89.

35. Foss Nichols, *Voice of Mother Earth*, cat. no. 50. For the revival of pottery making as a whole, see Susan Peterson, *Pottery by American Indian Women: The Legacy of Generations*, exh. cat. (New York: Abbeville Press, for the National Museum of Women in the Arts, 1997). For the Native American role in the modern crafts movement, see Ralph T. Coe, "Native American Craft," and Gail Tremblay, "Cultural Survival and Innovation: Native American Aesthetics," in *Revivals! Diverse Traditions: The History of Twentieth-Century American Craft, 1920–1945*, ed. Janet Kardon (New York: Harry N. Abrams, in association with the American Craft Museum, 1994), 65–83. See also Edwin L. Wade, "Straddling the Cultural Fence: The Conflict for Ethnic Artists within Pueblo Societies," in Wade, *Arts of the North American Indian*, 243–54.

36. Garth Clark, *Free Spirit: The New Native American Potter* ('s-Hertogenbosch: SM's-Stedelijk Museum, 2006); and David Revere McFadden and Ellen Napiua Taubman, eds., *Changing Hands: Art without Reservation*, exh. cat. (London: Merrell; New York: American Craft Museum, 2002).

37. For an overview, see Gerhard Hoffman, "Frames of Reference: Native American Art in the Context of Modern and Postmodern Art," in Wade, *Arts of the North American Indian*, 257–82.

38. Jaune Quick-to-See Smith, interview, in *I Stand in the Center of the Good: Interviews with Contemporary Native American Artists*, ed. Lawrence Abbot (Lincoln: University of Nebraska Press, 1994), 223.

39. See National Park Service images at http://www.nps.gov/elmo/photosmultimedia/photos.htm (accessed March 8, 2010).

40. For a painting by Hofmann, see MFA 1973.171.

41. Artist's statement, at http://www.rickrivet.ca (accessed December 19, 2009).

42. Ibid.

43. Fritz Scholder et al., *Fritz Scholder: Indian/Not Indian*, exh. cat. (Washington, D.C.: National Museum of the American Indian, 2008).

44. In Wade, *Arts of the North American Indian*, six principal vantage points are discussed—meaning, tradition, aesthetics, quality, individuality, and controversy—as well as a consideration of the future of Native American art.

45. Edwin L. Wade, "What Is Native American Art?" ibid., 16.

EUROPE AND THE AMERICAS

Transatlantic Passages

1. Henry James to Charles Eliot Norton, February 4, 1872, in *Henry James: Letters*, ed. Leon Edel, vol. 1 (Cambridge, Mass.: Harvard University Press, 1974), 274. I am grateful to Peter Gibian for sharing with me some of his thoughts on American cosmopolitanism.

2. See Patricia Seed, *Ceremonies of Possession in Europe's Conquest of the New World, 1492–1640* (Cambridge: Cambridge University Press, 1995).

3. Henry James to Thomas Sargeant Perry, September 20, 1867, in *Henry James: Letters* 1:77.

4. *Morning Chronicle* (London), May 26, 1772, as quoted in Tim Clayton, "The Role of Prints and Printmakers in the Diffusion of Portraiture," in *Citizens and Kings: Portraits in the Age of Revolution 1760–1830*, by Sébastien Allard et al., exh. cat. (London: Royal Academy of Arts, 2006), 50.

5. Nancy Mowll Mathews, *Mary Cassatt: A Life* (New York: Villard Books, 1994), 217.

6. Barbara A. Wolanin, *Constantino Brumidi: Artist of the Capitol* (Washington, D.C.: United States Capitol, 1998), 94.

7. Serge Guilbaut, *How New York Stole the Idea of Modern Art: Abstract Expressionism, Freedom and the Cold War* (Chicago: University of Chicago Press, 1983).

8. James to Perry, September 20, 1867.

The Classical Tradition

1. Classicism in American art has been addressed in numerous publications. Milo M. Naeve, *The Classical Presence in American Art*, exh. cat. (Chicago: Art Institute of Chicago, 1978), although brief, is one of the few attempts to address the subject in all media from the seventeenth to the twentieth century. The high point of Neoclassicism is thoroughly covered in Wendy A. Cooper, *Classical Taste in America, 1800–1840*, exh. cat. (New York: Harry N. Abrams, 1993). General works most useful for our purposes here are, in chronological order: *Classical America, 1815–1845*, exh. cat. (Newark, N.J.: Newark Museum, 1963), written largely by Berry B. Tracy and William H. Gerdts; Harold E. Dickson, *Arts of the Young Republic: The Age of William Dunlap*, exh. cat. (Chapel Hill: University of North Carolina Press, 1968); Beatrice Garvan, *Federal Philadelpha, 1785–1825: Athens of the Western World*, exh. cat. (Philadelphia: Philadelphia Museum of Art, 1987); Brian Cullity, *Arts of the Federal Period, 1785–1825*, exh. cat. (Sandwich, Mass.: Heritage Plantation of Sandwich, 1989); Stuart P. Feld and Wendell Garrett, *Neo-Classicism in America: Inspiration and*

Innovation, 1810–1840, exh. cat. (New York: Hirschl & Adler Galleries, 1991); Gregory R. Weidman et al., *Classical Maryland, 1815–1845: Fine and Decorative Arts from the Golden Age*, exh. cat. (Baltimore: Maryland Historical Society, 1993); Stuart P. Feld, *Boston in the Age of Neo-Classicism, 1810–1840*, exh. cat. (New York: Hirschl & Adler Galleries, 2001); Elizabeth Feld and Stuart P. Feld, *Of the Newest Fashion: Masterpieces of American Neo-classical Decorative Arts*, exh. cat. (New York: Hirschl & Adler Galleries, 2002).

2. The widespread nature of this international stylistic movement is captured in *The Age of Neo-Classicism*, exh. cat. (London: Arts Council of Great Britain, 1972).

3. For the general contours of the history of this period, see Stanley Elkins and Eric McKitrick, *The Age of Federalism: The Early American Republic, 1788–1800* (New York: Oxford University Press, 1993); and Gordon S. Wood, *Empire of Liberty: A History of the Early Republic, 1789–1815* (New York: Oxford University Press, 2009). For the role of art, see Lillian B. Miller, *Patrons and Patriotism: The Encouragement of the Fine Arts in the United States, 1790-1860* (Chicago: University of Chicago Press, 1966); Neil Harris, *The Artist in American Society: The Formative Years, 1790–1860* (New York: George Braziller, 1966); and Joseph J. Ellis, *After the Revolution: Profiles of Early American Culture* (New York: W. W. Norton, 1979).

4. Talbot Hamlin, *Greek Revival Architecture in America* (1944; repr., New York: Dover, 1964). For the persistent use of classicism for government buildings, see Henry-Russell Hitchcock and William Seale, *Temples of Democracy: The State Capitols of the U.S.A.* (New York: Harcourt Brace Jovanovich, 1976). Thomas Jefferson's design for the Virginia State Capitol was especially important in providing an example that would be followed many times.

5. See the entry by Robert F. Trent in Jonathan L. Fairbanks and Trent, *New England Begins: The Seventeenth Century*, exh. cat. (Boston: Museum of Fine Arts, 1982), 3:536–40; see also "The Concept of Mannerism," in *New England Begins*, 3:368–412.

6. Abbott Lowell Cummings, "The Foster-Hutchinson House," *Old-Time New England* 54, no. 3 (January–March 1964): 59–76. See also Abbott Lowell Cummings, "The Domestic Architecture of Boston, 1660–1725," *Archives of American Art Journal* 9, no. 4 (1971): 1–16.

7. See John Summerson, *The Classical Language of Architecture* (Cambridge, Mass.: MIT Press, 1963), for an overview. Pattern books by George Hepplewhite (1788) and such publications as James Stuart and Nicholas Revett's *Antiquities of Athens* (published in four volumes issued between 1762 and 1816) and Robert and James Adam's *Works in Architecture* (1773–99) were particularly important in the transmission of the Neoclassical style from Britain to America. See Helen Park, *A List of Architectural Books Available in America before the Revolution*, 2nd ed. (Los Angeles: Hennessey and Ingalls, 1973); Janice G. Schimmelman, "Architectural Treatises and Building Handbooks Available in American Libraries and Bookstores through 1800," *Proceedings of the American Antiquarian Society* 95, pt. 2 (October 1985): 317–500; Janice G. Schimmelman, "A Checklist of European Treatises on Art and Essays on Aesthetics Available in America through

1815," *Proceedings of the American Antiquarian Society* 93, pt. 1 (April 1983): 95–195; Morrison H. Heckscher, "English Furniture Pattern Books in Eighteenth-Century America," in *American Furniture 1994*, ed. Luke Beckerdite (Milwaukee: Chipstone Foundation, 1994), 173–205.

8. For a detailed analysis of this painting, see Jane C. Nylander, "Henry Sargent's *Dinner Party* and *Tea Party*," *Antiques* 121, no. 5 (May 1982): 1172–83.

9. See Philip M. Isaacson, *The American Eagle* (Boston: New York Graphic Society, 1975), for a discussion of the multiple meanings of the eagle (it represented the apotheosis of Caesar; it was the messenger of Jupiter, Rome's favorite god, and was therefore adopted by the Roman legions; it represented the Resurrection and was also associated with St. John the Evangelist; and it was related to the phoenix) and how it became the national symbol.

10. The rich history of classical motifs in American coinage is discussed in Cornelius Vermeule, *Numismatic Art in America: Aesthetics of the United States Coinage*, 2nd ed. (Atlanta: Whitman Publishing, 2007). See, for example, a gold eagle coin designed by Robert Scot, in the MFA's collection (1972.972). A Roman eagle from the third or fourth century is but one of numerous ancient prototypes for the American version; see object 1977.657 in the collection of the MFA.

11. As an example, see a silver sugar urn by Revere in the Museum's collection (35.1759).

12. Optical machines were a popular form of entertainment in early-nineteenth-century America. This perspective machine was operated by removing the medallion and inserting prints into a slightly angled rack in the base of the machine. Illuminated by the light of day from a window, the prints could be viewed through an eyepiece, which projected a magnified image. For a recent discussion of the ancient obelisk form, see Brian A. Curran, Anthony Grafton, Pamela O. Long, and Benjamin Weiss, *Obelisk: A History* (Cambridge, Mass.: Burndy Library, 2009).

13. The most recent discussion of this much-publicized object is Dean Lahikainen, *Samuel McIntire: Carving an American Style*, exh. cat. (Salem, Mass.: Peabody Essex Museum, 2007), 44, 63.

14. *A Poem on the Rising Glory of America*, written by Hugh Henry Brackenridge and Philip Freneau and delivered at the 1771 Princeton commencement, was one of many optimistic statements on America's developing cultural status. See Ellis, *After the Revolution*, 9–10.

15. Three rooms from Oak Hill are preserved at the MFA, furnished with most of their original furniture. See a special issue of the Museum of Fine Arts' *Bulletin* 81 (1983), with essays by Jonathan L. Fairbanks, Wendy Cooper, and Wendy Kaplan.

16. Quoted in Weidman et al., *Classical Maryland*, 93.

17. For the curule form, see David L. Barquist and Ethan W. Lasser, *Curule: Ancient Design in American Federal Furniture*, exh. cat. (New Haven: Yale University Art Gallery, 2003).

18. Jeannine Falino and Gerald W. R. Ward, eds., *Silver of the Americas, 1600–2000: American Silver in the Museum of Fine Arts, Boston* (Boston: MFA Publications, 2008), cat. no. 234, 300–302. See also Kenneth L. Ames, "What Is the Néo-Grec?" *Nineteenth Century* 2, no. 2 (Summer 1976): 12–21;

and Kenneth L. Ames, "Sitting in (Néo-Grec) Style," *Nineteenth Century* 2, nos. 3–4 (Autumn 1976): 50–58.

19. See Kathryn Greenthal, Paula M. Kozol, and Jan Seidler Ramirez, with an introductory essay by Jonathan L. Faribanks, *American Figurative Sculpture in the Museum of Fine Arts, Boston* (Boston: Museum of Fine Arts, 1986), 59–64.

20. Pierre Grimal, *The Penguin Dictionary of Classical Mythology* (New York: Penguin, 1991), 442–43.

21. Lura Woodside Watkins, *Early New England Potteries and Their Wares* (Cambridge, Mass.: Harvard University Press, 1950), chap. 28.

22. Frederic E. Church to Erastus Dow Palmer, May 14, 1869, Erastus Dow Palmer Papers, McKinney Library, Albany Institute of History and Art, N.Y.

23. Frederic E. Church to William H. Osborn, April 14, 1869, Church Archives, Olana State Historic Site, Hudson, N.Y.

24. For more on the MFA murals, see Carol Troyen, *Sargent's Murals in the Museum of Fine Arts, Boston* (Boston: Museum of Fine Arts, 1999).

25. Falino and Ward, *Silver of the Americas*, cat. no. 238, 306–8.

26. For Zucca, see Edward S. Cooke, Jr., Gerald W. R. Ward, and Kelly H. L'Ecuyer, with the assistance of Pat Warner, *The Maker's Hand: American Studio Furniture, 1940–1990*, exh. cat. (Boston: MFA Publications, 2003), 13, 83, 100–101.

27. As quoted in Harry Rand, *Byron Browne: Paintings and Drawings from the 30s, 40s and 50s*, exh. cat. (Roslyn, N.Y.: Nassau County Museum of Art, 1987), 10.

28. For de Staebler and Pappas, see Gerald W. R. Ward and Julie Muñiz, *Shy Boy, She Devil, and Isis: The Art of Conceptual Craft: Selections from the Wornick Collection*, exh. cat. (Boston: MFA Publications, 2007), 37, 49. See also Andreas C. Papadakis, ed., *The Post-Modern Object*, (London: Art & Design, 1987).

England

1. *Examination of Doctor Benjamin Franklin, before an August Assembly, relating to the Repeal of the Stamp-Act, &c.* (New York: James Parker, 1766).

2. The Kingdom of Great Britain was established in 1707 with the merger of England and Scotland. For the sake of clarity in this essay, the terms *England*, *Great Britain*, and *British* are used interchangeably.

3. Although other European countries founded colonies in North America as well, including the Dutch (New Netherland), the Swedish (New Sweden), the Spanish (New Spain), and the French (New France), by the end of the seventeenth century, England claimed most of the eastern seaboard of North America and the thirteen colonies that eventually became the United States of America.

4. Angela L. Miller et al., *American Encounters: Art, History and Cultural Identity* (Upper Saddle River, N.J.: Pearson Education, 2008), 78–83.

5. The Mannerist style originated in Italy during the late Renaissance period of the early sixteenth century and remained popular in Europe and its colonies into the late seventeenth century. Characterized by exaggerated figures, motifs, and proportions, Mannerism was a heavily orna-

mented style that focused on artifice, or the hand of the artist. Mannerism is often seen as a reaction to the rational order and calm of classicism. Anglo-Dutch Mannerist design includes heavy grotesque ornament, whorls and checkered patterns, abstracted tulips (or lilies), fruitlike motifs, urns (or balusters), and figures of imps or cherubs. For more information on the Mannerist style, particularly as it relates to Anglo-Dutch design, see Robert S. Trent, "The Concept of Mannerism," in Jonathan L. Fairbanks and Robert Trent, *New England Begins: The Seventeenth Century*, exh. cat. (Boston: Museum of Fine Arts, 1982), 3:368–79. For an essay refuting Mannerist influences on style in the North American colonies, see Joseph Manca, "A Matter of Style: The Question of Mannerism in Seventeenth-Century American Furniture," *Winterthur Portfolio* 38, no. 1 (Spring 2003): 1–36.

6. Gerald W. R. Ward et al., *MFA Highlights: American Decorative Arts and Sculpture* (Boston: MFA Publications, 2006), 29, 39–40.

7. Miller et al., *American Encounters*, 86–87.

8. John Hull, as quoted in Fairbanks and Trent, *New England Begins* 3:484.

9. Fairbanks and Trent, *New England Begins* 3:484.

10. See Peter Pelham, Sr., to Peter Pelham, Jr., September 12, 1739, in *Letters and Papers of John Singleton Copley and Henry Pelham* (Boston: Massachusetts Historical Society, 1914), 3–5.

11. For Smibert's career, see Richard H. Saunders, *John Smibert: Colonial America's First Portrait Painter* (New Haven: Yale University Press, 1995).

12. MFA 1971.737; see Jonathan L. Fairbanks et al., *Paul Revere's Boston, 1735–1818*, exh. cat. (Boston: Museum of Fine Arts, 1975), 32–44.

13. The first known bombé shape to be made in the North American colonies was a carved pulpit made in 1749–51 for the First Church in Ipswich by Captain Abraham Knowlton (1699–1751). It is believed that Knowlton copied his bombé design from an engraving in a book by the English architect Batty Langley, *City and Country Builder's and Workman's Treasury of Designs*, published in 1740.

14. The desk-and-bookcase by Benjamin Frothingham is in the collection of the Department of State, Washington, D.C. Clement E. Conger and Alexandra W. Rollins, *Treasures of State: Fine and Decorative Arts in the Diplomatic Reception Rooms of the U.S. Department of State* (New York: Harry N. Abrams, 1991), 94–95.

15. Fairbanks et al., *Paul Revere's Boston*, 29–32; Ellenor M. Alcorn, *English Silver in the Museum of Fine Arts, Boston*, vol. 2, *Silver from 1697* (Boston: MFA Publications, 2000), 100–102. Some of the Hancock silver came into the marriage with Lydia from the Henchman family.

16. Alcorn, *English Silver in the Museum of Fine Arts, Boston*, 100–102. Owing to the intrinsic value of silver, secondhand purchases were not seen as used or as less desirable.

17. Patricia E. Kane et al., *Colonial Massachusetts Silversmiths and Jewelers* (New Haven: Yale University Art Gallery, 1998), 578–615.

18. An excellent study of English pattern books in America is Morrison H. Heckscher, "English Furniture Pattern Books in Eighteenth-Century America," in *American Furniture,*

1994, ed. Luke Beckerdite (Milwaukee: Chipstone Foundation, 1994), 173–205.

19. See Morrison Heckscher, *American Furniture in the Metropolitan Museum of Art: Late Colonial Period; The Queen Anne and Chippendale Styles* (New York: Metropolitan Museum of Art, 1985), 50–52.

20. John T. Kirk, *American Furniture and the British Tradition to 1830* (New York: Alfred A. Knopf, 1982), 148. For more information on Newport furniture, see Michael Moses, *Master Craftsmen of Newport: The Townsends and Goddards* (Tenafly, N.J.: MMI Americana Press, 1984); Margaretta M. Lovell, "'Such Furniture as Will Be Most Profitable': The Business of Cabinetmaking in Eighteenth-Century Newport," *Winterthur Portfolio* 26, no. 1 (Spring 1991): 27–62; and Morrison H. Heckscher, *John Townsend: Newport Cabinetmaker*, exh. cat. (New York: Metropolitan Museum of Art, 2005).

21. Anonymous seventeenth-century ballad, as quoted in David Hackett Fisher, *Albion's Seed: Four British Folkways in America* (New York: Oxford University Press, 1989), 13.

22. Kathleen Burk, *Old World, New World: Great Britain and America from the Beginning* (London: Little, Brown, 2007), 194, 200.

23. The first transatlantic cable, laid in 1858, lasted less than a month. A successful cable was finally established in 1866. For more information on the transatlantic cable, see John Steele Gordon, *A Thread across the Ocean: The Heroic Story of the Transatlantic Cable* (New York: HarperCollins, 2003).

24. Jane Shadel Spillman, *American and European Pressed Glass in the Corning Museum of Glass* (Corning, N.Y.: Corning Museum of Glass, 1981), 13–20.

25. Charles L. Venable, *Silver in America, 1840–1940: A Century of Splendor*, exh. cat. (Dallas: Dallas Museum of Art, 1994), 20–22.

26. "Art Enterprise," *Boston Transcript*, August 12, 1863, as quoted in Janet L. Comey, "The Gems of Brazil," in *Martin Johnson Heade*, by Theodore E. Stebbins, Jr., exh. cat. (Boston: Museum of Fine Arts in collaboration with Yale University Press, 1999), 71.

27. Edward S. Cooke, "Talking or Working: The Conundrum of Moral Aesthetics in Boston's Arts and Crafts Movement," in *Inspiring Reform: Boston's Arts and Crafts Movement*, ed. Marilee Boyd Meyer, exh. cat. (New York: Harry N. Abrams, for the Davis Museum and Cultural Center, Wellesley College, 1997), 19–24.

28. Richardson's collaborators included John La Farge, Daniel Cottier, Edward Burne-Jones, William Morris and Company, Sarah Wyman Whitman, Eugène Oudinot, and others. For more information on Trinity Church, see James F. O'Gorman, ed., *The Makers of Trinity Church in the City of Boston* (Boston: University of Massachusetts Press, 2004).

29. Wright's drawings were published by the Berlin publisher Ernst Wasmuth under the title *Ausgeführte Bauten und Entwurfe von Frank Lloyd Wright*. The compilation is commonly known as the "Wasmuth Portfolio," after its publisher.

30. "The Sargent Portraits at the Museum of Fine Arts," *Boston Transcript*, June 12, 1903.

31. See Carol Kino, "David Hockney's Long Road Home," *New York Times*, October 18, 2009.

France

1. John Adams to Thomas Jefferson, December 18, 1819, in Charles Francis Adams, *The Works of John Adams, Second President of the United States: With a Life of the Author, Notes and Illustrations* (Boston: Little, Brown, 1856), 10:386. Adams, a Federalist who believed in a strong national government, also argued about politics with Jefferson and his followers, who preferred more diffused authority.

2. Melissa Lee Hyde, "Rococo Redux," in *Rococo: The Continuing Curve, 1730–2008*, by Sarah D. Coffin et al., exh. cat. (New York: Cooper-Hewitt, National Design Museum, 2008), 13.

3. William Wetmore Story, "Report on the Fine Arts," in *Reports of the United States Commissioners to the Paris Universal Exposition, 1878* (Washington, D.C.: Government Printing Office, 1880), 2:15.

4. On the adaptation of the Rococo in Mexico, see *Mexico: Splendors of Thirty Centuries*, exh. cat. (New York: Metropolitan Museum of Art, 1990), 357–360, 418.

5. On the Rococo in the British colonies, see Morrison H. Heckscher and Leslie Greene Bowman, *American Rococo, 1750–1775: Elegance in Ornament*, exh. cat. (New York: Metropolitan Museum of Art, 1992); and Coffin et al., *Rococo*.

6. For a Philadelphia high chest, see MFA 39.545.

7. For a teapot by Paul Revere, Sr., see MFA 1972.122; for works by Paul Revere, Jr., see esp. the Sons of Liberty Bowl, MFA 49.45.

8. France supplied only 5 percent of the total migration from Europe to America between 1500 and 1800. Its relatively secure system of peasant landholding meant that few of its people sought to migrate abroad. See James Pritchard, *In Search of Empire: The French in the Americas, 1670–1730* (New York: Cambridge University Press, 2004), 17; see also Leslie Chocquette, *Frenchman into Peasants: Modernity and Tradition in the Peopling of French Canada* (Cambridge, Mass.: Harvard University Press, 1997).

9. Pritchard, *In Search of Empire*, 11–13.

10. For overviews of French colonial material culture and especially furniture, see Donald Blake Webster, *Rococo to Rustique: Early French-Canadian Furniture in the Royal Ontario Museum* (Toronto: Royal Ontario Museum, 2000); and also Francis J. Puig, "The Early Furniture of the Mississippi River Valley, 1760–1820," in *The American Craftsman and the European Tradition, 1620–1820*, ed. Francis J. Puig and Michael Conforti, exh. cat. (Minneapolis: Minneapolis Institute of Arts, 1989), 152.

11. Similarly, French-style furniture survived in Louisiana as well; see Jessie Poesch, *Early Furniture from Louisiana* (New Orleans: Lousiana State Museum, 1972). France maintained its political interests throughout the Caribbean and into Mexico, which it ruled during the 1860s.

12. For related French examples, see *Meubles et ensembles normands* (Paris: Editions Charles Massin, n.d.), 5, 15, and 36. See Edward S. Cooke, Jr., entry in *Decorative Arts and Sculpture, 1971–1991*, exh. cat. (Boston: Museum of Fine Arts, 1991), 47.

13. On the arbelète form, see Jean Palardy, *The Early Furniture of French Canada*, trans. Eric McLean (Toronto: Macmillan of Canada, 1963), 302. For other examples of similar commodes, see Webster, *Rococo to Rustique*, 93–95.

14. An elaborate commode attributed to Georges Joubert, made in Paris about 1735, is an example of the arbelète form when it was at the height of fashion; see MFA 25.79.

15. Palardy, *The Early Furniture of French Canada*, 299–300.

16. On the presence of English claw-and-ball feet on Montreal furniture, see ibid., 302. For a Newport chest of drawers with claw-and-ball feet, attributed to John Goddard, see MFA 1981.665. This object suggests a two-way exchange of styles between French and English settlements, as the Newport chest resembles a commode in the French manner.

17. *Autobiography of Thomas Jefferson* (1821; New York: G. P. Putnam's Sons, 1914), 157.

18. On Houdon, see Anne L. Poulet et al., *Jean-Antoine Houdon: Sculptor of the Enlightenment*, exh. cat. (Washington, D.C.: National Gallery of Art, 2003).

19. A terra-cotta plaster version is in the collection of Monticello. Susan R. Stein, *Jean-Antoine Houdon's Bust of Jefferson*, at http://www.monticello.org/highlights/houdon.html (August 2002) (accessed December 12, 2008). See also Susan R. Stein, *The Worlds of Thomas Jefferson at Monticello* (New York: Harry N. Abrams, 1993).

20. Translation of a statement signed by a former owner of the bust, P. Le Clerq de Chateauvieux, May 3, 1934; copy in Museum of Fine Arts, Boston, Department of Art of Europe, object file, 34.129.

21. Robert I. Goler, *The Legacy of Lafayette* (New York: Fraunces Tavern Museum, 1984), as cited in Kathryn Greenthal, Paula M. Kozol, and Jan Seidler Ramirez, with an introductory essay by Jonathan L. Fairbanks, *American Figurative Sculpture in the Museum of Fine Arts Boston* (Boston: Museum of Fine Arts, 1986), cat. no. 8; and Sylvia Neely, "The Politics of Liberty in the Old World and the New: Lafayette's Return to America in 1824," *Journal of the Early Republic* 6, no. 2 (Summer 1986): 151–71.

22. See Lafayette commemorative fan, MFA 1976.385, and "Lafayet" pressed glass salt dishes, such as MFA 1979.680.

23. Jonathan L. Fairbanks, "A Century of Classical Tradition in American Sculpture, 1830–1930," in Greenthal et al., *American Figurative Sculpture*, xi–xviii; see also Jan Seidler Ramirez, entries for Horatio Greenough, ibid., 4–26.

24. Greenthal et al., *American Figurative Sculpture*, 13–14.

25. See Irma B. Jaffe, *John Trumbull: Patriot-Artist of the Revolution* (Boston: New York Graphic Society, 1975), 17–18. Trumbull's copies after Le Brun are in the Beinecke Rare Book and Manuscript Library at Yale University.

26. Ibid., 71.

27. Thomas Jefferson to James Barbour, January 19, 1817, James Barbour Papers, Manuscripts and Archives Division, New York Public Library; John Adams to John Trumbull, January 1, 1817, and Trumbull to Adams, March 3, 1817, both in Trumbull's interleaved Autobiography, Franklin Collection, Yale University; all as quoted ibid., 235–36, 237. The *Death of General Warren* was not one of the scenes Trumbull selected for the Capitol.

28. Cecilia Jackson Otto, "French Furniture for American Patriots," *Antiques* 79, no. 4 (April 1961): 370–73.

29. Eleanor P. DeLorme, "James Swan's French Furniture," *Antiques* 107, no. 3 (March 1975): 452–61.

30. For an important example of Quervelle's furniture, see MFA 2004.562. On Quervelle's life and work, see Robert C. Smith, "Philadelphia Empire Furniture by Antoine Gabriel Quervelle," *Antiques* 86, no. 3 (September 1964): 304–8, and a series of five articles on Quervelle by Smith in *Antiques* in 1973 and 1974. On Lannuier, see Peter M. Kenny, Frances F. Bretter, and Ulrich Leben, *Honoré Lannuier, Cabinet Maker from Paris: The Life and Work of a French Ebéniste in Federal New York*, exh. cat. (New York: Metropolitan Museum of Art, 1998).

31. See MFA 56.1246. On the Tucker firm, see Alice Cooney Frelinghuysen, *American Porcelain, 1770–1920*, exh. cat. (New York: Metropolitan Museum of Art, 1989), 14–21 and 83–105.

32. On the Napoleonic Empire style, see Odile Nouvel-Kammerer, *Symbols of Power: Napoleon and the Art of the Empire Style, 1800–1815*, exh. cat. (New York: Abrams, 2007).

33. For related French examples, see Marie-Noelle de Grandry, *Le mobilier français: Directoire Consulat Empire* (Paris: Editions Massin, 1996), 80; and *Meubles et ensembles Directoire-Empire* (Paris: Editions Charles Massin, 1958), pls. 15, 25, and passim.

34. *Independent Chronicle and the Boston Patriot*, June 1, 1825, 3.

35. Alexis de Tocqueville to Edouard de Tocqueville, May 28, 1831, translated by Frederick Brown, *Hudson Review* 62, no. 3 (Autumn 2009), at http://hudsonreview.com/new/issues/110/letters-from-america (accessed December 12, 2009).

36. "The Generations of Fashions," *Harper's New Monthly Magazine* 9, no. 54 (November 1854): 750.

37. See, for example, *Godey's Lady's Book*, no. 49 (August 1854): 97.

38. See Kenneth L. Ames, "Designed in France: Notes on the Transmission of French Style to America," *Winterthur Portfolio* 12 (1977): 103–14. For examples of Rococo Revival furniture, see MFA 2005.1116 and 1977.753; see also Marvin D. Schwartz et al., *The Furniture of John Henry Belter and the Rococo Revival* (New York: E. P. Dutton, 1981).

39. Andrew Jackson Downing, *The Architecture of Country Houses* (New York: D. Appleton, 1850; repr., New York: Dover, 1969), 432.

40. On a table in the MFA's collection, the label reads "From / A. Roux / French / Cabinet Maker / Nos. 479 & 481 Broadway / New York." See MFA 1983.325. According to city directories, Roux was at this address on Broadway from 1850 to 1857. On Roux, see Dianne D. Hauserman, "Alexander Roux and His 'Plain and Artistic Furniture,'" *Antiques* 93, no. 2 (February 1968): 210–17; and Downing, *Architecture of Country Houses*, 412.

41. For related examples and the period use of the term "French cabinet," see Anna Tobin d'Ambrosio, ed., *Masterpieces of American Furniture from the Munson-Williams-Proctor Institute*, exh. cat. (Utica, N.Y.: Munson-Williams-Proctor Institute, 1999), 106–7; *19th-Century America: Furniture and Other Decorative Arts*, exh. cat. (New York: Metropolitan Museum of Art, 1970), cat. no. 164; and Donald C. Peirce, *Art and Enterprise: American Decorative Art, 1825–1917*, exh. cat. (Atlanta: High Museum of Art, 1999), 126–27.

42. Kenneth L. Ames, "What Is the Néo-Grec?" *Nineteenth Century* 20, no. 2 (Fall 2000): 24–31; reprinted from *Nineteenth Century* 2, no. 2 (Summer 1976).

43. Barbara Laux, "The Furniture Mounts of P. E. Guerin," *Antiques* 161, no. 5 (May 2002): 140–49.

44. Henry James, "John Singer Sargent," *Harper's New Monthly Magazine* 75 (October 1887): 683.

45. See MFA 17.1485.

46. Walt Whitman, *Specimen Days* (1892) (Whitefish, Mont.: Kessinger Publishing, 2004), 197 (Whitman visited Shaw in 1881); Whitman to Horace Traubel, as quoted in Larry J. Reynolds, *European Revolutions and the American Literary Renaissance* (New Haven: Yale University Press, 1988), 128.

47. Fortunately for Boston, a local collector had already purchased the painting for the MFA.

48. On Tiffany and the Art Nouveau, see Alice Cooney Frelinghuysen, "Louis Comfort Tiffany and New York," in *Art Nouveau, 1890–1914*, ed. Paul Greenhalgh, exh. cat. (London: Victoria and Albert Museum, 2000), 398–411. For an example of Tiffany's Art Nouveau–influenced glass, see MFA 65.216.

49. For Martelé silver, see MFA 69.1291–97.

50. Edward S. Cooke, Jr., in *Collecting American Decorative Arts and Sculpture*, 46. See also Sharon Darling, *Chicago Furniture: Art, Craft, and Industry, 1833–1983* (New York: W. W. Norton, 1984), 194–96.

51. James Johnson Sweeney, *Stuart Davis*, exh. cat. (New York: Museum of Modern Art, 1945), 16.

52. Stuart Davis to his father, September 17, 1928, as quoted in Karen Wilkin, *Stuart Davis* (New York: Abbeville Press, 1987), 120. See Lowery Stokes Sims's entries on the *Egg Beater* series in Sims et al., *Stuart Davis: American Painter*, exh. cat. (New York: Metropolitan Museum of Art, 1992), 184–90.

53. Alexander Calder and Jean Davidson, *Calder: An Autobiography with Pictures* (New York: Pantheon Books, 1966), 76.

54. See Joan Simon, *Calder: The Paris Years*, exh. cat. (New York: Whitney Museum of American Art, 2008).

55. On Ruhlmann, see Pierre Kjellberg, *Art Deco: Les maîtres du mobilier, le décor des paquebots* (Paris: Editions de l'amateur, 1986), 154–67; Florence Camard, *Ruhlmann: Master of Art Deco* (New York: Abrams, 1984); and Alastair Duncan, *Art Deco Furniture: The French Designers* (New York: Holt Rinehart and Winston, 1984).

56. Angela Meincke et al., "Early Cellulose Nitrate Coatings on Furniture of the Company of Master Craftsmen," *Journal of the American Institute of Conservation* 48 (2009): 1–24.

57. Tyler Stovall, *Paris Noir: African Americans in the City of Light* (Boston: Houghton Mifflin, 1996), 72.

58. Margaret Rose Vendryes, "Casting *Feral Benga*: A Biography of Richmond Barthé's Signature Work," at http://www.artsnet.org/anyonecanfly/library/Vendryes_on_Barthe.html (accessed December 20, 2008); Patricia Hills and Melissa Renn, *Syncopated Rhythms: 20th-Century African American Art from the George and Joyce Wein Collection*, exh. cat. (Boston: Boston University Art Gallery, 2005); and Vincent Cronin, *Paris: City of Light, 1919–1939* (New York: HarperCollins, 1994).

59. Raoul Dautry, as quoted in Shanny Peer, *France on Display: Peasants, Provincials, and Folklore in the 1937 Paris World's Fair* (Albany: State University of New York Press, 1998), 168–69.

60. Twachtman to J. A. Weir, January 2, 1885, Weir Papers, Archives of American Art, Smithsonian Institution, Washington, D.C.; Gertrude Stein to Thornton Wilder, December 11, 1935, in *The Letters of Gertrude Stein and Thornton Wilder*, ed. Edward M. Burns and Ulla E. Dydo with William Rice (New Haven: Yale University Press, 1996), 69.

Italy

1. The long political history of the peoples who have lived on the boot-shaped Italian peninsula and its islands is at best a complicated story; as a unified country, Italy did not come into existence until the third quarter of the nineteenth century. For a capsule history, see Spencer M. DiScala, *Italy: From Revolution to Republic, 1700 to the Present* (Boulder, Colo.: Westview Press, 1995); see also *Merriam-Webster's Geographical Dictionary*, 3rd ed. (Springfield, Mass.: Merriam-Webster, 1997), q.v. "Italy"; and "Italy," in *Reference Library of European America*, 4 vols. (Detroit: Gale Research, 1998), 3:249–64.

2. For these explorers, see Samuel Eliot Morison, *The European Discovery of America*, 2 vols. (New York: Oxford University Press, 1971–74).

3. See Jonathan L. Fairbanks and Robert F. Trent, *New England Begins: The Seventeenth Century*, exh. cat. (Boston: Museum of Fine Arts, 1982), 3:368–79; and Joseph Manca, "A Matter of Style: The Question of Mannerism in Seventeenth-Century American Furniture," *Winterthur Portfolio* 38, no. 1 (March 2003): 1–36.

4. For more on the impact of the classical cultures on American artists, see "The Classical Tradition" chapter in this publication. On American artists in Italy, see Irma Jaffe, *The Italian Presence in American Art, 1760–1860* (New York: Fordham University Press, 1989); Irma Jaffe, *The Italian Presence in American Art, 1860–1920* (New York: Fordham University Press, 1992); Theodore E. Stebbins, Jr., et al., *The Lure of Italy: American Artists and the Italian Experience, 1760–1914*, exh. cat. (Boston: Museum of Fine Arts, in association with Harry N. Abrams, 1992); William L. Vance, *America's Rome* (New Haven: Yale University Press, 1989); and William L. Vance et al., *America's Rome: Artists in the Eternal City, 1800–1900*, exh. cat. (Cooperstown, N.Y.: Fenimore Art Museum, 2009). There are many monographs on individual American artists in Italy; for a recent example of a relatively little-known painter, see John F. McGuigan, Jr., and Mary K. McGuigan, *James E. Freeman, 1808–1884: An American Painter in Italy*, exh. cat. (Utica, N.Y.: Munson Williams Proctor Arts Institute, 2009).

5. North America did have a variety of ancient cultures, of course, although the evidence pertaining to them was largely archaeological and, in the case of the so-called Mound Builders of the Mississippian Tradition, largely misunderstood until the late nineteenth century. See Brian M. Fagan, *Ancient North America: The Archaeology of a Continent*, 3rd ed. (New York: Thames and Hudson, 2000).

6. David Alan Brown, *Raphael and America*, exh. cat. (Washington, D.C.: National Gallery of Art, 1983), 20.

7. John Singleton Copley to Henry Pelham, March 14, 1775, in *Letters and Papers of John Singleton Copley and Henry Pelham, 1739–1776*, ed. Guernsey Jones (Boston: Massachusetts Historical Society, 1914), 304.

8. A painted Italian fan dating from 1740–80 in the Museum's collection, picturing Saint Peter's Basilica, the Bernini colonnades, and the Vatican on one side, and Hadrian's Tomb on the other, is but one of innumerable such souvenirs; see MFA 1976.346.

9. Stebbins et al., *Lure of Italy*, 34.

10. Ibid., 156. Although many travelers to Italy enjoyed their time there, it did not always exert a major influence. Charles Bulfinch, the Boston architect, took a grand tour to Europe, including Italy, in 1785–87, partly to study Roman and Italian architecture, but the direct impact of Italy on his career was not extensive; see Harold Kirker, *The Architecture of Charles Bulfinch* (Cambridge, Mass.: Harvard University Press, 1969), 6–7, 12.

11. For attitudes toward the fine arts in the early republic, see Neil Harris, *The Artist in American Society: The Formative Years, 1790–1860* (New York: George Braziller, 1966), esp. chaps. 1–2, and Lillian B. Miller, *Patrons and Patriotism: The Encouragement of the Fine Arts in the United States, 1790–1860* (Chicago: University of Chicago Press, 1966), esp. parts 1–2. See also William Howard Adams, ed., *The Eye of Thomas Jefferson*, exh. cat. (Washington, D.C.: National Gallery of Art, 1976).

12. Kathryn Greenthal, Paula M. Kozol, and Jan Seidler Ramirez, with an introductory essay by Johnathan L. Fairbanks, *American Figurative Sculpture in the Museum of Fine Arts, Boston* (Boston: Museum of Fine Arts, 1986), 157; the visitor to the shop was David Maitland Armstrong. For *Nydia*, see MFA 1973.617.

13. Quoted in Greenthal et al., *American Figurative Sculpture*, 164.

14. Stebbins et al., *Lure of Italy*, 351–53. See also Greenthal et al., *American Figurative Sculpture*, 266–67, which suggests that Thaxter may have known firsthand or through engravings Bernini's *Old Market Woman* in the Vatican collection.

15. Stebbins et al., *Lure of Italy*, 176.

16. Thomas Cole, "Sicilian Scenery and Antiquities," *Knickerbocker Magazine* 23 (February–March 1844): 2–3.

17. John Gadsby Chapman to Robert O. Fuller, December 1867, Museum of Fine Arts, Boston, Department of Art of the Americas, object file, 1973.281.

18. *Crayon* 6 (December 1859): 379–80.

19. For an overview of the style, see Grand Rapids Art Museum, *Renaissance Revival Victorian Furniture* (Grand Rapids, Mich.: Grand Rapids Art Museum, 1976).

20. John La Farge, "The American Academy at Rome," *Scribner's Magazine* 28 (August 1900): 253, quoted in Brooklyn Museum, *The American Renaissance, 1876–1917*, exh. cat. (New York: Pantheon Books, 1979), 30.

21. For the Museum's *Madonna of the Clouds* by Donatello, see MFA 17.1470.

22. For Duveneck's memorial to his wife, see Greenthal et al., *American Figurative Sculpture*, cat. no. 64, 211.

23. Stebbins et al., *Lure of Italy*, 371–72.

24. For example, the Gorham Manufacturing Company of Providence, Rhode Island, exhibited many wares, including a jeweled claret jug, indebted to Renaissance *objets de vertu* for both its form and decoration. For the jug, see MFA 2006.1246a–b. For the fair as a whole, see Carolyn Kinder Carr and George Gurney et al., *Revisiting the White City: American Art at the 1893 World's Fair*, exh. cat. (Washington, D.C.: National Museum of American Art and National Portrait Gallery, 1993).

25. Lilian B. Miller, *Patrons and Patriotism: The Encouragement of the Fine Arts in the United States, 1790–1860* (Chicago: University of Chicago Press, 1996), 67–84; quotation from Representative Owen Lovejoy of Illinois at 78. The controversy over Brumidi, among other things, neatly encapsulates the difficulties that public art commissions have always encountered in America.

26. Barbara A. Wolanin, *Constantino Brumidi: Artist of the Capitol* (Washington, D.C.: U.S. Government Printing Office, 1998).

27. See Roger Daniels, *Coming to America: A History of Immigration and Ethnicity in American Life* (New York: HarperCollins, 1990), 185–211, for a discussion of immigration from the Mediterranean area. For a wide-ranging overview of the contributions to all walks of life made by these immigrants, see Jerre Mangione and Ben Morreale, *La Storia: Five Centuries of the Italian American Experience* (New York: HarperCollins, 1992); and George Pozzetta, "Italian Americans," in *Reference Library of European America* 2:331–48.

28. See Wayne Craven, *Sculpture in America* (New York: Thomas Y. Crowell, 1968), 500–501; see also 404–5 for a description of the Piccirilli workshop and their work on French's *Lincoln*. See also Mangione and Morreale, *La Storia*, 22–24, which emphasizes Attilio Piccirilli's assimilation into American society.

29. For example, see MFA 1992.267, a greyhound by Charles I. D. Looff, who was born in Schleswig-Holstein, on the border between Denmark and Germany, and who came to New York in 1870. The paintings of the "folk artist" Ralph Fasanella are often cited as expressions of his Italian American background. For his life, see Paul D'Ambrosio, *Ralph Fasanella's America*, exh. cat. (Cooperstown, N.Y.: Fenimore Art Museum, 2001).

30. Marion Dentzel, *The Dentzel Carousel Menageries: A Five-Generation Living Tradition*, exh. cat. (San Diego: Mingei International Museum of Folk Art, 1996).

31. Most of the discussion here is based on material in the object's data file in the Department of Musical Instruments; we are grateful to Darcy Kuronen, curator of the department, for his assistance. See also Mary Murray O'Brien, "Somerville Man Refused Mrs. Jack Gardner's $10,000 for Jewelled Banjo," *Boston Sunday Globe*, April 3, 1949.

32. This extraordinary banjo was exhibited by Consalvi and received the highest awards at major international exhibitions, including the Paris Exhibition (1900), the Pan-American World's Fair in Buffalo (1901), the Crystal Palace Exhibition in London (1902), and the Saint Louis World's Fair (1904). It may also have been included in the exhibition "The Native Arts of Our Foreign Peoples" at the Museum of Fine Arts, Boston, in 1912.

33. See Stebbins et al., *Lure of Italy*, 382–83; and Greenthal et al., *American Figurative Sculpture*, 399–403.

34. For a brief statement of the purpose of the academy, lists of its founders, and its decision to locate in Rome, see *The American Academy in Rome* (New York: American Academy in Rome, 1904), 6–17, quotations at 12, 5, available online from Google Books, http://books.google.com (accessed December 28, 2009).

35. William Kelso, *Jamestown: The Buried Truth* (Charlottesville: University of Virginia Press, 2006), 183.

36. This point of intersection is covered in detail in Sarah Nichols, Susanne K. Frantz, and Matthew Kangas, *Viva Vetro! Glass Alive! Venice and America*, exh. cat. (Pittsburgh, Pa.: Carnegie Museum of Art, 2007).

37. Tina Oldknow, in *Richard Marquis: Objects*, exh. cat. (Seattle: University of Washington Press, 1997), 17–25, includes a discussion of Marquis's experience in Italy.

38. Harris's *Artist in American Society*, chap. 6, contains a good discussion of the "perceptions and conceptions" that colored American attitudes toward Italian and European art in general in the first half of the nineteenth century.

Germany

1. A. G. Roeber, "In German Ways? Problems and Potentials of Eighteenth-Century German Social and Emigration History," *William and Mary Quarterly* 44, no. 4 (October 1987): 757, 763.

2. See Scott T. Swank et al., *Arts of the Pennsylvania Germans* (New York: W. W. Norton, 1983). Metalsmiths like Johann Christoph Heyne, a German-born immigrant to Lancaster, Pennsylvania, and the Philadelphia pewterer William Will drew on their Germanic training to cater to a population in the Pennsylvania colony that was about one-third German during the eighteenth century, creating remarkable pewter ware for domestic and religious settings. See Charles F. Montgomery, *A History of American Pewter* (New York: Praeger Publishers, 1973).

3. Roeber, "In German Ways?" 757.

4. Recent analysis has determined that these artists had access to pigments imported from Asia, as well as pigments such as chrome yellow that were commercially available in Philadelphia by the early eighteenth century. Jennifer Mass, Catherine R. Matsen, and Janice Carlson, "Materials of the Pennsylvania German Fraktur Artist," *Antiques* 168, no. 3 (September 2005): 132–33.

5. Beatrice B. Garvan and Charles F. Hummel, *The Pennsylvania Germans: A Celebration of Their Arts, 1683–1850*, exh. cat. (Philadelphia: Philadelphia Museum of Art, 1982), 36.

6. William M. Kelso, *Jamestown: The Buried Truth* (Charlottesville: University of Virginia Press, 2006), 181–83. George S. McKearin and Helen McKearin, *American Glass* (New York: Crown Publishers, 1948), 75–78.

7. Kenneth M. Wilson, *New England Glass and Glassmaking* (New York: Thomas Y. Crowell Company, 1972), 41–51.

8. Arlene Palmer, *Glass in Early America: Selections from the Henry Francis du Pont Winterthur Museum* (Winterthur, Del.: Henry Francis du Pont Winterthur Museum, 1993), 9–12; Arlene Palmer, "Glass Production in Eighteenth-Century America: The Wistarburgh Enterprise," *Winterthur Portfolio* 11 (1976): 75–101.

9. Palmer, "Glass Production," 70–71; "New Discoveries in American Glass," *Glass Club Bulletin* 194 (Autumn 2002): 6.

10. Kirk J. Nelson, "The 'Short Biography' of the Glass Engraver Louis Vaupel," *Antiques* 149, no. 4 (April 1996): 564–73.

11. Jane Shadel Spillman, "American Glass in the Bohemian Style," *Magazine Antiques* 149, no. 1 (January 1996): 146–55.

12. Lonn Taylor and David B. Warren, *Texas Furniture: The Cabinetmakers and Their Work, 1840–1880* (Austin: University of Texas Press, 1975), 33.

13. Barbara S. Groseclose, *Emanuel Leutze, 1816–1868: Freedom Is the Only King* (Washington, D.C.: Smithsonian Institution Press for National Collection of the Fine Arts, 1975), 13–14. Gordon Hendricks, *Albert Bierstadt: Painter of the American West* (New York: Harry N. Abrams, in association with the Amon Carter Museum, 1974), 13 and 23. Nancy K. Anderson and Linda S. Ferber, "Chronology," in *Albert Bierstadt: Art and Enterprise*, exh. cat. (New York: Hudson Hills Press, 1991), 117.

14. John I. H. Baur, *Eastman Johnson, 1824–1906: An American Genre Painter*, exh. cat. (Brooklyn: Brooklyn Institute of Arts and Sciences, 1940), 10.

15. Anthony F. Janson, *Worthington Whittredge* (Cambridge: Cambridge University Press, 1989), 36.

16. Ibid.

17. Sanford Gifford described the Malkasten (Hendricks, *Bierstadt*, 34): "Their rooms are decorated with frescoes, &c. There is a theatre belonging [*sic*], where comical plays and operas, composed and conducted by the artists, are performed often. It is a place where they congregate in the evening to sup, smoke, talk, drink beer, play billiards, and amuse themselves in various ways. [A] true brotherhood seems to reign among them. They are very natural and free in their intercourse with each other, [but] with all of their love of social relaxation they are very industrious, and are very early risers."

18. Hendricks, *Bierstadt*, 26. The painting referred to as among the best he painted is *Sunlight and Shadow: Study*, 1855, oil on paper, Newark Museum.

19. Albert Bierstadt to John Hay, August 22, 1863, John Hay Collection, John Hay Library, Brown University, Providence, R.I., quoted in Anderson and Ferber, *Albert Bierstadt*, 178.

20. See Hendricks, *Bierstadt*, 154. *Rocky Mountains* sold at the Chicago Sanitary Fair to James McHenry for $25,000. See also Natalie Spassky et al., *American Paintings in the Metropolitan Museum of Art*, vol. 2, *A Catalogue of Works by Artists Born between 1816 and 1845* (New York: Metropolitan Museum of Art, in association with Princeton University Press, 1985), 319–25.

21. Carrie Rebora Barratt, "Mapping the Venues: Art Exhibitions," in *Art and the Empire City*, exh. cat. (New York: Metropolitan Museum of Art, 2000), 62–63.

22. *Boston Evening Transcript*, January 8, April 12, June 11, and December 25, 1869. Anderson and Ferber, "Chronology," 117.

23. Robert Neuhaus, *Unsuspected Genius: The Art and Life of Frank Duveneck* (San Francisco: Bedford Press, 1987), 7.

24. Lisa N. Peters, "'Youthful Enthusiasm under a Hospitable Sky': American Artists in Polling, Germany, 1870s–1880s," *American Art Journal* 31, nos. 1–2 (2000): 58.

25. Elizabeth Wylie, *Explorations in Realism, 1870–1880: Frank Duveneck and His Circle from Bavaria to Venice*, exh. cat. (Framingham, Mass.: Danforth Museum of Art, 1989), 6.

26. Neuhaus, *Unsuspected Genius*, 13.

27. Ibid., 24.

28. Wylie, *Explorations in Realism*, 6. For Duveneck's leadership among the Americans in Munich, see Michael Quick, Eberhard Ruhmer, and Richard V. West, *Munich and American Realism in the 19th Century*, exh. cat. (Sacramento, Calif.: E. B. Crocker Art Gallery, 1978), 26. By 1877–78 Duveneck, along with the American artist Frank Currier, attracted a following and established a painting class for men and women, in which he taught the painting of portrait heads such as *The Old Professor* (1871, MFA 19.96).

29. We are grateful to Cody Hartley, Assistant Curator, Art of the Americas, for his research on the title of this painting.

30. As Neuhaus notes (*Unsuspected Genius*, 15), Duveneck's fellow pupil in Munich painted the same model in a now-lost composition entitled *Circassian Soldier*.

31. See Paul B. Henze, "Marx on Muslims and Russians," *Central Asian Survey* 6, no. 4 (1987): 33–45.

32. Michael Quick, *An American Painter Abroad: Frank Duveneck's European Years*, exh. cat. (Cincinnati: Cincinnati Art Museum, 1987), 19.

33. Robert-Hermann Tenbrock, *A History of Germany*, trans. Paul J. Dine (London: Longmans, Green, 1968), 208–9, 210.

34. Ibid., 238.

35. Donald E. Gordon, *Expressionism, Art and Idea* (New Haven: Yale University Press, 1987), 79.

36. Townsend Luddington, *Marsden Hartley: The Biography of an American Artist* (Boston: Little, Brown, 1992), 93.

37. Barbara Haskell, *Marsden Hartley*, exh. cat. (New York: Whitney Museum of American Art, 1980), 42. For Hartley's experience in Berlin, see also Patricia McDonnell, "Portrait of Berlin: Marsden Hartley and Urban Modernity in Expressionist Berlin," 39–67, and Wanda Corn, "Marsden Hartley's Native Amerika," in *Marsden Hartley*, ed. Elizabeth Mankin Kornhauser, exh. cat. (New Haven: Yale University Press, 2003), 69–85.

38. For an excellent overview of the many German-speaking émigrés to the United States, see Donald Fleming and Bernard Bailyn, *The Intellectual Migration: Europe and America, 1930–1960* (Cambridge, Mass.: Belknap Press of Harvard University Press, 1969), esp. Peter Gay, "Weimar Culture: The Outsider as Insider," 11–93, and William H. Jordy, "The Aftermath of the Bauhaus in America: Gropius, Mies, and Breuer," 485–526.

39. Gordon, *Expressionism*, 193.

40. See Judith Bookbinder, *Boston Modern* (Durham: University of New Hampshire Press, 2005), 169. Zerbe wrote: "In 1938, I read about encaustic, and I experimented with a bead of bee's wax and powdered pigment heated in a frying pan. I found one book in German on encaustic, and it took me two years to reinvent the technique."

41. See Dorothy Gees Seckler, "Changing Means to New Ends," *Art News* 51, no. 4 (Summer 1952): 66–69, 89–91. Zerbe is pictured on 66 with the following caption: "New Plastic Medium. The white substance in the Mason jar which Karl Zerbe is mixing with his pigment is polymer tempera, a water-based plastic, handled like gouache, he has adopted in place of his former encaustic. The first sketch for *Diesel Engine* is on the easel."

42. As quoted in Bookbinder, *Boston Modern*, 316, and noted in a letter from Maria Zerbe Norton to William H. Lane, April 14, 1986, describing *Job* as a "self-portrait, as the last encaustic, and a comment on the concentration camps in Germany"; Museum of Fine Arts, Boston, Department of Art of the Americas, Zerbe file, 1993.969.

43. Virginia M. Mecklenburg, *The Patricia and Phillip Frost Collection: American Abstraction, 1930–1945; Presented to the National Museum of American Art*, exh. cat. (Washington, D.C.: Smithsonian Institution, 1989), 1–8.

44. Hans Hofmann, *Search for the Real* (1948), ed. Sara T. Meeks and Bartlett H. Hayes (Andover, Mass.: Addison Gallery of American Art, in association with MIT Press, 1967), 49. Hofmann goes on to observe (44): "Nor is depth created by tonal gradation—(another doctrine of the academician which, at its culmination, degraded the use of color to a mere function of expressing dark and light)."

45. Fritz Bultman, "The Achievement of Hans Hofmann," *Art News* 62, no. 5 (September 1963): 44.

46. Ellen G. Landau, "Space and Pictorial Life: Hans Hofmann's *Smaragd Red and Germinating Yellow*," *Bulletin of the Cleveland Museum of Art* 72, no. 5 (September 1985): 318.

47. Ibid., 313.

48. See Christian Witt-Dörring, "Austria: Idealism or Realism," in *The Arts and Crafts Movement in Europe and America: Design for the Modern World*, ed. Wendy Kaplan (London: Thames and Hudson, 2004), 108–41; and Andrzej Szczerski, "Central Europe," and Juliette Hibou, "Arts and Crafts in Vienna," in *International Arts and Crafts*, ed. Karen Livingstone and Linda Parry, exh. cat. (London: V&A Publications, 2005), 238–51, 252–55.

49. Dard Hunter, *My Life with Paper: An Autobiography* (New York: Alfred A. Knopf, 1958), 43–44.

50. Wendy Kaplan, *"The Art That Is Life": The Arts and Crafts Movement in America, 1875–1920*, exh. cat. (Boston: Museum of Fine Arts, 1987), 168–69; and Robert Judson Clark, ed., *The Arts and Crafts Movement in America, 1876–1916* (Princeton: Princeton University Press, 1972), 45.

51. Andreas Haus, "Bauhaus: History," in *Bauhaus*, ed. Jeannine Fiedler, with contributions from Ute Ackerman, Olaf Arndt, Christoph Asendorf, et al. (Cologne: Könemann, 2006), 14, 16.

52. Ibid., 19.

53. Martin Faass, "Lyonel Feininger," ibid., 276, 274.

54. Norbert M. Schmitz, "Lázsló Moholy-Nagy," ibid., 295.

55. Ibid.

56. Walter Gropius, "Postscript to Abstract of an Artist," quoted in Terry Suhre, introduction to *Moholy-Nagy: A New Vision for Chicago*, exh. cat. (Springfield: University of Illinois Press, 1991), 11.

57. Jeannine Fiedler, "The Self-Portrait—Photography as the Trigger of Reflected Perception," in Fiedler, *Bauhaus*, 159.

58. See Kelly H. L'Ecuyer, et al., *Jewelry by Artists: In the Studio, 1940–2000* (Boston: MFA Publications, 2010).

59. See "Chronology," in Douglas Dreishpoon, *Theodore Roszak: Constructivist Works, 1931–1947; Paintings, Constructions, Drawings, Photograms*, exh. cat. (New York: Hirschl & Adler Galleries, 1992), 7.

60. See, for example, MFA 2001.10 (Moholy-Nagy) and MFA 2002.891 (Kandinsky).

61. Friederike Kitchen, "Josef Albers," in Fiedler, *Bauhaus*, 309.

62. Ibid., 313.

63. See Mary Emma Harris, "Josef Albers: Art Education at Black Mountain College," in *Josef Albers: A Retrospective*, exh. cat. (New York: Solomon R. Guggenheim Museum, 1988), 53; and Paul Betts, "Black Mountain College, North Carolina," in Fiedler, *Bauhaus*, 64.

64. See Frederick Horowitz and Brenda Danilowitz, *Josef Albers: To Open Eyes; The Bauhaus, Black Mountain College, and Yale* (New York: Phaidon Press, 2006), 247. Albers noted that his 1931 glass painting *In the Water* was "not an abstraction derived from an experience in nature. Its name has been chosen—after the composition has been finished—because it reminds me of the movement of water plants. Therefore the name functions as distinction, not as topic."

65. See Nicholas Fox Weber, "The Artist as Alchemist," in *Josef Albers: A Retrospective*, 33–34, where Weber also discusses Albers's fascination with a Janus helmet mask, of the type he would have been able to see at the Staatliches Museum für Völkerkunde, Munich, when he lived in that city (1919–20).

66. Michael Craig-Martin, "The Teaching of Josef Albers: A Reminiscence," *Burlington Magazine* 137, no. 1105 (April 1995): 248, 252.

67. Rob Roy Kelly, "Recollections of Josef Albers," *Source Design Issues* 16, no. 2 (Summer 2000): 3.

68. Craig-Martin, "Teaching of Josef Albers," 248.

69. Horowitz and Danilowitz, *Albers*, 144–45.

70. Ibid., 245. See Robert Birmelin, telephone interview with the author, May 23, 2006, ibid., 272n44.

71. Neal Benezra, "Chronology," in *Josef Albers: A Retrospective*, 290.

72. See César Paternosto, *White/Red*, exh. cat. (New York: Cecilia de Torres, 2001), 93. For Paternosto's writings on Albers, see César Paternosto, *The Stone and the Thread: Andean Roots of Abstract Art*, trans. Esther Allen (Austin: University of Texas Press, 1989), esp. 205–11. See also Harris, "Josef Albers," in *Josef Albers: A Retrospective*, 51.

73. See Paternosto, *White/Red*, 93.

74. Ibid.

75. See Weber, "The Artist as Alchemist," 43.

76. Anja Baumhoff, "Women at the Bauhaus," in Fiedler, *Bauhaus*, 102.

77. Ibid., Walter Gropius to Annie Weil, February 23, 1921.

78. Ibid.

79. *Modern Handmade Jewelry*, Museum of Modern Art, New York, September 17–November 17, 1946.

80. See "Handweaving for Modern Interiors," *Craft Horizons* (Winter 1949): 24.

81. "Albers was a detonator . . . [he] sparked an explosion in us," is how one student described the effect Josef Albers had on him in the 1950s. See Horowitz and Danilowitz, *Josef Albers*, 9.

Spain

1. See Diana Fane, ed., *Converging Cultures: Art and Identity in Spanish America*, exh. cat. (New York: Brooklyn Museum, in association with Harry N. Abrams, 1996).

2. For related portraits, see Guillermo Tovar de Teresa, *Miguel Cabrera: Drawing Room Painter of the Heavenly Queen* (Mexico City: InverMéxico, 1995), 38–39, 220–21, 352.

3. The authors thank Cristina Esteras Martin for researching the chalice and generously providing this information.

4. See Jeannine Falino and Gerald W. R. Ward, eds., *Silver of the Americas, 1600–2000: Silver in the Museum of Fine Arts, Boston* (Boston: MFA Publications, 2008), 465–66, 470–72, 480; and Michael Gannon, *Florida: A Short History* (Gainesville: University Press of Florida, 1993), 3–24.

5. Georgia O'Keeffe, *Georgia O'Keeffe* (New York: Viking Press, 1976), unpaginated text accompanying ill. 82.

6. Evan Charteris, *John Sargent* (New York: Charles Scribner's Sons, 1927), 28.

7. William C. Brownell, "American Pictures at the Salon," *Magazine of Art* 6 (1883): 498.

8. Erica E. Hirshler, *Sargent's Daughters: The Biography of a Painting* (Boston: MFA Publications, 2009), 108–115. "Four corners and a void" is the critical statement most often repeated about the painting. Reportedly taken from a French journal, its origin remains untraced. It is first repeated in Charteris, *John Sargent*, 57.

9. See Mitchell A. Codding, "A Legacy of Spanish Art for America: Archer M. Huntington and the Hispanic Society of America," in *Manet/Velázquez: The French Taste for Spanish Painting*, ed. Gary Tinterow and Geneviève Lacambre, exh. cat. (New York: Metropolitan Museum of Art, 2003), 307–34.

10. Ibid., 22.

11. Nita M. Renfrew, "An Interview with Carlos Mérida," in *A Salute to Carlos Mérida*, exh. cat. (Austin: University Art Museum, University of Texas at Austin, 1976), 23.

The Netherlands and Scandinavia

1. Massachusetts Historical Society, *Proceedings of the Massachusetts Historical Society, 1867–1869* (Boston, 1869), 47.

2. See Louisa Dresser et al., *Seventeenth Century Painting in New England: A Catalogue of an Exhibition Held at the Worcester Art Museum in Collaboration with the American Antiquarian Society, July and August, 1934*, exh. cat. (Worcester, Mass.: The Trustees, Worcester Art Museum, 1935); James Thomas Flexner, "Lambs in a Large Place," *Magazine of Art* 40 (1947): 59–64; James Thomas Flexner, *First Flowers of Our Wilderness* (Boston: Houghton Mifflin, 1947). The "Elizabethan" traits of the Freake-Gibbs paintings have been assumed to be an atavistic style that survived in remote provincial areas of England before being carried to America. The career of the Dutch painter Daniel Mytens, court painter to Charles I and the leading portraitist in the 1630s before Van Dyck's arrival, suggests that the Freake-Gibbs paintings were still relatively fashionable for their era.

3. Henry VIII's greatest influence on British painting was the selection of Hans Holbein the Younger as his court painter in 1536. A German, Holbein brought the advancements of

the northern Renaissance to England, introducing a new level of naturalism and erudition to English painting. Although not Netherlandish, Holbein emerges from the broader northern European artistic culture of which the Netherlands was an important component. Some of the best-known images of Queen Elizabeth, regal and triumphant, are by the Dutch-born painter Marcus Gheeraerts II. In his portraits of English nobility, particularly those of mothers and children, the stiff, direct presentation of his subjects provides a Netherlands-via-England parallel for the work of the Freake-Gibbs painter. See Karen Hearn and Rica Jones, *Marcus Gheeraerts II: Elizabethan Artist*, exh. cat. (London: Tate Publishing, 2002).

4. The Dutch established outposts in South America and the Caribbean in the seventeenth century, and there were small waves of Swedish and Dutch immigration to a number of South American destinations. In this chapter we emphasize the Dutch and Swedish presence in North America, where those colonies had a sustained impact on the art and culture of the region.

5. Russell Shorto, "The Un-Pilgrims," *New York Times*, November 27, 2003, A39; Russell Shorto, *The Island at the Center of the World: The Epic Story of Dutch Manhattan and the Forgotten Colony That Shaped America* (New York: Doubleday, 2004), 272, 107.

6. Shorto, *Island at the Center*, 275.

7. Deborah Dependahl Waters et al., *Elegant Plate: Three Centuries of Precious Metals in New York City* (New York: Museum of the City of New York, 2000), 121.

8. Patricia E. Kane et al., *Colonial Massachusetts Silversmiths and Jewelers: A Biographical Dictionary Based on the Notes of Francis Hill Bigelow and John Marshall Phillips* (New Haven: Yale University Art Gallery, 1997), 62–65, 622–25.

9. For an example of a silver sugar box marked by Edward Winslow, see MFA 42.251.

10. Louisa Wood Ruby, "Dutch Art and the Hudson Valley Patroon Painters," in *Going Dutch: The Dutch Presence in America, 1609–2009*, ed. Joyce D. Goodfriend et al. (Leiden: Brill, 2008), 28, 29. On devotional paintings, see Ruth Piwonka and Roderic H. Blackburn, *A Remnant in the Wilderness: New York Dutch Scripture History Paintings of the Early Eighteenth Century*, exh. cat. (Albany, N.Y.: Bard College Center, 1980).

11. Joyce D. Goodfriend, "Why New Netherland Matters," in *Explorers, Fortunes, and Love Letters: A Window on New Netherland* (Albany, N.Y.: New Netherland Institute and Mount Ida Press, 2009), 151.

12. John Adams, *A Collection of State-Papers, Relative to the First Acknowledgement of the Sovereignty of the United States of America* (London: John Fielding, John Debrett, and John Sewell, 1782), 13.

13. For an overview of how Dutch and Flemish painting, particularly genre scenes, influenced American art in the nineteenth century, see H. Nichols B. Clark, "A Taste for the Netherlands: The Impact of Seventeenth-Century Dutch and Flemish Genre Painting on American Art, 1800–1860," *American Art Journal* 14, no. 2 (Spring 1982): 23–38.

14. Emerson's speech, "The American Scholar," which Oliver Wendell Homes described as America's literary Declaration of Independence, was made in a commencement address to the Phi Beta Kappa Society at Harvard in 1837. Ralph Waldo Emerson, *The American Scholar* (New York: Laurentian Press, 1901).

15. For example, Jan Steen's *Twelfth-Night Feast* (MFA 54.102) invites us into the home of a prosperous Dutch family as they celebrate the arrival of the three kings in Bethlehem to rejoice at the birth of Jesus. Steen balances a generally sympathetic portrayal with ribald humor.

16. All quotes from Irving's history are taken from Washington Irving [Diedrich Knickerbocker, pseud.], *A History of New York from the Beginning of the World to the End of the Dutch Dynasty* (New York: Dodd, Mead and Company, 1915).

17. For recent interpretations of the influence of Henry Adams on American historiography, see Garry Wills, *Henry Adams and the Making of America* (Boston: Houghton Mifflin, 2005); Robin Fleming, "Picturesque History and the Medieval in Nineteenth-Century America," *American Historical Review* 100, no. 4 (1995): 1061–94.

18. The first comment on Whitney's sculpture comes from critic James Jackson Jarves writing in the *Boston Evening Transcript* in 1886; the second appeared in *Harper's Weekly*, November 1887; see Janet A. Headley, "Anne Whitney's 'Leif Eriksson': A Brahmin Response to Christopher Columbus," *American Art* 17, no. 2 (2003): 50nn15, 16. Headley also provides an overview of the Norse craze in late-nineteenth-century America. For more on how Viking legends were deployed, particularly by Norwegian immigrants to the United States, see J. M. Mancini, "Discovering Viking America," *Critical Inquiry* 28, no. 4 (Summer 2002): 868–907. For more on the search for Viking history in Massachusetts, including places where Viking motifs appear in late-nineteenth-century Boston buildings, see Gloria Polizzotti Greis, "Vikings on the Charles," at http://greisnet.com/needhist.nsf/VikingsontheCharles (accessed September 27, 2009).

19. For an overview of how American historians handled the Dutch, see Annette Stott, *Holland Mania: The Unknown Dutch Period in American Art and Culture* (Woodstock, N.Y.: Overlook Press, 1998), 78–100.

20. John Lothrop Motley, *The Rise of the Dutch Republic*, vol. 1 (New York: Harper and Brothers, 1856), v.

21. Ibid., vi.

22. Stott, *Holland Mania*; and Annette Stott, "The Dutch Dining Room in Turn-of-the-Century America," *Winterthur Portfolio* 37, no. 4 (Winter 2002): 219–38.

23. On the early and enthusiastic reception of Dutch art in the United States, see Stott, *Holland Mania*, 19–42. For the history of collecting Dutch art in Boston, see Ronni Baer, *The Poetry of Everyday Life: Dutch Painting in Boston*, exh. cat. (Boston: MFA Publications, 2002); and Carol Troyen and Pamela S. Tabbaa, *The Great Boston Collectors: Paintings from the Museum of Fine Arts*, exh. cat. (Boston: Museum of Fine Arts, 1984), 16. For the paintings included in the Hudson-Fulton exhibition at the Metropolitan Museum of Art, see Wilhelm Reinhold Valentiner, *Catalogue of a Loan Exhibition of Paintings by Old Dutch Masters Held at the Metropolitan Museum of Art in Connection with the Hudson-Fulton Celebration* (New York: Metropolitan Museum of Art, 1910). Dennis Weller considers the impact of the Hudson-Fulton exhibition in "Old Masters in the New World: The Hudson-Fulton Exhibition of 1909 and Its Legacy," in Goodfriend et al., *Going Dutch*.

24. Philip Leslie Hale, *Jan Vermeer of Delft* (Boston: Small, Maynard, 1913), 6. For more on the Boston School aesthetic, see Erica E. Hirshler et al., *A Studio of Her Own: Women Artists in Boston, 1870–1940*, exh. cat. (Boston: MFA Publications, 2001), 100–103.

25. For example, Israëls's *The Day before Parting* presents a grieving widow, her head turned down in mourning, as she prepares herself for the burial of her husband. Her right hand supports her head and hides her emotion. The left holds her place in the Bible. Her daughter sits at her feet, staring into the darkened room, where a single candle keeps vigil, an emblem of the departed father. It is a study of pious sorrow and familial affection, tender, noble, and virtuous. See the painting in the MFA's collection (18.278).

26. For a history of Gallatin's museum, see Gail Stavitsky, "A. E. Gallatin's Gallery and Museum of Living Art (1927–1943)," *American Art* 7, no. 2 (Spring 1993): 47–63.

27. Ilya Bolotowsky and Henry Geldzahler, "Adventures with Bolotowsky," *Archives of American Art Journal* 22, no. 1 (1982): 8–31.

28. Charmion von Wiegand, "Mondrian: A Memoir of His New York Period," *Arts Yearbook* 4 (1961): 58.

29. A page from the photo essay first published by *Life* magazine in 1954, "Mathematics by the Yard: Science's Symbols Decorate Fabrics," was reprinted in Christa C. Mayer Thurman, *Rooted in Chicago: Fifty Years of Textile Design Traditions* (Chicago: Art Institute of Chicago, 1997), 8.

30. "Markelius, Sven," in *Oxford Art Online*, at http://www.oxfordartonline.com/subscriber/article/grove/art/T054446 (accessed December 14, 2009); Mel Byars, *The Design Encyclopedia* (New York: John Wiley and Sons, 1994), 358.

31. For a general survey of design of this period, see George H. Marcus, *Design in the Fifties: When Everyone Went Modern* (Munich: Prestel-Verlag, 1998).

32. Jewel Stern, *Modernism in American Silver: 20th-Century Design* (New Haven: Yale University Press, 2005), 192–99, 375–76.

33. For an example of an innovative silver teapot made during Ebendorf's time abroad, see Barbara McLean Ward and Gerald W. R. Ward, eds., *Silver in American Life: Selections from the Mabel Brady Garvan and Other Collections at Yale University*, exh. cat. (New York: American Federation of the Arts, 1987), 86–87, cat. 57.

34. See Thomas S. Michie and Christopher P. Monkhouse, eds., *John Prip: Master Metalsmith* (Providence: Rhode Island School of Design, 1987).

35. For examples of the production line of the *Dimensions* service, see MFA 2008.79.1, 2008.79.2, 2008.79.3a–b, 2008.79.4, 2008.79.5, and 2008.79.6a–b.

36. Stern, *Modernism in American Silver*, 246–51, 367–68.

AFRICA, THE NEAR EAST, ASIA AND THE AMERICAS

Artistic Influences of the Non-Western World

1. George Kuwayama, *Chinese Ceramics in Colonial Mexico* (Los Angeles: Los Angeles County Museum of Art, 1997), 11–25; Mitchell A. Codding, "The Decorative Arts in Latin America, 1492–1820," in *The Arts of Latin America, 1492–1820*, ed. Joseph J. Rishel et al., exh. cat. (New Haven: Yale University Press, 2006), 57–69.

2. Isabel Breskin, "'On the Periphery of a Greater World': John Singleton Copley's 'Turquerie' Portraits," *Winterthur Portfolio* 36, nos. 2–3 (Summer–Autumn 2001): 97–123.

3. Edward Sylvester Morse, *Japanese Homes and Their Surroundings* (Boston: Ticknor, 1886).

4. Dale Rosengarten, Theodore Rosengarten, and Enid Schildkrout, *Grass Roots: African Origins of an American Art*, exh. cat. (New York: Museum for African Art, 2008).

5. Edward W. Said, *Orientalism* (New York: Pantheon Books, 1978).

6. Philip F. Gura and James F. Bollman, *America's Instrument: The Banjo in the Nineteenth Century* (Chapel Hill: University of North Carolina Press, 1999).

7. Hannah Sigur, *The Influence of Japanese Art on Design* (Layton, Utah: Gibbs Smith, 2008).

Africa

1. *Africa*, like the continent it describes, is a broad term. In many cases, the peoples discussed here would not identify themselves primarily as African. Like people everywhere, they define themselves by ethnicity, shared languages, and cultural practices. While we use *Africa* frequently here as a convenient handle, we also have made an effort to be more specific where possible in acknowledgment of the rich diversity within Africa.

2. Joseph E. Holloway, "The Origins of African-American Culture," in *Africanisms in American Culture*, ed. Joseph E. Holloway (Bloomington: Indiana University Press, 1990), 17.

3. This is the crux of the "Herskovits-Frazier" debate that shaped twentieth-century research on African American culture. The sociologist E. Franklin Frazier believed that the experience of African Americans, namely slavery, eliminated all traces of African culture. In contrast, the anthropologist Melville J. Herskovits argued for the persistence of African culture in the Americas. He popularized the notion of Africanisms—aspects of African American culture that could be traced to African sources—and identified hundreds of examples. See Melville J. Herskovits, *The Myth of the Negro Past* (New York: Harper and Brothers, 1941). In recent decades, scholars have turned away from the idea of Africanisms, which often imply a singular African culture. Instead they favor concepts like the Black Atlantic and the African diaspora, which support a more nuanced understanding of the diversity of Africa and the complexity of the cultural interchange that resulted from the dispersal of African peoples throughout the globe. Paul Gilroy, *The Black Atlantic: Modernity and Double Consciousness* (Cambridge, Mass.: Harvard University Press, 1993).

4. Quoted in David Driskell, *Two Centuries of Black American Art*, exh. cat. (Los Angeles: Los Angeles County Museum of Art; New York: Alfred A. Knopf, 1976), 20. On slave artisans in cities and on plantations, see also Judith Wragg Chase, *Afro-American Art and Craft* (New York: Van Nostrand Reinhold Company, 1971), 65–91; and John Michael Vlach, *The Afro-American Tradition in Decorative Arts*, exh. cat. (Cleveland: Cleveland Museum of Art, 1978).

5. Robert Fitts, *Inventing New England's Slave Paradise: Master/Slave Relations in Eighteenth-Century Narragansett, Rhode Island* (New York: Garland Publishing, 1998), 69–104.

6. On Robinson family slave ownership, see Carl R. Woodward, *Plantation in Yankeeland* (Wickford, R.I.:

Cocumsussoc Association, 1971), 72–73, and Robinson Family Genealogical and Historical Association, *The Robinsons and Their Kin Folk* (New York: Robinson Family Genealogical and Historical Association, 1906), 23–25, 43.

7. For recent scholarship on recovering the work of slave craftsmen, see Daniel Kurt Ackermann, "'Black and White All Mix'd Together': The Hidden Legacy of Enslaved Craftsmen," *Antiques and Fine Art* 9, no. 2 (Winter–Spring 2009): 261–65.

8. Theodore C. Landsmark, "Comments on African American Contributions to American Material Life," *Winterthur Portfolio* 33, no. 4 (Winter 1998): 261–82. On the question of African American craftsmen and their assimilation into white culture, see also Jonathan Prown, "The Furniture of Thomas Day: A Reevaluation," *Winterthur Portfolio* 33, no. 4 (Winter 1998): 215–29.

9. Vlach, *Afro-American Tradition*, 76.

10. For an interpretation of this inscription, see Leonard Todd, *Carolina Clay: The Life and Legend of the Slave Potter Dave* (New York: W. W. Norton, 2008), 239. Todd traces the word *lucre* to "filthy lucre" in 1 Timothy 3:8. On Dave the Potter's life and career, see Jill Beute Koverman, ed., *I Made This Jar . . . : The Life and Works of the Enslaved African-American Potter, Dave*, exh. cat. (Columbia: McKissick Museum, University of South Carolina, 1998).

11. Aaron De Groft, "Eloquent Vessels/Poetics of Power: The Heroic Stoneware of 'Dave the Potter,'" *Winterthur Portfolio* 33, no. 4 (Winter 1998): 249–60; Landsmark, "Comments on African American Contributions," 270–72.

12. For a detailed survey of colonial writers' observations of the banjo as an African instrument, see Dena J. Epstein, "The Folk Banjo: A Documentary History," *Ethnomusicology* 20 (1976): 347–71; and Philip F. Gura and James F. Bollman, *America's Instrument: The Banjo in the Nineteenth Century* (Chapel Hill: University of North Carolina Press, 1999).

13. Gura and Bollman, *America's Instrument*, 4–5.

14. Epstein, "Folk Banjo." See also David Evans, "The Reinterpretation of African Musical Instruments in the United States," in *The African Diaspora: African Origins and New World Identities*, ed. Isidore Okpewho, Carole Boyce Davies, and Ali A. Mazrui (Bloomington: Indiana University Press, 1999), 379–90; and Leo G. Mazow, *Picturing the Banjo*, exh. cat. (University Park: Pennsylvania State University Press, 2005).

15. The most recent and detailed study of the quilt is Kyra Hicks, *This I Accomplish: Harriet Powers' Bible Quilt and Other Pieces* (n.p.: Black Threads Press, 2009). The historian Laurel Thatcher Ulrich has recently lectured on the evolving interpretations of the quilt over time. See Laurel Thatcher Ulrich, "'A Quilt unlike Any Other': Rediscovering the Work of Harriet Powers" (unpublished manuscript from a lecture, Museum of Fine Arts, Boston, Department of Textile and Fashion Arts, March 21, 2008, object file, 64.619).

16. On the relation to Fon appliqués and the problems of linking those works historically to Powers, see Marie Jeanne Adams, "The Harriet Powers Pictorial Quilts," *Black Art* 3, no. 4 (1980): 24–25, as well as Vlach, *Afro-American Tradition*, 44–54.

17. Maude Southwell Wahlman, "African Symbolism in Afro-American Quilts," *African Arts* 20, no. 1 (November 1986): 68–76, 99.

18. Ulrich, "A Quilt unlike Any Other." See Anita Zeleski Weinraub, ed., *Georgia Quilts: Piecing Together a History* (Athens: University of Georgia Press, 2006).

19. On the narrative interpretation of the quilt, see Adams, "Harriet Powers," 17–21. Powers's description is preserved in an unsigned, handwritten transcription, Museum of Fine Arts, Boston, Department of Textile and Fashion Arts, ANC.2816.

20. For the most detailed historical account of coiled baskets, see Dale Rosengarten, Theodore Rosengarten, and Enid Schildkrout, *Grass Roots: African Origins of an American Art*, exh. cat. (New York: Museum for African Art, 2008). On particular African origins, see esp. 20–61.

21. Vlach, *Afro-American Tradition*, 7–10.

22. Dale Rosengarten, *Row upon Row: Sea Grass Baskets of the South Carolina Lowcountry*, exh. cat. (Columbia: McKissick Museum, University of South Carolina, 1986).

23. Maurice de Vlaminck, *Portraits avant décès*, reprinted in *Primitivism and Twentieth-Century Art: A Documentary History*, Documents of Twentieth-Century Art, ed. Jack D. Flam and Miriam Deutch (Berkeley: University of California Press, 2003), 28.

24. Marius de Zayas, *African Negro Art: Its Influence on Modern Art* (New York: Modern Gallery, 1916), in Patricia Hills, *Modern Art in the USA: Issues and Controversies of the 20th Century* (Upper Saddle River, N.J.: Prentice Hall, 2001), 17.

25. Picasso, in Flam and Deutch, *Primitivism and Twentieth-Century Art*, 33.

26. Max Weber, "The Fourth Dimension from a Plastic Point of View," *Camera Work*, no. 31 (July 1910): 25, reprinted in Hills, *Modern Art in the USA*, 24.

27. Ibid., 23.

28. The photograph, taken by his student Clara Sipprell, evokes the perspective of *New York*, which looks down from the Singer Building at the Liberty Tower as a kind of carved figure. By manipulating the focus, Sipprell has emphasized Weber's active contemplation of the Yaka sculpture. See MFA 2005.301.

29. Clifford Ross, *Abstract Expressionism: Creators and Critics; An Anthology* (New York: H. N. Abrams, 1990), 211–12, reprinted in Lawrence Alloway et al., *The Pictographs of Adolph Gottlieb*, exh. cat. (New York: Hudson Hills Press, in association with Adolph and Esther Gottlieb Foundation, 1994), 34.

30. Ibid., 32.

31. Ibid., 34.

32. Langston Hughes, "The Negro Artist and the Racial Mountain," *Nation*, June 23, 1926. Hughes was writing in response to George Schuyler, who had argued that black Americans shared the same social and cultural experiences as white Americans, refuting the idea that a distinct black identity or aesthetic could or should exist in an egalitarian society.

33. Alain Locke, "Notes on African Art," *Opportunity, Journal of Negro Life* (May 1924), reprinted in Flam and Deutch, *Primitivism and Twentieth-Century Art*, 188, 192.

34. Some of the first anthropological studies of Africanisms appeared in the mid-1920s and focused on folklore and religion. See Holloway, *Africanisms in American Culture*.

35. See, for example, the early-twentieth-century Shango staff in the MFA's collection, 1991.1070.

36. On anaforuana, see Robert Farris Thompson, *Flash of the Spirit: African and Afro-American Art and Philosophy* (New York: Random House, 1983); and Saki Mafundikwa, *Afrikan Alphabets: The Story of Writing in Africa* (West New York, N.J.: Mark Batty, 2004).

37. Max Pol Fouchet and Wifredo Lam, *Wifredo Lam* (New York: Rizzoli, 1976), 188.

38. Matt Backer, *"Black Spirit": Works on Paper by Eldzier Cortor*, exh. brochure (Bloomington: Indiana University Art Museum, 2006).

39. Romare Bearden and Harry Henderson, *A History of African-American Artists: From 1792 to the Present* (New York: Pantheon Books, 1993), 276.

40. Elton C. Fax, *Seventeen Black Artists* (New York: Dodd, Mead, 1971), 88.

41. For a typical Farm Security Administration photograph of such an interior, see Marion Post Walcott's 1939 photograph *Interior of Negro Tenant's Home on Marcella Plantation. Mileston, Mississippi Delta, Mississippi*, available through the Library of Congress, Prints and Photographs Online Catalog, http://hdl.loc.gov/loc.pnp/fsa.8c10751 (accessed February 5, 2010).

42. For Smith's discussion of African influences and good design, see Art Smith, "Jewelry-Making Is My Craft," *Opportunity: The Journal of Negro Life* (Winter 1948): 14–15. Fashion articles about Art Smith and his jewelry, with photographs, appeared in more than a dozen mainstream publications in 1953, many with the same professional photos of a model, suggesting a coordinated promotional campaign. Art Smith Papers, 1953 press clippings, Hatch-Billops Collection, New York.

43. Quoted in Arthur Smith and James L. de Jongh, "Arthur Smith: An Autobiography," in Jamaica Arts Center, *Arthur Smith: A Jeweler's Retrospective*, exh. cat. (Jamaica, N.Y.: Jamaica Arts Center, 1990), not paginated.

44. On Smith's family background, see Charles Russell, "Arthur Smith: His Life and Work" (manuscript, Museum of Fine Arts, Boston, Department of Art of the Americas, May 3, 2009, Art Smith artist file), pt. 1, chap. 1, 1–28.

45. On Smith's career, see Barry Harwood, *From the Village to Vogue: The Modernist Jewelry of Art Smith*, exh. cat. (New York: Brooklyn Museum, 2008); Toni Greenbaum, *Messengers of Modernism: American Studio Jewelry, 1940–1960*, exh. cat. (Paris: Flammarion, in association with Montreal Museum of Decorative Arts, 1996), 86–95; and Jamaica Arts Center, *Arthur Smith*.

46. Russell, "Arthur Smith," pt. 1, chap. 3, 12.

47. This observation was made by Toni Lesser Wolf in "Mid-Century Jewelry and Art Smith," in Jamaica Arts Center, *Arthur Smith*.

48. Edmund Barry Gaither, "African and African American Art: An African American Legacy," in *Art of the Senses: African Masterpieces from the Teel Collection*, ed. Suzanne Preston Blier, (Boston: MFA Publications, 2004), 47–50.

49. Review in *Craft Horizons* 32, no. 5 (October 1972): 55. Cummings, quoted in Carol Ann Lyons Miller, "The Artistry of Clockmaking: The Intuitive Designs of Frank Cummings," *Clockwise* (March 1980): 21.

50. For details on the clock's elaborate handmade mechanisms, see Miller, "Artistry of Clockmaking." See also Edward S. Cooke, Gerald W. R. Ward, and Kelly H. L'Ecuyer, *The Maker's Hand: American Studio Furniture, 1940–1990*, exh. cat. (Boston: MFA Publications, 2003), 69 and 116.

51. Cummings discussed his African experiences, the clock, and its reception in museum exhibitions in great depth in an oral history interview in 2007. See "Oral History Interview with Frank E. Cummings, III, 2006 Dec. 28–2007 Jan. 5," Smithsonian Archives of American Art, pp. 25–28, transcript available online at www.aaa.si.edu/collections/oralhistories/transcripts/cummin06.htm (accessed June 15, 2009).

52. Cole's most complete formulation of iron brands as a metaphor for the slave trade is found in his large-scale woodblock print *Stowage*, from 1997; see *Anxious Objects: Willie Cole's Favorite Brands*, exh. cat. (Montclair, N.J.: Montclair Art Museum, 2006), 60–61, 72–73, 86–87. See Cole's *Many Spirit Mask* triptych, MFA 2005.125.1–3.

53. Interview with Cole, ibid., 89–99.

The Near East

1. For the primarily historical purposes of this essay, the authors have chosen to use the period terminology of "the Near East." A landmark study of Western attitudes and treatment of this region is Edward W. Said's *Orientalism* (New York: Pantheon Books, 1978), which used primarily literary evidence. In *Noble Dreams, Wicked Pleasures: Orientalism in America, 1870–1930*, exh. cat. (Princeton: Princeton University Press, 2000), Holly Edwards expands Said's approach to encompass the visual arts and narrows it to specifically American art. An excellent summary of the study of Islamic art is Sheila S. Blair and Jonathan M. Bloom, "The Mirage of Islamic Art: Reflections on the Study of an Unwieldy Field," *Art Bulletin* 85, no. 1 (March 2003): 152–84.

2. Sarah E. Sherrill, *Carpets and Rugs in England and America* (New York: Abbeville Press, 1996), 13–27.

3. Margaret Swain, "The Turkey-Work Chairs of Holyroodhouse," in *Upholstery in America and Europe from the Seventeenth Century to World War I*, ed. Edward S. Cooke, Jr. (New York: W. W. Norton, 1987), 51–63.

4. Ibid., 51–63.

5. Examples include an important maple and oak couch made in Boston in 1697 or 1698 for John Leverett (Peabody Essex Museum, Salem, Mass.); two Boston side chairs, one dating 1660–1680 and the other 1670–1700 (Metropolitan Museum of Art, New York); and a Boston side chair dating 1680–1700 (New York State Education Department, Albany).

6. Swain, "Turkey-Work Chairs," 51–63; Donald King and David Sylvester, eds., *The Eastern Carpet in the Western World: From the 15th to the 17th Century*, exh. cat. (London: Arts Council of Great Britain, 1983), 9; Benno M. Forman, *American Seating Furniture, 1630–1730* (New York: W. W. Norton, 1988), 201–4. A chair with the same pattern of turkey-work design is illustrated in Mildred B. Lanier, *English and Oriental Carpets at Williamsburg*, (Williamsburg, Va.: Colonial Williamsburg Foundation, 1975), 10–11. Lanier cites one chair at the Victoria and Albert Museum, London, and four at the Brooklyn Museum, which appear to be from the same set. Wood analysis on the MFA's chair was inconclusive.

7. The term *arabesque* can be confusing, as it was (and is) also used erroneously to describe grotesque decoration from ancient Greece and Rome that was revived and adapted by artists during the sixteenth-century Renaissance in Italy. The mixing of terms presumably is because the Greek and Roman grotesques incorporated characteristics similar to the Arabian designs. When the ancient grotesque designs were labeled "arabesque" in the sixteenth century, Westerners then often called the original Arabian art form the Saracenic, Moresque, or Moorish. For more on the similarities and differences between the Saracenic arabesque and the Renaissance arabesque, see Richard Ettinghausen, Oleg Grabar, and Marilyn Jenkins-Madina, *Islamic Art and Architecture, 650–1250* (New Haven: Yale University Press, 2001), or Hugh Chisholm, ed., *Encyclopedia Britannica*, 11th ed. (New York: Encyclopedia Britannica, 1911), 2:253.

8. Héctor Rivero Borrell Miranda et al., *The Grandeur of Viceregal Mexico: Treasures from the Museo Franz Mayer*, exh. cat. (Houston: Museum of Fine Arts; Mexico City: Museo Franz Mayer, 2002), 160–61.

9. William J. Bernstein, *A Splendid Exchange: How Trade Shaped the World* (New York: Atlantic Monthly Press, 2008), 243–51; "Coffee Notes," research files of Gerald W. R. Ward; and a manuscript version of Michelle Craig McDonald and Steven Topik, "Americanizing Coffee: Consumption, Culture and Diplomacy," in *Food and Globalisation*, ed. Frank Trentmann and Alexander Neutzenadlel (Oxford: Berg, 2008).

10. For more information on turquerie in Copley's portraits, see Isabel Breskin, "'On the Periphery of a Greater World': John Singleton Copley's 'Turquerie' Portraits," *Winterthur Portfolio* 36, nos. 2–3 (Summer–Autumn 2001): 97–123.

11. Turquerie was most often worn as a form of fancy dress or at costume balls. See Aileen Ribero, *Dress in Eighteenth-Century Europe, 1715–1789* (New Haven: Yale University Press, 2002), 265–72.

12. Early New England Congregationalists, for example, saw themselves as the successors to the ancient Israelites, forming a new promised land in the wilderness of America. Neil Asher Silberman, *Digging for God and Country: Exploration, Archaeology, and the Secret Struggle for the Holy Land, 1799–1917* (New York: Alfred A. Knopf, 1982), 30–33.

13. Steven W. Holloway, "Nineveh Sails for the New World," *Iraq* 66 (2004): 243–56.

14. Elihu Vedder, *The Digressions of V.* (Boston: Houghton Mifflin, 1910), 451.

15. Amelia B. Edwards, *A Thousand Miles up the Nile* (1877; London: George Routledge, 1899), xvii.

16. Katherine C. Grier, *Culture and Comfort: People, Parlors, and Upholstery, 1850–1930*, exh. cat. (Rochester, N.Y.: Strong Museum, 1988), 183–200.

17. For more information on gender roles in the mid-nineteenth century and the "cult of domesticity," see Nancy F. Cott, *The Bonds of Womanhood: "Woman's Sphere" in New England, 1780–1835* (New Haven: Yale University Press, 1997); and Signe O. Wegener, *James Fenimore Cooper versus the Cult of Domesticity: Progressive Themes of Femininity and Family in the Novels* (Jefferson, N.C.: McFarland, 2005).

18. The "Moorish" smoking room was originally installed in 1881 by the real-estate tycoon Arabella Worsham in her brownstone mansion at 4 West Fifty-fourth Street in New York. It was thought to have been done under the direction of the little-known interior design firm George A. Schastey and Company. John D. Rockefeller purchased the home from Worsham in 1884 and kept the smoking room intact.

19. Oliver Coleman, *Successful Homes* (1899), quoted in Cheryl Robertson, "Male and Female Agendas for Domestic Reform: The Middle-Class Bungalow in Gendered Perspective," *Winterthur Portfolio* 26, nos. 2–3 (Summer–Autumn 1991): 138.

20. Grier, *Culture and Comfort*, 187–93.

21. Marilyn Jenkins-Madina, "Collecting the 'Orient' at the Met: Early Tastemakers in America," in "Exhibiting the Middle East: Collections and Perceptions of Islamic Art," ed. Linda Komaroff, special issue, *Ars Orientalis* 30 (2000): 79.

22. Zeynep Çelik, "Speaking Back to Orientalist Discourse at the World's Columbian Exposition," in Edwards, *Nobel Dreams*, 77–82, 192–99.

23. Ibid., 206.

24. Ibid., 200–205.

25. Edward J. Sullivan, "Interview with Claudio Bravo," in *Claudio Bravo and Morocco*, exh. cat. (Paris: Institut du Monde Arabe, 2004), 16.

Asia

1. For more on the Silk Road, see Anne Wardwell and James Watt, with an essay by Morris Rossabi, *When Silk Was Gold,* exh. cat. (New York: Abrams, 1997); or John Vollmer et al., *Silk Roads, China Ships,* exh. cat. (Toronto: Royal Ontario Museum, 1983).

2. For summaries of the formation of the early China trade, see Dawn Jacobson, *Chinoiserie* (London: Phaidon Press, 1993); Oliver Impey, *Chinoserie: The Impact of Oriental Styles on Western Art and Decoration* (New York: Charles Scribner's Sons, 1977), 29–50; Amanda E. Lange, *Chinese Export Art at Historic Deerfield,* exh. cat. (Deerfield, Mass.: Historic Deerfield, 2005), 9–11; and Ellen Paul Denker, *After the Chinese Taste: China's Influence in America, 1730–1930,* exh. cat. (Salem, Mass.: Peabody Museum, 1985), 1–8.

3. Some estimates suggest that nearly one-third of all silver exported from the Americas in this period was sent to China. Elena Phipps, Johanna Hecht, and Christina Esteras Martín, *The Colonial Andes: Tapestries and Silverwork, 1530–1830,* exh. cat. (New Haven: Yale University Press, 2004), 247.

4. Gauvin Alexander Bailey, "Asia in the Arts of Colonial Latin America," in *The Arts in Latin America, 1492–1820,* ed. Joseph J. Rishel et al., exh. cat. (New Haven: Yale University Press, 2006), 57–69. In addition, visits by Asian nobility, complete with large cargoes of Asian products, are documented in the early 1600s, and European religious and civil servants often served missionary stints in Asian colonies before taking up posts in the Americas. Ibid.

5. Ibid., 65–66; and Phipps, Hecht, and Martín, *The Colonial Andes,* 250–53.

6. As quoted in George Kuwayama, *Chinese Ceramics in Colonial Mexico* (Los Angeles: Los Angeles County Museum of Art, 1997), 24.

7. Margaret Connors McQuade, "Jar and Jar with Iron Lid," in *The Grandeur of Viceregal Mexico: Treasures from the Museo Franz Mayer,* by Héctor Rivero Borrell Miranda et al., exh. cat. (Houston: Museum of Fine Arts; Mexico City: Museo Franz Mayer, 2002), 230–32; Mitchell A. Codding, "The Decorative Arts in Latin America, 1492–1820," in Rishel et al., *The Arts in Latin America,* 99–113; Jean McClure Mudge, *Chinese Export Porcelain in North America* (New York: Clarkson N. Potter, 1986), 49.

8. Immigrants already exposed to the Chinese taste may have brought Asian objects, such as porcelains, with them, but the colony's small population did not inspire extensive trade.

9. Impey, *Chinoiserie,* 42–43; and Jacobson, *Chinoiserie,* 19.

10. Impey, *Chinoiserie.*

11. Japanning was also practiced in Latin America, specifically around San Juan de Pasto (present-day Colombia) and Michoacán (New Spain), where it was combined with pre-Hispanic lacquer traditions to create a hybrid style. For more on japanning and lacquer in Latin America, see Bailey, "Asia in the Arts of Colonial Latin America," 65–66.

12. Stalker and Parker, as quoted in Edward S. Cooke, Jr., "In and Out of Fashion: Changing American Engagements with Chinese Furniture," in *Inspired by China: Contemporary Furnituremakers Explore Chinese Traditions,* by Nancy Berliner and Edward S. Cooke, Jr., exh. cat. (Salem, Mass.: Peabody Essex Museum, 2006), 43; and "Lacquer," in *The Grove Encyclopedia of Materials and Techniques in Art,* ed. Gerald W. R. Ward (New York: Oxford University Press, 2008), 318–31.

13. Dean A. Fales, Jr., "Boston Japanned Furniture," in *Boston Furniture of the Eighteenth Century* (Boston: Colonial Society of Massachusetts, 1974), 49–69.

14. Cooke, "In and Out of Fashion," 44–45. For illustrations and descriptions of comparable Chinese furniture, see Nancy Berliner, *Beyond the Screen: Chinese Furniture of the 16th and 17th Centuries,* exh. cat. (Boston: Museum of Fine Arts, Boston, 1996).

15. Cooke, "In and Out of Fashion," 44; and Sarah Fayen, "Tilt-Top Tables and Eighteenth-Century Consumerism," in *American Furniture 2003,* ed. Luke Beckerdite (Milwaukee: Chipstone Foundation, 2003), 95–137. See MFA Res.34.1 for a comparable Chinese export porcelain teapot.

16. The secret of making Chinese porcelain (called "true") was not in the process or technique but in the ingredients: flint, *petuntse* (china stone), and kaolin clay, an unusually pure white clay found only in Asia. "Ceramics," in Ward, *Grove Encyclopedia of Materials and Techniques,* 92–101.

17. Because English manufacturers created a version that incorporated bone ash, English soft-paste porcelain was called bone china. For more information on English soft-paste porcelain, see ibid., and Bertrand Rondot, ed., *Discovering the Secrets of Soft-Paste Porcelain at the Saint-Cloud Manufactory, ca. 1690–1766* (New Haven: Yale University Press for the Bard Graduate Center for the Studies in the Decorative Arts, New York, 1999).

18. Stanley South, "John Bartlam's Porcelain at Cain Hoy, 1976–1770," in *Ceramics in America 2007,* ed. Robert Hunter (Hanover, N.H.: University Press of New England for the Chipstone Foundation, 2007), 196–203. For more information on Bartlam's porcelain production, also see Stanley South, *John Bartlam: Staffordshire in Carolina,* South Carolina Institute of Archaeology and Anthropology Research Manuscript Series 231 (Columbia: University of South Carolina, 2004). The entire 2007 issue of *Ceramics in America* is dedicated to the study of Bonnin and Morris's American China Manufactory. Also see Alice C. Frelinghuysen, *American Porcelain, 1770–1920,* exh. cat. (New York: Harry N. Abrams for the Metropolitan Museum of Art, 1989), 6–11, 72–77.

19. The English designer Thomas Chippendale's famous *The Gentleman and Cabinet-Maker's Director,* 1st ed. (London, 1754) published a range of Rococo furniture designs, including some labeled "in the Chinese Manner." For more information on English printed design books, see Peter Ward-Jackson, *English Furniture Designs of the Eighteenth Century* (London: Her Majesty's Stationery Office, 1958); and Morrison H. Heckscher, "English Furniture Pattern Books in Eighteenth-Century America," in *American Furniture, 1994,* ed. Luke Beckerdite (Milwaukee: Chipstone Foundation, 1994), 173–205.

20. John T. Kirk, *American Furniture and the British Tradition to 1830* (New York: Alfred A. Knopf, 1982), 119. For an example of Chinese guardian lions, see MFA 01.5771–72.

21. Brandon Brame Fortune and Deborah J. Warner, *Franklin and His Friends: Portraying the Man of Science in Eighteenth-Century America,* exh. cat. (Philadelphia: University of Pennsylvania Press, 1999), 62; and Carrie Rebora et al., *John Singleton Copley in America,* exh. cat. (New York: Metropolitan Museum of Art, 1995), 224–28.

22. Hina Hirayama, "'A True Japanese Taste': Construction of Knowledge about Japan in Boston" (PhD diss., Boston University, 1999), 37; see also Philip Chadwick Foster Smith, *The Empress of China* (Philadelphia: Philadelphia Maritime Museum, 1984); and Lange, *Chinese Export Art at Historic Deerfield,* 11–14.

23. For the plate, see MFA 53.2084. For more on Thomas H. Perkins, see Thomas G. Cary, *Memoir of T. H. Perkins* (1856; Whitefish, Mont.: Kessinger Publishing, 2007); and Carl Seaburg and Stanley Paterson, *Merchant Prince of Boston, Colonel T. H. Perkins, 1764–1854* (Cambridge, Mass.: Harvard University Press, 1971).

24. Over the course of the eighteenth century, the Chinese government increasingly limited Western access to China. In 1720 the Co-Hong rule was implemented, which put thirteen Chinese merchants in charge of the Canton trade. In 1757 the government closed all Chinese ports except for Canton, making the small strip of land outside the Canton gates the only area in China that Westerners (men only) were allowed to visit from 1757 to 1841. Carl L. Crossman, *The Decorative Arts of the China Trade* (Woodridge, Suffolk: Antiques Collectors' Club, 1991), 15–20.

25. At the end of the Opium Wars in 1842, the British established a colony in Hong Kong and negotiated for greater freedom of movement for Westerners in China and the opening of several Chinese ports for trade, including Shanghai, Xiamen, Fuzhou, and Ningbo. In 1844 the U.S. government was granted similar trading privileges.

26. For an extensive discussion of the perceptions and stereotyping of Chinese immigrants in the United States, see Robert McClellan, *The Heathen Chinee: A Study of American Attitudes toward China, 1890–1905* (Columbus: Ohio State University Press, 1971).

27. John Rogers Haddad, *The Romance of China: Excursions to China in U.S. Culture, 1776–1876* (New York: Columbia University Press, 2008).

28. For more information on the opening of Japanese ports and the resulting political turmoil in Japan, see William Hosley, *The Japan Idea: Art and Life in Victorian America,* exh. cat. (Hartford, Conn.: Wadsworth Atheneum, 1990), 17–28; Hirayama, "'True Japanese Taste,'" 60–62; and Clay

Lancaster, *The Japanese Influence in America: The First Century Following Ratification of Perry's Treaty* (Salvisa, Ky.: Warwick Publications, 1983), 18.

29. For general background on the influence of Japanese prints on European and American artists, see Colta Feller Ives, *The Great Wave: The Influence of Japanese Woodcuts on French Prints*, exh. cat. (New York: Metropolitan Museum of Art, 1974); and Gabriel Weisberg et al., *Japonisme: Japanese Influence on French Art, 1854–1910*, exh. cat. (Cleveland: Cleveland Museum of Art, 1975). See also Vivian Green, "Aestheticism and Japan: The Cult of the Orient," in *The Third Mind: American Artists Contemplate Asia, 1860–1989*, by Alexandra Munroe et al., exh. cat. (New York: Guggenheim Museum, 2009), 59–71.

30. For more on the development of japonisme in Europe, see Siegfried Wichmann, *Japonisme: The Japanese Influence on Western Art in the 19th and 20th Centuries* (New York: Harmony Books, 1980). For an excellent overview of the influence of Japanese art on the United States, see Hannah Sigur, *The Influence of Japanese Art on Design* (Layton, Utah: Gibbs Smith, 2008).

31. The bibliography on Whistler is extensive. See esp. David Park Curry, *James McNeill Whistler at the Freer Gallery of Art*, exh. cat. (Washington, D.C.: Smithsonian Institution; New York: W. W. Norton, 1984); Margaret F. MacDonald, *James McNeill Whistler: Drawings, Pastels, and Watercolors; A Catalogue Raisonné* (New Haven: Yale University Press for the Paul Mellon Centre for Studies in British Art, 1995); Linda Merrill, *The Peacock Room: A Cultural Biography* (Washington, D.C.: Freer Gallery of Art, Smithsonian Institution; New Haven: Yale University Press, 1998); and Thomas Lawson and Linda Merrill, *Freer: A Legacy of Art* (New York: Harry N. Abrams, 1993). See Wichmann, *Japonisme*, 8, for a quote by William Michael Rossetti, who observed: "It was through Whistler that my brother and I became acquainted with Japanese woodcuts and color prints. [I] hardly know that anyone in London paid any attention to Japanese designs prior to this."

32. Henry Adams, "John La Farge's Discovery of Japanese Art: A New Perspective on the Origins of Japonisme," *Art Bulletin* 67, no. 3 (September 1985): 449–85.

33. See MFA 21.1442 and Res.27.93, respectively.

34. For a convincing analysis of La Farge's early involvement with Japanese art before Bracquemond and Whistler, see Adams, "La Farge's Discovery of Japanese Art."

35. Hosley, *The Japan Idea*, 27–28; and Sigur, *The Influence of Japanese Art on Design*, 20.

36. The Japanese government appointed thirty prominent figures to direct the country's participation in the 1876 fair and allotted them a $600,000 budget (roughly $10 million today) to commission Japan's best craftsmen. Sigur, *The Influence of Japanese Art on Design*, 40–42.

37. Hosley, *The Japan Idea*, 183.

38. For more information on the market for Japanese art and antiquities and Japanese-style goods in the United States, see Sigur, *The Influence of Japanese Art on Design*, 63–89.

39. Ibid., 151–71.

40. For more information on the Aesthetic movement, see Doreen Bolger Burke et al., *In Pursuit of Beauty: Americans and the Aesthetic Movement*, exh. cat. (New York: Rizzoli for the Metropolitan Museum of Art, 1986).

41. Source books of Japanese design were published both in Japan, including Hokusai's *Manga*, *Kacho Gaden*, and *Musa Koeki Mocha*, and in the West, including Louis Gonse's *L'art japonais*, S. Bing's *Artistic Japan*, and Christopher Dresser's *Japan: Its Architecture, Art and Art Manufactures*. Sigur, *The Influence of Japanese Art on Design*, 158.

42. See MFA 2008.69a–b, 2008.70, and 2008.71.

43. For more information on the Japanese influence on Rookwood Pottery, with special attention to Kitaro Shirayamadani, see Elizabeth J. Fowler, "The Rookwood Sage: Kitaro Shirayamadani, Japanism, Art Nouveau, and the American Art Pottery Movement, 1885–1912" (PhD diss., University of Minnesota, 2005). See also Anita J. Ellis, *Rookwood Pottery: The Glorious Gamble*, exh. cat. (New York: Rizzoli, 1992).

44. The Japanese parlor that Herter Brothers created for William H. Vanderbilt's New York home was a particularly extravagant example of Aesthetic-style japonisme. For the decoration of President Ulysses S. Grant's White House, the firm incorporated Japanese export textiles and a Japanese-made folding screen.

45. Gerald W. R. Ward, "West Meets East: American Furniture in the Anglo-Asian Taste at the Museum of Fine Arts, Boston," *Apollo* 162, no. 495 (May 2003): 24–29.

46. We are grateful to Anne Coleman for identifying this fabric in a discussion in April 2001.

47. The Fine Arts Museums of San Francisco, de Young, acquired a nearly identical composition, probably produced at the same time as a pair of panels intended to decorate a room.

48. Kathleen A. Foster, "John La Farge and the American Watercolor Movement: Art for the 'Decorative Age,'" in *John La Farge*, by Henry Adams et al., exh. cat. (New York: Abbeville Press, 1987), 150; and Henry A. La Farge, "Painting with Colored Light: The Stained Glass of John La Farge," ibid., 195–223. For further discussion of La Farge's engagement with Japan, see Gabriel P. Weisberg, "Sowing Japonisme on American Soil," in Julia Meech and Gabriel P. Weisberg, *Japonisme Comes to America: The Japanese Impact on the Graphic Arts, 1876–1925* (New York: Harry N. Abrams, 1990), 57–94.

49. One of Tiffany's mentors, Edward C. Moore, head designer at his father's silver manufacturing company, was an early collector of Japanese art, and Tiffany himself started collecting Japanese wares in the late 1870s, with the help of the British designer Christopher Dresser. Tiffany was also closely tied to Siegfried Bing, a French collector and promoter of Japanese art and design who published the magazine *Artistic Japan*.

50. Sigur, *The Influence of Japanese Art on Design*, 134–44. Tiffany most likely drew the composition of the window from ancient sources.

51. See Nancy Mowll Mathews and Barbara Stern Shapiro, *Mary Cassatt: The Color Prints*, exh. cat. (New York: Harry N. Abrams, in association with Williams College Museum of Art, 1989), esp. 65–67. See also Elliot Bostwick Davis, "Mary Cassatt's Color Prints," *Antiques* 154, no. 4 (October 1998): 484–93. See also Colta Feller Ives, "Degas, Japanese Prints, and Japonisme," in *The Private Collection of Edgar Degas*, by Ann Dumas, Feller Ives, Susan Alyson Stein, and Gary Tinterow, exh. cat. (New York: Metropolitan Museum of Art, 1997), 256.

52. Edward Hopper's etching *House Tops* (1921), for instance, recalls Cassatt's print from the series *In the Omnibus*, which was acquired in 1916 by the Metropolitan Museum of Art, New York, where Hopper frequented the galleries.

53. Julia Meech, *Frank Lloyd Wright and the Art of Japan: The Architect's Other Passion* (New York: Japan Society and Harry N. Abrams, 2001).

54. Dow may have encountered Japanese prints as early as the summer of 1885 during his trip to Pont-Aven in Brittany, France. See Nancy Finlay, "Some Influences on the Color Woodcuts of Arthur Wesley Dow," *Harvard Library Bulletin* 35, no. 2 (Spring 1987): 187–88.

55. See also Clay Lancaster, "The Artistic Theory of Fenollosa and Dow," *Art Journal* 28, no. 3 (Spring 1969): 286–87.

56. We are grateful to Anne Nishimura Morse and Sarah Thompson for their assistance in identifying this Hiroshige landscape print from the vast collection of the MFA, Boston.

57. As quoted in Allison Eckardt Ledes, "Current and Coming: The Influential Arthur Wesley Dow," *Antiques* 156, no. 1 (July 1999): 26–28.

58. Nancy Green and Jessie Poesch, *Arthur Wesley Dow and American Arts and Crafts*, exh. cat. (New York: American Federation of the Arts, 1999).

59. David James Clarke, "The Influence of Oriental Thought on Postwar American Painting and Sculpture" (PhD diss., Courtauld Institute, London, 1988), 28–29. See also Frederick C. Moffatt, "Arthur Wesley Dow and the Ipswich School of Art," *New England Quarterly* 49, no. 3 (September 1976): 352.

60. Clarke, "The Influence of Oriental Thought," 29.

61. Harry Harootunian, "Postwar America and the Aura of Asia," in Munroe, *The Third Mind*, 45–55.

62. Daniel Belgrad, *The Culture of Spontaneity: Improvisation and the Arts in Postwar America* (Chicago: University of Chicago Press, 1988).

63. Mark Tobey, as quoted in Clarke, "The Influence of Oriental Thought," 209.

64. Kline, however, was known to admire Japanese art and collected Japanese prints. See Clarke, "The Influence of Oriental Thought," 207.

65. Ibid., 208; and B. H. Friedman, *Jackson Pollock: Energy Made Visible* (New York: McGraw Hill, 1972), 176. The quotation is excerpted from the following: "Well, method is, it seems to me, a natural growth out of a need, and from a need the modern artist has found new ways of expressing the world about him. I happen to find ways that are different from the usual techniques of painting, which seems a little strange at the moment, but I don't think there's anything very different about it. I paint on the floor and this isn't unusual—the Orientals did that."

66. Clarke, "The Influence of Oriental Thought," 207.

67. Belgrad, *The Culture of Spontaneity*, 171–73.

68. Jeremy Lewison, *Brice Marden Prints, 1961–1991: A Catalogue Raisonné*, exh. cat. (London: Tate Gallery, 1992), 52.

69. Ibid., 46–47.

LIST OF ILLUSTRATIONS

A New World Imagined: Artistic Innovation and Inspiration in the Americas

Fig. 1
Jost (Jodocus) Hondius (Netherlandish, 1563–about 1611)
Map of North and South America
Engraving
Image: 37.5 x 50.5 cm (14⅞ x 19⅞ in.)
Bequest of Abram Edmands Cutter, 1901 M16242

The Americas' First Art

Fig. 2
Teotihuacan
Incense burner
Mexico, A.D. 350–650
Earthenware with traces of red and yellow post-fire paint
43.5 x 43.3 x 28 cm (17⅛ x 17⅟₁₆ x 11 in.)
Gift of Landon T. Clay 1988.1229a–b

Fig. 3
Teotihuacan
Tripod vessel
Highland Mexico, A.D. 250–550
Earthenware with red, white, green, and black post-fire paint on white stucco
H. 11.4 cm (H. 4½ in.)
Promised Gift of Landon T. Clay

Fig. 4
Maya
Drinking vessel
Alta Verapaz, Southern Highlands, Guatemala, A.D. 700–800
Earthenware with slip paint
16.3 x 14.8 cm (6⁷⁄₁₆ x 5¹³⁄₁₆ in.)
Gift of Landon T. Clay 1988.1170

Fig. 5
Guanacaste-Nicoya
Jaguar effigy vessel
Northwestern Costa Rica, A.D. 1000–1350
Earthenware with slip paint
H. 29.2 cm (H. 11½ in.)
Museum purchase with funds donated by Leigh B. and Steve Braude 2005.9

Fig. 6
Guanacaste-Nicoya
Jaguar effigy metate (ceremonial bench)
Northwestern Costa Rica, A.D. 300–700
Basalt
L. 84.5 cm (L. 33¼ in.)
Museum purchase with funds donated by Jeremy and Hanne Grantham and Timothy Phillips 2008.169

Fig. 7
Olmec
Shaman effigy figure
Gulf Coast region, Mexico, 1150–550 B.C.
Jadeite
H. 11 cm (3½ in.)
Promised Gift of Landon T. Clay

Fig. 8
Colima
Shaman effigy figure
Mexico (Colima or Michoacán), Coahuayana style, 300 B.C.–A.D. 200
Earthenware
H. 54.6 cm (H. 21½ in.)
Gift from the Collection of Shirley and Hy Zaret 2008.198

Fig. 9
Tairona
Shaman-bat effigy pectoral
Northern Colombia, A.D. 900–1600
Gold alloy
16 x 12.5 x 2 cm (6⁵⁄₁₆ x 4¹⁵⁄₁₆ x ¹³⁄₁₆ in.)
Gift of Landon T. Clay 2000.813

Fig. 10
Diquís or Chiriquí
Shaman-bird-crocodile effigy pendant
Southern Costa Rica or western Panama, A.D. 700–1550
Gold alloy
11.1 x 13 cm (4⅜ x 5⅛ in.)
Gift of Landon T. Clay 1977.613

Fig. 11
Olmec
Portrait mask
Veracruz or Tabasco, Mexico, 1150–550 B.C.
Jadeite with black inclusions (fire-grayed)
21.6 x 19.4 x 5.5 cm (8½ x 2¾ x 2¼ in.)
Gift of Landon T. Clay 1991.968

Fig. 12
Maya
Drinking vessel
Motul de San José area, Petén lowlands, Guatemala, A.D. 740–780
Earthenware with slip paint
22.5 x 12 cm (8⅞ x 4¾ in.)
Gift of Landon T. Clay 1988.1168

Fig. 13
Maya
Tripod plate
Holmul area, Guatemala, A.D. 672–830

Earthenware with slip paint
14 x 33 cm (5½ x 13 in.)
Museum purchase with funds donated by Landon and Lavinia Clay 2006.844

Fig. 14
Inka
Tunic
Peru, 1476–1534
Camelid fiber
84.5 x 78 cm (33¼ x 30¾ in.)
William Francis Warden Fund 47.1097

Fig. 15
Paracas
Embroidered mantle
South Coast, Peru, 0–A.D. 100
Camelid fiber
142 x 241 cm (56 x 94⅞ in.)
William A. Paine Fund 31.501

Fig. 16
Colonial Peru (K'echwa [Quechua])
Woman's mantle
Peru, late 16th–early 17th century
Cotton, wool, silk, metal-wrapped thread
95.5 x 127.5 cm (37⅝ x 50⅛ in.)
Denman Waldo Ross Collection 97.448

Fig. 17
Colonial Peru (K'echwa [Quechua])
Chair seat or cushion cover
Peru, 16th–17th century
Cotton, wool
45 x 67 cm (17¾ x 26⁵⁄₁₆ in.)
Denman Waldo Ross Collection 07.845

Fig. 18
Désiré Charnay (French, 1828–1915)
Palace of the Governors, Uxmal, Mexico, 1860
Photograph, albumen print
Image: 43.5 x 31.1 cm (17⅛ x 13⅟₁₆ in.)
Charles Amos Cummings Fund 2000.660

Fig. 19
Edward Weston (American, 1886–1958)
Pirámide del Sol, 1923
Photograph, gelatin silver print
Sheet: 18.9 x 23.7 cm (7⁷⁄₁₆ x 9⁵⁄₁₆ in.)
The Lane Collection

Fig. 20
Steve Wheeler (American, 1912–1992)
Man Menacing Woman, about 1943

Oil on canvas
76.2 x 63.5 cm (30 x 25 in.)
Sophie M. Friedman Fund 2002.127

Fig. 21
César Paternosto (Argentinian, born in 1931)
Staccato, 1965
Oil on canvas
149.9 x 179.7 cm (59 x 70¾ in.)
Leigh and Stephen Braude Fund for Latin American Art
2008.1405

Fig. 22
Olga de Amaral (Colombian, born in 1932)
Cesta Lunar 64
Bogotá, Colombia, 1998
Fiber, gold leaf, acrylic
185.4 x 152.4 cm (73 x 60 in.)
Promised gift of Ronald C. and Anita L. Wornick

Native North American Art

Fig. 23
Mimbres
Bowl
Mimbres River Valley, New Mexico, Classic Black-on-white,
Style III, 1000–1150
Earthenware with slip paint
H. 12.1 cm, diam. 28.6 cm (H. 4¾ in., diam. 11¼ in.)
Museum purchase with funds donated by the Seth K.
Sweetser Fund and supporters of The Department of
American Decorative Arts and Sculpture 1990.248

Fig. 24
Seneca
Rattle
New York, 19th century
Turtle shell, elm wood, chokecherry pips
L. 43.3 cm, w. 17.5 cm, d. 6.5 cm
(L. 17¹¹/₁₆ in., w. 6⅞ in., d. 2⁹/₁₆ in.)
Leslie Lindsey Mason Collection 17.2233

Fig. 25
Mississippian Tradition
Effigy
Diehlstaat, Missouri, about 900–1400
Earthenware
16.5 x 14 cm (6½ x 5½ in.)
Gift of Mr. and Mrs. George Washington Wales 95.1430

Fig. 26
Kwakwaka'wakw (Kwakiutl)
Potlatch figure
Kwakwaka'wakw (northern Vancouver Island), British
Columbia, Canada, about 1840
Red cedar, paint
172.1 x 47 cm (67¾ x 18½ in.)
Museum purchase with funds donated by a Friend of the
Department of American Decorative Arts and Sculpture
1998.3

Fig. 27
(left)
Eastern Woodlands
Sash
Eastern Great Lakes region, United States or Canada, mid-
to late 18th century

Plaited (finger-woven) wool with porcupine quills
L. 208.3 cm (L. 82 in.)
Gift of Timothy Phillips 2008.1456

(center)
Eastern Woodlands
Sash
Eastern Great Lakes region, United States or Canada, early
19th century
Plaited (finger-woven) wool with glass beads
L. 284.5 cm (L. 112 in.)
Gift of Timothy Phillips 2008.1455

(right)
Sash
French-Canadian Métis, mid- to late 19th century
L'Assomption, Quebec, Canada
L. 381 cm (L. 150 in.)
Plaited (finger-woven) wool
Gift of Timothy Phillips 2008.1458

Fig. 28
Probably Wendat (Huron)
Moccasins
Eastern Great Lakes region, United States or Canada, late
18th–early 19th century
Leather, woven and appliquéd porcupine quills, moose or
deer hair, silk, wool, tinned sheet iron, bast fiber thread
6.5 x 10.5 x 23.5 cm (2⁹/₁₆ x 4⅛ x 9¼ in.)
Gift of Miss Ellen A. Stone 98.1006-7

Fig. 29
Side chair with quillwork panels
Chair: Nova Scotia, Canada; or possibly Maine, 1860–80
Quillwork: Mi'kmaq (Micmac), Nova Scotia, Canada,
1850–70
Ebonized mahogany, porcupine quillwork with vegetable
dyes on birchbark with spruce root; porcelain, iron, and
brass casters
109.2 x 47 x 47.8 cm (42 x 18½ x 18¾ in.)
Museum purchase with funds by exchange from a Gift of
the Estate of Jeannette Calvin Hewett in memory of her
husband Roger Sherman Hewett, Bequest of Greenville
Howland Norcross, Bequest of George Nixon Black, and
Bequest of Mrs. Stephen S. FitzGerald 1992.521

Fig. 30
Diné (Navajo)
Panel from a woman's dress
Arizona or New Mexico, about 1850–70
Wool interlocked tapestry
130.8 x 96.5 cm (51½ x 38 in.)
Denman Waldo Ross Collection 00.676

Fig. 31
Diné (Navajo)
Horse's headstall
Arizona, about 1875–1900
Silver, leather
64.8 x 44.5 x 5.1 cm (25½ x 17½ x 2 in.)
Gift of Ruth S. and Bertram J. Malenka and their sons,
David J. and Robert C. Malenka 2008.2003

Fig. 32
Diné (Navajo)
Sarape

Arizona or New Mexico, about 1860–65
Wool interlocked tapestry
141.6 x 184.2 cm (55¾ x 72½ in.)
Gift of Mrs. Harold D. Walker and Miss Eleanor W. Brooks
in memory of their mother Mrs. N. B. K. Brooks 52.1369

Fig. 33
Apsáalooke (Crow)
Martingale
Plains region, probably Montana, before 1884
Buckskin, glass beads, wool trade cloth
85 x 53 cm (33⁷/₁₆ x 20⅞ in.)
Gift of Reverend Herbert Probert 87.92

Fig. 34
Hopi
Tile with a warrior or guard kachina
Hopi Pueblo, Arizona, about 1892–99
Earthenware with slip paint
18.1 x 9.8 x 1.3 cm (7⅛ x 3⅞ x ½ in.)
Seth K. Sweetser Fund 1998.5

Fig. 35
Hopi
Tile with Palhikwmana kachina
Hopi Pueblo, Arizona, about 1892–99
Earthenware with slip paint
18.4 x 10.5 x 1.3 cm (7¼ x 4⅛ x ½ in.)
Seth K. Sweetser Fund 1998.6

Fig. 36
Haida
Button blanket
Haida Gwaii (Queen Charlotte Islands), British Columbia,
Canada, 1865–80
Wool twill embroidered with dentalium shells and
mother-of-pearl buttons
139.7 x 177.8 cm (55 x 70 in.)
Mary S. and Edward J. Holmes Fund 2007.498

Fig. 37
Johann Hürlimann (Swiss, 1793–1850) after Karl Bodmer
(Swiss, active in France, 1809–1893)
Mato-Tope (Indian in War Dress), 1834–43
Hand-colored engraving on paper
59.8 x 44.3 cm (23⁹/₁₆ x 17⁷/₁₆ in.)
Fund in memory of Horatio Greenough Curtis 1971.229

Fig. 38
De Witt Clinton Boutelle (American, 1820–1884)
Indian Surveying a Landscape, 1855
Oil on canvas
101.9 x 137.8 cm (40⅛ x 54¼ in.)
Gift of Martha C. Karolik for the M. and M. Karolik
Collection of American Paintings, 1815–1865 47.1223

Fig. 39
Walter Mitschke (American, born in Germany, 1886–1972),
designer
H. R. Mallinson and Company, manufacturer
Length of dress fabric: *Sioux War Bonnet* from the *American
Indian* series
New York, New York, 1927
Silk plain weave, printed
99.1 x 121.9 cm (39 x 48 in.)
Gift of Robert and Joan Brancale 2008.1945

Fig. 40
Clifton Art Pottery
Vase
Newark, New Jersey, about 1906–11
Earthenware
30.5 x 24.8 x 24.8 cm (12 x 9¾ x 9¾ in.)
Gift of Mr. Charles Devens 1985.360

Fig. 41
Cyrus E. Dallin (American, 1861–1944)
Appeal to the Great Spirit
Created in Arlington or Boston, Massachusetts
Manufactured in Paris, France, 1909
Bronze, green patina, lost-wax cast
309.9 x 111.1 x 260.4 cm (122 x 43¾ x 102½ in.)
Gift of Peter C. Brooks and others 13.380

Fig. 42
Marsden Hartley (American, 1877–1943)
Arrangement—Hieroglyphics (Painting No. 2), 1914
Oil on canvas
108 x 88.3 cm (42½ x 34¾ in.)
Gift of the William H. Lane Foundation 1990.412

Fig. 43
Peter Busa (American, 1914–1985)
Birth of the Object and the End of the Object, 1945
Oil on canvas
64.8 x 76.2 cm (25½ x 30 in.)
The Hayden Collection—Charles Henry Hayden Fund, by
exchange 2005.121

Fig. 44
JoAnne Russo (American, born in 1956)
Porcupine basket
Saxtons River, Vermont, 1999
Black ash, pine needles, porcupine quills, Createx fiber
reactive dye
26.7 x 15.2 cm (10½ x 6 in.)
American Decorative Arts Curator's Fund 1999.19

Fig. 45
Evelyn Cheromiah (Sru tsi rai) (Laguna, born in 1928)
Water jar
Laguna Pueblo, New Mexico, 1993
Earthenware with slip paint
23.2 x 24.1 cm (9⅛ x 9½ in.)
Museum purchase with funds donated by The Seminarians
1993.671

Fig. 46
Joe David (Nuu-Chah-Nulth [Nootka], born in 1946)
Loren White (American, born in 1941)
Took-beek
Dayton, Oregon, 1982
Painted red cedar
H. 188 cm (H. 74 in.)
Gift of Dale and Doug Anderson in honor of Ron and
Anita Wornick 2005.373

Fig. 47
Nathan Begaye (Hopi/Diné [Navajo], born in 1969)
Squash Maiden
Santa Fe, New Mexico, 2002
Earthenware with slip paint, beads
35.9 x 14.6 x 14 cm (14⅛ x 5¾ x 5½ in.)
Gift of James and Margie Krebs 2006.1911

Fig. 48
Preston Singletary (Tlingit, born in 1963)
Raven Steals the Moon
Seattle, Washington, 2002
Blown red glass; black overlay with sandblasted design
H. 49.5 cm, diam. 15.2 cm (H. 19½ in., diam. 6 in.)
Gift of Dale and Doug Anderson and Preston Singletary
2003.350

Fig. 49
Jaune Quick-to-See Smith (Salish [Flathead], born in 1940)
El Morro #34, 1981
Pastel on paper
Sheet: 76.2 x 57.2 cm (30 x 22½ in.)
George Peabody Gardner Fund 2003.626

Fig. 50
David Paul Bradley (Ojibwa [Chippewa], born in 1954)
Greasy Grass Premonition #2, 1995
Mixed media on canvas
76.2 x 61 cm (30 x 24 in.)
Gift of James and Margie Krebs 2009.2799

Fig. 51
Rick Rivet (Métis, born in 1949)
String Game—2 (Kayaker), 2001
Acrylic on canvas
106.7 x 106.7 cm (42 x 42 in.)
Gift of James and Margie Krebs 2009.4342

Fig. 52
Fritz Scholder (Luiseño, 1937–2005)
Cowboy Indian, 1974
Color lithograph
Sheet: 61 x 43.2 cm (24 x 17 in.)
Lee M. Friedman Fund 2003.624

The Classical Tradition

Fig. 53
Possibly by William G. Henis (American, active 1860–after
1886)
Goddess of Liberty weather vane
Philadelphia, Pennsylvania, 1860–80
Copper with traces of gilding
92.7 x 73.7 x 7.6 cm (36½ x 29 x 3 in.)
Gift of Jean S. and Frederic A. Sharf 2008.46

Fig. 54
Corinthian pilaster capital
Roman, early Imperial Period, 25–1 B.C.
Marble
58.4 x 74.3 x 6.7 cm (23 x 29¼ x 2⅝ in.)
Charles Amos Cummings Fund 2001.134

Fig. 55
Corinthian capital
Boston, Massachusetts, about 1800
Gilt and painted wood
41.9 x 49.5 x 41.3 cm (16½ x 19½ x 16¼ in.)
Gift of Henry Forbes Bigelow 27.850

Fig. 56
Thomas Sheraton (English, 1751–1806), author and illustrator
"Corinthian Order," part 1, plate 12, from *The Cabinet-
Maker and Upholsterer's Drawing-Book, in Three Parts [and
Appendix]* (London: Thomas Bensley), 1791–93

Illustrated book with 98 engravings
Book (each vol.): 27 x 21.7 x 3.8 cm (10⅝ x 8⁹⁄₁₆ x 1½ in.)
Image: 23 x 25 cm (9¹⁄₁₆ x 9⅞ in.)
The William N. Banks Foundation 1971.330a–b

Fig. 57
Henry Sargent (American, 1770–1845)
The Tea Party, about 1824
Oil on canvas
163.5 x 133 cm (64⅜ x 52⅜ in.)
Gift of Mrs. Horatio Appleton Lamb in memory of
Mr. and Mrs. Winthrop Sargent 19.12

Fig. 58
Woman's formal dress
Possibly France, worn in America, about 1805
Embroidered cotton plain weave (mull)
Center front: 121.9 cm (48 in.)
Center back: 210.8 cm (83 in.)
Gift in memory of Helen Kingsford Preston 1989.347

Fig. 59
Design and carving attributed to Samuel McIntire
(American, 1757–1811)
Chest-on-chest
Salem, Massachusetts, 1806–9
Mahogany, mahogany veneer, ebony and satinwood inlay,
white pine
260.4 x 118.7 x 61 cm (102½ x 43¾ x 24 in.)
The M. and M. Karolik Collection of Eighteenth-Century
American Arts 41.580

Fig. 60
Samuel McIntire (American, 1757–1811)
Eagle
Salem, Massachusetts, about 1786–99
Gilt white pine
99.1 x 76.2 cm (39 x 30 in.)
Gift of a Friend of the Department of American Decorative
Arts and Sculpture, The Estate of Gilbert L. Steward, Sr.,
Mrs. Ichabod F. Atwood and Mrs. Elaine Wilde, The
French Foundation in memory of Edward V. French,
The Seminarians, and an anonymous donor 1991.535

Fig. 61
Relief plaque by Samuel McIntire (American, 1757–1811)
Perspective machine
Salem, Massachusetts, 1800–10
Pine, glass lens
Machine: 191.8 x 60.6 x 46.4 cm (75½ x 23⅞ x 18¼ in.)
Gift of S. Richard Fuller and Dudley Leavitt Pickman,
Harriet Otis Cruft Fund and Charles Hitchcock Tyler
Residuary Fund, by exchange 60.532

Fig. 62
Side chair
Baltimore, Maryland, about 1815
Painted wood, cane
81 x 51.1 x 53.5 cm (31⅞ x 20⅛ x 21 in.)
Gift of Jean and Michael Dingman and Otis Norcross Fund
1981.26

Fig. 63
Attributed to Hugh Finlay (American, 1781–1831)
Grecian couch
Baltimore, Maryland, about 1820

Yellow poplar, cherry, white pine; rosewood graining and gilded painting; partial original foundation and new foundation materials, cover, and trim
90.8 x 232.4 x 61.6 cm (35¾ x 91½ x 24¼ in.)
Gift of Mr. and Mrs. Amos B. Hostetter, Jr., Anne and Joseph P. Pellegrino, Mr. and Mrs. Peter S. Lynch, Mr. William N. Banks, Jr., Eddy G. Nicholson, Mr. and Mrs. John Lastavica, Mr. and Mrs. Daniel F. Morley, and Mary S. and Edward J. Holmes Fund 1988.530

Fig. 64
Possibly by Duncan Phyfe (American, born in Scotland, 1768–1854)
Sofa
New York, New York, about 1820
Mahogany, cherry, cane
86.4 x 193.7 x 59.1 cm (34 x 76¼ x 23¼ in.)
The M. and M. Karolik Collection of Eighteenth-Century American Arts 39.114

Fig. 65
Pier table with canted corners
New York, New York, about 1815–20
Rosewood veneer, mahogany veneer, mahogany, white pine, yellow poplar, marble
84.5 x 101.6 x 48.3 cm (33¼ x 40 x 19 in.)
Museum purchase with funds donated by the W. N. Banks Foundation 1975.274

Fig. 66
Roman architectural panel with a griffin
Italy, Imperial Period, about A.D. 175–200
Marble
104 x 139.2 cm (40¹⁵⁄₁₆ x 54¹³⁄₁₆ in.)
Francis Bartlett Donation of 1900 03.747

Fig. 67
Edward C. Moore (American, 1827–1891), designer
Tiffany and Company, manufacturer
Coffeepot
New York, New York, about 1858–73
Silver
27.2 x 20.5 x 14.2 cm (10¹¹⁄₁₆ x 8¹⁄₁₆ x 5⁹⁄₁₆ in.)
Marion E. Davis Fund 1981.403

Fig. 68
John Singleton Copley (American, 1738–1815)
Galatea, about 1754
Oil on canvas
94 x 132.7 cm (37 x 52¼ in.)
Picture Fund 12.45

Fig. 69
George de Forest Brush (American, 1855–1941)
Orpheus, 1890
Oil on panel
30.5 x 50.8 cm (12 x 20 in.)
Gift of JoAnn and Julian Ganz, Jr. 1995.767

Fig. 70
Thomas Crawford (American, about 1813–1857)
Orpheus and Cerberus
Rome, Italy, 1843
Marble
171.5 x 91.4 x 137.2 cm (67½ x 36 x 54 in.)
Museum purchase with funds by exchange from a Gift of Mr. and Mrs. Cornelius C. Vermeule III 1975.800

Fig. 71
Frederic Edwin Church (American, 1826–1900)
Erechtheum, 1869–70
Oil on paper mounted on canvas
33 x 27.9 cm (13 x 11 in.)
Gift of Barbara L. and Theodore B. Alfond in honor of Carol Troyen, Kristin and Roger Servison Curator of American Paintings, 1978–2007 2008.47

Fig. 72
Frederic Edwin Church (American, 1826–1900)
Study for The Parthenon, 1869–70
Oil on paper mounted on canvas
33 x 50.8 cm (13 x 20 in.)
Gift of Barbara L. and Theodore B. Alfond in honor of Carol Troyen, Kristin and Roger Servison Curator of American Paintings, 1978–2007 2008.48

Fig. 73
Chelsea Keramic Art Works
Ewer
Chelsea, Massachusetts, 1873–78
Earthenware with slip decoration
39.4 x 19.7 x 19.1 cm (15½ x 7¾ x 7½ in.)
The Lloyd and Vivian Hawes Collection 2000.696

Fig. 74
Abbott Handerson Thayer (American, 1849–1921)
Caritas, 1894–95
Oil on canvas
216.5 x 140.3 cm (85¼ x 55¼ in.)
Warren Collection—William Wilkins Warren Fund and contributions 97.199

Fig. 75
John Singer Sargent (American, 1856–1925)
Classic and Romantic Art, 1921
Oil on canvas
255 x 424.2 cm (100 ³⁄₈ x 167 in.)
Francis Bartlett Donation of 1912 and Picture Fund 21.10514

Fig. 76
John Singer Sargent (American, 1856–1925)
Three Graces
Boston, Massachusetts, 1919–20
Plaster with oil paint
201.9 x 114.3 x 19.1 cm (79½ x 45 x 7½ in.)
Francis Bartlett Donation of 1912 21.10502

Fig. 77
John Singer Sargent (American, 1856–1925)
The Sphinx and the Chimaera, 1921
Oil on canvas
302.6 x 234.3 cm (119⅛ x 92¼ in.)
Francis Bartlett Donation of 1912 and Picture Fund 21.10515

Fig. 78
Whiting Manufacturing Company
Pitcher
Probably North Attleboro, Massachusetts, about 1875–76
Silver
29.9 x 24 x 17.2 (11¹³⁄₁₆ x 9⅜ x 6¹³⁄₁₆)
Marion E. Davis Fund 1975.669

Fig. 79
Edward Zucca (American, born in 1946)
XVIIIth Dynasty Television
Woodstock, Connecticut, 1989
Mahogany, yellow poplar, ebony, gold leaf, silver leaf, rush, latex paint, ebonizing
154.9 x 85.1 x 106.7 cm (61 x 33½ x 42 in.)
Gift of Anne and Ronald Abramson 1989.263

Fig. 80
Byron Browne (American, 1907–1961)
Variations on a Greek Urn, 1935–37
Oil on canvas
122.2 x 152.4 cm (48⅛ x 60 in.)
The Hayden Collection—Charles Henry Hayden Fund 1979.3

Fig. 81
Stephen De Staebler (American, born in 1933)
Seated Figure with Striped Right Arm
Berkeley, California, 1984
Fired clay with pigment
182.9 x 43.2 x 73.7 cm (72 x 17 x 29 in.)
Promised gift of Ronald C. and Anita L. Wornick

Fig. 82
Diego Romero (Cochiti, born in 1964), painter
Nathan Begaye (Hopi/Diné [Navajo], born in 1969), potter
Death of Hector canteen
Española, New Mexico, 2003
Earthenware with slip paint
H. 30.5 cm, diam. 26.7 cm (H. 12 in., diam. 10½ in.)
Gift of James and Margie Krebs 2006.1908

Fig. 83
Marilyn R. Pappas (American, born in 1931)
Nike of Samothrace with Golden Wing
Somerville, Massachusetts, 2001
Cotton, 2% gold threads embroidered on linen
396.2 x 148.8 cm (156 x 58⅝ in.)
Promised gift of Ronald C. and Anita L. Wornick

England

Fig. 84
Attributed to the Ralph Mason (1599–1678 or 1679) and Henry Messinger (died in 1681) shops
Turnings attributed to the Thomas Edsall (1588–1676) shops
Chest of drawers
Boston, Massachusetts, 1640–70
Oak, cedrela, black walnut, cedar, ebony
130.2 x 119.9 x 58.6 cm (51¼ x 47³⁄₁₆ x 23¹⁄₁₆ in.)
Bequest of Charles Hitchcock Tyler 32.219

Fig. 85
Attributed to Thomas Dennis (American, born in England, 1638–1706) or William Searle (American, born in England, 1611–about 1667)
Joined chest
Probably Ipswich, Massachusetts, 1670–1700
Oak, white pine
77.5 x 112.7 x 48.3 cm (30½ x 44⅜ x 19 in.)
Gift of John Templeman Coolidge 29.1015

Fig. 86
John Hull (American, born in England, 1624–1683)
Robert Sanderson, Sr. (American, born in England, 1608–1693)
Wine cup

Boston, Massachusetts, 1660–80
Silver
20.3 x 11.5 cm (8 x 4½ in.)
Anonymous gift 1999.91

Fig. 87
John Smibert (American, born in Scotland, 1688–1751)
Daniel, Peter, and Andrew Oliver, 1732
Oil on canvas
99.7 x 144.5 cm (39¼ x 56⅞ in.)
Emily L. Ainsley Fund 53.952

Fig. 88
George Wickes (English, 1698–1761)
Two-handled covered cup
London, England, after 1722
Silver
28.5 x 27.5 x 17.8 cm (11¼ x 10¹³⁄₁₆ x 7 in.)
Gift of the heirs of Samuel May (1723–1794) 30.437a–b

Fig. 89
Jacob Hurd (American, 1702 or 1703–1758)
Two-handled covered cup
Boston, Massachusetts, about 1740–50
Silver
34.3 x 30.5 x 21 cm (13½ x 12 x 8¼ in.)
Helen and Alice Colburn Fund 36.415

Fig. 90
Thomas Chippendale (English, 1718–1779), author and designer
"Chairs," plate XIV from *The Gentleman and Cabinet-Maker's Director: Being a Large Collection of the Most Elegant and Useful Designs of Household Furniture, in the Most Fashionable Taste* (London: Printed for the author), 1762
Illustrated book with 199 engravings
Book: 46.8 x 30.8 x 6.5 cm (18⁷⁄₁₆ x 12⅛ x 2⁹⁄₁₆ in.)
Image: 22.5 x 35.2 cm (8⅞ x 13⅞ in.)
Gift of Maxim Karolik 31.995

Fig. 91
Side chair
Boston, Massachusetts, about 1770
Mahogany, maple, pine
93.3 x 56.5 x 45.7 cm (36¾ x 22¼ x 18 in.)
Museum purchase with funds by exchange from Gift of Mary W. Bartol, John W. Bartol, and Abigail W. Clark, Gift of Dr. and Mrs. Thomas H. Weller, Bequest of Mrs. Stephen S. FitzGerald, Bequest of Dr. Samuel A. Green, Gift of Gilbert L. Steward, Jr., Gift of Mrs. Daniel Risdon, Gift of Miss Elizabeth Clark in memory of Mary R. Crowninshield, Gift of Mrs. Clark McIlwaine, Gift of Mr. and Mrs. Russell W. Knight—Collection of Ralph E. and Myra T. Tibbetts, Gift of Elizabeth Shapleigh, Gift of Miss Harriet A. Robeson, Gift of the John Gardner Greene Estate, Bequest of Barbara Boylston Bean, Gift of Miss Catherine W. Faucon, Gift of Jerrold H. Barnett and Joni Evans Barnett, and Gift of Dr. Martha M. Eliot 2004.2062

Fig. 92
John Singleton Copley (American, 1738–1815)
Nathaniel Sparhawk, 1764
Oil on canvas
231.1 x 149.9 cm (91 x 59 in.)
Charles H. Bayley Picture and Painting Fund 1983.595

Fig. 93
John Singleton Copley (American, 1738–1815)
A Boy with a Flying Squirrel (Henry Pelham), 1765
Oil on canvas
77.2 x 63.8 cm (30⅜ x 25⅛ in.)
Gift of the artist's great-granddaughter 1978.297

Fig. 94
Desk-and-bookcase
Newport, Rhode Island, 1760–75
Mahogany, chestnut, pine, cherry
241.9 x 101.3 x 66 cm (95¼ x 39⅞ x 26 in.)
The M. and M. Karolik Collection of Eighteenth-Century American Arts 39.155

Fig. 95
Martin Johnson Heade (American, 1819–1904)
Orchids and Hummingbird, 1875–83
Oil on canvas
35.9 x 56.2 cm (14⅛ x 22⅛ in.)
Gift of Maxim Karolik for the M. and M. Karolik Collection of American Paintings, 1815–1865 47.1164

Fig. 96
Martin Johnson Heade (American, 1819–1904)
Lake George, 1862
Oil on canvas
66 x 125.4 cm (26 x 49⅜ in.)
Bequest of Maxim Karolik 64.430

Fig. 97
Henry Hobson Richardson (American, 1838–1886), designer
A. H. Davenport and Company, possible manufacturer
Armchair for the Woburn Public Library
Boston, Massachusetts, 1878
Oak, leather (replaced)
85.4 x 74.9 x 71.1 cm (33⅝ x 29½ x 28 in.)
Gift of Woburn Public Library 61.236

Fig. 98
Brewster armchair
Possibly Gardner, Massachusetts, about 1876
Oak, maple, cushion (replaced)
114.3 x 53.3 x 44.5 cm (45 x 21 x 17½ in.)
Arthur Mason Knapp Fund 1978.386

Fig. 99
Frank Lloyd Wright (American, 1867–1959), designer
John W. Ayers and Company, manufacturer
Tall-back side chair
Chicago, Illinois, 1900
Oak, leather (replaced)
129.5 x 47 x 48.9 cm (51 x 18½ x 19¼ in.)
Gift of American Decorative Art 1900 Foundation in honor of David A. Hanks 2006.1439

Fig. 100
John Singer Sargent (American, 1856–1925)
Mrs. Fiske Warren (Gretchen Osgood) and Her Daughter Rachel, 1903
Oil on canvas
152.4 x 102.6 cm (60 x 40⅜ in.)
Gift of Mrs. Rachel Warren Barton and Emily L. Ainsley Fund 64.693

Fig. 101
David Hockney (English, born in 1937), artist
Tyler Graphics, Ltd., New York, publisher
Lithograph of Water Made of Thick and Thin Lines, a Green Wash, a Light Blue Wash and a Dark Blue Wash (Pool I), 1978–80
Lithograph in seven colors
Sheet: 66 x 87.6 cm (26 x 34½ in.)
Anonymous gift 2001.748

France

Fig. 102
Circle of José Maria Rodallega (Mexican, 1741–1812)
Antonio Forcada y La Plaza (active 1790–1818), assayer
Chalice (*caliz*)
Mexico City, Mexico, about 1790–1812
Silver with gold wash
24 x 14.6 x 7.7 cm (9⁷⁄₁₆ x 5¾ x 3¹⁄₁₆ in.)
Gift of E. L. Beck 19.119

Fig. 103
Attributed to Pierre Antoine Petit dit La Lumière (died in 1815)
Buffet
Vincennes, Indiana, about 1800
Yellow poplar, curly maple, sycamore
117.5 x 121.9 x 61.6 cm (46¼ x 48 x 24¼ in.)
Gift of Daniel and Jessie Lie Farber and Frank B. Bemis Fund 1989.50

Fig. 104
Commode
Montreal, Quebec, Canada, 1780–90
Butternut, white pine
87 x 120 x 62.9 cm (34¼ x 47¼ x 24¾ in.)
Gift of Miss Dorothy Buhler in memory of Sarah M. Gilbert, Gift of Estelle S. Frankfurter, and gift of John Gardner Greene Estate, by exchange 1994.83

Fig. 105
Jean-Antoine Houdon (French, 1741–1828)
Thomas Jefferson
Paris, France, 1789
Marble
56.5 x 48 x 26 cm (22¼ x 18⅞ x 10¼ in.)
George Nixon Black Fund 34.129

Fig. 106
Horatio Greenough (American, 1805–1852)
Marie Joseph Paul Yves Roch Gilbert du Mortier, Marquis de Lafayette
Florence, Italy, about 1833
Marble
33 x 28.6 x 17.8 cm (13 x 11¼ x 7 in.)
Bequest of Mrs. Horatio Greenough 95.1386

Fig. 107
John Trumbull (American, 1756–1843)
The Death of General Warren at the Battle of Bunker's Hill, 17 June, 1775, after 1815–before 1831
Oil on canvas
50.2 x 75.6 cm (19¾ x 29¾ in.)
Gift of Howland S. Warren 1977.853

Fig. 108
Thomas Emmons (American, active 1813–1825)
George Archibald (American, active 1813–1834)
Fall-front secretary (*secrétaire à abattant*)
Boston, Massachusetts, 1813–25
Mahogany, mahogany veneer
153.7 x 97.8 x 49.5 cm (60½ x 38½ x 19½ in.)
Gift of a Friend of the Department and Otis Norcross Fund
1985.335

Fig. 109
Nelson Gustafson (active 1873–1875)
Mounts marked by P. E. Guerin
Cabinet
New York, New York, about 1873–75
Mahogany, rosewood, exotic woods, porcelain and bronze
plaques
143.5 x 179.1 x 41.9 cm (56½ x 70½ x 16½ in.)
Edwin E. Jack Fund 1981.400

Fig. 110
Thomas Eakins (American, 1844–1916)
Starting Out after Rail, 1874
Oil on canvas mounted on Masonite
61.6 x 50.5 cm (24¼ x 19⅞ in.)
The Hayden Collection—Charles Henry Hayden Fund
35.1953

Fig. 111
Winslow Homer (American, 1836–1910)
The Fog Warning, 1885
Oil on canvas
76.8 x 123.2 cm (30¼ x 48½ in.)
Otis Norcross Fund 94.72

Fig. 112
Mary Stevenson Cassatt (American, 1844–1926)
The Tea, about 1880
Oil on canvas
64.8 x 92.1 cm (25½ x 36¼ in.)
M. Theresa B. Hopkins Fund 42.178

Fig. 113
Augustus Saint-Gaudens (American, born in Ireland,
1848–1907)
The Puritan
Paris, France, after 1899
Bronze
77.8 x 48.9 x 33 cm (30⅝ x 19¼ x 13 in.)
Edwin E. Jack Fund 1980.5

Fig. 114
John White Alexander (American, 1856–1915)
Isabella and the Pot of Basil, 1897
Oil on canvas
192.1 x 91.8 cm (75⅝ x 36⅛ in.)
Gift of Ernest Wadsworth Longfellow 98.181

Fig. 115
S. Karpen and Brothers
Armchair
Chicago, Illinois, 1901–10
Mahogany, maple, gold leaf; original upholstery
106.7 x 82.6 x 64.8 cm (42 x 32½ x 25½ in.)
Gift of Daniel and Jessie Lie Farber 1986.749

Fig. 116
Stuart Davis (American, 1892–1964)
Egg Beater #3, 1927–28
Oil on canvas
63.8 x 99.4 cm (25⅛ x 39⅛ in.)
Gift of the William H. Lane Foundation 1990.391

Fig. 117
Alexander Calder (American, 1898–1976)
Vache (Cow)
Paris, France, about 1929
Brass wire
40.6 x 61 cm (16 x 24 in.)
Decorative Arts Special Fund 60.240a–b

Fig. 118
James Richmond Barthé (American, 1901–1989)
Feral Benga
Probably Paris, France, modeled in 1935
Bronze
47.6 x 17.8 x 11.1 cm (18¾ x 7 x 4⅜ in.)
William Francis Warden Fund and American Decorative
Arts Deaccessioning Fund 2007.1

Fig. 119
Company of Master Craftsmen for W. and J. Sloane
Armoire
New York, New York, 1926–42
Mahogany, lumber-core plywood, cherry, tulipwood, maple,
rosewood, brass
134.6 x 92.7 x 52.1 cm (53 x 36½ x 20½ in.)
Gift of Priscilla Cunningham in honor of Charles C.
Cunningham Jr. and Thomas L. Cunningham 2004.2200

Italy

Fig. 120
John Singleton Copley (American, 1738–1815)
The Ascension, 1775
Oil on canvas
81.3 x 73 cm (32 x 28¾ in.)
Bequest of Susan Greene Dexter in memory of Charles and
Martha Babcock Amory 25.95

Fig. 121
John Singleton Copley (American, 1738–1815)
Mr. and Mrs. Ralph Izard (Alice Delancey), 1775
Oil on canvas
174.6 x 223.5 cm (68¾ x 88 in.)
Edward Ingersoll Brown Fund 03.1033

Fig. 122
Harriet Goodhue Hosmer (American, 1830–1908)
Sleeping Faun
Rome, Italy, after 1865
Marble
87.6 x 104.1 x 41.9 cm (34½ x 41 x 16½ in.)
Gift of Mrs. Lucien Carr 12.709

Fig. 123
Edward R. Thaxter (American, 1857–1881)
Meg Merrilies
Florence, Italy, about 1881
Marble
66.7 x 47 x 38.7 cm (26¼ x 18½ x 15¼ in.)
William E. Nickerson Fund 63.5

Fig. 124
Washington Allston (American, 1779–1843)
Moonlight, 1819
Oil on canvas
63.8 x 91 cm (25⅛ x 35¾ in.)
William Sturgis Bigelow Collection 21.1429

Fig. 125
Thomas Cole (American, born in England, 1801–1848)
The Temple of Segesta with the Artist Sketching, about 1842
Oil on canvas
49.9 x 76.5 cm (19⅝ x 30⅛ in.)
Gift of Martha C. Karolik for the M. and M. Karolik
Collection of American Paintings, 1815–1865 47.1198

Fig. 126
John Gadsby Chapman (American, 1808–1889)
Harvesting on the Roman Campagna, 1867
Oil on canvas
73 x 182.2 cm (28¾ x 71¾ in.)
Seth K. Sweetser Fund 1972.982

Fig. 127
John Singer Sargent (American, 1856–1925)
Venice: Under the Rialto Bridge, about 1909
Transparent and opaque watercolor over
graphite pencil on paper
Sheet: 27.6 x 48.3 cm (10⅞ x 19 in.)
The Hayden Collection—Charles Henry Hayden Fund
12.203

Fig. 128
Augustus Saint-Gaudens (American, born in Ireland,
1848–1907)
Frame attributed to Stanford White (American, 1853–1906)
Mildred Howells
New York, New York, 1898
Bronze, brown patina, lost-wax cast
Frame: 78.7 x 73.7 cm (31 x 29 in.)
Diam. of bronze 53.3 cm (21 in.)
Gift of Miss Mildred Howells 57.558

Fig. 129
Frank Duveneck (American, 1848–1919)
Clement John Barnhorn (American, 1857–1935)
Tomb Effigy of Elizabeth Boott Duveneck
Florence, Italy, 1894
Marble
71.1 x 218.4 x 100.3 cm (28 x 86 x 39½ in.)
Gift of Frank Duveneck 12.62

Fig. 130
John La Farge (American, 1835–1910)
The Infant Bacchus window
Probably New York, New York, 1885
Leaded stained, enameled, and opalescent glass
226.2 x 112.7 cm (89 1/16 x 44⅜ in.)
Gift of Washington B. Thomas 23.249

Fig. 131
Salvatore Cernigliaro ("Cherni") (American, born in Sicily,
1879–1974), carver
Attributed to Gustav A. Dentzel Carousel Company,
manufacturer
Carousel figure of a pig
Philadelphia, Pennsylvania, about 1905

Painted wood, glass
76.2 x 127 x 29.2 cm (30 x 50 x 11½ in.)
Mary E. Moore Gift 2001.545

Fig. 132
Icilio Consalvi (American, born in Italy, 1865–1951)
Banjo
Boston, Massachusetts, 1895
Maple, ebony, mother-of-pearl, abalone, ivory, silver,
semiprecious stones
88.9 x 27.9 cm (35 x 11 in.)
Gift of the Consalvi and Pidgeon Families 2006.1928

Fig. 133
William James Glackens (American, 1870–1938)
Italo-American Celebration, Washington Square, about 1912
Oil on canvas
65.4 x 81.3 cm (25¾ x 32 in.)
Emily L. Ainsley Fund 59.658

Fig. 134
Joseph Stella (American, 1877–1946)
Old Brooklyn Bridge, about 1941
Oil on canvas
193.7 x 173.4 cm (76¼ x 68¼ in.)
Gift of Susan Morse Hilles in memory of Paul Hellmuth
1980.197

Fig. 135
Paul H. Manship (American, 1885–1966)
Lyric Muse
Rome, Italy, 1912
Bronze, dark green patina; lost-wax cast; copper wire
32.4 x 17.3 x 14 cm (12¾ x 6¹³⁄₁₆ x 5½ in.)
Gift of Miss Mary C. Wheelwright 42.373

Fig. 136
Dale Chihuly (American, born in 1941)
Rembrandt Blue and Oxblood Persian
Seattle, Washington, 1990
Blown glass
88.9 x 67.3 x 69.9 cm (35 x 26½ x 27½ in.)
Promised gift of Ronald C. and Anita L. Wornick

Fig. 137
Lino Tagliapietra (Italian, active in United States, born in
1934)
Vessel from the *Mandara* series
Seattle, Washington, 2006
Blown glass
59.7 x 36.8 x 19.7 cm (23½ x 14½ x 7¾ in.)
Gift of Dale and Doug Anderson and UrbanGlass
2006.1259

Germany
Fig. 138
Martin Licht, 1814, 1814
Watercolor and pen in red and black ink on paper
Sheet: 33.7 x 40.6 cm (13¼ x 16 in.)
Gift of Maxim Karolik for the M. and M. Karolik Collection
of American Watercolors and Drawings, 1800–1875 56.766

Fig. 139
Attributed to John Neis (1775–1867)
Plate

Upper Salford Township, Montgomery County,
Pennsylvania, 1834
Earthenware with incised and slip decoration
3.81 x 27.3 x 27.3 cm (1½ x 10¾ x 10¾ in.)
Anonymous gift 02.323

Fig. 140
Attributed to the New Bremen Glass Manufactory of John
Frederick Amelung (American, born in Germany, 1741–1798)
Covered goblet (*pokal*)
Frederick County, Maryland, 1784–95
Nonlead glass, free blown
31.4 x 11.4 cm (12⅜ x 4½ in.)
Museum purchase with funds donated by The Seminarians
and Mr. and Mrs. Daniel F. Morley 1994.82a–b

Fig. 141
Louis Vaupel (American, born in Germany, 1824–1903),
engraver
New England Glass Company, manufacturer
Goblet
East Cambridge, Massachusetts, about 1860–75
Blown, cobalt blue cased glass, cut and engraved
15.9 x 7.6 x 7.6 cm (6¼ x 3 x 3 in.)
Bequest of Dr. Minette D. Newman 61.1219

Fig. 142
Heinrich Kuenemann II (American, born in Germany,
1843–1914)
Wardrobe
Fredericksburg, Texas, about 1870
Southern yellow pine
221.7 x 143.5 x 59.7 cm (87¼ x 56½ x 23½ in.)
Gift of Mrs. Charles L. Bybee 1990.483

Fig. 143
Attributed to John Henry Belter and Company
Slipper chair
New York, New York, 1844–67
Carved and laminated rosewood; replaced upholstery
114.3 x 45.7 x 43.2 cm (45 x 18 x 17 in.)
Gift of George Henry Bissell 2005.1116

Fig. 144
John Whetten Ehninger (American, 1827–1889)
Turkey Shoot, 1879
Oil on canvas
63.5 x 110.2 cm (25 x 43⅜ in.)
Gift of Maxim Karolik for the M. and M. Karolik Collection
of American Paintings, 1815–1865 46.854

Fig. 145
Albert Bierstadt (American, born in Germany, 1830–1902)
Valley of the Yosemite, 1864
Oil on paperboard
30.2 x 48.9 cm (11⅞ x 19¼ in.)
Gift of Martha C. Karolik for the M. and M. Karolik
Collection of American Paintings, 1815–1865 47.1236

Fig. 146
Frank Duveneck (American, 1848–1919)
A Circassian, 1870
Oil on canvas
128.3 x 105.4 cm (50½ x 41½ in.)
Gift of Miss Alice Hooper 76.296

Fig. 147
Karl L. Zerbe (American, 1903–1972)
Job, 1949
Pigmented wax on Masonite
94.3 x 65.1 cm (37⅛ x 25⅝ in.)
Gift of the William H. and Saundra B. Lane Collection
1993.969

Fig. 148
Hans Hofmann (American, born in Germany, 1880–1966)
Twilight, 1957
Oil on plywood
121.9 x 91.4 cm (48 x 36 in.)
Gift in the name of Lois Ann Foster 1973.171

Fig. 149
Roycroft Community (active 1895–1938)
Dard Hunter (American, 1883–1966), designer
Karl Kipp (American, 1882–1954), maker
Hanging lantern (one of a pair)
East Aurora, New York, about 1906–8
Copper, nickel silver, stained glass, leather
76.2 x 40.6 x 15.2 cm (30 x 16 x 6 in.)
Harriet Otis Cruft Fund 1980.280

Fig. 150
Lyonel Feininger (American, active in Germany, 1871–1956)
Regler Church, Erfurt, 1930
Oil on canvas
126.7 x 102.2 cm (49⅞ x 40¼ in.)
The Hayden Collection—Charles Henry Hayden Fund
57.198

Fig. 151
Margaret De Patta (American, 1903–1964)
Ring
San Francisco, California, 1947–48
18-karat white gold, tourmalinated quartz
2.4 x 1.9 x 3.2 cm (¹⁵⁄₁₆ x ¾ x 1¼ in.)
Promised gift of The Daphne Farago Collection

Fig. 152
Theodore Roszak (American, born in Poland, 1907–1981)
Untitled, 1930–40
Photograph, photogram, gelatin silver print
25.3 x 20.3 cm (9¹⁵⁄₁₆ x 8 in.)
Sophie M. Friedman Fund 1984.235

Fig. 153
Josef Albers (American, born in Germany, 1888–1976)
Gay Desert, about 1947–54
Oil on Masonite
52.4 x 91.8 cm (20⅝ x 36⅛ in.)
Gift of Susan Morse Hilles 1992.241

Fig. 154
Anni Albers (American, born in Germany, 1899–1994)
Brooch
North Carolina, 1941–46
Aluminum strainer, paper clips, safety pin
10.8 x 7.9 x 1 cm (4¼ x 3⅛ x ⅜ in.)
The Daphne Farago Collection 2006.44

Spain

Fig. 155
Miguel Cabrera (Mexican, 1695–1768)
Don Manuel José Rubio y Salinas, Archbishop of Mexico, 1754
Oil on canvas
181.9 x 124.9 cm (71⅝ x 49³⁄₁₆ in.)
Charles H. Bayley Picture and Painting Fund 2008.1

Fig. 156
Pedro Hernández Atenciano (Spanish, worked in Guatemala and Peru, 1510–1584)
Chalice
Santiago de los Caballeros (La Antigua), Guatemala, about 1560
Silver-gilt
28.3 x 19.1 cm (11⅛ x 7½ in.)
Private collection

Fig. 157
Tapestry cover
Peru, late 16th–17th century or later
Cotton and wool interlocked and dovetailed tapestry
238.5 x 216 cm (93⅞ x 85¹⁄₁₆ in.)
Charles Potter Kling Fund 67.25

Fig. 158
Cross (*cruz guión*)
Probably Mexico, 1721
Silver
33.2 x 18.2 x 7.8 cm (12⅛ x 7½ x 3 in.)
Gift in memory of Mr. and Mrs. William H. Keith
28.468

Fig. 159
Raymond López (American, born in 1961)
Our Lady of Sorrows (Nuestra Señora de los Dolores)
Santa Fe, New Mexico, about 2000
Painted and carved wood
52.7 x 23.5 x 15.2 cm (20¾ x 9¼ x 6 in.)
Gift of James and Margie Krebs 2006.1924

Fig. 160
Georgia O'Keeffe (American, 1887–1986)
Deer's Skull with Pedernal, 1936
Oil on canvas
91.4 x 76.5 cm (36 x 30⅛ in.)
Gift of the William H. Lane Foundation 1990.432

Fig. 161
Georgia O'Keeffe (American, 1887–1986)
Patio with Black Door, 1955
Oil on canvas
101.6 x 76.2 cm (40 x 30 in.)
Gift of the William H. Lane Foundation 1990.433

Fig. 162
Gilbert Stuart (American, 1755–1828)
Matilda Stoughton de Jaudenes, 1794
Oil on canvas
128.6 x 100.3 cm (50⅝ x 39½ in.)
The Metropolitan Museum of Art, New York
Rogers Fund, 1907 07.76

Fig. 163
Diego Rodríguez de Silva y Velázquez (Spanish, 1599–1660)
Las Meninas, or The Family of Philip IV, 1656
Oil on canvas
318 x 276 cm (125³⁄₁₆ x 108¹¹⁄₁₆ in.)
Museo Nacional del Prado, Madrid P01174

Fig. 164
John Singer Sargent (American, 1856–1925)
The Daughters of Edward Darley Boit, 1882
Oil on canvas
221.9 x 222.6 cm (87⅜ x 87⅝ in.)
Gift of Mary Louisa Boit, Julia Overing Boit, Jane Hubbard Boit, and Florence D. Boit in memory of their father, Edward Darley Boit 19.124

Fig. 165
El Greco (Doménikos Theotokópoulos) (Greek, active in Spain, 1541–1614)
Fray Hortensio Félix Paravicino, 1609
Oil on canvas
112.1 x 86.1 cm (44⅛ x 33⅞ in.)
Isaac Sweetser Fund 04.234

Fig. 166
Diego Rodríguez de Silva y Velázquez (Spanish, 1599–1660)
Luis de Góngora y Argote, 1622
Oil on canvas
50.2 x 40.6 cm (19¾ x 16 in.)
Maria Antoinette Evans Fund 32.79

Fig. 167
John Singer Sargent (American, 1856–1925)
General Charles J. Paine, 1904
Oil on canvas
86.7 x 72.7 cm (34⅛ x 28⅝ in.)
Gift of the heirs of Charles J. Paine 54.1410

Fig. 168
Robert Henri (American, 1865–1925)
Spanish Girl of Segovia, 1912
Oil on canvas
103.5 x 84.1 cm (40¾ x 33⅛ in.)
New Britain Museum of American Art, Connecticut
John Butler Talcott Fund 1941.07

Fig. 169
José Clemente Orozco (Mexican, 1883–1949)
The Franciscan, about 1929
Lithograph
30.5 x 25.4 cm (12 x 10 in.)
Bequest of W. G. Russell Allen 63.411

Fig. 170
Carlos Mérida (Guatemalan, 1891–1984), artist
Graphic Art Publications, publisher
"Thus the creation and the formation of man took place. . .," from the portfolio *Impressions of the Popol-Vuh (Estampas del Popol-Vuh)*, 1943
Color lithograph
Sheet: 42.9 x 32.7 cm (16⅞ x 12⅞ in.)
Gift of W. G. Russell Allen 49.231

Fig. 171
Carlos Mérida (Guatemalan, 1891–1984)
Architectures (Arquitecturas), 1955–66
Oil on canvas
76.2 x 62.2 cm (30 x 24½ in.)
Gift from the Stephen and Sybil Stone Foundation 1971.701

The Netherlands and Scandinavia

Fig. 172
Unidentified artist (Freake Gibbs painter) (active late 17th century)
Margaret Gibbs, 1670
Oil on canvas
102.9 x 84.1 cm (40½ x 33⅛ in.)
Bequest of Elsie Q. Giltinan 1995.800

Fig. 173
Jacob Boelen I (American, born in Holland, about 1657–1729 or 1730)
Two-handled bowl
New York, New York, 1690–1710
Silver
4.6 x 16.8 x 12.2 cm (1¹³⁄₁₆ x 6⅝ x 4¹³⁄₁₆ in.)
Museum purchase with funds donated by a Friend of the Department of American Decorative Arts and Sculpture and the Frank B. Bemis Fund 1992.511

Fig. 174
Henry Hurst (American, born in Sweden, about 1666–1717 or 1718)
Tankard
Boston, Massachusetts, about 1700
Silver
H. 17.8 cm, diam. of base 13.2 cm
(H. 7 in., diam. of base 5¹³⁄₁₆ in.)
Gift of Mr. and Mrs. Dudley Leavitt Pickman 31.228

Fig. 175
Isaac Blessing Jacob, about 1740
Oil on canvas mounted on Masonite
78.1 x 102.6 cm (30¾ x 40⅜ in.)
Robert Jordan Fund 1977.774

Fig. 176
Attributed to Roelef D. Demarest (American, 1769–1845)
Kast
Bergen County, New Jersey, 1790–1810
Red gum, yellow poplar, pine
198.1 x 188 x 68.9 cm (78 x 74 x 27⅛ in.)
Gift of a Friend of the Department of American Decorative Arts and Sculpture 1994.44

Fig. 177
Charles Bird King (American, 1785–1862)
Still Life on a Green Table Cloth, about 1815
Oil on panel
47.6 x 55.9 cm (18¾ x 22 in.)
Gift of Mrs. Samuel Parkman Oliver 1978.184

Fig. 178
Adriaen Brouwer (Dutch, about 1606–1638)
Peasants Carousing in a Tavern
Oil on panel
33.3 x 49.2 cm (13⅛ x 19⅜ in.)
Ernest Wadsworth Longfellow Fund 56.1185

Fig. 179
John Quidor (American, 1801–1881)
Rip Van Winkle and His Companions at the Inn Door of Nicholas Vedder, 1839
Oil on canvas
68.9 x 86.7 cm (27⅛ x 34⅛ in.)
Bequest of Martha C. Karolik for the M. and M. Karolik Collection of American Paintings, 1815–1865 48.469

Fig. 180
John Quidor (American, 1801–1881)
A Battle Scene from Knickerbocker's History of New York, 1838
Oil on canvas
68.6 x 87.9 cm (27 x 34⅝ in.)
Bequest of Martha C. Karolik for the M. and M. Karolik Collection of American Paintings, 1815–1865 48.468

Fig. 181
Arthur Stone (American, born in England, 1847–1938)
Porringer
Gardner, Massachusetts, 1925
Silver
5.4 x 21.6 cm (2⅛ x 8½ in.)
Gift of John Herbert Ross and Barbara O'Neil Ross
2003.817

Fig. 182
Edmund Charles Tarbell (American, 1862–1938)
Girl Reading, 1909
Oil on canvas
81.9 x 72.4 cm (32¼ x 28½ in.)
The Hayden Collection—Charles Henry Hayden Fund
09.209

Fig. 183
Marcia Oakes Woodbury (American, 1865–1913)
Mother and Daughter: The Whole of Life (Moeder en Dochter, Het Geheele Leven), 1894
Watercolor on paper
Left and right sheets: 67.3 x 30.5 cm (26½ x 12 in.)
Center sheet: 67.3 x 62.2 cm (26½ x 24½ in.)
Gift of Charles H. Woodbury 18.215

Fig. 184
Ilya Bolotowsky (American, born in Russia, 1907–1981)
Spiral Movement (Small Configurations within a Diamond), 1951
Oil on canvas
71.8 x 71.8 cm (28¼ x 28¼ in.)
Tompkins Collection—Arthur Gordon Tompkins Fund
1980.208

Fig. 185
Charmion von Wiegand (American, 1899–1983)
City Rhythm, 1948
Oil on canvas
43.2 x 30.5 cm (17 x 12 in.)
Robert Jordan Fund 1985.330

Fig. 186
Sven Markelius (Swedish, 1889–1972), designer
Length of furnishing fabric: *Pythagoras*
Stockholm, Sweden (marketed in United States), 1952
Screen-printed cotton
171 x 130 cm (67⁵⁄₁₆ x 51³⁄₁₆ in.)
Mary L. Smith Fund 1998.92

Fig. 187
Robert J. King (American, born in 1917), designer
John Van Koert (Canadian, 1912–1998), designer
Towle Manufacturing Company, manufacturer
Contour beverage service
Newburyport, Massachusetts, 1953–about 1960
Silver, melamine
Pitcher: 26.2 x 17.8 x 10.2 cm (10⁵⁄₁₆ x 7 x 4 in.)
Museum purchase with funds donated by The Seminarians in memory of Nathaniel T. Dexter 2001.260.1–3

Fig. 188
John Prip (American, 1922–2009)
Onion teapot
Rochester, New York, 1954
Silver, ebony, rattan
15.8 x 27.5 x 19.1 cm (6³⁄₁₆ x 10¹³⁄₁₆ x 7½ in.)
Gift of Stephen and Betty Jane Andrus 1995.137

Africa

Fig. 189
Pair of andirons
Rhode Island, about 1700
Wrought iron
41.6 x 17.8 x 44.5 cm (16⅜ x 7 x 17½ in.)
Gift of Mr. and Mrs. Samuel Rodman Robinson III
1979.379a–b

Fig. 190
Dave Drake (Dave the Potter) (American, about 1800–about 1870)
Made for Lewis J. Miles Pottery
Storage jar
Edgefield County, South Carolina, 1857
Stoneware with alkaline glaze
H. 48.3 cm, diam. 45.1 cm (H. 19 in., diam. 17¾ in.)
Harriet Otis Cruft Fund and Otis Norcross Fund 1997.10

Fig. 191
William Esperance Boucher, Jr. (American, 1822–1899)
Banjo
Baltimore, Maryland, about 1845–55
Oak, maple, calfskin
30.9 x 9 x 94.7 cm (12³⁄₁₆ x 3⁹⁄₁₆ x 37⁵⁄₁₆ in.)
String length: 60 cm (23⅝ in.)
Helen B. Sweeney Fund and Seth K. Sweetser Fund
2007.51

Fig. 192
Harriet Powers (American, 1837–1910)
Pictorial quilt
Athens, Georgia, 1895–98
Cotton plain weave, pieced, appliquéd, embroidered, and quilted
175 x 266.7 cm (68⅞ x 105 in.)
Bequest of Maxim Karolik 64.619

Fig. 193
Mary A. Jackson (American, born in 1945)
Basket with lid
Charleston, South Carolina, 1992
Sweet grass, pine needles, bulrush, palmetto fiber
H. 43.2 cm, diam. 45.7 cm (H. 17 in., diam. 18 in.)
Gift of Charles Devens, Mrs. Frances W. Lawrence, and The Seminarians 1992.523a–b

Fig. 194
Max Weber (American, born in Russia, 1881–1961)
New York (The Liberty Tower from the Singer Building), 1912
Oil on canvas
46.4 x 33.3 cm (18¼ x 13⅛ in.)
Gift of the Stephen and Sybil Stone Foundation 1971.705

Fig. 195
Max Weber (American, born in Russia, 1881–1961)
Three Literary Gentlemen, 1945
Oil on canvas
73.7 x 92.7 cm (29 x 36½ in.)
Gift of the William H. Lane Foundation 1990.454

Fig. 196
Charles Sheeler (American, 1883–1965)
Fang Figure, 1916–17
Photograph, gelatin silver print
Sheet: 22.8 x 16 cm (9 x 6⁵⁄₁₆ in.)
The Lane Collection

Fig. 197
Charles Sheeler (American, 1883–1965)
Ore into Iron, 1953
Oil on canvas
61.3 x 46 cm (24⅛ x 18⅛ in.)
Gift of William H. and Saundra B. Lane and Henry H. and Zoe Oliver Sherman Fund 1990.381

Fig. 198
Adolph Gottlieb (American, 1903–1974)
Alkahest of Paracelsus, 1945
Oil and egg tempera on canvas
152.4 x 111.8 cm (60 x 44 in.)
Tompkins Collection—Arthur Gordon Tompkins Fund 1973.599

Fig. 199
James Weldon Johnson (American, 1871–1938), author
Aaron Douglas (American, 1899–1979), illustrator
Judgment Day, from *God's Trombones: Seven Negro Sermons in Verse* (New York: Viking Press), 1927
Illustrated book with eight collotypes
Book: 23 x 16.5 x 1.4 cm (9¹⁄₁₆ x 6½ x ⁹⁄₁₆ in.)
Image: 15 x 11.4 cm (5⅞ x 4½ in.)
Gift of Mr. and Mrs. Deac Rossell APP.1977.51

Fig. 200
Wifredo Lam (Cuban, 1902–1982)
Untitled, 1943
Oil on burlap
61 x 78.7 cm (24 x 31 in.)
Museum purchase with funds by exchange from a Gift of Mr. and Mrs. Joshua Binion Cahn in memory of Dr. Philip H. Walker, Gift of Mrs. Morton Dexter, Gift of Miss Mary C. Wheelwright, Gift of Mrs. Melbourne H. Hardwick, Gift of Mrs. E. Stuart Peck, Gift of Charles H. Bayley, Gift of Louis Kronberg, The John Pickering Lyman Collection—Gift of Miss Theodora Lyman, Gift of Mrs. Eleanor M. Proctor, Bequest of Ernest Wadsworth Longfellow, Anonymous gifts, Bequest of Maxim Karolik, Gift of Mr. and Mrs. Henry Herbert Edes, Gift of Miss Lucia R. Peabody, Bequest of Kathleen Rothe, Gift of James M. Rosenberg, Gift of Edgar William and Bernice Chrysler Garbisch, Gift of Mrs. Edith Floyd, Bequest of Mrs. Edward Jackson Holmes, Gift of Miss A. E. Hardy, Gift of the Estate of Dr. Elizabeth DeBlois, A. Shuman Collection, and Gift of Mrs. Henry Lyman 2007.4

Fig. 201
Eldzier Cortor (American, born in 1916)
Room No. V, 1948
Oil on Masonite
78.7 x 68.6 cm (31 x 27 in.)
Charles H. Bayley Picture and Painting Fund and by exchange from a Gift of Frederick L. Jack, The Hayden Collection—Charles Henry Hayden Fund, Anonymous gift in memory of Dewey D. and Anne A. Stone, Robert Jordan Fund, Gift of Mrs. Arthur Tracy Cabot, Bequest of Ernest Wadsworth Longfellow, Gift of the John and Elizabeth Crawford Collection, Bequest of Grenville H. Norcross, Gift of Mrs. William Baxter Closson in memory of William Baxter Closson, Gift of the Estate of Paul Dougherty, Zoe Oliver Sherman Collection, Bequest of Dr. Arthur Tracy Cabot, Ellen Kelleran Gardner Fund, Bequest of Mrs. Edward Jackson Holmes, Edward Jackson Holmes Collection, The Henry C. and Martha B. Angell Collection, Bequest of Miss Lucy Ellis, Gift of Amy and David Dufour, Bequest of Miss Catharine A. Barstow, and Annie Anderson Hough Fund 2007.2

Fig. 202
Kongo power figure (*nkisi nkondi*)
Democratic Republic of the Congo, 19th–20th century
Wood, glass, iron nails, pigment, sacred material
61 x 30.5 x 20.3 cm (24 x 12 x 8 in.)
Gift of William E. and Bertha L. Teel 1991.1064

Fig. 203
Romare Bearden (American, 1911–1988)
Mysteries, 1964
Collage with hand-applied color
Sheet: 28.6 x 36.2 cm (11¼ x 14¼ in.)
Ellen Kelleran Gardner Fund 1971.63

Fig. 204
Art Smith (American, born in Cuba, 1917–1982)
Modern Cuff
New York, New York, 1948
Copper, brass
10.8 x 6.4 x 5.7 cm (4¼ x 2½ x 2¼ in.)
The Daphne Farago Collection 2006.531

Fig. 205
Frank E. Cummings III (American, born in 1938)
Clock
Long Beach, California, 1979–80
Ebony, ivory, African blackwood, 14-karat gold, black star sapphires, glass
172.7 x 61 x 40.6 cm (68 x 24 x 16 in.)
Museum purchase with funds donated anonymously and from a Gift of the Seminarians in memory of William A. Whittemore and Beck F. Whittemore, and with funds donated by Anne M. Beha and Robert A. Radloff, Susan W. Paine, The Doran Family Charitable Trust, and by exchange from a Gift of J. Templeman Coolidge, Gift of Miss Ruth K. Richardson, Gift of Richard S. Fuller in memory of his wife, Lucy Derby Fuller, Gift of Miss Annie J. Pecker, Gift of William E. Beaman, Gift of George R. Meneely, Gift of Joseph Randolph Coolidge IV, Bequest of Mrs. Ethel Stanwood Bolton, Bequest of Dr. Samuel A. Green, Bequest of Miss Eleanor P. Martin, Bequest of Miss Kate A. Gould, and Bequest of Sarah E. Montague 2004.563

Fig. 206
Willie Cole (American, born in 1955)
Silex Male, Ritual, 2004
Digital ink-jet print on heavy white wove paper
Sheet: 154.9 x 111.8 cm (61 x 44 in.)
Museum purchase with funds donated by Johanna and Leslie Garfield 2006.1397

The Near East

Fig. 207
Indo-Persian carpet
Probably Isfahan, Persia, 17th century
Cotton warp, cotton weft, wool pile, asymmetrical knot
202 x 141 cm (79½ x 55½ in.)
Gift of John Goelet 66.229

Fig. 208
Turkey-work chair
England or America, about 1675
Maple, beech, turkey-work upholstery (black background is replaced)
94 x 52.1 x 48.3 cm (37 x 20½ x 19 in.)
Bequest of Charles Hitchcock Tyler 43.1509

Fig. 209
Embroidered trunk
Mexico, about 1750–75
Leather, embroidered with linen, silk, and metallic thread; iron, canvas lining, wood
44 x 49 x 68 cm (17 5/16 x 19 5/16 x 26¾ in.)
Gift of Mrs. W. Scott Fitz 15.842

Fig. 210
John Singleton Copley (American, 1738–1815)
Elizabeth Ross (Mrs. William Tyng), about 1766
Oil on canvas
127 x 101.6 cm (50 x 40 in.)
The M. and M. Karolik Collection of Eighteenth-Century American Arts 39.248

Fig. 211
William Jay Dana (American, 1839–1913)
Under the Natural Bridge, Lebanon, 1880
Wood engraving
Sheet: 30.3 x 24.1 cm (11 15/16 x 9½ in.)
Gift of William Jay Dana M10203

Fig. 212
Elihu Vedder (American, 1836–1923)
The Questioner of the Sphinx, 1863
Oil on canvas
92.1 x 107.3 cm (36¼ x 42¼ in.)
Bequest of Mrs. Martin Brimmer 06.2430

Fig. 213
Elihu Vedder (American, 1836–1923)
Fisherman and the Genie, about 1863
Oil on panel
19.4 x 35.2 cm (7 5/8 x 13 7/8 in.)
Bequest of Mrs. Martin Brimmer 06.2431

Fig. 214
William Rimmer (American, born in England, 1816–1879)
Flight and Pursuit, 1872
Oil on canvas
46 x 66.7 cm (18⅛ x 26¼ in.)
Bequest of Miss Edith Nichols 56.119

Fig. 215
Moorish Smoking Room, the John D. Rockefeller House
Built about 1864–65; remodeled about 1881
Entire room: 5.3 x 4.7 m (17½ x 15½ ft.)
Brooklyn Museum 46.43 Gift of John D. Rockefeller, Jr. and John D. Rockefeller III

Fig. 216
Man's smoking cap
United States, 19th century
Wool embroidered with wool, silk tassel
21.6 x 16.5 x 19 cm (8½ x 6½ x 7½ in.)
Gift of Miss Laura R. Little 45.538

Fig. 217
Jean-Léon Gérôme (French, 1824–1904)
Moorish Bath, 1870
Oil on canvas
50.8 x 40.6 cm (20 x 16 in.)
Gift of Robert Jordan from the collection of Eben D. Jordan 24.217

Fig. 218
Frederick Arthur Bridgman (American, 1847–1928)
A Circassian, 1881
Oil on canvas
22.9 x 18.1 cm (9 x 7⅛ in.)
Bequest of Ernest Wadsworth Longfellow 37.591

Fig. 219
John Singer Sargent (American, 1856–1925)
Head of an Arab, about 1891
Oil on canvas
80 x 58.7 cm (31½ x 23⅛ in.)
Gift of Mrs. Francis Ormond 37.49

Fig. 220
John Singer Sargent (American, 1856–1925)
Frieze of the Prophets, about 1892
Oil on canvas
56.2 x 71.1 cm (22⅛ x 28 in.)
Gift of Mrs. Francis Ormond 37.45

Fig. 221
Henry Ossawa Tanner (American, 1859–1937)
Interior of a Mosque, Cairo, 1897
Oil on canvas
52.1 x 66 cm (20½ x 26 in.)
Museum purchase with funds by exchange from The Hayden Collection—Charles Henry Hayden Fund, Bequest of Kathleen Rothe, Bequest of Barbara Brooks Walker, and Gift of Mrs. Richard Storey in memory of Mrs. Bayard Thayer 2005.92

Fig. 222
Kimbel and Cabus
Sideboard
New York, New York, about 1870–75
Ebonized cherry, porcelain
156.2 x 43.2 x 114.3 cm (61½ x 17 x 45 in.)
H. E. Bolles Fund 1999.93

Fig. 223
Tiffany and Company
Pitcher
New York, New York, 1875

Silver, copper
21 x 10.6 x 9.5 cm (8¼ x 4³⁄₁₆ x 3¾ in.)
Gift of Gideon F. T. Reed 77.61

Fig. 224
Sara Galner (American, born in Austria–Hungary,
1894–1982), decorator
Paul Revere Pottery of the Saturday Evening Girls club,
manufacturer
Tea caddy
Boston, Massachusetts, 1914
Glazed earthenware
11.1 x 7.6 x 7.6 cm (4⅜ x 3 x 3 in.)
Gift of Dr. David L. Bloom and family in honor of his
mother, Sara Galner Bloom 2007.365

Fig. 225
Maxfield Parrish (American, 1870–1966), artist and designer
Edison General Electric Light Company, publisher
Edison Mazda / The Lamp Seller of Bagdad, 1922
Poster
65 x 41 cm (25⁹⁄₁₆ x 16⅛ in.)
Gift of Miss Marjorie W. Childs Poster49

Fig. 226
Fernand Cesar Auguste Bernard James Moreau (American,
born in France, 1853–1920), designer (pedestal)
Fritz Wilhelm Albert (American, born in Alsace-Lorraine,
1865–1940), designer (lamp)
Northwestern Terra Cotta Company, manufacturer
Pedestal and lamp
Chicago, Illinois, about 1911
Glazed terra-cotta
162.6 x 33 x 30.5 cm (64 x 13 x 12 in.)
Gift of J. Parker Prindle 2009.5318.1–2

Fig. 227
Claudio Bravo (Chilean, born in 1936)
Interior with Landscape Painter, 1989
Oil on canvas
199.4 x 152.4 cm (78½ x 60 in.)
Melvin Blake and Frank Purnell Collection 2003.27

Asia

Fig. 228
Cover
Peru, late 17th–18th century
Wool, silk, cotton, and linen tapestry weave
238.3 x 207.3 cm (93¹³⁄₁₆ x 81⅝ in.)
Denman Waldo Ross Collection 11.1264

Fig. 229
Jar (*tibor*)
Puebla, Mexico, about 1700–1725
Tin-glazed earthenware
26 x 11.5 cm (10¼ x 4½ in.)
Denman Waldo Ross Collection 00.389

Fig. 230
High chest of drawers
Boston, Massachusetts, about 1730–40
Japanned butternut, maple, white pine
182.2 x 108.9 x 62.9 cm (71¾ x 42⅞ x 24¾ in.)
Bequest of Charles Hitchcock Tyler 32.227

Fig. 231
Side chair
Massachusetts, 1740–60
Walnut, maple
100.3 x 49.5 x 41.6 cm (39½ x 19½ x 16⅜ in.)
Bequest of George Nixon Black 29.842

Fig. 232
Jacob Hurd (American, 1702 or 1703–1758)
Teapot
Boston, Massachusetts, about 1730–35
Silver
13.3 x 21.8 x 10.8 cm (5¼ x 8⅝ x 4¼ in.)
Gift of William Storer Eaton in the name of Miss Georgiana
G. Eaton 13.558

Fig. 233
American China Manufactory of Gousse Bonnin (about
1741–1780) and George Anthony Morris (1742 or 1745–1773)
Fruit basket
Philadelphia, Pennsylvania, 1771–72
Soft-paste porcelain, underglaze blue decoration
6.8 x 17.5 cm (2¹¹⁄₁₆ x 6⅞ in.)
Frederick Brown Fund 1977.621

Fig. 234
Dressing table
Philadelphia, Pennsylvania, about 1760–70
San Domingo mahogany, mahogany veneer, yellow poplar,
cedar
81 x 51.8 x 92.1 cm (31⅞ x 20⅜ x 36¼ in.)
The M. and M. Karolik Collection of Eighteenth-Century
American Arts 39.150

Fig. 235
John Singleton Copley (American, 1738–1815)
Nicholas Boylston, about 1769
Oil on canvas
127.3 x 101.6 cm (50⅛ x 40 in.)
Bequest of David P. Kimball 23.504

Fig. 236
Wallpaper
Probably Guangdong Province, China, about 1805
Opaque watercolor on paper
335.3 x 121.9 cm (132 x 48 in.)
Gift of W. Carlton Rich and Harold B. Raymond, Trustees
Res.27.36

Fig. 237
Karl L. H. Müller (American, born in Austria, 1820–1887),
designer
Union Porcelain Works, manufacturer
Pitcher
Greenpoint, Brooklyn, New York, about 1876
Porcelain
24.1 x 27.3 x 15.9 cm (9½ x 10¾ x 6¼ in.)
Museum purchase with funds donated by The Karolik
Society 2008.72

Fig. 238
James Abbott McNeill Whistler (American, active in
England, 1834–1903)
Harmony in Flesh Colour and Red, about 1869
Oil and wax crayon on canvas
39.7 x 35.6 cm (15⅝ x 14 in.)
Emily L. Ainsley Fund 60.1158

Fig. 239
Kitagawa Utamaro (Japanese, died in 1806)
Tsutaya Jūzaburō (Kōshodō), publisher
Courtesans beneath a Wisteria Arbor, about 1795
Woodblock print triptych; ink and color on paper
Left sheet: 39 x 25.7 cm (15⁵⁄₁₆ x 10⅛ in.)
Center sheet: 38.2 x 25.5 cm (15¹⁄₁₆ x 10¹⁄₁₆ in.)
Right sheet: 38.8 x 25.5 cm (15¼ x 10¹⁄₁₆ in.)
Denman Waldo Ross Collection 11.14383, 06.1129, 11.14388

Fig. 240
John La Farge (American, 1835–1910)
Vase of Flowers, 1864
Oil on gilded panel
47 x 35.6 cm (18½ x 14 in.)
Gift of the Misses Louisa W. and Marian R. Case 20.1873

Fig. 241
Gorham Manufacturing Company
Tea caddy
Providence, Rhode Island, 1881
Copper, silver
10.5 x 10.5 x 9.4 cm (4⅛ x 4⅛ x 3¹¹⁄₁₆ in.)
Gift of Mr. and Mrs. Fred G. Peil, Irma M. Lampert, Henry
B. and Klaudia S. Shepard Jr., Gage Bailey Jr., Dr. and Mrs.
Francis de Marneffe, Charles S. Nichols, Frank and M. L.
Coolidge, Jane E. Coolidge, Angela B. Fischer, Elisha W. Hall
II, Ruth F. Hamlen, Faith Moore, Olivia and John Parker,
Mr. and Mrs. Walter W. Patten, Jr., J. E. Robinson III, John
and Patricia Rodgers, Irvin and Rebekah Taube, Anne D.
Moffett, and Louise and Jonathan L. Fairbanks 1991.636

Fig. 242
*The Japanese Exhibition at the Philadelphia Centennial
International Exposition*, 1876
Photograph
Courtesy of the Free Library of Philadelphia Archives
11-2247

Fig. 243
Gorham Manufacturing Company
Punch bowl and ladle
Providence, Rhode Island, 1885
Silver, gilding
Punch bowl: H. 25.7 cm, diam. 38.7 cm (H. 10⅛ in.,
diam. 15¼ in.)
Ladle: L. 35.6 cm. w. 9.5 cm (L. 14 in., w. 3¾ in.)
Edwin E. Jack Fund 1980.383–84

Fig. 244
Rookwood Pottery Company
Perfume jar
Cincinnati, Ohio, 1889
Earthenware with underglaze decoration
12.7 x 17.8 x 17.8 cm (5 x 7 x 7 in.)
Gift of Mrs. Maria Longworth Nichols 82.163

Fig. 245
Herter Brothers
Cabinet
New York, New York, about 1880
Maple, bird's-eye maple, oak or chestnut, stamped and gilt
paper, with gilding, inlay, and carved decoration; original
brass pulls and key
133.4 x 184.8 x 38.4 cm (52½ x 72¾ x 15⅛ in.)
Museum purchase with funds donated anonymously and
the Frank B. Bemis Fund 2000.3

Fig. 246
Charles Caryl Coleman (American, 1840–1928)
Still Life with Azaleas and Apple Blossoms, 1878
Oil on canvas
180.3 x 62.9 cm (71 x 24¾ in.)
Charles H. Bayley Picture and Painting Fund, Paintings
Department Special Fund, American Paintings Deaccession
Fund, and Museum purchase with funds donated by
William R. Elfers Fund, an anonymous donor, Mr. and Mrs.
E. Lee Perry, Jeanne G. and Stokley P. Towles, Mr. Robert M.
Rosenberg and Ms. Victoria DiStefano, Mr. and Mrs. John
Lastavica, and Gift of Dr. Fritz B. Talbot and Gift of Mrs.
Charles Gaston Smith's Group, by exchange 2001.255

Fig. 247
John La Farge (American, 1835–1910)
The Fish (or *The Fish and Flowering Branch*)
Probably New York, New York, about 1890
Glass, lead
66.7 x 67.3 cm (26¼ x 26½ in.)
Edwin E. Jack Fund and Anonymous gift 69.1224

Fig. 248
Louis Comfort Tiffany (American, 1848–1933), designer
Tiffany Glass and Decorating Company, manufacturer
Parakeets and Gold Fish Bowl
New York, New York, about 1893
Glass, lead, bronze chain
195.6 x 97.8 cm (77 x 38½ in.)
Gift of Barbara L. and Theodore B. Alfond in honor of
Malcolm Rogers 2008.1415

Fig. 249
Greene and Greene (active 1894–1916), designers
Hall Manufacturing Company, manufacturer
Bench for the Robert R. Blacker House
Pasadena, California, 1907
Mahogany, ebony
52.1 x 115.6 x 31.8 cm (20½ x 45½ x 12½ in.)
Harriet Otis Cruft Fund 1982.407

Fig. 250
Mary Stevenson Cassatt (American, 1844–1926)
The Coiffure, about 1891
Drypoint and color aquatint on paper
Platemark: 36.5 x 26.2 cm (14⅜ x 10⁵⁄₁₆ in.)
Gift of William Emerson and The Hayden Collection—
Charles Henry Hayden Fund 41.807

Fig. 251
Kitagawa Utamaro (Japanese, died 1806)
Matsumura Tatsuemon, publisher
Takashima Ohisa, about 1795
Woodblock print; ink and color on paper

36.3 x 25 cm (14⁵⁄₁₆ x 9¹³⁄₁₆ in.)
William S. and John T. Spaulding Collection 21.6410

Fig. 252
Arthur Wesley Dow (American, 1857–1922)
Bend of a River, about 1898
Color woodcut on paper
Image: 23 x 6.1 cm (9¹⁄₁₆ x 2⅜ in.)
Gift of Mrs. Ethelyn H. Putnam 41.716

Fig. 253
Utagawa Hiroshige (Japanese, 1797–1858)
Uoya Eikichi, publisher
Nihon Embankment, Yoshiwara, 1857, from the series *One
Hundred Famous Views of Edo*
Woodblock print; ink and color on paper
33.5 x 21.8 cm (13³⁄₁₆ x 8⁹⁄₁₆ in.)
William Sturgis Bigelow Collection 11.16740

Fig. 254
Alvin Langdon Coburn (American, 1882–1966), artist
The Dome of Saint Paul's, photogravure from *The Novels
and Tales of Henry James V: The Princess Casamassima I*
(New York: Charles Scribner's Sons), 1922
Book illustrated with one photogravure by Coburn
Book: 22 x 15 x 4 cm (8¹¹⁄₁₆ x 5⅞ x 1⁹⁄₁₆ in.)
Image: 10.1 x 8.8 cm (4 x 3⁷⁄₁₆ in.)
Gift of Richard Germann 2001.383

Fig. 255
Jackson Pollock (American, 1912–1956)
Number 10, 1949
Oil, enamel, and aluminum paint on canvas mounted
on panel
46 x 272.4 cm (18⅛ x 107¼ in.)
Tompkins Collection—Arthur Gordon Tompkins Fund
and Sophie M. Friedman Fund 1971.638

Fig. 256
Peter Voulkos (American, 1924–2002)
Camelback Mountain
Berkeley, California, 1959
Stoneware
115.6 x 49.5 x 51.4 cm (45½ x 19½ x 20¼ in.)
Gift of Mr. and Mrs. Stephen D. Paine 1978.690

Fig. 257
Brice Marden (American, born in 1938)
Plate 5 from *Etchings to Rexroth* (25 illustrations inspired by
Thirty-six Poems by Tu Fu, translated by Kenneth Rexroth),
1986
Etchings with sugar-lift aquatint on paper
Platemark: 20.3 x 17.5 cm (8 x 6⅞ in.)
Gift of Azita Bina and Elmar W. Seibel 1999.711

SUGGESTED READING

General

Baarsen, Reinier, et al. *Courts and Colonies: The William and Mary Style in Holland, England, and America.* Exh. cat. New York: Cooper-Hewitt Museum, the Smithsonian Museum's National Museum of Design; Pittsburgh, Pa.: Carnegie Museum of Art, 1988. Distributed by University of Washington Press.

Bailyn, Bernard. *Atlantic History: Concept and Contours.* Cambridge, Mass.: Harvard University Press, 2005.

Brook, Timothy. *Vermeer's Hat: The Seventeenth Century and the Dawn of the Global World.* New York: Bloomsbury Press, 2008.

Conforti, Michael, and Francis J. Puig, eds. *The American Craftsman and the European Tradition, 1620–1820.* Exh. cat. Minneapolis: Minneapolis Institute of Arts, 1989. Distributed by University Press of New England.

Daniels, Roger. *Coming to America: A History of Immigration and Ethnicity in American Life.* 2nd ed. New York: HarperCollins, 2002.

Eaton, Allen H. *Immigrant Gifts to American Life: Some Experiments in Appreciation of the Contributions of Our Foreign-Born Citizens to American Culture.* New York: Russell Sage Foundation, 1902.

Elliott, J. H. *Empires of the Atlantic World: Britain and Spain in America, 1492–1830.* New Haven: Yale University Press, 2006.

Fernando-Arnesto, Felipe. *The Americas: A Hemispheric History.* New York: Modern Library, 2003.

Karp, Ivan, and Steven D. Levine, eds. *Exhibiting Cultures: The Poetics and Politics of Museum Display.* Washington, D.C.: Smithsonian Institution Press, 1991.

Kraus, Michael. *The Atlantic Civilization: Eighteenth-Century Origins.* 1949. Reprint, Ithaca, N.Y.: Cornell University Press, 1966.

Kubler, George. *The Shape of Time: Remarks on the History of Things.* New Haven: Yale University Press, 1962.

Mack, John. *The Museum of the Mind: Art and Memory in World Cultures.* London: British Museum Press, 2003.

Marzio, Peter C., ed. *A Nation of Nations.* Exh. cat. Washington, D.C.: Smithsonian Institution, 1976.

Miller, Angela L., et al. *American Encounters: Art, History and Cultural Identity.* Upper Saddle River, N.J.: Pearson Education, 2008.

Rishel, Joseph J., ed. *The Arts in Latin America, 1492–1820.* Exh. cat. Philadelphia: Philadelphia Museum of Art, 2006.

St. George, Robert Blair. *Possible Pasts: Becoming Colonial in Early America.* Ithaca, N.Y.: Cornell University Press, 2000.

Thernstrom, Stephen, ed. *The Harvard Encyclopedia of American Ethnic Groups.* Cambridge, Mass.: Harvard University Press, 1980.

Upton, Dell. *America's Architectural Roots: Ethnic Groups That Built America.* Washington, D.C.: Preservation Press, National Trust for Historic Preservation, 1986.

Winterthur Conference on Museum Operation and Connoisseurship. *Spanish, French, and English Traditions in the Colonial Silver of North America* (1968 Winterthur Conference Report). Winterthur, Del.: Henry Francis du Pont Winterthur Museum, 1969.

Mesoamerica

Berrin, Kathleen, and Esther Pasztory. *Teotihuacan: Art from the City of the Gods.* Exh. cat. San Francisco: Fine Arts Museum of San Francisco; New York: Thames and Hudson, 1993.

Coe, Michael D., and Rex Koontz. *Mexico: From the Olmecs to the Aztecs.* 5th ed. London: Thames and Hudson, 2002.

Coe, Michael D., et al. *The Olmec World: Ritual and Rulership.* Exh. cat. Princeton: Art Museum, Princeton University, 1995.

Foundation for the Advancement of Mesoamerican Studies, Inc. (FAMSI). http://www.famsi.org/index.html.

Pasztory, Esther. *Aztec Art.* New York: Harry N. Abrams, 1983.

Reents-Budet, Dorie, Joseph Ball, Ronald Bishop, Virginia Fields, and Barbara MacLeod. Exh. cat. *Painting the Maya Universe: Royal Ceramics of the Classic Period.* Durham, N.C.: Duke University Press, 1994.

Schele, Linda, and David Freidel. *A Forest of Kings: The Untold Story of the Ancient Maya.* New York: William Morrow, 1990.

Schele, Linda, and Mary Ellen Miller. *Blood of Kings.* Exh. cat. Ft. Worth, Tex.: Kimbell Art Museum, 1986.

Sharer, Robert, and Loa Traxler. *The Ancient Maya.* 6th ed. Stanford, Calif.: Stanford University Press, 2006.

Central America

Abel-Vidor, Suzanne, ed. *Between Continents/Between Seas: Precolumbian Art of Costa Rica.* New York: Harry N. Abrams, 1981.

Hearne, Pamela, and Robert J. Sharer, eds. *River of Gold: Precolumbian Treasures from Sitio Conte.* Philadelphia: University of Pennsylvania Museum of Archaeology and Anthropology, 1992.

Jones, Julie, ed. *Jade in Ancient Costa Rica.* Exh. cat. New York: Metropolitan Museum of Art, 1998.

Labbé, Armand. *Guardians of the Life Stream: Shamans, Art and Power in Prehispanic Central Panamá.* Exh. cat. Santa Ana: Cultural Arts Press/Bowers Museum of Cultural Art; Seattle: University of Washington Press, 1995.

Lange, Frederick, and Doris Stone, eds. *The Archaeology of Lower Central America.* Santa Fe: School of American Research, 1984.

Andean South America

Botero, Clara Isabel, Roberto Lleras Pérez, Santiago Londoñoz Vélez, and Efraín Sánchez Cabra, eds. *The Art of Gold: The Legacy of Pre-Hispanic Colombia.* Exh. cat. Bogotá: Fondo de Cultura Económica and Banco de la República, 2008.

de la Vega, Garcilaso. *Royal Commentaries of the Incas: El Inca [1539–1616].* Austin: University of Texas Press, 1966.

Labbé, Armand. *Colombia before Columbus.* New York: The Americas Foundation and Rizzoli Press, 1986.

McEwan, Colin, ed. *Precolumbian Gold: Technology, Style and Iconography.* Exh. cat. London: Trustees of the British Museum; Chicago: Fitzroy Dearborn Publishers, 2000.

McEwan, Gordon F. *The Incas: New Perspectives.* New York: W. W. Norton, 2006.

Quilter, Jeffrey. *Treasures of the Andes: The Glories of Inca and Precolumbian South America.* London: Duncan Baird Publishers, 2006.

Stone, Rebecca. *Art of the Andes: From Chavin to Inka.* London: Thames and Hudson, 2002.

Stone-Miller, Rebecca. *To Weave for the Sun: Andean Textiles in the Museum of Fine Arts, Boston.* Exh. cat. Boston: Museum of Fine Arts, 1992.

Ancient American and Modern Latin American Art

Braun, Barbara. *Pre-Columbian Art and the Post-Columbian World: Ancient American Sources of Modern Art.* New York: Harry N. Abrams, 1993.

Cahill, Holger. "American Sources of Modern Art." In *American Sources of Modern Art,* 5–21. Exh. cat. New York: Museum of Modern Art, 1933.

Fry, Roger. *Vision and Design.* London: Chatto and Windus, 1925.

Paternosto, César. *The Stone and the Thread: Andean Roots of Abstract Art.* Translated by Esther Allen. Austin: University of Texas Press, 1996.

Native North American Art

Berlo, Janet Catherine, and Ruth B. Phillips. *Native North American Art.* New York: Oxford University Press, 1998.

Boehme, Sarah E., et al. *Powerful Images: Portrayals of Native America.* Exh. cat. Seattle: Museums West, in association with University of Washington Press, 1998.

Crosby, Alfred W., Jr. *The Columbian Exchange: Biological and Cultural Consequences of 1492.* Westport, Conn.: Greenwood Press, 1972.

Douglas, Frederic H., and Rene d'Harnoncourt. *Indian Art of the United States.* Exh. cat. New York: Museum of Modern Art, 1941.

Fagan, Brian M. *Ancient North America: The Archaeology of a Continent.* 3rd ed. New York: Thames and Hudson, 2000.

Fane, Diana, Ira Jacknis, and Lise M. Breen. *Objects of Myth and Memory: American Indian Art at the Brooklyn Museum.* Exh. cat. Brooklyn, N.Y.: Brooklyn Museum, in association with University of Washington Press, 1991.

Her Many Horses, Emil, ed. *Identity by Design: Tradition, Change, and Celebration in Native Women's Dresses.* Exh. cat. New York: Collins, in association with the National Museum of the American Indian, Smithsonian Institution, 2007. See also the online exhibition, 2008, at http://www.nmai.si.edu/exhibitions/identity_by_design/IdentityByDesign.html.

Holm, Bill. *Northwest Coast Indian Art: An Analysis of Form.* Seattle: University of Washington Press, 1965.

Horse Capture, Joseph D., and George P. Horse Capture. *Beauty, Honor, and Tradition: The Legacy of Plains Indians Shirts.* Exh. cat. Minneapolis: Minneapolis Institute of Arts; Washington, D.C.: National Museum of the American Indian, Smithsonian Institution, 2001.

Hutchinson, Elizabeth. *The Indian Craze: Primitivism, Modernism, and Transculturation in American Art, 1890–1915.* Durham, N.C.: Duke University Press, 2009.

Jacknis, Ira. *The Storage Box Tradition: Kwakiutl Art, Anthropologists, and Museums, 1881–1981.* Washington, D.C.: Smithsonian Institution Press, 2002.

Kennedy, Roger G. *Hidden Cities: The Discovery and Loss of Ancient North American Civilization.* New York: Free Press, 1994.

Krech, Shepard, III, and Barbara A. Hail, eds. *Collecting Native America, 1870–1960.* Washington, D.C.: Smithsonian Institution Press, 1999.

McLennan, Bill, and Karen Duffek. *The Transforming Image: Painted Arts of the Northwest Coast First Nations.* Vancouver: UBC Press; Seattle: University of Washington Press, 2000.

McMaster, Gerald, and Clifford E. Trafzer, eds. *Native Universe: Voices of Indian America by Native American Tribal Leaders, Writers, Scholars, and Storytellers.* Washington, D.C.: Smithsonian National Museum of the American Indian, in association with National Geographic Society, 2004.

Ostrowitz, Judith. *Privileging the Past: Reconstructing History in Northwest Coast Art.* Seattle: University of Washington Press; Vancouver: UBC Press, 1999.

Penney, David W. *North American Indian Art.* New York: Thames and Hudson, 2004.

Phillips, Ruth B. *Trading Identities: The Souvenir in Native North American Art from the Northeast, 1700–1900.* Seattle: University of Washington Press; Montreal: McGill-Queen's University Press, 1998.

Richter, Daniel K. *Facing East from Indian Country: A Native History of Early America.* Cambridge, Mass.: Harvard University Press, 2001.

Rushing, W. Jackson, III. *Native American Art in the Twentieth Century: Makers, Meanings, Histories.* London: Routledge, 1999.

Smith, Paul Chaat. *Everything You Know about Indians Is Wrong.* Minneapolis: University of Minnesota Press, 2009.

The Classical Tradition

Arts Council of Great Britain. *The Age of Neo-Classicism.* Exh. cat. London: Arts Council of Great Britain, 1972.

Cooper, Wendy A. *Classical Taste in America, 1800–1840.* Exh. cat. New York: Harry N. Abrams, 1993.

Dickson, Harold E. *Arts of the Young Republic: The Age of William Dunlap.* Exh. cat. Chapel Hill: University of North Carolina Press, 1968.

Feld, Elizabeth, and Stuart P. Feld. *Of the Newest Fashion: Masterpieces of American Neo-classical Decorative Arts.* Exh. cat. New York: Hirschl & Adler Galleries, 2002.

Feld, Stuart P. *Boston in the Age of Neo-Classicism, 1810–1840.* Exh. cat. New York: Hirschl & Adler Galleries, 2001.

Hamlin, Talbot. *Greek Revival Architecture in America.* 1944. Reprint, New York: Dover, 1964.

Hitchcock, Henry-Russell, and William Seale. *Temples of Democracy: The State Capitols of the U.S.A.* New York: Harcourt Brace Jovanovich, 1976.

Lahikainen, Dean. *Samuel McIntire: Carving an American Style.* Exh. cat. Salem, Mass.: Peabody Essex Museum, 2007.

Naeve, Milo M. *The Classical Presence in American Art.* Exh. cat. Chicago: Art Institute of Chicago, 1978.

Summerson, John. *The Classical Language of Architecture.* Cambridge, Mass.: MIT Press, 1963.

Tracy, Berry B., and William H. Gerdts. *Classical America, 1815–1845.* Exh. cat. Newark, N.J.: Newark Museum, 1963.

Troyen, Carol. *Sargent's Murals in the Museum of Fine Arts, Boston.* Boston: Museum of Fine Arts, 1999.

Weidman, Gregory R., et al. *Classical Maryland, 1815–1845: Fine and Decorative Arts from the Golden Age.* Exh. cat. Baltimore: Maryland Historical Society, 1993.

England

Bailyn, Bernard. *The Peopling of British North America: An Introduction.* New York: Alfred A. Knopf, 1986.

Bailyn, Bernard, with the assistance of Barbara DeWolfe. *Voyagers to the West: A Passage in the Peopling of America on the Eve of the Revolution.* New York: Alfred A. Knopf, 1986.

Burk, Kathleen. *Old World, New World: Great Britain and America from the Beginning.* London: Little, Brown, 2007.

Erffa, Helmut van, and Alan Staley. *The Paintings of Benjamin West.* New Haven: Yale University Press, 1986.

Fairbanks, Jonathan L., et al. *Paul Revere's Boston, 1735–1818.* Exh. cat. Boston: Museum of Fine Arts, 1975.

Fairbanks, Jonathan L., and Robert F. Trent. *New England Begins: The Seventeenth Century.* 3 vols. Exh. cat. Boston: Museum of Fine Arts, 1982.

Ferber, Linda S., and William H. Gerdts. *The New Path: Ruskin and the American Pre-Raphaelites.* Exh. cat. Brooklyn: Brooklyn Museum, 1985.

Fischer, David Hackett. *Albion's Seed: Four British Folkways in America.* New York: Oxford University Press, 1989.

Heckscher, Morrison H. "English Furniture Pattern Books in Eighteenth-Century America." In *American Furniture 1994,* ed. Luke Beckerdite. Milwaukee, Wis.: Chipstone Foundation, 1994.

Hirshler, Erica E. "'A Prince in the Royal Line of Painters': Sargent's Portraits and Posterity." In *Great Expectations: John Singer Sargent Painting Children,* edited by Barbara Gallati, 150–79. Exh. cat. Brooklyn: Brooklyn Museum, 2004.

Kane, Patricia E., et al. *Colonial Massachusetts Silversmiths and Jewelers.* New Haven: Yale University Art Gallery, 1998.

Kaplan, Wendy. *The Arts and Crafts Movement in Europe and America: Design for the Modern World.* Exh. cat. New York: Thames and Hudson for the Los Angeles County Museum of Art, 2004.

Kino, Carol. "David Hockney's Long Road Home." *New York Times,* October 18, 2009.

Kirk, John T. *American Furniture and the British Tradition to 1830.* New York: Alfred A. Knopf, 1982.

Letters and Papers of John Singleton Copley and Henry Pelham. Boston: Massachusetts Historical Society, 1914.

Livingston, Karen, and Linda Perry, eds. *International Arts and Crafts.* Exh. cat. London: V&A Publications, 2005.

Meyer, Marilee Boyd, ed. *Inspiring Reform: Boston's Arts and Crafts Movement.* Exh. cat. New York: Harry N. Abrams for the Davis Museum and Cultural Center, Wellesley College, 1997.

Neff, Emily Ballew, and William L. Pressly. *John Singleton Copley in England.* Exh. cat. Houston, Tex.: Museum of Fine Arts, 1995.

Rebora, Carrie, et al. *John Singleton Copley in America.* Exh. cat. New York: Metropolitan Museum of Art, 1995.

Rhode Island School of Design, Museum of Art. *The Catalogue of Old and New England: An Exhibition of American Painting of Colonial and Early Republican Days together with English Painting of the Same Time.* Exh. cat. Providence: Museum of Art, Rhode Island School of Design, 1945.

Saunders, Richard H. *John Smibert: Colonial America's First Portrait Painter.* New Haven: Yale University Press, 1995.

Stebbins, Theodore E., Jr. *Martin Johnson Heade.* Exh. cat. Boston: Museum of Fine Arts in collaboration with Yale University Press, 1999.

France

Adler, Kathleen, et al. *Americans in Paris, 1860–1900.* Exh. cat. London: National Gallery, 2006.

Ames, Kenneth L. "Designed in France: Notes on the Transmission of French Style to America." In *Winterthur Portfolio 12,* edited by Ian M. G. Quimby, 103–14. Charlottesville: University Press of Virginia for the Henry Francis du Pont Winterthur Museum, 1977.

Balderrama, Maria R., ed. *Wifredo Lam and His Contemporaries, 1938–1952.* Exh. cat. New York: Studio Museum in Harlem, 1992.

Barter, Judith A., et al. *Mary Cassatt: Modern Woman.* Exh. cat. Chicago: Art Institute of Chicago, 1999.

Choquette, Leslie. *Frenchmen into Peasants: Modernity and Tradition in the Peopling of French Canada.* Cambridge, Mass.: Harvard University Press, 1997.

Cikovsky, Nicolai, Jr., and Franklin Kelly. *Winslow Homer.* Exh. cat. Washington, D.C.: National Gallery of Art, 1995.

Cooper, Helen A. *John Trumbull: The Hand and Spirit of a Painter.* Exh. cat. New Haven: Yale University Art Gallery, 1982.

Cronin, Vincent. *Paris: City of Light, 1919–1939.* New York: HarperCollins, 1994.

Eccles, W. J. *Canada under Louis XIV, 1663–1701.* Toronto: McClelland and Stewart, 1964.

———. *The Canadian Frontier, 1534–1760.* Reprint, Albuquerque: University of New Mexico Press, 1983.

Hills, Patricia, and Melissa Renn. *Syncopated Rhythms: 20th-Century African American Art from the George and Joyce Wein Collection.* Exh. cat. Boston: Boston University Art Gallery, 2005.

Jaffe, Irma B. *John Trumbull: Patriot-Artist of the Revolution.* Boston: New York Graphic Society, 1975.

Johns, Elizabeth. *Thomas Eakins: The Heroism of Modern Life.* Princeton: Princeton University Press, 1983.

Mathews, Nancy Mowll. *Mary Cassatt: A Life.* New York: Villard Books, 1994.

Palardy, Jean. *The Early Furniture of French Canada.* Translated from the French by Eric McLean. Toronto: Macmillan of Canada, 1963.

Poesch, Jessie J. *Early Furniture of Louisiana.* Exh. cat. New Orleans: Louisiana State Museum, 1972.

Pritchard, James. *In Search of Empire: The French in the Americas, 1670–1730.* New York: Cambridge University Press, 2004.

Sewell, Darrel, et al. *Thomas Eakins.* Exh. cat. Philadelphia: Philadelphia Museum of Art, 2001.

Sims, Lowery Stokes. *Wifredo Lam and the International Avant-Garde, 1923–1982.* Austin: Texas University Press, 2002.

Sims, Lowery Stokes, et al. *Stuart Davis: American Painter.* Exh. cat. New York: Metropolitan Museum of Art, 1992.

Wilkin, Karen. *Stuart Davis.* New York: Abbeville Press, 1987.

Italy

Brooklyn Museum. *The American Renaissance, 1876–1917.* Exh. cat. New York: Pantheon Books, 1979.

Brown, David Alan. *Raphael and America.* Exh. cat. Washington, D.C.: National Gallery of Art, 1983.

Craven, Wayne. *Sculpture in America.* New York: Thomas Y. Crowell, 1968.

Harris, Neil. *The Artist in American Society: The Formative Years, 1790–1860.* New York: George Braziller, 1966.

Jaffe, Irma. *The Italian Presence in American Art, 1760–1860.* New York: Fordham University Press, 1989.

———. *The Italian Presence in American Art, 1860–1920.* New York: Fordham University Press, 1992.

Mangione, Jerre, and Ben Morreale. *La Storia: Five Centuries of the Italian American Experience.* New York: HarperCollins, 1992.

Miller, Lillian B. *Patrons and Patriotism: The Encouragement of the Fine Arts in the United States, 1790–1860.* Chicago: University of Chicago Press, 1966.

Nichols, Sarah, Susanne K. Frantz, and Matthew Kangas. *Viva Vetro! Glass Alive! Venice and America.* Exh. cat. Pittsburgh, Pa.: Carnegie Museum of Art, 2007.

Stebbins, Theodore E., Jr., et al. *The Lure of Italy: American Artists and the Italian Experience, 1760–1914.* Exh. cat. Boston: Museum of Fine Arts, in association with Harry N. Abrams, 1992.

Vance, William L. *America's Rome.* New Haven: Yale University Press, 1989.

Vance, William L., et al. *America's Rome: Artists in the Eternal City, 1800–1900.* Exh. cat. Cooperstown, N.Y.: Fenimore Art Museum, 2009.

Wolanin, Barbara A. *Constantino Brumidi: Artist of the Capitol.* Washington, D.C.: U.S. Government Printing Office, 1998.

Germany

Bergdoll, Barry, and Leah Dickerman. *Bauhaus: Workshops for Modernity, 1919–1933.* Exh. cat. New York: Museum of Modern Art, 2009.

Bivins, John, Jr. *The Moravian Potters in North Carolina.* Chapel Hill: University of North Carolina Press for Old Salem, 1972.

Bookbinder, Judith. *Boston Modern.* Durham: University of New Hampshire Press, 2005.

Borchardt-Hume, Achim, ed. *Albers and Moholy-Nagy: From the Bauhaus to the New World.* Exh. cat. New Haven: Yale University Press, 2006.

The Düsseldorf Academy and the Americans. Exh. cat. Atlanta: High Museum of Art, 1972.

Fabian, Monroe. *The Pennsylvania-German Decorated Chest.* New York: Universe Books, a Main Street Press Book, 1978.

Fiedler, Jeannine, ed. *Bauhaus.* Cologne: Könemann, 2006.

Fleming, Donald, and Bernard Bailyn. *The Intellectual Migration: Europe and America, 1930–1960.* Cambridge, Mass.: Belknap Press of Harvard University Press, 1969.

Forster-Hahn, Francoise, ed. *Imagining Modern German Culture, 1889–1910.* Washington, D.C.: National Gallery of Art, 1996.

Fuhrmeister, Christian, Hubertus Kohle, and Veerle Thielemans, eds. *American Artists in Munich: Artistic Migration and Cultural Exchange Processes.* Berlin: Deutscher Kunstverlag, 2009.

Garvan, Beatrice B., and Chales F. Hummel. *The Pennsylvania Germans: A Celebration of Their Arts, 1683–1850.* Exh. cat. Philadelphia: Philadelphia Museum of Art, 1982.

Gordon, Donald E. *Expressionism, Art and Idea.* New Haven: Yale University Press, 1987.

Herr, Donald M. *Pewter in Pennsylvania German Churches.* Birdsboro, Pa.: Pennsylvania German Society, 1995.

Hofmann, Hans. *Search for the Real.* Edited by Sara T. Meeks and Bartlett H. Hayes. 1948. Reprint, Andover, MA: Addison Gallery of American Art, in association with MIT Press, 1967.

Horowitz, Frederick, and Brenda Danilowitz. *Josef Albers: To Open Eyes; The Bauhaus, Black Mountain College, and Yale.* New York: Phaidon Press, 2006.

Josef Albers: A Retrospective. Exh. cat. New York: Solomon R. Guggenheim Museum, 1988.

Kornhauser, Elizabeth Mankin, ed. *Marsden Hartley.* Exh. cat. New Haven: Yale University Press, 2003.

Lanmon, Dwight P., and Arlene M. Palmer. "The New Bremen Glassmanufactory of John Frederick Amelung." *Journal of Glass Studies* 15 (1973): 9–128.

McKearin, George S., and Helen McKearin. *American Glass.* New York: Crown Publishers, 1948.

Montgomery, Charles F. *A History of American Pewter.* New York: Praeger Publishers, 1973.

Nelson, Kirk J. "The 'Short Biography' of the Glass Engraver Louis Vaupel." *Magazine Antiques* 149, no. 4 (April 1996): 564–73.

Neuhaus, Robert. *Unsuspected Genius: The Art and Life of Frank Duveneck.* San Francisco: Bedford Press, 1987.

Palmer, Arlene. *Glass in Early America: Selections from the Henry Francis du Pont Winterthur Museum.* Winterthur, Del.: Henry Francis du Pont Winterthur Museum, 1993.

———. "Glass Production in Eighteenth-Century America: The Wistarburgh Enterprise." *Winterthur Portfolio* 11 (1976): 75–101.

Paret, Peter. *Art as History: Episodes in the Culture and Politics of Nineteenth-Century Germany.* Princeton: Princeton University Press, 1988.

———. *German Encounters with Modernism, 1840–1945.* New York: Cambridge University Press, 2000.

Paternosto, César. *White/Red.* Exh. cat. New York: Cecilia de Torres, 2001.

Peters, Lisa N. "'Youthful Enthusiasm under a Hospitable Sky': American Artists in Polling, Germany, 1870s–1880s." *American Art Journal* 31, nos. 1–2 (2000): 56–91.

Quick, Michael. *An American Painter Abroad: Frank Duveneck's European Years.* Exh. cat. Cincinnati: Cincinnati Art Museum, 1987.

Quick, Michael, Eberhard Ruhmer, and Richard V. West. *Munich and American Realism in the 19th Century.* Exh. cat. Sacramento, Calif.: E. B. Crocker Art Gallery, 1978.

Spillman, Jane Shadel. "American Glass in the Bohemian Style." *Magazine Antiques* 149, no. 1 (January 1996): 146–55.

Steinfeldt, Cecilia, and Donald Lewis Stover. *Early Texas Furniture and Decorative Arts.* Exh. cat. San Antonio, Tex.: Trinity University Press for the San Antonio Museum Association, 1973.

Suhre, Terry. *Moholy-Nagy: A New Vision for Chicago.* Exh. cat. Springfield: University of Illinois Press, 1991.

Swank, Scott T., et al. *Arts of the Pennsylvania Germans.* New York: W. W. Norton for the Henry Francis du Pont Winterthur Museum, a Winterthur Book, 1983.

Taylor, Lonn, and David B. Warren. *Texas Furniture: The Cabinetmakers and Their Work, 1840–1880.* Austin: University of Texas Press, 1975.

Van Ravenswaay, Charles. *The Arts and Architecture of German Settlements in Missouri: A Survey of a Vanishing Culture.* Columbia: University of Missouri Press, 1977.

Wilson, Kenneth M. *New England Glass and Glassmaking.* New York: Thomas Y. Crowell Company, 1972.

Wylie, Elizabeth. *Explorations in Realism, 1870–1880: Frank Duveneck and His Circle from Bavaria to Venice.* Exh. cat. Framingham, Mass.: Danforth Museum of Art, 1989.

Spain

Bailey, Gauvin Alexander. *Art of Colonial Latin America.* London: Phaidon Press, 2005.

Boone, M. Elizabeth. *Vistas de España: American Views of Art and Life in Spain, 1860–1914.* New Haven: Yale University Press, 2007.

Codding, Mitchell A. "A Legacy of Spanish Art for America: Archer M. Huntington and the Hispanic Society of America." In *Manet/Velázquez: The French Taste for Spanish Painting,* edited by Gary Tinterow and Geneviève Lacambre, 307–34. Exh. cat. New York: Metropolitan Museum of Art, 2003.

Falino, Jeannine, and Gerald W. R. Ward, eds. *Silver of the Americas, 1600–2000: Silver in the Museum of Fine Arts, Boston.* Boston: MFA Publications, 2008.

Fane, Diana, ed. *Converging Cultures: Art and Identity in Spanish America.* Exh. cat. New York: Brooklyn Museum, in association with Harry N. Abrams, 1996.

Hirshler, Erica E. *Sargent's Daughters: The Biography of a Painting.* Boston: MFA Publications, 2009.

Kagan, Richard L., ed. *Spain in America: The Origins of Hispanism in the United States.* Urbana: University of Illinois Press, 2002.

Kilmurray, Elaine, and Richard Ormond, eds. *John Singer Sargent.* Exh. cat. Princeton: Princeton University Press, 1998.

Pierce, Donna, Rogelio Ruiz Gomar, and Clara Bargellini, with an introduction by Jonathan Brown. *Painting a New World: Mexican Art and Life, 1521–1821.* Exh. cat. Denver: Frederick and Jan Mayer Center for Pre-Columbian and Spanish Colonial Art, Denver Art Museum, 2004.

Phipps, Elena, Johanna Hecht, and Cristina Esteras Martín. *The Colonial Andes: Tapestries and Silverwork, 1530–1830.* Exh. cat. New York: Metropolitan Museum of Art, 2004.

Taylor, Lonn, and Dessa Bokides. *New Mexican Furniture, 1600–1940: The Origins, Survival, and Revival of Furniture Making in the Hispanic Furniture.* Santa Fe: Museum of New Mexico Press, 1987.

Weber, David J. *The Spanish Frontier in North America.* New Haven: Yale University Press, 1992.

The Netherlands and Scandinavia

Baer, Ronni. *The Poetry of Everyday Life: Dutch Painting in Boston.* Exh. cat. Boston: MFA Publications, 2002.

Blackburn, Roderic H., et al. *Remembrance of Patria: Dutch Arts and Culture in Colonial America, 1609–1776.* Exh. cat. Albany, N.Y.: Publishing Center for Cultural Resources for the Albany Institute of History and Art, 1988.

Clark, H. Nichols B. "A Taste for the Netherlands: The Impact of Seventeenth-Century Dutch and Flemish Genre Painting on American Art, 1800–1860." *American Art Journal* 14, no. 2 (1982): 23–38.

Goodfriend, Joyce D., Benjamin Schmidt, and Annette Stott. *Going Dutch: The Dutch Presence in America, 1609–2009.* Leiden: Brill, 2008.

Jacobs, Jaap. *The Colony of New Netherland: A Dutch Settlement in Seventeenth-Century America.* Ithaca, N.Y.: Cornell University Press, 2009.

Krohn, Deborah L., and Peter N. Miller, eds. *Dutch New York between East and West: The World of Margrieta van Varick.* Exh. cat. New York: Bard Graduate Center and New York Historical Society, 2009.

Mancini, J. M. "Discovering Viking America." *Critical Inquiry* 28, no. 4 (2002): 868–907.

Nooter, Eric, and Patricia U. Bonomi, eds. *Colonial Dutch Studies: An Interdisciplinary Approach.* New York: New York University Press, 1988.

Panetta, Roger, ed., *Dutch New York: The Roots of Hudson Valley Culture.* Exh. cat. New York: Hudson River Museum/Fordham University Press, 2009.

Shattuck, Martha Dickinson. *Explorers, Fortunes, and Love Letters: A Window on New Netherland.* Albany, N.Y.: New Netherland Institute and Mount Ida Press, 2009.

Shorto, Russell. *The Island at the Center of the World: The Epic Story of Dutch Manhattan and the Forgotten Colony That Shaped America.* New York: Doubleday, 2004.

Stott, Annette. *Holland Mania: The Unknown Dutch Period in American Art and Culture.* Woodstock, N.Y.: Overlook Press, 1998.

Africa

Bearden, Romare, and Harry Henderson. *A History of African-American Artists: From 1792 to the Present.* New York: Pantheon Books, 1993.

Chase, Judith Wragg. *Afro-American Art and Craft.* New York: Van Nostrand Reinhold Company, 1971.

Driskell, David. *Two Centuries of Black American Art.* Exh. cat. Los Angeles: Los Angeles County Museum of Art; New York: Alfred A. Knopf, 1976.

Flam, Jack D., and Miriam Deutch. *Primitivism and Twentieth-Century Art: A Documentary History; The Documents of Twentieth-Century Art.* Berkeley: University of California Press, 2003.

Gaither, Edmund Barry. "African and African American Art: An African American Legacy." In *Art of the Senses: African Masterpieces from the Teel Collection,* edited by Suzanne Preston Blier, 43–51. Boston: MFA Publications, 2004.

Gilroy, Paul. *The Black Atlantic: Modernity and Double Consciousness.* Cambridge, Mass.: Harvard University Press, 1993.

Grossman, Wendy, Martha Ann Bari, and Letty Bonnell. *Man Ray, African Art, and the Modernist Lens.* Exh. cat. Washington, D.C.: International Arts and Artists, 2009.

Holloway, Joseph E. *Africanisms in American Culture.* Bloomington: Indiana University Press, 1990.

Landsmark, Theodore C. "Comments on African American Contributions to American Material Life." *Winterthur Portfolio* 33, no. 4 (1998): 261–82.

Okpewho, Isidore, Carole Boyce Davies, and Ali A. Mazrui, eds. *The African Diaspora: African Origins and New World Identities.* Bloomington: Indiana University Press, 1999.

Powell, Richard J. *Black Art and Culture in the 20th Century: World of Art.* New York: Thames and Hudson, 1997.

Rosengarten, Dale, Theodore Rosengarten, and Enid Schildkrout. *Grass Roots: African Origins of an American Art.* Exh. cat. New York: Museum for African Art, 2008.

Vlach, John Michael. *The Afro-American Tradition in Decorative Arts.* Exh. cat. Cleveland: Cleveland Museum of Art, 1978.

Walker, Sheila S. *African Roots / American Cultures: Africa in the Creation of the Americas.* Lanham, Md.: Rowman and Littlefield, 2001.

The Near East

Bernstein, William J. *A Splendid Exchange: How Trade Shaped the World.* New York: Atlantic Monthly Press, 2008.

Blair, Sheila S., and Jonathan M. Bloom. "The Mirage of Islamic Art: Reflections on the Study of an Unwieldy Field." *Art Bulletin* 85, no. 1 (March 2003): 152–84.

Breskin, Isabel. "'On the Periphery of a Greater World': John Singleton Copley's 'Turquerie' Portraits." *Winterthur Portfolio* 36, nos. 2–3 (Summer–Autumn 2001): 97–123.

Edwards, Holly. *Noble Dreams, Wicked Pleasures: Orientalism in America, 1870–1930.* Exh. cat. Princeton: Princeton University Press, 2000.

Forman, Benno M. *American Seating Furniture, 1630–1730.* New York: W. W. Norton, 1988.

Grier, Katherine C. *Culture and Comfort: People, Parlors, and Upholstery, 1850–1930.* Exh. cat. Rochester, N.Y.: Strong Museum, 1988.

King, Donald, and David Sylvester, eds. *The Eastern Carpet in the Western World: From the 15th to the 17th Century.* Exh. cat. London: Arts Council of Great Britain, 1983.

Komaroff, Linda, ed. "Exhibiting the Middle East: Collections and Perceptions of Islamic Art." Special issue, *Ars Orientalis* 30 (2000).

Miranda, Héctor Rivero Borrell, et al. *The Grandeur of Viceregal Mexico: Treasures from the Museo Franz Mayer.* Exh. cat. Houston: Museum of Fine Arts; Mexico City: Museo Franz Mayer, 2002.

Ribero, Aileen. *Dress in Eighteenth-Century Europe, 1715–1789.* New Haven: Yale University Press, 2002.

Said, Edward W. *Orientalism.* New York: Pantheon Books, 1978.

Silberman, Neil Asher. *Digging for God and Country: Exploration, Archaeology, and the Secret Struggle for the Holy Land, 1799–1917.* New York: Alfred A. Knopf, 1982.

Sullivan, Edward J. "Interview with Claudio Bravo." In *Claudio Bravo and Morocco.* Exh. cat. Paris: Institut du Monde Arabe, 2004.

Swain, Margaret. "The Turkey-Work Chairs of Holyroodhouse." In *Upholstery in America and Europe from the Seventeenth Century to World War I,* edited by Edward S. Cooke, Jr., 51–63. New York: W. W. Norton, 1987.

Asia

Adams, Henry. "John La Farge's Discovery of Japanese Art: A New Perspective on the Origins of Japonisme." *Art Bulletin* 67, no. 3 (September 1985): 449–85.

Belgrad, Daniel. *The Culture of Spontaneity: Improvisation and the Arts in Postwar America.* Chicago: University of Chicago Press, 1988.

Berliner, Nancy, and Edward S. Cooke, Jr. *Inspired by China: Contemporary Furnituremakers Explore Chinese Traditions.* Exh. cat. Salem, Mass.: Peabody Essex Museum, 2006.

Burke, Doreen Bolger, et al. *In Pursuit of Beauty: Americans and the Aesthetic Movement.* Exh. cat. New York: Rizzoli for the Metropolitan Museum of Art, 1986.

Clarke, David James. "The Influence of Oriental Thought on Postwar American Painting and Sculpture." PhD diss., Courtauld Institute, London, 1988.

Crossman, Carl L. *The Decorative Arts of the China Trade.* Woodbridge, Suffolk: Antiques Collectors' Club, 1991.

Hirayama, Hina. "'A True Japanese Taste': Construction of Knowledge about Japan in Boston." PhD diss., Boston University, 1999.

Hosley, William. *The Japan Idea: Art and Life in Victorian America.* Exh. cat. Hartford, Conn.: Wadsworth Atheneum, 1990.

Impey, Oliver. *Chinoserie: The Impact of Oriental Styles on Western Art and Decoration.* New York: Charles Scribner's Sons, 1977.

Lancaster, Clay. *The Japanese Influence in America: The First Century Following Ratification of Perry's Treaty.* Salvisa, Ky.: Warwick Publications, 1983.

Lawson, Thomas, and Linda Merrill. *Freer: A Legacy of Art.* New York: Harry N. Abrams, 1993.

Lewison, Jeremy. *Brice Marden Prints, 1961–1991: A Catalogue Raisonné.* Exh. cat. London: Tate Gallery, 1992.

Matthews, Nancy Mowll, and Barbara Stern Shapiro, *Mary Cassatt: The Color Prints.* Exh. cat. New York: Harry N. Abrams, in association with Williams College Museum of Art, 1989.

Meech, Julia, and Gabriel P. Weisberg. *Japonisme Comes to America: The Japanese Impact on the Graphic Arts, 1876–1925.* New York: Harry N. Abrams, 1990.

Munroe, Alexandra, et al. *The Third Mind: American Artists Contemplate Asia, 1860–1989.* Exh. cat. New York: Guggenheim Museum, 2009.

Sigur, Hannah. *The Influence of Japanese Art on Design.* Layton, Utah: Gibbs Smith, 2008.

Wichmann, Siegfried. *Japonisme: The Japanese Influence on Western Art in the 19th and 20th Centuries.* New York: Harmony Books, 1980.

INDEX

CREDITS

Grateful acknowledgment is made to the copyright holders for permission to reproduce the following:

fig. 21: © CP

fig. 22: Courtesy of Ronald C. and Anita L Wornick. Reproduced with permission

fig. 42: Marsden Hartley materials are reproduced with the permission of the Yale University Committee on Literary Property

figs. 43, 44, 46, 47, 48, 50, 82, 132, 135, 149, 151, 152, 188, 193, 204, 224: Reproduced with permission

fig. 49: Permission given by Jaune Quick-to-See Smith (Enrolled Salish, member of the Confederated Salish and Kootenai Nation, Montana)

fig. 51: Copyright owned by Rick Rivet

fig. 52: © Estate of Fritz Scholder

fig. 79: © Edward Zucca

fig. 80 (pp. 76, 79, 99): © Stephen B. Browne

fig. 81: © Stephen De Staebler

fig. 83: © Marilyn Pappas

fig. 99: © 2010 Frank Lloyd Wright Foundation, Scottsdale, AZ / Artists Rights Society (ARS), NY

fig. 101: © David Hockney / Tyler Graphics Ltd.

fig. 116: Art © Estate of Stuart Davis / Licensed by VAGA, New York, NY

fig. 117 (pp. 126, 149): © 2010 Calder Foundation, New York / Artists Rights Society (ARS), New York

fig. 118: © Barthé Trust

fig. 136: © Dale Chihuly

fig. 137: © Lino Tagliapietra, Inc.

fig. 147: © Maria Zerbe Norton

fig. 148: © 2010 Renate, Hans & Maria Hofmann Trust / Artist Rights Society (ARS), New York

fig. 150: © 2010 Artists Rights Society (ARS), New York / VG Bild-Kunst, Bonn

figs. 153, 154: © 2010 The Josef and Anni Albers Foundation / Artists Rights Society (ARS), New York

fig. 159: Copyrighted

figs. 160, 161: © 2010 Georgia O'Keeffe Museum / Artists Rights Society (ARS), New York

fig. 162: Image copyright © The Metropolitan Museum of Art / Art Resource, NY

fig. 163: Erich Lessing / Art Resource, NY

fig. 168: Courtesy of the New Britain Museum of American Art

fig. 169: © Clemente V Orozco

figs. 170, 171: © 2010 Artists Rights Society (ARS), New York / SOMAAP, Mexico City

fig. 184: Art © Estate of Ilya Bolotowsky / Licensed by VAGA, New York, NY

fig. 185 (pp. 216, 235): Courtesy of Michael Rosenfeld Gallery, LLC, New York, NY

figs. 194 (pp. 21, 255), 195: © Estate of Max Weber

fig. 198: Art © Adolph and Esther Gottlieb Foundation / Licensed by VAGA, New York, NY

fig. 199: Copyright 1927 The Viking Press, Inc., renewed © 1955 by Grace Nail Johnson. Used by permission of Viking Penguin, a division of Penguin Group (USA) Inc.

fig. 200: © 2010 Artists Rights Society (ARS), New York / ADAGP, Paris

fig. 201: © Eldzier Cortor; Courtesy of Michael Rosenfeld Gallery, LLC, New York, NY

fig. 203: Art © Romare Bearden Foundation / Licensed by VAGA, New York, NY

fig. 205: © F. Cummings III 79

fig. 206 (pp. 246, 269): © Willie Cole

fig. 215: Courtesy of the Brooklyn Museum

fig. 227: © Claudio Bravo, courtesy Marlborough Gallery, New York

fig. 242: Courtesy of the Free Library of Philadelphia Archives

fig. 255: © 2010 The Pollock-Krasner Foundation / Artists Rights Society (ARS), New York

fig. 256: © Voulkos Family Trust. Ann Voulkos, Trustee

fig. 257: © 2010 Brice Marden / Artists Rights Society (ARS), New York

MFA PUBLICATIONS
Museum of Fine Arts, Boston
465 Huntington Avenue
Boston, Massachusetts 02115
www.mfa.org/publications

Support for this publication was provided by the
Vance Wall Foundation.

Additional support was provided by the
Andrew W. Mellon Publications Fund.

Copyright © 2010 by Museum of Fine Arts, Boston

ISBN 978-0-87846-760-0 (hardcover)
Library of Congress Control Number: 2010926784

All rights reserved. No part of this book may be repro-
duced in any form or by any electronic or mechanical
means, including information storage and retrieval
systems, without written permission from the publisher,
except in the case of brief quotations embodied in
critical articles and reviews.

The Museum of Fine Arts, Boston, is a nonprofit institu-
tion devoted to the promotion and appreciation of the
creative arts. The Museum endeavors to respect the copy-
rights of all authors and creators in a manner consistent
with its nonprofit educational mission. If you feel any
material has been included in this publication improperly,
please contact the Department of Rights and Licensing at
617 267 9300, or by mail at the above address.

While the objects in this publication necessarily represent
only a small portion of the MFA's holdings, the Museum
is proud to be a leader within the American museum
community in sharing the objects in its collection via its
Web site. Currently, information about more than 330,000
objects is available to the public worldwide. To learn more
about the MFA's collections, including provenance, publi-
cation, and exhibition history, kindly visit
www.mfa.org/collections.

For a complete listing of MFA publications, please contact
the publisher at the above address, or call 617 369 3438.

Front cover: Albert Bierstadt, *Valley of the Yosemite*,
detail (fig. 145).
Back cover: Olmec, Portrait mask (fig. 11).

All illustrations in this book were photographed by the
Imaging Studios, Museum of Fine Arts, Boston, except
where otherwise noted.

Edited by Fronia Simpson, Mark Polizzotti, and
Emiko K. Usui
Copyedited and proofread by Dalia Geffen

Designed by Cynthia Rockwell Randall
Produced by Terry McAweeney and Jodi Simpson
Printed and bound at Arnoldo Mondadori Editore,
Verona, Italy

Available through D.A.P. / Distributed Art Publishers
155 Sixth Avenue, 2nd floor
New York, New York 10013`
Tel.: 212 627 1999 · Fax: 212 627 9484

FIRST EDITION
Printed and bound in Italy
This book was printed on acid-free paper.

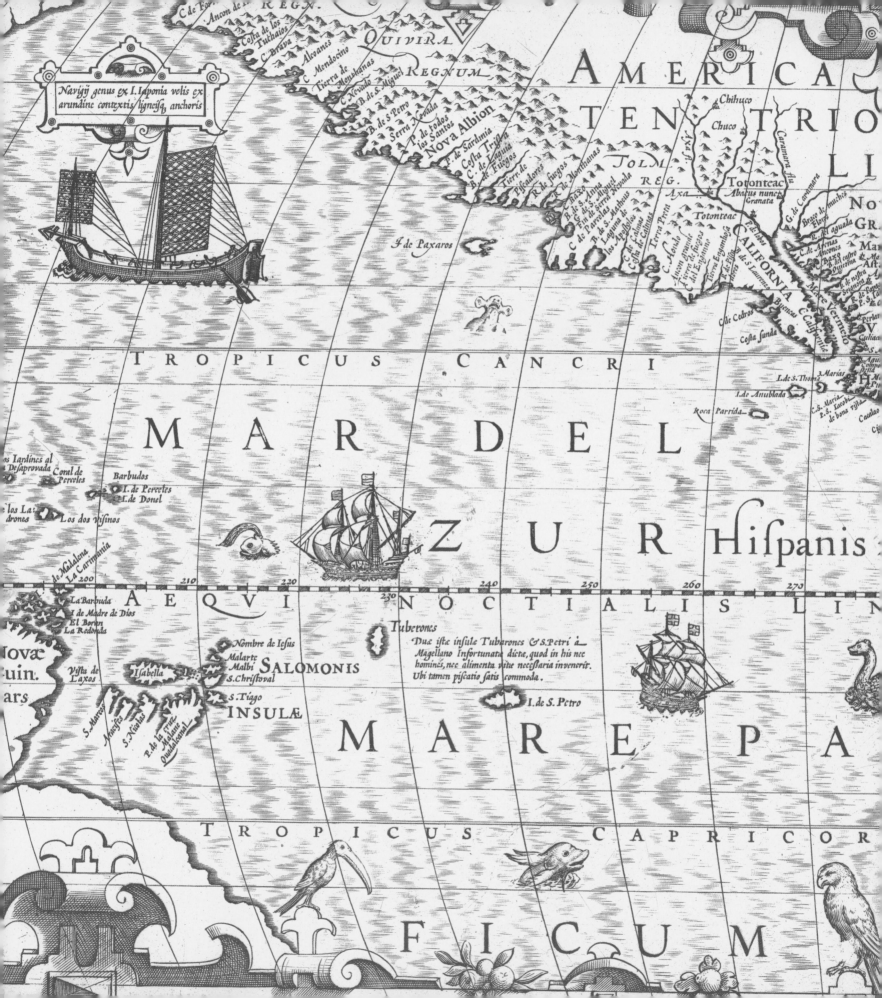

REGN.

C. de Far. Ancon de
Costa de los
Tuchaios
C. Brava QUIVIRA AMERICA

Alcoanes
C. Mendocino REGNUM TEN TRIO
C. Tierra de
Monthanas Chihuço

C. Nevada B. de S. Miguel LI
B. de S. Petro Chuco
Serra Nevada Nova Albion Caramara flu.
T. de Fodos
los Santos
T. de Sardinia TOLM Totonteac

Costa Trista Abatus nunc
C. de Laguia Granata No
C. de Fuegos REG. G. de Caramara
Tierr. de AXA Brazo de muchis GRA.
Pischadores R. de fuegos Florio
R. de Monthanas Totonteac R. del aguala
C. de Baxo C. de Arenas Ma
B. de S. Anna
I. de S. Miguel Ancones
Fin de Serra Nevada B. del castro & M
de Parcelas Quicaina Aft
B. de S. Matheus R. de nostra
B. de S. Matheus CALIFORNIA Sennora
Laguna de Monte R. de Eng.
los Apostolos R. de Pillo P. S. Io.
C. de Colima des oltres P. E. S. I
Costa de Calmas Tierra Engantosa Perla
Ancon grande Tierra de fuegos V
Tierra Prieta del Engano Culiaca
I de Paxaros C. Aendo Aqu
CALIFORNIA Buenas
C. de Cedros Montie I. de S. Thom. I. Marias
Costa funda I. de Anublada H.

TROPICUS CANCRI S. Maria

Roca Parrida P. S. Iacobi
de bona vista
MAR DEL Cacalao
Cig

os Iardines al
Desaprovada
Coral de Barbudos
Percelos I. de Percelos
I. de Donel
os La: Los dos visinos
drones ZUR Hispanis

de Malalena
La Carimania
200 210 220 240 250 260 270

La Barbuda AEQVI 230 NOCTIALIS LIN
I de Madre de Dios
El Boven Tuberones
La Redonda Due iste insule Tuberones & S. Petri à
Magellano Infortunate dicte, quod in his nec
Novæ Nombre de Iesus homines, nec alimenta vite necessaria invenerit.
Guin. Malarte Ubi tamen piscatio satis commoda.
ars Vista de Malbi SALOMONIS
Laxos Isabella S. Christoval
S. Marcos S. Tiago
Meusses INSULÆ I. de S. Petro
S. Nicolas
I. de la cruz MAR E PA
Malane
Quadacanal

TROPICUS CAPRICOR

FICUM